Psychology and Culture

91-161

For Marilyn, Jay, Alyssa, and Andrea,
and for Nancy, Andrea, and Wendy

Psychology and Culture

Editors:

Walter J. Lonner
Center for Cross-Cultural Research
Department of Psychology
Western Washington University

Roy S. Malpass
Department of Psychology
University of Texas at El Paso

Allyn and Bacon
Boston • London • Toronto • Sydney • Tokyo • Singapore

Vice President, Publisher: Susan Badger
Editorial Assistant: Laura Ellingson
Production Administrator: Marjorie Payne
Editorial-Production Service: Chestnut Hill Enterprises, Inc.
Cover Administrator: Linda Dickinson
Composition Buyer: Linda Cox
Manufacturing Buyer: Megan Cochran

Copyright © 1994 by Allyn and Bacon
A Division of Simon & Schuster, Inc.
160 Gould Street
Needham Heights, MA 02194

Library of Congress Cataloging-in-Publication Data

Psychology and culture/editors, Walter J. Lonner and Roy
 S. Malpass.
 p. cm.
 Includes bibliographical references (p.) and index.
 ISBN 0-205-14899-9 (acid-free paper)
 1. Ethnopsychology. I. Lonner, Walter J. II. Malpass, Roy S.
GN502.R43 1994
155.8—dc20
 93-14050
 CIP

Printed in the United States of America
10 9 8 7 6 5 4 99 98 97 96

Contents

Preface

About 25 years ago, in the mid-1960s, a number of developments took place that heralded significant changes in how a growing number of psychologists viewed their field. These changes involved taking culture and ethnicity much more seriously than ever before in psychology's approximately 110-year history. Until these developments, relatively few experiments or studies were done in the non-Western world or among ethnic groups in multicultural societies such as the United States and Canada. Consequently, the millions of students who took basic psychology courses annually in the United States and other Western countries were subjected to a strongly biased and restricted data base. Indeed, people who finished such courses were led to believe that what they had learned about human behavior from this narrow perspective was valid everywhere. This was an unfortunate state of affairs, but such shortsightedness is currently being rectified throughout the world. The psychologists who wish to help correct this imbalance describe their work as *cultural* or *cross-cultural* depending mostly on the methods used in their research. Like their colleagues in anthropology who examine behavior from the level of entire groups or cultures, these psychologists carefully study how and why culture, ethnicity, and ecological factors affect human behavior—but at the level of the *individual*. That is, how does *my* culture, ethnicity, and environment influence *my* behavior?

One of the pioneers in the study of relationships between psychology and culture, Professor Emeritus Gustav Jahoda of Scotland, colorfully and accurately described the situation as it existed in the late 1960s when he wrote (in 1970) that this state of affairs (meaning psychology's constrained borders) reminds one

> of Parson Thwackum in Tom Jones [Henry Fielding's humorous 1749 novel about a commoner being raised among the English nobility] who said, "When I mention religion, I mean the Christian religion; and not only the Christian religion, but the Protestant religion, and not only the Protestant religion, but the Church of England." This might well be suitably transposed as "When I mention a psychological subject, I mean a subject from a western industrialized culture; and not only from a western industrialized culture, but an American; and not only an American, but a college student." No doubt this is unfair, reflecting as it does the amount of work that has been done in the United States. Nonetheless, the excessive concentration on such an odd (as far as humanity at large is concerned) population makes one wonder about the range of application of the "laws" experimentally derived in this manner (p. 2).

Several years later, Robert Guthrie, an accomplished U.S. psychologist, echoed Jahoda's concerns about psychology's myopia in the important area of learning theory. He pointed out that, for the better part of psychology's history, much of what had been established about how organisms learn was based on experi-

mentation with animals such as rats, mice, and rabbits. Such animals are inexpensive, extremely similar (especially within each species), and they don't show up late for experiments or criticize what the experimenter is doing. When humans instead of animals were subjects, little attention was given to the cultural context in which learning took place, no doubt because widely varying cultural contexts would tend to mess up otherwise neat and clean experimental designs. Guthrie's criticism of this narrowness was contained in his book with the tellingly pithy title *Even the Rat Was White* (Guthrie, 1976).

During this period of increasing activity aimed at expanding psychology's horizons, a large number of books in the area were published. Several specialized journals were also inaugurated, the most important of which (in our opinion) was the *Journal of Cross-Cultural Psychology*, which first appeared in 1970. Paralleling this activity in publications, a growing number of institutions, mainly in the United States and Canada, began to offer courses in psychology that made culture and ethnicity the focal point. For instance, one of us (WJL) designed a course at Western Washington University about 20 years ago, giving it the title "Psychology and Culture." A number of books and other reading materials have been used in that course but only with limited success. Key books in the area were (and, in our opinion, still are) either too advanced for a beginning undergraduate audience or too focused on one topic. What usually worked better than anything else was a packet of highly selected readings (book chapters, journal articles, and several personal manuscripts), generally designed a bit differently for each course. Yet that approach was also not as satisfactory as desired. Thus the book you now hold in your hands was to some extent born out of frustration. We were frustrated that we could not direct students who wanted to learn about culture's influence on the psychological makeup of individuals from different corners of the world to a relatively inexpensive book that would introduce them to a wide assortment of psychological topics in simple language.

We decided that such a book could best be developed by including a large number of short and easy-to-read chapters, written by authorities in the field. However, like all academics who decide to put together a book of original readings we immediately had to face a daunting and challenging task—which topics to include, and whom to ask to write about the topics that we selected. Psychology is a vast and varied discipline. Hardly anything in everyday life, especially when it involves behavior, thought, and social interaction, can escape psychological scrutiny and analysis. What we have done in this book, therefore, is to include a fairly broad *sample* of topics that have been chosen to introduce beginning students to the interesting area of cross-cultural psychology—an area in which psychology and its enormous range of topics is placed in juxtaposition with an even more enormous range of lifestyles or worldviews that are commonly called *cultures* or *ethnic groups*. To help explain this interface between the topics of psychology and the realities and vicissitudes of culture, we enlisted the aid of nearly sixty individuals who are experts in specific areas. The authors we lined up form an impressive list of psychologists and a few scholars who represent other disciplines who have spent most of their careers trying to understand interrelationships between culture and human behavior. We are indebted to them for agreeing to write *original* short chapters exclusively for this book.

The introductory chapter, written by the editors, summarizes the nature and purposes of cross-cultural psychology and several of its major problems and difficulties. We believe that a careful reading of that chapter *first* will prime the pump so to speak, and prepare the reader for the rest of the book. The 43 chapters cover many important topics. However, these topics are only, but importantly,

representative of the wondrously diverse field of psychology. Just scan the topics listed in the contents and notice the variety of coverage.

The topics we chose are central to an understanding of the many ways in which culture and ethnicity interact with human behavior, thought, and action. For instance, we have chosen chapters on human development, on intelligence, on memory and perception, on problems of adjusting to other cultures, on depression, on diagnosis, and so on.

The topics have been arranged by section—seven of them. Each section begins with a brief introduction to some of the focal issues raised in particular areas. Arranging the chapters into seven sections of roughly equal length was based partially on common sense and partially on arbitrary placement. The skilled and insightful instructor or student will be able to discover different and interesting ways to arrange or to "package" all these chapters. But that's not the main point we want to make. *All* the chapters are important on their *own* terms and each chapter is in many interesting ways linked with each of the other 42 chapters. The dedicated scholar will forge and manufacture such linkages in a creative effort to understand the essential *interconnectedness* of these chapters.

More than anything else, we hope that this book will give the relatively unsophisticated and culturally naive beginning student a taste of the many flavors that make up the seemingly endless smorgasbord of topics that psychology offers, all of which can be expected to vary by culture. Furthermore, we hope that students, with their instructors, will identify (as we have done in our own classes) interesting topics that can be researched by individuals or groups. Such projects can be used to *supplement* the many chapters in this book.

For many years we have received telephone calls and letters from fellow college and university instructors seeking advice. Having heard of our dedication to cross-cultural psychology, or having heard that we have designed undergraduate courses in this area, many have wanted help in selecting books or appropriate readings. It is going to be a happy day, after this book has been published, to tell people that *Psychology and Culture* should serve their needs well. Perhaps future calls we receive from colleagues will be more advisory, *to us*. We might be told, for example (and we hope we are), that we missed an important topic or an important point. That can only help us in the future when we attempt to improve this text—so goes the progression of knowledge, and so goes the improvement of books. So just to let you, the student, know that we are serious about getting your feedback as well as commentary from your instructors, here are our addresses:

Walter J. Lonner
Center for Cross-Cultural Research
Department of Psychology
Western Washington University
Bellingham, WA 98225 U.S.A.
E-Mail: LONNER@NESSIE.CC.WWU.EDU
Fax: (206) 650-3693

Roy S. Malpass
Department of Psychology
University of Texas at El Paso
El Paso, TX 79968 U.S.A.
E-Mail: EPRM@UTEP.BITNET
Fax: (915) 747-5505

Let us know what you like, what you don't like, what we ought to have done instead, and what we ought to make sure to do for the next (we hope) edition.

We also have a number of people to thank. Heading the list are Marilyn Lonner and Nancy Malpass, for putting up with us during the year-and-a-half it took to put all the pieces of this book together. Golf "widows" suffer through a lot; so do editors' "widows." Edited books with many chapters, such as this one,

are difficult to complete without frustrating delays. Juggling class schedules and other obligations adds to the frustration. And one of us (RSM) actually changed jobs and, in effect, cultures midway through work on the book when he left his position at SUNY-Plattsburgh for a position at the University of Texas at El Paso.

The many contributors to this book are the main people to be thanked for accepting our invitations to write short chapters. Only three of the original 45 invitees could not, finally, accept our invitation.

We are grateful to Susan Badger of Allyn and Bacon for being the first of several editors at major publishing companies to express strong interest in this book. Our thanks also go to a number of anonymous reviewers who not only gave us some good ideas about organization but also were unwavering in their encouragement to continue with this project. Thanks also to various support people at Western Washington University for their assistance during the past 15 months. This short list primarily includes Cathie Patrick, Meredith Jacobsen, and Ruth Hackler, all of the Department of Psychology. At UTEP, thanks go to Whitney McKinley of the Criminal Justice Department.

References

Guthrie, R. (1976) *Even the rat was white: A historical view of psychology.* New York: Harper and Row.

Jahoda, G. (1970) A cross-cultural perspective in Psychology. *Advancement of Science, 27,* 1–14. [Presidential Address delivered to Section J (Psychology) on September 4, 1970 at the Durham Meeting of the British Association]

Psychology and Culture

When Psychology and Culture Meet: An Introduction to Cross-Cultural Psychology

WALTER J. LONNER AND ROY S. MALPASS

For both of us, launching this volume of original commentaries on cross-cultural psychology is a rewarding and long-awaited experience. We have spent most of our careers teaching at both the undergraduate and graduate level, and have taught a variety of courses of various sizes over a wide range of topics. But we have never faced an audience of the size that this book will (we hope) reach. And the timing for this message about the cultural aspects of psychology has never been better. So we have to take more seriously than usual the need to be clear about what it is you should know about culture and behavior. We will try to write in plain and simple

language, and above all we will try to take a personal view of what we think is important. In doing so, we will try to speak directly and personally to you from our own life experiences.

SOME BACKGROUND CONSIDERATIONS

The findings of researchers in the natural sciences, such as chemistry and physics, are almost certainly as valid in rural Japan, busy and bustling Bangkok, the placid fiords of Norway, or the Florida Ever-

Walter J. Lonner is Professor of Psychology and Director of the Center for Cross-Cultural Research at Western Washington University in Bellingham. Born and bred in multi-ethnic Butte, Montana, he has bittersweet memories of working, in his late teens and early twenties, with people from many countries in Butte's world famous copper mines. His Ph.D. is from the University of Minnesota, where ice rather than copper is mined. Both places, for different reasons, taught him the value of education. He is the Founding Editor (and currently Senior Editor) of the *Journal of Cross-Cultural Psychology*, started in 1970. Lonner served as president of the International Association for Cross-Cultural Psychology from 1986 to 1988. He has spent sabbatical-research years in Mexico and Germany, the latter as a Fulbright scholar. His main interests in cross-cultural research include methodological problems and issues and introducing cross-cultural psychology to younger students, where it may eventually do the most good.

Roy S. Malpass is Professor of Psychology and Director of the Criminal Justice Program at the University of Texas at El Paso. His Ph.D. is in Social Psychology from Syracuse University. His research interests are focused on cross-race face recognition and the effects of intergroup social experience. This interest led to research on eyewitness identification, facial recognition in laboratory and field settings, and computer-based simulations of social experience. He has also written extensively on cross-cultural research methodology. Malpass is a past President of the Society for Cross-Cultural Research and is currently President of the International Association for Cross-Cultural Psychology. He is the founding President of the Psychology and Law Division of the International Association for Applied Psychology. As a youth Malpass spent many happy times in New York's Adirondack mountains. He has a lifelong affection for the Adirondacks, and during the summer he often can be found there, walking, canoeing, swimming, or snoozing.

glades as they are anywhere else on the planet. Well-established laws that govern the non-human world serve as reliable guides to workers in these fields. They have served humankind as guides for many years and we can all be confident that they will continue serving us well as we muddle our way through a very complex world of minerals, plants, quarks, anteaters, and so on. But unlike these sciences, psychology and its sister disciplines, such as anthropology and sociology, must deal with the *extremely* dynamic and complex human being who survives by moving and adapting. This has produced a great variety of cultures and ethnic groups.

The typical psychology text contains hundreds of concepts, terms, and theories, all of which were designed by psychologists to help explain, predict, and (maybe) control human behavior. Most of these abstractions are used *as if* it has already been established that they are applicable everywhere. This is a premature if not dangerous assumption to make. Because modern psychology was developed largely in the Western world, we must be careful when any of these concepts, terms, and theories are used in many parts of the world. Just because some psychological term or concept has been useful in the culture in which these ideas originated—the United States or Canada, for example—does *not* automatically mean they can be transported elsewhere and used with the same level of confidence.

To a very large extent, psychology has been culture-bound and culture-blind. It is *culture-bound* because its roots are deeply planted in the rich and productive soil of European-American thought and theory. Consequently, modern psychology has developed without significant input from scientists and thinkers who represent the non-Western world. It has been estimated that over 90 percent of all psychologists *who have ever lived* are from the Western world. It has also been estimated that over 90 percent of all the world's psychological literature has come from the minds of Westerners and laboratories in the industrialized world. This obviously means that the vast majority of psychological research and scholarship on humans have used people from the "highly psychologized" world—that is, those parts of the world that have been studied intensely because that's where most of the psychologists have lived and worked.

The accusation of *culture-blindness* stems from the fact that psychology has not significantly taken into account a great variety of factors, *not* generally found in the West, that influence the behavior of millions of humans elsewhere. For instance, different values placed on children, different beliefs about how men and women should behave or be treated, different ways to diagnose illness, among many other widely differing antecedents to behavior, have not customarily been part of theory development or research designs in psychology. Some aspects of these factors, and much more, are found among the chapters in this book.

We mention these historical facts and trends *not* to "trash" our discipline (which we believe is important), but to alert the reader that any serious study of human psychology and its related disciplines must include cultural and ethnic variation. To ignore these realities, or to trivialize them, is to contribute to a science while wearing blinders. We strongly believe that psychology offers humanity a very important and interesting way to look at the world. However, we also believe that psychology must expand its vistas. In the words of the late Gardner Murphy, an influential United States psychologist, we must learn to "consult all that is human."

The study of psychology, indeed, the study of *any* of the social and behavioral sciences, is incomplete without giving serious consideration to the ecological, cultural, and ethnic factors that contribute to human variability. These factors exert powerful influences on human behavior. This fact is often overlooked or underemphasized in most of the many thousands of courses offered in the educational institutions in the United States and other countries—whether they are two-year community colleges or junior colleges, four-year colleges, or major universities. There are many different reasons for this short-sightedness. For instance, in the United States, the study of cultural variation has received little attention because the typical American (a term that rankles many because technically all people indigenous to North and South America can claim to be "American") has had relatively little direct contact and experience with other cultures. The increasing interdependence of the world's many cultures is, however, leading to a "shrinking world" and global economy in which the "survivors" will be acutely aware of cultural and ethnic differences, and will learn to live with and adapt to these differences. By the same token, the "non-survivors" will be too slow to adjust to the realities of the shrinking globe. Also, within different nations one usually finds strong efforts toward *heterogeneity* or cultural pluralism rather than the *homogeneity* of a "melting pot" mentality which was once highly

valued in the United States and still might be elsewhere. It has been projected that in less than a century the once white-dominant United States will be 24 percent Hispanic, 15 percent African-American, and 12 percent Asian-American. In other words, the *white* population in the United States will be in the *minority* for the first time in about three centuries. Other countries are experiencing similar dramatic demographic changes.

Moreover, one should not use the terms *racial* or *ethnic* minority without considering the very pluralistic nature of such minorities, most of whom represent wide variations in values, languages, family structures, political orientations, and so on. There are, for instance, several hundred recognized tribes or bands among the widely distributed Native American, or Native Canadian, populations. And, although the United States is one of the more heterogeneous and pluralistic of all nations, most of the rest of the world's nation-states can boast tremendous cultural and ethnic variation within their borders. Indeed, today's stories in the world's newspapers and news magazines will undoubtedly carry graphic reports on body counts, assassinations, coup d'etats, and the like as a result of racial and ethnic tensions. Identification with a particular group, a feeling of solidarity with "like-minded" people, a line drawn in the sand in the middle east or across a playground in an inner-city ghetto, are powerful forces that shape and define what we call *cultures* or *ethnic groups*.

Another reason for the relative lack of significant coverage of cultural variation in typical psychology courses is the scientist's desire to simplify events and behavior in the interest of finding psychological *order*. Science is basically a search for orderliness, a search for reasons why things work the way they do. Things that tend to be very complicated and hard to grasp, such as culture, might easily be avoided in this search for order. Complexity confuses; simplicity clarifies or so it seems.

Consider also that the United States has been a dominant economic, political, and military force for many years. The United States and its citizens have often been accused of cultural, economic, political, and even scientific snobbery—a situation that is rapidly changing in this tumultuous world. These factors have contributed to a sense of isolationism—a political stance that was once part of national policy in the United States and still remains somewhat popular among a sizeable minority of active politicians. The United States's unique geopolitical situation, where its neighbors have never

been a serious threat and instead have largely been congenial partners and allies, has led to a sort of malaise. As a result, the United States developed into a nation where most of its citizens have been monolingual and only superficially interested in the rest of the world. These different factors have contributed to "America bashing" and to such name-calling as the "ugly American" or the "superficial Yank."

Finally, it appears that a majority of teachers or professors who teach most of the psychology courses that are offered in the several thousand institutions throughout the United States are not very familiar with the considerable culturally-related literature that exists in many books and journals. Many who teach courses in the social and behavioral sciences may *want* to cover such topics as cultural and ethnic diversity. Indeed, we often receive phone calls and letters from instructors who request advice on such matters. But their busy schedules and relative lack of concrete ideas concerning how such courses might be structured can easily result in ignoring such important information or skirting by it in a most superficial way.

Taken together, all of these factors not only inhibit the growth of psychology but they tend to give an incomplete picture of the immense breadth and scope of human variation. If we do not understand such variation, we cannot fully appreciate the considerable regularities, or universals, there are in human behavior. Constraining factors such as these have been mentioned in various places lately, including a recent publication of the American Psychological Association (Bronstein and Quina, 1988) and also in a study that documented the relatively scant coverage in basic psychology texts of how and why culture influences human behavior (Lonner, 1990).

THE EMERGENCE OF THE STUDY OF PSYCHOLOGY AND CULTURE

There is a growing movement within psychology to help correct these deficiencies. As briefly noted in the Preface, a sizeable and increasing number of psychologists around the world are deeply involved with research that is designed to help psychology develop into a truly universal science. A major activity is to test the validity, or generalizeability, of psychological theory, and to help rectify discrepancies between theory and cultural realities.

It is in the spirit of wanting to help create a better and more complete psychology, and with it a broader and deeper understanding of other cultures and world views, that this book was prepared.

This book is not, however, a complete and formal introduction to cross-cultural psychology. By carefully scanning the short list of references that follow each chapter in this book, one will find a number of recent publications that give broad introductions to this area in psychology. Such publications contain much theory and many methodological points, and we recommend them highly. General orientations such as those you will find in the references are specially relevant for students

It is in the spirit of wanting to help create a better and more complete psychology, and with it a broader and deeper understanding of other cultures and world views, that this book was prepared.

who are considering psychology as a college major or even as a career, however, we feel that they are not quite appropriate for those who want to get a *taste* of the relationships that exist between psychology and culture. Accordingly, the main goal of this book of specially prepared readings is to introduce the student to a wide variety of topics, issues, and problems that are of major interest to cross-cultural psychologists and others who study the broad spectrum of human variability.

This book covers a lot of territory. We hope the reader will be convinced that the study of culture and behavior is important and interesting. For those who wish to delve more deeply into the subject, there are two excellent recent treatments of the subject (Berry, Poortinga, Segall, and Dasen, 1992; Shweder and Sullivan, 1993). But let's get personal for a moment. People from all over the world have been leaving their countries of origin for Western Europe and North America. If you are able to get to an international airport and watch who is getting on and off airplanes, you will see what we mean. The impact on you is that you are going to meet some of these people, maybe even hundreds of

them. You may end up working with or for (or even marrying) one of them. And your children are going to grow up with the children of their cross-cultural marriages—and maybe marry one of *them*. It is nearly certain that in your lifetime you will meet and get to know people with cultural backgrounds that differ from your own, that is, if you don't *already* have a number of such acquaintances. *It is in your own personal interest to understand the psychological aspects of culture.*

If you are attending a college where you do not have friends and acquaintances whose cultural background contrasts with your own, you are one of a small (and dying) breed. The worldwide trends toward increased contact are inescapable. Today the world is not just interconnected by mail and air travel, but by telephone, facsimile (fax), and computer-based (E-mail) communication. Even small companies and agencies have occasion to be in contact with and work with persons from and in other nations or cultures. Just as you will need to understand how to use computers to be competitive in the work environment of the 21st century, you will likely have to be able to work with people from a wide range of cultural backgrounds.

And the old ways of adapting to the United States (and perhaps other countries) are on the way out. It used to be that monolingual speakers of English could assume that other immigrants to North America would (usually gladly) learn English and give up their *foreign* culture to assimilate during the great influx of largely European immigrants 70 or 80 years ago. As was mentioned in the Preface, this was the "melting pot" concept that was prevalent at the time. But that's not happening much any more. The trend now is for newcomers to retain their cultural identity, and to do so with great pride and fanfare. In fact, there are strong reasons to believe that it is a *natural* human tendency to want to belong to some smaller, different group and not some monolithic nation-state with its homogenizing influences. This trend has not always been obvious. Running shoes and T-shirts are worldwide phenomena. It is startling to walk on a nearly deserted beach in Transkei (Southern Africa), only to be greeted by a young local man wearing a "Button your fly" T-shirt! It is also unsettling that a very popular pastime among a group of *very* traditional, non-Westernized youths in a remote area of New Guinea is to try to look, dress, and sing like Elvis Presley!

The shirts, shoes, and jackets worn all over the world would look familiar to even the casual

United States mall-walker, even though the local cultural differences might still be great. And, although the English language is becoming the "lingua franca" of the world, it does not mean that the Romanian (Haitian, Pakistani, Filipino) cab driver who picks you up at Kennedy airport, and who speaks to you in a reasonable approximation of English, goes home after work with a mindset that duplicates your own. It is in your own *personal* interest to understand the psychological aspects of culture. Consider this book of original readings on psychology and culture to be a starter kit toward reaching the goal of being more culturally sensitive and expansive in your global outlook.

We want to give you an example of what we mean when we say that learning about psychology and culture will benefit you personally. As coincidence would have it, just when one of us (Lonner) was in his office working on this chapter, one of his former students knocked on his door. LeAnn (not her real name) had just returned from France, where she spent the preceding term in a study abroad program. She came to Lonner's office and said, "I just want to tell you how much your course (psychology and culture, which she had taken some months earlier) contributed to making my trip to France a really great experience." Beaming and salivating for more praise to brighten up a cold and windy day, he asked LeAnn, now a senior psychology major, how this was so. She said, "When I went to France during my sophomore year I didn't enjoy it at all. Nothing made much sense. But this time I was able to see things differently. Many of the things we talked about and read about in your class just jumped out at me this time, in living color. The whole experience was wonderful because I was better equipped to see how all kinds of cultural things make the French what they are, and how and why the French differ from Americans and people from other countries as well."

Later in the day, Lonner reflected a bit about LeAnn's kind words. He wondered if her successful experience could be explained by the old proverb, "Experience is the best of schoolmasters," reflecting nothing at all about what was said or done in the course. Or maybe she just matured. On the other hand, he noticed that LeAnn's unsolicited report was totally consistent with one of the items on his course syllabus listed under *course objectives*. That item reads, "To help the student understand and appreciate cultural differences so that future intercultural interaction might be more enjoyable and productive." Several other course objectives were listed, most of them associated with academic goals.

Clearly, LeAnn benefited from learning about culture through books, papers, and discussion before experiencing it firsthand. Importantly, she thirsts for more travel and for more international travel and intercultural contact. She seems well on her way to becoming a student of the world, outstripping her age-mates who have yet to discover that the world is a large and fascinating place—a place to enjoy and experience and understand.

MORE ABOUT THIS BOOK

In the Preface, we explained some of the characteristics of this book. At this juncture we want to expand a bit on some of the points we made there. This book is an introduction to the kinds of questions and problems that are of interest to psychologists and other behavioral scientists who study interrelationships between culture and human behavior. As mentioned earlier, however, it is not a complete introduction. A comprehensive grounding in the various aspects of the world of cross-cultural research would require much more space than this book affords. For instance, a complete foundation would have to introduce students to many *methodological* problems such as how to make research studies equivalent across cultures, how to translate tests and instructions so that they are understood equally well in different languages, how to select appropriate samples of individuals to participate in experiments, and so on. Instead of emphasizing *methods*, this book presents a broad sampling of many *topics* that interest cross-cultural psychologists. Collectively, we believe that the readings in this volume give a unique and wide-ranging picture of assorted general concerns and problems facing mankind and how these concerns and problems are approached by cross-cultural researchers.

Each of the authors who prepared chapters for this book was selected on the basis of his or her expertise in specific areas. The authors were asked to tell, in his or her words, what he or she considers important to know at a fundamental level about the topic with which he or she has become intimately familiar by studying other cultures or by doing research in them. Each chapter was kept intentionally short so that we could have *breadth* of coverage rather than *depth* in a smaller number of areas. We

asked authors to emphasize what *they* think is important for the beginning student to know.

Each section of the book is concerned with a number of interrelated topics and questions, and each of the chapters concern a certain "slice" of these topics and questions. We asked each author (or authors) to provide a short list of references to which students could turn for further and more detailed information about each topic. As editors, we have introduced each section by explaining some of the more basic concerns and questions that each chapter, in its own way, covers.

The orientation throughout this volume is decidedly psychological. However, several of the authors represent other disciplines, including anthropology, sociology, and medicine. A few authors, though they are psychologists, are as familiar with other disciplines as they are with psychology. Counting ourselves, 57 experienced researchers representing approximately 25 different cultures or ethnic groups have contributed to this book. We are indebted to the many talented and experienced researchers and scholars who accepted our invitation to write chapters for this book.

And, finally, we must pay tribute to the large number of people throughout the course of human history who have tried to understand the immense complexities of human behavior. We are still somewhat smitten by the sense of awe that Theophrastos, one of Aristotle's students, must have felt in 319 B.C. when he said,

> *I have often applied my thoughts to the perplexing question—which will probably puzzle me forever—why, while all Greece lies under the same sky and all Greeks are educated alike, we have different personalities. I have been a student of human nature for a long time, and have observed the different composition of men. I thought I would write a book about it (Cohen, 1969).*

Theophrastos's puzzlement would have been compounded beyond his imagination had he known then about the total extent of human variation that the world embraced beyond Greece's skies during his days on earth; he would have been absolutely stunned if he could have peered nearly 2,400 years into the future. For (although it can never be known precisely), it is believed that there are now approximately 4,000 distinctly different psycholinguistic groups in the world. These groups range all the way from huge nation states like China

and the United States, to smaller groups such as the Basque people in Spain, or to tiny groups such as the Amish of Pennsylvania.

AN OVERVIEW OF SOME MAJOR CONCERNS IN STUDYING RELATIONSHIPS BETWEEN CULTURE AND BEHAVIOR

Understanding the relationships between culture and behavior is difficult both *conceptually* and *organizationally*. Regarding the latter, studying behavior "in the raw" or in the "real world" often creates problems of the kind that are never experienced within the warm surroundings of a cozy and well-heated psychology laboratory. In the field, things can get uncomfortably wet or dry, or dangerously hot or cold; one can become seriously ill and expect little or perhaps strange treatment. People who are counted on to participate in well-planned experiments may have no idea what the researcher is doing, or may never show up. Or they may tell falsehoods to humor, beguile, or thwart their foreign inquisitors. (One of our favorite cartoons depicts a family of *natives* in their home. One of the family members is saying, "Here come the anthropologists again! Quick, put the VCR and the chess set away, and throw those books under the waterbed!"). It may also be very difficult to find adequate funding to carry out the research, and to get enough time off from one's job at home to conduct research in exotic, unusual places. These logistical and organizational problems are enough to make one wonder if it's worth all the effort. On the positive side, it can be exhilarating to be in a totally different place and experience new languages, foods, and beliefs. Such forays into other parts of the world can also give one a sense of accomplishment, a feeling that something different, unique, and bold is being done.

When one does decide to delve into the broader world for research purposes, he or she must grapple with a number of conceptual problems. Several of these problems are summarized on the following pages.

Culture

A common word-game among cross-cultural psychologists is to ask, "What is Culture?" We play this game despite the fact that after many years of

studying the effects of "culture" on human behavior, neither they, nor anthropologists, nor anyone else has devised a definition that satisfies everyone. Almost unbelievably, about 175 definitions of culture can be found in the social scientific literature! These range from complex and fancy definitions to simple ones such as "culture is the programming of the mind" or "culture is the human-made part of the environment." We have neither the space nor the inclination here to weed through these definitions, or to tell you what we think is right or wrong about them. But it's an important concept that needs to be understood in at least a *general* way.

Back to our question, "What is Culture?" We have our own answer, but first we should build a context. Concepts like *values, personality, society, development,* and *culture* are not God-given ideas. They were not discovered written on the bottom of a rock somewhere amid the pyramids, or at some prestigious university! They are all rather recent constructions, made by social scientists. And like nearly all scientific concepts—physical, social, or behavioral—the concepts are used to name sets of observations, or ideas, that certain observations are thought to exemplify. So when adolescents wear clothing, use language, or listen to music that has the (likely) disapproval of their parents and other adults, it is often claimed that they "value" the favor of their friends more than their parents. That may or may not be true, but the abstract concept *value* was invented to explain such observations.

So what about culture? Culture is a term invented to characterize the many complex ways in which peoples of the world live, and which they tend to pass along to their offspring. It includes just about everything, from the stuff people own, make, buy, or trade (sometimes called *material culture,* and if you think it refers to the same things sung about by the "material girl," you're right), to family structure, to how life decisions are made, to how one plays with toys, to the position people assume when they say their prayers (if they say them) and go to the toilet.

Many uses of the term *culture* to explain differences between groups are circular. Culture is at least a label for a large category of differences among human groups. Using it as an *explanation* for these differences is like telling a man with an injury to his lower leg that he can't walk because he's lame, or like asserting that the reason a particular group of people frequently attacks its neighbors is because it's a warlike culture! Using a label as an explanation doesn't help our understanding very

much. So when it is claimed, in this book and elsewhere, that an observed difference between groups is cultural, what is meant generally is that the nature or importance of the difference can be found in one of the many differences suggested by the term *culture.* In other words, a more specific inquiry is usually needed to understand the difference.

Let's take an example from one of the chapters in this book. The concept of *intelligence* (a *highly* controversial concept) is thought by most researchers who study it to contain, in part at least, various visually related skills, like making stick figures, drawing, and modelling objects. It would be appropriate to say that there are cultural differences in this area of intelligence, as Robert Serpell shows in Chapter 23. It turns out that children in Zambia have a lot of experience making models out of wire and sticks, but they don't get to do too much drawing, like children from the highly industrialized Western world do. Some Zambian children are generally much better at making wire models and U.S. children are much better at drawing—both performances that are thought to be part of a certain kind of intelligence. To say that there are cultural differences in intelligence means, in this case, that because the cultures of Zambian and U.S. children differ in the materials used as part of modelling and making things, their representational skills are specialized in somewhat different ways. The *cause* of the differences lies within the respective cultures. To say that the difference is cultural just means that we have to look for the explanation in the details of how people live. Mistry and Rogoff (Chapter 20) make a similar argument for cultural differences in memory. The same kind of argument is at the center of the discussion of the idea of cleanliness and culture discussed in Chapter 9 by Fernea and Fernea. In fact, you'll find the same approach throughout this book. When Triandis starts Chapter 24 with the observation that the start of the Desert War of 1991 was at least to some extent the result of a cross-cultural misunderstanding, it is an invitation to try and understand exactly what the misunderstanding was and how it could have occurred.

This way of treating the idea of culture is so pervasive, and is used by most researchers in the field so automatically, that we thought we ought to explain it rather than to assume that you already know how it works. An implication of this way of thinking about culture is that the important stuff is in the details. We think that's very true.

Consider another example. One of us (RSM) grew up in a small city in New York's Mohawk

Valley. Everybody in the high school knew that there were cultural differences between the western European groups who had been in the United States for many generations and the eastern European groups who had not been in the United States for so long. In fact, many of the high school kids were the first in their families to grow up with English as their first language. The high school folk wisdom (if that is not a contradiction in terms) was that the (insert insulting ethnic label here) were (whatever) and that the (insert another ethnic label here) were (something else). Generally it was thought that, for example, the Poles were much more family-centered than the Scots or English. But the ways in which that made itself apparent were really meaningful to a young man who loved the outdoors, and water sports of all kinds. He (RSM) is from an English background, and while he liked the water, his family did not own property on one of New York's many Adirondack lakes. His family didn't own a boat (not even a canoe, let alone a power boat). And when he learned to water ski, it was at summer camp. But in his high school there were many Polish kids who were not as well off as his family was who appeared to have access to a camp on the lake, water skis, a power boat, and many other upscale objects. He gave a lot of thought to where that stuff came from, and wondered for a while whether his parents were holding out on him! Then he got invited to go water skiing at the camp of one of his Polish friends. It turned out that the camp was owned by the eldest uncle in the family, the boat by another uncle, the water skis by a brother, and it went on and on like that. The summer vacation and sports opportunities that the Polish boy had access to really were the aggregate of about six families, some younger, some older, with many income-producing families participating. RSM's family could *never* get together and share like that. It just wasn't done. To him, that was some impressive cultural difference, although it was years before he really understood what was going on. To say it was a cultural difference explains *nothing* on its own. But the explanation that finally emerges—that the Polish kids lived in a more collectivistic culture, one aspect of which is sharing resources among a more extended kinship network than in more individualistic cultures—takes its meaning from the specifics of the differences.

Probably everyone who reads this chapter will be able to recount stories that are similar to the one just given, provided there was contact with people from other cultures or countries, and provided enough time has elapsed to permit reflection on why (usually) intriguing differences in values, beliefs, or behavior were observed or experienced. In experiences similar to RSM's, the other editor of this book (WJL) was literally bathed in a sea of cultures. He grew up in Butte, Montana, a colorful and rather tough copper mining town that boasted many little cultural enclaves. Thus there was "Finntown," "Little Italy," "Dublin Gulch," and so on. The town (really a small city) of some 60,000 was a miniature United Nations (although diplomacy was *not* one of Butte's strengths; a certain amount of physical "persuasion" was the norm) and was that way long before the U.N. was formed. Just about all of these groups of people had colorful name tags—"Micks" (Irish), "Cousin Jacks" (English), "Bohunks" (various Slavic people), Chinks (Chinese), "Dagos" or "Wops" (Italians) come to mind as quick and *printable* examples. If someone got into a certain kind of trouble, or if there was a certain kind of accident, or a certain type of interpersonal happening, it was generally common knowledge among Butte residents what the likely nationality of the responsible party was. For example, one would often hear such comments as "What else can you expect from the (insert proper group)," or "It must have been a (you name it) who did that."

This was stereotyping, pure and simple (see Chapter 12 by Taylor and Porter). But there is often a "kernel of truth" in stereotyping. Attributions like these in Butte were often correct (but certainly not always), thereby reinforcing the stereotype *on both sides* and perpetuating the relentless biases. However, the perspective and wisdom provided by the years has allowed WJL to understand that it wasn't being Irish, or Austrian, or Scottish as *categories* or *names* that "caused" these different behaviors. It was the details—details that can only be understood by examining very specific socialization and enculturation factors for each group.

These personal experiences are very long ways for us to tell you that the term *culture* is a non-explanatory label, refers to a lot of stuff, and that the precise and *interesting* meaning is indeed in the details.

Culture, therefore, is analogous to knowing the "rules of the game." When one becomes socialized (through rule-governed learning and child-rearing practices) and enculturated (through subtle informal learning) in a specific society, he or she has

learned a complex set of explicit as well as implicit rules concerning how he or she should behave among his or her fellows who share the same culture by virtue of being raised under the same rules. Just as one cannot either play or understand the game of basketball by using a baseball rule book, one who has learned how to "play the game" of culture in Korea should not expect to be equally competent in "playing the game" on New Zealand's terms.

Universalism versus Relativism

Cross-cultural psychologists often have to deal with a very important question: How much of the behavior that one observes in another culture (or one's own) can *generally* be seen in other cultures? Of course, this implies a corollary question: Is what one has observed or experienced in another culture (or in one's own) restricted to that *single* instance? This is the issue concerning how much of human behavior is universal as opposed to its being totally relative to each and every culture. Relativists, under the slogan, of "radical cultural relativism," generally argue that people must be studied *only* within the context of their own culture. At the other extreme are the "universalists" who argue that all humans, at base, are the same; they might point out that only a few *surface* elements, such as language, manners, or clothing create the impression of astonishing differences where there are few or even none. Another position, which we think is untenable, is called *absolutism*. An absolutist would argue that all human behavior is essentially the same, and may just be masked by variations in languages and various superficial features such as clothing and modes of transportation. Thus, they would believe that studying "culture" is unnecessary. Chapter 18 by Adamopoulos and Lonner discusses these distinctions in more detail.

This issue is related to the "leash principle" developed by the sociobiologist E. O. Wilson (1980). Some behaviors, such as eating, sleeping, drinking, and sexual activity, are on very "short and tight leashes"—the biological characteristics and physical needs of the species literally guarantee great similarity in such behaviors across cultures. Behavior on "long and flexible leashes," on the other hand, permit much greater differences across cultures. These "leashes" permit clear and distinct differences in clothing, in music, in bodily adornment, and in many other behaviors. But despite such widespread differences in behavior, so say the so-

ciobiologists, the "biogrammar" of the species places an absolute ceiling on culture or anything else *not* biological as a way to explain human behavior. If one wanted to pursue this argument further, it might be argued that cultural relativism is untenable. Different and exotic behaviors that seemingly exist nowhere else would simply be colorful and rare extensions of basic universal dimensions of behavior.

We are thus faced with a series of age-old questions: In what ways are humans alike? Different? What accounts for these similarities and differences? Perhaps we must be content with a famous statement made years ago by two prominent social scientists: In some ways each of us is like all other humans; in other ways we are like some other humans; and in still other ways we are like no other human.

SOME RECURRING ISSUES AND CONCERNS

Psychologists and others who study behavior in global perspective must contend with a number of other challenges. We will close this introduction to *Psychology and Culture* by introducing the reader to several of these challenges. Many of these issues and concerns are to be found throughout the book.

1. *What is the nature of the samples?* The scientific method involves making generalizations from samples to some specific universe that the samples are believed to represent. For instance, a geologist might wish to develop an accurate picture of the nature of the Earth's crust. But he or she cannot study the entire surface of the planet. Thus, he or she would want to get a number of good and representative samples and not, for example, samples from around the Swiss Alps only. So it is with making generalizations about human behavior. Cross-cultural psychologists are concerned about samples at four levels: the *societal* level, the *community* level, the *person* level, and the *behavioral* level. Thus the culture-comparative researcher would ask the following questions: How many *societies* do I need, and why?; how many *communities* or groups within each society do I need, and why?; how many *individuals* in each community do I need, and why?; and which *behaviors* manifested by these people must I measure,

and why? Only when these questions are satisfactorily answered and actually carried out in the research can one hope to make reasonable generalizations about that aspect of human behavior that is being investigated.

2. *The "hard-data" versus "soft-data" issue.* Many scholars who study culture tend to distrust data that are based upon, for instance, observations by *one* researcher, using *one* method (e.g. an interview), involving just a *single* culture. Studies that involve *several* researchers, using several *different* methods, and several *strategically chosen* cultures are difficult to conduct, but their sophistication usually pays off. If all "arrows" from these multiple probes point in the same direction, one would assume that something solid has been found. In the former example, the data could be biased because of researcher bias or because of flaws inherent in a single method.

3. *The problem of "deviant" cases.* What does one do with a unique case among an otherwise solid pattern of regularity? For instance, if in a sample of 25 cultures we find that the data from 24 are consistent with theoretical expectations while the data from the 25th are not, would this be sufficient evidence to discount the otherwise uniform pattern? In other words, would one exception to the rule lead us to conclude that we had better not trust the evidence provided by all the other cases? One research strategy involves probing deeply into the deviant case in an effort to find out why it departed from the others. It is a method primarily associated with anthropology, and goes by the unsurprising title, *deviant case analysis.* Those who use this strategy are more interested in the *irregularities* and reasons underlying them than in the general rule.

4. *The problem of equivalence.* Before valid comparisons can be made across cultures, equivalent bases of comparison must be established. For instance, if one wanted to study aggression across cultures, it may be inappropriate to use, as a basis of comparison, the number of people in prisons in different cultures who have been incarcerated for armed robbery. This is because it may be that each culture has its own criteria for imprisonment. Or the great variation there is in the availability of handguns may form an inappropriate basis for comparison. The problem of *linguistic* equivalence must also be ad-

dressed. This means that words or concepts must mean the same thing, or approximately the same thing, to people who have been sampled in different cultures. It takes a lot of thought and hard work to construct such things as useful and sophisticated questionnaires. Some researchers have tried to minimize translation problems by using technology. But this can backfire. One of our favorite examples is the translation machine that translated the idiomatic phrase "Out of sight, out of mind" from English into Russian. The resulting Russian "equivalent": "Invisible maniac."

5. *The clarity of concepts studied.* The social and behavioral sciences have their share of rather obscure phrases or concepts. These concepts can mean many different things to different people, or they may simply be too difficult to measure with any precision. An example is the (apparently) common mental condition of depression. Depression is *not* an exact term, and because of this it is extremely difficult to measure it. Chapter 41 by Manson describes a procedure that is useful in understanding culture-specific meanings of depression. Depression as a concept certainly can't compete, for instance, with concepts such as *calorie* or *white blood cell count*, both of which have very specific and clear definitions everywhere.

6. *The problem of "deep culture" versus "cultural gloss."* Have you ever noticed how well you know your closest friend, or your brother or sister? You have acquired this knowledge through years of sharing things with that person and observing his or her behavior under many different circumstances. When someone says to her bosom buddy, "Look, Cynthia, I just *know* you wouldn't do such and such," she is demonstrating deep knowledge of Cynthia compared with a shallow or superficial knowledge. You probably know many people pretty well, but only one or two *really* well. It is the same with cultures. In a sense, cultures have their own "personalities," and it takes a long while to understand one of them—even your own—deeply. Anthropologists, when they study cultures, speak of "deep cultural immersion." Through this process, which can take years, the anthropologist hopes to get to know the culture in question very deeply, perhaps even intimately. Contrast this with a fleeting or shallow knowledge of a culture. Under these

circumstances, the observer or researcher may pick up some superficial aspects, or the surface gloss, of a culture or ethnic group, but in the process may overlook the essential character of a culture. In the past, some cross-cultural researchers have been called "jet-set" researchers: they would fly to some exotic place, spend a few weeks giving tests or supervising people conducting interviews, then return home to write the research report in some comfortable office. They scarcely knew anything about the culture they studied, despite their good intentions. So, we have a rule of thumb to recommend: place more value on research done over a longer period of time and with local support and collaboration than research which seems to have been rushed or characterized by what appears to be "glossy" and superficial interpretations.

7. *A fundamental problem: how much of behavior is learned as opposed to being inherited genetically?* This, of course, concerns the hollow and unanswerable question: What is more important in understanding behavior: nature or nurture? It is impossible to answer this question definitively. We can only say with certainty that *both* are important, and that the learning atmosphere (nurture) and the biological background (nature) are in a constant state of complex interaction. On the other hand, we can also be reasonably assured that the more that behaviors are linked to *physiological* factors (such as basal metabolism, blood pressure, and speed of neural transmission in the central nervous system) the more universal and less variable they are. The corollary here is that the more that behaviors are dependent on strictly cultural factors, the less universal and more culturally variable they will be. These relationships are shown in Figure 1.

But even with this simple diagram we can see how interactions can complicate matters. For instance, it is usually a physiological necessity to wear some kind of clothing. Clothing is therefore a universal based upon this biological imperative. That being the case, why then don't all the people of the world wear the same kinds of clothes? The answer, of course, lies in the domain of culture. An Eskimo would look silly trekking across the tundra in Scottish kilts, just as a man in Scotland would look out of place on the golf tee wearing a

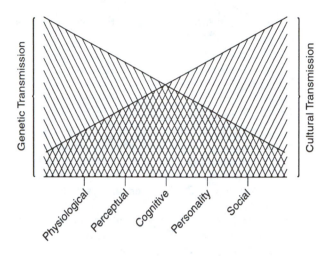

FIGURE 1 A schematic representation of the extent of genetic and cultural inheritance in five domains of behavior (cf. Poortinga, Kop & Van de Vijver, 1989)

hand-stitched jacket made from untanned caribou hide.

SOME CONCLUDING COMMENTS

In this introduction we have given a brief sketch of some of the background factors that influence the cross-cultural psychologist's interest in, and concern about, the interrelationships between culture and behavior. We believe that such a foundation is needed to understand and appreciate the many chapters in this book. Taken together, these chapters give a broad introduction to many of the ways culture influences behavior. However, important as these topics are, they constitute only a small fraction of the total number of topics that could be included in a potentially neverending book. We hope that as a *sample* of topics written in interesting ways by very competent people the reader will gain a deeper appreciation for the many ways in which culture shapes, modifies, and otherwise adds distinctiveness to human behavior. In a shrinking world which is chronically suffering from open warfare, other forms of intergroup hostility, social injustices, interpersonal misunderstandings, competition for scarce resources, and so on, it is imperative that we develop more respect for and understanding of the realities of the many cultural

and ethnic groups that make up the species called *homo sapiens.*

REFERENCES

Berry, J. W., Poortinga, Y. H., Segall, M. H., and Dasen, P. R. (1992). *Cross-Cultural Psychology: Research and applications.* Cambridge: Cambridge University Press.

Bronstein, P. A. and Quina, K. (1988). *Teaching a psychology of people: Resources for gender and sociocultural awareness.* Washington, D. C.: American Psychological Association.

Cohen, J. (1969). *Personality assessment.* Series Separate 18 from the Eyewitness Series in Psychology. Chicago: Rand McNally and Company, p. 6.

Lonner, W. J. (1990). The introductory psychology text and cross-cultural psychology: Beyond Ekman, Whorf, and biased I.Q. tests. In D. Keats, D. Munro, and L. Mann (Eds.), *Heterogeneity in cross-cultural psychology. Selected papers from the Ninth International Conference of the International Association for Cross-Cultural Psychology.* Lisse: Swets and Zeitlinger.

Poortinga, Y. H., Kop, P. F. M., and Van de Vijver, F. (1989). Differences between psychological domains in the range of cross-cultural variation. Paper presented at the First European Conference of Psychology, Amsterdam, July.

Shweder, R. A. and Sullivan, M. A. (1993). Cultural Psychology: Who needs it? *Annual Review of Psychology, 44,* 497–523.

Wilson, E. O. (1980). Comparative social theory. *The Tanner lectures on human values.* Presented at the University of Michigan, Ann Arbor, MI.

Section I

The Universal Experience of Being Different

Very early in life, perhaps just hours after birth, the human being probably starts to develop a sense of *self*—that is, a sense of "that which is me" and "that which is not me." This sense allows the infant to separate himself or herself from both the non-human world as well as from the world of fellow human beings. It also enables the growing person to develop a sense of identity and individuality. Thus humans truly experience the universal phenomenon of being "different," and indeed they are. However, as interesting as this process of individuation is, the focus of this first group of chapters concerns the related process of being different in terms of culture, ethnicity, skin color, or other identifiable characteristics that clearly separate one person, or one group, from all others.

To get a good sample of chapters that might capture the essence of this universal experience of "differentness," we had to make decisions that were somewhat arbitrary. One knowledgeable estimate says that there are about 4,000 *cultures* in the world—that is, about 4,000 groups of people who have acquired a sense of *cultureness* or *cultural identity* through some combination of their having mutually unintelligible languages, by agreeing what they should call themselves, who should be included as a member of their culture, what should be passed on to succeeding generations, and so on. Using such criteria for inclusion or exclusion, members of any one of the cultures so established would indeed feel "different" if placed in any one of the other groups. Even members of one segment of a culture can feel quite out of place in the company of another segment of the same culture. For instance, poor people will likely feel quite different and uncomfortable in the presence of rich people (or vice versa), even though all may be members of the same general *culture*. There are unlimited permutations of such contrasts.

We decided to ask several people to report, for the most part in an anecdotal way, some of the most salient aspects of their experience of being different. In the United States, one of the most obvious ways of being "different" is to be a member of a visible minority group or ethnic group. The Afro-American experience in the United States is a classic case. It is not easy, in such limited space, to describe the many factors, economic, historical, and experiential, that separate African Americans from the very dominant white majority. However, James Jones, a very active Afro-American psychologist, has attempted to capture some of the essence of being Black in America. He does so in the first chapter, which is both hard-hitting and hopeful. Similarly, we asked Gerardo Marin to comment on the experience of being Hispanic in the United States, and he has done so in Chapter 2. It is well known that the Hispanic population is the fastest growing minority group in the country. In fact, Los Angeles, California has the *third largest* population of native speakers of Spanish in the Western hemisphere if not the world—right after Mexico City and Monterrey.

Paralleling the growth of Hispanic peoples has been the great influx of people of Asian decent to all corners of North America. D. John Lee, a Canadian of Chinese ancestry and Christine C. Iijima Hall, a citizen of the United States with ties to both Japanese and Black ancestry, are well qualified to report on many of the psychological dimensions of being Asian in the United States or Canada, both of which have very large groups of people who have come from China, Japan, Korea, the Philippines, and other countries that are part of the world's largest continent. Their observations are in Chapter 3. The American Indian (or Native American) experience is at once romantic, saddening, and heroic. By no means a uniform group (there are many distinct

tribes or bands of Native Americans in North America, the experiences of these proud people are many and varied. Sandra Bennett, in Chapter 4, summarizes many of the key characteristics of what it means to be Indian in America.

The final two chapters in this section were written by two psychologists who have had what anthropologists call "deep immersion" in cultures in which they were not originally socialized. In Chapter 5, Michael Bond reports on his "continuing encounters" with Hong Kong. Bond, a Canadian by birth, has been a psychology professor in Hong Kong for many years, and during this period he has been experiencing that large and diverse society like one experiences an onion: Layer after interesting layer is peeled off, with each new layer exposing yet another dimension of that heavily populated city known as the "Pearl of the Orient." Finally, in Chapter 6 some of the experiences of Ernest Boesch are chronicled. Although he is multilingual and has had extensive exposure to most of the cultures of Europe, it wasn't until mid-life that Boesch experienced the complexities of Thailand. This urbane, sophisticated, and experienced Swiss scholar found himself in what was for him a place quite unlike any he had experienced before. After a productive and successful stay in Thailand, Boesch returned to Europe a changed person, and a much richer person because of what he learned there and what the Thai people taught him. He has returned to Thailand many times since, and now feels very much at home there.

While all of these chapters give unique accounts of what it is like to be different, we want to mention that a central theme in all of them concerns the concept of *self*. For many years psychologists have been intrigued by the phenomenon of self. Many researchers are currently studying the various dimensions of this singularly human phenomenon. Most visible among this research are numerous studies that have attempted to understand how self is construed (understood) in non-Western, and particularly Asian, cultures. According to many reviews (see especially Markus and Kitayama, 1991) as well as supporting anthropological accounts, members of Asian cultures see themselves as inherently connected or interdependent with others. For them, the social context is extremely important, and their identity is heavily defined by the group or groups to which they belong. Contrast this view with interpretations of self that are associated strongly with the West. In the Euro-American world, where nearly all research on

the self has taken place, it has been assumed that the self is autonomous, and is quite distinct from all other persons. Figure 1 displays these two different construals of self. The top part shows the *independent* view of the self. In this view, the person (self) is bounded by a solid line, connected with others in a way that might be described as "distant," and not terribly close. The bottom part depicts the *interdependent* construal of self, which is characteristic of most Asian cultures. Notice how in this view the self is shown as bounded by a dotted line—a line that suggests more permeability between self and others.

To a certain extent, all the chapters in this section focus on different reports on self and how it relates to society. We urge readers to learn more

FIGURE 1 (A) Independent construal of Self, (B) Interdependent construal. From Markus, H., & Kitayama, S. (1991), Culture and the self: Implications for cognition, emotion and motivation. *Psychological Review, 98,* 224–253

about how self is defined differently in other parts of the world. These varied definitions are critically important when trying to understand how being different, although a universal experience, is mediated by socialization factors that vary widely across cultures. We also urge readers to read Chapter 24 by Triandis in Section V in the context of trying to understand cultural variations in the phenomenon of "self." That chapter gives more information about the two construals of self—individualistic and collectivistic—which currently are being studied extensively by psychologists in many countries.

REFERENCE

Markus, H. and Kitayama, S. (1991) Culture and the self: Implications for cognition, emotion, and motivation. *Psychological Review*, 98, 224–253.

1

The African American: A Duality Dilemma?

JAMES M. JONES

When the 6'1" ebony-black, finely chiseled, muscular Jack Johnson fought the 5'7" white, soft-looking Tommy Byrnes in 1906 in Australia for the heavyweight championship of the world, heavy betting initially was on Byrnes because, it was argued, no black man could beat any white man at anything. Once people got a good look at the two, the heavy money switched to Johnson because, it was argued, he was an animal, not altogether human and therefore was an unfair match for the gentle young Mr. Byrnes.

Being African American in the United States is a constant up-hill climb. Forbidden by law to learn to read; later denied admission to colleges for no other reason than the color of your skin; forced to play movie roles depicting you as a buffoon, clown, superstitious, dancing, happy-go-lucky child; beaten savagely by the police who are then acquitted because they were simply following police procedure; then claimed to be genetically inferior because of a constant 15 point IQ difference; redlined into poorer neighborhoods and provided schools with less of all needed supplies and resources; discriminated against in employment; then criticized for attempting to regain an even footing through group-based programs because these plans violate the principle of individual liberties and rights; you find you mistrust whites individually and collectively, you feel that any advance you make is in spite of your ability or qualifications, and you wonder how you can root for the United States—yet you do.

Being African American in the United States is seen often as a dual reality—African and American. Television journalist Marvin Kalb made this distinction clear when he challenged Presidential candidate Jesse Jackson in 1984 in these terms:

Kalb: The question .. [is] .. are you a black man who happens to be running for the presidency, or are you an American who happens to be a black man running for the presidency?

Jackson: Well, I'm both an American and a black at one and the same time. I'm both of these . . .

Kalb: What I'm trying to get at is something that addresses a question no one seems able to grasp and that is, are your priorities deep inside yourself, to the degree that anyone can look inside himself, those of a black man who happens to be an American, or the reverse?

Jackson: Well I was born black in America, I was not born American in black! You're asking a funny kind of catch-22 question. *My* interests are *national* interests. [excerpted from *Meet the Press*, February 13, 1984.]

James M. Jones is Professor of Psychology at the University of Delaware, and Director of the Minority Fellowship Program at the American Psychological Association. He earned his Ph.D. at Yale University studying cognitive aspects of humor, and tested his ideas out in Trinidad, West Indies with the support of a Guggenheim Fellowship. He published *Prejudice and Racism* in 1972 (McGraw Hill), and numerous articles on race, culture, and personality. He currently serves as Secretary-Treasurer of the Society of Experimental Social Psychology.

Are you black *OR* American? This either/or view is at the crux of the psychological reality of African Americans. It frames what I call the *duality dilemma*.

W. E. B. DuBois captured this duality in his essay *The Souls of Black Folk* in 1903.

> *It is a peculiar sensation this double-conscious-ness, this sense of always looking at oneself through the eyes of others, of measuring one's soul by the tape of a world that looks on in amused contempt and pity. One ever feels his twoness—an American, a Negro; two warring ideals in one dark body, whose dogged strength alone keeps it from being torn asunder . . . The history of the American Negro is the history of this strife—this longing to attain self-conscious manhood, to merge his double self into a better and truer self. In this merging, he wishes nei-ther of the older selves to be lost . . . He simply wishes to make it possible for a man to be both a Negro and an American, without being cursed and spat upon by his fellows, without having the doors of opportunity closed roughly in his face. (p. 214–215)*

DuBois framed it and Kalb gave it voice—being African American in the United States is perceived, by blacks and whites alike, to be a conflict. For whites, blacks are either set apart because they are different and usually judged to be less worthy than whites, *or* are judged to be no different from whites hence no different from any other American. In either case, one's black identity seems to be a basis for either discrimination or invisibility, but not a foundation from which to build basic participation in U.S. society. For blacks, their racial identification is either a social category that they feel compelled to transcend since it is so frequently a basis for discrimination, or an identity that sets them apart from mainstream America and thereby puts them in opposition to the broader society. The psycho-logical dilemma for African Americans and whites alike is to find a way to acknowledge and accept the legitimacy of African-American participation in U.S. society that draws upon the unique cultural foundation of the experiences of African origins, and unique African-American experiences.

Being African American in the United States is to have survived the brutality and systematic un-fairness of slavery, the meanness of segregation, bigotry, discrimination, hatred and the myriad bar-riers to fair and equal opportunities. Why did this happen? How *could* this happen in the cradle of liberty, the land of the free, the land of opportunity? It could happen because white people of European descent felt that black people of African descent were genetically, culturally, and socially inferior *and* because it was economically, socially, politically, and psychologically to their collective advantage to feel so. Because it was so ugly, mean, cruel, and unfair, and because it was built into the fabric of our society and its institutions, it is an important cul-tural legacy of the United States. It is a cultural legacy because it formed the content and character of the U.S. culture (including efforts to eradicate slavery) and because it gave shape to the rationali-zations that were required to live with this flagrant contradiction of the ethos of the American Revolu-tion (the intellectuals, scientists, historians, politi-cians, clergy, and businessmen all found "evidence" for the inferiority and the legitimacy of the slave trade and the institution of slavery). Racism thus is embedded in U.S. society and affects all of us who live here.

But lest we Americans get an inferiority com-plex, we should recognize that racism is not unique to the United States, nor is institutional and cultural conflict fueled by social and biological differences. The "ethnic cleansing" in the former Yugoslavia is

The history of the world is a history of conflicts in which one group asserts its superiority over another, then seeks to dominate that other group through physical, economic, social, or whatever means necessary.

as heinous and inhumane as any racist assault on African Americans. The history of the world is a history of conflicts in which one group asserts its superiority over another, then seeks to dominate that other group through physical, economic, so-cial, or whatever means necessary. Is intergroup violence and hate universal? Is this tendency a tragic flaw in the human character? Boucher, Lan-dis and Clark (1987) have edited a book of essays that describe how widespread human unkindness

and hostility is, and seems to suggest that the answer is yes.

Why is this "race-thing" *still* an issue? Well, from a white perspective, I often hear students claim, "I was not raised to be a racist, I was raised to respect everyone and that the color of a person's skin doesn't make any difference." A well known social historian (Bloom, 1987) wrote

> . . . *White and Black students do not in general become friends with one another . . . The forgetting of race in the university, which was so predicted and confidently expected when the barriers were let down, has not occurred. There is now a large Black presence in major universities . . . but they have, by and large, proved indigestible . . . The programmatic brotherhood of the sixties did not culminate in integration but veered off toward Black separation . . . The discriminatory laws are ancient history, and there are large numbers of blacks at universities. There is nothing more that white students can do to make great changes in their relations to black students.* (p. 91–92)

Allan Bloom's thesis suggested that black people achieved equality in 1964, and that by 1993, any continuing friction between blacks and whites was now the fault of black students! His idea of blacks being *indigestible* is a graphic illustration of what the melting pot idea means to a black person; you disappear in the belly of the beast who has oppressed you. In this analysis, to resist being devoured leaves you contentious, fractious and lacking in brotherhood. In 25 short years, Bloom seems to feel that the slate has been wiped clean. We are on an equal footing, and African Americans should open their arms and embrace these well-intentioned white people who approach them. Not only is 25 years no longer than an eyeblink in the history of racial strife in the United States, it is a nanosecond in the march of ethnic conflict through the history of the planet.

African Americans say white people will do anything to maintain their power. They believe that racism is alive and well, and there are enough statistics and examples to give credence to this viewpoint. Let me give you one clever scientific finding that illustrates this point. White subjects were brought into a laboratory for the purpose of helping another student learn some word associations (Rogers and Prentice-Dunn, 1981). The helper was instructed to deliver electric shocks when the learner made an incorrect response. The experimenters were interested in how much aggression the subjects showed toward the learners as indicated by the level of shock administered and how long they held down the shock button. Now there were two interesting twists. First, some of the learners were African American and some were white. Second, some of the subjects "overheard" the learner make disparaging remarks about them ("I know people like him; they're jerks; I'd be surprised if he could even figure out how to work that apparatus" and so forth). The results showed that race had a significant influence on the behavior of the white subjects. Specifically, the white subjects delivered *less* shock to the African American than the white learners, when they had not been insulted. *But*, when the subjects had been insulted, the African-American learners were shocked much more than the whites were. So, we may conclude, that the white subjects were "sympathetic" toward the African Americans when they were normal, but when they got "out of place," *zap!*

Swedish sociologist Gunnar Myrdal called it *An American Dilemma*; W. E. B. DuBois called it *Double Consciousness*; I call it a *Duality Dilemma*. In our ideal world, whites should treat African Americans fairly and African Americans should be open and trusting of whites. Sounds good, but there are some fundamental problems that are embedded in the culture of the United States that have to be worked out. We have always espoused values that were not met. The principles of the American Revolution were noble and good, but they did not extend to Americans of African descent. Slavery was not just an economic institution—it was a psychological one. That is, coping with the oppression not only took a psychological toll on African Americans, but it also created a psychological resilience necessary for survival. It also required a psychological hardness on the part of the slave owner, and a belief in the rightness of the cause to offset the atrocity of the actual practices. How could a white American leader live with the contradictions? What should an African American think about fighting for the United States and then, when not killed defending his or her country, come home to second class citizenship, denial of rights, limitations of opportunity? How could a white person submit an African American to that? Because, again, whites believe that African Americans are inferior and that belief *somehow* makes the disadvantage, the oppression, and the unfairness palatable or tolerable, acceptable or even appropriate.

U.S. institutions were not created to serve African-American people. When not designed to oppress them directly, at best, they ignored them. Having made official acknowledgment of these discriminatory biases, we now try to discern what is fair and practice it. Former Secretary of Education William Bennett argued that we should be a color-blind society and the best way to achieve that goal is ". . . to act as if color doesn't matter." Well, if you are African American it *does matter!* The stakes are not mutual and reciprocal. African Americans potentially have a lot to lose by acting as if race doesn't matter. You could argue that things are bad enough that they have more to lose if they don't act that way! An interesting question that needs lots of conversation and perhaps some more data.

I wrote a book in 1972 called *Prejudice and Racism.* I had just finished graduate school where I learned about experimental social psychology. I did not learn anything about prejudice or racism as a scientific or academic subject matter. I did, though, have my own ideas about it as a black man of some 28 years. When I read the literature in social psychology, I felt it was inadequate to address the problems of race in the United States. It focused too much on prejudiced individuals, bigots, and usually southerners. In my view as a black man who grew up in northern Ohio, I knew that bigotry was not limited to the South, and that institutional practices were designed to maintain the status quo of limited racial contact, and lower opportunities for blacks. We could set pins at the bowling alley, but we couldn't bowl there. We could caddie at the country club, but we couldn't join it. We could skate at the roller rink but only on Thursday nights when blacks came from all over northern Ohio for black night at the rink. The interesting thing, though, is that growing up in a racist society had its problems, but it also demanded a certain amount of ingenuity, resilience, determination, and hard work. As my aunt used to always say, a black person had to be twice as good as a white person to get the same opportunity. Because of those personal experiences and observations, I felt that I could blend the psychological reality of my life with the social and behavioral science of racial studies to make some different and useful observations. Thus, in *Prejudice and Racism*, I tried to distinguish prejudice from racism at both a personal and a social level. Prejudice was closest to racism when considering what I called *individual racism* [". . . one's belief that Black people, as a group are inferior to Whites because of physical traits (p. 118)"]. But, when institutional practices and outcomes yielded inequalities along racial lines, *institutional racism* was the diagnosis [". . . those established laws, customs, and practices which systematically reflect and produce racial inequalities in American society (p. 131)"]. This diagnosis was appropriate *whether the individuals running the institutions intended them or not!* Finally, I argued that the whole ball of wax was understood within the broadest context of *cultural racism.* That is, the values, symbols, history, and meaning that sustained and reinforced the creation of institutions and the socialization of young children. When all three levels are combined in one definition of racism, we have the following:

> *Racism results from the transformation of race prejudice and/or ethnocentrism through the exercise of power against a racial group defined as inferior, by individuals and institutions with the intentional or unintentional support of the entire culture. (p. 117)*

I believe that racism at the cultural level is the defining issue that needs to be understood to solve our problems today. In my class on black psychology, a young white woman was reduced to tears because her effort to join with a black woman in a class project was rejected and her intentions or motivations challenged. This young woman's self-concept was strongly egalitarian, non-racist, and accepting. She was offended and hurt to be treated as if she was just another white racist. The mistrust of the African American student was strong and uncompromising. I pointed out to both of them that they, as indeed the whole class, were victimized to some extent by the facts of our cultural past as far as race is concerned. We cannot expect things to flow smoothly and gently. There are deep scars for African Americans, feelings of guilt and a misunderstanding of privilege among whites.

There are real opportunities for many African Americans, and an absence of opportunities where many think they exist. The future of the United States as a country cries out for the solution of the "race question." This question is now even more complicated because it is expanded to include the "diversity" question. The challenge to "celebrate diversity" is to resolving the racism problem, as "just say no" is to solving the drug problem. We tend to blame or praise the individual without appreciating the complicating factors of history, society, and culture.

Now, I have emphasized the negative aspects of white racism and oppression as a recurring and vitally important aspect of being African American in the United States. However, I want to be clear that the tension, conflict, and difficulty of this perpetual conflict is a factor in producing the creative energy and drive that has made the African American a unique and powerful cultural group in the world. Whether you are an artist, an athlete, a scientist, a politician, or a laborer, as an African American, the struggle against racism is embedded in your soul, your collective unconscious as Jung would say. It may not be a "chip on your shoulder" or a "heart on your sleeve," but it lurks constantly as a force that has meaning for who you are and what you can and will become. Being African American is dangerous, exciting, stimulating, wonderful, tragic, and important. The sociologist Alphonso Pinkney (1993) provides a broad and informative account of how African Americans cope with and adapt to being black in America. America is what it is, the most open society on earth, because of its struggles with liberty and its successes and failures in embracing all of its citizens.

As we stand on the brink of a new century, we are confronting the challenge of inclusion and diversity in the most straight-ahead way we ever have as a nation. The challenge and guidance of African Americans is crucial to the ultimate success of maintaining our strength and purpose. As a psychologist, I am interested in figuring out how we can create a society in which people feel better about themselves, have legitimately expanded opportunities that do not simultaneously stigmatize them for taking advantage of them. I believe that just as slavery was a psychological as well as an economic institution, social policies can help solve the race problems only if they are understood in psychological terms. My own work on race, culture, and personality is provoked by my belief that the problems and solutions are social psychological in nature. I invite you to read and learn more about what we know and formulate your own ideas about what you can do as a teacher, a scholar, or a citizen to make the 21st century more respectful of our rich human diversity and the strength it provides upon which the future of our humanity ultimately rests.

REFERENCES

Bloom, A. (1987) *The closing of the American mind.* New York: Simon & Schuster.

Boucher, J., Landis, D. & Clark, K.A. (Eds.) (1987). *Ethnic conflict: International perspectives.* Beverly Hills, CA: Sage Publications.

DuBois, W.E.B. (1903). *The souls of black folk.* Chicago: A.C. McClurg & Co.

Jones, J.M. (1972). *Prejudice and racism.* Reading, MA: Addison Wesley Publishers.

Pinkney, A. (1993). *Black Americans, 4th ed.* Englewood Cliffs, NJ: Prentice Hall.

Rogers, R. and Prentice-Dunn, S. (1981). Deindividuation and anger-mediated interracial aggression: Unmasking regressive racism. *Journal of Personality and Social Psychology, 41,* 63–73.

2
The Experience of Being a Hispanic in the United States

GERARDO MARÍN

The 1990 population census indicates that there were over 22.4 million Hispanic Americans in the United States, approximately 12% of the total population. These figures made Hispanics the second largest ethnic/racial minority group in the country in 1990 and, given their current growth rate (53% between 1980 and 1990), they will become the largest ethnic group around the year 2020. Hispanic Americans are found in most cities and in every single state as well as in all professions and careers. In some cities and in some states, they make up a large segment of the population. For example, over 40% of the residents of Los Angeles and at least one of every four Californians or Texans are Hispanic Americans. Despite their numbers, there is a general lack of understanding of who they are and what it means to be a Hispanic American. This chapter presents an overview of the experiences of being a Hispanic American in the United States in the latter part of the 20th century.

Gerardo Marín, a native of Colombia, is currently Professor of Psychology and Associate Dean of Arts and Sciences at the University of San Francisco in San Francisco, California. He received a Ph.D. in Experimental Social Psychology from DePaul University in Chicago in 1979. He has published over 90 books and articles in areas such as stereotyping, cultural values, community interventions, and health promotion. He is currently conducting research on the development of culturally appropriate community interventions for promoting health among Hispanics.

There is a minor controversy in the scientific literature regarding the appropriate label for individuals who trace their background to Latin America or Spain. Some scientists prefer to use a label different from "Hispanic" and, as such, they use words such as *Latino, Raza, Spanish,* or *Chicano.* The arguments for the use of a given label are based on its origin, its assumed referent, patterns of current use, and so on. In this chapter we will use the word *Hispanic* as a label of convenience. We have chosen to use this label since it has received certain levels of acceptance across society and is currently frequently used by the government and the media.

WHO ARE THEY?

Hispanics are generally considered to be those individuals who reside in the United States or Canada and who were born in or trace the background of their families to one of the Spanish-speaking countries in the Americas or to Spain. Generally, Brazilians (who are Portuguese-speaking) and those who trace their family background to countries in the Americas that speak French (e.g, Haiti), English (e.g., Jamaica), or Dutch (e.g., Curaçao), are not considered to be Hispanic. Nevertheless, Hispanics are a varied group of people. Among them we could find people like José who came to the United States from Cuba in 1972 at the age of 7 fleeing the revolution headed by Fidel Castro; or Marta who left her native Colombia when she was 21 in search of better education and of an improved standard of living. Ignacio, a New Yorker born in the Bronx of

Puerto Rican parents is also a Hispanic, as well as Guadalupe who came in the 1940s from Mexico together with her husband to work the fields of California and Texas. What these four people represent is a large group of individuals who have come from different countries, who have had different reasons for migration, who are at different levels of the economic ladder, but who share a common set of basic values. Those values (that define the Ibero-American culture as something unique in the world) are the result of the interactions of the native indigenous cultures of the Americas with the Spaniards who came after Columbus' voyage in 1492 together with the African traditions and values brought to the Americas by those individuals that came in bondage as part of slavery.

It is important at the outset to note that because of this diversity, Hispanics do not belong to one "race," or profess one religion, or share one same language. There are Hispanics who are Caucasian, others who are African American, others who are Asian. Racial characteristics depend on the background of their ancestors so that Hispanics who are descendants of the slaves brought to the Americas by the Spanish during the conquest could exhibit physiognomic characteristics usually found among blacks. At the same time, those Hispanics who trace their background to immigrants from Japan, China, or another Asian country would exhibit facial and skin characteristics typically found among Asians. There are Hispanics who speak only Spanish, while others speak only English. Some speak both languages quite well or even three or four more. By the same token, there are Hispanics who are Roman Catholic, some who are Protestants, some who are Jewish, and even some who are agnostics. What makes an individual a Hispanic, therefore, is the sharing of a set of beliefs, of values, and of ways of perceiving the world that go beyond national origin, race, religious faith, linguistic ability, and so on.

Heterogeneous group membership is of course not unusual when we talk about human beings as members of large social structures (e.g., nations) or even of ancestral and religious groups. For example, in the social sciences we talk about people from a given nation (such as France) or about members of a religious faith (e.g., Roman Catholics) as if they were fairly similar to each other. What we acknowledge is that beyond personal idiosyncrasies and behavioral and attitudinal differences, people who belong to one of these groups share some significant characteristics that make them feel as if they belong to a special group. This is also true among Hispanics. Despite their differences, there is a set of values (cultural beliefs) that unify Hispanics and makes them feel different from Asian Americans, African Americans, or any of the other ethnic and racial groups in the United States.

HOW ARE HISPANICS DIFFERENT FROM OTHER GROUPS?

As mentioned above, Hispanics in general differ from other ethnic or racial groups in the United States in terms of a number of demographic characteristics. More importantly, though, is the fact that Hispanics as a group share a common set of values that are considered central to their perceptions of the world and to their understanding of reality. These shared values form a constellation of values and of beliefs that are at the essence of being a Hispanic.

Cultures differ along a number of dimensions. It is these dimensions that allow us to differentiate people from one culture from those of another. Hispanics, as an ethnic group, identify with or prefer some of these dimensions over others. Indeed, some dimensions are more central than others particularly those related to interpersonal relations, the value placed on personal interactions, and the reliance on the in-group for support and as behavioral and attitudinal referents.

One of the central characteristics of Hispanics is the emphasis placed on the needs, objectives, and points of view of similar others (members of the "in-group"). This characteristic has been called *allocentrism* and it identifies the opposite of *individualism*. As allocentric individuals, Hispanics experience significant levels of personal interdependence. As such, Hispanics are more likely to be sensitive to the characteristics of the social or physical environment, to be empathetic to others' feelings and wants, to be willing to sacrifice for the welfare of peers, and to trust the members of the in-group. Research has shown, for example, that when given a choice, Hispanics prefer interpersonal relationships that are nurturing, loving, intimate, and respectful rather than confrontational and superordinated. At a job, for instance, Hispanics are more likely to prefer a convivial group of employees and a boss who is nurturing and "down to earth."

Another important characteristic of Hispanic culture is the preference for smooth and pleasant social relationships. This social script has been labeled *Simpatía* and it refers to a behavioral style that values empathy for the feelings of others, that safeguards the dignity of an individual by showing respect, and that strives for harmony. In a conflict situation whether at home, work or at school, Hispanics tend to prefer the avoidance of confrontation. It would be likely, therefore, that the conflict will be reshaped in order to allow for face-saving on the part of all involved, or that Hispanics would prefer to "leave the field" by physically or psychologically withdrawing from the conflict. This doesn't mean that Hispanics do not express anger, frustration, and similar emotions. *Simpatía* refers to the fact that when situations are conflictive, particularly among members of the in-group, solutions will be sought that avoid acrimonious confrontations, hurt feelings, and the loss of self-respect.

Familialism is another central value of Hispanics that deserves mention here. It is quite true that all cultures value the members of their families. Nevertheless, Hispanics show a particular level of familialism that differentiates them from other cultural groups. To Hispanics, familialism involves an individual's strong identification and attachment to the nuclear and the extended family, as well as strong feelings of loyalty, reciprocity, and solidarity with members of the family. Relatives (parents as well as grandparents, uncles, cousins, and so on) are individuals who have particularly important roles within the social structure of Hispanics. For example, Hispanics feel an obligation to provide material and emotional support to their relatives and not just to siblings and parents but also to members of the extended family. Likewise, Hispanics can expect to receive help and support from their relatives whether monetary aid, or help in finding jobs, or providing housing for extended periods of time. Finally, relatives are perceived by Hispanics as important attitudinal and behavioral referents who help shape their actions, their beliefs, and their attitudes.

These cultural values are of significance because they explain how Hispanics are different from non-Hispanics and because they can be considered as the root of misunderstandings when Hispanics interact with other groups. Different values and different perceptions of the world when misunderstood can produce hurt feelings, stereotypic perceptions, prejudice, and discrimination.

BEYOND THE MELTING POT

As could be expected, there are Hispanics who have lived in the United States for a substantial period of time, some who have lived in the United States all of their lives, and some whose parents and grandparents were born in the United States. For immigrants, the experience of living in a new culture promotes a process by which they learn a new language, a new way of doing things, and a new approach to life. This process of learning a new culture has been labeled by social scientists as *acculturation*. In this sense, we assume that the contact with members of a new culture or with the physical characteristics of a new nation exposes the individual to the new culture's values, attitudes, expectancies, and behaviors. Immigrants are usually able to choose which "new" attitudes or behaviors to take as their own and which ones to reject as part of the acculturation process. A particularly powerful channel for acculturation is the learning of a new language since so much of a culture is transmitted through its spoken and written language.

For Hispanic immigrants, there is a somewhat powerful pressure for acculturation present in the need to learn English. This push to acculturate can take different forms but in a certain sense is supported by educational institutions, the commercial world, and by the media. It is difficult to progress in the educational system of the United States if an individual doesn't speak and write English. By the same token, a job is usually difficult to keep unless individuals have some rudiments of English that allow them to communicate with supervisors and to understand job-related instructions. Overall, most of the mass media are in English and even visual media (e.g., television) are difficult to understand and enjoy for those individuals who lack knowledge of English.

The acculturative pressures mentioned above that support the learning of English and of the United States "mainstream" culture have been the basis for the assumption that the United States was a "melting pot." In this case, different traditions represented in the great variety of immigrants of the beginnings of the 20th century "melted" into one culture. The experience for Hispanics has been different. Hispanics have learned the language and the mainstream culture of the United States (over 60% are proficient in English) but also have kept alive the Spanish language, and the traditions and culture of their countries of origin.

This new migration experience is usually described as a "tossed salad" phenomenon where different traditions and cultures contribute to a common whole without losing their value and their distinctiveness. To continue with the gourmet analogy, Hispanics have chosen to retain their culture and to contribute to a new more exciting world view the same way that a tomato retains its flavor in a salad while enhancing the salad's attractive-

It is common therefore to find a Hispanic who has obtained a doctoral degree, who speaks English as fluently as Spanish, and who holds dear the value of familialism and whose interpersonal relations are ruled by the social script of *Simpatía*.

ness and overall taste. The end result of the Tossed-Salad phenomenon is that it is not unusual to find Spanish-language radio and television stations in most major cities in the country as well as areas of our cities where Spanish is spoken with equal frequency as English. By the same token, Hispanic traditions and values have been kept alive despite the acculturative experiences of Hispanics. It is common therefore to find a Hispanic who has obtained a doctoral degree, who speaks English as fluently as Spanish, and who holds dear the value of familialism and whose interpersonal relations are ruled by the social script of *Simpatía*.

The acculturative process among Hispanics can be assumed to have produced a movement toward biculturalism: Individuals who feel not only comfortable interacting in either culture but who also value the characteristics that are central to both cultures. This means that bicultural Hispanics can not only speak both English and Spanish but also value individualism and collectivism and feel honored and privileged in their multiple cultural traditions. This biculturalism has been found among individuals who show great interpersonal resources, who are efficient and admired leaders, and who enjoy their fluency in two cultural traditions.

ALL MEN AND WOMEN ARE CREATED EQUAL

The literature in psychology and in sociology of the last few years has shown how men and women, who while verbally adhering to the statement that all people are created equal, would be willing to bar certain individuals from entry into their country, or from voting, or from access to certain societal institutions, or from becoming their friends or relatives. This perception that some people are less equal than others is usually called prejudice and its behavioral effects are often labeled discrimination.

Hispanics are frequently the object of prejudicial attitudes that, while of uncertain origin, remain of importance even in the decade of the 90s. It is not uncommon to find among certain individuals, and even in the media, the beliefs that Hispanics are lazy, dumb, devious, or aggressive. Movies and television shows as well as certain advertising campaigns often show Hispanics as the lazy worker who would rather take a *siesta* than work all day, as the dumb gardener or cook who can easily be confused by the smarter non-Hispanic, or as the drug dealing gangster of contemporary times.

While these examples are usually dismissed as exceptions rather than the rule, their effect is significant in creating a false sense of consensual validation. These repeated false representations of Hispanics as lazy or as dangerous crooks can reinforce the wrong belief that there may be some kernel of truth in the stereotype. The overall effect is that these prejudicial attitudes help support a negative perception of Hispanics that manifests itself in discriminatory behaviors. The prejudicial attitudes supported by stereotypical behaviors serve only to minimize the intrinsic value of the members of a given group by outsiders and even by members of the group. These stereotypes "make us all smaller" in the words of the character of a recent movie, a Hispanic rancher in Texas, who had decided to burn those billboards where Hispanics were shown as either drunkards or as sleepy and lazy people.

A significant reason for these stereotypical attitudes is of course the fact that Hispanics in general are different from other residents of the United States. The color of their skin may be darker, they may speak with an accent, they may value different worldviews, or they may even prefer soccer over football or tacos over hamburgers. Nevertheless, as is true for the members of any other ethnic group, Hispanics are as varied as they can be. This fact renders most ethnic stereotypes invalid.

As suggested by the literature on intergroup harmony, we need intergroup contact based on equality and mutual respect to dispel some of these faulty assumptions. This may come as we move into the future where by the year 2020 Hispanics will become the largest minority group in the United States. Meanwhile, Hispanics will continue to contribute to the lifestyle of the United States through the arts, the sciences, business, and commerce such as pioneering Hispanics have been doing for many years. From Linda Rondstadt and Charlie Sheen to the President of the Coca Cola Company and the Treasurer of the United States in the Bush administration, Hispanics will continue to play a key role in the life of the country. Among these new pioneers are the thousands of unnamed Hispanics who made the jeans you are wearing, who harvested the oranges we eat for breakfast, who put together the chips in your computer, and who in the spirit of Jaime Escalante, the Los Angeles teacher immortalized in the movie "Stand and Deliver," taught us that personal change can happen.

SUGGESTED ADDITIONAL READINGS

Acosta-Belén, E., & Sjostrom, B. R. (1988). *The Hispanic experience in the United States.* New York: Praeger.

Geisinger, K.F. (Ed.) (1992). *Psychological testing of Hispanics.* Washington DC: American Psychological Association.

Hayes-Bautista, D.E., Schink, W.O., & Chapa, J. (1988). *The burden of support: Young Latinos in an aging society.* Stanford, CA: Stanford University Press.

Langley, L.D. (1988). *MexAmerica: Two countries, one future.* New York: Crown Publishers.

Marín, G., & Marín, B.V. (1991). *Research with Hispanic populations.* Newbury Park, CA: Sage.

Shorris, E. (1992). *Latinos: A biography of the people.* New York: W. W. Norton & Company.

Weyr, T. (1988). *Hispanic U.S.A.: Breaking the melting pot.* New York: Harper & Row Publishers.

3
Being Asian in North America

D. JOHN LEE AND CHRISTINE C. IIJIMA HALL

There is some evidence that people from Asia landed on the shores of California around the year 500 A.D., well before Christopher Columbus crossed the Atlantic (Mertz, 1972). Over the last century, however, many more Asians have made the trip across the Pacific to make North America their home. We will describe some aspects of what it is like to be Asian in North America.

RUTH: A CASE OF MISTAKEN IDENTITY

Ruth was born in Korea but she was adopted as an infant by a Swedish-American family and raised in an English-speaking Christian home. Her childhood was not unlike many middle-class Americans. She attended a suburban public school, went to church on Sundays, and enjoyed a McDonald's hamburger once a week after her Girl Scout meeting. In high school, Ruth did well academically and her gymnastics team won the state title the year she graduated. She was offered scholarships at several large universities but decided to attend a small, private, liberal arts college. Like most first-year college students, Ruth had to make some adjustments being away from home and friends. However, the

most difficult challenge she faced was unexpected. Ruth experienced racism.

One of the first questions her roommate asked her was "How long have you been in America?" She assumed that Ruth was a recent immigrant or an international student. Ruth was also embarrassed by a professor who thought she was Japanese and asked for her opinion about Japanese management style in class. On another occasion, her math professor assured her that she should do well in her course since "you people do so well in mathematics." Also, her resident assistant paused uncomfortably when she met Ruth "Jorgenson," expecting to meet someone who looked Swedish rather than Korean. These kinds of mistakes were also made by Asian students. For example, a Korean-speaking student greeted Ruth and upon realizing that she could not answer in Korean quickly turned away with an embarrassed and somewhat judgmental smile. And when Ruth agreed to go out on a date with a "white" man, a Chinese girl in her dorm jokingly called her a "banana" (yellow on the outside, white on the inside). To say the least, these experiences hurt and confused Ruth.

We present this case study to illustrate some aspects of being Asian in North America. However, Ruth's particular circumstances (i.e. being adopted

D. John Lee is an Associate Professor of Psychology at Calvin College in Grand Rapids, Michigan. He edited *Ethnic-Minorities and Evangelical Christian Colleges* (University Press of America, 1991). His Ph.D. is from Kansas State University, and his interest in cross-cultural psychology was enhanced at Western Washington University, where he earned his Master's degree.

Christine C. Iijima Hall, Ph.D., is Vice Provost at Arizona State University West in Phoenix. Prior to this position, she was the Director for the Office of Ethnic Minority Affairs for the American Psychological Association in Washington, D.C.

and raised in an English-speaking Christian environment) should not be taken as representative of all Asian Americans. The total number of adopted Korean children is minuscule compared to the 7.3 million Asian Americans. Ruth's situation should be taken as an illustration of how diverse Asian Americans are, how racism is often directed towards Asians, and why many Asian Americans experience some degree of marginality.

Diversity among Asian Americans

The terms, "Asian American" and "Asian Canadian"[1] have been used to refer to a variety of peoples who immigrated or whose ancestors immigrated to North America from countries in Asia. Some of these countries include China, Japan, Korea, Taiwan, Vietnam, Laos, Cambodia, Thailand, India, and the Philippines. Sometimes the term, "Asians and Pacific Islanders" is used to encompass people from the Pacific Islands of Fiji, Hawaii, Samoa, Guam, and many others. And although people from these nations share some similarities, there are vast differences between and among them. For example, there are well over 15 different languages represented by the Asian-American label and there are 55 different ethnic groups or sub-cultures of Chinese. In addition to this diversity among Asian Americans, each group has its own history of migration to the United States and Canada.[2] The Japanese and Chinese, for instance, arrived in the late 1800s voluntarily while the Southeast Asians (e.g. Vietnamese, Cambodians, Thais, and Hmong) have only recently immigrated having been forced out of their homelands because of political and military unrest. The differences between the cultures subsumed under the Asian-American label are far greater than the similarities. Thus, it is extremely difficult to talk about "Asian Americans" as if they were a single cultural group.

The diversity among Asian Americans is often not recognized by those who have limited contact with them. Although it may initially appear that "all Asians look alike," it is possible with enough experience to tell the difference between some Asian groups. Ruth's experience of being treated as if she were Japanese is not an uncommon experience among Asians. This kind of error was made in 1982 when Vincent Chin, a Chinese-American, was beaten to death with a baseball bat by two Detroit unemployed autoworkers because they thought he was Japanese. The murderers were convicted of manslaughter but were only sentenced to three years probation and fined $3,750. If two Chinese men had beaten a white man to death with a baseball bat, we think the sentence would have been much more severe . . . which brings us to the topic of racism.

Racism

Racism is usually associated with violent behaviors, like the murder of Vincent Chin. But racism can be much more subtle as in the case of Ruth's roommate assuming that she was an international student or her resident assistant's uncomfortable pause during their introduction. Racism includes the attitudes, practices, and policies that result from a belief that skin tone determines attributes or be-

> **Racism includes the attitudes, practices, and policies that result from a belief that skin tone determines attributes or behaviors.**

haviors. Just because Ruth *looked* Korean did not mean that she grew up in Korea, had a Korean name, spoke Korean, and would excel in mathematics. Ruth's personality and interests are reflected more by the "culture" she grew up in and not the color of her skin or "race." She spoke English, attended a Christian church, valued education, and loved gymnastics because of the family environment in which she was raised. Instead of inquiring into the kind of culture Ruth was from, the people at her college were simply using Ruth's physical features to infer her social and personal characteristics. This kind of racism is common in North America and occurs between and among all groups and not just among those folk who have "white" skin. For example, the student who addressed Ruth in Korean made the same kind of racist error as her roommate and math professor committed. All of these people were guilty of assuming something about Ruth solely on the basis of her physical features, which is at the core of racism.

Marginality

In confronting racism Ruth would learn that her skin color does influence how other people perceive

her and what they expect of her. Ruth is a partial member of two groups but not fully accepted by either one. As shown in Figure 1, she is a member of one group that does not fully accept her because of her skin tone or race (racism). And, she is a member of another group which does not fully accept her because of her ethnicity or culture (ethnocentrism). How she responds to this situation, or what sociologists call "marginality" (Stonequist, 1937), can vary. At one extreme, she might rebel against or ignore the expectations people have of her and continue living as a Swedish American who looks Korean. At the other extreme, she might try to embrace Korean culture and reclaim what could have been hers if she had been raised in Korea. Or, Ruth might learn to live her life between the extremes taking what her family had given her and exploring Korean and Korean American cultures for what they had to offer her as well. How Ruth responds to her marginality cannot be easily predicted, but we can confidently predict that she will continue to encounter the kind of racist and ethnocentric attitudes and behaviors that place her on the margins in the first place.

How people deal with marginality has been the focus of much research and debate among social scientists. One of the first articles to describe marginality among Asian Americans was written by two Chinese-American psychologists, Stanley and Derald Sue.[3] In 1971, they published an article that described three personality types among Chinese-Americans and the type of mental health issues each encounters. Ben Tong (1971) in the premiere issue of *Amerasia* criticized the Sue brothers for psychologizing (and thus legitimizing) the effects of racism on Chinese-Americans. The debate continued for a while but it became clear that any discussion of Asian-American marginality or cultural

identity could not take place without addressing racism as well (Atkinson, Morten, & Sue, 1983). Marginality can also occur among Euro-Americans. Janet Helms (1990) offers a model of "white racial identity development" which describes stages Euro-Americans go through in becoming conscious of their own subculture and racism. It is our conclusion that how a person learns to live on the margins depends on many factors. These include family, language proficiency, income, friendships, place of residence, religion, and other cultural variables.

RACISM AGAINST ASIANS

We now return to the problem of racism against Asian Americans. We believe that a major aspect of the Asian experience in North American culture is learning how to deal with other people's perceptions of us because our skin color is something other than "white." That is, learning how to live with and to confront racism is part of being Asian in North America. We have chosen historical as well as contemporary examples because the Chinese exclusion acts and Japanese-American internment have frequently been omitted or misrepresented in high school and college history textbooks.

Chinese Exclusion Acts

In 1882, the U.S. Federal Government passed the Chinese Exclusion Act, and in 1923, the Canadian Parliament signed into law the Chinese Immigration Act. These laws restricted the immigration of Chinese into North America and required that every person of "Chinese origin," even those who had been born in North America, to formally register with the government and denied them the right to vote. These Acts went through a variety of revisions, but were not fully repealed until 1965 in the United States and 1962 in Canada.

The Chinese exclusion laws were acts of racism. They defined and identified people of "Chinese origin" solely on the basis of physical features. A person with "white" skin who was raised in a Chinese culture was not affected by these laws. But, a person with "yellow" skin who was raised in a British culture would be denied immigration. Newspapers, magazines, and even school textbooks described Chinese people as unclean, diseased, sexually perverse, opium addicts, gamblers, thieves, deceitful, and unable to assimilate into the English-speaking Euro-American mainstream culture. Thus, people

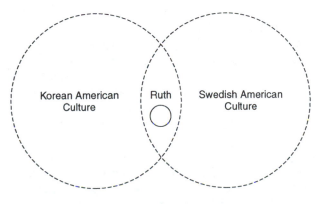

FIGURE 1 Marginality: Ruth on the margins

believed if a person looked Chinese then he or she supposedly possessed these "Chinese" characteristics. The stated rationales for the acts pointed to these racial traits with little or no reference to how the Chinese immigrants were willing to work for lower wages than their white-skinned Euro-American counterparts. That is, racial incompatibility was used to justify the acts, while protecting jobs for "white" immigrants was probably more salient in the legislators' minds (Ward, 1978).

Japanese American Internment

On December 8, 1941, the day after the attack on Pearl Harbor, the United States declared war on Japan. On February 19, 1942, President Franklin D. Roosevelt signed Executive Order 9066 which ordered the removal of all people of "Japanese ancestry" living within 200 miles of the Pacific Ocean. A similar move was taken by the Canadian government on February 27, 1942.

These Japanese-American internment laws were acts of racism. They were directed at a group of U.S. and Canadian citizens who were discernible because of their physical features. A person with "white" skin who was raised in a Japanese culture was not removed from his or her home by federal agents. But, a person with "yellow" skin who was raised in a British culture would be ordered to move. The internments were justified by an appeal to national security. Keep in mind that German and Italian Americans were *not* perceived as a threat and ordered to relocate. (We need to stress that we do not advocate any internment-type act but wish to show how racism was involved in the internment of Japanese Americans.) The difference, of course, is that German and Italian Americans do not have salient *physical* features that set them apart from other Americans. The *cultural* characteristics that did set them apart were quickly hidden or rejected. For example, the German and Italian languages were quickly silenced during the war and last names were often "anglicized" to sound and appear English (e.g. some German Americans named Schmidt changed their names to Smith).

It was also argued that the internment was necessary in order to protect the Japanese Americans. While this may in part be true, there are other ways to provide protection for citizens besides forcing them to sell all their property, shut down their businesses, relocate to the desert, and imprison them behind barbed wire. Although there were acts of violence towards German and Italian Americans

during World War II, none were to the extent of interning over one hundred thousand Japanese Americans and Canadians.[4] The stated rationale for the relocations were national security and protection with no reference to the prime agricultural and ocean-front real estate owned by many Japanese Americans.

During the 1970s and 1980s, Japanese Americans decided to demand some type of redress (compensation) for the internment. The Commission on Wartime Relocation found that Executive Order 9066 was not justified by military necessity and that the causes of the internment were "race prejudice, war hysteria, and a failure of political leadership." In 1988, the U.S. government passed House Resolution 442 which mandated an apology and compensation be paid to each living internee or his or her surviving family. A similar redress act was passed in Canada in 1989.

The Chinese Exclusion Acts and Japanese-American internments exemplify how Japanese and Chinese citizens of Canada and the United States were denied some of their basic human rights and publicly humiliated to serve the economic interests of those who held political and financial power. It is worth emphasizing that these examples clearly demonstrate how racism, especially when it becomes institutionalized, is designed to maintain the status quo or protect those who control the economic and political power.

Racism Today

Acts of racism towards Asian Americans are still very real in North America today. In fact, "hate crimes" (violence due to ethnic and racial discrimination) against Asian Americans are on the increase according to the U.S. Justice Department. In addition, "Asian-bashing" (verbal ridicule and degrading statements), particularly "Japan-bashing" fueled by the economic crises in North America, are also on the rise. "Hidden" acts of discrimination are also prevalent in North America. The act of exclusion or benign neglect can be just as racist as overt behaviors of racism. One exclusionary act that often goes unnoticed is that Asians are often not listed when demographic statistics are reported. That is, when a study is reported or a survey conducted, the groups that are usually listed are white, Black, and maybe Hispanic. This exclusion conveys to Asian Americans that we are not important enough to be surveyed or counted. Continued physical and verbal acts of hostility are signs that most North

Americans are still unwilling to accept and live with Asians.

The most frequently discussed topic concerning Asian Americans is why they have consistently scored the highest on North American tests of educational achievement. This topic is highly controversial since it has been suggested that the "mongolian" race (sic) is genetically superior to other races when it comes to intelligence. Although this may appear to be a compliment to us, we judge this hypothesis and its supporting evidence to be racist. We reject the conclusion that skin color is causally related to academic achievement. Recent research strongly suggests that Asian cultures, with the particular family values and child-rearing practices, emphasize the need to succeed educationally (Caplan, Choy, & Whitmore, 1992; Stevenson, 1992). Sue and Okazaki (1990) do a thorough job of reviewing the theories put forth to explain Asian-American educational achievements.

Dealing with stereotyping, racism, and marginality are three of the topics often discussed by social scientists when considering Asian Americans. But, we would be remiss if we did not acknowledge the other social psychological dynamics (e.g. economics and religion) that help shape the experience of being Asian in North America. One thing is for certain—Asian-Pacific Americans are a diverse people in motion and in transition.

ENDNOTES

[1]Although people in the United States are commonly referred to as "Americans," Canadians can also use the term since Canada is part of North America. For the sake of brevity, we will be using the term "Asian American" for those Asians who are residents or citizens of the United States and Canada.

[2]*Amerasia*, a periodical published by the Asian American Studies Center at the University of California, Los Angeles (UCLA), has printed several articles exploring the reasons why Asian groups have immigrated to North America. Another excellent resource is Ronald Takaki's *Strangers from a different shore* (1989).

[3]The combined work of Stanley, Derald, and David Sue (a third brother who is also a psychologist) stands as a monument of psychological inquiry into the Asian American experience.

[4]Nagata (1990) and Tateishi (1984) describe the physiological and psychological damages to Japanese-American internees.

REFERENCES

Atkinson, D. R., Morten, G., & Sue, D. W. (1983). Proposed minority identity development model. In D. R. Atkinson, G. Morten, & D. W. Sue (Eds.). *Counseling American minorities: A cross-cultural perspective.* 2nd Ed. Dubuque, IA: Wm. C. Brown.

Caplan, N., Choy, M. H., & Whitmore, J. K. (1992). Indochinese refugee families and academic achievement. *Scientific American. 266* (2), 36–42.

Helms, J. E. (1990). Toward a model of white racial identity development. In J. E. Helms (Ed.) *Black and white racial identity: Theory, research, and practice.* New York: Greenwood Press.

Mertz, H. (1972). *Pale ink: Two ancient records of Chinese exploration in America.* 2nd Ed. Chicago: Swallow Press.

Nagata, D. K. (1990). The Japanese American internment: Exploring the transgenerational consequences of traumatic stress. *Journal of Traumatic Stress, 3,* 47–69.

Stonequist, E. V. (1937). *The marginal man.* New York: Charles Scribner & Sons.

Sue, S. & Okazaki, S. (1990). Asian-American educational achievements: A phenomenon in search of an explanation. *American Psychologist, 45,* 913–920.

Sue, S. & Sue, D. (1971). Chinese-American personality and mental health. In Regents of the University of California, *Roots: An Asian American Reader.*

Stevenson, H. W. (1992). Learning in Asian schools. *Scientific American, 267*(6), 70–76.

Takaki, R. (1989). *Strangers from a different shore.* Boston: Little Brown.

Tateishi, J. (1984). *And justice for all.* New York: Random Hall.

Tong, B. (1971). The ghetto of the mind: Notes on the historical psychology of Chinese America. *Amerasia, 1,* 1–31.

Ward, W. P. (1978) *White Canada forever.* Montreal: McGill-Queen's University Press.

4
The American Indian: A Psychological Overview

SANDRA K. BENNETT

Being Indian is more than checking the box for ethnic origin. It is a way of life, a way of being. The love for family, respect for your elders, spirituality, self-determination, integrity, pride, understanding, protecting the environment, humor, and socializing are all the essence of being Indian.[1]

For the non-Indian, American Indian people are often an enigma. Cinema, television, popular fiction, and the media have presented a picture of Indian people as primitive and savage on one hand, and spiritual, romantic, and noble on the other. Somewhere between these two extremes lies a truer

Sandra K. Bennett is Assistant Professor of Counseling Psychology at the University of Oklahoma where she earned her Ph.D. in 1991. Her research has focused on American Indian mental health issues and racial identity attitudes. She is currently president of the Society of Indian Psychologists and serves as a consultant on several advisory boards concerned with cross-cultural psychology.

The author gratefully acknowledges the assistance provided by the members and officers of the University of Oklahoma American Indian Student Association in their willingness to share their personal views and experiences.

Author's Note

The terms "American Indian" and "Indian" are used interchangeably throughout the text of this chapter and refer to the indigenous tribes of what is today the United States.

description of Indian people in America today. The following sections offer an "Indian" perspective on some of the issues with which American Indians struggle. These include stereotyping, acculturation, social and mental health concerns, and responses to continuing racism and discrimination.

STEREOTYPING AND BEING INDIAN

Part of being Indian is doing away with stereotyping so we can get past this and get on with the many opportunities available to us.

Stereotypes are used to explain and predict a person's behavior when no other knowledge of that person is available. Some of the more common stereotypes applied to American Indians rely on descriptors such as lazy, drunk, childish, savage, proud, irresponsible, and immoral (Trimble, 1988). Unfortunately, American Indians today must, more often than not, deal with these stereotypes. One need only check the local bookstore to find book cover illustrations that exemplify and perpetuate such uninformed attitudes. An important question, then, is "How do Indian people go about overcoming such stereotypes?" One solution is found in educating non-Indians about who we are and what that means to us. For example, American Indians today are no more "primitive" or "savage" than any other group of people. In fact, as Indians we have never really considered ourselves primitive or savage, but have prided ourselves on our historic gov-

ernmental organization and diplomacy. Because this organization differed from Eurocentric governmental styles, it was considered less sophisticated or civilized. It is true that tribes waged war on one another and on European settlers. However, these wars were fought to ensure a tribe's or band's means of survival and rarely, if ever, over differing political ideologies. Further, while there remain Indian warrior societies within various tribes that honor those Indian men who have fought for this country, these societies are no more primitive and savage than are other "warrior" organizations such as the Vietnam Veterans, or the Veterans of Foreign Wars.

Many times American Indians are "romanticized" (Trimble, 1988) and thought to be more spiritual, or even mystical, in comparison with other groups. Indian people, however, vary on the amount of spirituality they exhibit as do other members of U.S. society. Some try to follow the more traditional Indian religious paths, some are devoted to the Native American Church and its peyote ceremonies, and some are Catholic, Protestant, agnostic, and even atheist. Traditional Indian religious ceremonies as well as some of those of the Native American church are closed to the general public. Because they are in fact purposeful, emotionally charged, spiritual occasions, they are considered sacred and are not undertaken for "show." Through these ceremonies, Indian people give thanks to the Creator and renew their spiritual selves.

In agreement with the above comments, most authors writing about Indian people note that American Indians are *very* diverse. Tribes in the Northeast have different customs and traditions

There is no *one* Indian language, no *one* Indian religion, and no *one* Indian culture. Instead there are numerous languages, religious practices, and cultural norms.

than do those in the Southwest (Debo, 1972). There is no *one* Indian language, no *one* Indian religion, and no *one* Indian culture. Instead there are numerous languages, religious practices, and cultural

norms. With all this difference, it seems logical to wonder if any commonalities remain. In fact, there are certain common themes underlying American Indian culture. American Indians, in general, tend to value generosity, cooperation, community, and family (Attneave, 1982). However, the specific ways in which these values are exhibited may be different from tribe to tribe. For instance, generosity is seen in certain Northwestern tribes in the form of the "potlatch" in which valuable gifts are given to friends and neighbors. In the Southwest, Pueblo Indian villages accomplish the same thing through a "throw away," and many western tribes such as the Caddo and Cheyenne have a "give away." So, while called by different names and carried out in somewhat different ways, the underlying idea is that honor and prestige are gained not through the accumulation of property, but through the generous actions of gift-giving.

FULL-BLOODS, MIXED-BLOODS, AND TRADITION

In the present day (20th Century) most Indians who are traditional and speak their native language are elders. It is assumed that the younger generation is letting their culture die. I do not live on a reservation, but in a city. I personally am very interested in keeping my Kiowa tradition alive.

According to U.S. Census information, there are over 200 federally recognized American Indian tribes whose members can be found in virtually every part of the United States. The population is young (the average age of American Indians is only 22.4 years) and growing. In 1990, the Indian population was reported to be over 1.9 million which far exceeds the 1980 figures and growth projections made from those figures. Yet American Indians remain the smallest ethnic minority group in the United States.

While the number of people identifying themselves as "American Indian" in the most recent census was large, some questions have been raised about whether all are actually Indian. Defining the term "Indian" has become problematic. To the dismay of many tribal people, the federal government has been active in denoting who is Indian and who is not for over 100 years. This dismay stems in part from the fact that no other racial/ethnic group in this country must rely on the government to define

their racial background. The tribes themselves have also been active in defining membership or citizenship requirements. Many times there is disagreement between the two governmental entities (tribal government and federal government). To be acknowledged as "Indian" by the federal government, a person has only to prove that she or he is a descendant of an Indian person. The amount of Indian blood (blood quantum) is relatively inconsequential. However, for tribal membership, blood quantum is crucial. In some tribes the person must be at least 1/4 Indian to meet citizenship requirements. Thus situations arise in which a person is considered to be Indian by the federal government but is not considered as such by his or her tribe.

When considering this problem, one also hears discussions of "cultural" Indianness. In other words, does the person adhere to the traditions and cultural norms of his/her tribe? In a 1982 unpublished manuscript, Loye and Robert Ryan revised earlier cultural designations and presented five descriptors relating to the concepts of assimilation and traditionality. Those American Indians who were never taught tribal traditions and norms or who have totally embraced the traditions and norms of the majority Anglo-American culture are considered *assimilated* or *acculturated*. If assimilation is considered to be one extreme, *traditional* and *transitional* Indians might be considered the opposite extreme. Traditional people are few and far between. These people observe the old traditions and values, know and speak little English, and are living examples of the cultural heritage of their respective tribes. Transitional Indians tend to speak both their native language and English and, while not yet able to embrace the dominant culture's values, may question basic traditions and religious beliefs.

Varying degrees of assimilation and traditionality can be seen in Indians today. There are those who are said to be "bicultural" (referring to their knowledge and acceptance of Indian culture and traditions as well as those of Anglo America). Bicultural Indians are not necessarily full-blooded or of mixed ancestry (both Indian and non-Indian ancestors). The important thing about these people is that they do seem competent and comfortable in both the Indian and Anglo worlds.

On the fringes of Indian and Anglo cultures is the "marginal" Indian person. In general, the marginal, or marginalized, person feels no strong ties to either culture. The psychological importance of group membership and identification is such that some psychologists, anthropologists, and sociologists have suggested that the person who does not identify strongly with either group may experience more life problems than do Indians in any of the other cultural positions.

Cultural position should not, however, be thought of as unchanging or permanent. Realignments may occur in response to life experiences that cause a period of self-analysis and sometimes a concerted effort to regain a heritage that seems lost. This is exemplified in the following statement.

> *I do not consider my upbringing to be "traditional," but I always knew that I was Indian and was proud of that. When I came to college I interacted and became friends with "traditional" Indians. This experience has made me reflect on my upbringing, family, and friends.*

For most American Indians culture is an important part of our lives. We socialize together, form friendships, and share information about different tribal traditions. Assimilated, bicultural, traditional, transitional, or marginal, we are all members of the same ethnic/racial group.

SOCIAL AND MENTAL HEALTH ISSUES

Many American Indian people have moved from reservations and other tribal communities to urban areas in search of job opportunities. This migration from rural to urban settings may be a direct result of the high instance of poverty found among American Indians. The jobless rate for Indians continues to be above that for the rest of the United States and is compounded by a lack of education. While educational opportunities are available and funded through tribal and Bureau of Indian Affairs monies, only a small percentage of American Indians earn college degrees. In fact, as reported in 1988, the average educational attainment for Indians was only 12 years (high school). Career opportunities for high school graduates who have no further training are limited, salaries minimal, and possibilities of job advancement relatively nonexistent. This harsh truth has placed many Indian people in a downward spiral culminating in situations that look and sometimes are hopeless, creating depression and increased instances of suicide. Such an atmosphere further encourages the use and abuse of alcohol and other substances as means of escape from reality.

Given this, it is not surprising to discover that there are many concerns among those mental health service providers who deal directly and indirectly with American Indian populations. These concerns include the high incidence of alcohol and substance abuse, fetal alcohol effect/syndrome, depression, family violence, and child abuse and neglect (Manson, 1982).

Indian Health Service (IHS), as a part of the Public Health Service, is the largest provider of health services to American Indians in the United States. A recent survey of IHS mental health service providers indicated that the most prevalent problem treated was that of alcohol and substance abuse. This echoes the findings of many researchers who have noted that the problems of alcohol and substance abuse seem to be more pervasive than any other among Indian populations. The effects of such abuse are further thought to influence the incidence of many mental health problems including the increasing incidence of fetal alcohol syndrome and fetal alcohol effect among Indian newborns (May, Hymbaugh, Aase, & Samet, 1983).

Fetal alcohol syndrome (FAS) and fetal alcohol effect (FAE) are relatively new problems to the mental health field. Alcohol use and abuse is the direct cause of both with FAE being a somewhat milder version of FAS. An FAS child has cognitive and emotional difficulties resulting from the mother's use of alcohol during pregnancy. Recently, it has been suggested that the father's use of alcohol at the time of conception may also increase the risk of FAS in children. Preventative measures taken with American Indian populations have ranged from educational groups to much more severe measures including the incarceration of pregnant mothers who either refuse or are unable to quit drinking on their own for the duration of their pregnancy. Unfortunately, even the moderate success of such preventions cannot change the fact that many Indian children (and children of other racial/ethnic backgrounds) suffer from FAS/FAE.

Indian children coming from homes affected by alcoholism, drug abuse, or other such problems are often placed in foster care or, in some cases, given up for adoption. In the past, the tribes expressed concern about the environment into which Indian children were being placed. This concern was focused on the loss of tradition and culture when Indian children were placed in non-Indian homes. In 1978, the Indian Child Welfare Act was passed to address this concern by requiring that cultural values be taken into account when Indian children are placed for adoption. However, the way in which this legislation has been implemented creates even further difficulty. Questions subsequently arising include how to define what constitutes an Indian family (i.e., one parent of Indian descent versus both of Indian descent), issues of crossing tribal boundaries (i.e., adoptive parents members of a tribe different from that of the child's birth parents), and whether tribal courts or federal courts should provide the necessary adjudication.

Besides these social and mental health issues, American Indians continue to face instances of racism and discrimination on a more personal basis than have been suggested to relate to the clash between traditional Indian beliefs and those of the dominant culture (Locust, 1988). In various parts of the country Indian people are exposed to discrimination in housing, employment, and education. The fact that, in general, American Indians have not been as vocal as other racial/ethnic groups in demanding equal rights may be in part responsible for the continuing struggles faced.

In summary, American Indians face situations of poverty perpetuated, in general, by educational attainment levels lower than the majority of American society. Further, alcohol and substance abuse, FAS/FAE, depression, child abuse and neglect, and family violence have been identified as problems that may be related to such situations. Finally, racism and discrimination are continuing problems that have so far eluded resolution.

The above discussion has been necessarily brief. The experience of being Indian in America today is a complex issue that cannot be adequately addressed in such limited space. However, certain key points are important to remember. First, American Indians are a diverse people with diverse customs. Stereotypical attributions to Indians are unfair, uninformed, and generally inaccurate. Second, although our numbers are increasing, we are still a minority among minority groups. Being a small but growing group, we are concerned about the loss of tradition occurring through child welfare actions and through the death of our elders who have always been the keepers of our heritage. Third, we suffer from many of the ills of U.S. society and share in some of the triumphs. We are doctors, lawyers, teachers, tribal chairmen/women, farmers, factory workers, students, homemakers, indigents, and administrators. We work and play and laugh and cry. We are like everyone in some ways, but are also very different. Finally, is being Indian more than just "checking" the box labeled Ameri-

can Indian for ethnic origin? For most of us it is much more, it is indeed a *way of life, a way of being.*

REFERENCES

Attneave, C. (1982). American Indians and Alaska Native families: Emigrants in their own homeland. In M. McGoldrick, J.K. Pearce, & J. Giordano (Eds.), *Ethnicity and family therapy* (pp. 55–83). New York: The Guilford Press.

Debo, A. (1972). *A history of the Indians of the United States.* 1st ed. Norman, OK: University of Oklahoma Press.

Locust, C. (1988). Wounding the spirit: Discrimination and traditional American Indian belief systems. *Harvard Educational Review, 58,* 315–330.

Manson, S.M. (Ed.). (1982). *New directions in prevention among American Indian and Alaska Native communities.* Portland, OR: The Oregon Health Sciences University.

May, P.A., Hymbaugh, K.J., Aase, J.M., & Samet, J.M. (1983). Epidemiology of fetal alcohol syndrome among American Indians of the Southwest. *Social Biology, 30,* 374–387.

Trimble, J.E. (1988). Stereotypical images, American Indians, and prejudice. In P.A. Katz & D.A. Taylor (Eds.), *Eliminating racism: Profiles in controversy* (pp. 181–201). New York: Plenum Press.

ENDNOTE

[1]All quotations are from members of the American Indian Student Association at the University of Oklahoma. This organization has a membership of approximately 150 students representing over 40 different tribes in the United States. Their statements were made in response to the question "What would you like non-Indian students to know about what it means to be Indian?"

5
Continuing Encounters with Hong Kong

MICHAEL HARRIS BOND

*A foreign country is a mirror
in which each traveller
contemplates his own image.* —ANDRE MAUROIS

It is Christmas Eve, 1991, and I have been living in Hong Kong for over 17 years. I know that this surviving fragment of the British Empire is geographically located just south of the Tropic of Cancer at longitude 114°, but I am still charting my cultural bearings. For, within a 50 km radius of where I now sit are over 6 million Cantonese people. On a daily basis I eat, commute, conduct research, celebrate, hold meetings, bargain, commiserate, teach, exchange gifts, speak various languages, vie for promotion, and generally go about the business of living with a kaleidoscopic subset of this tiny subset of the world's Chinese population. To say that we do things differently would be an understatement. But out of these differences have emerged some discoveries about how we are similar; others still await landfall.

Michael Harris Bond was born in Toronto, Canada, where he received a transplanted public school education from teachers with British accents. Subsequent travels took him to exotic cultures, like California, where he received his Ph.D. from Stanford University in 1970. He continued going West as a young man until he arrived in the Far East, where he has now reached middle age teaching psychology at the Chinese University in Hong Kong. He recently co-authored the book *Social Psychology across Cultures* (Allyn and Bacon, 1993).

I should have realized that something intriguing was afoot when my wife, one-year old daughter, and I deplaned on August 10, 1974 at Kai Tak International Airport. We had arrived in Hong Kong, pearl of the Orient, home to (then) almost five million Cantonese people, lingering outpost of the British Empire, prize of the 1842 Opium war, and charter member of the Asian economic dragons. I had a accepted a job at the Chinese University to teach psychology and was wondering if my lecture notes would arrive by ship in time for my September classes. That would be the least of the challenges awaiting this very green Canadian as I began the professional quest of figuring out the psychology of Chinese people and the personal struggle of living fruitfully with them.

Puzzles announced themselves early. As we left the air-conditioned Boeing 747, we were hit by the distinctive wall of heat, humidity, noise, color, and odor that greets all new arrivals. I had just been reading that in the Chinese language "Hong Kong" translates as "fragrant harbour." Although I saw boats at anchor in the distance, the fetid stench that hung in that miasma was anything but fragrant!

So, at the verbal level my first encounter with Hong Kong appeared half correct. The other half eventually followed. For I quickly learned to dab my left wrist with a musky after-shave to help recalibrate my nostrils when the "fragrance" became especially noxious. This small accommodation on my part has enabled me to transform an apparent contradiction into a workable truth. Struggling with other puzzles has likewise yielded a few scientific truths.

Passports to Discovery

*Most cultural exploration begins
with the experience of being lost.* —EDWARD HALL

My basic thesis is that I have become a better cross-cultural psychologist because I live in a foreign culture. Before reaching the age of maturity, I was raised in Anglo-Saxon Toronto. The ground rules I absorbed during those formative years helped me adapt successfully to that special milieu, but prepared me to experience a host of puzzles, irritations, and delights when exported to Hong Kong.

By stumbling around "in alien corn," as Keats called it, I encountered all sorts of weird and wonderful differences. As a citizen, I had to negotiate these differences by learning to anticipate them so that I could avoid certain situations, accommodate myself to others, and seek out the rest. As a behavioral scientist, they became grist for my intellectual mill. What did that behavior mean? Could one measure the behavior in a controlled setting? Could this setting be used to compare both Chinese people and Canadian people? If a difference was discovered, how could it be explained? Some of my most fruitful experiments emerged from these prods when applied to differences I noticed.

In this paper, I will describe some of the encounters that led to some of these experiments. This exercise may be useful for younger readers, because science often seems a remote and daunting activity when stripped of its human dimension. But, in the behavioral sciences, this human dimension is a unique resource for us to use in developing ideas.

Many who travel thoughtfully come to realize that a cultural system is an adaptive set of conventions.

Our own phenomenology can be mined in the context of discovery to unearth important hypotheses. In the cross-cultural field, these hypotheses educate us about culture, the very foundation our reality.

So, the journey is not without potential disruption. Many who travel thoughtfully come to realize that a cultural system is an adaptive set of conven-

tions. These operating assumptions are unconsciously held by most people, but may be shaken loose by the confrontation with a different culture. Indeed, after 17 years of daily encounters with Chinese reality, I have come to question some of my Canadian assumptions. Perhaps in consequence I have been "Sinicized," just as some Chinese have been Westernized. Some of these changes in my personal culture may become apparent to the sensitive reader, as I recount some of my earlier surprises.

A FRIED RICE OF CULTURAL SURPRISES

A Case of False Modesty?

Our psychology department was searching for a lecturer in cognitive psychology to replace a visiting appointee. Whereas most of our candidates apply from overseas, a local Chinese Ph.D. had signalled his interest, so a seminar was promptly arranged. The faculty was delighted to have the rare opportunity of assessing a candidate's lecturing skills before hiring and all teachers attended the presentation.

Our department chairman introduced the candidate in a serious manner, detailing his accomplishments since high school. The candidate sat with head lowered, leafing through a thick sheath of notes. When our Chairman finished, the presenter responded to the introduction. With his head still lowered, he allowed that, "It has been a very busy last month, so I have had little time to prepare my presentation to you. Furthermore, it addresses a complex topic that I find very difficult. So, I am afraid many of you will find my talk rather superficial and disorganized. Perhaps you would help me by offering any insights you might have."

I was flabbergasted. We knew from inquiries already made to others that our candidate was very keen to be hired. The job market was tight, our salary competitive, and our research support abundant. How could any sensible professional present himself so disparagingly on such a decisive occasion? I searched the faces of my Chinese colleagues for some social confirmation of my surprise, but saw nothing untoward. They looked rather bored, as if suffering some ritual before the main event.

And indeed the main event was excellent. The candidate was articulate, informed, and organized. His academic presentation belied the introduction

he gave it, so my confusion was further confounded by the discrepancy. What was happening here?

Psychological Connections

At this time professionally, I was working in the area of attributions, exploring how Chinese persons explained their successful and unsuccessful outcomes in life. When uttered publicly, attributions like, "I got an A because I worked hard" or "I broke up with my boyfriend because we weren't fated to be together" become acts of self-presentation with social consequences. We may talk about our outcomes in an arrogant, self-serving way or in a humble, self-effacing way. Of course what the listener regards as arrogant or humble may vary from place to place, but whatever we say will have some social impact in any given context.

Our job candidate had certainly introduced his talk with modest words. From my cultural vantage point this modesty appeared excessive and, after the presentation, simply false. I was irritated at having been mislead, but puzzled that my colleagues took no offense, indeed, regarded his introduction as normal.

We know from the attribution literature that departures from expectation generate cognitive activity to explain that departure, so that it then becomes predictable. Well, my Canadian expectations had been violated and I was vigorously searching for a rationale to explain what I had just observed.

I recalled a Chinese proverb I had recently encountered—"Haughtiness invites ruin, humility receives benefits." This seemed pretty strong advice to someone raised in a "know thyself" and "look out for number one" tradition, so it occurred to me that the Chinese thermostat for self-presentations might just be set lower than it was in Canada. Self-deprecating comments do after all invite social support and defuse status competition. They may then become normative in cultural systems emphasizing interpersonal harmony. So, my students and I began examining aspects of this interface between attributions and self-presentation.

The Modesty Bias

Our first challenge was to establish that Chinese people did in fact prefer a self-effacing attribution style. To determine this preference, we allowed subjects to overhear contestants explaining their success or failure in an intellectual competition. A modest attribution involved asserting that one's success arose because of luck and an easy task; one's failure, because of lack of ability and lack of effort. Self-serving attributions were exactly the opposite. Sure enough, our listeners liked the self-effacing contestants more and preferred to work with them on future tasks.

To be fair, research has occasionally shown that Western perceivers prefer modest attributors. However, these preferences for modesty occurred for group, not for individual, performances. But even with interdependent performances, I believe that the Chinese thermostat will be set to approve of relatively more modest attributions than are found in Western cultures.

When Modesty Fails

But the plot thickens. The revered Chinese principle of balance might lead us to expect that modesty at the personal level should be compensated by haughtiness somewhere else. A possibility suggested itself one day when I casually remarked to a Chinese colleague that, "Canadians are awful narrow-minded sometimes!" She looked aghast and whispered to me over the lunch "You should never speak about your own country that way." I paid some attention to her admonition as it is only in extreme cases of egregious foreign behavior that my colleagues will comment.

So, it appeared that the possible balance for individual modesty was collective haughtiness. As a typical individualist, I had attempted with my remark to draw a distinction between myself and my fellow Canadians, a standard technique for claiming personal distinctiveness. Chinese, however, are more collectively socialized and regard their groups' successes and failures as more personally relevant than do Canadians.

Much subsequent research has reinforced this intuition. But at the time the individualism-collectivism contrast was in its infancy for psychologists, and I tried a simple experiment to test the hypothesis my colleague had inspired by her chiding. Basically, we turned the previous experiment upside down. That is, we asked the subject to evaluate a group member who made group-effacing as opposed to group-enhancing attributions for their group's success or failure. As expected, modesty failed. In the case of group performance, Chinese subjects preferred those who protected the group by attributing group success to ability and effort; group failure, to bad luck and task difficulty.

In hindsight, this contrast between what happens when individual and group performance is explained seems obvious. It is also obvious, however, that the preponderance of social psychology is (a) done in individualistic cultural settings, and (b) ignores group processes while focusing on individual behaviors. Living in a collectivist culture provided me with daily manifestations of this contrast. I was like the innocent fish, pulled from the water, suddenly realizing that air existed and that I had spent all my previous life in water. Our change of surroundings made what was implicit, explicit.

INSULTING CHINESE

I had just finished writing a review of the literature on Chinese aggression (Bond and Wang, 1983). Given the available data base, especially from psychological experiments, I had concluded that levels of overt aggression were generally low.

Shortly after the article's publication, I attended a meeting of the University Library Committee. Each department had selected is representative and the Library sent the Senior Assistant Librarian plus a recording secretary. As the previous year's allocations were being discussed, the professor of accounting launched a scathing attack on the librarian present. It had something to do with alleged mismanagement of the appropriation to the Business School. The details now escape me, for my attention was riveted by the intensity of the abuse. For a good two minutes, the professor impugned the competence, the integrity, and the discipline of that librarian. She responded by lowering her head until the storm was spent. The committee quickly moved on to other business.

My ears were ringing. For my benefit, the meeting was being conducted in English and I was shaken by the reverberations of this personal invective. What had happened to my normally placid, cheerful colleagues? How could they tolerate such excessive abuse? What had I missed in my review of Chinese aggression?

The Veil of Language

A glance around the table suggested to me that I was more shaken than my colleagues. A number of possible explanations for this discrepancy suggested themselves. One in particular intrigued me.

I was working in my first language; my Chinese colleagues, in their second (or third, or fourth).

Could it be then that I had been buffeted by the full emotional impact associated with these words in English, whereas my fellow committee members were buffered because English was a foreign tongue? After all, they had learned their English in classrooms and from books; I had learned mine in the rough and tumble of everyday life. A simple application of principles from classical conditioning suggested that an English word should carry more force for me than for them.

This line of reasoning suggested a simple experiment: allow bilinguals to discuss neutral and emotionally aversive topics in both their first and second languages. The buffering hypothesis would suggest that discussing the aversive topics in a second language should be relatively less upsetting. In consequence, the bilinguals should speak relatively longer on the aversive topics in their second language as opposed to their first language.

A few months later we ran just such an experiment, confirming my earlier intuition. So, it now seemed likely to me that the professor of accounting had not spoken with the same savagery that I had heard. Nor had my Chinese committee members heard the same intensity that had so disturbed me. As Alphonse Bertillon put it, "One can only see what one observes, and one observes only things that are already in the mind." Years of daily English usage had prepared my mind differently from my colleagues. Henceforth, I would certainly be careful whom I insulted in the Chinese language.

Juniors and Seniors Have Their Ranking

But there was more. The language issue was only one piece to the puzzle. The downcast eyes, the shuffling of papers, the clearing of the throats, the shortness of the meeting, and the quiet rush to depart all bore testimony that a serious attack had occurred.

As we left the meeting room, my counterpart from the Sociology Department remarked,

"Well, the Assistant Librarian received quite a scolding, isn't it?"

"A scolding?!", I queried.

"Yes, that professor often treats his students like that."

The penny dropped. An insult is not always an insult. This one had been a rebuke, delivered by an

irritated father to a misbehaving daughter. An older, male professor had scolded a younger female administrator. In the Confucian hierarchy the aggressor outranked the victim on every conceivable dimension; his attack could thus be condoned, or at least tolerated, because it had not violated the social ordering.

So, I had not been witness to an exchange between individuals jealously protecting their professional integrity before the eyes and ears of other fellow professionals. This was not the House of Commons where the sweet voice of reason would be summoned to marshall the facts, select the principles, and assess the blame. Instead, this was a hierarchical family drama, legitimized by 4000 years of tradition.

This time a cross-cultural experiment seemed in order. What would happen if Americans and Chinese were privy to an insult in just such a meeting, delivered either by a superior to a subordinate, or vice versa? My guess was that there would be a bigger difference in likeability ratings of the insulter in Chinese culture than in a Western culture. Being someone's boss where I had come from was a temporary arrangement, based on limited, task-specific expertise. One had to treat one another with a professional respect that would extend to equals outside of office hours. The data from the study supported this line of reasoning—the Chinese censured a senior insulting a junior much less than a junior insulting a senior; Americans made no distinction based on the insulter's rank.

Provoking a Response

The insulted librarian had not replied to the insult in any way during the meeting. Such passivity under fire set me to wondering, however. Under what conditions would Chinese human beings counterattack, or at least defend themselves, when verbally attacked?

I had just been reading Felson's (1978) brilliant paper on "aggression as impression management." Felson had suggested that people respond to undeserved provocation from others with counterattack in order to establish that they are not the sort of person one can attack with impunity. He did allow, however, that the insulted party might "play it cool" to win the approval of any audience to the insult.

Chinese culture places a high value on the qualities of self-restraint and moderation. Sidestepping a provocative insult, then, could be a judicious act of impression management, especially in front of an audience whose approval one seeks. Conversely, a spirited defense of one's family, work-group, or village could be perceived by others as indicating selfless loyalty, valued qualities in any collective culture.

The professor of accounting had insulted the librarian personally in a large meeting, and she had kept silent. What would have happened, I later wondered, if he had insulted the library staff in general? Or had insulted the librarian in private?

These musings led to another experiment where confederates gratuitously insulted a subject under a variety of circumstances. We were interested to discover whether overt resistance to an insult about one's competence was greater when one was verbally abused in private or in public. Of particular importance was the issue of whether the audience was composed of colleagues or of strangers. Given my experience at the committee meeting, I expected that resistance would be *less* when insults were passed in front of acquaintances than when alone or in front of strangers.

This impression was in fact confirmed. Of greater interest, however, was a small change we made to the content of the insult. Half the subjects were insulted personally; the other half were insulted both personally and as the member of a group (their academic department, actually). In this latter case our subjects responded with vigorous, spirited resistance—they disagreed with the abuse, offered excuses, or even challenged their insulter. It appears as if the group nature of the insult had justified our Chinese subjects in reacting with unusual assertiveness regardless of the social situation. How clever was the accounting professor not to have insulted the whole library staff, but only the librarian!

The degree of resistance was greatest not in front of colleagues or even when alone with the insulter, but rather in front of strangers. The general social mandate to respond temperately can apparently be relaxed in front of strangers, especially if one's group name is being impugned. Again, we see evidence of how important group memberships and association become in collective cultures.

Deeper into the Labyrinth

Encounters like the one at the library can be endlessly construed and reconstrued; they take good measure of a social scientist's creativity. It has occurred to me, for example, that our professor of

accounting might have been engaging in the Chinese strategy of "cursing the mulberry while pointing at the ash." That is, the issue could really have been between him and the head of the library who was not present. In his stead the Senior Assistant Librarian was an available, assailable target who would dutifully pass on the implied message to her boss. Such a line of reasoning would have deflated the personalism of the invective for the Senior Assistant Librarian, making it much easier for her to suffer the attack in silence.

Experiments in social psychology are typically bounded by 45-minute time frames and involve strangers. As such it may be more difficult to test this "indirection" hypothesis in a realistic manner. But what is the advantage of traveling culturally if it does not stretch our intellectual roadmaps? So, I am currently wrestling with this latest conundrum as a way of enlarging my limits as a Western-trained social psychologist.

Future Pacings

To know that you are ignorant
is best;
To know what you do not
is a disease;
But if you recognize the malady of mind
for what it is,
Then that is health. —TAO TE CHING, POEM 71

So, it appears to me as if these early puzzles have yielded to my curiosity and persistence. The tolerance and insights of my colleagues have also helped! The premise sustaining the intellectual struggle is that all people behave reasonably from their own perspective. Unfortunately, it is all too reasonable for reasonable men to believe that another's reasonableness is folly. Or at least difficult to fathom, and hence not worth the effort.

A healthy skepticism about this all-too-universal dismissal of others is an invaluable visa for cross-cultural explorers. It certainly makes life more interesting! Why did my Chinese host at dinner persist in loading my plate with food when I told him five times that I am full to bursting? Why did that Chinese laborer whom I blocked when he tried to jump the train queue shout non-stop at me for a good ten minutes until we reached my destination? Why did my failing student ask for a "compassionate" pass and what is a compassionate pass, anyway?

These and other intellectual charmers should fill my dance-card for the next decade or so, by which time they will have been replaced by other partners. I may take some solace at this lengthy process by recalling the Chinese proverb that it takes 10 years to grow a tree, but a 100 years to develop a scholar. While I am waiting for this scholarship, I will continue to enjoy the delights of daily encounters with a generally modest, temperate, loyal, and diligent group of my fellow human beings.

The way you call the way
is not the way. —TAO TE CHING, POEM 1

REFERENCES

Bond, M.H. (1991). *Beyond the Chinese face: Insights from psychology.* Hong Kong: Oxford University Press.

Bond, M.H. and Wang, S.M. (1983). Aggressive behavior in Chinese society: The problem of maintaining order and harmony. In A.P. Goldstein and M. Segall (Eds.), *Global perspectives on aggression* (pp. 58–74). New York: Pergamon.

Felson, R.B. (1978). Aggression as impression management. *Social Psychology Quarterly, 41,* 205–213.

Triandis, H.C. (1990). Cross-cultural studies of individualism and collectivism. In J. Berman (Ed.), *Nebraska Symposium on Motivation, 1989.* Lincoln, NE: University of Nebraska Press.

6
First Experiences in Thailand

ERNEST E. BOESCH

People travel for a hundred different reasons—just for getting away from everyday chores, or for adventure, information, glamor, business, or any other reason you may name. Mine may have been somewhat unusual: One day, quite unexpectedly, I received an offer to go to Thailand for an extended period, interrupting my work in a university position I had taken up only four years earlier. I had never been outside Europe, had not the slightest knowledge of Thailand (which, at that time, was still untouched by tourism), and could not even claim any competence in anthropology or cultural psychology. In spite of that I was given the task of studying the impacts of culture on the minds and actions of people, and this appealed to me not simply because I was a psychologist, but because it met a natural inclination.

Thus, instead of telling about the sights and wonders of an exotic culture, I rather want to relate, in the pages to follow, some of the difficulties met in trying to understand people of other cultures, difficulties which we tend to underestimate. All too often we think that, with some knowledge of the

Ernest E. Boesch, who holds a Ph.D. from the University of Geneva and an honorary doctorate from the University of Bern, worked as a school psychologist in his native part of Switzerland. In 1951 he accepted the chair of psychology at the new University of the Saarland, in Saarbruecken, Germany. After serving UNESCO in Thailand from 1955 to 1958, he initiated at his university a research center for cultural psychology, and thus resurrected a branch of psychology which had become practically extinct in Europe after World War II.

language or with a good interpreter, we can easily become acquainted with those quaint or colorful customs which we associate with an exotic culture and, thus, gain the impression of "knowing" it. I want, instead, to convey to the reader the fact that very often it is not the strikingly strange appearance, but deeper, less conspicuous meanings that are important for understanding other ways of life. What impresses the tourist may sometimes hide rather than reveal the essential constituents of a culture.

On my first visit to Thailand, some thirty years ago, the airline put me up for the night at its resthouse, situated near the airport and a half an hour's drive from Bangkok. The resthouse was a relatively simple wooden structure, built on stilts over some water. For the first time in my life I slept surrounded by a mosquito net. And also for the first time I listened to the nightly noises of the tropics—the concert of frogs and toads, the chirping of the small house geckos, the sonorous call of the tuckae (a large gecko), and the splashing of some bigger animal in the water below my room.

None of these noises was known to me, none of them could be connected with the specific image of an animal, and it was even difficult to determine which noise came from the outside or which from the inside of the room. Before setting out on this first journey to a tropical country I had, of course, been amply provided with warnings concerning the dangers I would meet, colorfully recounted by well-meaning former travelers. So I confess that I passed an uneasy night, bedeviled by my imagination and the warning tales on snakes, spiders, and other kinds of threats. Each cracking of the wooden floor, each scratching on the wall planks was mys-

terious and potentially ominous. I was thankful for the protection, however flimsy, of the mosquito net.

I am not normally irrationally afraid of animals—I am even rather interested in their ways and nature. Some months after that unsettling first night, I was able to identify the sounds and spent interesting moments observing some of the creatures that had frightened me at first. I listened with pleasure to the call of the tuckae living under my roof, looked with amusement at the graceful games of the house geckos, enjoyed the nightly concert of frogs in the pond and the lawn near my house, observed the activities of ants and termites, and even hospitably allowed a black dotted green snake to climb under my roof. What had changed in the meantime?

What I had experienced during the very first night of my stay in the tropics was, in fact, a quite rare occurrence: I had met nature as an almost pure phenomenon, untainted by any knowledge precise enough to allow me to classify what I perceived, to identify the sounds and noises surrounding me. The child born and growing up in Thailand will, on hearing the call of the tuckae, as a matter of course know the kind of animal it is, will know its whereabouts, its habits, the danger it does or does not represent. But for me, its call was a mere sound without any experience or knowledge attached to it: it was my inability to establish order among my perceptions, to attach meaning to them which genuinely frightened me. I was left without the usual means to react in the ways I would have known to be appropriate.

However, this is only partly true. I did not simply hear unknown noises: some of them did frighten me, particularly when I tried to interpret them, to attach meaning to them. In other words, I tried to understand the noises in terms of my *own* knowledge and past experience. I did not succeed: we might say that it was precisely the fact that the nocturnal sounds did not fit my existing molds of understanding which made the situation a threatening one. We can only feel safe in a world which fits our expectations and patterns of explanation—therefore, we always will attempt to reduce new events to previous experience.

Such congruence, of course, helps us to get around in our world and act appropriately. But it may also become a trap as soon as we leave the surroundings we are used to. In order not to feel lost or disoriented, we will try to interpret new things we encounter in our accustomed ways, often without even suspecting that the meanings at-

tached to a situation may be entirely or partly inadequate. Take the tuckae whose call I heard on that first night. It is a large house gecko, a lizard about thirty centimeters long. In our usual framework of thinking, animals can be caught, killed, cooked, eaten, or kept in cages, tamed to be pets, or have to be avoided should they happen to be poisonous or otherwise dangerous. None of these frameworks includes the meaning given to the tuckae in Thailand. There, it is said to eat the liver of unruly children; traditionally it is believed never to die, because when it has grown old the green snake will come, insert its head into the tuckae's mouth down to its belly and eat its liver. Then a new liver will grow and the animal will go on living. These slightly sinister and weird associations will become connotations of the animal, will be heard in its call, and will determine attitudes towards the gecko. Thus, the tuckae acquires magical qualities; it would be a sin to kill it, and by doing so one would attract unlucky consequences upon oneself as well as one's house. Note that this belief extends beyond the meanings we tend to attach to animals: the tuckae, as a "disciplinarian" of unruly children as well as by its immortality, somehow acquires moral as well as magical qualities.

Had I, in my conceited rationality, failed to worry about such indigenous beliefs, or had I, sticking to my usual conception of animals, dismissed them as fabulous grandmother tales, I would of course have known nothing of the tuckae's liver, nor of the liver as a seat of life, nor of the symbiotic relationship between tuckaes and green snakes. I would have missed, then, a specific kind of symbolic and moral meaning applied to nature, and the Thais and I would have communicated about different kinds of tuckaes, and I might have even, by killing one, deeply offended and frightened them.

Of course, the night passed, and in the new day everything looked much more normal again. The pond in the compound, covered with lotus flowers, also the first I had ever seen, appeared very unlikely to harbour dangerous animals, and the traffic outside the fence looked quite familiar. Still, there was this heaviness of the air, the unreal light and smell of the tropical atmosphere, but I had no long leisure to wonder about it or anything: A car from the Ministry of Education came to get me, and, perspiring already at that early hour in my uncomfortably thick clothes, I was driven to Bangkok. The traffic and the flat landscape and even the monotonous low buildings which after a while started flanking the road presented no surprises, and only

the ubiquitous three-wheeled rikshas and occasional truckloads of workers in their colorful clothes gave me some feeling of a different culture.

I got "processed" through the Ministry to the College of Education where I met the members of my future Thai staff, got handed over from one person to another while getting to a hotel, to tailors for my tropical wardrobe, to people of importance I had to know, to restaurants for my first acquaintance with Thai food, and in my free time was conducted to some of the marvels of Bangkok—its temples. Although all this was bewildering, it was made easy and pleasant by the friendliness and the ever enticing smile of the Thais. That smile—I shall come back to it. But let me not be tempted by telling traveler stories, you can find plenty of them elsewhere. So, before proceeding further, let me invite you to some reflections that might help us in understanding better the psychological implications of the first experience of a culture.

We all are continuously torn between two antagonistic tendencies. We want change, novelty, excitement, and surprise, but we also want stability, comfort, and security. Some social scientists speak of *conservatives* and *innovators,* suggesting that some people consistently prefer stability, others change. Such would be a misleading simplification, since all of us always want both, albeit to different degrees and at different moments. The person who goes to

> # We all are continuously torn between two antagonistic tendencies. We want change, novelty, excitement, and surprise, but we also want stability, comfort, and security.

a foreign culture looks for change—unless, like a fugitive, he or she acts under constraint. Yet, the kinds of change one will meet will be likely to differ in some ways from the ones we looked forward to. Such discrepancies may disappoint, may surprise and excite, or can even be felt to be threatening, and we will react accordingly. As we just saw, my first night in Thailand was not entirely comfortable, but, because of my basically positive anticipations, anxi-

ety was soon followed by curiosity, inquiry, or exploration that made familiar those things that had initially disturbed me. Had the first anxiety been very strong, it might have led to *rejection, avoidance* or, more extremely, even *flight.* We all know examples of sudden and almost pathological homesickness which may drive a traveler back home again.

Thus, we now understand *stability* and *change* to be *goals of action* which we try to attain or maintain by certain means. Curiosity and exploration strive toward change, while rejection and avoidance try to maintain stability. To familiarize oneself with the unknown is, as we just saw, a process by which we establish stability among new elements, thereby somehow managing to "have our cake and eat it"—or, more technically worded, to achieve a balance between our conservative and innovative leanings. In contacting the new culture we would therefore not only learn, but also reject: in other words, we *select.* No newcomer will accept, or even perceive, all that he encounters, but his attention will be caught by some events more than by others, his interest will dwell on those features that provide welcome kinds of novelty, and it will turn away from others. Would that mean that we perceive only agreeable and attractive features? Far from it; there are even people who almost obsessively discover negative traits in their new surroundings. Within reasonable limits such negative discoveries are useful, too: they contribute to preparing ourselves against possible dangers and may thereby strengthen one's coping potentials. They also reinforce one's tendencies toward stability and thereby prevent attempts at change that are too reckless. Yet, also in this respect we remain selective: we tend to perceive only such negative traits as threaten to jeopardize our intentions, hopes, and wishes, and we may even embellish what others call drab, or find attractive what is objectively dangerous.

This brings me back to the Thai smile. I don't know of any traveller to Thailand who was not charmed by it. Why? Smiles, in Western culture, tend to be comparatively rare; we usually smile only in situations and relationships which justify and allow for it. Indeed, we smile out of pleasure, not out of trouble, out of friendliness, not out of anger, out of contentment, not out of frustration, and therefore a smiling face for us definitely expresses positive moods and inclinations. Being continuously confronted, in Thailand, with that open, enticingly friendly smile which goes straight to the heart, we therefore associate with it an unthreatening, friendly, easygoing culture. To an insecure new-

comer this smile promises security: it somehow counterbalances the anticipated threats of the unfamiliar culture. Change without threat, novelty without imbalance are of course promises particularly attractive to those many who want diversion without sacrificing too much of their accustomed comfort or mastery. Yet, the Thai smile may be deceptive, occasionally even deeply disappointing those expecting to enjoy a permanently sunny social climate. In my schooldays we learned an English song: *"There isn't any trouble just to s-m-i-l-e, so smile when you're in trouble, they will vanish like a bubble if you s-m-i-l-e."* This, as I just explained, is not our usual way to smile, and therefore we liked the song. We didn't know, of course, that it expressed exactly the Thai function of smiling: the smile, for the Thai, is an antidote against worry, frustration, anger, troubles as much as, and sometimes even more than, an expression of friendly intention, of pleasure and contentment. A Thai smile, in other words, has many more meanings than does the smile in Western culture.

A widely heard stereotype speaks of the "inscrutable Asian face"; Thai faces are far from it—their openness, indeed, surprised me on my initial contacts. Yet, as I just said, their smile, friendly though it appears, will be used, too, for dealing with adversity, for hiding embarrassment, avoiding social disapproval or conflict, concealing falseness or an aggressive mood; one can be cheated with a most friendly smile, can be hated behind a smiling mask, and many a smile covers resentment or even despair. Such a strategy, of course, makes social life much more agreeable, creates an appearance of harmony, mutual understanding—it "greases the wheels of the social fabric"—but it also complicates the task of mutual empathy. An outsider may all too often misunderstand it—a servant breaks an expensive plate and smiles. Her American employer will angrily exclaim, "the bitch even laughed about it!" A Thai would, of course, understand—and he would, by the way, be quite unlikely to exhibit a similar angry outburst.

Because safeguarding smooth social relationships is of paramount importance for a Thai, and therefore social interactions, be they in the way of gestures, language, deeds, will tend to establish harmony, or at least to create an impression of deference, understanding, sympathy, consideration; the messages are often symbolic, too subtle for the outsider and yet easily understood by the Thai. But then, suddenly, will occur an incident that is striking in its complete disregard of others and in a carelessness about conflict. Let me give you an example which became quite significant for me.

It was, I think, in my second Thailand year. At that time, any foreign visitor to Bangkok would have been struck by the number of tricycle rikshas (called *samlors*, i. e. "three-wheels"—the term being applied to the vehicle as well as to its driver). They were normal bicycles, but the rear consisted of two wheels which carried a seat large enough for one fat or two slim persons, covered by a colorful sunshine roof, decorated with all kinds of magical or merely fancy emblems. The men pedaling them were mostly sturdy young and middle-aged peasants from poorer provinces, illiterate or semi-literate, who, during the time they were not needed in the fields, looked for additional income. One day a Thai friend was driving me to the airport on a large road with moderately dense but quickly flowing traffic. Suddenly, out of one of the many sidelanes, one of these *samlors*, without a merest glance at the oncoming vehicles, unconcernedly turned directly in the path of our car, and it was only by a rapid braking that we avoided an accident—while the *samlor* continued his way as if nothing had happened. When we had recovered from our shock, I asked my friend: why did he do that? Oh, he answered, they are dull people without education, they don't think. I objected, "He is on the road all day long, he certainly has seen many accidents, you don't need much intelligence to become aware of the dangers of Bangkok traffic." My friend answered, "Maybe he believes in his luck charm." The example is instructive. Confronting unusual events, we tend to explain them by reasons readily at hand, easily applicable and plausible, and once we have done so, we feel that we have understood the phenomenon. Thus, prejudices are born and strengthened. We later found similar negative stereotypes held by Thai doctors concerning their rural patients, often seriously hampering their communication. In the case of our *samlor*, the incident went on preoccupying me. Suddenly I was struck by the thought that the meaning and structure of the *samlor*'s space was different from mine. For me, the opening of the sidelane into the main road implied an invisible frontier which would force me to stop and to ascertain the safety of proceeding further; for the *samlor*, on the contrary, for reasons whatsoever, this did not seem to be so. Space, I reasoned, was of course structured by its material features; those, however, would receive significance from mental patterns, shaped and controlled by our action and its meaning within a cultural cadre.

Of course, as my friend suggested, the *samlor* driver might have possessed and trusted a luck charm (or even many). Thus, the spiritual contents of his mind would have contributed to structuring his space. Later I learned that, indeed, Thai space implies a system of meanings alien to our conception of space, but again different from what I observed with that *samlor*. We tend to think in materialistic terms of causation: it is the material configuration of space which determines the spatial patterns of our action. Yet, this uneducated *samlor* taught me a lesson: our reality is, as we might say, more than meets the eye; the ways in which we shape our space, our time or our social relations, are determined by many influences, often quite subtle to detect. The *samlor* driver's behavior might have been due less to disregard of danger or unconcern of other people's action than to a trust in providence. Human life is ruled by forces of destiny, and being in accord with those forces may be more relevant than traffic laws. Although I shall never know the real reasons for that man's action, I learned from him a basic general rule: to distrust easy ready-at-hand explanations. This is the only condition that will allow a strange culture to become more than a superficial touristic interlude, namely, this is a means to deepening insight into human nature.

SUGGESTED READINGS

Boesch, E.E. (1991). *Symbolic action theory and cultural psychology.* Heidelberg/New York: Springer (from which some sections of the above article have been borrowed).

Klausner, W.J. (1983). *Reflections on Thai culture.* Bangkok: The Siam Society.

Potter, S.H. (1977). *Family life in northern Thailand.* Berkeley: University of California Press.

Smith Bowen, E. (1964). *Return to laughter. An anthropological novel.* New York: Doubleday & Co.

Tambiah, S.J. (1970). *Buddhism and the spirit cults in northeast Thailand.* Cambridge: Cambridge University Press.

Section II

Cultural Variations on Some Common Human Dimensions

There are many aspects of culture in which peoples of the world differ. Some of these are widely *known*—which is another way to say *believed*. Sometimes what is believed is knowledge, sometimes it more closely resembles a stereotype—a belief about a group in general that is held to cover all members of the group. It is not possible, even in a sizeable book with a special focus, to go into the important areas of cultural similarity and difference in comprehensive detail. This section does, however, sample some interesting areas, and contains as well a caution about the perils of stereotyped beliefs.

The feeling that one's own cultural beliefs and customs are the right and natural way may well be universal. Sometimes it can be a real challenge to understand that the way in which other people view the world may be substantially different from one's own, and may also be perfectly "correct." This is the essence of *ethnocentrism*, literally the universally held view that one's own ethnic group is at the center of things. But when fundamental differences are the reality you have to live with, it may also be a challenge to tolerance. Consider the people of Salamanca, New York. They live with an interesting and perhaps unique system of land ownership. As a result of a longstanding treaty with the U.S. government, and events that ignored the terms of the treaty, the Seneca Nation owns the land on which Salamanca was built. Usual concepts of property are strained in this unusual case. The land ownership and transfer system imported to North America by Europeans sits on top of a *different* system of ownership and a *different* concept of property. You can sell your land and house in Salamanca, but at base, the land is Seneca and you have it on lease. To many Native Americans and other indigenous people around the world, it is preposterous to think that land can actually be "sold," as if you're buying it off the shelf. The exploration of the property concept and of some interesting attributes of culture that go along with varying ideas of property is a relatively new area of study in cross-cultural psychology, with a long history.

If our sense of what belongs to us seems stable, surely our sense of being in touch with "reality" also has an absolute quality. Or does it? One of psychology's pioneers, William James, wrote eloquently about the nature of human consciousness. Among other things, James said it was continuous, like a stream (hence the now popular phrase *stream of consciousness*), ever changing and highly personal. One theme that can be drawn from Colleen Ward's Chapter 8 on altered states of consciousness is the power of cultural and personal contexts in determining and defining experience. What is considered an "escape into fantasy" for one person may be, for another, a powerful religious or philosophical experience. We can transpose this to the cultural level. What is thought of as an escape in one cultural context may have religious and community meaning elsewhere. One prevalent and voluntary way to alter one's consciousness is through the consumption of alcohol and an incredible array of psychoactive drugs. In Chapter 11, Joseph Trimble focuses on these mood and consciousness-altering drugs. He surveys a wide range of knowledge about these substances and their social and behavioral significance in many different societies. In the process of condensing a massive amount of information and misinformation, Trimble questions many cultural stereotypes about drugs and alcohol, and affirms others. Because of the common ground covered by Ward and Trimble it is highly recommended that these chapters be read together.

Probably most North American Christians do not think of their morning shower as having much religious significance, even if they view it as an escape. It is unlikely that such a high proportion of everyday life is viewed with religious implications in North American society as is the case in Muslim

society that Elizabeth and Robert Fernea write about in Chapter 9. It is probably a shock for Americans, Canadians and others of European descent to be thought of by other people as "unclean" in their eating and bathing habits by other people. After all, baths involve immersing oneself in one's own dirty water! But when the supporting reasons and beliefs are examined, along with the contrast in living conditions, there is much here that is sensible—even to a Euro-American mind.

The sense of what is clean and what is disgusting is one of those areas of life in which our knowledge of what is good and bad seems fundamental, obvious, and unchangeable. How are we to act in view of our knowledge of the views and customs of other cultures? Should North Americans, English, Scots (who may have the biggest bathtubs in the world), and others give up their baths? No more than Muslims the world over should readjust their views on cleanliness.

If we have learned that views of what is clean and what is not vary from place to place and people to people, have we also learned that what is good and bad likewise vary? It seems not, but it is a complex story. It appears that at low levels of abstraction, for specific details of culture and behavior, there are many interesting and important contrasts. But at higher levels of abstraction there are important similarities. Just as Dasen, Serpell, and Segall show in Section IV, specific differences appear against a background of similarity. While people develop different skills in dealing with their particular social and physical environment, what develops appears to be well within the broad framework of universal human psychological processes. So it is not too surprising to find Lutz Eckensberger in Chapter 10 discussing particular differences against the background of universal processes in moral development. It appears that what is moral and immoral, or, more precisely, how one *thinks* about what is moral and immoral, shows a lot of communality across cultures, even though the specifics may differ from place to place. Perhaps we have to amend the view we set forth in the introductory chapter. The interesting stuff may not be *only* in the details. It is fascinating to consider that while we may think about and value different things, the ways in which we think and value may display great similarity across cultures. Is this what

is known as the "psychic unity of mankind"? It is probably not much comfort to international negotiators to reflect that even though their differences are great, and people are being killed and turned into refugees because of international disagreements, we are after all the same kind of being because we think our different thoughts with the same kind of "mind." On the other hand, it is probably a good thing that the people in Washington and Moscow who had their hands on the nuclear triggers for four decades could largely understand each other's decision making processes. Just think how dangerous it would be to have a forty-year standoff with a being whose mental and behavioral processes are completely foreign to our understanding!

Inevitably the concrete, specific differences between ourselves and others are what catch our attention. It takes thought, reflection, and in some cases years of study to frame concepts that help humans understand their background of communality. But, in everyday life, it is the immediate, the obvious, the specific that seem to be the currency of intergroup perceptions. The idea of stereotypes of ethnic and cultural groups is commonplace in our multi-cultural societies, and it is often difficult to discern whether public policy is formed on the basis of stereotype or something more substantial and, one is tempted to say, respectable. After all, stereotyping is not a respectable process. Or is it? What if we cannot escape it? What if it is another universal, varied in specifics, but common to all in principle and process? Donald Taylor and Lana Porter (in Chapter 12 this section, and in a different way Devine and Zuwerink in Section V) take us through the interplay between stereotyping's general processes and specific contents that have interested psychologists for decades and have become a central topic of study for social psychologists.

This section of the book introduces two kinds of things: (a) a set of topic areas in which cross-cultural psychologists have found interesting things to study; and (b) the subtleties of the interplay between the specific and the general, the abstract and the concrete, the phenomena of everyday life and the stuff of the science of behavior. In many ways, these are the central issues of the cross-cultural study of behavior. Here's a beginning sample. There's more to come.

7
Property

FLOYD W. RUDMIN

THE IMPORT OF PROPERTY

Mine. It is a small word, a rather common word in the English language. It is one of the first words mastered by toddlers newly making their way in the world. It is deceptive in its power and importance, like the smallest roots of trees, fragile yet capable of splitting bedrock, trivial yet necessary for sustaining towering, mature individuals and whole forests. It is ubiquitous yet invisible. It controls our behavior, but we rarely notice, as we move about our world restricting ourselves to narrow walkways and to those places for which we have keys. There is almost no action we can take, certainly no objects or spaces we can use, without some momentary or unconscious calculation of possession and permission. The world has been shattered into a myriad of private pieces, and all of us are separated and related to one another by the rights and duties of property.

Mine is also at the very heart of our sense of self, at the very core of our consciousness. William James (1890), Harvard philosopher and founder of American psychology, explained that "between what a man calls me and what he simply calls mine the line is difficult to draw" (p.291), that "a man's Self is the sum total of all that he can call his, not only his body and his psychic powers, but his clothes and his house, his wife and children, his ancestors and friends, his reputation and works, his lands and horses, and yacht and bank account" (p. 291). At a still deeper level, James theorized that the unity and coherence of consciousness comes from minute moments of thought successively claiming attachment, ownership, to their immediate predecessors: "Each Thought is thus born an owner, and dies owned, transmitting whatever it realized as its Self to its own later proprietor" (p. 339).

However, you will not find "possessions," "property," "ownership," or research on the meaning of "mine" in most modern psychology textbooks. Contemporary psychologists who study these concepts have each, at one time or another, questioned and lamented the lack of interest in these topics (Furby, 1991). When I was beginning my doctoral studies, one psychology professor said that the whole topic area is not worth an undergraduate seminar paper. But that attitude is relatively new. Until 1954, property was a topic heading in Psychological Abstracts, and most prominent psychologists from Greek antiquity to the to 1940s had some discussion of property and ownership.

Usually the disappearance of topics from psychology in the mid-nineteenth century is blamed on behaviorists and their refusal to consider questions about consciousness and thought. But the foremost behaviorists (Pavlov, Thorndike, Watson) all discussed the psychology of ownership. The best explanation is that Cold War fear of Communism, or rather, fear of serious discourse about Communism,

Floyd W. Rudmin holds a Canada Research Fellowship at Queen's University, with cross-appointment in the Faculty of Law and the School of Business. Both are interested in his research on the psychology of possession and ownership. He has also published on human communication disorders, history of psychology, and peace studies. His book *Bordering on Aggression* was released in 1993. Dr. Rudmin has lived and studied in the United States, the Phillippines, Japan, Quebec, and other parts of Canada.

purged property as a topic from psychology. Taboo is not just something that happens in primitive societies.

One of my motivations for beginning a career of study on property, ownership, and possession was concern that the social and behavioral sciences should serve humanity and help resolve pressing social questions. For decades we have been preparing to destroy ourselves by nuclear war, wasting trillions of dollars on weapons that might have gone to peaceful production, creating a military-industrial complex that corrupts our own society. Why? To win a debate about which property regime is better—private or communal. This is an intellectual debate, to be engaged by discourse and data, not by bombast and bombs.

And the debate will not disappear just because the communist state of the Soviet Union has collapsed. The debate is ancient. Plato in his *Republic* advocated communal property and his student Aristotle in his *Politics* argued for private property. The debate is timeless, embedded in our religions. It is arising in new forms as global environmental crises challenge the rights of private owners to exploit and consume their property as they wish. Traditional systems of private property are also being critiqued by feminists who argue that private property is a means of male dominance over one another and over women. These debates, whatever courses they take, need to be informed by facts and inferences based on facts. It is dangerous to let debates like these run on rhetoric alone.

SCIENCE OF SOCIETY

It is ironic and paradoxical that if you want to study human psychology, you must study cultures. Humans always come enculturated. There is no such thing as a "natural" person. It is only by studying people from several cultures that it is possible to know whether something is characteristic of human psychology or of the culture in which the people live. Much of what passes for psychology is actually a kind of experimental cultural anthropology of the United States. But it is incorrect to presume that U.S. behaviors and thoughts are universal. Take any introductory psychology textbook, especially the sections on social, developmental, and clinical psychology, and it is relatively easy to think of societies where the findings would be false.

There can be no doubt that property practices are culturally bound. In the United States, land can be bought, but not brides. For the Abipon people in South America and for the Rwala Arabs, it is the reverse. We can own genes; Australian aborigines can own dreams. The study and debate of property practices has long been cross-cultural. It might even be argued that, historically, it was this topic that

> ## In the United States, land can be bought, but not brides. For the Abipon people in South America and for the Rwala Arabs, it is the reverse. We can own genes; Australian aborigines can own dreams.

motivated the development of cross-cultural methodology (Rudmin, 1988). Philosophers and political economists have long tried to examine the "natural" origins and evolution of ownership. Presuming that their own contemporary societies were civilized and "unnatural," they sought to see property practices in primitive societies. This quest for the origins of ownership has also led to study of the possessive and territorial behaviors of animals (Beaglehole, 1968).

However, just as there are no "natural" persons, so too are there no "natural" societies. All cultures are human creations, constructed, evolved, and adapted to cope with local environments, local demands and local limitations. Ideally, cross-cultural studies need to examine a wide sample of cultures, treating them all relatively equally, to get a representation of the diversity and variety of ways humankind has arranged social practices and the values, beliefs, and behaviors that perpetuate those practices. This has been called the *science of society*, *quantitative comparative anthropology*, or most recently *holocultural research*. The technique is to randomly sample independent cultures or societies and to characterize them by data from histories, ethnographies, or survey questionnaires so that statistical methods can be used to see how cultural characteristics relate to one another.

CROSS-CULTURAL CORRELATES OF PRIVATE PROPERTY

Despite the importance of property as a regulator of human behavior and as a cause of international and ideological conflict, there have been few systematic cross-cultural studies of ownership. People in the past have been too ready to spin theories and to use selected cultures to prove their point. That is what Karl Marx did. That is what John Locke did. What I have been seeking to do is to firmly establish just what are the correlates of private ownership. The plan is to replicate the same findings repeatedly using different samples of cultures and different measures until there is confident information with which to inform theory and rhetoric. One of these studies will be summarized here.

I reexamined Leo Simmons' 1937 data base of 109 cultural variables measured on 71 societies (Rudmin, 1992). Of these, 3 societies were eliminated from the study because they were closely related to other societies in the study, and 20 variables were eliminated, 12 because of too much missing data, 7 because of invariance, meaning that almost all of the societies were given the same score, and 1 because of unreliability, meaning that Simmons' judgments about which societies exhibited that variable did not agree with judgments by others doing similar research. Statistical analysis was used to identify those characteristics of societies that co-exist with the private ownership of land and personal possessions. Of the variables examined, 21 were found to be related to private ownership. These were further analyzed to see how they grouped or clustered together. Three clusters were evident.

The cluster of characteristics most closely related to private ownership consisted of the following practices: having permanent residence, farming, not abandoning houses even if people die in them, keeping domestic animals, using grain for food, practicing slavery, and engaging in warfare. These are all characteristics directed to farming and the need to live on, work, acquire, and protect agricultural land. Marx had argued that private property arose with agriculture practices, and this is supportive of that claim. This cluster would also suggest that sedentary farming societies would be least receptive to Communism, and that might explain the brutality that Stalin employed in the 1930s to collectivize the Ukrainian farmers.

The second cluster consisted of the following cultural practices: debt, castes and classes, rule by the wealthy, trade, the use of money, little sharing of food, and married couples living in the husband's community. This shows that private ownership is related to social stratification and gradations of power and status based on unequal divisions of wealth. Private ownership is prerequisite for many of the characteristics in this cluster, which may explain why it correlates with them.

The third cluster consisted of the following cultural practices: having a constant food supply, not taking a wife by kidnap and rape, not leaving sick people outside to die, having judges with authority, having codified laws, and using elaborate ceremonies and rituals. These are all practices of social security, primarily constraining people from freedom to do as they wish to weaker people. As a group, these characteristics seem to relate private ownership to other practices of private rights and security. Property allows a person an exclusive domain of resources which cannot be taken or threatened.

In these data, there was little evidence that private ownership is oppressive to women. Of 32 gender-defined variables characterizing these societies, only two of them correlated with practices of private ownership. The practice of patrilocal residence, meaning that married couples live in the husband's community, was one of the social stratification practices. Not allowing marriage by capture is improved treatment of women. One of the gender-defined variables was the "subjugation or inferiority of women" which had near-zero correlation with four different measures of private ownership.

What might be concluded from these cross-cultural data? First, the practice of private ownership is not universal to all cultures. It is thus not inborn or instinctive in human psychology. Second, where people become bound to land because of farming, norms of private ownership flourish. Territoriality is a powerful prototype of ownership. Third, private property is apiece with wealth accumulation and the differentiation and separation of people based on wealth. That is the downside of private property so often criticized by reformers and revolutionaries. Fourth, the upside—private property is apiece with other measures of social security. Property requires everyone to be spontaneously self-constrained, to respect property boundaries, to leave alone what is not your own.

Although private property is commonly considered to be an expression of selfishness, it, in fact, requires that social order and obedience to law be a principle higher than selfishness. Finally, these data do not support theories that private ownership is a male device to control and oppress women.

This is but one study, and alone, by itself, it can have little impact on property theory and rhetoric. I have completed other studies that have substantially replicated these findings and others that have shown that males favor property for privacy, power, autonomy, while females favor property for competence and for connections to other people. Although I began alone, working on an abandoned and tabooed topic, I have found and created a community of scholars with similar interests. Gradually, eventually, my own program of research, in concert with that of other people, will establish a body of facts and knowledge that will give shape and direction and limits to wider public discussions and policies concerning the ownership of property.

REFERENCES

Beaglehole, E. (1968). Property. In D.L. Sills (ed.), *International encyclopedia of the social sciences* (vol. 12, pp. 589–592). New York: Macmillan Co. and the Free Press.

Furby, L. (1991). Understanding the psychology of possession and ownership. In F.W. Rudmin (ed.), To have possessions: A handbook on ownership and property, special issue of *Journal of Social Behavior and Personality*, 6: 457–463.

James, W. (1890). *The principles of psychology* (vol. 1, chap. 10, The consciousness of self, pp. 291–401). New York: Dover.

Rudmin, F.W. (1988). Dominance, social control, and ownership: A history and a cross-cultural study of motivations for private property. *Behavior Science Research*, 22: 130–160. (Due to printer's error, the article begins on paragraph 5 on page 132. Paragraphs 1 through 4 should follow paragraph 8 on page 133.)

Rudmin, F.W. (1992). Cross-cultural correlates of the ownership of private property. *Social Science Research*.

8
Culture and Altered States of Consciousness

COLLEEN WARD

In a colorful Hindu Temple in Penang, Malaysia, a devotee clad in a bright yellow *doti* (like a sarong, or loincloth) closes his eyes as the men and women around him chant and ask for blessings from the gods. The temple is enveloped in fragrant incense and as the chanting quickens and becomes louder, the man enters a trance state, turning inward and dissociating from the surrounding sounds, smells, and colors. At the appropriate moment, the attendant Hindu priest takes a skewer and pierces the man's right cheek, extending it through the mouth to the inside of the left cheek and exiting on the outside. The devotee does not flinch, he feels no pain, he does not bleed. The piercing continues. Small *vels* (needles with spade-shaped ends) are inserted at the forehead, the third eye point; larger hooks are placed in rows down the man's back. Still there is no evidence of pain or bleeding. When the piercing is complete, the devotee and his support group begin their pilgrimage to the Waterfall tem-ple to make offerings to Lord Murugan. At the journey's end the hooks and skewers are removed, without evidence of bleeding, and although physically exhausted, the devotee reports feeling refreshed and contented. The experience was like "floating on air."[1]

In a church in Trinidad, women are preparing for a period of "mourning." They are washed and anointed, dressed in white and given inscribed bands of cloth which are used to cover their eyes and ears. They are then "led to the ground," each given a place in the prayer room attached to the Spiritual Baptist church. For seven days and nights the women lie in mourning and are exposed to extended periods of darkness and isolation alternating with praying, chanting, singing, and clapping by animated visitors. The women "travel," experiencing vivid dreams and hallucinations concerning the development of their spiritual lives. The mourners describe the experience as "seeing without sleeping" and "jumping energy in the body." "I was no longer myself," is a common refrain.

In a Mexican desert, a student of anthropology assumes an apprenticeship role to a Yaqui sorcerer. He experiments with alternative realities and various hallucinogenic substances—*datura inoxcia, psilocybe mexicana*. On one session he recalls, "All of a sudden I was pulled up. I distinctly felt I was being lifted. And I was free, moving with tremendous lightness and speed in water or in air. I swam like an eel. I contorted and twisted and soared up and down at will. I felt a cold wind blowing all around me, and I began to float like a feather back and

Colleen Ward received her Ph.D. from the University of Durham, England. She has held teaching and research positions at the University of the West Indies, Trinidad, Science University of Malaysia, National University of Singapore, and University of Canterbury, New Zealand. She is currently the Secretary-General of the International Association for Cross-cultural Psychology and recently edited *Altered States of Consciousness and Mental Health: A Cross-cultural Perspective* (Sage,1989). For several years she was Book Review Editor of the *Journal of Cross-Cultural Psychology*.

forth, down, down and down" (Castaneda, 1969, p. 157).

The passages above describe the experience of altered states of consciousness (ASCs): trance and possession states, lucid dreaming, visions, and drug-induced states. These phenomena differ somewhat from the ASCs conventionally described in introductory psychology texts, which are more likely to include laboratory-based studies of nocturnal dreams, sensory deprivation, hypnosis, biofeedback, and perhaps meditation. Although more "exotic" altered states may seem unusual, even pathological, from a Western perspective, in other cultural settings these experiences are meaningfully integrated into everyday life. In fact, such ASCs are extremely common on a cross-cultural basis. Bourguignon and Evascu's (1977) anthropological study of 488 societies demonstrated that about 90% (437) displayed naturally occurring trance or possession states.

This chapter considers cultural influences on various altered states of consciousness: drug induced states, hallucinations, trances, and spirit possession. On the most fundamental level, our genetic heritage and biological makeup determine the limits of our experience of consciousness. However, a cross-cultural perspective reveals that there is great diversity within these limits and that sociocultural influences pattern the evaluations and interpretations of these phenomena.

THE NATURE OF CONSCIOUSNESS AND ITS CULTURAL INFLUENCES

Consciousness refers to a general state of awareness and responsiveness to our external environment and internal mental processes. "Normal" consciousness is the state in which we spend the bulk of our waking hours. It is an *active,* directed, mentally alert state. As you are reading this chapter you are (probably) experiencing a normal, ordinary state of consciousness with focused attention and logical thought processes. Altered states of consciousness, by contrast, involve subjectively recognized, qualitative shifts in the typical pattern of mental functioning. ASCs are generally *receptive* mental states. You may have experienced them as daydreams, alcoholic intoxication or in the practice of meditation. ASCs are characterized by diffuse attention, paralogical (unorthodox) thought, and dominance of sensory experiences.

The *active* and the *receptive* modes of consciousness represent innate human capacities; however, in Western cultures we value the primacy of active cognitive processing in normal waking consciousness. In line with evolutionary theory, it is widely accepted that this active mode of ordinary consciousness is adaptive and functional and serves to enhance the survival of the species. It simplifies and selectively processes information and guides and monitors our intra- and interpersonal actions. Although the receptive mode, characteristic of many altered states of consciousness, is viewed as deviant, mysterious, and occasionally pathological from a Western perspective, it also serves adaptive functions. Receptive mode ASCs often provide avenues for psychological growth and development; they are also commonly used as therapeutic mechanisms in ritual contexts. The fact that these ASCs are so widely pursued on a cross-cultural basis suggests that there may be a universal human need to produce and maintain varieties of conscious experiences.

On the most basic level culturally shared views about consciousness pattern our experiences of "normal" and "altered" states of awareness. In

On the most basic level culturally shared views about consciousness pattern our experiences of "normal" and "altered" states of awareness. In short, human potentials for various states of consciousness are culturally conditioned.

short, human potentials for various states of consciousness are culturally conditioned. Through the learning process, a finite number of a wide range of potentials are fixed in a relatively stable way to produce an ordinary state of awareness. As we will see, however, we should guard against viewing "normal" states of consciousness as "optimal" or "best" (Tart, 1975).

The learning process similarly limits common alternatives or extraordinary states of awareness. You, for example, are unlikely to be able to attain the expanded states of consciousness available to long term practitioners of Yoga or to achieve spontaneously the altered states of awareness demonstrated by Fijian firewalkers. Furthermore, it is difficult, maybe impossible, for us to appreciate fully the subtle distinctions in consciousness that may be experienced in other cultures. For example, Sanskrit has about 20 nouns which translate into "consciousness" or "mind" in English simply because we do not have the vocabulary to distinguish different shades of meaning.

In terms of cross-cultural comparisons, the repertoire of culturally patterned ASCs in Euro-American societies appears more limited and less ritualized than in many other cultures. This partially explains the concentration on rigourously controlled, lab based studies of biofeedback, drug and hypnotic states, and sensory deprivation in our psychology texts. In the tradition of experimental psychology, unusual states of consciousness are artificially induced in isolated laboratory sessions; the ASC experiences are detached from the subjects' lives and lack real purpose or meaning. Cross-cultural perspectives on ASCs, however, offer the unique opportunity to explore real world experiences in their natural environments—altered states of awareness that are common, perhaps everyday, experiences imbued with purpose and meaning. Hallucinations and trance and spirit possession receive particular attention here.

CULTURAL VARIATIONS IN ASCS

Hallucinations

Hallucinations may be defined as "pseudoperception(s), without relevant stimulation of external or internal sensory receptors, but with subjective vividness equal to that aroused by such stimulation" (Wallace, 1959, p. 59). From this perspective most individuals have experienced hallucinations, and there are no cultures in which hallucinatory experiences are unknown. Despite the universal prevalence of hallucinations, however, there are aspects of the hallucinogenic experience which are dependent upon cultural learning. In the cross-cultural context hallucinations often occur in ritual settings and are associated with religious beliefs and tradi-

tions. As the surrounding events are usually public rather than private activities, the social context affects the phenomenology of hallucinations. In many instances, the experience of hallucination is a learned phenomenon with cultural values and social expectations providing the necessary cues for the ASC production and manifestation.

Medical, psychological, and anthropological literature on hallucinations and mescaline use provides a compelling illustration of this point. Reviewing the literature in this area Wallace (1959) contrasted the hallucinatory experiences of Anglo- and native Americans in response to the ingestion of mescaline. The former group were generally "normal" white subjects in clinical trials. The latter were more regular users of peyote[2] who consumed the substance in ceremonial contexts and in connection with religious rituals. The summaries of experiences are presented in Table 1. Overall, Anglo-Americans were more likely to display extreme variations of mood, to demonstrate a lack of social inhibitions and idiosyncratic hallucinations, and to experience an unsettling, unpleasant "split with reality." In contrast, native Americans reported religious ecstasy, hallucinations of a spiritual nature, therapeutic benefits, and an experience of a "higher order" of reality. The researchers concluded that the descriptions of the hallucinatory experiences were so different that informants did not seem to be talking about the same thing!

Cultural views of ASCs also affect the interpretation of these experiences in relation to psychopathology. In Western psychiatry hallucinations are considered as defining features of psychotic disorders. This view, however, is not shared cross-culturally. Westermeyer and Wintrob's (1979) study on the folk criteria for mental illness, "being insane in sane places," paints a different picture of hallucinatory experiences.

In this research two transcultural psychiatrists surveyed 27 villages in rural Laos and identified 35 people who were labelled baa (insane). They then interviewed friends, families and neighbors of those individuals in order to isolate the defining criteria of insanity. The categories used by Laotian informants in their folk diagnoses were: (a) danger to self and others, (b) nonviolent but socially disruptive behavior, (c) socially dysfunctional behavior, (d) problems with speech or communication, (e) delusions, (f) mood disturbances, and (g) physical symptoms. Noticeably absent, however, was hallucination as a defining characteristic of psychopa-

TABLE 1 **Responses to Mescaline Intoxication**

Anglo-Americans	Native Americans
Variable and extreme mood shifts (agitated depression, euphoria, depending on stage of intoxication and personal characteristics)	Initial relative stability of mood, followed by religious anxiety and enthusiasm with tendency toward feelings of religious reverence and personal satisfaction when vision achieved, and often, also expectation of "cure" of physical illness
Frequent breakdown of social inhibitions display of "shameless" sexual, aggressive, behavior	Maintenance of orderly and "proper" behavior
Suspiciousness of others present in the environment	No report of suspiciousness
Unwelcome feelings of loss of contact with reality, depersonalization, meaninglessness, "split personality"	Welcome feelings of contact with a new, more meaningful higher order of reality, but a reality prefigured in doctrinal knowledge and implying more, rather than less, social participation
Hallucinations largely idiosyncratic in content	Hallucinations often strongly patterned after doctrinal model
No therapeutic benefits or permanent behavioral changes	Marked therapeutic benefits and behavioral changes (reduction of chronic anxiety level, increased sense of personal worth, more satisfaction in community life)

Excerpted from Wallace (1959).

thology—despite the fact that this was found in the majority of the 35 subjects!

Trance and Possession

Of all the exotic ASCs that may be examined, ritual possession holds the greatest fascination for Western observers. Possession trance occurs in many forms and varied settings. In North America, possession by the Holy Spirit may be observed in charismatic Christian churches. In less familiar settings, ritual trance and possession may also be found in Shango and Voodoo practitioners in the Caribbean, devil dancers in Sri Lanka, temple mediums in Singapore, Hong Kong, and Korea, diviners in Sierre Leone, shamans in Thailand, Sasale dancers in Niger, Bantu rituals in South Africa, Candomble participants in Brazil, as well as Thaipusam devotees described in the opening passage.

How do these ASCs occur? While the possession trance is usually displayed in a public ceremony, it often involves private preparation beforehand, such as fasting or purification rites. The ritual trance itself is typically induced by sensory bombardment—repetitive clapping, singing, and chanting. Burning pungent incense, repeated stroking of the skin, spinning or whirling in circles which precipitate disorientation to additionally facilitate trance induction. Ritual possession is a pub-

lic event; as such, social expectations are also instrumental in the ASC production.

What does spirit possession look like? From external observations, the onset of possession is usually characterized by gross and uncontrollable body movements. Eyes appear glazed and still, sometimes only the whites showing. The possessed individual frequently takes on the demeanor of the possessing deity. They may become fierce and demanding or childlike and playful. The transformation can be quite dramatic. For example, in a Shango ceremony in Trinidad, I witnessed a man radically change movements, facial expression, voice— to a feminine persona when in the possession of a female deity.

From the devotee's perspective, possession is experienced in various ways. Unusual bodily sensations are very common. Haitian Voodoo participants refer to the experience as being ridden like a horse. In other cults it has been likened to being struck with lightning or to floating on air. Although largely unaware of the surrounding environment and apparently disoriented, possessed individuals maintain enough control for safety. For example, in Afro-Caribbean cults possessed participants may dance "wildly" with swords or machetes without danger to self or others. Temporal and spatial distortion usually occur, and hallucinations may or may not be present. At the end of the possession

ritual, it is common for individuals to experience a physical and emotional collapse. When they regain normal consciousness, they are generally unable to remember their activities during the possession episode.

In adopting the role of the possessing deity, individuals who enter ritual trance may make demands on others or prophesize about the future. A well-known anthropologist once told me that an entranced Shangoist predicted her second marriage—while she was still happily married to her first husband! Many native healers render diagnoses and treatment plans when in the altered state of consciousness. Still others, such as temple mediums in Singapore, attempt to produce winning lottery numbers!

Western observers have been quick to label these ASCs as pathological, describing them as various manifestations of hysteria, dissociative personality, epilepsy, and psychotic disorders, particularly schizophrenia. This assessment, however, fails to appreciate the cultural significance and evaluation of the ASCs (Ward, 1989). It is important to recognize that these altered states of consciousness have adaptive features on a number of levels:

1. *Biological*—There is evidence that the physiological mechanisms underlying ritual trance are similar to techniques used by psychiatrists to evoke emotional catharsis, the release, suddenly, of pent up psychological energy. Ritual possession has been compared to psychiatric abreaction (emotional discharge) and is likely to involve "fine-tuning" in the autonomic nervous system (Sargant, 1973).
2. *Psychological*—Ritual possession offers a variety of psychological benefits. Participants generally report feelings of contentment, well-being, and/or rejuvenation after possession experiences. It is not uncommon for them to indicate alleviation of physical or psychological symptoms.
3. *Social*—During possession episodes there are also opportunities for individuals to indulge in a range of behaviors generally restricted in normal waking consciousness, such as dropping social inhibitions, making demands for favors, or assuming positions of authority. In addition, status and prestige in the community are acquired as a consequence of ritual possession. For example, a successful Thaipusam pilgrimage, without evidence of pain or bleeding, indicates purity of heart. In the Shango cult, the

devotee's status in the community may mirror the possessing deity's status in a supernatural hierarchy. In Malaysia and Singapore, Malay *bomohs* and Chinese *dang ki* (temple mediums) are extremely well-respected and held in high regard by the general public.
4. *Socio-cultural*—Ritual possession functions to reinforce the religious beliefs of a community and to promote social cohesion among the group. In opposition to the popular view that these unusual altered states constitute psychopathology, then, there is strong evidence to suggest that they offer therapeutic benefits.

CONCLUDING COMMENTS

A cross-cultural approach offers a unique opportunity to expand our understanding of human consciousness. To benefit from this perspective, however, we must be open to new possibilities. Research tells us that our narrow definition of "normal" consciousness is not one which is shared cross-culturally. Different attitudes toward and experiences of hallucinations, dissociative episodes, trance, and spirit possession are found across cultures. Alternative varieties of conscious experience are encouraged, esteemed, and even formally institutionalized in diverse socio-cultural contexts.

The ethnocentric tendency to regard unusual ASCs with suspicion and scepticism, a view held by Western scientists and laypeople alike, limits our understanding of normal and altered states of awareness. Contrary to popular theorizing, there is no evidence that these "exotic" ASCs are intrinsically pathological. Indeed, on many counts there is ample evidence that such altered states of awareness serve therapeutic purposes. There is a lesson here for us to learn: To understand any one ASC, it must be appreciated in its own terms and its appropriate sociocultural context; otherwise, we run into problems created by overgeneralizing about behaviors in other cultures. To understand ASCs more comprehensively, however, cross-cultural threads of our knowledge about these phenomena must be skillfully interwoven.

Ultimately, we can only hope to achieve a deeper and more meaningful appreciation of human consciousness when we are able to shed our cultural blinders. As Tart (1975) aptly states: "We are simultaneously the beneficiaries and victims of our culture. Seeing things according to consensus reality is good for holding a culture together, but a

major obstacle to personal and scientific understanding of the mind" (p. 33). *What do you think?*

FOOTNOTES

[1]Although the description is based on my fieldwork in Malaysia, the term "floating on air" comes from Ronald Simon's film of the same name.

[2]Peyote is the Spanish word for the tops (mescal buttons) of a small cactus (*Lophophora williamsii*) which is used in Amer-Indian religious ceremonies for hallucinogenic effects. Mescaline is the psychedelic derivative obtained from the cactus.

REFERENCES

Bourguignon, E., & Evascu, T. (1977). Altered states of consciousness within a general evolutionary perspective: A holocultural analysis. *Behavior Science Research, 12,* 199–216.

Castaneda, C. (1969). *The teachings of Don Juan: A Yaqui way of knowledge.* Los Angeles: University of California Press.

Sargant, W. (1973). *The mind possessed.* New York: Lippincott.

Tart, C. (1975). *States of consciousness.* New York: Dutton & Co.

Wallace, A.F.C. (1959). Cultural determinants of response to hallucinatory experience. *American Anthropologist, 1,* 58–69.

Ward, C. (Ed.) (1989). *Altered states of consciousness and mental health: A cross-cultural perspective.* Newbury Pk, CA: Sage.

Westermeyer, J., & Wintrob, R. (1979). "Folk" criteria for the diagnosis of mental illness in rural Laos: On being insane in sane places. *American Journal of Psychiatry, 136,* 755–761.

9
Cleanliness and Culture

ELIZABETH FERNEA AND ROBERT A. FERNEA

"We have a very nice shower in the house," said our prospective landlord, a middle-aged Baghdadi businessman.

"What about a bathtub?" I asked tentatively, still a bit uncertain about this new world that we, as American newlywed graduate students, were entering for the first time: Iraq in the 1950s. Bob had a grant to do his cultural anthropological field research here for a Ph.D. from the University of Chicago.

The middle-aged man, graying and wearing what today we would call a rumpled leisure suit, sniffed, or more accurately, snorted.

"No bathtub," he replied.

"No bathtub?" I echoed. "Well, then. . . ."

"I don't care whether I rent these rooms or not," said the Baghdadi gentleman, "so I might as well tell you what I think about bathtubs."

I was startled. Why this diatribe against bathtubs? Didn't every respectable family, in the United States at least, have one? Showers were for gyms. Those who didn't have a tub were considered, well, underprivileged or very poor. How else could one get clean?

"Sitting in dirty water," went on the gentleman, a trifle testily, "Why do you Westerners want to *sit* in your dirt? What a custom! How do you ever get clean?"

We did not rent the rooms, for various reasons, but our first lesson in multicultural perceptions of cleanliness was soon confirmed by other experiences in Iraq, and by learning what Islam—the major religion of the Middle East—counsels its members. For cleanliness of the body and purity of the soul are related, and are among the religious goals to which the faithful Muslim must aspire, as several verses in the *Koran*, the basis of Islamic belief, testify. For example, Surah (Chapter) IV *Women*, Verse 43, states:

Believers, do not approach your prayers when you are drunk, but wait till you can grasp the meaning of your words; nor when you are polluted—unless you are traveling the road—until you have washed yourselves. If you are ill and cannot wash yourselves; or, if you have relieved yourselves or had intercourse with women while traveling and can find no water, take some clean sand and rub your faces and your hands with it. Allah (God) is benignant and forgiving. (Dawood translation, p. 371)

Elizabeth Fernea is Professor of English and Middle Eastern Studies at the University of Texas at Austin. She is a filmmaker and writer. She and her anthropologist husband, Robert (see below), have travelled and written extensively, including two recent books: *The Arab World: Personal Encounters* (Anchor Press/Doubleday) and *Nubian Ethnographies* (Waveland Press).

Robert A. Fernea is Professor of Anthropology and received his Ph.D. from the University of Chicago. He is currently president of the Society for Cultural Anthropology. Together with his wife, Elizabeth, they have written many things, including two recent books (see above).

This clear admonition to the faithful occurs not once, but twice in the Koran; almost the same phrases are repeated in Surah V, *The table*, with an additional explanation to the faithful about why cleanliness is so important. "Allah (God) does not wish to burden you; he seeks only to purify you and to perfect his favor to you, so that you may give thanks" (Verse 6). The same prescriptions urging cleanliness are also found, in different forms, in the *Hadith*, the other great body of guidelines for the faithful. A collection of thousands of the traditions and sayings of the Prophet Mohammed, founder of Islam, the *Hadith*, (with the *Koran*) are considered together as the *Sunna* (the straight path), the guide to everyday life as well as to religious life. Different Islamic sects may differ about which hadiths are "valid," but they do not differ on the validity of the Koran, which Muslims believe to be literally the words of God, revealed to Mohammed. (The Prophet is not divine, but merely the "messenger" of God.)

Cleanliness is identified with purity and good, in contrast to dirt, which is identified with the devil! In Surah XXIV (Light) of the *Koran*, Verse 21 says

> *You, that are true believers, do not walk in the footsteps of Satan. He that walks in Satan's footsteps is incited to indecency and evil. But for Allah's grace and mercy, none of you would have been cleansed of sin. Allah purifies whom He will: He hears all and knows all. (Dawood translation, p. 215)*

These two verses probably sound familiar to a practicing Christian, for whom the Biblical idea of purity is associated with good, and the idea of dirt ("dirty talk, dirty minds") is associated with evil. Islamic practice goes further, past the association, to legislate the actual cleaning of body as a symbolic cleaning of the soul.

Muslim women, furthermore, are told to purify themselves after menstruation, a custom also prescribed in orthodox Judaism. *Mikvah*, a ritual bath, is required of Judaic women after the menstrual period has ended and before the resumption of marital sexual relations. The *Koran* legislates the same requirement, and as a handbook of rules for everyday life, might in many ways be viewed closer in spirit to Judaism than to Christianity. On menstruation, the Koran is clear:

> *They ask you about menstruation. Say: "It is an indisposition. Keep aloof from women during their menstrual periods and do not touch them until they are clean again. Then have intercourse with them as Allah enjoined you. Allah loves those that turn to Him in repentance and strive to keep themselves clean." (Surah II The Cow, Verse 222, Dawood translation, p. 356)*

Cleanliness is also prescribed before and after eating. The faithful are not just invited "to wash their hands"; the washing place is literally brought to them. During one of the first meals we had in an Iraqi home, Bob and I were sitting stiffly in the living room of a local urban middle class family, who had invited us to lunch. We had brought messages and presents from their son, studying in Washington, D.C. A woman servant glided in, and presented us with a copper basin, a sieved top covering whatever was below, and a fresh bar of white soap gracing the raised middle of the basin.

"Please . . ." Our hostess, smiling, gestured at the copper basin.

I peered into it. Where was the water? The servant cleared her throat and I looked up. Ah! She was holding what could only be an old-fashioned pitcher, like those china ones in my grandmother's guest rooms, except this was in copper to match the proffered basin. She indicated that I was to hold my hands over the basin. I did as I was told, and the servant, her head tied up in a kerchief and her apron tucked into her skirt, dribbled water over my outstretched hands, once to wash and lather, once to rinse. Finally she handed me a towel.

The servant then sidled over to Bob with the basin, who of course manipulated the ceremony perfectly, having observed my trial, I thought! The hostess smiled once more, and said, "How do you do it in America?"

I felt it would be rude to say that we had private sinks for this purpose, but Bob had no such qualms and soon he and the hostess were merrily discussing a medley of American versus Iraqi customs about washing.

"We try to welcome our guests this way, " said the hostess-sister.

"Yes, of course," I replied meekly.

"And that way you help them fulfill their religious duty to be clean," added Bob, a bit obviously, I thought.

"Yes," said the hostess, and translated for her mother, who nodded and cast a sidelong glance at me.

Cleanliness is indeed an ideal condition of the faithful, and any obvious departure from the

stated cultural norm is a matter for discussion and criticism.

Such concern is noted early in the history of relations between the Muslim community and foreigners. Ibn Fadlan, a tenth-century Muslim trader,

Cleanliness is indeed an ideal condition of the faithful, and any obvious departure from the stated cultural norm is a matter for discussion and criticism.

traveled as far as Europe, and wrote about his experiences with the peoples of the north. His account of Scandinavian merchants on the Volga, published in 972 A.D., includes descriptions of their boats, their marriage customs, their treatment of the sick (they let them die), their death rituals, and their personal ornamentation. He also includes the following acerbic judgment.

> They are the filthiest race that God ever created. They do not wipe themselves after going to stool, nor wash themselves after a nocturnal pollution, any more than if they were wild asses. (quoted in Archibald Lewis, The Islamic World and the West, 622–1492 A.D., John Wiley & Sons, Inc., New York, 1970)

Clearly Ibn Fadlan found the Europeans' sanitary customs far from satisfactory.

As late as the nineteenth century, accounts of east-west encounters include cultural judgments based on the valuing of cleanliness. Rif'ah al-Tahtawi, a religious educator, was in the first group of Egyptian leaders to be sent to Paris to learn about the ways of the upcoming superpowers—France and Britain.

Tahtawi published a book about his European adventure, noting many things that he loved and admired in Paris—the wide streets, the parks, the theater. He was particularly interested in French attitudes to cleanliness, and devotes a whole chapter to French health, and the French apparent failure to recognize the importance of regular bathing to stay healthy. He is more polite and circumspect

in his remarks than Ibn Fadlan, perhaps reflecting the political and economic realities of the period in which the two men wrote. After all, in the tenth century Ibn Fadlan as a Muslim was a representative of the most powerful and culturally advanced civilization in the world of the time. But by the nineteenth century, the roles were reversed. Britain and France, like the other countries of Europe, had assumed control of much of the then known world, and Tahtawi's country, Egypt, was already part of the European colonial empire. Tahtawi tells his Egyptian readers that Parisian baths are not as good as those in Egypt, because the water is not as hot. But more importantly, not everyone has access to a means of cleanliness; the entire city boasts only *thirty* public baths!

Paris, thus, according to Tahtawi, was deficient, compared to the Middle East at the time, where public baths, with hot and cold running water, had been taken for granted for centuries in the neighborhoods of all cities and towns. Ecologically, to our modern perceptions, Middle Eastern baths were efficient and catered to the needs of all the people, located accessibly in each quarter of the city or town, and sharing a wall with the neighborhood bakery. This was to save fuel; the fuel used to heat the bakery oven could also heat, at the same time, the water for the neighborhood's public bath. Further, the baths were usually built next to the mosque, so the faithful, coming from a distance, could bathe before fulfilling their prayer duties.

In Marrakech, in 1971 and 1972, we lived in the *medina*, or traditional section of the city, and our house was exactly opposite the bath, which, according to tradition, was next to the bakery. We actually had a bathtub in our medina house, courtesy of the French family that had lived there before us, so the children and I, being somewhat shy about public bathing, did not use the bath across the street. Bob did, however, visiting with men in the bath whom he often saw on the street or behind the counters of the shops along Rue Trésor, the small street where we lived. It was a sex-segregated affair, open on alternate days to men and women. The men kept themselves wrapped in towels most of the time, Bob said. Women and children were somewhat less concerned about covering their bodies, we were told, and had a festive time together. I would watch, sometimes, the women and children visiting the bath on family days, carrying bundles of towels and clean clothing in, and coming out with a bundle of presumably soiled clothing, to be taken home and laundered.

In Arab cities and towns, men and women regularly visit the public baths once a week, usually before Friday prayers. A trip to the canal or a wash in a large basin may replace the bath in the countryside, but a bath at least once a week and a change of clothing is usually part of every household routine. Furthermore, dressing the family in clean garments is a matter of pride for the women of the household as much as it is regarded as a necessity by the men. In the smallest village markets, packets of blueing are found today, along with detergents, to help insure dazzling white clothes. The low humidity over most of the Middle East and the loose nature of traditional garments also helps maintain a dry, clean body. Also, the *Koran* is very clear in specifying that all five daily prayers must be preceded by a washing of the hands, arms, and feet. Though baths may be nearby, mosques regularly provide a fountain or water taps where this ritual cleansing of body (the ablutions) may take place before entering. In the Iraqi community where we lived in the 1950s, communal eating was always preceded and followed by the washing of the right hand, which was used to carry food from the common tray to the individual mouth.

However, while being clean is part of what is expected of a good Muslim adult, most children are not expected to maintain the same standards. The runny noses and flies around the faces of babies and toddlers in Middle Eastern villages often appall Western visitors who know the germ theories of disease. However, the problems of maintaining washed faces in the midst of many Middle Eastern neighborhoods are far different from those of middle-class Western suburbs. No matter how clean the interior of urban or village homes may be, the streets are where children play. Animal droppings, garbage, and waste water accumulate in an economic setting where a high standard of public hygiene is still a luxury. Furthermore, a clean, well-dressed baby invites envious glances and in traditional terms, the evil eye. Bad luck brought by the "eye," is taken seriously in the Middle East as in many other societies, including our own. Many Americans today wear religious medals or carry a rabbit's foot charm to help protect them. The possibility that the evil eye would be drawn out of envy to an attractive baby is seen by some Muslims as a greater danger than a runny nose and dirty clothes. Further, young children are not yet fully practicing Muslims, and personal cleanliness is partly embedded in the same maturation that brings with it the duties of daily worship.

Traditionally in the Middle East, the left hand is reserved for cleaning oneself after going to the toilet. In upper class urban homes, toilet paper is used for drying one's private parts only after they have been cleansed with running water; Arab friends visiting the United States have found the practice of using toilet paper for a dry wipe quite disgusting, just as the middle-aged Baghdadi businessman found sitting in the bathtub full of dirty water offensive. Indeed, the bathrooms of most modern Middle Eastern homes more often than not include a bidet and, lacking this, most toilet bowls (including so-called Turkish toilets) have a flexible built-in water pipe to sit over that directs a stream of water upwards to do much the same cleaning job as a bidet. Even the most humble country toilet, a hole in the ground over which one squats, always has a can of water placed alongside to be used for cleaning oneself after defecation. Many Arabs coming to the States find American toilets seriously lacking in this regard.

As in many societies, the degree of cleanliness one can maintain in the Arab world frequently reflects social status. Thus, young children are not as clean as older ones, women may not be able to dress as well as their immaculately attired husbands whose clothes they wash, nor are working class urbanites and peasant farmers likely to stay as clean as merchants and other white collar workers. Above all, accumulated filth is a reflection of the powerlessness of the poor; the richer the neighborhoods, the cleaner the streets. Being clean and staying that way in clean surroundings is a condition widely admired and sought after by practically all adults in the Middle East, as in the Western world, but this is not available to all.

Cleanliness certainly was one of the characteristics the women always remarked upon in discussing other women's housekeeping habits. Aisha, who worked for us in Marrakech, and who lived in a tiny apartment across the street, was proud of the immaculate way she kept her place. And she tried to do the same for us. Washing the floor every day was expected, and when I once suggested that she did not need to do it *every* day, she straightened up from her labors, and said, in some astonishment, "Why not? How else can we keep ourselves clean if the house isn't clean?"

This was true in our Cairo household, as well, where the daily routine involved hanging out all the bedclothes every morning to be aired, beating all the rugs, and washing all the surfaces in the apartment, including the floors. The city had taken

over responsibility for sweeping the streets twice a day, at least in upper class neighborhoods. However, private individuals collected the garbage daily, sorting and recycling materials of any value as a way of earning a modest living.

In Western societies, cleanliness has become justified by science and commercialized by billion dollar businesses who promise to kill germs, prevent diseases, *and* improve our social standing if only we will use their many hygienic and cosmetic commodities. Though the notion "cleanliness is next to Godliness" may linger in the homes of the more religiously minded Americans, we are warned far more often on TV and other media that we must wash not to be religiously pure but to stay well. Further, we are told we must smell sweet (or not at all) to remain socially acceptable.

Middle Eastern societies have acquired many of these secular ideas through the expansion of Western capitalism. Today, in cities like Cairo or Damascus the media are full of ads for soaps, deodorants, and shampoos. Undoubtedly these newly hyped commodities are finding customers, attracted by the same promises of social success that have be-

guiled the public in other settings. However, for many millions of Middle Easterners, washing the body is also an ablution, a ritual that remains part of religious discourse, even as promoters of "science" and "beauty" assert the claims about cleanliness now so commonplace in the Western world. Thus though both Middle Eastern and Western peoples share the desire for personal cleanliness, our reasons why and our ways of being clean are likely to vary for many years to come.

REFERENCES

The Koran, translated with notes by N. J. Dawood, Penguin Books, 1956.

Archibald Lewis, editor, *The Islamic World and the West, 622–1492 A.D.,* John Wiley & Sons, Inc., New York 1970.

Rifa'ah al-Tahtawi, *Takhlis al-ibriq fi Talkhis Paris,* unpublished partial translation by A. M. Bibi, 1977.
 Tahtawi's book was published in Turkish in 1832, and used in Egyptian schools in the 1830s. The Arabic translation was published first in 1847.

10
Moral Development and Its Measurement across Cultures

LUTZ H. ECKENSBERGER

Andere länder, andere Sitten ("Other countries, other customs"), as a German aphorism goes, tells us that when we think of other cultures, we usually do so in terms of how they differ from our own culture. Cultural differences in languages, manners, customs, lifestyles, and so on are evident everywhere. Growing up in a specific culture means that many behaviors and evaluations of them will be "offered" to the child, while certain "selective constraints" will be imposed on other behaviors. Thus, each cultural environment supports, rewards, and praises some activities, while it discourages, punishes, and prohibits others. Under the doctrine of *cultural relativism* we would have to accept the proposition that cultures not only *differ* from one another in many ways, but should also be *respected* and *understood* in their own right.

It must have been somewhat shocking to most relativistic social scientists when, in 1969, Harvard University professor Lawrence Kohlberg claimed that moral categories and reasoning are *not* cultur-

ally relative, as many believed them to be, but develop in the same sequence of stages in each and every culture. Since Kohlberg's bold assertions, cross-cultural theory and research on morality and how it develops have stimulated a healthy tension between universal and relativistic perspectives.

In this discussion, I will attempt to explicate this theory of universal moral development. Presented first is a basic definition of morality and how it differs from other normative concepts. This is followed by a brief summary of how moral judgments, or categories, develop in the individual, according to the theory. Finally, I will place Kohlberg's postulates under a critical, evaluative eye against the background of two decades of empirical cross-cultural research that has used his methodology.

WHAT IS MEANT BY "MORAL CATEGORIES" AND THEIR DEVELOPMENT?

As mentioned above, differences in behavioral categories across cultures are everywhere. Based on much research and theorizing over the past ten years, at least three different types of normative behavior have emerged, each resulting from different types of interpretation and understanding: personal concerns, conventions, and morality. These are summarized in Table 1 and explained in the text to follow.

Personal concerns are considered to be private, one's own business, idiosyncratic, and subjective.

Lutz H. Eckensberger has been full Professor of Psychology (Development and Culture) since 1976 at the University of the Saarland, Saarbruecken, Germany. He started cross-cultural psychology in the mid 1960's in Afghanistan and Thailand. His focus is now on methods, moral development and on the relation between cognition and affect. He finished his Doctorate in 1970, and his Habilitation in 1972. He is a member of the IACCP, and was a member of the Executive Committee from 1984-1986 and from 1988-1990, representing Western Europe.

TABLE 1 **Distinctions between personal concerns, conventions, and morality**

Personal Concerns Characteristics:	Conventions Characteristics:	Morality Characteristics:
Formal	*Formal*	*Formal*
Idiosyncratic	Culturally relative	Universal, absolute, objective
Material	*Material*	*Material*
Behavior is based upon personal and subjective preference.	Behaviors are coordinated in a group by standards of a rule; groups vary in their applied standards and corresponding behaviors; obligation without "natural law."	Behavior is intrinsically good/bad; it is not subject to any particular rule. Interests, rights, claims, authority. Obligations are based upon justice, common welfare, avoidance of harm to others, and it is important to the actor.
Examples	*Examples*	*Examples*
Haircut, wearing jeans, choice of friends	Forms of greeting, table manners, addressing a chief by his first name, school rules	Truthfulness, responsibility, appreciation of other peoples' concerns
Development	*Development*	*Development*
Changing interests, preferences	Content learning, agreement by social consensus	Rational deliberations; construction of morals by insight into principles of humanity

They change in response to the situations encountered during personal development. *Conventions*, on the other hand, are obligations that are based on cultural consensus. They serve to stabilize a group or society, to coordinate its social interactions. Conventions are tied to historical developments unique to each specific culture. They are acquired by individuals during the socialization process, and have specific contents such as table manners, how to address superiors, and so on. Finally, *morality* refers to what we consider "naturally" or intrinsically good or bad. Morals serve to coordinate interests of people, but also to refer to human rights in general, and to individual rights and obligations in particular. They consist of standards of justice, of general welfare, and of the avoidance of harm. Examples are personal honesty, responsibility, and readiness to act when someone is in need of help. Theft, murder, and dishonest behavior are examples of what may happen in the absence of moral guidance. From this point of view, it may be seen why Kohlberg claimed that moral categories in the interpersonal domain are as universal as logical categories in the cognitive domain. Although they refer to the social world, they are also considered to be "rational" and objective, and are assumed to develop uniformly all over the world by way of the individual's increasing insight into social obligations and necessities.

Kohlberg's work is based substantially on the developmental theory of Jean Piaget whose book, *The Moral Judgements of the Child,* first published in 1932, inspired Kohlberg. Piaget studied the moral judgment of children up to the age of twelve. Approximately thirty years later, a publication of Kohlberg's theory appeared. Since then, his theory has been substantially revised, and many publications on his work are available. The most recent critical overview of the Kohlbergian extension of Piaget's seminal views is by Modgil and Modgil (1986).

THE DEVELOPMENT OF MORAL JUDGMENTS AND THEIR MEASUREMENT

Kohlberg began his research by interviewing 6- to 8-year-old children. Over a period of thirty years, he interviewed the same children many times. This longitudinal and developmental approach enabled him to extend his study of moral development far into adulthood, and to give an account of any changes and transitions involved. Basing them on the above-mentioned criteria for morality, Kohlberg designed little vignettes, or stories, each representing a hypothetical moral "dilemma." The situations encountered in each dilemma are not

necessarily part of "real" life, but contain universal moral issues such as life, property, authority, trust, and so on, which are in conflict with each other—hence the term *dilemma*. The so-called "Heinz Dilemma" is a good example of one of these little stories:

> *In Europe, a woman was near death from a special kind of cancer. There was one drug that the doctors thought might save her. It was a form of radium that a druggist in the same town had recently discovered. The drug was expensive to make, but the druggist was charging ten times what the drug cost him to make. He paid $200 for the radium and charged $2000 for a small dose of it. The ailing woman's husband, Heinz, went to everyone he knew to borrow the money, but he could only get together about $1000, which was half of the amount required. He told the druggist that his wife was dying, and asked him to sell it cheaper, or let him pay later. But the druggist said, "No, I discovered the drug and I'm going to make money from it." So Heinz got desperate and broke into the man's store to steal the drug for his wife. Should Heinz have done that? Why or why not?*

In addition, several other probing questions are usually asked.

Kohlberg constructed a total of nine dilemmas, three of which are usually used to assess an individual's "moral judgment." This procedure is very time-consuming and involved, since subjects are usually interviewed individually. Recently, "paper and pencil tests" have been developed for use with groups. They offer a number of predefined arguments to the subject, who is asked to choose the one he or she likes best, or considers most appropriate. The most popular test in use was constructed by James Rest, a scholar who worked under Kohlberg.

To comprehend the theory better, it is important to understand that it is not actually a person's *decision* (Yes, he should have done it; No, he shouldn't have) which represents the moral judgment, but rather the *reasoning* used by a subject to explain or justify his/her choice. These arguments are grouped into six types, according to their complexity. The types of reasoning vary with age, or more precisely, with cognitive growth, and are therefore called *stages* of moral development. Kohlberg grouped them on three levels, with each level containing two stages. The *complexity* of a stage, i.e., its form or structure, is primarily defined by the de-

gree to which aspects of social reality are included in subjective considerations. For example, children present reasons for arriving at a certain judgment, which include the main actor and his or her immediate social environment. In the course of development, an increasing number of persons and groups, and their respective forms of interaction, cooperation, and organization, enter into individual awareness and consideration. In the next step, formal laws and legal principles are considered. Finally, the ultimate principles of humanity are understood and appreciated with respect to their contribution to human dignity. Hence, the arguments presented in the course of individual development become increasingly abstract, and are decreasingly tied to specific situations. At this point of lofty abstraction, moral issues are considered from an independent, ethical point of view. Table 2 summarizes these stages.

The main postulates in Kohlberg's theory are as follows:

1. The stages are not learned by modeling or via reinforcement of certain behaviors, nor by transmission of the content knowledge of the rules and regulations pertinent to a particular cultural setting. Rather, stages are *constructed* by the subject, and construction assumedly reflects his or her personal individual experience in view of the surrounding social environment.
2. The development of moral stages is not only related to, but dependent upon, cognitive development. Each consecutive stage is marked by a further refinement of previously attained cognitive stages. Thus, moral stages are also assumed to follow a "developmental logic," implying an invariant order of succession of the stages.
3. It is assumed that a person will not reach higher (especially the final) stages unless he or she is exposed to adequate "incitement conditions" (experiences), which trigger developmental progress.

Generally, role-taking opportunities, participation in cooperative decisions, and taking up responsibilities facilitate moral development. On the other hand, repression, denial of contradictions in the social domain, and standardized, mechanical communication are detrimental to progression in moral development. Emotionally stable relationships, social acceptance by teachers and peers, and feedback by others concerning the consequences of one's own actions *enhance* the development of the con-

TABLE 2 **Stages of moral development and corresponding developmental antecedents**

Stage/Level	What is considered to be right is	Developmental antecedents for
Preconventional Level:		
Stage 1: Obedience and punishment orientation	To avoid breaking rules backed by punishment; obedience for its own sake, avoiding physical damage to persons and property	
Stage 2: Instrumental purpose and exchange	To follow rules only when it is to someone's immediate personal interest; right is an equal exchange, a good deal	
Conventional Level:		*Transition to conventional level* (Positive) stable emotional acceptance by parents; social acceptance by teachers and peers; information about the consequences of one's own behavior for others' (negative) inconsistent behavior on the part of authorities; unjustified demands for obedience, power assertion, love withdrawal.
Stage 3: Interpersonal accord and harmony	To live up to what is expected by people close to you or what people generally expect of people in your role; being good is important	
Stage 4: Social accord and system maintenance	To fulfill the actual duties which you have agreed to; laws are always to be upheld except in extreme cases when they conflict with other fixed social duties; right is also to contribute to society, the group, and to institutions.	
Postconventional Level:		*Transition to postconventional level* (Positive) confrontation with diverging norms and roles; experience of true responsibilities; chance to shape one's own life; (Negative) confrontation with diffuse social environments or completely incompatible standards; lack of responsibilities.
Stage 5: Social contract utility—individual right	To be aware that people hold a variety of opinions, that most values and rules are relative to your group but should usually be upheld because they are the social contract; some non-relative values and rights like life and liberty, however, must be upheld in any society regardless of the majority opinion.	
Stage 6: Universal ethical principles	To follow self-chosen ethical principles; particular laws or social agreements are usually valid because they rest on such principles; when laws violate these principles, one acts in accordance with the principle; principles are universal principles of justice; the equality of human rights and respect for the dignity of beings as individual persons; the reason for doing right is the belief as an emotional person in the validity of universal moral principles, and a sense of personal commitment to them.	*General positive influence* Role taking opportunities; participation in cooperative decisions; attainment of responsible positions; *General negative influences* Repression or denial of contradictions; standardized, power-based, mechanical communication.

ventional levels. In contrast, inconsistent behaviors on the part of authorities and unjustified demands for obedience tend to *inhibit* these transitions. The transition to post-conventional levels of morality is facilitated by confrontations with divergent norms and rules, and by granting the individual opportunities to shape his or her own life. But such transformation to higher stages is obstructed when there is total diffusion or disruption of the social order in which a person grows up, or, for instance, when a

person is prevented from attaining responsible positions.

CROSS-CULTURAL RESEARCH AS A TOUCHSTONE FOR KOHLBERG'S THEORY

Cross-cultural research is critical for the examination of certain aspects of the theory. Such research attempts to answer two complementary questions on moral development. First is the question of generality: Do moral judgments in fact develop universally in an invariant sequence? Are the very same incitement conditions present in all cultural contexts? The second question concerns differential development: How is moral development quantitatively and/or qualitatively affected by various cultural incitement conditions? In other words, do all stages occur in all cultures? Are there cultures in which this development is accelerated or retarded when compared with other societies? If

Do moral judgments in fact develop universally in an invariant sequence? Are the very same incitement conditions present in all cultural contexts?

so, under which conditions? Are there moral arguments which do not fit the scheme that was developed in the United States and formulated at the prestigious Harvard University, which some call the bedrock of liberal democratic idealism?

AN OVERVIEW OF THE CROSS-CULTURAL FINDINGS

The Range of Cultures Involved

Reviews by Snarey (1985), Edwards (in Modgil & Modgil, 1986), Moon (1986) and the present author count over fifty studies which were done with Kohlbergian theory and/or method, or were associated with it. Although the distribution of cultures involved in these studies is not ideal, the range of cultures studied is impressive. Included are several

African cultures, about a dozen countries in Asia, various countries in Eastern and Western Europe, four countries in the Near East and the Mediterranean area, several Caribbean and Latin American societies, Mexico, and of course the United States and Canada. Most of these studies were cross-sectional, that is, the investigation was done on one occasion with different subjects at different ages.

The Cultural Adequacy of the Dilemma Method

Because the dilemmas were selected in the West, charges of "cultural bias" and even "gender bias" have been raised, thereby questioning their adequacy for the definition and study of moral reasoning in non-Western areas. Although the adaptation of the interview or test material is a serious problem in all of cross-cultural research, it should be remembered that the dilemmas are explicitly intended to represent *hypothetical* situations. That is, they do not intend to represent a certain context or what people *would* do in a certain cultural context. Quite to the contrary, they are intended to trigger general "moral arguments" about what people should do *ideally*. The empirical research on this issue is astonishingly meager. For the most part, the original dilemmas were used unchanged. Now and then a few aspects are adapted (e.g., the amount of money in the Heinz dilemma is changed to suitable cultural standards, or the names of the actors are familiarized). Occasionally, new stories are invented, which are intended to represent the same issues/problem (e.g., a conflict between property and life).

Examination of the available data presents a contradictory picture regarding the success of these efforts. In some cases, the adaptation of the entire dilemma to reflect local issues makes no difference in the obtained results; in other cases, simply familiarizing the names of the actors in the dilemma changes the moral arguments. For instance, *Heinz* might be changed to *Enrique* or *Abdul*, depending on the culture. A minimum requirement in such research is to ensure that all the "facts" in the dilemma have been understood and represent a genuine moral conflict for the interviewee—one that is as equivalent as possible across cultures.

The Scoring of Arguments

A similar problem arises in the context of assigning the responses given by members of different cul-

tures to the "stages." Kohlberg and his associates developed an increasingly precise scoring manual over the years, which was constructed exclusively on the basis of case examples collected in the United States, where most of the research was done. In cross-cultural research, however, the answers given by the subjects in the interview are obviously loaded with culture-specific contextual information, irrespective of their "hypothetical" status. Thus, in cross-cultural research, it is often necessary to "detect" the underlying moral structure of an argument which is not contained in the scoring manual's compendium of examples. Table 3 gives examples of "stage two answers" from four different cultures to two questions referring to the initially presented Heinz dilemma. These problems had been understood as a moral issue—with each associated argument interpreting the value of the other person as somehow instrumental for one's own interests.

THE TRANSCULTURAL EXISTENCE OF STAGES

Although Kohlberg and his associates may not have expected that all stages would be found in all cultures (depending upon the existence/non-existence of adequate incitement conditions), a rather clear trend is discernible: Stages one and five are

rare, but stages two, three and four can be found in many cultures.

INVARIANCE OF THE STAGE SEQUENCE

An important criterion for testing the postulated sequentiality of the stages and its implicit notion of an underlying "developmental logic" is whether any stage regressions or omissions in the regular progression occur. Snary (1985) did an extensive metaanalysis (analysis of analyses) of the research in this area. He also took into account the different versions of the scoring manual. According to Snary, irregularities in stage transitions, such as regressions, are so rare that they can be accounted for by measurement errors.

INCITEMENT CONDITIONS (ANTECEDENTS TO MORAL DEVELOPMENT)

What do we know about the generalizability of developmental antecedents (see Table 2)? In Western societies, the socioeconomic status and the level of education of the parents are rather unspecific indicators of the child's moral development. The available data from cross-cultural studies, in particular

TABLE 3 **Examples of stage two answers in the Heinz-dilemma from different cultures**

QUESTION:	Should Heinz steal the drug (food)* for his wife (friend)**?	What if Heinz did not love his wife (friend)**?
ANSWERS:		
American:	Yes, because his wife needs it and will die without it.	No, because this is not worth the trouble.
Turkey:	Yes, because his wife was hungry (food) otherwise she will die.	
	Yes, because one day when he is hungry his friend would help.	No, because when he does not love him, it means that friend will not help him later.
Eskimo:	Yes, because his wife is starving (food). Because they need food.	Yes, because nobody will cut fish for him.
Puerto Rico:	Yes, because he should save the life of his wife.	Because he should protect the life of his wife so he doesn't have to live alone.
UNDERLYING STRUCTURE:	The other person is in need (morality).	The basis of evaluating the other person is self-interest and the appreciation of the instrumental value of stealing. (Stage 2)

*The dilemma was changed into a situation where the wife was in need of food.
**Some probing questions referred to a friend.

from Africa, reveal that this is also true transculturally. In Africa, socioeconomic status and education are part of the "modernness" of a family. Data from other areas show that religiousness has some influence on moral development. For instance, religious fundamentalism seems to have an inhibiting effect. Furthermore, living conditions (i.e., living in rural as opposed to urban environments) have proven influential. Quite compatible with the basic idea that role-taking opportunities and participation in social decisions are important, some studies do in fact show that the amount of "experiences outside the family" are decisive for the attainment of higher level moral reasoning. In particular, formal education is important for the development of stage four arguments and judgments.

Some of the studies conducted in India measured the particular influence of child-rearing practices on moral development, as defined by moral judgment interviews. Indian data generally support the trends found in the United States: power assertion and love withdrawal are rather negative. Other-oriented induction, however, is positively related to moral judgment. Interestingly, a whole series of paper and pencil studies conducted in a wide range of cultures do not show any relationship between moral development and child rearing practices. This questions the validity of paper and pencil methods to assess moral reasoning.

What accounts for cultural differences when they are found? It has already been stated that stage five occurs only rarely. The highest stages have been found in Israel among members of the Kibbutzim, followed by Germany and the upper classes of the United States, Taiwan, and India. Poland and members of the lower classes in the United States obtained medium-range scores. Lower scores have been recorded in the Bahamas, Kenya, Papua, and Turkey. In all of these studies, Kohlberg's interview was applied. On the other hand, studies conducted with paper and pencil tests containing simpler definitions of principled thinking reveal that South Korea, Taiwan, and Greece, on the whole, scored high, whereas in Belize, Sudan, and Trinidad-Tobago moral reasoning was at a low level. According to a number of detailed analyses, and quite opposed to what many researchers had anticipated, it was not the dichotomy of "Westernized vs. non-Westernized cultures" that mattered, but rather the extent of "cultural complexity"—the degree to which a given culture had developed social institutions, roles, and positions to account for the empirical differences that were found between the cultures under investigation. These results fit well into the theory.

UNIVERSALITY OF MORAL CONTENT

Kohlberg's claim of a universal development of moral stages primarily referred to the structure (form) of the moral arguments presented in the moral dilemma interviews. Unfortunately, however, he also claimed that the moral issues in his dilemmas were universal and complete. This would imply that the material presented in his scoring manuals is sufficient to score all kinds of responses from all over the world.

Recent studies, however, demonstrate that this is not the case. There *are* cultural differences in moral themes that appear clearly in the interview material, and these are difficult to score. For instance, data from India and from the monks of Ladakh demonstrate that the issue of *nonviolence* and the *sacrecy of (all) life* are not morals restricted to human beings, but include all forms of life, including animals. These moral issues are grounded in the inseparable unity of religion and morality in India and in other Buddhist or Hindu cultures, and are quite opposite of Western thought. Another example involves data from Israel, which refer to a moral concern called *collective happiness*. This, too, is an objective that is not present in Western traditions. Finally, answers from Taiwan underscore the great importance of *filial piety* and *collective utility* in traditional Chinese moral reasoning. All of these examples are obviously not random and cannot be scored adequately with the present scoring manual.

SOME DOUBTS ABOUT STAGE STRUCTURES

Beyond the rarity of stages one and five, some problems concerning the structural definition of the stages are evident. On the basis of Icelandic and German data, the definition of stage two (instrumental exchange) was called into question by the present author. It was found that concern for other persons seems to be far more important, even at this early age, than was originally believed. Stage four, on the other hand, seems to be too heavily based upon formal legal conceptions. Data from Kenya and other traditional societies, for instance, indicate that it might be more reasonable to conceptualize the stage in terms of the capacity to understand and appreciate rules and roles.

GENERAL EVALUATION OF THE THEORY AND PRESENTLY OPEN ISSUES

There is substantial, but by no means complete, cross-cultural support for Kohlberg's theory of the development of moral judgment. This research has also generated many unresolved questions. Some of the results mentioned above clearly call for a better elaboration of what is known as the "form or structure" of the stages of moral reasoning. Also, the range of moral contents, and their relationship to moral reasoning, has not been fully clarified. However, the most outstanding and difficult issue is the relationship of the three rule schemata outlined in Table 1 (personal concerns, conventions, and morality) to the three developmental levels of morality in Table 2 (preconventional, conventional, and postconventional). At first glance, they look very similar. Nevertheless, Table 1 refers to different *horizontal* domains of social norms, which can be differentiated by children very early in development. Additionally, as shown in Table 2, it is claimed that there is a sequential *vertical* order in the reconstruction of these domains. How, then, can we resolve this obvious contradiction between the theory and the corresponding data it generates? While the debate is still quite open, some of the following concluding remarks might be a hint at a solution.

It is difficult to find behaviors that are exclusively defined as being personal, conventional, or moral. Rather, any assessment of behavior according to these categories rests on a *personal* interpretation of this behavior as being such. For instance, in the United States, premarital sex is generally thought to be a *personal* concern. In Zambia, however, premarital sex is a moral event. Why? Because in Zambia there is a theory of illness positing that sexually active (hot) individuals somehow make sexually inactive (cold) individuals (children, elderly) ill by practicing premarital sex. Hence, premarital sex affects the well-being of others, and is, therefore, a moral matter. On the other hand, even in Zambia, premarital sex *could* turn into a personal matter, or even a generally accepted convention, if the theory of illness were replaced by a more *modern* view. Likewise, in the United States premarital sex could turn into a moral concern because of growing concern about AIDS and other illnesses or conditions that are usually transmitted sexually.

Also, Kohlberg's dilemmas purportedly refer to problems which are of direct (not mediated) moral relevance to everyone. The dilemmas refer to stealing, keeping promises, and so on. Therefore, anyone is assumed to be able to attribute the hypothetical situations of the interview to the moral domain. The intuitive interpretation of a dilemma as a moral event does not, however, imply that subjects at any age can also explain or justify their decision in terms of a universal view, for instance, in the issue of *stealing* or not in the Heinz dilemma. Instead, children and young adolescents explain moral implications by referring to the personal or mutual interests involved in their judgments. A person's life is evaluated from an instrumental point of view: Heinz should steal, because if he didn't his wife will die. Later, they explain moral standards by means of their functionality in regulating personal relationships, the organization of small groups, or society as a whole. It is of utmost importance, however, to note that in making reference to a person, personal interests, or mutual expectations, the arguments submitted remain unequivocally within the sphere of morality. Thus, it would be incorrect to interpret Kohlberg as saying that morals ultimately emerge from conventions. This would be an inaccurate interpretation of his theory.

In conclusion, it can be stated that both the horizontal and the vertical perspectives of morality are not necessarily in conflict with each other. However, future research will have to attend to the theoretical and methodological problems evolving from their interrelationship.

REFERENCES

Kohlberg, L. (1969). Stage and sequence: The cognitive developmental approach to socialization. In D. A. Goslin (Ed.) *Handbook of socialization theory and research* (pp 347–480). Chicago: Rand McNally.

Modgil, S. & Modgil, C. (Eds.). (1986). *Lawrence Kohlberg: Consensus and controversy*. London, Philadelphia: Falmer Press.

Moon, Y. L. (1986). A review of cross-cultural studies on moral development using the Defining Issues Test. *Behavior Science Research, 20*, 147–177.

Shweder, R. A., Mahapatra, M. & Miller, J. G. (1990). Culture and moral development. In J. W. Stigler, R. A. Shweder & G. Herdt (Eds.), *Cultural psychology. Essays on comparative human development*, (pp. 130–204). Cambridge: Cambridge University Press.

Snarey, J. R. (1985). Cross-cultural universality of social-moral development: A critical review of Kohlbergian research. *Psychological Bulletin*, 202–232.

11
Cultural Variations in the Use of Alcohol and Drugs

JOSEPH E. TRIMBLE

The study of consciousness has a long-standing tradition in psychology. Topics like attention and attentiveness, sleep, hypnosis, self-awareness, and biological rhythms typically are explored and discussed as evidence of our conscious and unconscious behavior. Philosophers and theologians, too, have discussed and debated the topic for centuries. In some philosophical circles, the debate continues about the meaning, source, location, and the influence of consciousness and conscious thought and action.

Psychologists and psychiatrists also are keenly interested in exploring phenomena and elements that alter and change consciousness. Sleep patterns and states of reverie consume much of their interest. For decades, researchers have been examining a

Joseph E. Trimble (Ph.D., University of Oklahoma, 1969) is a Professor of Psychology at Western Washington University, where he has been a faculty member since 1978. Throughout his academic career, he has focused his efforts on promoting psychological research with indigenous, ethnic populations, especially American Indians. In the past decade he has been working on drug abuse prevention and intervention research models with native youth. He has presented over 200 papers and invited lectures at professional meetings and has generated over 100 publications dealing with topics concerning psychology and culture.

The author wishes to express his gratitude for the support provided to write this chapter by the Tri-Ethnic Center for Prevention Research at Colorado State University through NIDA grant P 50 DA07074.

multitude of conditions, circumstances, and classes of things that specifically alter sleep and biological or circadian rhythms. And we now know that sleep patterns, a significant form of consciousness, can be altered by such things as stress, fatigue, anxiety, depression, warm baths, one's developmental stage, and boring lectures. We also know quite conclusively that *psychoactive* drugs can drastically alter sleep and, for that matter, all forms of consciousness.

Altering or changing consciousness through the use of psychoactive drugs such as alcohol, cocaine, and marijuana has become a major concern in recent decades. For a variety of reasons, more and more people, particularly youth, are experimenting with and using drugs than ever before. Although the rates of drug and alcohol use vary among different groups of people, most use the substances to change their levels of consciousness. Some use such substances to feel good, get a "high" or a "buzz," to ward off or deaden depressive experiences, or to heighten one's sense of belonging to an admired group. There are other reasons, yet no matter what they are, the underlying motive for using psychoactive drugs and alcohol is to alter, however temporarily, one's sense of awareness.

PSYCHOACTIVE AND NONPSYCHOACTIVE DRUGS

Not all drugs and natural substances can alter consciousness. Drug researchers, therefore, prefer to

draw a distinction between psychoactive and nonpsychoactive or medicinal drugs. Psychoactive drugs are those natural or synthetic substances that produce changes in emotion, thought, and behavior because they change the function and operation of the brain's nervous system. Certain psychoactive drugs are often referred to as *psychotomimetic* drugs because they produce hallucinations and an altered sense of reality—that is, the drugs allow individuals to "see into their minds" in a vivid, almost nonordinary manner. Often psychotomimetic drugs are classified as *psychedelic* (literally "mind sense") because the individual may have a psychotic-like experience while under the influence of drugs such as *psilocybin* (*psilocybe mexicana*, a cactus indigenous to Mexico), *mescaline* (the primary active agent in *peyote*), and *morning glory seeds* (especially the plant, *Rivea corymbosa*), and the *Datura* plant species. Synthetic psychedelics or hallucinogens such as LSD-25 (d-lysergic acid diethylamide), DOM (2, 5-dimethoxy-4-methylamphetamine), and PCP (phencyclidine) produce effects similar to their natural counterparts; use of certain synthetic psychedelics have been shown to create irreparable tissue damage along with the short-lived euphoric experience.

ETHNOPHARMACOLOGISTS, PSYCHOPHARMACOLOGISTS, AND ETHNOBOTANISTS

Psychoactive drugs can be roughly ordered between a natural to a synthetic or human produced category. At one level, *ethnopharmacologists* study our use of natural intoxicating compounds and *psychopharmacologists* study all agents that have intoxicating properties. Drugs also can be categorized as either *licit* (lawful) and *illicit* (unlawful). Caffeine, nicotine, and alcohol are lawful and therefore federally regulated whereas marijuana, cocaine, heroin, and LSD-25 are illicit drugs principally because the public is prevented from possessing and consuming them. And finally, drugs can be classified into categories that represent the effect they have on the human body; narcotics, antipsychotics, and hallucinogens.

Ethnobotanists tell us that psychotomimetic drugs found in certain flora worldwide have been in existence for millions of years; human use and consumption of narcotics and hallucinogenic plants undoubtedly can be traced to our beginnings. No one is really certain when homosapiens first used

drugs. Nonetheless, there is evidence to suggest that they were used frequently and abundantly by many cultures. The Chinese as early as 2700 B.C. used *cannibas sative* (marijuana) to treat many illnesses. Native populations in present-day Guatemala cultivated mushrooms some 4,000 years ago for use in cult-like ceremonies. Ancient Sumerians in the Mesopotamia region used the narcotic residue of the opium poppy for a variety of purposes about 7,000 years ago. South American Indians have chewed the leaves of the coca plant for as long as they lived in the region. And we find evidence of warriors described in the Greek classics, the *Iliad* and the *Odyssey*, using plant concoctions for poisons and intoxicants.

Caffeine found in numerous plants remains to this day one of the most frequently consumed psychoactive substances. Alcohol, however, tops the list of most used drugs both today and in days gone by. Alcohol is produced when yeasts, molds, and certain bacteria interact with glucose found in legumes and fruits. Historical records suggest that fruit wines were available in Asia and the Mideast about 7,000 B.C. Ancient Egyptians produced beer and wine-type beverages over 5,500 years ago. Probably the oldest known alcoholic beverage is *mead*, a sweet drink made from fermented honey and water. Historical records suggest that it was used about 8,000 B.C. Most likely all cultures had access to drugs and alcohol substances in some form. The substances were used for nourishment, ceremonials, healing psychological and physical problems, and relieving the pressures of daily living. Undoubtedly, along with positive effects produced by the drugs, all cultures had to deal with the negative side effects.

Ethnobotanists estimate that there may be over 800,000 different plant species. Of this number, about 5,000 species are known to contain alkaloids which are nitrogen-containing bases found in most psychotomimetic drugs. About 20 of these species are the ones most frequently used because of their intoxicating properties. Four of these—coca, opium poppy, tobacco, and hemp—are cultivated commercially largely because they are in greatest demand worldwide. In the Americas, particularly in the Central and South American regions, ethnobotanists claim that about 120 plants can be found that induce psychotomimetic states. However, only 20 or so can be found anywhere else in the world. Along with the availability of naturally present narcotic-containing plants, humans are cultivating drugs resulting from the hybridization of species—

these *cultigens* produce intoxicating effects that are far greater than the original species.

MAJOR CULTURAL USES OF PSYCHOACTIVE DRUGS

As near as we can determine, most cultural groups indigenous to the Americas used many psychoactive drugs for religious and ceremonial purposes. Tribal groups developed strict codes regulating and restricting the use and possession of drugs. In almost all groups, the more powerful psychoactive drugs were used by shaman and religious leaders. Recall that psychoactive drugs directly affect the brain's behavior thereby altering consciousness. Because of the effect indigenous peoples ascribed and attributed spiritual powers to the drugs—the more potent the plant or a concoction of narcotic-like plants the greater the power attributed to them. Because of the potency of some drugs, many groups actually feared and worshipped certain plants. In addition, consumption of a drug often produced bizarre behavior in the user. For example, the Mojo Indians from eastern Bolivia use *marari* to assist healers in interviewing helpers from the spirit world. The user would be thrust into a 24-hour state of hyperactivity accompanied by extreme pain and sleeplessness. Consequently, Mojo shaman were reluctant to use *marari* because of the side effects yet respected it because it permitted communication with spiritual authorities.

Often aboriginal peoples classified hallucinogenic species according to the effects they produced—the weaker the effect the lower the plant's status and thus the more tolerant for greater, widespread use. Peyote or *Lohophora Williamsii* is one such plant, the common name for which is a variation of the Aztec word, *peyotl*. The Tarahumara from the northwestern region of Mexico identified and revered five varieties of the cactus plant. *Mulato* enabled the user to see sorcerers along with actually enlarging the size of the eye; hence, the plant served to protect one against evil spells and practices because the sorcerer could be identified only when one was in an altered state of consciousness. *Hikuli walula saliami* is extremely rare among the Tarahumaras, thus it is attributed the greatest power and authority. Use of the *hikuli* variation grants one extreme spiritual powers.

Because there are numerous psychoactive drugs and hundreds of aboriginal groups in the Americas, the study and discussion of the use patterns would be exceedingly complex. Indeed, the topic is rich with unique accounts of the way indigenous people incorporated drug use in their daily lifestyles and religious practices. But what is equally important is the finding that most indigenous people did not have to deal with the problems associated with drug abuse. There are, sadly, certain drugs that were once tightly controlled and regulated by indigenous peoples that are now being used and abused for recreational and self-serving purposes. *Kava* (Piper methysticum) is a relatively unknown psychoactive substance in the Americas, yet kava is deeply tied to the traditions and customs of South Pacific Islanders. Kava use is undergoing changes where abuse and all its attendant problems are causing great concern.

Kava or *kava-kava* can be found in most island groups in the South Pacific. Essentially, Kava (also kawa, ava, or awa) is a beverage prepared from a perennial shrub (Piper methysticum Forst) that has non-alcoholic intoxicating properties; fresh roots are preferred in the preparation process. Kava preparation varies from one island or atoll group to the next. In the main, the roots of the pepper-like shrub are cut into small pieces, chewed or pulverized in stone mortars (galvanized buckets are often used today). After the root chips are pounded into a powder, water is slowly added. Periodically the mixture is poured through a mesh-like strainer to remove the root's fibers. Eventually a liquid of varying levels of concentration is produced; kava is then considered ready for use. The beverage produces a tingling sensation in the mouth and a brief numbness of the tongue; consumption rates and potency levels can bring about variations in the overall effect.

Reports vary all over the South Pacific about kava's intoxicating properties. Some claim that the numbness experienced initially in the mouth eventually spreads throughout the body to the point that users have difficulty walking. Most users, however dramatic the effect they experience, claim that kava does not produce the infamous hangover common to alcohol use. Prolonged kava use does reportedly produce some negative side effects—habitual users typically are known to have bleary eyes, dull skin tones, and scaly-like skin.

For centuries, use of kava among Hawaiians, Tahitians, Tongans, and Samoans, for example, was governed by very strict codes of behavior. Paramount chiefs and shaman regulated its use following highly stylized rituals. Ceremonies where kava was used were major social events involving village

and community members. Rituals varied from one island group to the next. Essentially, kava preparation and consumption took center stage. The reverence and respect given to kava underscored its importance in the island cultures. Abuse of the plant and the beverage was not tolerated and, in some instances, resulted in the abuser being banished from the village or stoned to death.

Today some of the ceremonies persist in the Pacific, however, the content, activity, and reverence have changed considerably from pre-colonial times. Early missionaries did their best to eliminate kava ceremonies and practices and were successful on some islands. Kava use now is on the increase to the extent that it is being abused largely by youth. For them the ancient ceremonies are meaningless and irrelevant. Getting "high" and feeling numb are more important. Kava use today is emerging as a major drug problem in certain Pacific Island groups. Habitual users are becoming psychologically addicted to kava's effects. The addiction leads to other social and psychological problems that are disruptive to families and communities.

INVARIANT BIOLOGICAL REACTIONS TO DRUGS

While customs surrounding the use of psychoactive drugs vary from one cultural group to the next, the action of drugs on the human body is fairly consistent. Cultural customs influence the way drugs are used. However, the customs have little influence on drug action in the brain. Mescaline, the main active

While customs surrounding the use of psychoactive drugs vary from one cultural group to the next, the action of drugs on the human body is fairly consistent.

ingredient in peyote cactus, is rapidly and completely absorbed in the brain within 30 minutes after consumption. Both the autonomic and central nervous systems are affected, suggesting that mescaline acts much like certain neurotransmitters. Regardless of one's cultural background, mescaline

will affect everyone in a fairly predictably manner. Variations in the drug's effectiveness can occur through constant use and that can occur through a cultural medium such as a religious group.

At present there is no substantial evidence that supports the notion that certain cultural groups have biologically-based weaknesses or strong tolerances for particular psychoactive drugs. Contrary to pockets of common belief, American Indians and Alaska Natives are no more genetically inclined towards alcohol intoxication than any other ethnic group. The Chinese are not likely to become opium addicts because they are Chinese; and the French are not likely to become wine addicts merely because they drink a lot of wine. People become addicted to drugs because they misuse and abuse them not because of their biological heritage (see Trimble, in press).

WHAT ACCOUNTS FOR PATTERNS OF DRUG ABUSE IN NORTH AMERICA

Biological factors alone, as stated above, have not been able to account for patterns in the use of psychoactive drugs. Yet when we view the growing numbers of people in North America who are using and abusing drugs we do notice differences between ethnic and religious groups. The differences in use rates cannot solely be attributed to one's ethnic background. Nonetheless, there are social and psychological factors that can contribute to use levels. Some of these factors may be more present among certain subgroups within ethnic and religious groups than others. Hence, customs can and do influence drug use rates. They always have.

The use of psychoactive drugs occurs in all 50 of the United States. Because of population distribution patterns use levels are higher in areas with dense populations; thus, one finds drug use to be greater in U.S. metropolitan areas than in rural areas. Metropolitan areas such as Detroit, Washington-Baltimore, New York City, and Miami tend to show greater drug use patterns among ethnic-minorities (Johnson et al., 1990). In these cities ethnic-minorities collectively are in the majority so the finding is not an exaggeration. The findings do not support the notion that ethnic-minorities have greater problems with drugs than the dominant culture even though many try to do so.

Concentrations of ethnic-minorities also occur in rural and remote areas of the country, particu-

larly for American Indians and Mexican Americans. Drug use indeed appears to be a problem in these settings, too. Segal (1992) points out that the drug use prevalence rates in certain Alaska Native villages is quite high and in a few instances reach epidemic-like levels. Beauvais (1992) found that American Indian youth in rural areas have higher drug use rates than non-Indian youth for nearly all drugs. Among Hispanic youth, Gilbert and Alcocer (1988) report high incidences of polydrug use. The authors emphasize that alcohol use quite often leads to a progressive use and abuse of hard drugs.

The distribution of ethnic-minority drug use nationwide may give credence to the notion that the groups are inclined to use drugs more frequently than the dominant culture. The notion tends to be reinforced by the generalized news media. It appears that both the electronic and print media tend to focus their drug use stories on the problems that occur in U.S. intercity communities. A cursory review of the drug use stories appearing in the weekly news magazines reveals the frequent use of photos of African-American and Hispanic drug users, crime statistics showing disproportionate numbers of ethnics arrested for drug related crimes, and harrowing tales of drug abuse in public housing projects. What we rarely see in the magazines are stories and photos of drug use and abuse that occur in the affluent suburbs or predominantly non-ethnic minority communities and neighborhoods. Yet we know from the ongoing drug use studies of Johnston, O'Malley, and Bachman (1988) and the National Institute on Drug Abuse (1991) that drug use occurs among almost all groups. Both the accounts in the news media and research reports tend to emphasize innercity drug problems and that, in itself, fosters the stereotypic notion that ethnic-minorities, especially African Americans, are more likely to be addicts than whites and Anglos. The notion is an illusion as there is no definitive evidence available to support the contention (Tucker, 1985).

Drug and alcohol use are not problems among ardent members of certain religious groups in the United States. Studies show, for example, that there are few—in some areas no—addicts and alcoholics among the Amish, Mennonites, members of the Church of Latter Day Saints (Mormon), and those who closely follow the tenets of Judaism. For the first three groups, use of psychoactive drugs is forbidden among their followers. In general, traditional Jews have relaxed standards for alcohol use, yet survey results show that they have few problems. Again we can appeal to the general notion that customs can affect the drug and alcohol use practices.

Just as cultural groups set standards for drug use they also set standards for defining abuse, addiction, and deviance. What may be viewed as normal and standard in one culture may be highly deviant in another. For example, several Indian tribes in the Amazon basin in South America use intoxicating snuffs on a regular basis—men from the Yukuna, Tanimuka, Waika tribes among many others, blow snuff into the noses of their partners both in rituals and for recreation. Use of hallucinogenic snuff is illegal in the United States. However, if we saw or knew of someone who used the drug daily we would consider them addicted. Amazonian Indians see these phenomena as part of their daily lives—no one is considered addicted there.

The Irish and Irish-Americans view alcohol use quite differently than most Americans. In Ireland and in Irish-American neighborhoods heavy and frequent use of alcohol is not viewed as deviant or problematic. In part, pub and bar drinking serves to reinforce ethnic group solidarity and ethnic affiliation. If Irish Americans openly refuse to participate in the evening and weekend drinking activities their ethnic identity and allegiance may be challenged.

In some social circles strict distinctions are made between social drinking and binge alcoholic drinking—the first is more acceptable especially in middle and upper class circles. Binge drinking often is associated with lower class status; the two are often interchangeable. Hence, if one is deemed an alcoholic, he or she also must be a member of lower class. Drinking patterns, therefore, are attributable to class and ethnic groups to further stigmatize their status. Members of the elite high status groups engage in *social drinking* while members of lower class or outgroups *drink to excess* and therefore are viewed as borderline alcoholics at a minimum. Groups within the United States contrive definitions for deviant behavior such as drug and alcohol use to enhance their status and thereby suppressing the status and acceptability of undesirable groups.

There are a multitude of reasons for using drugs and alcohol. The reasons vary from one cultural group to another. Whatever the reasons may be, they can all be grouped under the basic fact that psychoactive drugs alter consciousness by affecting the brain's activity. Not to be forgotten, however, is the universal finding that all cultures have devised

practices to alter consciousness without relying on psychoactive drugs. Prayer, meditation, exercise, privation of basic necessities, such as food, sleep, and material goods, and biofeedback exercises are general examples. An exploration of nondrug stimulated altered states of consciousness indeed would reveal that cultural groups have developed unique and effective techniques and procedures. Many of these practices are as effective, if not more so, than the states achieved through drug states. And in some instances, the practices are more beneficial to health than the use of certain drugs.

REFERENCES

Beauvais, F. (1992). Indian adolescent drug and alcohol use: Recent patterns and consequences. *American Indian and Alaska Native Mental Health Research, 5*(1), 1–78.

Gilbert, M. J. & Alcocer, A. M. (1988). Alcohol use and Hispanic youth: An overview. *Journal of Drug Issues, 18*(1), 33–48.

Johnson, B. D., Williams, T., Dei, K. A., & Sanabria, H. (1990). Drug abuse in the inner city: Impact on hard drug users and the community. In M. Tonry & J. Q. Wilson (Eds.), *Drugs and crime*. Chicago: University of Chicago Press.

Johnston, L. D., O'Malley, P. M., & Bachman, J. G. (1988). *Illicit drug use, smoking, and drinking by America's high school students, college students, and young adults: 1975–1987*. Washington, DC: U.S. Government Printing Office.

National Institute on Drug Abuse (1991). *National household survey on drug abuse: Population estimates 1991* (ADM 92–1887). Rockville, MD: Division of Epidemiology and Prevention Research, National Institute on Drug Abuse.

Segal, B. (1992). Ethnicity and drug taking behavior. In J. Trimble, C. Bolek, & S. Niemcryk (Eds.), *Ethnic and multicultural drug abuse: Perspectives on current research*. Binghamton, NY: Harrington Park Press.

Trimble, J. E. (in press). Drug abuse prevention strategies among ethnic-minority populations. In R. Coombs & D. Ziedonis (Eds.), *Handbook on drug abuse prevention*. Englewood Cliffs, NJ: Prentice Hall.

Tucker, M. B. (1985). U.S. ethnic minorities and drug use: An assessment of the science and practice. *International Journal of the Addictions, 20*, 1021–1047.

12
A Multicultural View of Stereotyping

DONALD M. TAYLOR AND LANA E. PORTER

Psychologists are expected to be scientific, objective, and emotionally detached in their pursuit of knowledge about human behavior. But all of these ideals seem to be abandoned when scientists turn their attention to the subject of prejudice and discrimination. This is especially true when we examine, in detail, the concept that has been the most influential in our understanding of relations between racial groups, ethnic or cultural groups, and gender groups—the *Stereotype*.

Stereotypes involve members of one group attributing characteristics to members of another group. Italians are excitable, Blacks are athletic, the Scots are stingy, the Japanese are technical wizards, Hispanics are emotional, men are competitive, and women are sensitive. These are stereotypes and no group escapes the stigma of being stereotyped.

Most of us are reluctant to admit that we engage in stereotyping. We would prefer to believe that only racists and bigots stereotype other groups, yet all of us are guilty of stereotyping. Stereotyping, then, is a universal process at both the group and individual level. Thus, every group in society stereotypes every other group, and every individual member of a group engages in stereotyping to a greater or lesser extent. In this sense, stereotyping is not a mysterious process. It is part of the wider human capacity and need to render our environment manageable. For example, despite our ability to make subtle distinctions among thousands of different colors we typically simplify the world by categorizing colors into eight categories. We then proceed to stereotype these colors by attributing "passion" to red, "coolness" to blue, and "warmth"

Donald M. Taylor is a Professor of Psychology at McGill University. Taylor's research interest is intergroup relations. His research has been conducted in diverse regions of the world, including the United States, Canada, Britain, and South and Southeast Asia. He has contributed numerous articles in Canadian, American, European, and Asian journals, and co-authored three books on issues related to cultural diversity and intergroup relations. *Social Psychology in Cross-Cultural Perspective* (Freeman,1993), written with F. Moghaddam and S. Wright, is his most recent book.

Lana E. Porter is a senior graduate student in Social Psychology at McGill University in Montreal, Canada. Of particular interest to her is minority group members' perceptions of discrimination and the relationship of these perceptions to social identity. She has done research with a variety of minority groups, including younger and older women, black women and men, and Native Americans. Among her publications is the Ontario Symposium chapter, *Dimensions of Perceived Discrimination* (co-authored with Donald Taylor and Stephen Wright).

The preparation of this chapter was made possible by a grant from the Social Sciences and Humanities Research Council of Canada.

to yellow. The racial, ethnic, and gender stereotypes, then, are part of the normal process by which people attempt to simplify and organize the complex social world with which they must cope on a day-to-day basis.

Surprisingly, psychologists seem reluctant to recognize that stereotyping is a normal, and universal human process. Instead, psychologists seem intent upon characterizing the stereotype as a destructive social process, and this is clear from how they define the stereotype. For example, the stereotype has been variously defined as a "rigid impression, conforming very little to the facts" (Katz & Braly, 1933), or as an "inaccurate, irrational overgeneralization" (Middlebrook, 1974), or as "unjustified" perceptions (Brigham, 1971). Psychologists condemn the process of stereotyping for both intellectual and moral reasons. Intellectually, they believe that stereotyping is an inferior cognitive process that involves overgeneralization and overcategorization. Morally, they believe that stereotyping involves lumping members of a group together when members of that group don't want to be characterized as all the same, and when, in fact, it is clear that there is great variability among the members of any group.

If we explore the historical-cultural context that gave rise to the stereotype we can begin to appreciate why psychologists have been so "unscientific" in their approach to the process and how the modern approach to the study of stereotyping is so different.

STEREOTYPES IN HISTORICAL PERSPECTIVE

The meaning of the word *stereotype* has been evolving since its introduction as a term to describe a printing duplication process "in which the original is preserved and in which there is no opportunity for change or deviation in the reduplications" (Rudmin, 1989, p.9). It is useful to consider the archival work done by Rudmin (1989) investigating the etiology of the use of the term *stereotype*. It was James Morier, in 1824, who first used the word *stereotype* and subsequently, Walter Lippman, in 1922, described the stereotype simply as "pictures in our heads." It is important to delineate, however, the difference in meaning between Morier's and Lippmann's conception of the stereotype. Essentially the controversy boils down to whether stereo-

types are perceptions that accurately reflect the characteristics of a group or whether they involve characteristics that have no basis in reality. That is, to what degree is there a bias in the perception of behaviors, and to what degree is there a "kernel of truth" (see Smith, Griffith, Griffith, & Steger, 1980) in stereotype behaviors? Some have argued that stereotypes must be biased perceptions since they often contain logical impossibilities. For example, they note that Jewish people are stereotyped as *sticking together* at the same time that they are stereotyped as *always trying to push their way into gentile society*. Those who argue for a *kernel of truth* acknowledge that distortions and elaborations do exist but that the core characteristics in the stereotype have a basis in reality. Our own view is that because stereotypes are a normal process designed to simplify our complex social environment, they will have some basis in reality. However, they will also involve distortion since they are one way in which members of one group can express their positive or negative attitudes toward the other group.

Although researchers had not delineated the subtleties underlying the meaning of stereotype," it was generally agreed that stereotyping was a destructive process and should be reduced or eliminated. One important reason for social scientists wanting to eliminate stereotyping was that it had proven to have a powerful impact on intergroup relations. For example, research indicated clearly that once a stereotype develops, it is very resistant to change. As well, the stereotype influences the judgments a member of one group makes of another. If I stereotype a particular cultural group as "aggressive" then I will believe that to be true of every member of that group I meet. Research indicates that I will even believe the person is aggressive when there is evidence to the contrary. Taking the process one step further, if all the members of Group A stereotype all members of Group B as "aggressive," then eventually Group B will come to conform to the stereotype and act aggressively; in short, aggressive behavior will come to be a self-fulfilling prophecy for members of Group B. Thus, the stereotype is a very powerful process that can have a major impact on relations between members of different racial, cultural, and gender groups.

For three important reasons psychologists set out to rid society of this powerful process. First, the main cultural context for the study of stereotypes was the United States, and thus the focus was usu-

ally on white stereotypes of African Americans. Needless to say, the historical record shows that these stereotypes were not flattering and this explains why scientists saw the process of stereotyping as so insidious and destructive.

The second reason for the elimination of stereotypes is political ideology. The political philosophy in the United States has been, and still is to some extent, based on the premise that members of a cultural group should give up their heritage culture when they come to the United States and become "Americans." This philosophy is captured eloquently in the image of America as a *melting pot.* All the cultures in the United States get stirred in the same great pot until cultural differences are boiled away and a single culture remains—American. Clearly there is no room for stereotyping in such a philosophy. After all, stereotypes recognize group differences on the basis of culture, ethnicity, race, gender, and nationality.

Finally, there is a third, more scientific reason for viewing stereotypes as a destructive social process. Psychologists conducting research in the area of interpersonal attraction have established an important principle: the more similar two people are to each other, the more likely they are to like one another. So, the more similar two people are along such dimensions as age, social class, religion, values, and in the present context, race and culture, the more likely they are to be attracted to one another. This has important implications for social harmony because it suggests that the converse is also true: that the more dissimilar people are in terms of race and culture, the less likely they are to get along with each other. Thus, the stereotype, which draws attention to group differences, would be instrumental in creating barriers to cross-group friendships.

There are, then, compelling reasons for why psychologists working in the United States viewed stereotyping as a destructive social force. This culturally-based view had far-reaching consequences. It biased the scientific investigation of stereotypes and led to an enormous investment in human and financial resources to rid people of their "wicked" stereotypes. School textbooks were scrutinized for any hint that a particular group was being stereotyped, and well-meaning exchange programs were set up to instigate contact between different racial and cultural groups. The idea was that personal contact would soon make people *color-blind* or *culture-blind* and hopefully lead to the elimination of all stereotyping.

CHALLENGING THE TRADITIONAL VIEW OF STEREOTYPING

It took social psychologists in Europe and Canada to raise critical questions about how stereotyping was approached in the United States. The argument made by these European and Canadian researchers was that their cultural experience was totally different. They were brought up in contexts where it was *normal* to categorize people into groups, where they *expected* society to be culturally diverse, and where often people were proud to be associ-

> It took social psychologists in Europe and Canada to raise critical questions about how stereotyping was approached in the United States. The argument made by these European and Canadian researchers was that their cultural experience was totally different.

ated with a particular group. Of course, as with racial stereotypes in the United States, the ethnic categories in Europe often involved bitter disputes. The difference was that in Europe it was deemed normal to divide society along social-class and ethnic lines even if relations between these groups were conflictual.

What these psychologists were doing was challenging the U.S. view of stereotyping. They were noting that from their cultural experience people wanted to be associated with a particular cultural or social-class group. Even in the United States, this idea made some sense. After all, in the United States, students proudly wear their school jackets and college T shirts. And, they wear them by choice and with pride hoping that others will stereotype them—that they will achieve status and recognition by association with their group.

Nowhere does this different view of stereotyping arise more clearly than in the domain of politi-

cal philosophy regarding cultural diversity. The U.S. melting pot emphasized cultural homogeneity, but in other countries (e.g., Canada) the emphasis is on cultural diversity captured in such images as mosaic, tossed salad, and patchwork quilt.

Finally, the U.S. view of stereotyping was consistent with the research on interpersonal attraction. Those who challenge the American viewpoint emphasize a different psychological process: the need people have to be unique or distinctive. The idea is that people need to feel that they are special and part of that process involves belonging to groups that have their own special characteristics (Tajfel & Turner, 1979).

In summary, the American approach to stereotyping arose because of cultural realities that exist in the United States. Psychologists whose cultural realities are quite different have challenged the American view. They take the position that stereotyping is a normal process. Therefore, it is not necessarily an inferior cognitive process, nor is it necessarily socially destructive.

SOCIALLY DESIRABLE STEREOTYPING: TURNING A NEGATIVE INTO A POSITIVE

The approach to stereotyping described here is one developed by Taylor and Simard (1979) and summarized more recently by Taylor and Moghaddam (1987). It begins with the premise that instead of trying to get rid of stereotypes our aim should be to foster stereotypes that allow each group to maintain its cultural distinctiveness, but where each group is respectful of the other's characteristics.

The pattern of intergroup stereotyping that would be viewed as socially desirable from this perspective is depicted in Figure 1. The columns refer to the groups that are doing the stereotyping (Group I and Group II) and the rows refer to the groups that are being stereotyped. The capital letters in each cell represent specific stereotype characteristics and the (+) sign signifies that these characteristics are judged positively.

What is depicted in Figure 1 (Section A) is an idealized situation where each group stereotypes the other in a manner that is consistent with each group's stereotype of itself (*autostereotype*). Thus, each group has pride in its own characteristics while respecting the characteristics of the other group. The result, then, is social harmony in a com-

A. Socially Desirable Intergroup Stereotyping

	Group doing stereotyping	
	I	II
Group being stereotyped I	ABC +	ABC +
II	XYZ +	XYZ +

B. Intergroup Conflict

	Group doing stereotyping	
	I	II
Group being stereotyped I	ABC +	ABC −
II	XYZ −	XYZ +

C. Inferiority Complex

	Group doing stereotyping	
	I	II
Group being stereotyped I	ABC +	ABC +
II	XYZ −	XYZ −

D. Stereotype Misattribution

	Group doing stereotyping	
	I	II
Group being stereotyped I	ABC	DEF
II	UVW	XYZ

FIGURE 1 Patterns of Intergroup Stereotyping

munity that is characterized by racial and cultural diversity.

We refer to the socially desirable pattern depicted in Figure 1 as idealized because our own experience tells us that it is rare that you get cultural groups coexisting in such harmony. More often there is intergroup conflict, but at least the pattern described in Figure 1 (Section A) offers a model for society to aim for. And, the present model is no more difficult to achieve than the original U.S.-based aim of erasing stereotypes from society.

Theories, however, must deal with reality and so we present in Figure 1 (Sections B, C, and D), three patterns of intergroup stereotyping that are less than ideal. Section B describes the pattern of stereotypes associated with intergroup conflict. In this pattern everyone agrees on the stereotype characteristics, but each group downgrades the other

group's characteristics. The challenge here, then, is not to *eliminate* the stereotypes, but rather to get each group to respect the characteristics of the other.

In Section C we describe a pattern of "inferiority complex" that can arise when one group (Group I) has tremendous power over another (Group II). In this case Group I downgrades the characteristics of Group II. But instead of reciprocating, the group with little power (Group II) envies the characteristics of the powerful group (Group I) and actually downgrades its own characteristics. This is a pattern that every oppressed group goes through for a period of time and Native peoples and African Americans are among many groups who have had to cope with this pattern. Clearly, this is a pattern of stereotyping that can lead to destructive psychological consequences, such as self-hatred and the development of profound feelings of inadequacy and inferiority.

Finally, we present in Section D the classic case of "stereotype misattribution" that leads to so many misunderstandings. In this case, each group has the wrong stereotype of the other and this leads to misinterpretations of each other's behavior and errors in judgments about the other's intentions.

The stereotyping model outlined in Figure 1 represents a fundamental departure from traditional views about stereotyping. It begins with the assumption that stereotyping is a normal cognitive process that people use to organize their thoughts and feelings about other people. It sets up as the ideal, not the elimination of stereotypes, but rather the fostering of stereotypes that allows societal groups to maintain their distinctiveness in a climate of mutual respect. Finally, by setting up such an ideal it is possible to examine the stereotype structures that arise when there are deviations from the ideal. These less than desirable structures at least point to where stereotypes must be altered in order for the ideal to be achieved.

RECENT ADVANCES IN STEREOTYPE RESEARCH

The notion that stereotyping is a normal cognitive process has led to exciting new developments in stereotype research both within the United States and elsewhere. U.S. researchers, for example, have shifted attention away from eliminating stereotypes to understanding how they operate, and by doing

so, have uncovered a number of key cognitive concepts that may be constructive in promoting intergroup harmony.

For example, statements about members of an out-group such as "Oh, them. They're all alike. I can't tell one from the other," were once considered to be unequivocally bigoted and discriminatory. But recent research has shown that such statements may stem from a very natural cognitive process—the *outgroup homogeneity effect* (e.g., Quattrone, 1986). As the label implies, people tend to perceive members of an outgroup as highly similar (stereotype) whereas they tend to see all kinds of individual differences among members of their own group. This differential perception of ingroup and outgroup members is not necessarily the result of outgroup prejudice. Rather, it is the natural outgrowth of social interaction patterns. Ingroup and outgroup members interact with one another relatively infrequently, and when they do, it is usually restricted to a limited number of impersonal situations. This lack of in-depth contact naturally fosters a simplified social representation of the other group and therefore makes it necessary and indeed convenient to view all of the outgroup members as similar.

Although out-group homogeneity may be a natural human tendency, there is no reason to think that it is necessarily "wrong" or resistant to modification. It is not the *process* that needs to be modified, but rather the *content*. In fact, we may not be able to alter the process; it may be "hard-wired" as an element of human cognition. Much research on human cognitive processes such as memory and problem solving shows that organizing elements by category or other salient characteristics is simply a fact we can not alter any more than we can alter skin color or eye color. However, if out-groups were seen to be relatively homogenous in comparison to one's in-group, it would not be as deleterious if it was perceived as homogenous along *positively* valued dimensions rather than negative ones.

The *illusory correlation* (Chapman, 1967; Hamilton & Gifford, 1976) has also been useful in understanding the process of stereotyping. Simply stated, when two variables that are unusual or distinct in some way become linked on one occasion, people have a tendency to believe that they are *always* associated in that way. For example, if a minority group member, who by definition is unique compared to the majority, is involved in a unique or infrequent event (e.g., serious crime) then the two

get linked together. The result is an illusory correlation in the sense that the minority group is always linked to crime on the basis of one isolated event. In contrast, if a member of the majority group was involved in a similar crime, no link is made between the two since being a member of a majority group is not unique in any way.

The problem with the illusory correlation is that it may foster negative stereotypes about an outgroup. However, if people are made aware of their natural tendency to make associations between variables when none actually exists, they can hopefully avoid giving in to the illusion. For example, when the media report that a brutal crime is perpetrated by a minority-group member, an illusory correlation may be made between being a member of that minority-group and some inherent propensity towards crime. Both the electronic and print media are especially prone to foster this illusory correlation. Newsworthy items involve unique people involved in events that stand out, and these unique features are naturally highlighted. An awareness of how the illusory correlation operates allows the very powerful media to minimize opportunities for misattribution. In fact, many news sources have recognized this and have made a conscious effort to either omit mentioning group membership entirely, thereby eliminating any "paired distinctiveness" between minority groups and negative events, or to report group membership consistently be it minority or majority, thus rendering group membership as too irrelevant or mundane in terms of a feature upon which to base an illusory correlation.

In conclusion, the traditional view of stereotypes as aberrant isolated phenomena have been replaced by the current view that stereotypes are natural extensions of normal cognitive processes. The implication underlying this belief of stereotypes as a fundamental part of human cognition is that perhaps there is nothing "wrong" with them. However, as Taylor and Fiske (1984) indicate, viewing stereotypes as a normal part of cognition does not mean they cannot be rechanneled. The task is not to eliminate these natural cognitive processes, but rather, to change the dimensions along which they operate. Just as these cognitive mechanisms

are part of our normal human functioning, so are the varied and numerous groups that comprise our current society. People must learn to appreciate the unique characteristics of these groups and to value the differences between them.

REFERENCES

Allport, G.W. (1954). *The nature of prejudice.* Reading, Mass.: Addison-Wesley.

Brigham, J.C. (1971). Ethnic stereotypes. *Psychological Bulletin, 76*, 15–38.

Chapman, L.J. (1967). Illusory correlation in observational report. *Journal of Verbal Learning and Verbal Behaviour, 6*, 151–155.

Hamilton, D.L., and Gifford, R.K. (1976). Illusory correlation in interpersonal perception: a cognitive basis of stereotypic judgements. *Journal of Experimental Social Psychology, 12*, 392–407.

Katz, D., and Braly, K. (1933). Racial stereotypes of one hundred college students. *Journal of Abnormal and Social Psychology, 28*, 280–290.

Middlebrook, P. N. (1974). *Social psychology and modern life.* New York: Free Press.

Quattrone, G.A. (1986). On the perception of a group's variability. In S. Worchel and W.G. Austin (eds.), *The Psychology of Intergroup Relations.* Chicago: Nelson-Hall.

Rudmin, F. (1989). The pleasure of serendipity in historical research: On finding "stereotype" in Morier's (1824) Haiji Baba. *Cross-cultural Psychology Bulletin, 23*, 8–11.

Smith, R. J., Griffith, J. E., Griffith, H. K., and Steger, M. J. (1980). When is a stereotype a stereotype? *Psychological Reports, 46*, 643–651.

Tajfel, H., & Turner, J.T. (1979). An integrative theory of intergroup conflict. In W.G. Austin and S. Worchel (eds.), *The Social Psychology of Intergroup Relations,* pp. 33–47. Monterey, Cal.: Brooks/Cole.

Taylor, S.E., and Fiske, S.T. (1984). *Social Cognition.* New York: Random House.

Taylor, D.M., and Moghaddam, F.M. (1987). *Theories of Intergroup Relations: International Social Psychological Perspectives.* New York: Praeger.

Taylor, D.M., and Simard, L.M. (1979). Ethnic identity and intergroup relations. In D.J. Lee (ed.), *Emerging Ethnic Boundaries,* pp. 155–171. Ottawa: University of Ottawa Press.

Section III

Culture's Influence on Social and Developmental Processes

In the introductory chapter we mentioned that a quotation from Kluckhohn, Murray, and Schneider (1953) is a useful starting point in helping to understand human diversity: "Every man is in certain respects like all other men, like some other men and like no other men." Each person shares certain *universal* behavioral tendencies and other characteristics with all human beings. For example, all humans are influenced by the same general rules for language, all people must adapt to climatic changes, all must find ways to feed themselves, all have commonalities in caring for their young and disposing of those who have died, and so forth. At the next level, each person shares a variety of *group-related* characteristics with certain kinds of people. For instance, people who belong to the same family, neighborhood, club, tribe, or culture will behave in similar ways and share certain beliefs. Finally, each person is totally *unique* — no two people, not even identical twins, are *exactly* alike in every way.

While this section is concerned with *culture's* influence on social and developmental processes, it must be remembered that there are two major thrusts in life that shape behavioral tendencies which range from universality to uniqueness. One of them indeed concerns culture, or in more general terms, *nurture*. The other thrust is *nature*, and this force involves such things as biological givens and other characteristics that are not learned. Space does not permit us to summarize the basic arguments in the age-old nature-nurture debate (many would call it a dead horse). The reader may already know that *both* of these powerful influences are in a constant state of interaction to such an extent that it is virtually impossible to prove that nature is solely responsible for one particular human characteristic and nurture is the sole cause of another.

The specific psychological makeup of any individual is the result of both *biological* transmission (nature) and *cultural* transmission (nurture). Figure 1 displays the major factors that combine to shape the individual, represented by the circle in the middle. Below the horizontal line are the *biological* factors that contribute to creating a specific individual, while the *cultural* factors are above this line. The vertical line concerns direct transmission, either biological or cultural, and for each there are both *distal* and *proximal* influences. For example, at the biological level, one's parents are proximal influences: each individual's genetic composition comes equally from his or her biological mother and father. At the distal level, one's distant relatives and the specific biological blend they form are also significant factors that contribute to biological individuality. Here we may speak of *race* or degree of *sanguinity* (blood quantum) that contribute to individuality. Somewhat *indirect* and generally transitory biological influences include food intake, ecological and climatic factors, various epidemiological factors contributing to the spread of disease or life expectancy, and the like.

Cultural factors—those above the horizontal line—can be viewed similarly from direct and indirect influences as well as distally and proximally. For instance, factors contributing to distal cultural transmission which directly shape the individual are such things as cultural beliefs regarding the nature and worth of children, the assignment of specific age, or gender-related tasks to individuals, and so on. Proximal influences are primarily the parents or primary caregivers, adults who, during consistent daily interaction with the child play the greatest role in socializing this growing member of the culture. On the other hand, there are many *indirect* cultural influences, and many of them are very pervasive and powerful. These include other significant adults (especially teachers, mentors, older siblings, grandparents), peers, television, neighbors (including the people next door who may well be from another country or ethnic group as well as

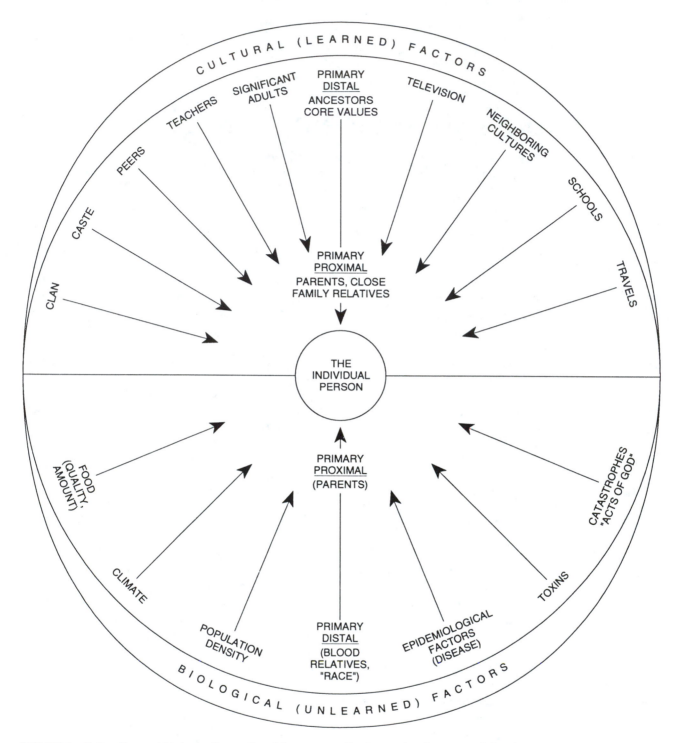

FIGURE 1 Culturally- and biologically-mediated factors contributing to the shaping and development of the individual

the people who might live across the border in another country), and any caste, clan, or club to which the individual belongs either voluntarily or involuntarily.

The factors contributing to cultural transmission are generally subsumed under a process called *socialization*. Given the extreme plasticity or pliability of how individuals can be *taught* how to behave, it is possible to shape the behavior of children in potentially unlimited ways. However, through the process of socialization, which is *culture-specific*, ✱ each new generation of children is instructed to

follow specific cultural *rules*. These rules are usually quite clear and agreed upon by the culture in general. In a sense, teaching a child how to be a member of a particular culture is analogous to teaching that child how to follow a set of rules that elders in the culture agree should be followed and passed on to succeeding generations. Thus learning one's "culture" is like learning how to "play the game" according to explicit guidelines.

A similar, but more subtle, concept is *enculturation*. Enculturation also involves learning one's culture, but *not* in accordance within a set of specific and clearly articulated beliefs, values, traditions, and the like that are part of the socialization process. Rather, enculturation involves *implicit* learning or *tacit* learning. By modeling the behavior of others, mastering the intricate nuances of pronunciation, observing how rewards are distributed in everyday behavior, and so forth, people pick up the interesting subtleties that result in there being *no doubt* where a person is from. The phrase "You can take the boy out Brooklyn but you can't take Brooklyn out of the boy" nicely captures the essence of enculturation. Speech dialects, manner of walking, subtle tips of the head or facial expressions, and the like are learned tacitly, and these behaviors mark an individual's origins just as surely as a military uniform marks the branch of the service to which one belongs. Ask any member of a specific Native American tribe, for instance, to describe how he or she might make discriminations between even seemingly similar tribes. You will likely be treated to a detailed account of what is involved in making fine-grained distinctions between individuals who belong to the many Native American groups. In a talk he gave at Western Washington University on January 14, 1993, University of California sociologist Troy Duster used the accordion as an analogy to explain this phenomenon. The accordion, he said, when viewed from afar looks like a simple musical instrument. But when it is examined closely and up front, Duster explained, one will see that it is made up of many pleats and ridges and buttons. Moreover, it can be bent, squeezed, and twisted in many ways to make a great variety of sounds that are similar but also interestingly different. The variability within *any* group (Afro-Americans, Hispanics, Ukrainians, Girl Scouts, college professors) is so great that it would be a disservice to both the observer and observed to treat all members of a group as identical. The proverbial "bottom line" is individuality.

The readings in this section all have important things to say about the processes of socialization and enculturation. The first two chapters are highly related. In Chapter 13, Charles Super and Sara Harkness explain the major forces that shape the developing individual. They use the term *niche* in this context. The specific influences that shape any individual can be found in that niche. All humans share the general components of this niche, but to explain *individuality* one has to examine the matter more closely, up front and close, like Duster's accordion. Anne Tietjen, in Chapter 14, discusses the social worlds of children from an ecological perspective. Tietjen studied at Cornell University under Urie Bronfenbrenner who is recognized as a pioneer in the study of how ecological factors contribute to variability both between and among groups.

In the 1960s and 1970s, a series of very influential anthropological research projects were conducted by John and Beatrice Whiting of Harvard University. Known generally as the "Six Cultures Project," the Whitings enlisted the aid of many colleagues to collect and interpret data in far-flung field sites. Two of their colleagues were Ruth and Robert Munroe, a psychologist and anthropologist, respectively. Part of the Six Cultures research strategy involved the systematic recording and subsequent analysis of data collected by carefully observing and coding ongoing behavior in natural settings. The Munroes explain the essence of this technique, and give samples of findings derived from it, in Chapter 15.

The Six Cultures Project (Whiting and Whiting, 1975) showed that there are patterns of behavior that are the result of such factors as type of household or family and nature of the subsistence economy. Using research methods similar to some of the methods used in that project, another anthropologist, Ronald Rohner, in Reading 16, found definite patterns, worldwide, in parenting—and in both accepting and rejecting children. Such patterns strongly influence the developing child. For many years, Rohner has been refining his techniques and using them to collect data in many cultures. His summary, therefore, has the power of a systematic and continuous research plan.

Except in *extremely* rare cases of hermaphrodites, who are biologically male *and* female, sexuality is one of the clearest dichotomies in the world: one is *either* male *or* female, based upon one's chromosomal makeup. There is no biological equivocation here. Not so with *gender*, a term usually

reserved for discussions of the *social* definitions of "maleness" or "femaleness." Gender, and gender-related behavior, must be understood in the context of specific cultures. Carole Wade and Carol Tavris are leading authorities on the psychology surrounding gender and all of the issues that have shrouded that term. People learn, and learn early, how to behave "properly" in keeping with one's gender. Such learning occurs during the culturally variable socialization and acculturation processes. Wade and Tavris summarize this complex area in Chapter 17. Two other chapters in this book—Chapters 27 and 28—are highly related to the Wade and

Tavris summary. We urge the reader to treat them as a unit.

REFERENCES

Kluckhohn, C., Murray, H. A., and Schneider, D. M. (eds.) (1953). *Personality in nature, society, and culture.* New York: Knopf.

Whiting, J. and Whiting, B. (1975). *Children of six cultures: A psychocultural analysis.* Cambridge: Harvard University Press.

13
The Developmental Niche

CHARLES M. SUPER AND SARA HARKNESS

Most psychology is about middle-class North Americans of European ancestry, or about middle-class Europeans. This book is concerned with the limitations of a culture-bound approach to our understanding of human behavior around the world and among ourselves. The richness of variation in settings of human life, behavior, and ways of thinking about the world challenges us to develop a more comprehensive frame of knowing about people in their contexts, whether these be the snowy wastelands of the arctic regions, the densely populated cities of Asia, or the suburbs of middle America.

It is important to step back from the cross-cultural panorama and ask: If culture is so powerful in organizing an individual's behavior, how does it come to be that way? For the comparative social scientist interested in human development, the central question concerns not so much *differences* in behavior today, but rather *variations* in social forces that interact with development over the life-course to produce differences that are observable at any given point. In particular, how does the culture of one's childhood lay a distinctive foundation, one that may be altered in adulthood but still lasts a lifetime? How is it that growing up in a particular cultural setting—whether it be Boston, Rio de Janeiro, or the Serengeti plains of Tanzania—leads to the establishment of ways of thinking and acting so integral to one's identity that they will survive even radical changes of environment in later years? Understanding the mind and its behavioral manifestations—psychology—ultimately also requires understanding the culture that shaped it. To see the interplay of ethos and psyche, one needs to look at how individuals develop in cultural context.

Over the last century, several ways of studying this process have contributed to our present understanding (for one summary of this work, see Harkness & Super, 1987). Anthropologists have carried out detailed studies of life in other societies, many

Charles M. Super is Professor of Human Development and Family Studies at the Pennsylvania State University. He received a Ph.D. in Developmental Psychology from Harvard University and was trained in child clinical psychology at the Judge Baker Guidance Center in Boston. His research interests include the role of culture in shaping early development, and the design of preventive interventions to reduce the risk of problems such as chronic malnutrition and behavior disorders. As a licensed professional psychologist, Dr. Super works to apply research findings in counseling individual parents and children. He has carried out basic and applied research in many countries around the world, and has served as consultant to UNICEF and the World Health Organization.

Sara Harkness is Associate Professor of Human Development and Anthropology at the Pennsylvania State University. She holds a Ph.D. in Social Anthropology and a Master of Public Health degree from Harvard University. Her research centers on the cultural structuring of human development and health, and she has done research on children and families in Guatemala, Kenya, and the United States. She is co-editor, with Charles Super, of the Culture and Human Development series published by Guilford Press, and co-author of an edited volume entitled *Parents' Cultural Belief Systems*, also to be published by Guilford.

of them now fundamentally altered by modern change. This has provided us with pictures of child life and family functioning from around the world. Some of these have had a wide influence on American ideas about growing up, as when Margaret Mead's study of adolescence in Samoa in the late 1920s became a best-seller (Mead, 1928). In another approach, cross-cultural psychologists have taken tests of development and other standardized measures to children who live in distinctly different environments, such as communities where Western-style schooling has not yet been introduced. Although the results of comparisons with middle-class Western children have sometimes been construed as showing developmental "deficits" or lags in the non-Western group, they have increasingly been used to illustrate the different developmental paths that distinct cultural environments offer. In all societies, most children grow up to be competent adults; an important contribution of systematic cross-cultural comparisons has been to show how competence can be variously defined and how children come to achieve it.

INSIGHTS GAINED FROM CROSS-CULTURAL RESEARCH

Two important insights have been gained from research on children and families in other cultures. The first concerns regularities in how different parts of a culture work together as a *system.* The ways that children are reared, for example, tend to follow certain aspects of the society's economic means of production. Children in traditional agriculturally based societies usually have many household chores, and they are taught responsibility and obedience from an early age (see for example, Whiting & Edwards, 1988). The families of these children are often large, with many children and other members of the extended family living in the same household or nearby; and the families are also governed by stronger lines of authority from older to younger. In contrast, children of Western middle-class families—especially U.S. middle-class children—tend to grow up in small, nuclear families oriented to developing their own individual capacities to the utmost, while the parents support the family economically and through their labor in the household. In both kinds of environments, children learn about what is expected of them through multiple messages in the environment—from the way that the living space is organized, to the activities that

parents plan for children and the ways they interact with them.

The second discovery of cross-cultural research is that parents and children in all times and places face some of the same problems, experience some of the same needs, and seek some of the same rewards and pleasures. Although the experience of each child and of the children of each culture is unique, the overall experience of childhood is constructed around a common story of human development. All children must learn to walk, to play with other children, to experience the departure and return of their mothers, and to submit to the care of various different people. Boys and girls everywhere must learn gender-appropriate roles—even though the content of these may vary radically—and before they reach the cultural definition of adulthood, children everywhere must learn how to be responsible contributors to their own communities.

WHAT IS MEANT BY THE "DEVELOPMENTAL NICHE?"

The idea of the *developmental niche* combines the above two main lessons into a framework for thinking about human development in cultural context (Super & Harkness, 1986). It can be used to organize information about children's development and to focus investigations for improving the lives of children and families. Although it is not a *theory* of development in the formal sense, the developmental niche provides a *framework* for understanding how cultures guide the process of development. By using this framework, it is possible to see how the cultural environments of particular children are organized—to see how the culture is presented to the child at any particular time.

The term *niche* is borrowed from biological ecology, where it is used to describe the combination of features of the environment a particular animal, or a species of animal, inhabits. Thus a pigeon and a robin might live "in the same place" in the sense of dwelling in the same part of a city park. But exactly where they build their nests and from what materials, the kind of food they seek in the surrounding environment, their vulnerability to various predators, all these are distinct. The particular way they fit into and exploit the same general environment is different, and they thus create a distinct niche for themselves. At the center of the developmental niche, therefore, is a particular child, of a certain sex and age, with certain temperamental

and psychological dispositions. By virtue of these and other characteristics, this child will inhabit a different cultural "world" than the worlds inhabited by other members of his family—and further, the child's world will also change as the child grows and changes.

There are three major aspects of this child's culture that shape his or her life. These three components together make up the developmental niche. The first component is the *physical and social settings* of everyday life. This includes such basic facts of social life as what kind of company the child keeps. In rural Kenya, for example, families are large—mothers often have eight or more children—and with the activities of these people based mainly at home, the baby or young child is likely to have several playmates and caretakers who are siblings. The size and shape of the living space is also an important feature of physical and social settings. By contrast, in the southern part of Holland where many people live in a small geographic area, houses are very compact and the living room also serves as the children's playroom. Typically, if there is a baby or toddler in the house, there will be a playpen located in this room, where he or she can play independently with toys while yet in close proximity to other members of the family. Even aspects of life as basic as sleeping and eating schedules are organized by the physical and social settings of daily life. While Kenyan babies sleep with their mothers and wake to nurse at intervals through the night, for example, Dutch children are put to bed rather early by U.S. standards and learn to stay there until it's time to get up. In contrast, young children in Italy and Spain are often kept up until late at night in order to participate in family and community events.

One cannot get very far in studying the physical and social settings of children in different cultures without realizing that many aspects of children's environments are organized by customary practices; and it is for this reason that we identify *customs of child care and child rearing* as the second component of the developmental niche. The use of older siblings as caretakers in rural Kenya, for example, is customary. There are special terms for these child nurses in the native languages of Kenya, and they are expected to care for their young charges in a special way that is different from mothers' care. Likewise, the use of playpens in Holland is *customary*, it is a commonly accepted solution for the problem of how to keep babies and toddlers safe and happy in the Dutch living environment. And both bedtimes and sleeping arrangements for infants also tend to follow customary patterns in different communities. This fact points to an important aspect of customs—that they are normative for families and communities. Very often, in fact, customs of care are seen by their users as the *only* reasonable solution to whatever need they address, indeed, the *natural* way to do things. Customs of care are thus a source of support for

Why do North American Jews and most Christians circumcise their infant sons? Why are Japanese children taught just the right brush strokes to write the pictographs of the Japanese alphabet? Why do many Native American adolescents embark on a solitary *spirit quest*?

parents and other caretakers because they provide ready-made solutions to the myriad of issues that developing children present, from how to protect children from hazards in the environment to how to ensure that they are adequately educated for their future roles in society. But sometimes the function of a custom is less easy to specify because its value is primarily symbolic. Why do North American Jews and most Christians circumcise their infant sons? Why are Japanese children taught just the right brush strokes to write the pictographs of the Japanese alphabet? Why do many Native American adolescents embark on a solitary *spirit quest*? To understand these customs of child care and child rearing, one needs to take into account cultural traditions related to spirituality and concepts of the person. Although these abstract dimensions of culture are difficult to describe, the study of customs which represent them can provide insights into the cultural ways of thinking that organize the lives of families and children.

It is these cultural ways of thinking and feeling, held by parents and other caretakers, that we recognize as the third component of the developmental

niche, the *psychology of the caretakers.* Parents' cultural belief systems and related emotions underlie the customs of child rearing and validate the organization of physical and social settings of life for children. In cultures where babies and young children customarily sleep close to their parents, for example, parents often feel that to put the child elsewhere—or even worse, to fail to attend to a child who wakes crying in the night—amounts to no less than neglect. On the contrary, among U.S. middle class families where babies are often put to bed in their own separate rooms, practices geared to teaching the baby to sleep through the night and quiet itself upon waking are understood as part of a larger agenda to train the child to be independent, a culturally important attribute throughout life. We can see in this case that parental beliefs about sleeping arrangements in both kinds of settings reflect more general ideas about the person in society. The psychology of the caretakers, thus, is an important channel for communicating general cultural belief systems to children, through very specific context-based customs and settings.

Figure 1 illustrates these three components of the developmental niche and their relationships to each other, the child, and the wider environment. First, the settings, customs, and caretaker psychology, as explained above, form the immediate micro-environment of the child: they are the developmental niche.

The three double-headed arrows represent an important relationship within the niche, that is, that the three components influence each other. A variety of forces, psychological and practical, promote a sense of harmony among the three components. Parents do not easily leave their children in settings which they judge to be dangerous. The customs of child care are generally adapted to the particular physical and social settings, as well as to what is symbolically acceptable to the caretakers. A steady state of complete harmony is rarely achieved, but as the irregular lines separating the components suggest, the points of contact are somewhat flexible. In this sense, the niche operates as a system, the semi-independent parts constantly influencing and adapting to each other.

The larger, single-headed arrows illustrate a second dynamic of the niche, namely that various aspects of the larger human ecology differentially influence the three components of the niche. The customs carry a particular weight of history and are a conservative force such that, other things being equal, many parents will, "without thinking," rear

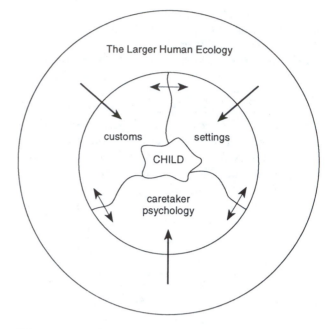

FIGURE 1 A schematic representation of the developmental niche

their children with many of the same traditions they grew up with. Economic and demographic changes may rapidly affect the settings of daily life for children. They may spend their day with fewer brothers and sisters, in a day care center, or in an urban environment. The psychology of the caretakers may be directly influenced by shifting ideas at the national or community level about the nature of children and their needs, as well as about what skills they will need for the future. In summary, there are many ways that changes in the larger society or physical environment can influence the child, but they do not all operate through the same components of the niche.

Finally, the developmental niche formulation recognizes the fact that the child and its environment accommodate each other: in Figure 1, their curves are mutually adjusted. Some views of child development emphasize the way child behavior is *shaped* by the environment, that is, the degree to which children must adapt to the requirements of their family and their culture. But it is also true, as more recent research has shown, that parents and caretakers alter their demands and their supports in response to the particular temperament and talents of the individual child. In addition, the child is a rapidly changing person, especially in the early years. Language and social skills develop, personal interests emerge, and the child learns to cope with,

or avoid, specific features of the niche. The niche, in this sense, also develops in response to the changing child, as well as to the outer influences. of course many features remain constant, or at least present challenges that grow in a way parallel to changes in the child. These are the themes that take on particular strength as the child matures, themes that are most deeply woven into the values, motives, and fears of the emerging adult.

In the beginning of this chapter, we asked how it is that the cultural experience of childhood is able to play such an important and lasting role in shaping the thoughts, feelings, and behavior of people throughout their lives. The theoretical framework of the developmental niche helps to achieve such an understanding through systematic analysis of the culturally constituted components of the child's environment and their relationships with each other, the wider environment, and the child. In this analysis, it is clear that the cultural environment of the child is powerful not only because it is experienced during the formative years of life, but also because it constitutes an interactive system in which the same cultural messages are conveyed through a variety of modalities. Just as in language where the same idea may be communicated through choice of words, grammatical structure and tone of voice, so in cultural environments the child may learn the same ways of thinking and acting through the physical and social settings of daily life, the customs in which he or she participates, and the expressions of parents' ideas that are conveyed in a variety of ways. Over the span of development, these messages become so internalized that they form the core of our understandings of the world and ourselves. It is in this sense that ethos and psyche—culture and individual psychology—are fused in the re-creation and transformation of culture within the individual mind.

REFERENCES

Harkness, S., & Super, C. M. (1987). The uses of cross-cultural research in child development. In G. J. Whitehurst & R. Vasta (eds.), *Annals of child development* (vol. 4) (pp. 209–244). Greenwich, Connecticut: JAI Press.

Mead, M. (1928). *Coming of age in Samoa.* New York: Morrow.

Super, C. M., & Harkness, S. (1986). The developmental niche: A conceptualization at the interface of child and culture. *International Journal of Behavioral Development, 9,* 545–569.

Whiting, B. B., & Edwards, C. P. (1988). *Children of different worlds: The formation of social behavior.* Cambridge, Mass: Harvard University Press.

14
Children's Social Networks and Social Supports in Cultural Context

ANNE MARIE TIETJEN

The relationships children have with other people, including parents, friends, teachers, grandparents, and others, have a deep and lasting impact on children's lives. It is through these relationships that children learn not only how to get along with others, but how to do and be the things their culture expects them to do and be. It is also through relationships with others that children achieve a sense of belonging and learn to deal with the stresses of life.

A comprehensive approach to studying children's relationships makes use of the concepts of *social networks* and *social supports*. A *social network* consists of the ties or linkages that connect individuals (and sometimes groups or institutions).

Anne Marie Tietjen is currently occupied with her clinical practice in Bellingham, Washington. She earned her Ph.D. in 1978 from Cornell University, where she studied developmental psychology. She received her clinical training from the University of Washington, and has taught at the University of British Columbia, the University of Washington, and Western Washington University. She has published articles based on her research in Sweden and Papua New Guinea in several scholarly journals and books.

This paper is based on two earlier chapters by the author. Fuller discussion of the ideas presented here may be found in Tietjen, A.M. (1989), "The ecology of children's social support networks," in D. Belle (Ed.), *Children's social networks and social supports*, New York: Wiley & Sons, Inc. and in Tietjen, A.M. (in press), Supportive interactions in cultural context, in K. Hurrelman and F. Nestmann (Eds.), De Gruyter Publishers.

These linkages can be conduits for a variety of resources. *Social support* may be defined as resources that are provided by other people and that arise in the context of interpersonal relationships. Supportive resources can include information, material assistance, affection, assistance in problem solving, and comforting (Belle, 1989).

Researchers have found that children's social networks vary for children of different ages, genders, social classes, and numbers of parents in the home. They have also found that children who have supportive networks are more competent and cope better with stress (see Belle, 1989). In this reading I will show that the patterns of relationships children have with others differ among cultures according to the values, beliefs, and social organization of the culture. In turn, the nature of children's social relationships influences the kinds of opportunities and experiences they will have, and hence the competencies they will develop. Thus, children's social networks or support systems are an important means by which children learn the competencies they will need for success as adults within their own culture.

Two contrasting examples of 8-year-old girls and their relationships in countries where I have done research illustrate the wide variations in social connections that can be found among cultures:

> Iris lives in a village of 250 people which lies between the rain forest and the sea in Papua New Guinea. She and her parents and five siblings share the two-room house in which she was born. The

house was built of sago palm stalks by her father and his brothers. Most of the family's daily activities, including cooking, eating, and sleeping, take place in public, on the verandah of the house. Iris's father's parents live in a house that stands about ten feet away, and her paternal uncles and their wives and children also live within a few yards. Iris plays with these children daily, and refers to them, according to her culture, as her older and younger siblings. She is taught to care for the younger ones and obey the older ones. Iris attends a school which serves her village and another about the same size, where she is one of nine second graders. She knows that very few of the children who go as far as they can in this school (through grade 6) will have an opportunity to obtain further education at a high school in the provincial or national capital. She also knows that she will probably marry into a nearby village of people who are related to her and speak the same language she does, and that she will maintain close ties with her family. At age 8 Iris has already learned from her mother and older sisters to do much of what she will be expected to do or to supervise as an adult, including caring for children, cooking, subsistence gardening, making crafts for daily or ceremonial use or for trade with other villages where people speak languages unrelated to hers. She participates in daily exchanges of cooked food with her relatives, confirming and strengthening the bonds established by birth and marriage.

Erika lives in an apartment with her parents and younger brother in a suburb of a city in Sweden with a population of more than a million. Her family moved there from a different city two years ago because of her father's job. She has met several children her age in her apartment complex, but some of the friends she made there have already moved away, and she no longer sees them. Erika visits her mother's parents about once every two months, and her father's parents at Christmastime and for one week during the summer. She has only one aunt and uncle and two cousins whom she also sees twice a year. Erika attends school in her suburb, where she is one of 90 second graders. After school she attends her music lesson or her dance class in the city, where she meets girls her age from many different parts of town. Because both of her parents are employed she sees them in the evenings and on weekends, and she knows very little about the work they do. Her usual chores are to keep her room clean and to set the table for dinner. Erika is planning to go to university one day and to become a doctor, and, since her family's trip to Spain last year, she has been thinking she might like to live and work in another country for a while.

The lives of these two children differ in many obvious ways. They live in very different physical surroundings and spend their time in different ways. The social networks of the two girls differ in the breadth of the girls' exposure and access to different kinds of people, in the amount and nature of the contact they have with parents, relatives, friends, and people who are unfamiliar to them, and in the obligations and privileges that accompany their various relationships. The girls may also be receiving different types of social support from their social network members. If we were to consider the question of which girl is receiving more or better social support, the answer would be that each girl is receiving support considered by her culture to be appropriate for helping her to develop the skills, knowledge, attitudes, and social connections she will need to become a competent member of her society and culture.

For example, Erika's social support network will expose her to a wide range of people, providing her with opportunities to develop the social skills she will need for meeting and developing relationships with people who are new to her. For Iris, social support that will enable her to learn the skills involved in maintaining exchanges of goods and services among her kin group is more likely to be appropriate.

HUMAN ECOLOGY, SUPPORTIVE INTERACTIONS, AND SOCIALIZATION

Human development occurs in the context of interaction between the person and the environment. For example, supportive interactions occur between children and members of their social networks, which are in turn part of a larger cultural context. Urie Bronfenbrenner of Cornell University has developed ideas about how this interaction works, and this way of thinking about development is generally referred to as an "ecological perspective." His 1979 book explains his thinking, which has influenced many psychologists, including myself.

From an ecological perspective, the particular shared beliefs, customs, values, and patterns of social organization of a culture are seen as giving meaning to interactions among people. So, supportive interactions may take different forms in different cultures. Cultural patterns influence the nature of the social relationships children will have, the

kinds of activities they will engage in, and the kinds of experiences they will have. In turn, activities and experiences influence the kinds of competencies children will develop. Children's social support systems, then, are the conduit by which children learn the competencies relevant to their ecological circumstances.

The idea that children become socialized into their cultures through interactions with others is part of every theory of socialization, although the mechanisms by which this is thought to occur are debated among theorists. Beliefs and behaviors developed from the accumulated experience of a cul-

> # The idea that children become socialized into their cultures through interactions with others is part of every theory of socialization, although the mechanisms by which this is thought to occur are debated among theorists.

ture and passed from adults to children by example and instruction are referred to as "cultural scripts" by some cross-cultural researchers (e.g. Whiting and Edwards, 1988). These "scripts" inform interpersonal behavior and account for differences seen among various cultural groups in many different behavior patterns. Taking a somewhat different, but not incompatible, approach, Shweder (1990) proposes that humans are motivated from birth to "seize meanings and resources out of a sociocultural environment that has been arranged to provide them with meanings and resources to seize on and use." (p. 1.)

Meanings and resources are provided to children by members of their social networks during supportive interactions. Different resources and meanings may be conveyed by different network members, such as parents, siblings, teachers, grandparents, and others. Through supportive interactions with a variety of network members, children develop the knowledge and skills they need to become competent in their culture.

CULTURAL VARIATIONS IN CHILDREN'S SOCIAL NETWORKS AND SOCIAL SUPPORTS

In this section, studies of children's social relationships in several different cultural settings will be discussed, with a focus on the variety of forms social support may take and the processes by which it is provided. Social support, like other forms of human interaction is made up of both *content*, or what is provided, and *process*, or how, when, and by whom support is provided.

Support Content

A developmentally-based categorization of the socialization content of social support could begin with support for a sense of belonging, followed by support for mastery of developmental and cultural tasks.

Support for Belonging

Developing a sense of connection to others is seen in Western developmental theories as essential for all other aspects of development. American and European research on early infant social relationships has traditionally emphasized the importance of the *mother* as the primary or only caregiver, and has presented infants as capable of forming only one primary emotional attachment. However, infants may have the capacity to achieve a sense of connectedness to *many* network members at an early age, as Tronick, Morelli, and Ivey (1992) have shown in their study of Efe infants and toddlers, born into a foraging culture in the Ituri forest of Zaire. These researchers systematically observed and recorded the amount of time Efe infants and toddlers spent in contact with others and in solitary activity, as well as whether the children were interacting with their mothers, fathers, other adults, or other children. They found that Efe infants spend about half of their time in social contact with individuals who are *not* their mothers and that Efe three-year olds spend 70 percent of their time in such company.

Efe patterns of providing support to children are closely linked to the social and physical ecology of the group. For example, cooperation and interdependence are necessary to Efe men and women for social, psychological, and material survival. Tronick and his colleagues propose that for the Efe and other communities as well, patterns of caring for

children are constructed by community members interacting with their social and physical ecologies, and that community-specific patterns of child care will be associated with particular developmental experiences and ways of conceptualizing self and others. The authors suggest that Efe infants' and toddlers' early experiences in multiple relationships with men, women, boys, and girls from birth onward may help the Efe children to develop a broad range of social skills, buffer them against feelings of insecurity, and enhance their self-confidence. They also suggest that Efe infants may be more dependent on others and thus may be more vulnerable when others are not present than infants accustomed to being cared for by a single individual.

Tronick et al. (1992) conclude that "As a consequence of a process of mutual regulation, in which individuals in social interaction negotiate their own motivations and goals with those of others, children develop culturally appropriate motivations and behaviors, appropriating knowledge of themselves and the social world" (p. 576). This process is specific to communities, and produces individuals who have a sense of self and others that is also specific to the community. Cultures provide their new members with support for a sense of belonging in ways that are congruent with their ecological circumstances and help to build children's current and future lives within their culture.

Support for Mastery of Developmental and Cultural Tasks

Patterns of interpersonal behavior are developed in activity settings, which are determined by social and physical ecology (Whiting and Edwards, 1988). Studies of children's social relations in many cultures have shown that social interaction and provision of social support often take place in the context of activities geared toward helping children learn to perform specific tasks that are required for adult economic, political, and social roles within their culture.

Ten and eleven-year old Giriama children in Kenya spend 38 percent of their daytime hours engaged in work, which includes food production, errands, housework, carrying, and child care (Wenger, 1989). These Giriama children perform tasks they will be required to perform or to supervise when they reach adulthood and, in the process, form important relationships with peers and siblings that will be continued in adolescent and adult life.

Differences in the underlying cultural meaning of children's task performance are evident from ways in which children in different cultures typically respond to their parents' requests. U.S. children tend to resist a parental request, or at least attempt to negotiate around it, feeling that doing chores is a favor to the parent. Giriama children, according to Wenger's study, recognize that their participation in household tasks is necessary for the well-being of household members, and usually comply with parental requests. It may appear the Giriama children are learning the skills they will need for success in their culture, while U.S. children are not. But U. S. children, through negotiating around household tasks, may also be learning values and skills related to success in their culture, such as independence and negotiation skills.

Abaluyia children in Kenya also engage in work that helps to prepare them for work they will do as adults, and, among Abaluyia adults, asking children to help with meaningful work is seen as supporting children (Weisner 1989). Requesting that children participate in important work teaches children not only about their duties but also about their connectedness to family or community networks.

In these examples from the Giriama and the Abaluyia, children are clearly provided with support for the development of culturally appropriate competence during interactions with various network members in important tasks, geared to their ability level, that they will be expected to perform or to supervise in adulthood.

The Process of Support

Who Provides Support

Studies of children's social supports in the United States as well as other cultures have found that *who* provides support to children is as important as *what kinds* of support are provided. Knowing who provides what kinds of support to children in a culture can tell us something about what the culture considers important for its children to learn.

In the Efe society described earlier many community members participate in direct care for infants and toddlers. This system provides a model of community interdependence and a message that the children may rely on their community, rather than only on their parents or immediate family members.

From his systematic observations of Abaluyia children in Kenya, Weisner (1989) found that in less than 1/4 of the supportive acts he observed mothers were the ones providing the support to their children. More than 3/4 of the supportive acts he observed either included other children along with the mother or took place when the mother was not present. Abaluyia children look to other children for support as much or more than to their mothers. Through providing each other with support, these children of different ages were learning through experience the rules of their culture about sex role obligations, hierarchy, and status.

A similar pattern is found in the Giriama community described by Wenger (1989). Giriama girls between the ages of eight and eleven provide a significant amount of child care to their younger siblings. An older sister may play an especially important supportive role for a younger child who is no longer allowed to sleep with his mother after the arrival of a new baby. Working together with older women in the household also prepares girls for their responsibilities as adults. Giriama boys spend more time than girls interacting with same-age peers, as they will do in adulthood.

Costa Rican children view their parents as the most important providers of social support, whereas U.S. children often consider their best friends to be more important in this regard than their parents, siblings, or grandparents (DeRosier & Kupersmidt, 1991). Between fourth and sixth grade, U.S. children shift from viewing relationships with family members as most important to viewing relationships with their peers as most important. For Costa Rican children, the family remains the primary perceived source of support. Best friends may tend to promote individualistic values, while family members are likely to support cooperative, group-oriented values. Costa Rican fourth and sixth graders, growing up in a culture that emphasizes interdependence and family solidarity, are more satisfied with all of their social relationships, particularly those with family members, than are U.S. children of the same age.

An example of the ways in which the pattern of children providing support to other children promotes interdependence and prosocial behavior in children is found among Kwara'ae children in the Solomon Islands (Watson-Gegeo and Gegeo, 1989). Although mothers and fathers are considered to be primary caregivers at home, Kwara'ae children also play important caregiving roles. From the age of five or six months infants spend many hours each week in the care of an older sister or brother, interacting with other village children of various ages. By the time they reach the age of five, children are allowed to go outside the village with older siblings, without adult supervision.

In the classificatory kinship system used by the Kwara'ae, one's parents' siblings are referred to as one's parents, and their children as one's siblings. In adulthood Kwara'ae siblings are strongly interdependent with one another in subsistence gardening, household chores, and child caregiving. Adult siblings share food and economic activities, and they negotiate and pay for marriages jointly. Taking responsibility for care of one's younger siblings is seen in the Kwara'ae culture as direct training for interdependence in adulthood. The mixed-age village peer group is likely to be the kin group with which the child will be interdependent as an adult, and children grow up experiencing this group as a continuing unit of strong mutual commitments. As siblings mature they may share in one another's successes. For example, older siblings sometimes pool their resources in order to send one brother to school, expecting that he will provide them with financial support from him once he has a paying job.

Kwara'ae children learn to care for their younger siblings from their parents, through participating in increasingly complex levels of caregiving tasks as they become more skilled. Children imitate the caregiving strategies they observe adults engaging in, as well as being directly taught by their parents. Adults structure interactions among siblings in order to promote their goals of helping their children learn kinship relations, rules governing the social hierarchy, and sibling cooperation.

How Support Is Provided

The manner in which social support is provided also conveys to children information about cultural values and expectations. An interesting example is found in the Kwara'ae culture, where the value of family interdependence is emphasized in *counseling sessions*. These sessions, which occur at the moment infants and toddlers misbehave, or after the evening meal for older children, teach cultural knowledge and world view as well as proper behavior. Delivered gravely and in formal language, the sessions reaffirm and elaborate themes introduced to children in the course of everyday interactions. During the sessions children are taught such things as how to express and control emotions, participate

in cooperative family activities, and in time, to re-solve family disputes.

Kwara'ae caregivers also use distinctive com-municative routines in providing support to chil-dren. *Directive* routines are used to teach children rights, obligations, roles, and expectations associ-ated with birth order, gender, and kin relations as well as work skills, language, and interactional skills. For example, infants as young as six months are directed (and assisted) to share food with their older siblings. Other directive routines include helping relatives with specific household chores, being nurturant to babies, and expecting nurtur-ance from older siblings and other relatives. Partici-pants are referred to in these directive routines by their kin terms, rather than by their proper names, in order to emphasize family interdependence fur-ther. *Repeating* routines also shape sibling relation-ships. In such routines, caregivers model appropriate behavior and children are expected to imitate both the action and the verbal description of the action.

For the Abaluyia in Kenya social support to children often occurs in a teasing or aggressive manner (Weisner, 1989). The juxtaposition of sup-port and aggression gives children cultural mes-sages about dominance and the importance of the hierarchy within the family. The support network these children experience is similar to the adult sup-port network in their culture, in that both networks are filled with conflict and based on knowledge of hierarchy and deference. Thus, culture-specific styles of support provision in childhood provide training for culture-specific styles of interaction en-gaged in by adults.

When and Where Support Is Provided
Supportive interactions occur continuously in the context of everyday activities in many cultures, whereas Western research has focused on social support as a buffer against stress or help during a crisis. Social support in many cultures is clearly support for the development of culturally appropri-ate competence.

SUMMARY AND CONCLUSION

The relationships children have with members of their social networks—family, friends, relatives, and others are essential to their development and to the perpetuation and development of their culture. Through supportive interactions with network members, children develop knowledge and skills and a sense of belonging that are specific to their culture, and the competencies they will need to be-come successful members of their culture.

REFERENCES

Belle, D.(Ed.), (1989). *Children's social networks and social supports.* New York: Wiley.

Bronfenbrenner, U. (1979). *The ecology of human develop-ment.* Cambridge, MA: Harvard University Press.

DeRosier, M.E. and Kupersmidt, J. (1991). Costa Rican children's perceptions of their social networks. *De-velopmental Psychology, 27,* 656–662.

Shweder, R.A. (1990). Cultural psychology—What is it? In J.W. Stigler, R.A. Shweder, & G. Herdt (Eds.), *Cul-tural psychology: Essays on human development.* Cam-bridge: Cambridge University Press.

Tronick, E.Z., Morelli, G., and Ivey, P. (1992). The Efe forager infant and toddler's pattern of social rela-tionships: Multiple and simultaneous. *Developmental Psychology, 28,* 568–577.

Watson-Gegeo, K. and D.W.. Gegeo (1989). The role of sibling interaction in child socialization. In P. Zukow (Ed.), *Sibling interaction across cultures.* New York: Springer-Verlag.

Weisner, T.S. (1989). Cultural and universal aspects of social support for children: Evidence from the Abaluyia of Kenya. In D. Belle (Ed.), *Children's social networks and social supports.* New York: Wiley.

Wenger, M. (1989). Work, play, and social relationships among children in a Giriama community. In D. Belle (Ed.), *Children's social networks and social supports.* New York: Wiley.

Whiting, B. & Edwards, C. (1988). *Children of different worlds: The formation of social behavior.* Cambridge, MA: Harvard University Press.

15

Behavior across Cultures: Results from Observational Studies

RUTH H. MUNROE AND ROBERT L. MUNROE

In cross-cultural settings, most of the things that children do plus a large number of the things that adults do can be systematically watched and recorded. Data from such activities allow us to address many issues centering around people's ordinary behavior. For example, we are a highly social species much involved in interaction with others, thus the general question may be posed: Are there social behaviors that are typical for certain types of people? We also must nurture and care for our basically helpless offspring if they are to survive; thus: Is there some universality in the way we meet infants' need for near-constant care? And we have to invest our labor each day, that is, we need to work if we are to live, thus: Can we discern any regularity in our work patterns? These spheres of life—our social behavior, our parenting, and our routines of daily activity—have been fruitfully investigated by means of observational techniques,

and we have chosen specific questions within each sphere for the present discussion.

Before proceeding with the questions themselves, we note that our emphasis is on observational studies that have been carried out in people's everyday environments while adhering to a set of methodological standards. The term *everyday environments* is self-explanatory; the studies sample people wherever they are. With respect to methodological standards, we feel it is insufficient to have only anecdotal accounts or casual observations of people's behavior. These can be very useful, but they must be looked upon as sources of hypotheses that will require verification on the basis of more formal studies. Thus, we might hear from an anthropologist that babies under six months of age are always kept indoors in a certain society. Our reliance on a statement like this would be bolstered considerably if the sample were described and if

Ruth H. Munroe is Professor of Psychology at Pitzer College. After undergraduate education at Antioch College, she received a Master's Degree in Measurement and Statistics and an Ed.D. in Human Development from Harvard University. For several years she served as Secretary-General of the International Association for Cross-Cultural Psychology. She is the co-author, with Robert L. Munroe, of a chapter entitled "Observations of Behavior as a Cross-Cultural Method," which is to appear in the *Handbook of Psychological Anthropology*, Philip K. Bock, Editor (Greenwood Press, forthcoming).

Robert L. Munroe is Professor of Anthropology at Pitzer College (of the Claremont Colleges, California), where he has taught since 1964. He has carried out research in Africa, Asia, Central and North America, and the Pacific. Recent publications include three monographs, co-authored with Ruth H. Munroe, on time use in Belize, Kenya, and Samoa. The monographs form part of a series edited by Allen Johnson of UCLA and published by HRAF Press, New Haven, CT.

observers had been trained and had achieved reliability using a standardized observation technique and schedule. In other words, if a general statement is made, we want not simply a flat assertion but also a detailed specification of the means used to derive it. So, keeping these methodological considerations in mind, we can now turn to the three representative question-sets and some partial empirical answers.

Question 1: Are boys everywhere more aggressive than girls? If such a sex difference exists, does it hold across all types of aggression? Aggression is of special interest as a form of social behavior both because it is frequently associated with males and because its range runs from children's mild attacks to full-scale warfare. Although aggression has been among the most widely studied topics in all of psychology, relatively little of the research has been based on the systematic observation of children and on standardized definitions for aggressive behavior. We want to report briefly on these kinds of data, which have been gathered from ten societies around the world, including most of the major culture areas. Children aged 3 to 11 were studied in their homes and communities as they engaged in normal social activities with others, nurturing, scolding, helping, and hitting—in short, doing those things that youngsters typically do. Several thousand behavioral acts were observed and coded according to the categories of social behavior into which the acts fell. The categories included three types of aggression: physical assault, rough-and-tumble play, and verbal attack such as insulting, threatening, or

challenging. As Table 1 indicates, a very strong preponderance of aggressive acts was displayed by boys. The last column in the table, which gives overall tendencies, shows that in no group did the girls display a higher level of total agonistic behavior than boys, even though there were two societies in which boys and girls were equal. (One of these semi-exceptional cases, interestingly enough, was the United States, which had formed the basis for the original generalization!) For each type of aggressive behavior considered separately, as we see in the first three columns, only one society in ten showed the girls to be higher than the boys. For verbal aggression, however, there were enough "ties" that just six of the ten societies had a higher level for boys than girls. Based on our data, then, we can say in answer to our initial question-set, first, that boys do seem to aggress more frequently than girls across a wide variety of cultures; and second, that while the subcategories of aggression also tend to show boys to be higher than girls, the cross-cultural tendency is relatively weak so far as verbal aggression is concerned. In general, this rough cross-cultural count mirrors quite well the usual Western-based finding, with boys almost always more frequently observed in the physical forms of aggression, but with girls not far behind in verbal aggression, and sometimes rivaling boys in that respect.

Question 2: Are females always the main caretakers of children? Don't fathers ever match mothers in this regard, or at least get themselves heavily involved in caretaking activities? Females *are* the main caretakers

TABLE 1 **Sex differences in aggression in 10 societies**

Society[a]	Type of Aggression			
	Assaulting	Horseplay	Verbal	All
Belize	+	+	+	+
India	+	+	=	+
Kenya (a)	-	+	=	=
Kenya (b)	+	-	+	+
Mexico	+	+	+	+
Nepal	+	+	+	+
Okinawa	+	+	+	+
Philippines	+	+	+	+
Samoa	+	+	-	+
U.S.A.	=	=	=	=

"+" indicates that boys' scores were higher than girls'.
"-" indicates that girls' scores were higher than boys'.
"=" indicates that boys' and girls' scores were approximately equal.

[a]Data for Belize, Kenya (b), Nepal, and Samoa were taken from Munroe and Munroe (1984). Data for India, Kenya (a), Mexico, Okinawa, the Philippines, and the U.S.A. were taken from Whiting and Edwards (1973).

of infants and young children in all known cultures. Available ethnographic evidence over the years led anthropologists to claim this, and subsequent observational studies have corroborated it. As to fathers, their involvement in caretaking does vary culturally, but it has always been reported as very low compared with that of mothers. Direct observation has, again, confirmed this point, with mothers found involved in direct care of infants about 20–25 percent of their time, fathers no more than 2–3 percent. This wide gap between mothers and fathers has prompted many speculations, including the possibility of a *maternal instinct* and a division of

These results lay to rest any supposition that adult males may be fundamentally disinclined to undertake intensive caretaking or nurturing behavior.

labor based on physical characteristics, such as size and strength, that differentiate the sexes in all societies. The findings of a recent observational project, however, have demonstrated that an extreme cultural instance can cause us to revise our ideas about what might seem to be natural behavior. Anthropologist Barry Hewlett (1991) lived with and studied the Aka Pygmies of the Western Congo Basin. He had noted, casually, that fathers were highly involved in infant care. He then carried out several hundred hours of systematic observations and, on that basis, reported that: fathers averaged a full hour per day holding the baby during daylight hours, spent 20 percent of their time in early evenings actively caring for the baby, were found no farther than an arm's length from their babies for half the day, and, in the Aka's forest-camp setting, were within view of the baby a remarkable 88 percent of the time. (Even with this level of involvement, father care of the Aka infant was below that of the mother.) These results lay to rest any supposition that adult males may be fundamentally disinclined to undertake intensive caretaking or nurturing behavior. Hewlett also found that Aka fathers, though intimate, affectionate, and helpful with their infants, did not engage in vigorous or

rough-and-tumble play. His data clearly do not support the recent idea that infants become attached to their fathers by means of father-initiated stimulating play. But to return to our question, we have in the Aka case a level of paternal care far exceeding anything hitherto reported. As in other societies, the Aka father's caretaking does not match that of the mother, but involvement with his baby is very high indeed.

Question 3: Does leisure time increase with modern urban life? Or is it in the technologically and economically simpler societies that people have time to spare? At mid-century, the consensus was that the Western world possessed a technical competency capable of granting us all the leisure we might want. It was argued that from the perspective of a hunter-gatherer like the Tasmanian, "we apparently had a magic which made the plants grow as abundantly as we wanted and the animals herd together as tame as dogs . . . ready to be slaughtered at will" (Forde, 1952, p. 2). And for their part, hunters were considered to be "threatened with starvation and working constantly to achieve bare survival" (Netting, 1977, p. 9). But this traditional view was completely reversed when the first systematic observations on time use among hunters began to be collected. The food quest, as among the !Kung Bushmen, occupied adults only a few hours per day on average, and foragers were suddenly rechristened "the original affluent society," with industrial peoples said to work longer and harder than all others.

Now, however, behavior observations have been extended to societies at all levels of cultural complexity and in many areas of the world, and we are able to answer the question of relative work and leisure in a more precise way. We note first, though, that the term "labor" is used more inclusively than for just subsistence activity and includes work as broadly defined, namely, the wage jobs most of us engage in, our household chores, the shopping, the preparation of food, active caretaking of children, and so on. It appears, contrary both to the earlier view and to the more recent one, that we in the urban-industrial world put in approximately the same time on daily labor as those in food-collecting societies. Yet lying between us and the hunting peoples on a scale of cultural complexity are the agrarian societies, and what we have learned from observation is that these agriculturalists work longer hours than either us or the hunter-gatherers. Not only adults but children too follow this pattern; one comparison, for example, showed that during nonschool hours for children aged 3–10, those in

farming communities were engaged in work more than 20 percent of the time, while U.S. and !Kung Bushmen children spent just 5 percent or less of their time working. We may ask why it is that the farmers stay busier than other peoples. Although the reasons are not known with any certainty, we can point to two classes of activities to which farmers must devote considerable time, whereas only one of them is performed steadily by hunter-gatherers, and only the other by us in the urban-industrial world. Farmers, and ourselves, spend a good deal of time doing chores, for instance, food preparation and storage, housekeeping, purchasing and taking care of material goods, laundering clothes, and so forth; but hunter-gatherers, who accumulate but minimal property, are spared much of this effort. Farmers also must dedicate time to subsistence labor, an activity in which they are joined by hunter-gatherers, but not by us, since we have specialists (farmers, ranchers, fishermen) whom we pay to do this work. So agriculturalists seem to be kept busy on both fronts, and we and the hunting peoples are seriously engaged in only one of these time-consuming activities. Whatever the reasons for agrarian industriousness, though, the surprise has been that as we observe work activities in societies varying sharply on the scale of cultural complexity, we do not find time-use patterns developing in a simple linear fashion.

Besides demonstrating the usefulness of observational research, each of the above sets of studies also illustrates the value of cross-cultural investigation generally (cf. Whiting, 1968). The findings on childhood aggression have helped us answer the question of whether a sex difference in Western-based findings was culture-specific or held up among people in general. The study of infant care among Aka fathers has enabled us to extend the range of known behavior; that is, it has discovered a set of behaviors that were normative in one culture even though exhibited by few or no individuals in other cultures. And the issue of labor and cultural complexity has posed a question that was cross-cultural in its very formulation, requiring data from several different types of societies if any findings were to be generated. Thus a cross-cultural perspective has enhanced the contribution of all the sets of studies we have considered.

We noted above that a host of topics are open to study by observational techniques. For instance, many who work in Third World countries believe that young children should be fed five small meals a day. Although we may question the need for ex-

actly five periods of food intake every day, the broader point is that children are more likely to achieve proper physiological development if they eat frequently. Implicit in such beliefs is the idea that children should and do eat more frequently than adults. As it happens, we can easily find out whether cross-culturally, under naturalistic conditions, this hypothesis receives support. Allen Johnson of UCLA has inaugurated a cooperative venture involving the publication, by the Human Relations Area Files, of a collection of standardized time-use databases. Now available for a total of eight societies ranging over several continents, the databases can be rapidly consulted to ask whether children do in fact eat and drink more frequently than adults. And the answer is yes, they are so engaged. For a total of twelve possible comparisons (youths vs. adults, toddlers vs. adults, etc.) for which such data were presented, every single one showed more time invested in eating by the younger groups than by the adults.

The great number of observational studies have focused on cultural patterns rather than individual differences, and on gross behavioral categories (e.g., infant care, labor) rather than micro-level behavior. But the varied approaches to observational research in standard psychological study (cf. Weick, 1985) might lead us to suspect that these previous foci are not the only bases on which cross-cultural behavioral observation can be founded. One recent cross-cultural study, for instance, compared father-absent boys with father-present boys, and the dependent measure was eye-gaze, the issue being whether in natural settings the father-absent boys paid more attention or less attention to males in their social environments. It turned out that father-absent boys looked *more* frequently at males, perhaps in unconscious compensation for the fact that they did not regularly have an adult male model in the home. (The attention of girls to males was unrelated to father absence in these samples.) Approaches of this sort, with a concentration on individual differences and molecular levels of behavior, can provide data that are complementary to traditional observational research in cross-cultural settings.

LIMITATIONS

The more sensitive and private aspects of people's lives are essentially off-limits to observational research. Observation-based inquiry is also not the

optimal choice, and certainly not the only choice, for the study of cognition, emotion, fantasy, and numerous other "internal" phenomena. Nevertheless, the study of overt behavior can be integrated with a great variety of methodologies in order to ferret out underlying processes. Regarding the higher rate of aggression among boys, for instance, we could bring to bear both physiological research and the investigation of relevant predispositions and circumstances, including impulsivity levels, the availability and importance of particular role models, socialization techniques, and interests. And although we were willing to speculate above as to the reason that father absence was associated with over-gazing at males, we obviously cannot talk with assurance about "unconscious" motivation unless something besides behavioral data can be mustered. So the contributions of observational research will undoubtedly be enhanced as they are incorporated into a larger, more unified effort to account for human behavior. In the meantime, we hope that the examples given in this brief presentation have helped make clear the usefulness of behavior observation as a tool for cross-cultural studies.

REFERENCES

Forde, C. D. (1952). *Habitat, economy and society*. London: Methuen.

Hewlett, B. S. (1991). *Intimate fathers: The nature and context of Aka Pygmy paternal infant care*. Ann Arbor: University of Michigan Press.

Munroe, R. L., & Munroe, R. H. (1984, November). *Aggression among children: Predictors and correlates in four societies*. Paper presented at the annual meeting of the American Anthropological Association, Denver.

Netting, R. McC. (1977). *Cultural ecology*. Menlo Park, CA: Cummings.

Weick, K. E. (1985). Systematic observational methods. In G. Lindzey & E. Aronson (Eds.), *The handbook of social psychology* (3rd ed.) (Vol. 1, pp. 567–634). New York: Random House.

Whiting, B., & Edwards, C. P. (1973). A cross-cultural analysis of sex differences in the behavior of children aged 3–11. *Journal of Social Psychology, 91*, 171–188.

Whiting, J. W. M. (1968). Methods and problems in cross-cultural research. In G. Lindzey & E. Aronson (Eds.), *The handbook of social psychology* (2d ed.) (Vol. 2, pp. 693–728). Reading, MA: Addison-Wesley.

16
Patterns of Parenting: The Warmth Dimension in Worldwide Perspective

RONALD P. ROHNER

A few years ago I interviewed a high caste Hindu woman about family matters in India. My attention was distracted by another woman seated nearby. The second woman quietly and carefully peeled an orange and then removed the seeds from each segment. Her 9-year-old daughter became increasingly animated as her mother progressed. Later, my Bengali interpreter asked me if I had noticed what the woman was doing. I answered that I had, but that I had not paid much attention to it. "Should I have?" "Well," she answered, "you want to know about parental love and affection in West Bengal, so you should know. . . ." She went on to explain that when a Bengali mother wants to praise her child—to show approval and affection for her child—she might give the child a peeled and seeded orange. Bengali children understand completely that their mothers have done something special for them, even though mothers may not use words of praise—for to do so would be unseemly, much like

praising themselves (Rohner and Chaki-Sircar, 1988). The same behavior in the United States would probably not be noticed or appreciated by the typical child, since peeling and seeding oranges has no special symbolic (i.e., cultural) meaning here.

So, once again, I had confirmation of the fact that parents in all societies have ways of expressing love, warmth, and affection for their children, even though the specific expression might not be understood by children in another society. Likewise, it is possible for parents everywhere to show displeasure with and even dislike of their children, though the specific expressions of these behaviors are also highly variable from society to society.

For more than 30 years we have been studying different styles of parenting such as those in the United States and cross-culturally. In particular we have concentrated on the *warmth dimension* of parenting, that is, on children's and adults' perceptions of parental acceptance and rejection, and on related styles of parenting—especially parental control and punishment. Parents around the world can express their love (acceptance) or love-withdrawal (rejection) in four principal ways, shown graphically in Figure 1. As I describe these, I invite you to think about your own family and the experiences you had as a child growing up in your own home. Think back to the time when you were about nine to twelve years of age, and think about the way the people most important to you, probably your par-

Ronald P. Rohner is Professor of Anthropology and Family Studies at the University of Connecticut, where he is also Director of the Center for the Study of Parental Acceptance and Rejection. He received his Ph.D. from Stanford University in 1964, and has been studying issues of parental love in the USA and cross-culturally ever since. He is author of nine books. Six deal with the issues of parental love. The other three should have.

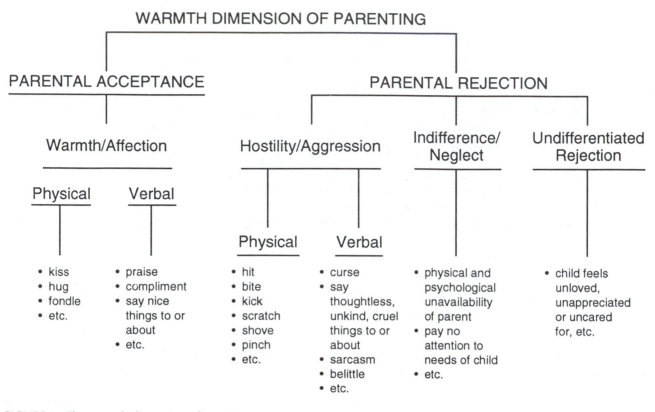

FIGURE 1 The warmth dimension of parenting

ent(s), treated you. Do not try to say that you were either accepted or rejected categorically, but try to place yourself somewhere along the warmth (i.e., acceptance-rejection) dimension, more or less. And remember that all humans everywhere, you and me included, can be placed somewhere on this parenting continuum.

As I said above, parental acceptance refers to the love that parents can give their children. Accepted children are generally wanted, valued, and appreciated. Parents everywhere can express their warmth and affection in two major ways, physically and verbally. Physical affection may be shown, for example, by such behaviors as kissing, hugging, fondling, and caressing. Verbal affection may be shown by complimenting children, saying nice things about them, praising them, and so forth. All are forms of behavior that cumulatively and individually are likely to induce children to *feel* loved or accepted. Some children never experience any of these things, and that is part of the rejection process where parents often dislike, disapprove of, or resent their children, or feel their children are an unwanted burden. In addition to these forms of parental coldness (i.e., the absence of warmth and

affection), parents anywhere can reject children in three other ways, also shown in Figure 1. That is, they may be hostile and aggressive toward their children, or they may be indifferent toward and/or neglecting of them. Or, in the absence of any objective signs of coldness, aggression, or neglect, children may simply feel that their parents do not love them or care about them. This latter form of rejection is called "undifferentiated rejection."

Parental hostility and indifference are both internal, psychological states within the parent. Hostility refers to anger, resentment, and enmity toward the child, whereas indifference is simply the lack of caring, interest, or concern about the child. Neither is necessarily observable directly, but both aggression and neglect are. Both aggression and neglect tend to result from parents' subjectively experienced feelings of hostility and indifference, respectively—though neglect can sometimes result from parents' efforts to deal with anger or resentment, too. As with parental affection, parental aggression can be displayed physically as well as verbally. Aggression is any form of behavior where there is the intention of hurting someone or something, either physically or symbolically. We humans

are remarkable in the number and variety of ways we have of hurting each other, including our children. Some of the more commonplace ways include hitting, pushing, pinching, scratching, biting, kicking, and beating with objects. Verbally aggressive parents can curse, mock, ridicule, satirize, belittle, or say endless other thoughtless, unkind, or cruel things to or about their children. Neglecting parents on the other hand, pay little attention to their children, or to their physical or emotional needs.

Contrary to loving behavior, all these behaviors—cumulatively and individually—are likely to induce children to *feel* unloved, or rejected. Even in warm and loving families, however, children are likely to experience at least occasionally a few of these hurtful behaviors. Thus it should be clear that most children around the world are neither accepted nor rejected categorically, but fall somewhere along the acceptance-rejection continuum. You can get a more precise measure of your own placement along this continuum by responding to a sample of items from the *Parental Acceptance-Rejection Questionnaire (PARQ)* displayed in Table 1. The whole questionnaire is in Rohner (1986, and especially 1991).

At this point it is important to caution you about the term *parental rejection*. In everyday American-English, the term connotes something bad, perhaps that these are bad parents or even bad people. In cross-cultural and cross-ethnic research, you must be careful not to make such evaluations. In research, the term is used merely to describe, not evaluate, parents' behavior. This issue is important because parents in about 25 percent of the world's societies behave in ways that are consistent with the above description of rejection (Rohner, 1975). But, of course, in the great majority of cases—including historically in the United States—these parents behave toward their children the way they think good, responsible parents *should* behave, as defined by cultural norms. One of our central tasks in comparative research is to understand people's cultural

TABLE 1 ADULT PARQ

The following statements describe the way different parents act toward their children. Read each statement carefully and think how well it describes the way your mother or major caretaker treated you while you were growing up. Especially think about the time when you were about 7–12 years old. Work quickly; give your first impression and move on to the next item. Do not dwell on any item.

Four lines are drawn after each sentence. If the statement is *basically* true about the way your mother treated you then ask yourself, "Was it *almost always* true?" or, "Was it only *sometimes* true?" If you think your mother almost always treated you that way, put an *X* on the line ALMOST ALWAYS TRUE; if the statement was sometimes true about the way your mother treated you then mark SOMETIMES TRUE. If you feel the statement is basically untrue about the way your mother treated you then ask yourself, "Is it *rarely* true?" or "Is it *almost never* true?" If it is rarely true about the way your mother treated you put an *X* on the line RARELY TRUE; if you feel the statement is almost never true then mark ALMOST NEVER TRUE.

Remember, there is no right or wrong answer to any statement so be as frank as you can. Respond to each statement the way you feel your mother or major caretaker really was rather than the way you might have liked her or him to be.

My Mother (Major Caretaker)	True of My Mother		Not True of My Mother		
	Almost Always True	Sometimes True	Rarely True	Almost Never True	
1. Said nice things about me	_____	_____	_____	_____	(WA)[1]
2. Ridiculed and made fun of me	_____	_____	_____	_____	(HOS)
3. Totally ignored me	_____	_____	_____	_____	(INDIF)
4. Did not really love me	_____	_____	_____	_____	(UNDIF)
5. Made me feel wanted and needed	_____	_____	_____	_____	(WA)
6. Hit me, even when I did not deserve it	_____	_____	_____	_____	(HOS)
7. Forgot things she was supposed to do for me	_____	_____	_____	_____	(INDIF)
8. Viewed me as a burden	_____	_____	_____	_____	(UNDIF)

[1]WA means Warmth/Affection; HOS means Hostility/Aggression; INDIF means Indifference/Neglect; UNDIF means Undifferentiated Rejection.

beliefs and culturally motivated behaviors, and then to measure the correlates and outcomes of these beliefs and behaviors. In this case, one of our own major tasks has been to determine whether or not children and adults everywhere respond in the

One of our central tasks in comparative research is to understand people's cultural beliefs and culturally motivated behaviors, and then to measure the correlates and outcomes of these beliefs and behaviors.

same way to the experience of perceived parental acceptance and rejection—regardless of cultural differences, racial differences, ethnic or social class differences, gender differences, or other such limiting conditions. This question takes us into parental acceptance-rejection theory (PARTheory, or simply PART), a topic to which I turn next.

PARTheory is a theory of socialization that attempts to explain and predict major consequences, causes, and correlates of perceived parental acceptance and rejection the world over. It asks five classes of questions. These include:

1. What happens to children who experience themselves to be loved or unloved by their parents? Do children everywhere, in different sociocultural systems, racial groups, language groups, and the like—including you and me—respond the same way when they perceive themselves to be rejected by their parents?

2. What are adults like who had been accepted or rejected as children? That is, do the painful effects of childhood rejection tend to extend into adulthood unless one is lucky enough to have contravening experiences with significant others along the way to adulthood? These two classes of questions are combined into PARTheory's personality theory described later.

3. What gives some children the resilience to stand up to the corrosive drizzle of day-to-day

rejection without becoming psychologically maladjusted the way most of us do? We call these children copers. Attempts to explain why some children cope more effectively than others with perceived rejection is included in PARTheory's coping theory, a theory described at greater length in Rohner (1986).

The next two issues in PARTheory address very different kinds of questions, questions incorporated into PARTheory's sociocultural systems model and theory (Rohner, 1975, 1986).

4. Why are some parents warm and loving and others cold, aggressive, neglecting—rejecting? Is it true that parents are likely to accept or reject their children wherever specific social, economic, demographic, or other structural conditions arise? For example, are single-parent households universally at greater risk for various forms of rejection than are families with fathers, grandparents, or other kin present? Is the frequency of rejection and other forms of child maltreatment associated positively with increasing industrialization and other forms of sociocultural complexity worldwide?

5. What are the sociocultural and expressive correlates of parental acceptance-rejection in the United States and internationally? For example, are the religious beliefs, artistic preferences, and other expressive behaviors and beliefs of a people related worldwide to childhood experiences of warmth or rejection? And, why do some people self-select themselves into one kind of activity or occupation and others choose very different activities or occupations? Are adult choices such as these related to childhood experiences of love and love withdrawal?

After more than three decades of research on these and other questions in many countries, we can say with some confidence that the answer to all seems quite clearly to be, yes. Issues such as these are amplified at length in Rohner (1975, 1986), but for now I turn to a more expanded discussion of PARTheory's personality theory. Here, too, I invite you to think about yourself.

PARTheory's personality theory postulates that most people find life's major joys and sorrows in personal relationships with others. For most of us, personal relationships seem to form the foundation of our sense of well-being. When important relationships fail or when they become distorted, and

thus when our own innermost psychological needs are unmet, then subjective distress mounts, often erupting into disordered behavior. In early and mid-childhood, relationships with our parents or parent substitutes comprise for most children around the world the most important of all relationships. By the time of adolescence and later, peers and others typically become vitally important. Research suggests that perceived rejection by parents in childhood, and by peers or parents in adolescence is a root cause of many of the most painful and pain-producing experiences that humans are capable of having, including various problems of psychological maladjustment, psychiatric disorder, acting-out and conduct problems, delinquency, drug abuse, peer problems, marital-adjustment problems, academic and intellectual-performance problems, and many more. Many of these maladaptive behaviors seem merely to be symptoms of the underlying and unresolved hurt associated with perceived parental rejection.

No single theory or program of research can deal effectively with such a huge array of problems, at least not all at once, so in PART's personality theory we focus primarily on a small number of personality dispositions that characterize in varying degrees all humans. These dispositions are, according to the theory, associated universally with the experience of love and love-withdrawal. As I describe them, I invite you to think about yourself and the way each characterizes you. You can get a more precise measure of these dispositions by responding to a sample of items from the Personality Assessment Questionnaire (PAQ) displayed in Table 2. The whole questionnaire is published in Rohner (1986, and especially 1991). By the time you finish this chapter you should have a clearer understanding of your own inner self and how it came to be that way.

The seven personality dispositions included at this time in PARTheory's personality theory include: dependence or defensive independence, de-

TABLE 2 **ADULT PAQ**

The following statements describe the way different people feel about themselves. Read each statement carefully and think how well it describes you. Work quickly; give your first impression and move on to the next item. Do not dwell on any item.

Four lines are drawn after each sentence. If the statement is *basically* true about you then ask yourself, "Is it almost *always* true?" or "Is it only *sometimes* true?" If you think the statement is almost always true put an *X* on the line ALMOST ALWAYS TRUE; if you feel the statement is only sometimes true mark SOMETIMES TRUE. If you feel the statement is *basically untrue* about you then ask yourself, "Is it *rarely* true?" or "Is it almost *never* true?" If it is rarely true then put an *X* on the line RARELY TRUE; if you feel the statement is almost never true mark ALMOST NEVER TRUE.

Remember, there is no right or wrong answer to any statement so be as frank as you can. Respond to each statement the way you think *you really are rather than the way you would like to be.*

	True of Me		Not True of Me		
	Almost Always True	Sometimes True	Rarely True	Almost Never True	
1. I feel resentment against people.	_____	_____	_____	_____	(HOS)[2]
2. I like to be given encouragement when I am having trouble with something.	_____	_____	_____	_____	(DEP)
3. I certainly feel worthless.	_____	_____	_____	_____	(NEG S-E)
4. I think I am a failure.	_____	_____	_____	_____	(NEG S-A)
5. I feel I have trouble making and keeping close, intimate friends.	_____	_____	_____	_____	(UNRESP)
6. I get upset easily when I meet difficult problems.	_____	_____	_____	_____	(INSTAB)
7. I view the universe as a threatening, dangerous place.	_____	_____	_____	_____	(NEG WV)

[2]HOS means Hostility/Aggression; DEP means Dependence; NEG S-E means Negative Self-Esteem; NEG S-A means Negative Self-Adequacy; UNRESP means Emotional Unresponsiveness; INSTAB means Emotional Instability; NEG WV means Negative Worldview.

pending on the form and degree of rejection; emotional unresponsiveness; hostility, aggression, passive aggression, or problems with the management of hostility and aggression; negative self-esteem; negative self-adequacy; negative world view; and emotional instability. I have cast these terms in the "negative" direction here, that is, in the direction most closely associated with perceived rejection. But it is important to remember that each disposition is really a continuum of more or less, for example more or less emotionally stable or unstable. You and I, along with all others, can be placed somewhere along each of the seven continua. Personality theory places greater emphasis on the negative end of each continuum, however, because perceived parental rejection seems to be a better predictor of present behavior and future development than does perceived acceptance. An analogy might help clarify this point. Children with very low IQs cannot ordinarily do well in school. That is, low intelligence is generally predictive of poor school performance. On the other hand, children with very high IQs should be able to do well, but for reasons having nothing to do with intelligence alone, they sometimes do not. Similarly, it appears that only a few children who experience themselves to be seriously rejected are well adjusted psychologically. On the other hand, children who experience love and acceptance by their parents have greater potential to develop the personality dispositions in the "positive" direction, but for reasons having nothing to do with perceived acceptance per se, some of these children are nonetheless psychologically maladjusted.

At this point I should also mention that PARTheory's personality theory tends to emphasize a phenomenological perspective to a greater degree than a behaviorist perspective. That is, PARTheorists generally recognize that the way you and I—and humans in general—subjectively experience or perceive our parents' love and love-withdrawal has greater impact on our own psychological state as well as future development than do so-called "objective" behaviors reported by another person about our families. Like beauty, parental love and acceptance are in the eyes of the beholder. This phenomenological orientation helps explain why many children who are legally defined as being abused or neglected do not necessarily feel rejected. Similarly, this perspective is important in cross-cultural and cross-ethnic research because almost any given "objective" behavior might be interpreted differently by people in different

sociocultural systems. That is what much of culture is all about, and that is an important part of what we study in comparative research. For reasons such as these, PARTheorists generally refer to *perceived* or *experienced* parental acceptance-rejection.

And now back to PARTheory's personality theory. According to the theory, the seven personality dispositions cited earlier are likely, for the following reasons, to emerge in most children who perceive themselves to be rejected, and they are apt to continue into maturity among many adults who had experienced rejection as children. The theory begins with the untested and probably untestable assumption that humans are born "prewired" with a fundamental need for positive response—for nurturance in infancy, warmth and affection in childhood, and positive regard from significant others in adulthood. And when we feel we do not get this positive response, damaging things begin to happen to us, especially when we get to be around 18 months of age and older. First of all, rejected children—children who feel they do not get their needs met satisfactorily for love, support, attention, and the like—generally increase their efforts, up to a point, to get such response from their parents. Young children may, for example, whine and cling when the parent is about to leave, or they may seek frequent physical contact when the parent returns. Older children and adults may express their need for positive response—especially in times of difficulty or illness—by seeking comfort, affection, solace, reassurance, approval, support, and like behaviors from people who are important to them—particularly from parents for youths, and from friends, spouses, or other kin for adults. These forms of behavior are called dependence.

In personality theory, dependence is construed as an emotional and behavioral continuum, with independence defining one end of the continuum and dependence the other. The dependence continuum refers to the degree to which individuals—you and I—rely emotionally on others, seek out others, or subjectively yearn for help, attention, or support from others, especially from people who are important to us. Independence refers to the relatively infrequent or unintense need for these behaviors; high dependence refers to frequent and strong needs for them. To make this more personal, reflect for a moment on the extent to which you seek or enjoy getting sympathy, encouragement, or comfort when you are not feeling well or when you are having some difficulty. (See also Table 2.) These are forms of dependence that normal people every-

where may engage in, in varying degrees. The accepted individual who is relatively independent—that is, healthily independent vs. defensively independent described below—feels the need to make such bids for attention, reassurance, and the like only occasionally. The rejected individual, who may be very dependent, may need constant reassurance, and emotional support.

Beyond a certain point in the rejection process, a point that varies from child to child, children are likely to feel ever-increasing anger, anxiety, and insecurity—emotions that become so painful that many rejected children close off emotionally from others in an effort to shield themselves from more hurt. And in so doing, many rejected children become emotionally unresponsive, and often defensively independent.

Defensive independence is different from healthy independence. In both cases the individual makes relatively few bids for positive response but in the case of defensive independence, the individual quits making bids for positive response not because of a true lack of felt-need for support, encouragement, love, but because of anger, distrust, and insecurity generated by the perceived rejection. Many defensively independent people say, in effect, "To hell with you! I don't need you. I don't need anybody. I can make it by myself." Such an attitude sometimes leads adolescents and young adults to counterreject their rejecting parent(s). Another common byproduct of the hurt associated with perceived rejection is the individual's reduced ability or willingness to either give love or to accept it from others, for to do so exposes one to the painful possibility of being rejected again.

The hurt of perceived rejection also tends to impair people's feelings of self-esteem and self-adequacy. Most people around the world, you and me included, seem to view themselves to some degree as they imagine significant others view them, and if we believe that our parents, as the most significant of others in childhood, do not like us, then we are apt to think of ourselves as being unlikable. If we feel they do not love us, then we often come to think of ourselves as being unlovable, perhaps even unworthy of love, and maybe even worthy of being despised. In this way many rejected children are apt to develop a sense of overall negative self-esteem and negative self-adequacy. Moreover, as a result of all the psychological damage so common among unloved children and adults, the rejected individual is inclined to have less tolerance for stress, and thus to be less emotionally stable than the typical

person who feels loved and accepted. To what extent do small setbacks tend to upset you (emotional instability)? Or alternatively, to what degree can you take a lot of frustration without getting angry or upset (emotional stability)?

Finally, individuals who have experienced so much hurt at the hands of their parents and who, as a result, often dislike themselves and are angry, insecure, and the like, come to expect little good from life. The very essence of life and of existence itself for many rejected people is viewed as threatening, dangerous, and unhappy. This is what we call negative world view, in personality theory. To what extent do you personally tend to view the world as a threatening, dangerous place (negative world view), or to what extent do you see it as good, friendly, and secure (positive world view)? As with the other six personality dispositions associated theoretically with perceived acceptance-rejection, personality theory postulates that one's worldview is influenced directly by the experiences of love and love-withdrawal that we had as youths growing up at home.

After studying several thousand individuals in the United States and an equal number within different communities internationally, and after reviewing parent-child relations and personality development in more than 200 societies worldwide, we conclude that the major postulates of PARTheory's personality theory are essentially correct—that they work for humans everywhere regardless of cultural differences, ethnic differences, racial differences, language differences, gender differences, social class differences, or under other such conditions. Remarkably, no society has yet been found where the principal tenets of our personality theory fail to be supported. In effect, it appears that we humans have become predisposed through the course of human evolution to respond in essentially the same way when we experience ourselves to be loved or unloved by the people most important to us in childhood.

What are some of the implications of these conclusions? Since PARTheory and research show definite consistencies worldwide in antecedents, effects, and correlates of perceived acceptance-rejection, it may now be possible to begin formulating social policies, parent education programs, mental health programs, and similar applied programs that will be fair and effective across social classes, ethnic groups, and sociocultural boundaries more widely. Policies and programs based solely on the idiosyncrasies of a specific people in a particular

time and place in history are policies and programs that will, in many cases, eventually prove unworkable, and probably even exploitative for some populations. Social policies and helping programs based on established principles of human behavior, however, stand a chance of working well as men and women of wisdom struggle to create a fair and humane social order for people of all nations and ethnic minorities.

REFERENCES

Rohner, R.P. (1986) *The warmth dimension: Foundations of parental acceptance-rejection theory.* Newbury Park, CA: Sage Publications, Inc. (Reprinted by UConn Coop, U-19, Storrs, CT 06269. 1991.)

Rohner, R. P. (1980). *Handbook for the study of parental acceptance and rejection.* Center for the Study of Parental Acceptance and Rejection, University of Connecticut, 1980; revised 1984, 1990. Second printing, 1991.

Rohner, R. P. (1975). *They love me, they love me not: A worldwide study of the effects of parental acceptance and rejection.* New Haven: HRAF Press, 1975. (Reprinted by UConn Coop, U-19, Storrs, CT 06269. 1991.)

Rohner, R.P. and M. Chaki-Sircar (1988). *Women and children in a Bengali village.* Hanover, NH: University Press of New England.

Rohner, R.P., and E.C. Rohner, eds. (1991). *Worldwide tests of parental acceptance-rejection theory.* Special Issue, Behavior Science Research, 1980, 15, (whole issue). (Reprinted by UConn Coop, U-19, Storrs, CT 06269.)

17

The Longest War: Gender and Culture

CAROLE WADE AND CAROL TAVRIS

A young boy notices, at an early age, that he seems different from other boys. He prefers playing with girls. He is attracted to the work adult women do, such as cooking and sewing. He often dreams at night of being a girl, and he even likes to put on the clothes of girls. As the boy enters adolescence, people begin to whisper that he's "different," that he seems feminine in his movements, posture, and language. One day the boy can hide his secret feelings no longer, and reveals them to his parents.

The question: How do they respond?
The answer: It depends on their culture.

In twentieth-century North America and Europe, most parents would react with tears, anger, or guilt ("Where did we go wrong?"). After the initial shock, they might haul their son off to a psychiatrist, who would diagnose him as having a "gender identity disorder" and begin intensive treatment. In contrast, if their daughter wanted to be "more like a man," the parents' response would probably be far milder. They might view a girl's desire to play hockey or become a construction worker as a bit unusual, but they probably wouldn't think she had a mental disorder.

These reactions are not universal. Until the late 1800s, in a number of Plains Indians and western Indian tribes, parents and other elders reacted with sympathy and understanding when a young person wanted to live the life of the other sex. The young man or woman was often given an honored status as a shaman, a person with the power to cure illness and act as an intermediary between the natural and spiritual worlds. A boy was permitted to dress as and perform the duties of a woman, and a girl might become a warrior. In some Native American cultures, the young man would be allowed to marry another man, the young woman to marry another woman.

In the Sambian society of Papua New Guinea, parents would react still differently. In Sambia, re-

Carole Wade earned her Ph.D. in cognitive psychology at Stanford University; taught at the University of New Mexico, where she initiated a course on gender; was professor of psychology at San Diego Mesa College; and currently teaches at College of Marin in California. She is co-author, with Carol Tavris, of *The Longest War: Sex Differences in Perspective* and of *Psychology,* the first textbook to emphasize critical thinking and to mainstream research on culture and gender into the introductory course. Wade is also co-author, with Sarah Cirese, of *Human Sexuality.*

Carol Tavris earned her Ph.D. in Social Psychology at the University of Michigan, where she first became interested in cross-cultural psychology and gender studies. She has taught at the New School and UCLA and is widely known as a writer and lecturer on many social issues. In addition to her books with Carole Wade, she is author of *The Mismeasure of Woman* and *Anger: The Misunderstood Emotion.*

It is impossible to remove all gender bias — and is there any need to?

Basic vs Applied

ports anthropologist Gilbert Herdt (1984), all adolescent boys are *required* to engage in oral sex with older men as part of their initiation into manhood. Sambians believe that a boy cannot mature physically or emotionally unless he ingests another man's semen over a period of several years. However, Sambian parents would react with shock and disbelief if a son said he wanted to live as a woman. Every man and woman in Sambian society marries someone of the other sex and performs the work assigned to his or her own sex; no exceptions.

What these diverse reactions tell us is that although anatomical *sex* is universal and unchangeable (unless extraordinary surgical procedures are used), *gender,* which encompasses all the duties, rights, and behaviors a culture considers appropriate for males and females, is a social invention. It is gender, not anatomical sex, that gives us a sense of personal identity as male or female. Cultures have different notions about what gender roles should entail, how flexible these roles ought to be, and how much leeway males and females have to cross the gender divide.

Perhaps, however, there is something essential about the sexes, something lying *beneath* the veneer of culture, immutable and eternal. That assumption is certainly widespread, and it has guided the research of social scientists as well as the beliefs of laypersons. Let us examine this assumption more closely. Are there some aspects of masculinity and femininity that occur at all times and in all places? If certain characteristics are common, why is that so? What determines how men and women should act toward each other, what their rights and obligations should be, and what it means, in psychological terms, to be female or male?

SEARCHING FOR THE ESSENTIAL MAN AND WOMAN

By comparing and contrasting different cultures around the world, social scientists have tried to identify those aspects of gender that are universally male or female. Their efforts may sound pretty straightforward. However, because researchers, like everyone else, are influenced by their own deeply felt perceptions and convictions about gender, the topic has been one of the most complex to study cross-culturally.

For many years American and European researchers looked for and found evidence that primate males (human and ape) were "by nature" competitive, dominant, and promiscuous, whereas primate females were "by nature" cooperative, submissive, and monogamous (Tavris, 1992). Because of their own preconceptions about male and female roles, based on their own cultural experiences, these observers often overlooked the evidence that contradicted their assumptions, even when the evidence was in front of their noses.

For example, many years ago the famous anthropologist Bronislaw Malinowski wrote a book on the Trobriand Islanders, in which he concluded that males controlled the economic and political life of the community. (Another of his biases is glaringly apparent in the title he gave his book: *The Sexual Life of Savages*.) But when Annette Weiner went to live among the Trobrianders many years later, she learned, by talking to the women, what Malinowski had not: that there was an important economic underground controlled by the labor and exchanges of women.

Similarly, in 1951, another famous anthropologist, E. E. Evans-Pritchard, reported that among the Nuer, a tribe living in the Sudan, husbands had unchallenged authority over their wives. Yet he himself described incidents in Nuer family life that contradicted his conclusion:

[Should a Nuer wife] in a quarrel with her husband disfigure him—knock a tooth out, for example—her father must pay him compensation. I have myself on two occasions seen a father pay a heifer to his son-in-law to atone for insults hurled at the husband's head by his wife when irritated by accusations of adultery.

We don't approve of domestic violence, nor do we think the wife's actions cancel out men's political power over women in Nuer culture. However, as anthropologist Micaela di Leonardo observes, a husband's authority in the home is not absolute if his wife can insult him and knock his teeth out, and all he can do is demand that his father-in-law fork over a cow!

Many early researchers not only assumed that male dominance and aggression were universally the province of men; they also assumed that female nurturance was universally the province of women. Because of this assumption, Western researchers often overlooked the nurturing activities of men, or even *defined* nurturance in a way that excluded the altruistic, caring actions of men. When anthropologist David Gilmore (1991) examined how cultures

around the world define manhood, he expected to find masculinity equated with selfishness and hardness. Instead he found that it often entails selfless generosity and sacrifice. "Women nurture others directly," notes Gilmore. "They do this with their bodies, with their milk and their love. This is very sacrificial and generous. But surprisingly, 'real' men nurture, too, although they would perhaps not be pleased to hear it put this way." Men nurture their families and society, he observes, by "bringing home food for both child and mother . . . and by dying if necessary in faraway places to provide a safe haven for their people." (pp. 229–230)

Our own cultural stereotypes, then, affect what we see in other cultures and how we interpret what we see. Still, a few common themes—not universal, mind you, but common—do emerge from the cross-cultural study of gender. Generally speaking, men have had, and continue to have, more status and more power than women, especially in public affairs. Generally speaking, men have fought the wars and brought home the meat. If a society's economy includes hunting large game, traveling a long way from home, or making weapons, men typically handle these activities. Women have had the primary responsibility for cooking, cleaning, and taking care of small children.

Corresponding with this division of jobs, in many cultures around the world people regard masculinity as something that boys must achieve through strenuous effort. Males must pass physical tests, must endure pain, must confront danger, and must separate psychologically and even physically from their mothers and the world of women. Sometimes they have to prove their self-reliance and courage in bloodcurdling initiation rites. Femininity, in contrast, tends to be associated with responsibility, obedience, and childcare, and it is seen as something that develops naturally, without any special intervention from others.

THE INVENTION OF GENDER

From these commonalities, some theorists have concluded that certain fundamental aspects of gender must be built into our genes. Biological factors—the fact that women are (so far) the only sex that gets pregnant and that men, on the average, have greater upper body strength—undoubtedly play some role in the sexual division of labor in many societies. But biology takes us only so far, because, when we remove our own cultural blind-

ers and look at the full cross-cultural picture, the range of variation among men and women, in what they do and in how they regard one another, is simply astonishing.

For instance, in some places women are and have been completely under the rule of men, an experience reflected in the haunting words of the Chinese poet Fu Hsuan: "How sad it is to be a woman! Nothing on earth is held so cheap." Women in Saudi Arabia today are not allowed to drive a car; many girls in India submit to arranged marriages as early as age nine; girls and women in the Sudan and other parts of Africa are subjected to

> But biology takes us only so far, because, when we remove our own cultural blinders and look at the full cross-cultural picture, the range of variation among men and women, in what they do and in how they regard one another, is simply astonishing.

infibulation (the practice of cutting off the clitoris and much of the labia, and stitching together the vaginal opening), allegedly to assure their virginity at marriage. Yet elsewhere women have achieved considerable power, influence, and sexual independence. Among the Iroquois, some of the older wives played an important role in village politics. Although they could not become members of the Council of Elders, the ruling body, they had a major say in its decisions. In this century, women have been heads of state in England, Israel, India, Sri Lanka, Iceland, and elsewhere.

Thus it is an oversimplification to say that men are the dominant sex, women the subordinate one. The status of women has been assessed by measures of economic security, educational opportunities, access to birth control and medical care, degree of self-determination, participation in public and political life, power to make decisions in the family, and physical safety. According to these indexes, the status of women worldwide is highest in Scandina-

vian countries and lowest in Bangladesh, with tremendous variation in between.

Similarly, cultures vary in many other aspects of male-female relations:

- The *content* of what is considered "men's work" and "women's work" differs from culture to culture. In some cultures, men weave and women do not; in others, it's the opposite. In many cultures women do the shopping and marketing, but in others marketing is men's work.

- In many cultures, women are considered the "emotional" sex and are permitted to express their emotions more freely than men. But in cultures throughout the Middle East and South America, men are permitted (and expected) to be as emotionally expressive as women, or even more so, whereas many Asian cultures expect *both* sexes to control their emotions. Moreover, the rules about which sex gets to display which emotion are quite variable. In one major international study, Israeli and Italian men were more likely than women to control feelings of sadness, but British, Spanish, Swiss, and German men were *less* likely than women to inhibit this emotion.

- Cultures differ in the degree of daily contact that is permitted between the sexes. In many farm communities and in most modern occupations in North America and Europe, men and women work together in close proximity. At the other end of the continuum, some Middle Eastern societies have a tradition of *purdah*, the veiling of women and the seclusion of wives from all male eyes except those of their relatives.

- In some cultures, as in Iran or the Sudan, women are expected to suppress all sexual feeling (and certainly behavior) until marriage, and premarital or extramarital sex is cause for the woman's ostracism from the community or even death. In others, such as Polynesia, women are expected to have sex before marriage. In still others, such as the Toda of India, women were allowed to have extramarital affairs (as long as they told their husbands and didn't sneak around).

Perhaps no society challenges our usual assumptions about the universal nature of psychological maleness and femaleness as profoundly as Tahiti. For over two centuries, Western visitors to Tahiti have marveled at the lack of sexual differentiation among its peaceful inhabitants. Early European sailors who arrived on the island reported that Tahitian women were free to do just about everything the men did. Women could be chiefs, they could take part in all sports, including wrestling, and they enjoyed casual sex with many different partners.

In the 1960s, anthropologist Robert Levy lived among the Tahitians and confirmed that they didn't share Westerners' ideas about gender. Men in Tahiti were no more aggressive than women, nor were women gentler or more maternal than men. Men felt no obligation to appear "manly" or defend "male honor," and women felt no pressure to be demure and "womanly." The Tahitians seemed to lack what psychologist Sandra Bem has called a "gender schema," a network of assumptions about the personalities and moral qualities of the two sexes. To Tahitians, Levy found, gender was just no big deal. Even the Tahitian language ignores gender: Pronouns are not different for males and females, and most traditional Tahitian names are used for both sexes.

The existence of cultures such as Tahiti, together with the wide variations in gender roles that exist around the world, suggest that the qualities that cultures link with masculinity and femininity are not innately male or female. Instead, they are, in the language of social science, *socially constructed*. As David Gilmore puts it, "gender ideologies are social facts, collective representations that pressure people into acting in certain ways."

WHERE DO THE RULES OF GENDER COME FROM?

When most people read about the customs of other cultures, they are inclined to say, "Oh, boy, I like the sexual attitudes of the Gorks but I hate the nasty habits of the Dorks." The point to keep in mind is that a culture's practices cannot easily be exported elsewhere, like cheese, or surgically removed, like a tumor. *A culture's attitudes and practices regarding gender are deeply embedded in its history, environment, economy, and survival needs.*

To understand how a society invents its notions of gender, we need to understand its political system and its economy, and how that economy is affected by geography, natural resources, and even the weather. We need to know who controls and distributes the resources, and how safe a society is

from interlopers. We need to know the kind of work that people do, and how they structure that work. And we need to know whether there is environmental pressure on a group to produce more children, or to have fewer of them. In short, we need to know about *production* and *reproduction*.

For example, David Gilmore found that rigid concepts of manhood tend to exist wherever there is a great deal of competition for resources—which is to say, in most places. For the human species, life has usually been harsh. Consider a tribe trying to survive in the wilds of a South American forest; or in the dry and unforgiving landscape of the desert; or in an icy Arctic terrain that imposes limits on the number of people who can survive by fishing. When conditions like these exist, men are the sex that is taught to hunt for large game, compete with each other for work, and fight off enemies. (As we've noted, this division of labor may originally have occurred because of men's relatively greater upper-body muscular strength and the fact that they do not become pregnant or nurse children.) Men will be socialized to resist the impulse to avoid confrontation and retreat from danger. They will be "toughened up" and pushed to take risks, even with their lives.

How do you get men to do all this? To persuade men to wage war and risk death, argues anthropologist Marvin Harris (1974), societies have to give them something—and the something is prestige, power, and women. That in turn means you have to raise obedient women; if the King is going to offer his daughter in marriage to the bravest warrior, she has to go when given. In contrast, David Gilmore finds, in cultures such as Tahiti, where resources are abundant and there are no serious hazards or enemies to worry about, men don't feel they have to prove themselves or set themselves apart from women.

The economic realities of life also affect how men and women regard each other. Ernestine Friedl has described the remarkable differences between two tribes in New Guinea. One tribe, living in the highlands, believes that intercourse weakens men, that women are dangerous and unclean, and that menstrual blood can do all sorts of terrifying things. Sex is considered powerful and mysterious; if it is performed in a garden, the act will blight the crops. Antagonism between the sexes runs high; men often delay marriage and many remain single. Not far away, another tribe has an opposite view of women and sex. People in this tribe think sexual intercourse is fun and that it revitalizes men. Sex, they say, *should* take place in gardens, as it will foster the growth of plants. Men and women do not live in segregated quarters, as they do in the highlands, and they get along pretty well.

One possible explanation for these differences is that the highland people have been settled a long time and have little new land or resources. If the population increased, food would become scarce. Sexual antagonism and a fear of sexual intercourse help keep the birth rate low. The sexy tribe, however, lives in uncultivated areas and needs more members to work the land and help defend the group. Encouraging positive attitudes toward sex and early marriage is one way to increase the birth rate.

Cross-cultural studies find that when the sexes are mutually dependent and work cooperatively, as in husband-wife teams, sexual antagonism is much lower than when work is organized along sex-segregated lines. Among the Machiguenga Indians of Peru, where the sexes cooperate in growing vegetables, fishing, and recreation, husbands and wives feel more solidarity with each other than with their same-sex friends. Among the Mundurucu, however, women and men work in same-sex groups, and friendships rarely cross sexual lines; women therefore feel a sense of solidarity with other women, men with men.

In our own culture, changing conditions have profoundly influenced our ideas about gender as well as our family relationships. According to Francesca Cancian (1987), before the nineteenth century, the typical household was a cooperative rural community in which both spouses shared responsibility for the material and emotional well-being of the family. Men didn't "go to work"; work was right there, and so was the family. Women raised both chickens and children. This is not to say that the two sexes had equal rights in the public domain, but in psychological terms they were not seen as opposites.

But with the onset of the industrial revolution, shops and factories began to replace farming, and many men began to work apart from their families. This major economic change, argues Cancian, created a rift between "women's sphere," at home, and "men's sphere," at work. The masculine ideal adjusted to fit the new economic realities, which now required male competitiveness and the suppression of any signs of emotional "weakness." The feminine ideal became its opposite: Women were now seen as being "naturally" nurturant, emotional, and fragile.

WHAT'S AHEAD?

In the twentieth century, two profound changes in production and reproduction are occurring that have never before happened in human history. Most jobs in industrial nations, including military jobs, now involve service skills and brainwork rather than physical strength. Reproduction, too, has been revolutionized; although women in many countries still lack access to safe and affordable contraceptives, it is now possible for women to limit reliably the number of children they will have and to plan when to have them. The "separate spheres" doctrine spawned by the industrial revolution is breaking down in this post-industrial age, which requires the labor of both sexes.

As these changes unfold, ideas about the "natural" qualities of men and women are also being transformed. It is no longer news that a woman can run a country, be a Supreme Court justice or a miner, or walk in space. It is no longer news that many men, whose own fathers would no more have diapered a baby than jumped into a vat of boiling oil, now want to be involved fathers.

What a cross-cultural, historical perspective teaches us, then, is that gender arrangements, and the qualities associated with being male and female, are not arbitrary. Our ideas about gender are affected by the practical conditions of our lives. These conditions are far more influential than our hormones in determining whether men are expected to be fierce or gentle, and whether women are expected to be financially helpless or Wall Street whizzes.

The cross-cultural perspective reminds us too that no matter how entrenched our own notions of masculinity and femininity are, they can be expected to change—as the kind of work we do changes, as technology changes, and as our customs change. Yet many intriguing questions remain. Do men and women need to feel that they are psychologically different from one another in some way? Will masculinity always rest on male achievements and actions, and femininity on merely being female? Since most of us cannot move to Tahiti, but must live in a world in which wars and violence persist, is it wise or necessary to make sure that at least one sex—or only one sex—is willing to do the dangerous work?

Marvin Harris has argued that male supremacy was "just a phase in the evolution of culture," a phase that depended on the ancient division of labor that put men in charge of war and women in charge of babies. Harris predicts that by the 21st century, male supremacy will fade and gender equality will become, for the first time in history, a real possibility.

Is he right? How will gender be constructed by our own culture in the next century? What do you think?

REFERENCES

Cancian, Francesca (1987). *Love in America: Gender and self-development*. Cambridge, England: Cambridge University Press.

Gilmore, David (1991). *Manhood in the making*. New Haven, CT: Yale University Press.

Harris, Marvin (1974). *Cows, pigs, wars, and witches: The riddles of culture*. New York: Random House.

Herdt, Gilbert H. (1984). *Ritualized homosexuality in Melanesia*. Berkeley: University of California Press.

Kimmel, Michael S. (1987). *Changing men: New directions in research on men and masculinity*. Beverly Hills, CA: Sage.

Tavris, Carol (1992). *The mismeasure of woman*. New York: Simon & Schuster.

Section IV

Culture's Influence on Basic Psychological Processes

Imagine that you are living on one of the islands in the South Pacific. Imagine also that the only way you can get from your island to other small islands, many miles away, is by small canoe. You have no navigational equipment on your simple but sturdy canoe, the seas are often treacherous, and even the shortest trip might take several days. How would you go about solving this navigational problem?

To many seafarers from Pulawat Island in the Carolines, some 2,000 nautical miles east of the Philippines, this is no problem. Moreover, their ancestors have been navigating vast ocean expanses on similar small canoes for centuries. What's their secret? They use various techniques, and one of the most effective uses the idea of the "moving island." The navigator visualizes his canoe as a small, stationary object, a fixed point under the sky. To him, the water is on an endless voyage, carrying with it the various islands and atolls that slip past in particular patterns and at rates that have been established from previous journeys. Almost without error these mariners use this navigational technique, which involves the intricate study of water currents and patterns which change as the island approaches. Then they catch it. Not even the most accomplished graduate of a Western naval academy would dare do this, yet the Pulawat argonauts get along just fine, night or day, fair weather or foul (see Gladwin, 1970).

Alas, this remarkable skill is slowly fading, replaced by technological innovations that are faster and more "modern." But such anecdotes are useful reminders to those who study how humans think, perceive, solve problems, and otherwise try to comprehend their world: cognitive and perceptual problems are often *relative* to each and every culture, and so are their solutions. Such reports also teach us that the Western way of solving problems and conceptualizing the universe is not the *only* way. If people could only shed themselves of ethno-centric thinking, they would see that humans are extremely adaptive, and that no one culture or group of people has a patent on the "best" way to solve pertinent and often complex problems.

What is meant by the phrase, "basic psychological processes?" It refers to the essential ways that humans process their world through the various sensory channels. These channels include vision, hearing, touch, smell, taste, and the kinesthetic senses. Basic processes also include memory, thinking, learning, and any other cognitive machinations humans possess, enabling them to comprehend and organize a complex world and give it order. They encompass, as well, phenomena in the social world. In fact, the human being processes *everything* he or she happens to encounter. A question has concerned psychologists and philosophers for many years: do *all* people use these basic processes in the same way? In Chapter 18, Adamopoulos and Lonner summarize some answers to this question, showing that there are essentially three ways to approach a possible answer: absolutely, relativistically, and universally. The chapter is an appropriate beginning to this section, for the remaining five chapters concern some important perspectives on basic psychological processes.

The substantive topics in this section were chosen because they represent important ways that cross-cultural psychologists have studied basic psychological processes. The authors were chosen because for a good portion of their careers they have been intrigued about the role culture plays in how humans perceive and organize their worlds. For instance, in 1966, Marshall Segall and two of his colleagues published a book that has proven to be a cross-cultural classic: *The Influence of Culture on Visual Perception.* In that book, a very simple yet crucial question was asked: What is more important in human vision, the basic physiology of the eye that

nearly all people share (with variations, usually minor, often correctable with glasses or surgery) or the culture in which they have been socialized? This is essentially the argument between *nativists* and *empiricists*, or the role played by the "hard-wiring" of human physiology as contrasted with ongoing interactions with complex environments. In Chapter 19 Segall presents the basic points that are enmeshed in this debate that has pitted nature against nurture.

About a generation ago, many anthropological reports and anecdotes from sojourners talked enthusiastically about the fantastic memory feats of people who live in pristine and "primitive" environments. One popular theory was that, since people (often poetically but pejoratively called the "noble savage") in such edenic places did not have to cope with the complexities of modern life their available mental energy was channeled into memory (or sometimes vision, taste, or other sensory processes). However, it is now known that any "fantastic" feat of memory displayed by certain groups of people can likely be explained by examining in detail the demands of particular environments. Jayanthi Mistry and Barbara Rogoff, in Chapter 20, explain how memory processes are best understood through a careful analysis of demands presented by particular cultures.

Developmental psychologists, as their title implies, are interested in the full range of changes that occur in the human being, both physically and mentally, as time marches on. A major focus in this area is cognitive development—that is, the changes in thought processes, reasoning, and in general comprehending the world that occur over time. Arguably the most influential person ever in theorizing and researching such changes has been the late Jean Piaget, a Swiss psychologist. Pierre Dasen, himself a Swiss developmental psychologist, studied under Piaget at the University of Geneva. Piaget's ideas have been carried to the far corners of the earth, and perhaps more than anyone else Dasen knows how to interpret the results of Piagetian research that has been done in other cultures. In Chapter 21, he summarizes several important parts of Piaget's theory, examining it from the perspective of culture.

Like almost everyone else, you have probably said something like this: "I can't study the way Jim

studies. He has to have a quiet room, with no distractions. That's just not my style. I do best when there's background noise, or when I hear lots of voices in the background." If such "learning styles" differ among people, might there be differences across cultures and ethnic groups as well? Do Native Americans in Alaska learn differently than African Americans in Detroit? Do Italians differ from Japanese when it comes to stuffing new knowledge in their heads? Judith Kleinfeld, who has worked for many years in Alaska, tackles the question of learning styles and culture in Chapter 22. You might be surprised by some of her observations and conclusions based upon her careful review of the evidence.

The last chapter in this section concerns what is probably the most controversial and most widely studied single concept in all of psychology: human intelligence. Books by the hundreds have been written on this topic. Theories about the nature and function of intelligence range all the way from totally genetic, which has spawned much bigotry and even riots, to totally environmental. And while it is ironic that psychologists still have not developed a completely satisfactory definition of intelligence, we can take some comfort in the fact that cross-cultural research has shed considerable light on the riddle of human competency. Robert Serpell has spent much of his professional life in Zambia. As an expert on how human intelligence is measured by tests and manifested in actual behavior, the insights he gives in Chapter 23 are valuable as an introduction to this thorny topic.

Taken together the chapters in this section, written by acknowledged experts in the careful study of human cognition and culture, serve our objective in this part of the book: to introduce the student to several key topics that are central to an understanding of fundamental psychological processes.

REFERENCE

Gladwin, T. (1970). *East is a big bird*. Cambridge: Cambridge University Press.

18

Absolutism, Relativism, and Universalism in the Study of Human Behavior

JOHN ADAMOPOULOS AND WALTER J. LONNER

Man is the measure of all things: of things that are, that they are; of things that are not, that they are not. [Protagoras (ca. 480–411 B.C.), Fr. 1 (Trans., Wheelwright, 1960)]

There is a doctrine of Protagoras in which he said that man is the measure of all things. He was saying, in other words, that each individual's private impression is absolutely true. But if that position is adopted, then it follows that the same thing is and is not, that it is both good and bad, and similarly for other contributions; because, after all, a given thing will seem beautiful to one group of people and ugly to another, and by the theory in question each of the conflicting appearances will be 'the measure' " [Aristotle (384–322 B.C.), Metaphysica, 1062b 13 (Trans., Wheelright, 1960)]

Vérité en-deça des Pyrénées, erreur au-delà (There are truths on this side of the Pyrenees which are falsehoods on the other.) —BLAISE PASCAL, 1623–1662

(Translated by G. Hofstede in his book Culture's consequences: International differences in work-related values*)*

John Adamopoulos is an Associate Professor of Psychology at Grand Valley State University, in Allendale, Michigan. He received his Ph.D. in social psychology at the University of Illinois in 1979, and taught for a number of years at Indiana University at South Bend. His research interests focus on models of interpersonal structure and on the emergence of meaning systems. He has been the Editor of the *Cross-Cultural Psychology Bulletin* since 1990.

De gustibus non disputandum (Latin: "There is no disputing about tastes.")

(W)hat is truly true (beautiful, good) within one intentional world . . . is not necessarily universally true (beautiful, good) in every intentional world; and, what is not necessarily true (beautiful, good) in every intentional world may be truly true (beautiful, good) in this one or in that one. (Shweder, 1990, p. 3).

Beauty is in the eye of the beholder.

Few problems have received more attention, or have generated more controversy, in our intellectual history than the argument about which is the most appropriate perspective in the analysis of human nature: Can we, as observers of nature, detach ourselves from our surroundings, our own culture, and form some objective understanding of who we are and what we do (as Aristotle seems to suggest), or are the conceptions and explanations that we generate about ourselves inextricably bound by our own experiences (i.e., we are, in Protagoras' terms, "the measure of all things")?

This argument has been framed in different terms, and described with different labels over the centuries (e.g., objectivism and absolutism *versus* subjectivism and relativism), but certain basic ideas seem to underlie much of the discussion. In this chapter we will present briefly some of the ideas that are found at the core of this debate, and will attempt to show how this controversy may inform the investigation of sociopsychological phenomena from different theoretical perspectives.

129

TWO DIMENSIONS OF THE INQUIRY INTO HUMAN NATURE

The process of examining and explaining our own nature is obviously an enormously complicated enterprise. However, there are two particular aspects of this enterprise that are especially relevant to the present discussion. The first aspect concerns the question of whether or not our attempts to explain psychological processes assume, and, even more important, emphasize the possibility that there are substantial commonalities in the psychological makeup, experience, and behavior of all human beings. We often refer to this general idea as the assumption of the *psychic unity* of humankind (e.g., Boas, 1911; Shweder, 1990), and to commonalities in human experience and behavior as *psychological universals*.

The second aspect of our inquiry concerns the extent to which we assume that human beings cannot be studied in a vacuum, and that behavior can only be understood in the context in which it occurs, within the framework of a certain social environment, and, more broadly, within a culture. Modern psychology generally favors research that attempts to extricate people from their social environment in order to get at the "core" of human nature—whatever that may be. Increasingly, however, this position, which is sometimes referred to as the "mainstream" view, has been criticized by advocates of alternative perspectives, some of which we will examine later in this chapter.

At first glance, it may appear that these two dimensions of the inquiry into human nature are similar. After all, it could be argued that if we assume the psychic unity of humankind, then we necessarily ignore the role of culture in psychological explanation. That is not necessarily so, however. Figure 1 shows that different positions on the two dimensions may lead to competing perspectives in psychological inquiry. In fact, the three dominant orientations in psychology today differ significantly from each other with respect to these dimensions.

Position 1 in the figure emerges if we assume that we should not look for universals in human behavior, and that the cultural context in which behavior occurs is irrelevant to our inquiry. This approach concentrates almost exclusively on the uniqueness of individuals, and leads to an orientation that is generally incompatible with scientific activity, which generally focuses on the systematic

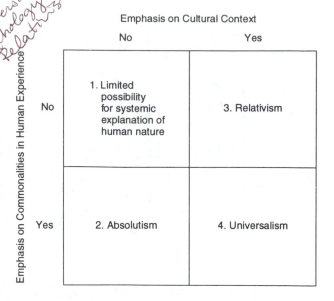

FIGURE 1 Emphasis on the importance of cultural context and of establishing commonalities in human nature in three major theoretical orientations

explanation of *patterns* of events or occurrences. For this reason, we will concentrate on the other three positions that emerge from this analysis.

ABSOLUTISM

Position 2 represents what we earlier called the "mainstream" orientation in modern psychology. It rests on the broad principle of psychic unity; in other words, it assumes that there is an underlying common ("true") nature to all human beings that can be identified, described, and used to explain the products of their activity. The fundamental assumption about the possibility of absolute truths is the reason why this position is occasionally referred to as "absolutism."

Scientists working from this position assume implicitly, and frequently explicitly, that there is a "true" psychological nature, which can be "discovered" if we manage to separate the participants in our research programs from the cultural and environmental forces that interact with their behavior. For this reason, much research in "mainstream" psychology aims at finding explanations for psychological phenomena by eliminating the environment or context within which they occur. An absolutist might view the colorful variations we call "cultures" as nothing more than a thin veneer that masks basic human truths that transcend both time

and context. The idea here, of course, is that "true" human nature will emerge when external, "nuisance" variables, such as cultural norms and expectations, ideologies, and so on, are sufficiently removed. As a result, this approach favors laboratory studies that minimize context and are low in realism.

[handwritten margin note: Life is not a laboratory. What good is it to understand behavior out of context – when does beh. not have a context?]

★ RELATIVISM

Absolutism has come under attack in recent years by many social and behavioral scientists, and by philosophers of science. These critics have argued that the search for absolute or fixed truths in the natural world is a futile endeavor, and is certainly unlikely to lead to any great insights about the human mind or human behavior. Instead, the critics suggest, it may be much more appropriate to concentrate on describing human beings as they exist and function within their sociocultural environment—an orientation that we may generally refer to as *relativism.*

This perspective has many faces, and has appeared in somewhat different forms in a variety of scientific disciplines. For example, work in American anthropology earlier in this century focused on the interpretation of the lives of various groups *exclusively* within the context of their own culture and modes of thought. In recent years, there has been a resurgence of this kind of thinking in an interdisciplinary field that is known as "cultural psychology" (Shweder, 1990).

Within psychology, "social constructionism" is a theoretical approach that has much in common with relativism. The general theme in this approach challenges the notion of fixed and universal truths in the explanation of human nature. Rather, it assumes that humans seek meaning, and *construct,* rather than *discover,* reality. Thus, explanations of human behavior are at least, in part, determined by the sociocultural and historical forces that impinge upon, interact with, and are invented by, the very people who formulate them (Gergen, 1982). Consequently, any attempt to generalize a particular psychological explanation to all human beings ultimately reflects *only* categories of thought that are indigenous to the scientists' own culture. One might even characterize this approach as "scientific isolationism," in the sense that what is scientifically valid in one culture is not *at all* intended to be valid elsewhere (although it *may* be valid elsewhere, either coincidentally or accidentally). Note that

from a relativistic standpoint even what is considered to be good and proper "science" *may* vary widely. One culture's complete reliance on the type of science that includes nuclear physics and almost miraculous surgical procedures may be equivalent to another culture's "science" that includes tea-leaf reading and animal sacrifice.

UNIVERSALISM ♠

Many psychologists interested in the dynamic interaction between human beings and their environment have, over the years, advocated yet another perspective—one that may be called *universalism.* This perspective assumes that it should, in theory, be possible to establish broad commonalities in human nature that reflect a deeper reality than the scientists' own conceptual categories. At the same time, advocates of this perspective agree with the relativists about the importance of culture, but insist that the search for psychological universals does not necessarily have to be conducted in a vacuum or out of context. In other words, they propose that it is possible to develop an

> **The universalist, like the absolutist, *may* view culture as a veneer that masks essential and eternal truths.**

approach to the study of human nature that emphasizes the importance of psychological universals, and is, at the same time, sensitive to cultural context. The universalist, like the absolutist, *may* view culture as a veneer that masks essential and eternal truths. However, while the absolutist tends to treat such cosmetic or superficial commonality as "nuisance" variation, the universalist considers cultural variation to be very important and very real regardless of what lies beneath the surface. In fact, many psychologists with a universalist orientation rely on research methods that emphasize both culture-specific and culture-general constructs (see the introductory chapter). Much research in the area of psychology and culture is done from this perspective. Psychologists interested in

comparisons of various phenomena across cultures often assume that psychological universals take a variety of forms, depending upon the constraints, requirements, and specific attributes of different cultures (Lonner, 1980). For example, Lonner (and *many* others) considers *aggression* (i.e., behavior that is intended to harm another person) to be a universal, because war and violent conflict have been present throughout the recorded history of our species (at an approximate rate of 2.6 wars per year). However, aggression may appear in different forms and circumstances in various societies: as ritualistic dance in one, as barroom brawls in another, and as verbal shouting and jousting in yet another. Universalism is an approach that formally seeks convergences and similarities in various human phenomena across cultures, while at the same time avoiding the shortsighted assumption that any given phenomenon occurs in exactly the same form in every occasion in which it is observed.

An important recent book by an anthropologist, Donald E. Brown, tackles the topic of universals (Brown, 1991). This well-written and well-researched book gives an impressive amount of information about human universals and how scholars over the years have grappled with the problem of universalism versus relativism. For the student interested in studying the topic further, this is the book that is a "must read."

As an illustration of the perspectives on human nature outlined above, we will present three different views of *intimacy,* which is generally considered to be one of the major forms of social interaction.

THE ANALYSIS OF INTIMACY

Intimacy cannot be understood as a single behavior. Rather, it is a psychological dimension (i.e., a dimension of meaning), along which may vary many particular forms of behavior and human communication. The three perspectives that we have been discussing, however, approach the study of intimacy in very different ways. What follows is a plausible theoretical analysis of intimacy from each perspective.

An Absolutist Perspective on Intimacy

The basic ingredient of this approach is, of course, reductionism, that is, an emphasis on reducing a natural phenomenon to its most basic, and, ideally, essential components. By observing many people in North America, with different personalities, interests, and value systems, researchers in this area have concluded that a key process in the experience of intimacy is *mutually rewarding self-disclosure.* That means that intimacy often involves, among other things, the closeness that people feel when they reveal very private thoughts to others, and learn what others feel and think about highly personal issues.

Once this key process is identified, scientists concentrate primarily on the causes and consequences of intimacy on very different people. For example, they ask questions such as, "How do people get others to self-disclose?" or, "Do we reveal more about ourselves after we hear another person self-disclose?" The particular identities of the persons involved in these exchanges—exactly who is disclosing personal information to whom, and in what circumstances—have little, if any, significance in this approach. Instead, it is generally assumed that if consistent answers to questions like the ones asked above are found for different people and circumstances, something about intimacy as a psychological process that applies to *all* human beings will have been discovered.

A Relativist Perspective on Intimacy

It is exactly questions about the identities of the participants in the process, their *own* ways of interpreting what happens during the interaction, that is of primary importance in a relativist analysis of this phenomenon. In other words, relativists object to the reductionism that is employed by researchers who believe that it is possible to isolate a psychological process from the particular circumstances that surround its occurrence.

A relativist account of this process might, for example, point to various cultures where intimate relationships (e.g., marriages) are arranged by the families of the people involved, and where the interaction of the two persons is constantly guided by convention and cultural norms that prohibit a great deal of disclosure of deep feelings between mates. In the Western world, such interaction may appear to lack spontaneity, and even intimacy, considering the description provided earlier. Yet, are we prepared to say that people in cultures that restrict self-disclosure are not capable of experiencing intimacy?

A relativist analysis of intimacy might also argue that even in situations and cultures where all the key ingredients *appear* to be present, what people often experience may in fact be very different from what "objective" science believes they do. Consider, for example, the relationship between Odysseus, the king of Ithaca, and his wife Penelope, in the great epic poem by Homer, *The Odyssey* (ca. 8th century B.C.). Following the fall of Troy, Odysseus overcame some 20 years of incredible hardship to join his wife. Both husband and wife showed remarkable patience and commitment to each other. When they finally reunited, they engaged in a great deal of self-disclosure and sexual intimacy. By our modern standards, Penelope and Odysseus seem to have experienced intimacy and love.

Yet, one may well ask if what these two people felt in their own time, within the context of their own culture, could possibly be the same as what modern mates experience in even vaguely similar circumstances. In fact, there is considerable historical evidence suggesting that feelings toward a member of one's family, in Homer's time, were not as personalized as they are today in the Western world. Instead, people often experienced a more "collective" love, that incorporated feelings toward a particular person, and feelings toward one's whole household (or *oikos*, in Ancient Greek). In other words, an analysis of intimacy from a relativist perspective would emphasize the need to understand how people *construct* and give meaning to this psychological experience in their own cultural and historical context.

A Universalist Perspective on Intimacy

Many psychologists who are interested in the search for universal processes, yet are sensitive to the importance of cultural context, would begin by noting that the notion of intimacy appears in many cultures in one form or another. For example, most cultures have some concept of friendship, interpersonal closeness, and love. While acknowledging that the context in which these notions appear is crucial, a universalist approach would attempt to identify common elements associated with the experience of intimacy.

This approach can also address some of the concerns expressed by social constructionism, reviewed earlier, regarding the historical and cultural limitations of psychological explanation. For example, while there may be many culturally-shaped ways of thinking about how people behave toward each other, there is not necessarily an infinite number of such ways. In addition, the particular ways in which people interact, and interpret interaction, in any given culture may not be haphazard.

Adamopoulos (1988), for example, has proposed that all behavior among people (interpersonal behavior) may ultimately, and in a very general way, be understood as the exchange of resources (see also Foa & Foa, 1980). Thus, when a person kisses another, she may be offering a resource of love to the other. In exchange, the other person may also offer love, in the form of, say, the statement "I love you." The particular behaviors, or forms of exchanging the resource of love, may differ significantly from culture to culture (e.g., a person may respond by offering flowers in one culture, while in another culture a person may respond by smashing one hundred dishes and dancing for two hours without a break!). The important thing is that in all these cases people are *exchanging resources*.

In the course of such exchanges, people may sometimes pay special attention to the identity and particular characteristics of the other person. Furthermore, the interaction may occasionally involve exchanges that are relatively concrete or material (as opposed to abstract or symbolic); for example, acts involving physical contact, or financial, material, or emotional support. In such cases, human beings may be experiencing intimacy. The specific forms that these exchanges take may be extremely different—even unrecognizable—across cultures. What is important is that human beings will develop the concept of intimacy, broadly defined, under certain conditions. The specification of these conditions is one of the major goals of the universalist perspective.

A CONCLUDING COMMENT

This chapter has introduced a number of philosophical concepts that have frequently been the source of much discussion and argument by scholars who study human behavior. We have briefly summarized three viable positions that have been adopted by those who seek to understand why humans behave the way they do:

1. The *absolutist* position, which treats cultural variation as a "nuisance" in attempts to establish iron-clad "laws" of human behavior.

2. The *relativist* position, which gives highest priority to the *context* in which behavior takes place, and which rejects reductionism.
3. The *universalist* position, which respects the relativists' views, but which also makes room for both culture-common phenomena and some underlying principles that may govern human behavior.

Two of these positions are somewhat related to the discussion of the "culture-general" versus "culture-specific" dichotomy described in the introductory chapter. There are complications in taking one side *or* the other; life isn't that simple. The absolutist position was also mentioned in the introductory chapter as a position that we think is untenable, or at least shortsighted. Readers, especially those who enjoy dabbling with interesting philosophy of science concepts, may find it helpful at this time to review the introductory chapter.

We also want to point out that limited space restricted a discussion of these ideas in the form of many concrete examples. We chose to show how one concept, *intimacy*, can be analyzed from the perspectives of absolutism, relativism, and universalism. However, *any* psychological concept that implies human variation (and that includes just about everything psychologists study) can be analyzed from these three perspectives. In fact, probably every topic in this book can be discussed along the lines presented in this chapter. Certainly an understanding of all the topics in the chapters to follow in this section could be aided by a review of the basic perspectives we have discussed in this brief chapter.

REFERENCES

Adamopoulos, J. (1988). Interpersonal behavior: Cross-cultural and historical perspectives. In M. H. Bond (Ed.), *The cross-cultural challenge to social psychology* (pp. 196–207). Newbury Park, Cal.: Sage.

Boas, F. (1911). *The mind of primitive man.* New York: Macmillan.

Brown, D. E. (1991). *Human universals.* Philadelphia: Temple University Press.

Foa, E. B., & Foa, U. G. (1980). Resource theory: Interpersonal behavior as exchange. In K. J. Gergen, M. S. Greenberg, & R. H. Willis (Eds.), *Social exchange: Advances in theory and research* (pp. 77–94). New York: Plenum.

Gergen, K. J. (1982). *Toward transformation in social knowledge.* New York: Springer-Verlag.

Lonner, W. J. (1980). The search for psychological universals. In H. C. Triandis & W. W. Lambert (Eds.), *Handbook of cross-cultural psychology: Perspectives* (Vol. 1, pp. 143–204). Boston: Allyn & Bacon.

Shweder, R. A. (1990). Cultural psychology—what is it? In J. W. Stigler, R. A. Shweder, & G. Herdt (Eds.), *Cultural psychology: Essays on comparative human development.* Cambridge: Cambridge University Press.

Shweder, R. A. and Sullivan, M. A. (1993). Cultural psychology: Who needs it? *Annual Review of Psychology, 44,* 497–523.

Wheelwright, P. (1960) (Ed.). *The Presocratics.* Indianapolis: Bobbs-Merrill.

19

A Cross-Cultural Research Contribution to Unraveling the Nativist/Empiricist Controversy

MARSHALL H. SEGALL

The premise that the world is what it appears to be was challenged many centuries ago by Plato (circa 390 BC) in his famous parable of the cave (*Republic* 7). According to the parable, people are imprisoned in the cave, able to see only shadows and reflections of what transpires about them. Plato's point was that the prisoners will take these shadows for reality. If the prisoners are released and directly witness the events that are casting the shadows, Plato said, the objects and events will appear less real than their reflections.

Other philosophers followed Plato in warning against naive realism—the widespread tendency of us mortals to assume that the world is as it appears, a tendency reinforced by the apparent clarity, constancy, and "thing-ness" of the content of most of our perceptions. To us, objects seem solid, despite all the space contained in every atom of any object.

Marshall H. Segall began his career in cross-cultural psychology in the 1950s, influenced by Donald Campbell, Melville Herskovits, Otto Klineberg, Leonard Doob, and Jean Piaget. Spending most of his career at Syracuse University, in the Maxwell School, and as Associate Dean of Arts and Sciences, he now lives in France where he directs the Syracuse program in Strasbourg. He has done research and taught in Europe and Africa. His recent cross-cultural textbooks, written with Pierre Dasen, John Berry, and Ype Poortinga, are being translated into several languages.

In other ways, too, the world is clearly not just the way it seems to be.

When stimulation changes, sometimes the related perception does not. The perception of the size of persons, viewed from nearby or from far away, is a good example. The stimuli, images on our retina, differ across distance; the perceived size does not. The fact that judgments of a varying stimulus may remain constant over a wide range of variation is a phenomenon that long ago was dubbed "perceptual constancy." Two main schools of thought have been developed to account for this phenomenon: *nativism* and *empiricism*.

Nativism includes any theory that attributes perceptual phenomena, including constancy, to the way the human nervous system is structured. Nativistic theories thus give much importance to inborn (or native) characteristics and, consequently, they give little importance to experience.

By contrast, *empiricist* theories deem experience to be critical in shaping the way we perceive. They believe that perception is neither stimulus-determined nor forced by the pre-wired nature of the human nervous system. They attribute to perceivers a very active role in shaping their own perceptions. Each person is considered to be an active player in perception, with the perceiver's state at the time a product of the perceiver's prior experiences. Every perception, then, is the result of an interaction between a stimulus and a perceiver shaped by prior experience.

One large-scale test of an empiricist theory of visual perception was done in the 1950s and 1960s by a team of psychologists and anthropologists (Segall, Campbell, & Herskovits, 1963; 1966). The study involved several geometric drawings, long known as *optical illusions,* and was conducted in more than fifteen societies, some in the United States and most in Africa. The researchers used illusions in this study primarily because some well-known nativist theorists (e.g., Gestalt psychologists in late 19th-century and early 20th-century Germany) explained them as virtually inevitable consequences of the way the human visual system was constructed. In short, to nativists, illusion susceptibility reflected inborn ways of perceiving. According to such nativist theorizing, all humans should be more or less equally susceptible to optical illusions, unless, of course, various humans had different kinds of nervous systems.

Segall and colleagues were skeptical of such nativist theorizing. They were influenced by an exceptional German-born psychologist, Egon Brunswik, who had asserted, in 1956, that all perception involves functional transactions between a viewer and the incoming sensory matter. These transactions are "functional" in the sense that they lead to perceptions that contribute to the organism's survival (by usually being accurate!). Elaborating on Brunswik's thinking, Segall and colleagues argued that there might well be cross-cultural differences in illusion susceptibility. Why did they think so? Because responses to illusion-producing figures, which have the potential for varying interpretations, might reflect learned ways to interpret inherently ambiguous cues. They reasoned that if people who grow up in different environments do learn to interpret cues differently, there should be ecological and cultural differences in perception of any ambiguous stimuli. The so-called optical illusions are good examples of ambiguous stimuli.

This line of reasoning is demonstrated most easily with a figure known as the Sander parallelo-

All perception involves functional transactions between a viewer and the incoming sensory matter.

gram, an example of which is shown in Figure 1. They explained this "illusion" by a particular version of Brunswikian theorizing, known as the "carpentered-world hypothesis." In the earlier research literature reporting laboratory research with illusions, most people who viewed this figure judged the left diagonal as longer than it really is and the right diagonal as shorter than it really is. Before the Segall et al. research, nearly all participants in research of this kind were university students residing in Europe or America. If the present reader lives in a carpentered environment, she, too, is likely to fall prey to this illusion.

This bias, or error, is understandable, according to the empiricists, as the result of a tendency to perceive the parallelogram, drawn on a flat, two-dimensional surface as if it were meant to represent a rectangular surface extended in three-dimensional space. Hence, the viewer judges the distance covered by the left diagonal as greater than the distance covered by the right diagonal.

The judgment, which produces an error in this case, is one that normally leads to accurate perception in environments that contain rectangular objects, especially rectangular tables. Put another way, "this judgment reflects a habit of inference that has ecological validity in highly carpentered environments" (Segall, Dasen, Berry, & Poortinga, 1990). Since people who live in places with tables usually see them from points of view that generate non-rectangular, parallelogram-shaped retinal images, complete with acute and obtuse angles at each corner, they must learn that the tables are to be perceived as rectangular, with 90 degree corners.

Imagine that the parallelogram shown in Figure 1 was intended to be a representation of a ping pong table top, seen from above, but from a somewhat rakish angle. If it were, and the center diagonal were meant to be the net, then consider how much longer the distance represented by the left diagonal is compared to that represented by the right diagonal. The Sander parallelogram is an "illusion" when it is taken to be a representation of a table top in three-dimensional space instead of

FIGURE 1 The Sander parallelogram illusion

merely a parallelogram on a two-dimensional surface (which it actually is)!

Inferring that acute and obtuse angles in retinal images are nearly always coming from right angles on objects in the environment is a functional habit of inference for people who live in carpentered worlds. This functional habit, empiricists argue, makes these same people susceptible to optical illusions like the Sander parallelogram.

It should now be clear why the team of researchers decided to collect data cross-culturally. While in carpentered settings, the tendency to interpret acute and obtuse angles as right angles is pervasively reinforced, there are places on earth where right angles are rare (non-carpentered environments), and the habit of interpreting acute and obtuse angles as right angles extended in space would not be so readily acquired. Hence, people in carpentered worlds should be relatively susceptible to illusions like the Sander parallelogram while persons in non-carpentered worlds, far less so. In short, specific cross-cultural differences in illusion susceptibility are predicted by this empiricist line of reasoning, while nativism makes no such prediction.

The carpentered world hypothesis is only one of several empiricist hypotheses that were derived from the general line of argument. The various hypotheses all predicted cross-cultural differences in illusion susceptibility on the basis of different learned habits of inference—different, but in all cases ecologically valid.

To test these ideas, a standard set of stimulus materials were administered by a dozen researchers to a total of 1,848 persons, children and adults, living in several African countries, in the Philippines, and in the United States. The materials included the Sander parallelogram, described above, the Müller-Lyer illusion, and two forms of the horizontal/vertical illusion. This particular set of illusions was employed because people living in the United States were expected to be more susceptible to some of the illusions, than, say, people living in Africa, while for other illusions, the reverse was predicted. Predicting differences in both directions was one of the methodological niceties of the research design.

It took six years for the data to be collected, analyzed, and presented in a book-length report (Segall, Campbell, & Herskovits, 1966). The findings, in a nutshell, were that the predicted differences in illusion susceptibility were indeed found. There were marked differences in illusion susceptibility across the cultural groups included in this study and these differences accorded well with the empiricist theory that attributes perceptual tendencies to ecologically valid inference habits.[1]

This empiricist position, despite its support from the cross-cultural data, did not long go unchallenged, however, from the nativist camp. Pollack (1970) was aware of laboratory findings (some of them from his own laboratory) that persons with relatively dense retinal pigmentation (who are usually dark-skinned persons) have more trouble detecting contours in visual stimuli. Arguing that contour detectability might be an aspect of susceptibility to some illusions (especially the Müller-Lyer), and noting that the non-Western samples employed in the Segall et al. study were mostly African peoples, Pollack suggested that "race" might be the real explanation for what had been presented as ecocultural differences.

A comment on the concept of "race" is needed here. Quotation marks (inverted commas) are used to indicate that the concept "race" is merely a social construct and not the biologically precise term it is usually taken to be. When Pollack spoke of race, he was in fact referring to people of European or African origin, with relatively light or relatively dark skin. Someday, it is hoped, the fuzziness of the concept will be generally understood, and people will cease attributing differences so offhandedly to such an ill-defined construct.

Anyway, Stewart (1973) made clear that Pollack's challenge to empiricist theory called for a dual research strategy, in which one first holds environment constant while allowing "race" to vary, and then testing across environments while holding "race" constant. So, first she administered the Sander parallelogram and the Müller-Lyer illusions to 60 "Black" and 60 "White" schoolchildren in Evanston, Illinois. She found no significant differences in susceptibility between the two groups. Then, she administered the same materials to Zambian schoolchildren, all of them "Black" Africans, but living in five different places in Zambia, ranging from the highly carpentered capital city, Lusaka,

[1]Students who would like more detailed accounts of the findings may consult Segall, Campbell, & Herskovits, 1966, for the most complete story of this project or Segall, Dasen, Berry, & Poortinga, 1990 (pp. 76–83), for a concise summary. Another excellent summary, embedded in a thorough review of cross-cultural research on many different kinds of perceptual topics, may be found in Berry, Poortinga, Segall, & Dasen, 1992 (pp. 147–149). Since these three accounts (and others) are readily available, and since space in the present volume is limited, no more will be said here about the findings of the original study.

to a very un-carpentered Zambezi Valley region. For both illusions, susceptibility varied positively with increases in the degree of carpenteredness of the five sites in Zambia. The combined data from Evanston and Zambia showed that susceptibility to both illusions increases with increasing carpenteredness whereas "race" mattered not at all!

During the subsequent decades of the 20th century, there have been several other cross-cultural studies of illusion susceptibility and of closely related kinds of perceptual processes, such as pictorial perception (see, for example, Deregowski, 1980 and Serpell & Deregowski, 1980). These all contribute support to the empiricist side of the nativist/empiricist controversy. Illusion susceptibility does, after all, appear to be a reflection of learned habits of inference that are always ecologically valid.

The point of all this theorizing and research was not merely to explain optical illusions. Rather, it was to explain how it is that human beings see the world as they do. Illusions were studied in this particular line of research because they were thought to constitute a special class of ambiguous stimuli that would reveal differences grounded in basic sameness. Thus, almost paradoxically, the cross-cultural differences that were predicted (and found) demonstrate the operation of fundamental perceptual processes, shared by human beings everywhere.

Nativism argues that human beings behave in ways that are largely predetermined by the nature of their anatomy, physiology, and, especially, their nervous systems. So, if groups of people behave differently, one group from the other, nativists tend to attribute these differences to differences in the nature of the groups. The human species then is viewed as if it comprised distinct and distinctly different subgroups, of which "races" have so tediously been considered prime examples. By contrast, empiricism argues that we are fundamentally all one species. We all learn from experiences. What varies across environmental settings is the kinds of experiences we have. So we learn different things. So we behave differently. But we are not different beings. Is the lesson that has been learned from cross-cultural research on optical illusions one that can help humankind learn to live as one?

A final note. This chapter was written in Strasbourg, France, on the first day of January, 1993, the day that the European Common Market came into official being. On this day also, what was once Czechoslovakia divided into two, and what was one Yugoslavia remained splintered into warring factions. Consciousness of ethnicity, a view of the world in which it appears divided into "us" and "them," competes with a view of the world as one. Those who advocate programs of "ethnic cleansing" are nativists in the extreme. Those who hold to the dream of a unified Europe and ultimately to a world containing only one people are empiricists. So, a little reflection can make it clear that this chapter is not, after all, about such a small matter as optical illusions.

REFERENCES

Berry, J.W., Poortinga, Y.H., Segall, M., & Dasen, P.R. (1992). *Cross-cultural psychology: Theory, method, and applications.* Cambridge: Cambridge University Press.

Deregowski, J.B. (1980). Perception. In H.C. Triandis, & W.J. Lonner (Eds.) *Handbook of Cross-Cultural Psychology, Vol. 3, Basic Processes.* Boston: Allyn & Bacon. Pp. 21–115.

Plato. (1956). [Republic] In W.H.F. Rouse (trans.), *The great dialogues of Plato.* New York: Mentor.

Pollack, R.H. (1970). Müller-Lyer illusion: Effect of age, lightness contrast and hue. *Science, 170,* 93–94.

Segall, M.H., Dasen, P.R., Berry, J.W., & Poortinga, Y.H. (1990). *Human behavior in global perspective.* Needham Heights, Massachusetts: Allyn & Bacon (Simon & Schuster).

Segall, M.H., Campbell, D.T., & Herskovits, M.J. (1963). Cultural differences in the perception of geometric illusions. *Science, 193,* 769–771.

Segall, M.H., Campbell, D.T., & Herskovits, M.J. (1966). *The influence of culture on visual perception.* Indianapolis: Bobbs-Merrill.

Serpell, R., & Deregowski, J.B. (1980). The skill of pictorial perception: An interpretation of cross-cultural evidence. *International Journal of Psychology, 15,* 145–180.

Stewart, V.M. (1973). Tests of the "carpentered world" hypothesis by race and environment in America and Zambia. *International Journal of Psychology, 8,* 83–94.

20
Remembering in Cultural Context

JAYANTHI MISTRY AND BARBARA ROGOFF

The purpose of this chapter is to discuss the necessity of understanding the cultural context of remembering. We begin with accounts provided by two 9-year-old children from different cultural communities when they were asked to retell a just-so story that they had heard 5 minutes before to a local adult. The story was based on a legend from the Mayan community which was no longer being told to children; some details in the story were adjusted for the U.S. children to make them more culturally appropriate in that setting.

Alright. There once was a buzzard and he was an angel in Heaven and God sent him down to . . . to take all the dead animals and um, and so the buzzard sent down/ the buzzard went down and he ate the animals and then he

was so full he couldn't get back up to heaven and so he waited another day and then he flew back up to heaven and God said, "You're not an angel anymore," and he goes, "Why?" And . . . and he said that "you . . . you ate the raw meat and now you're a buzzard and you'll have and . . . and you'll have to eat the arbage" and . . . and he goes "I didn't eat anything" and God said, "Open your mouth and let's see," and then he opened his mouth ant there was all the raw meat and he goes "It's true I did eat, I did eat the meat" and God goes, "That's . . . that's why you're the buzzard now," and the . . . and . . . and so the buzzard flew down and he, um, then he ate all the trash and everything.
—a middle-class Salt Lake City child

Jayanthi Mistry is an Assistant Professor in the Eliot-Pearson Department of Child Study at Tufts University, Medford, Massachusetts. She received her masters degree from M.S. University in India and her Ph.D. from Purdue University. She has recently co-authored a monograph titled "Guided Participation in Cultural Activity by Toddlers and Caregivers" (with Rogoff, Goncu, & Mosier, in press). Her research, publications, and teaching interests have centered on cultural perspectives on development with a focus on cognitive and language development.

Barbara Rogoff is Professor of Psychology (endowed chair) at the University of California, Santa Cruz. She received her B.A. from Pomona College and her Ph.D. from Harvard University. She has conducted extensive fieldwork in a Mayan community in Guatemala. She is author of "Apprenticeship in Thinking" (Oxford University Press) and has written extensively on cultural psychology and children's cognitive development. She has recently co-authored a monograph titled "Guided Participation in Cultural Activity by Toddlers and Caregivers" (with Mistry, Goncu, & Mosier, in press).

This chapter is an abridged and adapted version of Rogoff, B. & Mistry, J. (1985). Memory development in cultural context. In M. Pressley & C. Brainerd (Eds.) *The cognitive side of memory development*. N.Y. Springer-Verlag.

*When the angel came, cha [so I have been told],
from Heaven, well, when the angel came, he
came to see the Flood. . . . (The adult listener
prompts: What else?) He ate the flesh of the
people. . . . (And then?) He didn't return right
away, cha. . . . (What else?) That's all. He threw
up, cha, he threw up, cha, the flesh. "I liked the
flesh," he said, cha. . . . (What else?) "Now
you're going to become a buzzard," they told
him, cha. . . . (with further prompts, the retell-
ing continued similarly)*
—*a Guatemalan Mayan child*

These two retellings are clearly quite different,
and without an understanding of the cultural con-
text, it would be tempting (though, we argue, incor-
rect) to regard the second child's account as
indicating a less accurate memory. In this chapter,
we consider alternative ways to understand the re-
lation between an individual's memory efforts and
the sociocultural context in which the remembering
occurs. Later in the chapter we discuss the findings
from the study in which these two children partici-
pated.

We elaborate the theme that remembering skills
develop for the purpose of solving practical prob-
lems and that they are tied to the familiar tasks and
practices in which remembering takes place. Thus,
in order to understand the process of remembering
in cultural context we need to examine the practices
of people as they go about their usual activities that
call upon the need to remember.

We begin the chapter by contrasting our contex-
tual perspective with the more traditional view that
memory is a context-free skill. We elaborate what
we mean when we say that culture is meshed with,
rather than separate from, development, and we
contrast this with cross-cultural research that treats
memory and culture as separate variables. We illus-
trate these notions with examples of cross-cultural
research.

THEORETICAL PERSPECTIVES ON THE SOCIOCULTURAL CONTEXT OF REMEMBERING

We take the theoretical perspective that remember-
ing is integrally related to the social and cultural
contexts in which it is practiced. Our approach
builds on the writings of Sir Frederick Bartlett, a
pioneer in research on memory, the Laboratory of

Comparative Human Cognition (1983), and Vygot-
sky (1978).

Memory as Context-free Skill vs. Remembering as an Activity

Half a century ago, Bartlett (1932) argued that mem-
ory is a social phenomenon and cannot be studied
as a "pure" process. He emphasized that "both the
manner and the matter of recall are often predomi-
nantly determined by social influences" (p.244).
While Bartlett's work generated great interest in
studying the influence of previous knowledge and
background experience, within traditional theories
of memory, the role of prior experience or interest
has still been viewed simply as an amplifier of a
"pure" process of memory which operates sepa-
rately from experience and cultural patterns.

In explaining different approaches to cognition,
the Laboratory of Comparative Human Cognition
(1983) made a distinction between a central-proces-
sor model and a distributed-processor model. The
central-processor model assumes that there is a cen-
tral-processor that consists of context-free skills
(such as memory, reasoning, perception abilities)
that are called upon whenever an individual faces a
cognitive task. Individuals faced with particular
tasks would make use of the relevant skill con-
tained in the central processor to perform the task,
regardless of the nature of the task.

In contrast, the distributed-processing ap-
proach emphasizes that skills are closely tied to the
context of practice, because individuals develop
skills in particular tasks through experience. Skills
are customized to the task. This perspective is sup-
ported by cross-cultural research. Memory does not
involve context-free skills that may be applied in-
discriminantly across widely different problems or
tasks, but rather involves skills tied to somewhat
specific activities in context.

Culture and Memory as Separate Variables vs. as Enmeshed Processes

Cross-cultural research that assumes memory is a
context-free skill tends to treat culture as a separate
influence on memory. Such studies tend to use tasks
derived from laboratory studies done in the United
States and other Western countries to examine
whether people in other cultures perform in a simi-
lar manner. For example, in the typical "free-recall"

task individuals hear a list of words or see a series of pictures and are then asked to recall these words or pictures. The usual finding on such tasks has been that non-Western individuals do not perform as well as Western individuals (see reviews by Cole & Scribner, 1977; Rogoff, 1981). Often the lists contain items from several categories, e.g. coat, apple, dog, banana, pant, cat, shirt, cow. Individuals from the United States and other Western countries typically group or chunk items into categories (clothes, food, animals) to help in remembering or use some other mnemonic strategy, such as verbal rehearsal (repeating the words to memorize). When non-Western subjects do not perform as well as Western subjects, "culture" in terms of some specific aspect of background experience that varies between the groups (e.g. formal schooling) is used to explain the difference.

In contrast to the view that culture and memory are separate, we assume that culture and memory are enmeshed processes. If we think of memory as the "activity of remembering," rather than as a con-

Remembering is an activity that is defined in terms of the meaning of a task and its materials to the people remembering, and in terms of its function in the social and cultural system.

text-free skill, then it becomes easier to understand how culture is enmeshed in every aspect of remembering. An activity involves goals, materials, and procedures for how the activity is to be carried out, which are usually learned through practice and interaction with more experienced people. Culture comes into play in a remembering activity through all of these aspects of the activity. Remembering is an activity that is defined in terms of the meaning of a task and its materials to the people remembering, and in terms of its function in the social and cultural system. In the following sections we present examples from cross-cultural research that illustrate how culture is enmeshed with all aspects of the remembering activity.

MEANINGFULLY ORGANIZED CONTEXT RELATING THE MATERIALS

The majority of remembering tasks faced by modern and traditional people alike in their day to day life involve material which is organized in a complex yet meaningful fashion. For example, we generally can remember the arrangement of the top of a desk, because despite outward appearances, there is usually some conceptual order to the array which helps the user of the desk remember where specific objects are located.

However, Western literate people have special demands and opportunities to develop the use of memory aids that are useful for remembering lists of isolated pieces of information, especially through their experience with school. In day to day life there is usually no need to remember lists of unrelated material, but in school pupils often have to use strategies to ensure recall of materials that they have not understood and that are not organized by meaningful schemas. They get practice in the activity of remembering unrelated bits of information, such as lists of words, or series of pictures (the very same types of tasks used in most laboratory studies of memory). They learn strategies to organize these words or pictures in ways that make them easier to remember, and they learn rehearsal strategies (e.g. repeating the words/pictures as they see them). For example, when asked to remember a list of words, they may group them into relevant categories (food, clothes, vehicles) to ease remembering, because they have learned such organizational strategies to link words that are not otherwise linked in any meaningful way.

To determine if cross-cultural differences disappear when meaningfully organized materials are used, Rogoff and Waddell (1982) examined the performance of Mayan and U.S. children on the reconstruction of contextually organized three-dimensional miniature scenes. Each child watched as a local experimenter placed 20 miniature objects such as cars, animals, furniture, people, and household items into a panorama model of a town, containing a mountain, lake, road, houses, and some trees. Care was taken to ensure that both groups of children were familiar with the objects being used in the task. The 20 objects were removed from the panorama and mixed into a pool of 80 objects from which they had been drawn. After a delay of minutes, the child was asked to reconstruct the scene.

While the Mayan sample had not remembered as much as the U.S. children on a free recall task in a previous study, they performed just as well if not slightly better than the U.S. children on the test using contextually organized materials. In fact, the reason the Mayan children did somewhat better may have been that some U.S. children tried to use a rehearsal strategy as they studied the objects in the panorama. Rehearsing the names of items is an effective strategy for remembering lists of words (as in a free recall task), but would not work as well for reconstructing a contextually organized array.

Non-Western people have also been observed to remember impressive amounts of information in other activities in which information is contextually organized. For example, nonliterate bards in certain communities demonstrate exceptional memory for narrative material (Cole & Scribner, 1977). The rhythm of the song or chant and the verse structure often serve as aids to recall the long songs and stories that are remembered by these bards and storytellers. Similarly, expert Micronesian navigators use complex story mnemonics to organize their memory for the layout of the ocean and stars (Price-Williams, 1981). Often legends and stories that explain the formation and movement of constellations become aids in remembering the layout of the stars.

Meaningful Purpose for Remembering

In many instances of outstanding memory performance by non-Western people, remembering is accomplished in the service of a culturally important goal, with remembering a *means* rather than the *goal* of the activity. For example, this is true for remembering spatial information to avoid getting lost while navigating, and for remembering verbal material in narrating stories to entertain. It is also the case for the preservation of oral history by specialists in Africa (D'Azevedo, 1982) and by Iatmul elders in New Guinea (Bateson, 1982) whose phenomenal memory for lines of descent and history is required to resolve debates over claims to property by conflicting clans. In all of these examples a culturally important purpose integrates the act of remembering in meaningful activity.

Sir Frederick Bartlett (1932) describes the prodigious retentive capacity of Swazi herdsmen to recall the individual characteristics of their cattle. He relates the case of a Swazi herdsman who was able to remember details of all the cattle that his owner had bought a year ago. Bartlett argues that this was not surprising since Swazi culture revolves around the possession and care of cattle, and anything to do with cattle is of tremendous social importance. When the purpose of remembering did not have such social or economic importance then recall capacity was not so impressive. His experiments on the recall of a message of 25 words revealed that the recall of Swazi youth was not any better than that of typical European boys.

Individuals who are unfamiliar with performing solely for the evaluation of a teacher or an experimenter (such as young or nonschooled children) are likely to find the purpose of remembering items in a memory test obscure. This may give Western children a performance advantage when compared with non-Western, especially nonschooled, children. For schooled children, tests may not be a comfortable situation, but at least the children are familiar with what is expected of them and they have had some practice remembering for no other practical purpose than showing their proficiency in remembering. They have background knowledge in the social script for participating in a test which nonschooled subjects lack.

THE SOCIAL INTERACTIONAL CONTEXT OF MEMORY PRACTICE

The immediate social interactional context of learning and remembering also relates to an individual's remembering. Social interaction structures individual activity, especially because we learn about the mnemonic tools and practices of our society through interaction with more experienced members of our society.

Social aspects of experimental situations are unfamiliar to some groups. For example, the relationship between experimenter and subject may be rapidly grasped by Western children familiar with testing in school, but may be highly discrepant from familiar adult-child interactions for non-Western children and adults. Schooled people are more familiar with an interview or testing situation in which a high-status adult, who already knows the answer to the question, requests information of a lower-status person, such as a child (Irvine, 1978). Nonschooled children, having less experience with a testing situation, may be concerned with showing

respectful behavior to the tester and trying to figure out the tester rather than to figure out the problem.

An example of how conventions for social interaction can influence memory performance is provided by a study on story recall (Rogoff & Waddell, see Rogoff & Mistry, 1985). Even though story recall involves memory for material embedded in a meaningful context, in this study 9-year-old Guatemalan Mayan children remembered far less of the stories than did U.S. children. This was despite extensive efforts to make the task culturally appropriate for the Mayan children. The stories were adapted from the Mayan oral literature, told to the children by a familiar teenager speaking the local Mayan dialect in a familiar room. In the effort to make story recall more like telling the story rather than being tested by the same person who had just told it to them, the children told the stories to another local person (an older woman with whom they were familiar and comfortable) who had not been present when the teenager told them the story. With such efforts to make the task culturally appropriate to the Mayan children, why then was their performance so poor compared with Western children?

While not obvious from the outset, there were important social features of the test situation that made the Mayan children very uncomfortable. It is culturally inappropriate for Mayan children to speak freely to an adult. When carrying messages to adults, they must politely add the word "Cha" ("so I have been told") in order to avoid conveying a lack of respect by impertinently claiming greater knowledge than the adult. Though the Mayan children heard stories told by their elders, and talked freely among peers, it was a strange and uncomfortable experience for them to attempt to tell a story to an adult—no matter how comfortable they were with the content of the story, the testing situation, and the adult.

Far from school-style narrative being a natural mature form of discourse, it develops in the context of school and middle-class U.S. culture.

INSTITUTIONAL AND CULTURAL PRACTICES IN REMEMBERING

In addition to structuring relationships between people, cultural practices also provide tools and procedures involved in socially appropriate solutions to problems (e.g. using story mnemonics to remember the position of the stars, grouping items into categories to remember unrelated lists of items, using an abacus for mathematical operations).

However, practice in the use of these cultural or institutional tools does not result in an increased generalized skill or ability. Scribner and Cole (1981) designed a memory task which used the same incremental method of learning that is used by people literate in Arabic to learn the long verses of the *Q'uran*—learning a string of words in order and adding one word to the series on each attempt. They gave a variety of memory tasks to three groups of Vai people who were involved with different types of literacy—Arabic literacy through Q'uranic school, Vai literacy through practical correspondence, and English literacy through Western style schools. The Arabic literates did much better than the other groups on recall tasks that called for the preservation of word order, probably because they were well versed in that strategy of remembering. However, they did not do any better than the other groups on recall tasks where word order was not important.

Similarly, cultural tools for mathematical operations also hold a specific functional role for remembering information that is related to their use. Japanese abacus experts apparently represent the abacus mentally, calculating without an abacus as accurately as calculating with one, and often faster (Hatano, 1982). Abacus experts can recall a series of 15 digits either forward or backward, but the special processes involved in their impressive mental abacus operations are tailored to the activities in which they were practiced. Their memory span for the Roman alphabet and for fruit names is not different from the usual 7±2 units found for most adults in memory span tasks. In a memory span task individuals are asked to immediately repeat a series of unrelated bits of information that they hear or see, such as a series of numbers or letters. Most adults can remember up to 7±2 bits or units of information (such as a 5–9 digit number) on such tasks.

Thus, if remembering is viewed as an activity rather than as a context-free skill, then it becomes easier to understand how culture is enmeshed with every aspect of remembering. Culture is involved in the remembering process through the practical goals of activities which make it worthwhile to remember, through the meaningful context that provides a natural organization of the material to be

remembered, through familiarity with the material to be remembered and with the social interactional context of the activity, and through the cultural tools and practices related to the activity of remembering.

REFERENCES

Bartlett, F. C. (1932). *Remembering*. Cambridge: Cambridge University Press.

Bateson, G. (1982). Totemic knowledge in New Guinea. In U. Neisser (Ed.), *Memory observed: Remembering in natural contexts*. San Francisco, CA: W. H. Freeman.

Cole, M. & Scribner, S. (1977). Cross-cultural studies of memory and cognition. In R. V. Kail, & J. W. Hagen (Eds.), *Perspectives on the development of memory and cognition*. Hillsdale, NJ: LEA

D'Azevedo, W. A. (1982). Tribal history in Liberia. In W. Neisser (Eds.), *Memory observed: Remembering in natural contexts*. San Francisco, CA: W. H. Freeman.

Hatano, G. (1982). Cognitive consequences of practice in culture specific procedural skills. *The Quarterly Newsletter of the Laboratory of Comparative Human Cognition 4*, 15–17.

Irvine, J. T. (1978). Wolof "magical thinking": Culture and conservation revisited. *Journal of Cross-Cultural Psychology, 9*, 300–310.

Laboratory of Comparative Human Cognition, (1983). Culture and cognitive development. In J. H. Flavell & E. M. Markman (Eds.), *Handbook of child psychology: Vol. III. Cognitive development*. New York: Wiley.

Price-Williams, D. R. (1981). Culture, intelligence, and metacognition. Presented at the meetings of the American Psychological Association, Los Angeles.

Rogoff, B. (1981). Schooling and the development of cognitive skills. In H. C. Triandis & A. Heron (Eds.), *Handbook of cross-cultural psychology*. (Vol. 4). Boston: Allyn & Bacon.

Rogoff, B. & Mistry, J. (1985). Memory development in cultural context. In M. Pressley & C. Brainerd (Eds.), *The cognitive side of memory development*. N.Y.: Springer-Verlag.

Rogoff, B. & Waddell, K. J. (1982). Memory for information organized in a scene by children from two cultures. *Child Devekionebt, 53*, 1224–1228.

Scribner, S. & Cole, M. (1981). *The psychology of literacy*. Cambridge, MA: Harvard University Press.

Vygotsky, L. (1978). Mind in Society: The development of higher psychological processes. Cambridge, MA: Harvard University Press.

21

Culture and Cognitive Development from a Piagetian Perspective

PIERRE R. DASEN

Jean Piaget was a genius. Considering his enormous contributions, I would not hesitate to say he was much like Einstein, or Freud. At least we can say that without his many contributions, we would not have the same understanding of the cognitive development of humans. To be his student was fascinating, because there was this aura around the master (in French: "le patron"). He was challenging, because he expected a lot from those who worked and studied with him, and he did not make access to his theory very easy. He was amusing, had a series of quaint habits (such as answering his mail while lecturing or being several hours early to catch a plane) and he was also frustrating at times (for example, he might call at six in the morning to ask for a report on the latest study).

Studying psychology in Geneva for several years, as I did, necessarily meant studying Piagetian developmental psychology—or in more abstruse words, "genetic epistemology." Genetic, not because he studied genes, but because Piaget was interested in the *genesis*, the formation and development, of reasoning and thinking, and *epistemology* because he was passionately interested in the history and philosophy of science. He saw developmental psychology as a method and as the best way to study how scientific reasoning came about in Western culture.

Nowadays, while there may still be some declared or pure Freudians, there are hardly any "orthodox" Piagetians left; the newer research and theory building (that nevertheless acknowledges the master's influence) flies under the "neo-Piagetian" flag (Dasen & de Ribaupierre, 1987). Yet the basic Piagetian ideas continue to be influential in education as well as psychology. Essential to cognitive psychology and artificial intelligence is the careful study of thought processes rather than just test scores. Piaget introduced the so-called "clinical method" to the study of cognition: around some task to be solved, he would have an open, nonstandardized, dialogue with the child, much like a clinical psychologist may talk with a patient. The outcome would be a dynamic description of the child's thinking processes rather than a simple and static score on a psychological test, such as a score on an I.Q. test. A basic tenet of Piaget's theory is that these processes change qualitatively with age, in a succession of hierarchical stages (and substages). The stages necessarily appear in a fixed order, since

Pierre R. Dasen is Professor of the Anthropology of Education at the University of Geneva. He studied cognitive developmental psychology with Jean Piaget, and later spent several years testing Piaget's theory in different cultural contexts (Aborigines in Australia, Inuit in Canada, Baoule in Cote d'Ivoire, and Kikuyu in Kenya). His present interests are in the area of "everyday cognition." He has recently co-authored two textbooks in cross-cultural psychology with Marshall Segall, John Berry, and Ype Poortinga.

any one stage is based on the previous one. In a way, Piaget was a cartographer of the mind; his procedures helped him construct a map of the child's cognitive processes.

CROSS-CULTURAL PSYCHOLOGY: THE WORLD AS A LABORATORY

Because of Piaget's particular methodology (questioning a few children at length), his theory was established on very small samples. All of Piaget's theory of development in infancy (the so-called sensori-motor intelligence stage) was based on the careful observation of his own three children. For later stages, the research was mainly carried out in schools in the city of Geneva. Yet Piaget was not really interested in any particular children, of any particular nationality or social class; he was, in fact, interested in the reasoning of humans, and he assumed that what he was discovering in Switzerland with just a few children would be universal.

Was Piaget right in his assumption about the universality of these processes? Yes, to some extent—but no, not completely. For roughly twenty years, between about 1965 and 1985, researchers went to various, often exotic, cultural settings to answer this question. It is one of the goals of the cross-cultural, comparative method to put theories to what amounts to the "ultimate" test: Which aspects are indeed universal? Which must be understood in culture-relative terms only? Without empirical evidence, without convincing data, it is impossible to come up with clear answers to these questions. Within any single setting, too many variables are confounded, i.e., inextricably linked. For example, chronological age and environmental stimulation (such as schooling) are frequently bound together very tightly. In the setting where Piaget and his colleagues were doing their research, all children are schooled at the same age. What, then, produces the observed major shifts in behaviour, chronological age or schooling? To answer this question, cross-cultural research is needed, research in settings where children of a given age have differing amounts of schooling, including some who do not go to school at all.

Arranging such experimentation is more easily said than done. How do you study unschooled children? How do you make sure the sampling is not biased (because those who go to school are selected differently from those who don't)? How do you test unschooled children who are not used to being questioned? How do you make sure they understand your questions? All these and many other methodological questions make for very difficult

How do you test unschooled children who are not used to being questioned?

and time-consuming research. Wouldn't it simplify things to stay in the laboratory, or in some comfortable classroom? These settings are certainly safer and easier, but may be less interesting! Are you ready for a field-trip amongst hunters and gatherers?

The Eco-Cultural Framework: Nomadic and Sedentary People

My first cross-cultural research took me as far from Geneva as one can go, to remote parts of the desert in central Australia. It is there that I studied child development among the first inhabitants of that continent: Australian Aborigines, those who lived there "since the origins" (or what they themselves call the "dreamtime"), which in archaeological terms is at least 30,000 years. Aborigines have survived in an extremely harsh environment, gathering a large variety of plant foods, hunting, moving constantly from one place where water could be found to another, over a very large territory. Their material culture is extremely simple. Except for a few personal objects (such as the men's weapons and the women's digging stick), there are no goods to be owned, no produce to be stored or sold. On the other hand, they have an active spiritual life, one that includes elaborate (but egalitarian) social structures, rituals, myths, and symbolic art forms. Their value-system, and especially their relationship to the environment, is about as far removed from that of Western, industrial society as Alice Springs is from Geneva.

What about the cognitive development of Australian Aboriginal children? Would it follow the same stages as those Piaget found in Geneva? Would it proceed at the same speed? Or could it be radically different?

For this study with schooled Aboriginal children aged 8 to 14 years, Piagetian tasks were used in mainly two domains of so-called "concrete operational" reasoning: quantification and space. In the area of quantification, a typical Piagetian task is the conservation of liquids: Two identical glasses are filled with equal amounts of water, then the liquid in one of the glasses is poured into a container of a different shape, for example a long and narrow one. The young child, who pays attention to only one feature at a time, is struck by the height of the water in the second glass, and believes it now contains a larger amount to drink. Piaget called this a "non-conservation" or "pre-operational" answer. With concrete operational reasoning, the child will say that the amount of water does not change, that the water in the new glass may rise higher but is also narrower. The change from one type of reasoning to the other is not a sudden one, but occurs through intermediate substages, and in Geneva this shift occurs between the ages 5 and 7.

In Australian Aboriginal children, the same type of reasoning occurred, with the same stages and substages, but the shift was found to take place between 10 and 13 years; a fairly large proportion of adolescents and adults also gave non-conservation answers. This was also true with other conservation tasks, dealing with concepts of weight and volume.

Piagetian tasks were also used in the domain of spatial reasoning. In one of these, the child is confronted with two landscape models, one of which is turned around by 180 degrees; the task is to locate an object (like a doll, or a toy sheep) on one model, and then find the same spot on the second one. In another spatial task, a bottle is half filled with water, and is tilted into various positions, with a screen hiding the water-level; outline drawings of the bottle are produced and the child is asked to draw in the water-level.

With these tasks, the Australian Aboriginal children again displayed reasoning that followed the sequence of substages Piaget had described. But contrary to children in Geneva, who usually find these spatial tasks to be much more difficult than the conservation tasks, the Aboriginal children found them to be easier. Another way to express this finding is that, for the Aboriginal children, concrete operational reasoning in the spatial domain develops more rapidly than it does in the area of quantification. How can that be?

Considering Aboriginal culture, this actually makes good sense: Aborigines, at least in the tradi-tional setting, do not quantify things. To find water is important for survival, but the exact quantity of it matters little; if the hunt has been successful, the meat is shared, but not according to quantity or weight: each particular part of the animal has to go to a particular person, depending on kinship relationships (e.g. the best piece to the mother-in-law). Also, counting things is unusual: number words exist up to five, beyond which it is "many." In contrast to this, finding one's way about is very important: water holes have to be found at the end of each journey, and while members of a family may go different routes during the day, they find each other in the evening. The acquisition of a vast array of spatial knowledge is helped by the mythology, the "dreamtime" stories, that attribute a meaning to each feature of the landscape, and to routes travelled by the ancestral spirits; it is also reflected in the artwork that often symbolically depicts locations and the paths between them.

Thus, the relative rate of cognitive development in different domains, such as space and quantification, reflects what is highly valued in the culture, and what is less valued, and also what is needed, what is adaptive. That Aborigines may not feel a need to quantify things may, at first, seem strange to Westerners, who place such a high value on quantification, and on material possessions. For an orthodox Piagetian developmental psychologist, it takes some serious anthropological decentration to admit that the conservation of quantity may not be essential! Cross-cultural research points to the importance of the *context* in which the developmental changes and adaptations take place. In other words the settings, child-rearing customs and parental ethnotheories that make up the developmental niche are central.

These findings were later replicated in a study with Inuit (Eskimo) children, another traditionally nomadic people, whose subsistence was based more on hunting than it was on gathering. On the other hand, in two groups of sedentary, agricultural people (the Ebri) and the Baoulé of Côte d'Ivoire, West Africa), children were found to move rapidly through the stages in the domain of quantification, and much more slowly in spatial reasoning. This finding is again in congruence with an eco-cultural analysis of what is needed, valued, more easily expressed in the language, and promoted in child-rearing practices. The general eco-cultural perspective alluded to here has been developed over the years by John Berry, and serves as a theo-

retical framework of two textbooks in cross-cultural psychology in which more details can be found (Segall, Dasen, Berry, & Poortinga, 1990; Berry, Poortinga, Segall, & Dasen, 1992).

However, cross-cultural findings on Piagetian cognitive development are not quite as simple as presented here. Further distinctions have to be made, for example between the spontaneous performance of a task and the underlying competence this is supposed to reflect. Moreover, methodological problems occur, and frequently the effects of some factors (such as schooling) are more complex than initially expected. All these refinements have been dealt with in other reviews (e.g. Dasen & Heron, 1981) and books (e.g. Dasen, 1977) and need not concern us here.

Some Theoretical Implications

The theoretical implications of the many cross-cultural findings accumulated over the years by using a perspective based on Piaget's theories are the following:

1. The qualitative aspects of concrete operational cognitive development (the type of reasoning, the sequence of stages) are indeed universal. The affirmation of universality now rests on a large body of empirical facts rather than being claimed *a priori.*

2. The rates of cognitive development in various domains are not uniform, but depend on eco-cultural (and other environmental) factors. A similar lack of domain consistency was later found to be true for all children, even in Western settings. Comparative studies often serve as a magnifying glass: they draw attention to phenomena that may go unnoticed in a monocultural setting.

3. This implies that it is not possible to attribute to any individual a single stage of cognitive development (i.e. as a summary measure, such as an IQ).

4. *A fortiori,* it does not make sense to attribute such a single stage to a group. For example, it may not be said that Australian Aborigines are at the pre-operational stage because most of them spontaneously give non-conservation answers. For one thing, their reasoning is likely to be at the concrete operational stage for spatial concepts.

5. The eco-cultural framework within which the data are interpreted precludes attributing value judgments to developmental sequences: it is not necessarily "better" to give a conservation rather than a non-conservation answer, at least not for an Australian Aborigine in the traditional setting. In the new settings brought about by acculturation (for example, at school), it may indeed be more adaptive to handle quantification concepts with ease; in this case, they could be taught explicitly— and the more materialistic value system at the same time!

Practical Implications

Not everybody will be fortunate enough to meet an Australian Aborigine, an Inuit, or a Baoulé. But cross-cultural research also has implications for issues in Western, industrial settings. What could this research mean to, say, a teacher in a multicultural classroom in the United States, Canada, or Switzerland?

First of all, the eco-cultural framework would lead the teacher to look for the presence of skills brought along from the pupil's previous settings, instead of deploring only the absence of the particular skills required by the school. In other words, the framework leads to a "difference hypothesis" rather than a "deficit hypothesis." This does not preclude intervention measures, but determines their orientation. The deficit hypothesis leads to compensatory education, a "remedial" approach that implies a forceful assimilation to the dominant norms. The difference hypothesis, on the other hand, will lead to building on existing strengths, and provide the necessary skills without a derogatory value judgment on their absence.

Given this general outlook, the teacher's conception of the school as an institution might also change. If some pupils have problems, it may be not because they have some deficit, but because the school is not meeting their needs and characteristics. Maybe the school still has a monocultural philosophy, maybe only the dominant language (that of the majority, or the so-called national language) is deemed appropriate. Whether or not these speculations have some truth value obviously depends on each particular context.

A More Emic, or Relativistic, Perspective

The research described above has used, as a point of departure, a theory (and its attendant techniques) that originated in the West. The cross-cultural method served to test this theory for its universality, and to change it so as to take cultural variables into account. This approach is sometimes labeled the "etic" approach—"imposed etic" if the

theory is exported and applied as such, and "derived etic" if it can be shown to be locally relevant—which is what I would claim to be true for Piagetian concrete operational reasoning.

The fact that this reasoning occurs potentially everywhere does not mean that it is what is most valued everywhere. Even more so, hypothetico-deductive scientific reasoning, Piaget's last, so-called "formal" stage, is not necessarily what is most valued in every community, not even within Western societies. In fact, the development of formal reasoning (as strictly defined by Piaget) seems to be strongly dependent on secondary schooling. When Piaget studied formal reasoning in Geneva, he did so in schools that were highly selective, attended by only about five percent of the population in that age group. It needed studies with other samples to discover that formal reasoning is not as pervasive as initially thought.

I would still claim that some form of highly abstract reasoning occurs everywhere, but possibly taking different forms or cognitive styles. Recent research in Côte d'Ivoire by Tapé Gozé suggests that the abstract reasoning valued in the African world view is "experiential," symbolic, global, inductive, analogical, end oriented, and seeks to answer the question "why," as opposed to formal reasoning, which is experimental, analytical, deductive, digital, causality oriented, and asks "how."

Such a typology can be explored without returning to a sort of "great divide" theory, popular in the earlier parts of the century where dichotomies such as logical/pre-logical or civilized/primitive were often used. Replacing such ethnocentric thinking and theorizing is the much more fair idea of cognitive styles or learning styles.

Studies that are carried out within their own cultural context, with theories and methods indigenous to that context, are sometimes called "emic." While there are obvious advantages to this approach in terms of cultural validity, an extreme cultural relativism precludes any comparison, and hence excludes the possibility of finding out what is common to humanity. This is why more emic (indigenous, culturally relative) research may be a desirable goal, but cannot be the exclusive goal of cross-cultural psychology.

In our study of the concept of *n'glouèlê* among the Baoulé of Côte d'Ivoire, we found that this superordinate concept of intelligence referred to both "technological" aspects (cognitive alacrity) and "social" aspects (cooperative social responsibility). In the Baoulé parental belief system about the goals of

child development and education, the social aspects were clearly more valued than the technological ones. Cognitive skills are valued only if they are used for the good of the social group, not for individual promotion. When we asked the parents to evaluate their children in terms of that local definition of intelligence, there was, overall, no relationship between that assessment and the children's results on the Piagetian tasks, and even some statistically significant negative correlations with the spatial tasks. In other words, what the Baoulé parents value most in their children is not the same as, or is even the opposite of, what these Piagetian tasks measure.

CONCLUSION

We have seen that Piaget's theory has withstood the trial of cross-cultural testing rather well. The main aspect, namely the hierarchical sequence of stages and substages, was found to be universal. On the other hand, cultural differences were found in the relative rate of development of concepts in different domains (such as quantification or space). Another way to express these findings is that the *deep* structures, the basic cognitive processes, are indeed universal, while at the *surface* level, the way these basic processes are brought to bear on specific contents, in specific contexts, is influenced by culture. Universality and cultural diversity are not opposites, but are complementary aspects of all human behavior and development.

REFERENCES

Berry, J. W., Poortinga, Y. H., Segall, M. H. & Dasen, P. R. (1992). *Cross-cultural psychology: research and applications.* Cambridge: Cambridge University Press.

Dasen, P. R. (Ed.) (1977). *Piagetian psychology: Cross-cultural contributions.* New York: Gardner (Halsted/Wiley).

Dasen, P. R. & Heron, A. (1981). Cross-cultural tests of Piaget's theory. In H.C. Triandis & A. Heron (Eds.), *Handbook of cross-cultural psychology. Vol. 4: Developmental psychology* (pp. 295–342). Boston: Allyn & Bacon, 1981.

Dasen, P. R. & de Ribaupierre, A. (1987). Neo-Piagetian theories: Cross-cultural and differential perspectives. *International Journal of Psychology* 22, 793–832.

Segall, M. H., Dasen, P. R., Berry, J. W. & Poortinga, Y. H. (1990). *Human behavior in global perspective: An introduction to cross-cultural psychology.* Boston: Allyn and Bacon.

22
Learning Styles and Culture

JUDITH KLEINFELD

The notion that people from different cultural backgrounds have different styles of learning seems so reasonable, so intuitively sensible, that it is hard to believe that it is just not true. But after more than 25 years of research on cultural differences in learning styles, psychologists have been unable to show that one method of teaching works better for children of one cultural group while a different method of teaching works better for children of a different cultural group.

Children from different cultural backgrounds—as a group—*do* seem to have distinctive patterns of intellectual abilities. Native American children, for example, appear to have especially high levels of visual and spatial skills and do less well on tests of verbal ability in English. This does not mean that *every* Native American child will have this ability pattern, just that this pattern is more common among this cultural group than among certain other cultural groups, such as Caucasian or African-American children.

But just because different cultural groups have different cognitive strengths does not mean that teachers should narrowly *match* their teaching styles to these patterns of abilities. Such an approach to education would be destructive. Consider how foolish it would be for a teacher to say, "Since Native American children have high visual memory and spatial abilities, I'm going to teach all the Native American children in my class with a lot of pictures and movies and deemphasize reading and discussion." Can you spot the logical errors in such a statement? First, Native American children as a group may have high levels of visual-spatial abilities, but the children in this teacher's class are individuals, and some Native American children in this class may have highly developed verbal, not visual, skills. Second, Native American children, like other children, need to learn to read and speak well—these areas of their education should not be neglected.

But we can look at the notion of "learning styles" in a very different way, and this other way leads to better teaching. We all know that individuals are complicated, and we each learn differently. That's why the idea of learning styles makes such intuitive sense to us. Some people do their best work early in the morning, for example, while others can't get going until late at night. Some people like to work in groups while others prefer to work independently.

Many teachers find the notion of learning styles helpful because it reminds them to create rich and diverse classroom environments which offer many different ways to learn—films and books, independent study and group work, discussion in the classroom, and projects in the community. Teachers who instruct children in culturally distinctive communities, like schools in remote Alaskan villages, also find the notion of learning styles attractive because it reminds them to pay attention to life in the community and develop lessons which take into

Judith Kleinfeld is Professor of Psychology at the University of Alaska, Fairbanks. In 1969, she earned her doctorate at the Harvard Graduate School of Education, after doing research at the Alaska Native Medical Center in Anchorage. She has done research on learning styles for twenty years and is the author of many books and articles on small rural schools and issues in Alaska Native education.

account the cultural setting. Teachers need to think about such matters as people's style of speaking, children's background knowledge, and what people in this community find interesting and important.

Learning styles, in short, is a two-edged sword. The idea is helpful when it reminds teachers to expand the ways in which they teach, to pay attention to individual children and to the ways life is lived in different communities. But the idea is destructive when it is used to stereotype children of a particular cultural group and limit their education.

COGNITIVE STRENGTHS OF DIFFERENT CULTURAL GROUPS: AN ESKIMO[1] ILLUSTRATION

When I arrived in Alaska in 1969, I was eager to do research that mattered, to find ways of improving education for children who were not doing well in school. Eskimo communities were bearing the onslaught of rapid cultural change, and many children, especially those living in small isolated villages, had low achievement test scores.

I became intrigued with the idea of learning styles partly because it offered a way to stress the intellectual strengths of Eskimo children rather than focusing on academic problems. Many teachers in village schools mentioned that their students seemed to have unusually high visual memory. They might, for example, recall details of movies shown a year or more before. The students also seemed to have unusual strength in spelling, and teachers wondered if they were memorizing the visual form of unfamiliar English words. Standardized achievement test results supported the teachers' observations. For many Eskimo children, English was a second language and reading comprehension scores were low. But spelling scores were relatively high.

When I turned to the research literature, I found an exciting paper that seemed to explain why the teachers' observations about their students' cognitive strengths might well be right. John W. Berry, a Canadian psychologist, had developed a theory that predicted high visual and spatial skills among hunting and gathering groups, like the Eskimo, and low visual and spatial skills among agricultural groups, like the Temne in Sierra Leone. Berry (1966) argued that the ecological demands made by a particular environment, combined with the group's

cultural adaptations to these demands, developed specific types of cognitive abilities.

For thousands of years, Eskimos had survived in an extraordinarily difficult Arctic environment, where food supplies—walrus, caribou, seal, moose—were scarce and starvation was episodic. They had survived because of their hunting prowess and their ability to travel long distances across the Arctic terrain. In contrast to urban areas or farmland, the Arctic is a setting of extreme visual uniformity. The tundra stretches without trees or obvious landmarks, a vast expanse where the sky and land merge.

To adapt successfully to this environment, hunters need to notice and remember small visual cues. In his study of Eskimo hunting, Nelson (1969) observes, "On the flat and monotonous tundra or the jumbled piles of sea ice, the smallest unique features become important landmarks—an upturned rock, a cut in the river bank, an unusually large or strangely shaped ice pile. The Eskimos are extraordinarily skillful at observing such landmarks and remembering their spatial relationships" (p. 102).

Agricultural groups, like the Temne of Sierra Leone, live in a complex visual environment and do not need to travel long distances in search of food. "The Temne land is covered with bush and other vegetation providing a wealth of varied visual stimulation," Berry (1966) points out. "The Temne are farmers who work land near their villages and rarely have to leave the numerous paths through the bush" (p. 211).

To help them accomplish the tasks necessary for survival and expansion, cultural groups de-

> **To help them accomplish the tasks necessary for survival and expansion, cultural groups develop intellectual tools and technological devices.**

velop intellectual tools and technological devices. The United States in the late twentieth century, for example, is a specialized society where people coordinate their activities through careful attention to

time. The English language has complex verb tenses to describe time and a rich vocabulary of time concepts. An array of technological devices, from wristwatches to computer clocks, help people keep track of time.

Similarly, Eskimos appear to have developed sophisticated cultural tools which help them attend to spatial patterns. The language of Eskimo peoples, Berry points out, contains a vocabulary which makes far more elaborate spatial and geometrical distinctions than the language of the Temne. The Eskimo also use a linguistic system of "localizers," integral parts of words, which require speakers to note the spatial locations of objects they are speaking about.

Cultural groups also develop child-rearing practices adapted to the demands of their environments. When parents in the United States urge their children to do well in school, when they worry about children who are shy, they are responding to beliefs that success comes easier to people who have acquired academic skills and who are sociable. In hunting and gathering societies, like the Eskimo, successful hunters must be independent and venturesome, with the courage to travel alone or in small groups over great distances. In agricultural societies, like the Temne, members of the group need to conform to social demands, to follow seasonal styles which require everyone to plant and harvest at particular times.

When Berry (1966) examined the research on Eskimo and Temne patterns of childrearing, he found great differences in the extent to which each culture emphasized independence versus conformity. Eskimo parents tended to be highly indulgent toward children and allow them to make their own decisions, even at young ages. Temne parents tended to treat children with great affection until weaning but afterwards demanded strict obedience. Child-rearing styles that emphasize independence, psychologists find, are linked to higher levels of spatial skills.

In short, Berry predicted that the Eskimo would have higher levels of perceptual and spatial abilities than the Temne because such skills were more adaptive in an Arctic hunting culture. To test his ideas, Berry gave a series of spatial and visual tests to Canadian Eskimo, Temne in Sierra Leone, and, for a comparison group, Scots. In one test, for example, Berry projected onto a screen a series of triangles, squares, and rectangles, and asked people to draw what they saw. Each geometric form had a tiny gap on one side which gradually got bigger.

How big did the gap have to get before a person noticed it? The Eskimo, far more quickly than the Temne and indeed more quickly than the Scots, noticed and drew the tiny gaps. On a series of visual and spatial tests like this one, Berry found the same basic pattern: Eskimos far exceeded the Temne in spatial and visual skills. On many tests, the Eskimos' performance matched or came close to the Scots' performance, even though the Eskimo did not have as much education and were not familiar with western psychological tests.

Intrigued with Berry's clever research design and his striking findings, I decided to do a study of spatial and visual abilities among Alaska Eskimo children to see if they had similar strengths. On a test requiring children to reproduce from memory a series of difficult designs, first put on a chalkboard and then quickly erased, Alaska Eskimo children from 9 to 16 years of age did significantly better than urban Caucasian children (Kleinfeld, 1971).

When I looked at other research and at the writings of people who had lived and traveled with Eskimo, the evidence for strong visual and spatial abilities seemed overwhelming. Many studies had come up with the same results as Berry's research and my own. Compared to English verbal abilities, Eskimos appeared to have far greater strength in perceptual and spatial skills.

Anecdotal descriptions supported the research findings. People traveling with Eskimos remarked on their extraordinary ability to notice and recall visual detail, for example, drawing from memory a map later found to be about as accurate as one made from aerial photographs. Eskimos' mechanical and inventive abilities had become legendary—constructing a sled from pieces of frozen meat.

While psychologists were pointing out the high levels of perceptual and spatial abilities of Eskimos, anthropologists were making a similar point but from a different angle. Anthropologists who studied Eskimo and other Native American communities described a traditional system of education based on observation. Children watched carefully what adults did—such as repairing a fishing net or setting a trap—and then imitated their skills. They did not learn by asking and answering a lot of questions. Summarizing the ethnographic research on children's learning styles, Kaulback (1984) says:

Although far from conclusive, there is a growing body of research to suggest that distinctively different child-rearing practices—one stressing observational learning and another

emphasizing learning through verbalization—has fostered the development of very different styles of learning among Native and white children. Whereas many white children, by virtue of their upbringing and their linguistic exposure, are oriented towards using language as a vehicle for learning, Native children have developed a learning style characterized by observation and imitation (p. 34).

The implications for education seemed immense. Spatial and visual abilities were important in such fields as physics and mathematics. Einstein, after all, described his thinking processes as "visual and motion" with words not playing a part until the basic ideas had formed. Perhaps Eskimo people could make important contributions in these advanced fields.

Most teachers taught through methods that emphasized verbal skills—lectures, reading, and class discussion. Why not use visual methods which would build on Eskimo children's intellectual strengths and learning styles? The idea seemed to make so much sense. I just couldn't believe it wouldn't work.

Adapting Instruction to Native American Learning Styles

"Learning styles" does not have a clear and precise definition. It is a catch-all phrase used to refer to a wide array of abilities, ways of processing information, and personal preferences. Some people use *learning style* to refer to learning through visual, verbal, or kinesthetic channels. Others use the words to refer to ways of processing information, for example, preferring information presented in small, linear steps or large patterns. The most influential educator arguing that we should adapt instruction to learning styles, Rita Dunn, is referring to a lot more than cognitive abilities. By "learning styles," she and her colleagues mean adapting instruction to many individual preferences, such as whether children study better in the morning or afternoon, alone or in groups, in a quiet or noisy setting, or with bright or soft lights (Dunn & Griggs, 1988).

Dunn's viewpoint makes sense. We all try to arrange for ourselves the kinds of environments where we learn best and we resent being forced to learn in situations we find irritating. I do my best work in the morning, for example, and need quiet

in order to concentrate. My husband gets in high gear in late afternoon and works best with music in the background. Children, too, would learn better, most of us believe, if teachers adapted instruction to their learning styles rather than insisting that everyone study in exactly the same way.

But notice that we have shifted the argument here. We are no longer talking about matching instruction to the learning style of a cultural *group*. We are now talking about matching instruction to all the complicated preferences and abilities of people as *individuals*. These are not the same thing. When we talk about matching instruction to a cultural group, we are recommending that teachers make assumptions about individuals because they are Native American or African American or members of some other cultural group and teach members of these groups in the same way. When we talk about matching instruction to individuals, we are recommending that teachers find out about individual preferences and organize classrooms so that a variety of individual learning styles can be accommodated.

Teachers influenced by Dunn's conception of learning styles create rich and diverse classroom environments where some students sit at desks and others lounge on bean bags, where some students study from films and tapes while others do a lot of reading, where much learning is carried out through individual contracts and learning projects fine-tuned to students' interests and ways of doing things.

While I recognized that the term *learning styles* had very different meanings and very different classroom implications, depending on what definition you used, I had one particular meaning in mind. Psychologists had found high visual and spatial abilities among Eskimo and other Native American groups. Anthropologists emphasized that Native American children learned by watching. By adapting instruction to Native American learning styles, I meant teaching through visual ways of presenting information rather than only verbal ways. I wanted to see if Native American children indeed learned better when teachers presented information with the aid of films, pictures, and diagrams.

But consider what I would actually need to show to support the viewpoint that instruction should be *adapted to the learning styles of different cultural groups.* Suppose I did find that Native students learned better when teachers used films, pic-

tures, and diagrams. Maybe all students, no matter what their cultural group, also learned better when teachers used films, pictures, and diagrams. Maybe using such visuals was simply better instruction. To show that teachers should adapt instruction to cultural differences, researchers needed to show that children from one cultural group learned better with one method of instruction while children from a different cultural group learned better with a different method of instruction. I couldn't show this. . . . and neither has anyone else.

My efforts to show that visuals were more helpful to Native children than to non-Native children turned out to be failures. Disappointed, I never even bothered to publish the results. But a colleague who worked with me, Don Erickson, did write up the work. He was a teacher on St. Lawrence Island, a traditional Eskimo community, and had to write the paper to meet his degree requirements at the Harvard Graduate School of Education.

We developed a lesson on the classification of animals (herbivores, carnivores, and omnivores) and on the place of these animals in the food chain. In the verbal lesson, the instructor just talked about these concepts without using any pictures. In the visual lesson, the instructor not only talked about the concepts but also drew diagrams which highlighted the logical relationships and the cause and effect sequences. The instructor put a diagram of the food chain on the board, for example, to show students the links between plants, herbivores, and carnivores. By visually wiping out the links in the chain, the instructor showed children what happened when certain plants or animals were destroyed. After they had been taught with either the visual or verbal-only lesson, students answered such questions as, "if all the plants died, would herbivores be able to live?"

We gave this lesson both to Eskimo children living in a traditional village with a strong hunting culture and to Caucasian children living in an urban town. The Eskimo students, we found, did learn more with the visual lesson . . . but the Caucasian children benefited the same or more! We had not shown that visually based instruction was better adapted to Eskimo students' cultural learning style. All we had shown was that Eskimo and Caucasian children *both* learned better when diagrams were used to emphasize logical relationships.

Since I wasn't getting anywhere in trying to adapt instruction to cultural differences, I decided to turn my own attention to other educational issues which I hoped would make more of a difference to the well-being of Native American children. Twenty years later, I examined the research on learning styles to see if others had been more successful than I had been. Perhaps other researchers, using a different way of teaching, would have demonstrated the benefits of adapting instruction to cultural differences in learning styles.

But I found no such studies. Only two other studies on visual versus verbal instruction with Native American children had been published, and neither study showed that visual materials were more effective (Kleinfeld & Nelson, 1991). People were still writing about Native Americans' observational learning styles and the learning styles of African-American and other cultural groups. Teachers were still being urged to adapt their instruction to cultural differences in learning styles. But so far no one had been able to demonstrate with controlled research that teaching one cultural group in one way and another cultural group in an entirely different way had educational benefits.

Just because we do not now have research studies showing that one style of instruction is more effective for Native American children does not mean that we will never have such research evidence. Possibly other studies will be done showing that visually-based instruction indeed makes more of a difference to Native American children. Possibly the concept of "learning style" will be redefined, and this new concept of appropriate instruction will prove to be more effective. Some experienced teachers, for example, say that what works with Alaska village children is not so much a "visual" curriculum as a "kinesthetic" curriculum based on hands-on activities and projects.

Other educators argue that educational programs for Native American children are far more successful when they are based on the "cooperative" style of work characteristic of the traditional culture rather than the "competitive" style of American mainstream culture. Native American children, they believe, achieve more when teachers put children in cooperative groups. Such cooperative learning has been shown to be effective with children generally. Thus, the basic question remains: Are cooperative groups more effective for Native American children than children of other cultures? Furthermore, we must also consider whether we need to prepare Native American chil-

dren for different contexts, competitive as well as cooperative.

The Value of Learning Styles

If we have no scientific evidence that we should teach children of different cultural groups in different ways, why is the concept of "cultural differences in learning styles" still so popular?

The concept of learning styles is useful when it reminds teachers to create rich and interesting classrooms where children can learn in many different ways. "Don't always sit children down in rows of desks and teach them through lectures, textbooks, and worksheets," advocates of learning styles are saying, "What about cozy reading corners where students can lounge on bean bags? What about getting students out into the community to work at a soup kitchen?" Expanding learning opportunities makes good sense.

The concept of cultural learning styles is also helpful when it reminds teachers to pay attention to the ways of life in the communities in which they teach, especially when these are culturally distinctive communities. One of my teacher education students, for example, first prepared a demonstration science lesson for children in a remote Eskimo village which consisted of a boring lecture on calories and energy transformation. He talked too fast for children whose first language was not English and referred to many concepts outside the children's experience. After he had spent a few months teaching in an Eskimo village, he changed his teaching style dramatically. In a second demonstration science lesson, he asked Eskimo children to attend a steam bath, an important social event in many Eskimo communities, and to observe carefully when water was a liquid, solid, or gas. The children came back to class and talked about what they had seen and the principles behind it. They asked new questions, like what happened to the steam when the door of the steambath was opened. My student was now teaching science in ways adapted to the cultural setting. He would probably say he had adapted his teaching to students' learning styles.

Used in these ways, learning styles can be a fruitful idea. But the concept is dangerous when it amounts to an invitation to racial stereotyping. Assuming that all children of a particular group learn in one distinctive way, rather than considering them as individuals, limits children and reduces their opportunities.

ENDNOTE

[1]The choice of designator for a cultural group is always a sensitive matter. As John Active, a Yup'ik journalist, points out, non-Natives often use the term "Eskimo" but it is not what people of these cultural groups call themselves. In Southwest Alaska, the preferred term is "Yuliit" and in northern and northwest Alaska, "Inupiat." The research literature on which this paper is based, however, uses the term "Eskimo" and does not always make distinctions as to which group is designated. For this reason, I have used the term "Eskimo" in this paper. The term "Native American" is currently used by Native groups throughout the United States to emphasize cultural and political unity. I use this term in reviewing ethnographic research in learning styles since the reference is usually inclusive of various Native American groups. I have endeavored to be sensitive to current preferences, but the reader should keep in mind that the research literature is not always specific and group preferences change over time.

REFERENCES

Berry, J.W. (1966). Temne and Eskimo perceptual skills. *International Journal of Psychology, 1,* 207–199.

Dunn, R. & Griggs, S. (1988). *Learning styles: Quiet revolution in American secondary schools.* Reston, Virginia: National Association of Secondary School Principals.

Kaulbach, B. (1984). Styles of learning among native children: A review of the research. *Canadian Journal of Native Education, 11*(3), 27–37.

Kleinfeld, J.S. (1971). Visual memory in village Eskimo and urban Caucasian children. *Arctic, 24,* 132–138.

Kleinfeld, J.S. & Nelson, P. (1991). Adapting instruction to Native Americans' learning styles: An iconoclastic view. *Journal of Cross-Cultural Psychology, 22*(2), 273–282.

Nelson R.K. (1969). *Hunters of the northern ice.* Chicago: University of Chicago Press.

23
The Cultural Construction of Intelligence

ROBERT SERPELL

Why do psychologists assess intelligence? Since you are reading this chapter, you have probably been described by someone as an intelligent person. Whatever your immediate reasons for picking up this book and for turning to this chapter, it is likely that you are involved in a course or a program of higher education. A series of decisions led to your participation in those studies, some of which depended on estimates by other people of how well you were likely to understand such topics as psychology and culture. Those estimates almost certainly involved some elements of what is called the assessment of intelligence.

Some estimates may have been based in part on scores assigned to your performance on a standardized test. For instance, a college admissions committee may have selected you because your *S.A.T.* scores fell above a certain criterion. In other cases, the estimate may have involved a more informal, impressionistic synthesis from observations across a number of different settings, in which your behavior was compared to that of other people engaged in the same activities as you. For instance, a

letter of recommendation to the college by one of your high-school teachers might include such statements as "This is one of the *brightest* students in my class" . . . in Chemistry, in Literature, or in World History.

Each of these forms of assessment—by a committee looking at your test scores, or by a teacher reminiscing about your behavior in class—is derived indirectly from judgments of the quality of your responses to particular tasks. Consider a task of special interest to many school teachers: the student is asked to propose an explanation to the rest of the class for a surprising event you have all recently witnessed. In chemistry, the event might be a sudden change in color of the contents of a test-tube during an experiment, in literature it might be a betrayal of trust by the hero of a novel you are studying, in history it might be a news item announced last night on television or radio. Depending on the context and on her philosophy of education, the teacher might assess the quality of your response to such a challenge on only one or more of the following dimensions: How appropriate was the evidence you cited? How logically coherent was your reasoning? How much insight did you show into the nature of the problem? How precisely did you make your case? How subtle was your interpretation? How eloquently did you phrase your idea? And so on.

The tasks used for professional psychological assessment are usually more strictly controlled than this, and the best performance is defined as choosing the correct one among four or five alternatives. Critics of such tests often complain that the way in

Robert Serpell is Professor and Director of Applied Developmental Psychology at the University of Maryland Baltimore County. Born and raised in England, he received his degrees in psychology from the Universities of Oxford (1965) and Sussex (1969). In 1978, he became a citizen of Zambia where he has lived for most of his adult life. His research and publications have mainly centered around the influence of sociocultural factors on cognitive development and intelligence.

which their tasks are posed is unnatural, and their definition of a correct response is narrow and arbitrary. Both of these prevalent features of psychological tests arise from the attempt to control and standardize the task presented to the respondent. The construction of a multiple-choice test begins with an intuitive phase involving similar criteria to those used by the teacher in her classroom assessment, but is then followed by a systematic, empirical process known in the field of mental measurement as standardization. The idea is to reduce the chances that the personal opinions of the tester could bias his or her assessment of the subject's intelligence. Rather than following her intuitive judgment, the psychologist is trained to follow with great precision a standard set of procedures that have been tried out with many people before, and to interpret the subject's responses in accordance with a set of guidelines derived from the experience gained when the procedures were being standardized on other people with comparable experience. The quality of the subject's performance is thus compared with the performance of other subjects under very similar conditions.

This particular format of psychological assessment, grounded in systematic research and protected by professional regulations, has acquired a privileged status in the culture of the modern world, especially in the fields of education and mental health. Yet the evaluation of how intelligently a person has behaved is also regarded as transparent, in the sense that everyone is expected to agree at least about the most extreme cases. Professional psychology depends on this assumption to guarantee its cultural validity.

However, when the performance of people from different cultural backgrounds is compared on a single, isolated intelligence test, considerable differences are often observed. One interpretation of such findings has been that some cultures have greater potential than others for the cultivation of intelligence. An alternative view has been that the test is less appropriate for the assessment of intelligence in one culture than in another. Psychologists have debated these and other alternatives intensively, seeking to establish how psychological assessment can best contribute to educational practice.

In this paper, I will describe three different ways in which culture may be said to construct intelligence. We may think of culture: (1) as a nurturant environment from which the developing mind derives its nourishment; (2) as a system of

meanings in terms of which the nature of intelligence is formulated; or (3) as a forum in which alternative approaches to the definition and measurement of intelligence are debated. I do not intend to argue that one of these versions is radically superior to the others. But their emergence in my own thinking has been sequential, with each newer version arising in reaction to a limitation of its predecessor.

CULTURE AS A NURTURANT ENVIRONMENT

At the beginning of my research program at the University of Zambia, I thought of culture as achieving its constructive influence on the course of cognitive development in much the same way that evolutionary pressures over a much longer period of time have shaped the behavioral repertoire of different biological species to fit the ecological niche they inhabit. Examples of such ecological adaptation in biology include the capacity of mam-

Children are enculturated in the course of their development into a facility with the machines, the language, and the rituals of their society.

mals that live in trees to climb, and of those that live in water to swim. Human cultures add a further dimension of structure to the habitat, with technological artifacts and recurrent practices. Children are enculturated in the course of their development into a facility with the machines, the language, and the rituals of their society.

A distinctive feature of children's behavior all over the world is their playfulness. In addition to physical exercise and social interaction, children's play affords opportunities for the exercise of cognitive skills. Many of the games played by children in Western societies involve the solution of puzzles similar in design to those that are featured in the school curriculum, and psychological tests have often been designed to capitalize on children's familiarity with and interest in this type of game.

To a cross-cultural voyager to Zambia from Britain in the 1960s, certain differences in the types of games children played were immediately apparent. During the course of my visits to the homes of schoolchildren in the capital city of Lusaka, I very rarely saw any commercially manufactured toys, children's books, or crayons. Yet, in almost every neighborhood, I would meet a group of boys "driving" along the gravel road in front of them skeletal model cars built from scraps of wire (see Figure 1). These wire cars are popular all over central and southern Africa. They are constructed by boys between the ages of about six and fourteen, without any instruction manuals or any guidance from adults. The models vary in many points of detail, and most of the young craftsmen will gladly explain to a curious researcher how the axles are connected to the chassis, how the steering works, how the doors are hinged, etc., as well as telling what make of car the model represents.

The conspicuous skill and ingenuity displayed in this context impressed me as evidence of a high degree of competence in a cognitive domain very similar to that sampled by several Western psycho-logical tests, such as the Block Design assembly test, the Bender-Gestalt test, and the Draw-a-Person test. Yet, I soon discovered in my research laboratory at the university, that these were among the most difficult tests for Lusaka schoolchildren, and were even more difficult for children living in rural areas of the country. After reviewing and adding to an inconclusive literature on the nature of those difficulties, I designed a study to bridge the gap between Zambian children's skillful toy-making and their poor performance on Western tests.

The guiding hypothesis of the study (Serpell, 1979) was that the abstract psychological function of pattern reproduction can manifest itself in different ways according to the demands of the eco-cultural niche to which the subject's behavior is adapted. In an environment abundant with paper and pencils, children would be likely to acquire greater pattern reproduction skills in the medium of drawing than in an environment where the relevant materials were scarce. Conversely, in an environment where modeling in wire was a recurrent play activity, children would be likely to acquire greater pattern reproduction skills in the medium

FIGURE 1 An example of a wire car built by a Zambian boy.

of wire-modelling than in an environment where the activity was unknown.

We sampled two contrasting, low-income neighborhoods to test the hypothesis, one in Lusaka, the other in Manchester, England. Eight-year-old boys and girls were asked to reproduce a standard pattern, such as a square with diagonals, a human figure, or a flower. In the drawing version of the task the child was given a blank sheet of paper and a pencil and asked to copy a printed standard. In the wire-modelling task, the child was handed a strip of wire and asked to make a model just like a standard wire model. We also administered a clay-modelling version of the same task, which we predicted would be of equal difficulty for both samples, since many Zambian children make models from natural clay during the rainy season, and many English children play with industrially produced modelling clay. As we had predicted, the English children performed significantly better on the drawing task, while the Zambian children performed much better on the wire-modelling task, and there was no group difference on the clay-modelling task.

A similar pattern of results was obtained by Irwin, Schafer, and Feiden (1974) in a study that compared the performance of two groups of adult men with different cultural experience on two versions of another cognitive task often regarded in Western psychology as an index of intelligence. Mano rice-farmers in Liberia were able to sort bowls of rice according to three alternative dimensions significantly more often than psychology undergraduates in the United States, whereas the same Americans were able to perform significantly more sorts than the Liberians when the materials were cards displaying colored geometrical shapes. Thus cognitive flexibility in classification was found to depend on the cultural familiarity of the medium in which it was assessed.

In both of these studies, the focus is on culture as a source of structure in the external, material environment which the developing child explores and incorporates. The significance of culture for development is likened to that of a womb, enclosing and feeding the growing mind. However, the constructive cultural context of human development is not only material but also social: adults and older children provide guidance and feedback to the child's activity and interpret these interactions in terms of a shared system of meanings, which the developing child gradually appropriates as his or her own.

CULTURE AS A SYSTEM OF MEANINGS

While we admire the ingenuity of expert toymakers, farmers, and scholars, these are not the only qualities of mind that are valued by humans. Fairness and the capacity to appreciate another person's point of view often carry great weight in our choice of advisors in moments of crisis. These are qualities of mental depth rather than speed, and they feature prominently among the goals of child-rearing and education cited in studies of indigenous African cultures (Serpell, in press). The ideal endpoint of personal development in these societies is construed as someone who can preside effectively over the settlement of a dispute, whose judgment can be trusted in questions of character, who can and will take on social responsibility.

This broader range of applications for human intelligence came to my attention in the 1970s while reflecting on a professional problem raised by many clinicians in African mental health services. How should one approach the assessment of intelligence in the case of an adult patient referred for treatment because of socially deviant behavior in a rural community? Modern psychiatry takes account of a patient's intelligence in determining the diagnosis of psychological problems and in planning a course of treatment. But none of the tests standardized for the schoolgoing population seem at all appropriate for the assessment of intelligence in an adult who has never been to school, has not learned to read and write, and has lived all her or his life within a subsistence agricultural community.

The problem here is more fundamental than how to measure a particular cognitive process such as pattern reproduction. We need to know what qualities of mind are adaptive within such a sociocultural setting. I therefore sought an introduction through students enrolled at the University of Zambia to a remote rural community where we could invite some of the village elders to share their views with us. We decided to retain a focus on children, since adults in every society tend to hold definite views about how they wish their children to grow up. Our goal was to learn from elders about the qualities of child behavior they valued most, in contexts where it matters within the framework of the community's way of life (Serpell, 1982). A group of friends and colleagues who had grown up and lived in Zambian villages helped me to brainstorm a set of vignettes, including the following:

"If a house caught fire and there were just these children there, whom would you send to call others for help?"

"Suppose you go to a house early in the morning . . . and you find all the adults are away at work. Then these children come to you shouting 'thief,' 'knife,' 'he's run away.' The things the children are saying are not clear at all. Which child would you ask to explain clearly what had happened?"

"Suppose you are washing your clothes and you see that the place where you usually spread them out to dry is muddy, which of these girls would you send to search for another good place to spread your clothes?"

Before posing these questions, we identified for the respondent a set of between four and seven children of the same gender and similar age, all resident within the same village, and all well-known to him or her in the course of everyday life. After she had chosen one child for each hypothetical task, we asked the elder to explain her choice.

We sampled six small villages (with 60–170 inhabitants) within a small radius in Zambia's Katete District. The reasons cited by our informants for their choices provided a rich collection of words and phrases in common usage in this rural Chewa community for evaluating the behavior of children. We were also able to count the frequency with which a given child was cited as the best choice, within the village, for each task. We also administered several cognitive tests including a clay or wire modelling adaptation of the Draw-a-Person test and other tests based on recurrent local children's activities. Adults who were reinterviewed after an interval of several months were quite consistent, but the level of consensus among different informants was quite low. We therefore computed for each child an aggregated index of her ratings by four or five adults.

This index showed little or no correlation with our independent assessments of individual differences on the behavioral tests. Although some doubts can be raised about the reliability and validity of each of these two sets of estimates of intelligence, I regard their lack of convergence as a valid and significant finding. The indigenous Chewa point of view for conceptualizing children's intellectual development was articulated by our informants in terms of an overarching, superordinate concept, *nzelu*, which encompasses the notions of

wisdom and intelligence, as well as two subordinate dimensions, cognitive alacrity (*ku-chenjela*), and cooperative social responsibility (*ku-tumikila*). These elders, and indeed the young people themselves when we interviewed them many years later as young adults, indicated that *ku-chenjela* in the absence of *ku-tumikila* is a negative social force that runs contrary to the objectives of the indigenous educational philosophy (Serpell, in press). Despite the rarity with which its dimensions are explicitly articulated or affirmed in public discourse, and despite its low prestige in the arena of national and international debate about education, this system of constructs and the associated practices encoded in Chewa culture constitutes a coherent alternative to those represented by the system of formal schooling. Moreover the point of view represented by this indigenous system derives great strength from the facts of its familiarity and its continuity with many other aspects of contemporary life in the community.

Even in the United States, where the practice of intelligence testing, and the theoretical rationale for the tests have been widely promoted through the schools and the media for many decades, members of the general public have retained some skepticism about the psychological establishment's approach to the definition of intelligence. Sternberg, Conway, Ketron, and Bernstein (1981) asked two large samples of Americans, a group of specialists engaged in research on intelligence and a group of "laypeople" resident in a middle-class suburb on the East Coast, to rate each of a set of behaviors in terms of how characteristic they were of "an ideally intelligent person." Factor analysis of the responses revealed two main factors among the ratings by the specialists, centering on verbal ability and problem-solving ability. Ratings by members of the general public yielded these same two factors, but in addition a third factor that centered on social sensitivity and responsibility.

Now the specifics of how social competence is manifested will likely differ considerably from one culture to another. For instance, the item "is on time for appointments" (see Table 1) would have little meaning in the life of a Chewa village. Nevertheless, the research evidence points to a comparable challenge for educational psychology in both North America and Africa. Technical definitions and tests of intelligence cannot afford to become too far alienated from the wider culture's concerns about children's development, if they are to contribute to the task of optimizing the match between educational

TABLE 1 **Behaviors rated characteristic of an ideally intelligent person by members of the general public in Connecticut**

The social competence factor	Factor loading
Accepts others for what they are.	.88
Admits mistakes.	.74
Displays interest in the world at large.	.72
Is on time for appointments.	.71
Has a social conscience.	.70
Thinks before speaking and doing.	.70
Displays curiosity.	.68
Makes fair judgments.	.68
Does not make snap judgments.	.66
Assesses well the relevance of information to the problem at hand.	.66
Is sensitive to other people's needs and desires.	.65
Is frank and honest with self and others.	.64
Displays interest in the immediate environment.	.64

Excerpted from Sternberg et al., 1981, Table 4, p. 45.

provision and the developmental needs of individual children.

CULTURE AS A FORUM

If a parent's conceptions of intelligence and cognitive development differ from those implicit in the school curriculum, the parent has a number of choices. She or he can treat school and home as complementary environments, each with its own agenda for the child's socialization. Many immigrant families opt for this strategy and strive to ensure that their children become bicultural—competent in both the "mainstream" culture of the host society and also in the minority culture of their ancestors abroad. A more radical option is not to enroll one's children in school at all. In some societies, this option is prohibited by law. But various compromise formulas have been devised, such as establishing an alternative school designed to reflect the values of a particular minority culture.

Perhaps the most demanding strategy is to confront the dissonance between the parents' cultural agenda and that of the school, seeking through negotiation to work out a new curriculum that will respond to both sets of goals. One organization that has pursued this approach vigorously in recent decades is composed of parents with a child whose intelligence was seriously impaired early in life by a biological accident. Rather than accepting the pro-

vision of separate, protective services, parents of children with intellectual disability (or mental handicap) in many of the affluent industrialized nations have pressed for their children's right to participate in mainstream schooling and to receive special educational support within that setting (Mittler and Serpell, 1985).

In the rural Zambian community described above, the dissatisfaction of families with their local primary school was expressed in a variety of ways (Serpell, in press). Unlike the city schools, which every year experience long queues of eager parents clamoring to enroll their child in the first grade, at this school, the teachers felt the need to mount a door-to-door recruitment drive each year to fill the vacancies. Moreover, many pupils dropped out of school after two or three years, and only a small minority completed the full seven-year primary curriculum.

When we interviewed young men and women in this community about their reasons for dropping out, a few justified their decision with reference to immediate social or economic opportunities, such as getting married or herding cattle. But most of them stated that the curriculum had been too difficult, and described themselves as school failures. Many used the expression *ndinalibe nzelu*, meaning I lacked the necessary *nzelu*—the quality of mind that we had found so highly valued by their elders in the context of village life. Yet these voting people were coping resourcefully with the demands of a challenging environment. Some were growing cash crops and commuting with rides on long-haul trucks to sell their produce in the city; others had migrated to the city where they were scraping a living from marginal, poorly paid jobs. Many were raising young children with meager resources, and all of them planned to enroll their own children in school when they grew up.

A salient feature of the school system that most of these young people had abandoned is its rigid hierarchy of grade levels, segmented by competitive selection examinations. Less than 20 percent of more than 100,000 candidates who take the grade 7 exam each year are offered places in grade 8, and of the 20,000 or so who take the Grade 9 exam less than half are offered places in Grade 10. Locally constructed tests of verbal and nonverbal reasoning, modeled on Western intelligence tests play an important part in the national competition for places in Grade 8. The cut-off points on the scales of performance are arbitrary, simply reflecting the number of vacancies in the next grade. The strin-

gency of this selection process is well-known to rural communities. They also know that formal schooling only conveys a reliable advantage in the national labor market if the student completes Grade 12. Yet, rather than challenging the validity of a school system that denies real opportunities for educational success to all but a small minority, most of our cohort of young people blamed themselves as insufficiently intelligent.

Searching for ways to communicate the implications of our research to this community, we eventually found a fertile medium in popular participatory theater. A drama was composed with the active participation of young men and women from the community, portraying a variety of life journeys. At one extreme, explicit opposition to the culture of the school was represented by a young man enrolled in an indigenous secret society, while at the other was a young man whose success up to the level of Grade 9 had led him to seek his fortune in the city. Other characters in the play had left school either before or after completing the primary curriculum. Teachers and students as well as adult school-leavers role-played characters on stage very different from their actual lives, and the audience reacted with enthusiasm to the dilemmas portrayed. At the end of the drama, attention was drawn to the positive contributions made to the local community by those who had "failed" to qualify for further schooling, but had made a success of their life in other ways. Different constituencies within the community interpreted the significance of the drama in different ways (Serpell, in press). The drama thus became a forum for the articulation and debate of different perspectives on the significance of schooling as a resource for enhancement or frustration in the lives of local people.

Popular theater is one of several cultural modes of collaborative construction of shared meanings. Others are differently constituted. For example, when a psychologist seeks to share with the family of an intellectually disabled child some of the principles of task analysis and behavior modification, she or he may improve the demonstration of a specialized technique by inviting a parent or sibling to model a planned intervention with the child. In the course of such interaction, the caregiver is more likely to appropriate the new technology if her preexisting, indigenous ideas about disability and learning are acknowledged. Moreover, in any culture, the child's prospects of benefiting from planned intervention will be enhanced if the relationship between caregiver and professional is based on mutual respect for each other's complementary domains of expertise (Mittler & Serpell, 1985).

CONCLUSION

I have suggested three different metaphors for the function of culture in the construction of intelligence: the nurturant environment of a womb, the vocabulary of a language, and the exchange of ideas in a forum. Each of these metaphors of cultural construction is complementary to the others. Culture structures the effective opportunities for intellectual development, defines the goals of socialization, and constitutes the context within which the definition of goals and opportunities for attaining them is debated among the people who collectively own, belong to, and construct that culture.

The social problem of alienation between technical psychology and the mainstream of cultural understanding cannot be resolved by merely selling the ideas of science to the general public. Because intelligence is itself a culturally constructed aspect of the human mind, scientific theories of intelligence need to incorporate the common-sense intuitions of the society at large. Professional psychologists need to adapt their definitions, their assessment methods, and their interventions in the light of open and constructive discourse with other participants of the culture.

REFERENCES

Irwin, M.H., Schafer, G.N. & Feiden, C.P. (1974). Emic and unfamiliar category sorting of Mano farmers and U.S. undergraduates. *Journal of Cross-Cultural Psychology, 5*, 407–423.

Mittler, P., & Serpell, R. (1985). Services: An international perspective. In A. M. Clarke, A. D. B. Clarke, & J. M. Berg (Eds.), *Mental deficiency: The changing outlook* (4th edition), pp. 715–787. New York: Free Press.

Serpell, R. (1979). How specific are perceptual skills? A cross-cultural study of pattern reproduction. *British Journal of Psychology, 70*, 365–380.

Serpell, R. (in press). *The significance of schooling: Life-journeys in an African society.* Cambridge: Cambridge University Press.

Sternberg, R., Conway, B., Ketron, J., and Bernstein, M. (1981). People's conceptions of intelligence. *Journal of Personality and Social Psychology, 4*, 37–55.

Section V: _____

Everyday Modes of Functioning as Shaped by Culture

Nearly forty years ago a researcher by the name of Charles Morris did some research on human values involving different cultures which resulted in a debatable conclusion. He claimed that across the vastness of recorded human history and the great variation in cultures, religions, and ethics, people have designed or discovered 13 basic "Ways to Live." The basic idea was that each "Way" differs enough from the other 12 for it to stand alone as a distinct guide to living. Not long after Morris did his research, someone looked at his basic data and concluded that Morris's 13 Ways to Live could be reduced to just three really "pure" ways. These three ways were labelled in honor of Greek gods whose names captured the essence of the values subsumed under this trio of orientations to life:

The Promethean: Mastery over nature and active control of one's environment is the way to live, not reverence to natural resources. Industriousness and determination to succeed will be rewarded by exploiting and accumulating the riches of life.

The Dionysian: Life should be lived to its fullest. All the bounties that are available should be enjoyed to their fullest. Life is a feast, a party. As someone once said, "You're not here for a *long* time, you're here for a *good* time." Live fast, die young, and have a good-looking corpse.

The Buddhistic: The good life is one that is lived in relative solitude and quiet contemplation. Paying reverence to the wonders of nature is the best choice. Humbly relishing all the beauty and wonders that the earth has to offer is how humans should live out their years.

Does one of these ways to live fit your values philosophy, or the values and would view espoused by the culture or ethnic group to which you belong?

Is it possible to reduce life's offerings in this way? Perhaps a more basic question to ask is "Why do scientists and scholars get involved with such reductionism?" In answering this question we can merely point out that the attempt made by Morris is only one of hundreds of efforts that psychologists have made to categorize, quantify, label, or otherwise organize the great variations in human existence and experience that are available to most people. In fact, if science is *anything* it is an attempt by inquisitive people to discover regularities, or patterns, among the vast array of phenomena that make up the world and indeed the universe. Many believe that the only way science can proceed is by being reductionistic, that is, to find a small number of principles that might be generalizeable to as many situations as possible.

Kluckhohn and Strodtbeck (1961) made a similar and more widely known attempt to reduce values to a small number of dimensions. These dimensions, or categories, included: (1) Human nature (bad to good); (2) Relationships (lineal-hierarchical to individualistic); (3) Relationship of people to nature (living in harmony to total mastery); (4) Time orientation (past, present, future); and (5) Activity orientation (being to doing). Small and restricted sample sizes have caused many researchers to question the generalizeability of the categories, yet they do cover several very important human activities.

A more recent, energetic, and sophisticated attempt to organize human values around dimensions that might be generalizeable across cultures is the influential work of a Dutch psychologist, Geert Hofstede. Analyzing and quantifying certain responses contained in about 117,000 questionnaires from many countries (one of the *largest* sets of data with which we are familiar), Hofstede identified four basic orientations or preferences that people have; moreover, these orientations are consistent

with the idea of *patterns* of cultures and their orientations. This is consistent with Hofstede's belief that culture can be defined as the "programming of the mind." Because this research used information from mid-level managers working for IBM, one of the largest international companies, Hofstede (1980) called these orientations *work-related values*. After detailed statistical analysis, he built a convincing argument for the existence of four universal values dimensions. Briefly described, they are:

1. *Individualism.* This involves a somewhat selfish concern for oneself and a very small number of people who are close to oneself. This is contrasted with the obverse of this dimension, *collectivism*, where the needs and desires of the *group* are equal to or more important than the needs of the individual.

2. *Uncertainty avoidance.* This involves how much an individual (or a culture) needs formal rules and structure, as well as the extent to which ambiguity can be tolerated. The search for *the* right way to do things and, once it is found, to stick with it is the essence of this value.

3. *Power distance.* The basic idea here is the amount of *social* distance that exists between supervisors and subordinates in an organization and, quite importantly, the extent to which this is *accepted* by everyone in the group or culture. This is more commonly called the *pecking order.*

4. *Masculinity.* This involves how much value is placed on goals related to *productivity* (wages, promotions, profits) which depend upon assertiveness and competition as opposed to the value that is placed on *interpersonal* goals (getting along with workers, developing a friendly work atmosphere). The latter value is more related (perhaps stereotypically so) to the *opposite* of masculinity: *femininity.*

Data supporting the existence of these four dimensions do not preclude the existence, or the discovery, of other value orientations. Consider, for instance, the findings of an international network of scholars, led by Michael Bond, calling themselves the Chinese Culture Connection (1987), these researchers identified a value that has implications for the "Five Economic Dragons" of Asia (Taiwan, Hong Kong, Japan, South Korea, and Singapore). Labelling it "Confucian work dynamism," this value incorporates precepts of living associated with the life and writings of Kong Fu Ze, whose name was Anglicized to Confucius. Among the values included in more or less regional configurations are thrift, harmony, and a sense of shame.

Dimensionalizing, categorizing, and in general searching for cultural patterns in selected everyday modes of functioning is the main focus of the six chapters in this section. In Chapter 24, Harry Triandis summarizes some ways in which culture and social behavior are interrelated. He focuses on the currently popular dimension of *individualism/collectivism*, somewhat along the same lines of the most important of Hofstede's work-related values, mentioned above.

In Chapter 25, Caroline Keating discusses many of the main findings of a large number of researchers who have studied nonverbal behavior and how it relates to important human dimensions such as emotions and how they are expressed. This line of research can be directly attributed to one of the most prominent scientists of them all, Charles Darwin. Darwin was a reductionist as well as a great generalizer, for he not only generalized across the human species but across other species as well, finding much commonality in how emotions and other aspects of behavior are expressed nonverbally. The main topic of Chapter 26 is human values, written from the perspective of Norman Feather, an influential Australian social psychologist. When reading his chapter, one should keep in mind the values that others have uncovered, including the ones of Morris, Kluckhohn and Strodtbeck, Hofstede, and the Chinese Culture Connection, mentioned earlier. One should also wonder about other questions related to human values. How many values are there? How best can they be measured or understood? What purpose do they serve? How do they relate to observable behavior?

A large number of individuals in over 40 cultures have participated in research concerning a basic question of interest to most social scientists: How accurate are gender stereotypes such as the "aggressive" male or the "submissive" female? Do such gender stereotypes generalize across cultures? These questions are of central concern to the research of John Williams and Deborah Best, which they summarize in Chapter 27. The answers to similar questions have been sought by David Buss, who has been trying to determine if people around the world are looking for the same characteristics in their mate. Again, this is a problem of generalization. In Chapter 28 he summarizes his extensive research spanning many cultures which has been

concerned with mate selection. Finally, Patricia Devine and Julie Zuwerink explain how they and others have tackled what may be the most damaging and pernicious of all human characteristics: prejudice. Are all people prejudiced simply because that's how the human mind has been programmed by evolutionary factors? In Chapter 29 these young researchers give a quick glimpse into the common human tendency to prejudge others simply on the basis of certain salient characteristics they possess, such as skin color, religion, or country of origin.

The many dimensions which are addressed in this section themselves serve as a sample of topics that might be generalizeable. We urge the reader, when he or she is reading these short chapters, to keep in mind what we said at the beginning of this introduction: How generalizeable are the many common modes of functioning, such as values, traits attributed to gender, what people are looking for in a mate, and so on? We believe that it is interesting, intriguing, and even necessary to search for the answers to such questions. Most assuredly, the answers to such questions will have to take into account cultural influences and variations.

REFERENCES

The Chinese Culture Connection (1987). Chinese values and the search for culture-free dimensions of culture. *Journal of Cross-Cultural Psychology, 18,* 143–164.

Hofstede, G. (1980) *Culture's consequences: International differences in work-related values.* Newbury Park, CA: Sage Publications.

Klukhohn, F. R. and Strodtbeck, F. L. (1961). *Variations in value orientations.* Evanston, Illinois: Row, Patterson.

24
Culture and Social Behavior

HARRY C. TRIANDIS

On January 9, 1991, the Foreign Minister of Iraq, Tariq Aziz, and the Secretary of State of the United States, James Baker, met in Geneva, Switzerland, in a last-minute effort to avert the war between the two countries. Seated next to Tariq Aziz was the half-brother of Iraq's President, Saddam Hussein, who kept calling Saddam to give him an evaluation of what was going on. Baker who used the verbal channel of communication exclusively, stated very clearly: "If you do not move out of Kuwait we will attack you." Saddam's brother, however, paid most attention to the nonverbal forms of communication. He reported that Baker was "Not at all angry. The Americans are just talking, and they will not attack." As a result Saddam instructed Aziz to be totally inflexible, and give nothing. Six days later, to Saddam's great surprise, operation Desert Storm was unleashed. It devastated Iraq, killing untold thousands of people, and causing about $200 billion in property damage.

That was some cross-cultural mistake!

Harry C. Triandis is Professor of Psychology at the University of Illinois in Champaign-Urbana, Ill. He earned his Ph.D. (1958) from Cornell University, and authored *Culture and Social Behavior* (Boston: McGraw-Hill, 1994). He is President of the International Association of Applied Psychology and past President of the International Association for Cross-Cultural Psychology. He has received an honorary degree from the University of Athens, Greece, and the 1992 centennial award of the American Psychological Association for helping establish cross-cultural psychology as a distinct scientific field.

Not paying attention to the way culture influences social behavior is usually a mistake. In this chapter we will describe some of the ways culture affects social behavior, and make you aware of how things can go wrong if you do not pay attention to culture.

THE IMPORTANCE OF CONTEXT

The Iraqi example reflects one kind of cultural difference in social behavior: the relative importance of *context*. Cultures vary in how much people pay attention to the context rather than the content of what is said. Context includes level of voice, looking or not looking into the eyes, the distance between the bodies, the posture and orientation of the bodies, the extent to which one person is touching the other, and what parts of the body are being touched. Had Baker not been a perfect gentleman, he would have taken the Geneva Telephone Directory and aimed it at the head of Aziz, he would have looked fierce, banged the tables, and shouted; and there would have been no misunderstanding! But, that would have deviated from diplomatic behavior. In any case, it is very difficult for a person to change behavior so radically in order to conform to the expectations of persons from other cultures. The best we can do is to teach people to go part way in the direction that the others expect.

Context cultures are found mostly in societies that are homogeneous, relatively simple, and where people have to maintain long-term good relationships with others. Japan is a good example. In Japan people will rarely say "no." They are more likely to

take a deep breath, to frown, and to say "That is difficult." Saying "no" can make the other person lose face. They are quite concerned with saving both their own face and the face of the other person.

In other cultures people are even more subtle. For example, in Indonesia, a lower-class man and an upper-class woman met secretly and got to the point where they wanted to marry. They informed their parents, and following protocol the man's mother visited the woman's mother. The latter served her tea and bananas. Since tea is never served with bananas, that was a "dissonant" stimulus that said "no," without actually saying the word. Both women saved face.

In contrast to high-context cultures, we see low-context cultures, such as Switzerland, Germany, and other West European countries. The United States is a low-context culture also, but people do pay some attention to nonverbal cues. It is not as extreme a low-context culture as is Switzerland. Low-context cultures are nontraditional. Since people generally do not know each other very well, they have to spell out everything clearly and explicitly.

Four Types of Social Behavior Patterns

Four kinds of social behavior patterns have been identified across cultures (Fiske, 1990). *Community sharing* is a pattern where people know each other very well. Family life is the closest metaphor. What is mine is yours, intimacy, oneness, cooperation, and self-sacrifice within the ingroup (family, band, tribe) are typical behaviors. *Authority ranking* is the second pattern. The relationship between a general and a soldier is the closest metaphor. Obedience, admiration, and giving and following orders without questioning are the typical behaviors. The third pattern is *equality matching*, and the best metaphor is social behavior between totally equal friends. You go through the door first this time, and I go through it next time. Taking turns, dividing equally, one person one vote, are some of the typical behaviors. Finally, *market pricing*, the fourth pattern, is best described by the market. You pay and you get some goods. If it pays to be your friend, I will be your friend. If it costs too much, goodbye.

Collectivism and Individualism

Every culture is characterized by a combination of emphases on these four social behavior patterns. However, there is a tendency for cultures in tradi-tional societies, and especially in East Asia, to emphasize the first two patterns, and cultures in North-Western Europe and North America to emphasize the third and fourth patterns. This is the contrast between collectivist and individualistic cultures. It is also the contrast between cultures that are simple *and* homogeneous versus cultures that are complex *and* heterogeneous.

In complex, heterogeneous cultures (e.g. modern, Western, industrial) there are many groups to which one can belong. There are a myriad of "ingroups," that is, groups of people with whom an individual experiences some "common fate." One might join these ingroups if it "pays" to do so, and if the "costs" are not excessive. Joining is an *individual* decision, and the cultural pattern is individualism.

In homogeneous, simple cultures (e.g. subsistence farmers) there are not many choices about joining groups. One is more or less stuck with one's extended family and a few friends. So, the group is extremely important to the individual. The individual does what the group expects, and the cultural pattern is collectivism.

Some aspects of the environment make people pay a lot of attention to their ingroups. If people have only a few groups to which they can belong, and have to cooperate with those groups in order to survive, as happens when people must dig large irrigation canals, build big protective walls, or share the products of their hunting with their extended family, they become collectivists. Specifically, in many cultures when people hunt they kill an animal only once every three or four days, and since there is no refrigeration they must eat it soon or it will spoil. One way to ensure that they have something to eat every day is to share what they kill, since the others share as well. Collectivism also emerges in situations where people do not eat what they grow in their garden, but give it away, while their relatives and friends give away what they grow. Again this system protects people from poor crops and bad weather.

But hunters are less collectivist than agricultural people, because the latter must stay on the land, and can not walk away from their ingroups, while the former can do so. So, hunters are a shade more individualistic than subsistence farmers.

When people are affluent, they can "do their own thing" and no group can tell them what to do. Affluence is a major determinant of individualism.

The contrast between collectivism and individualism is one of the most important cultural differences in social behavior (Hofstede, 1980;

Triandis, 1990). Collectivists pay more attention to context than do individualists. But there are many other differences as well.

The contrast between collectivism and individualism is one of the most important cultural differences in social behavior.

Sense of Self

First, people cut the pie of experience differently if they grow in a collectivist rather than an individualistic culture. In a collectivist culture they think of themselves as embedded in a collective (Markus & Kitayama, 1991). In an individualist culture they tend to think of individuals as autonomous entities. Consider this: in traditional parts of Indonesia people do not use "personal names," but rather they use *teknonyms* (the equivalent of "the second son of the Smith family"). In other words, the person is not treated as an autonomous individual but an appendage of the group, in this case the family.

In studies in which we asked various samples of individuals in different parts of the world to complete 20 sentences that start with "I am . . .," we found that in collectivist cultures many of the sentence completions implied a group. For example, "I am a son" clearly reflects family; "I am Roman Catholic" clearly reflects religion. On the other hand such statements were rare in individualistic cultures. In individualistic cultures people referred mostly to their personal traits and conditions, e.g. "I am kind" or "I am tired." If we take the percent of group-related answers obtained from Illinois students as the basis, we found students of Chinese or Japanese background in Hawaii giving twice as many group-related responses, and students in the People's Republic of China giving three times as many such responses.

Determinants of Collectivism-Individualism

The United States is one of the most individualistic countries in the world. The reasons for this are because it is rich, its people have much social and geographic mobility (which allows them to leave their in-groups), and its people are exposed to very individualistic mass media. Most urban, industrial societies are rather individualistic. Europe is about

as individualistic as the United States. But Japan is not as individualistic as Europe, because while it is very complex, it is also rather homogeneous.

Homogeneous cultures tend to be collectivist. In homogeneous cultures people can have large areas of agreement concerning what behaviors are expected under what conditions. Norms of behavior are clear, and imposed with great certainty. Norms are also very important when the population is dense, since people have to learn to avoid running into each other. Japan is dense, so the rules of good behavior are very well spelled out. People are quite concerned about acting correctly.

In fact, many of the traditional Japanese ceremonies can be seen as exercises for learning correct behavior. The tea ceremony, for instance, involves people sitting in a row, according to the status of each, while a cup of bitter tasting tea is first given to the most important person who after drinking a little offers it to the next most important person, who also drinks a little and offers it to the next most important, and so it goes.

Each time the tea is offered the person refuses, so it must be offered repeatedly until the person accepts it. This ritual goes on until all have had some tea. The symbolism is very clear: we are all one group, we are together, but there is hierarchy, and we must act according to the rules. The ceremony can take more than an hour, and during that time one is supposed to admire the tea pot, the tea cup, the wall hangings, and other art objects; and enjoy the peaceful sound of water being poured, and experience great serenity. It is good discipline for learning to sit and behave properly and to pay attention to rank.

In Collectivism Behavior Reflects Norms

In collectivist cultures one does what the ingroup norms specify. One is very sensitive to what the group expects. Success is often attributed to the help of others, and failure to one's own lack of effort. In contrast, in individualistic cultures behavior reflects attitudes. People often attribute success to their own intelligence, while failure is seen as the result of the difficulty of the task or bad luck.

The Importance of Harmony

When there is conflict within the ingroup, in collectivist cultures people try to paper over it, and show calmness and decorum. But if they are dealing with an outgroup they can express their anger freely.

When they disagree with another, they are likely to act "correctly" while at the same time thinking how to change the situation. Thus, indi-

vidualists are likely to see them as insincere, because they do not present to the "outside" what is "inside." The correct evaluation of this behavior, however, is that, for the collectivist, "virtue," in the form of "proper action," is of the greatest importance. What an individual thinks is of no great importance when the group is all important.

On the other hand, the individualists express their dissonant views very clearly, and that makes the collectivists feel that they are outgroup members. The individualists often are much more concerned about what others think (e.g. Do you believe in God?) than what others do (e.g. if they cross the street against a red light, they just take personal chances and if they get hit that is their business).

Attitudes

The attitudes that collectivists endorse stress interdependence. For example, they agree that children should live with their parents until they get married and that older parents should live with their children until they die. On the other hand, the individualists stress independence from in-group others (e.g. I do my own thing and most members of my family do the same).

Goals

When the goals of the ingroup and the individual are in conflict (e.g. old parents require an action that interferes with one's career), the collectivist finds it natural to use the in-group goals, and the individualist to use the personal goals.

Values

The values stressed by collectivists are security, obedience, duty, ingroup harmony, hierarchy, and personalized relationships. The values stressed by individualists are pleasure, winning the competition, achievement, freedom, autonomy, and fair exchange.

Calamities

The worst thing that can happen to a collectivist is to be excluded from the ingroup; the worst thing for an individualist is to be dependent on and to have to conform to the ingroup.

Social Behavior

In collectivist cultures people interact very frequently with large groups of ingroup members and know a lot of them very well, but they know very little about outgroup members. In individualist cultures people have many relationships with a wide circle of people, but they do not know very much about any of them.

When there is a clash between vertical (e.g. parent to self) and horizontal (e.g. spouse to self) relationships, the collectivist considers it natural that the vertical relationship will have precedence; the individualist that the horizontal will have precedence.

Social behavior between an outgroup and ingroup member is *very* different in the case of collectivists, but not too different between individualists. In fact, individualists are often proud that they do *not* favor the ingroup—say in job selection or promotion. Collectivists think that it is natural that one should favor the ingroup.

The rights of the individual are important in both cultures, but if they conflict with the perceived well-being of the group, the collectivist finds it entirely natural to ignore them. The individualist gives great value to individual rights, and will not sacrifice them for the benefit of a group.

Since collectivists are very close to their ingroups, it is difficult to become close to them. However, if one is accepted by the ingroup, it is very easy to get to know them. In fact, once you are an ingroup member, they will ask you all sorts of "indiscreet" questions (e.g. How much money do you make? What kind of sex life do you have?).

Individualists are very easy to get to know, but one rarely asks or answers such indiscreet questions about any ingroup members. The relationship is "correct" but not close. Individualists figure out "how much do I profit from this relationship?" and "what are the costs of this relationship?" and arrive at a calculation on whether to continue it. Collectivists feel very close to their ingroup members and are willing to sacrifice for them; they do not compute the costs of the relationships.

When choosing a mate, collectivists think about "a good job," "chastity," "loyalty," and "togetherness" while individualists think of an "exciting personality," "physical attraction," and the "fun we can have together."

Evaluation

There are indications, not yet fully supported by research, that the confrontations so important to the individualists increase the frequency of heart attacks. The narcissistic individualism of many in the United States neglects the public good (Bellah et al., 1985).

The poor academic achievement of U.S. students, the drug problem, and delinquency, may be linked to excessive individualism—too much emphasis on having fun. Consider this: The boat people who came from Laos and Cambodia, in 1979–1980, without much English, had children in 1983 who performed, on the average, at the top quarter of the U.S. norms in arithmetic and science. The explanation seems to be, in part, that the collectivism of these cultures helped them. The whole family was rooting for the child to do well in school. Several hours of homework, helped by older siblings or neighbors, prepared the child for excellence in school.

Individualism is good for creativity; collectivism is good in other ways. Each has much to learn from the other.

REFERENCES

Bellah, R. N., Madsen, R., Sullivan, W. M., Swidler, A. & Tipton, S. M. (1985). *Habits of the heart: Individualism and commitment in American life.* Berkeley, Cal.: University of California Press.

Fiske, A. (1990). *Structures of social life.* New York: Free Press.

Hofstede, G. (1980). *Culture's consequences: International differences in work-related values.* Beverley Hills, Sage.

Markus, H. & Kitayama, S. (1991). Culture and self: Implications for cognition, emotion and motivation. *Psychological Review, 98,* 224–253.

Triandis, H. C. (1990). Cross-cultural studies of individualism and collectivism. In *Nebraska Symposium on Motivation, 1989.* Lincoln, Nebraska: University of Nebraska Press.

25
World without Words: Messages from Face and Body

CAROLINE F. KEATING

INTRODUCTION

Communication is powerful: It brings companions to our side or scatters our rivals, reassures or alerts our children, and forges consensus or battle lines between us. The power of communication to draw others near or to drive them away derives as much from how we appear as from the language we deploy. Applied either artfully or naively, nonverbal expressions, gestures, and signs can complement language or swamp it. These silent messages, expressed through face and body, can communicate true motives and thoughts, or they can embellish, minimize, and disguise them.

Nonverbal communication has taken place if a behavior, signal, or sign emitted by person A has a systematic influence on person B. If A smiles and B smiles back, communication has occurred. The correct information need not always be delivered. What if A was smiling past B at C? By our definition, communication occurred between A and B, even though B was misinformed by it. If A then gives "the finger" and B smiles back, we may have an additional type of communication problem—A and B may not share the same gesture meaning system! Notice that communication is no slave to a communicator's intentions. If A's finger gesture, which was directed at B, is inadvertently detected by C, C may move further away from A, even though A didn't intend for that to happen! If A then blushes, C may detect the embarrassment awash on A's face, regardless of A's attempt to look "cool" and disguise it.

Our broad definition of communication permits study of a wide range of nonverbal phenomena that, intuitively, appear communicative. By avoiding constraints posed by standards for verbal language, our definition allows us to examine human nonverbal communication within evolutionary and cross-species contexts, as well. This line of inquiry may ultimately reveal common denominators in the nature of human communication and sociability.

In this chapter we ask why some expressions, gestures, and appearances characterize people around the globe and why others are peculiar to specific cultures. We will not review every facial or body movement or sign that ever communicated anything to anyone. Rather, with our "whys" in mind, we will concentrate on theoretically-driven research endeavors that address our questions and our ultimate goals.

With this purpose in mind, we begin with an analysis of expressions of emotions, which reveal remarkable commonalty across cultures. Next we probe gestures that are not necessarily linked to

Caroline F. Keating is Associate Professor of Psychology at Colgate University in Hamilton, New York. She received her Ph.D. from Syracuse University in 1979. Dr. Keating studies human social development from cross-cultural and evolutionary perspectives. She investigates how nonverbal communication, face perception, and deception relate to dominance, power, and influence. At Colgate, she teaches cross-cultural human development and courses in social and emotional development.

emotional states. Some of these signaling systems appear to have global dimensions but others reveal plenty of cultural specificity, including the kind that can get you into some pretty awkward social situations if you are not privy to a particular gesture meaning system. Thirdly, we investigate how people's orientation in space and facial appearance (physiognomy) convey important social messages. We will discover that theorists have had some explanatory success in attributing cross-cultural commonalties to our evolutionary origins but provide little guidance for understanding the rich overlay of cultural differences in nonverbal communication.

EXPRESSION AND EMOTION

Emotions overlap to some degree with essential fight or flight responses characteristic of species besides the human kind. But human emotion is understood to be more than a basic response system providing for quick getaways and effective defensive or aggressive responses. Feelings of happiness and sadness, surprise and interest, as well as anger and fear are considered to be "basic" human emotions by many Western researchers.

Part and parcel of the feeling-state part of emotion is expressive behavior. Charles Darwin (1872, 1965) recognized this in 1872 when he studied the expression of emotion in humans and animals. Darwin proposed that humans, like other species, evolved to express emotions in a stereotypical way and provided illustrative, pictorial records revealing similarities in human expressive behavior from New Guinea to London. A century later, researchers began to explore the full impact of Darwin's thesis for human emotional expression.

Current work has concentrated on facial expressions of emotion. In his neurocultural theory of emotion, Ekman (1972) proposed that a distinctive facial expression was associated with each basic feeling state, it being "hardwired" into the human emotion system. Therefore, facial expressions of emotion, as well as the emotion categories themselves and the physiological state they are associated with, should be culturally universal and convey the same information everywhere on the globe.

To provide evidence for his theory, Ekman (1972) photographed Euro-American adults who posed six "basic" emotions and presented this collection of pictures to individual members of different national/cultural groups, including Swedes,

Kenyans, Japanese, and people native to the highlands of New Guinea. Individuals viewing the photographs were asked to match each posed expression with an emotion label (anger, fear, happiness, sadness, disgust, or surprise) or story (i.e., in New Guinea, "... a woman sees a wild pig at her door...") descriptive of the facial expression displayed in the photograph (in this case, fear!). There emerged remarkable agreement in the matching responses, both within and between cultures: Just about everywhere, happy labels or stories were matched with the happy poses, anger labels or stories were matched with the anger poses, and so on. Furthermore, college students in the United States were able to match the photographed expressions of New Guinea highlanders with appropriate emotion labels.

Although agreement across cultures is generally high when individuals are asked to match emotion labels or stories with photographed expressions, more detailed studies of emotional expression have detected cross-cultural variability in peoples' responses to facial expressions. For example, researchers like Janet Kilbride and Matt Yarczower or, more recently, Aaron Wolfgang and Michelle Cohen, have found that agreement declines when perceivers judge expressions portrayed by individuals from relatively unfamiliar cultural backgrounds. Paul Ekman and his colleagues now report that perceptions of the intensity with which an emotion is expressed is also culturally variable. So far, these wrinkles in the fabric of cross-cultural agreement in emotion identification and expression have escaped a coherent explanation.

There are reasons why we should expect cross-cultural variability in the way emotions are expressed and interpreted. For one thing, the emotion categories construed as "basic" by Western behavioral scientists may not seem so "basic" to non-Westerners, as Wierzbicka (1986), an anthropologist, has recently argued. If asked, denizens of other places in the world might offer "embarrassment" or "chagrin" or "pain" or some sad-anger mix (the equivalent of "sanger?") as a "basic" emotion. Perhaps they would reject a "categories" approach to emotion altogether, insisting, like earlier Western researchers, that emotions would be best represented by "shades" along an emotion "wheel," similar to what is used to represent color.

Even if cultures resign themselves to the category approach currently proposed in the West, labels for the "basic" emotion categories may not translate readily into every language or dialect

around the world. "Basic" or prototypical exemplars of all sorts of things (e.g., color hues, chairs, tastes, faces), when accompanied by unambiguous verbal labels, tend to be more readily identifiable than relatively atypical versions with fuzzier, more subtle relationships to categories. Thus cultures that do not share the Western ideal of basic emotion categories may operate at somewhat of a disadvantage in the standard recognition task invoked by researchers who do.

Considering all these reasons to expect cross-cultural variability, the amount of agreement in the interpretation of posed emotions around the world is all the more impressive. Let's put this into common context: If you sat and watched foreign soap operas and did not understand any spoken words, do you think you could tell what was going on between the characters based on their expressions alone? If you predict "yes," you are probably right! Research by Krauss, Curran, and Ferleger (1983) revealed that college students from the United States, who did not speak a word of Japanese, nevertheless understood the emotional content of Japanese soap operas merely by watching the facial expressions of Japanese actors.

Why does emotion have a communicative aspect to it anyway? Why don't we just experience our internal feelings and not waste time transmitting our inner state to others? What possible advantage could there be in making our private emotional experience a social event? It turns out that emotions are contagious—your emotional expressions can in-

What possible advantage could there be in making our private emotional experience a social event? It turns out that emotions are contagious.

fect or imbue others with feeling states compatible with your own. The evolutionary advantage of instantaneous, reliable, vicarious transmission of emotional states for most social species probably relates to its function as an alarm system. Among ungulates, for example, the display of fear in reaction to the detection of a predator by one member

of a herd has the effect of physiologically readying each member for a flight to safety. Species more closely related to humans also transmit information about their internal states. If you observe monkeys, for example, you will discover that the emotional tenor of their social groups resembles a sea of feelings. Emotional responses ripple through a troop like waves: Expressions of calm begets calm, excitement instills excitement, and fear creates splashes of monkeys up against the trees.

Humans pass their emotions along, too, partly via unconscious, facial-muscle mimicry that occurs when we observe the expressive behavior of others. We may even stimulate emotions in ourselves to some extent by "putting on a face." These subtle muscle movements, though not always detectable by the naked eye, apparently cue felt emotion through some kind of feedback to the central nervous system. This kind of emotion communication may form the basis of the human capacity to empathize: By mimicking the expressions of others, we may generate similar feelings in ourselves. Even infants reveal a subtle form of empathic, emotional communication: Infants become upset and cry at the sound of another crying infant.

All over the world, adults access the capacity to communicate emotion for practical purposes. Trobriand Island, Yanomamo, Greek, German, Japanese, and U.S. mothers intuitively use emotion communication to regulate the moods of their infants: They "infect" babies with happy moods by displaying happy expressions (Kanaya, Nakamura, & Miyake, 1989; Keller, Schlomerich, & Eibl-Eibesfeldt, 1988; Termine & Izard, 1988). Thus for social species (like humans), the benefits of emotion communication are considerable!

In much of human communication, however, revealing truly felt emotion could compromise your goals. Sumo wrestlers know this. The introductions to these wrestling matches comprise ritualized, nonverbal displays of threat and strength designed to instill fear in worthy opponents and to privatize any anxiety about the outcome of the game. Keeping emotions secret and even feigning them are decisive elements in a wrestler's victory or defeat. Similarly, mothers who attempt to cheer their wailing infants may not feel as happy as they try to look! In truth, pure, spontaneously-felt emotion is rarely seen and rarely studied. For example, the photographed expressions used for the study of emotion communication around the world comprise mostly posed—not felt—emotions. Thus the study of human emotional expression may tell us

more about the emotion system Western researchers propose to be universal than it tells us about everyday human nonverbal communication.

Cultures, in fact, regulate everyday emotional expression by inculcating norms for nonverbal behavior. These norms vary from place to place. For instance, Japanese college students inhibited negative expressions when they viewed a film which graphically portrayed a circumcision ritual—but only when an experimenter watched with them. Without an experimenter present, Japanese expressions resembled those of U.S. college students who reacted overtly negatively while viewing the film. Apparently, Japanese cultural "display rules" required the disguise of negative emotional expression when in another's presence (Ekman, 1972).

Cultural display rules are prevalent. Women in the West are expected to smile frequently, regardless of how happy they may feel at the time. Young men from traditional Masai society in East Africa are encouraged to appear stony-faced and produce long, unbroken stares. It is considered appropriate for Muslim men from some West African communities to reveal only muted emotional reactions all around.

The bulk of human nonverbal communication appears to circumvent displays of truly felt emotion. What we know about the central nervous system's control of emotions and expressions supports this view. Were you to tease out the systems in the brain that determined how you felt and how you looked, say, for example, at a funeral, you would wind up with nearly the whole brain unraveled in your lap; emotional, motor, perceptual, and cognitive systems included. Culture's opportunity to influence the transmission of emotion begins as stimulus events (say, the death of a loved one) are appraised for emotional value (grief) and experienced. Facial muscle movements compatible with feeling states are refracted or reflected by the cultural lens (German? Irish?) fit to a cultural context (funeral? wake?). Culture thereby filters or "gates" what gets revealed on the face (sadness? happiness?).

GESTURES, SPACES, AND FACES

Like bumper stickers on cars, nonverbal messages proclaim one's social rank (e.g., "A Woman's Place Is In The Mall"), willingness to engage in (or avoid) conflict (e.g., "This Vehicle Protected By A Pit Bull With AIDS"), age (e.g., "World's Greatest Grandpa"), and sexuality (e.g., "Honk if Horny"). They do this via many different expressive modes or "channels"; for example, through facial and body movements, postures, orientations in interpersonal space, touch, voice pitch and tone, and even through static, morphological characteristics alone.

Unlike expressions of emotions, gestures and other signaling systems of the face and body are not necessarily linked to emotion states. A display of lowered brows, for example, may convey an aggressive intent to observers, but whether the individual performing the display actually feels angry (or feels hurt or threatened and wishes to disguise it) is not key to understanding the meaning of that gesture. Following the logic of ethologists, the interpretation of a gesture is gleaned from its effect: If the effect of an individual's lowered brows is to make interactants beat a hasty retreat, then the gesture can be construed as a threat or dominance gesture. Similarly, if a fleeing individual displays a grimace, the expression may be interpreted as signaling submission. Thus inquiry about underlying emotion states is supplanted by probes of the display's function and effect.

Given their emancipation from implied, universal, biologically-based, emotion states, should we expect gestures to have interpretations that are arbitrarily assigned to them by cultures? If so, different gestures might mean different things in different cultures. Likewise, similar gestures may convey different meanings in different cultures. There is evidence (some potentially embarrassing!) that gestures and their meanings are arbitrary, cultural conventions. For instance, shaking your head "no" to convey disagreement in the West would convey agreement in India. Just as awkwardly, the three-fingers up, thumb and index finger circled, "OK" sign in the West signals "money" in Japan, and invites a sexual encounter in much of South America.

Other gestures and signals appear to be universal in form, function, and meaning. For example, ethologist Ireneaus Eibl-Eibesfeldt filmed social interactions around the world and discovered that the eyebrow flash, a 1/6th second raise of the brows, characterized the nonverbal greeting displays of such diverse peoples as the Samoans, Papuans, Bushmen, Balinese, Europeans, and Native South Americans. Universal facial displays for flirting and

others conveying embarrassment were also identified from the filmed records made in these countries. More recently, a pancultural, wrinkled-nose facial expression signaling "contempt" has been identified by Paul Ekman and his colleagues.

Is it true, as the Crosby, Stills, and Nash tune goes, that "the smile is something everybody everywhere does in the same language"? Together with colleagues from around the world, I tested for universality in the meaning of the smile. Rather than ask whether people looked happy when they smiled, we wanted to know whether smiling made people look powerful or weak. We also investigated eyebrow gestures. We compiled photographs of White, Black, Hispanic, and Asian women and men instructed to smile or not smile and to raise or lower their eyebrows. Copies of the photographs were secured in notebooks which contained standardized, readily translatable instructions for data collectors to use with the respondents they contacted.

Respondents were volunteers from farms, villages, high schools, and universities representing eight nations: Thailand, Brazil, Colombia, Kenya, Zambia, Spain, Germany, and the United States. Using native languages, we asked respondents to distinguish dominant or influential people in our photographs from those who appeared submissive. A few miscommunications occurred. Some respondents initially thought they were voting for officials in an election. A few suspected we were from the CIA and our photographed faces portrayed criminals. But after all was straightened out, respondents readily made dominance judgments. When our photographs revealed smiling individuals, rarely did respondents from any country choose them as dominant: Unlike raised-brows, smiles were associated with submissiveness in virtually every western and non-Western country (Keating, 1985). We concluded that smiles forecast a lack of threat. They invite others to approach and diffuse potentially threatening encounters. The next time you catch yourself smiling in a social situation, think: Are you really *feeling* happy, or are you signaling friendliness, submitting to social contact or engaging in an interaction with a superior? Smiles, you see, are often "polite" rather than heartfelt!

The fact that a common ballad depicts human evolutionary history may explain mutual gestural meaning systems like the smile. Jan van Hooff theorized that the "grin" nonhuman primates use to signal submissiveness ("I'm no threat!") is a genetically-based, signaling "program" so useful to social interaction that humans have inherited a gesture similar in both form and function—the smile. Thus the human smile and the nonhuman primate submissive grimace are believed to be homologous. The data we collected, showing that smiling faces appeared submissive to groups of people on five different continents, are consistent with Van Hooff's claim. Eibl-Eibesfeldt noted that the eyebrow flash greeting characteristic of many human groups has parallels among some nonhuman primate species. Carroll Izard and O. Maurice Haynes have argued that the wrinkled-nose, "contempt" expression common to many nations is homologous to the infrahuman snarl.

There are also signaling systems shared by nonhuman primates and humans but regulated and expressed differently by people from diverse cultures. For example, gaze and interpersonal distance (including touch) may express either intimacy (friendliness) or aggressiveness (unfriendliness). Across nonhuman primate species and human cultures, direct gaze for an extended period of time tends to be arousing or even threatening (except, perhaps, to intimate friends), and often serves as an aggressive challenge. Gaze aversion diminishes the arousal or threat. Just the "right" amount of gaze exchange and avoidance successfully carries a friendly, social interchange. Similarly, interindividual distances regulate and express the degree of intimacy and threat individuals experience.

Do you think you could predict peoples' relationships in any country merely by observing the distances between them? E. Gregory Keating and I thought so, and, based on earlier work by sociologist Allan Mazur, we launched a study in Kenya to test the idea. We limited our data collection to an available study population in a natural (nonlaboratory) setting; men frequenting public parks in Nairobi. Our attempts to quietly and unobtrusively photograph pairs of individuals on park benches were unsuccessful: Given Kenya's political climate at the time and its ubiquitous police force, men were suspicious of anyone taking photographs. We had unintentionally made people in the park anxious and uncomfortable because of our efforts to be discreet, which, in turn, altered the natural seating patterns we wished to observe.

So we devised a new approach. When we returned to the public parks, we sported Hawaiian shirts and Bermuda shorts. Camera bags bulged from our shoulders. We took turns photographing

each other. After initial glances, people in the park dismissed us as typical tourists and resumed their normal behavior. By using a telephoto lens, my co-researcher and I aimed over one another's shoulders and took photographs of pairs of men on benches, insuring the men's anonymity by photographing them from behind. We then determined if they were acquainted by observing whether they conversed. Based on our data and Mazur's, we concluded that you can successfully predict whether men are friends or strangers in such diverse cities as Nairobi, Seville, San Francisco, and Tangier by measuring the distance between them as they sit on park benches: In all these places, interpersonal distances are closer when individuals are acquainted than when they are not.

Generally speaking, too much "signal" or arousal produced by one nonverbal channel is compensated for by reductions in signal or arousal manufactured by other channels. Thus people who sit near each other typically avoid prolonged gazes. Nevertheless, cultures are differently tolerant of gaze exchanges and interpersonal distances. In the Middle East, relatively extended gaze exchanges are considered appropriate during interchanges between men. The comparatively abbreviated gazes of North Americans are sometimes interpreted as expressing a lack of interest and thus appear impolite, even to the British, who characteristically share longer gazes than citizens of the United States are comfortable with. In many cultures, women and children generally avert their gaze in deference to men or elders. The young Masai men of East Africa know how to take full advantage of the power of the stare by engaging in interminably long "stare-down" contests, which can be quite unnerving to outsiders.

Many societies are more tolerant of less interpersonal distance than are Europeans, Americans, and most Africans. If you observe couples frequenting restaurants in Puerto Rico, for example, you will find that the rate of touching between men and women is much higher than it is among couples frequenting restaurants in New York City. Similarly, the distance at which men in Muslim societies converse is typically closer than elsewhere. In fact, it is customary for Muslim men to hold hands with one another as they stroll. I experienced the consequences of cultural differences in interpersonal distance while walking with a Pakistani colleague of mine. As we began chatting and walking down the streets of Honolulu, I found myself clumsily step-

ping off the sidewalk. Without realizing it, the closer my Muslim colleague moved toward me (seeking the interpersonal closeness he was comfortable with) the more I moved over streetside (seeking the interpersonal distance I was comfortable with). Balanced precariously along the curb (and not being any kind of gymnast), I would suddenly disappear from his view, having fallen into the street; perhaps not "the ugly American," but a clumsy one!

Cultures also differ in the way body movements are used to punctuate speech. For example, although both Italians and Jews embellish speech with circular motions of arms and hands, by measuring the radius of these movements you could predict whether the speaker was of Italian or Jewish descent: The larger the radius, the more likely it is that the speaker is Italian! Eyebrow movements also modulate spoken communication: Brow raises and frowns accentuate the content of speech. In some Asian countries, however, cultural practices resulting in the muting of brow movements date back centuries to Confucius, whose teachings about the acceptability of facial gestures were explicit. Confucius taught that dramatic brow movements were unattractive. In fact, women were instructed to inhibit brow movements so as not to give the appearance that "wriggling hairy caterpillars" bedecked their faces.

Without any movement at all, human faces can relay information that transcends culture. Similar to other species, the physiognomy or facial morphology characteristic of babyhood apparently has an innate appeal for us. According to ethologist Konrad Lorenz, infantile features like large eyes, large heads, small round chins, and rounded profiles serve as "releasing factors" and elicit caretaking responses by adults of the species. In essence, we evolved to see babies as "cute"! Moreover, these immature facial features convey the babylike messages of nonthreat, submissiveness, and weakness, whether they are displayed by babies or adults, as biologist R. Dale Guthrie observed. Thus, Leslie Zebrowitz McArthur and Diane Berry found that adults with babyish facial characteristics were perceived to have babylike psychological traits when judged by people in the United States and Korea. In contrast, my colleagues and I found that faces characterized by mature structures, like large jaws, bushy eyebrows, and small eyes, appeared dominant to raters in Thailand, Zambia, Kenya, Germany, Spain, the United States, Brazil, and

Colombia (Keating, 1985). Quite apart from any gestures or expressions, facial structures alone can convey messages of social submissiveness and dominance around the globe.

UNIVERSAL DIMENSIONS OF NONVERBAL MESSAGES

Is there a "deep structure" of meaning underlying all nonverbal communication? In other words, are there universal dimensions by which all nonverbal messages may be classified and understood? To resolve these questions, researchers typically recruit observers from diverse countries and ask them to rate different expressions and gestures on scales indexing a variety of psychological traits; for example, dominance, warmth, intelligence, aggressiveness, happiness, satisfaction, importance, and so on. Statistical measures determine whether trait ratings tend to cluster; that is, across expressions and gestures, if ratings for dominance are high, are ratings also high for aggressiveness and importance? If ratings for dominance are low, are they also low for aggressiveness and importance? If so, perhaps dominance-aggressiveness importance or "power" is a dimension along which meaningful distinctions between nonverbal messages are made.

Using these kinds of research strategies, Tsutomu Kudoh and David Matsumoto found that Japanese adults, similar to United States college students, assessed 40 body postures along three basic dimensions or themes: self-fulfillment, interpersonal positiveness, and interpersonal consciousness. However, different, "basic" dimensions have emerged from other studies. For example, William Gudykunst and Stella Ting-Toomey reported that the bulk of responses to affective nonverbal communication could be subsumed by these four dimensions: collectivistic-individualistic, uncertainty avoidance, masculine-feminine, and power distance. Two of these dimensions, power distance and individualism, successfully described cross-cultural appraisals of facial expressions of emotion, according to David Matsumoto. Then again, David Chan found that the "basic" dimensions used by Chinese students who rated facial expressions of emotions were different; positive versus negative emotions and open versus controlled styles of expressions. At present, there is no consensus as to whether universal meaning systems apply to non-

verbal communication and no consensus as to what their basic, underlying themes might be.

UNSOLVED MYSTERIES

Can we produce and interpret nonverbal messages correctly when communicating with people from cultures other than our own? Even for signals rooted in our evolutionary past, the answer is, at best, a qualified yes. For example, we have found that the meanings of gaze, interpersonal distance, smiling, and the eyebrow flash seem universal, although local cultures reveal varied tolerances and expectations for their display. Facial expressions of emotions are interpretable cross-culturally, but depending on where you travel, it may be more appropriate to portray an emotion you do not feel than to reveal one that you do. Cultures even regulate the messages that parts of our anatomy convey. For example, in order to promote a youthful appearance and character, conventional Western women use make-up techniques to mimic babylike facial traits, lining eyes to make them look round and large, thinning eyebrows, and lengthening eyelashes.

But *why* these cross-cultural differences? What kind of explanatory lens can make the kaleidoscopic array of cross-cultural variations in nonverbal communication understandable? Can we resolve consistent patterns relating features of culture to features of nonverbal behavior, and its meaning, expression, and control?

Perhaps in societies where access to resources, power, and prestige is heavily dependent upon cooperation among adult males, nonverbal modes of communication have adapted to secure close male bonds. In such societies, interpersonal distances, gaze, and gesture would operate to reinforce bonds between men. What would you predict? Close interpersonal distances and tolerance for long gazes? Striking differences in the nonverbal habits of men and women?

What would you predict for societies in which the outcomes of competition between individuals orders the social hierarchy? Would gazes, distances, and gestures foster less intimacy between individuals and especially between individuals from different social classes? Detailed analyses of nonverbal behavior reveal that members of dominant social groups often treat those perceived as "outsiders" in a less friendly, more defensive manner. Whether

intended or not, members of a group sometimes discriminate against individuals from other groups through nonverbal channels.

Perhaps there is some degree of local, biocultural selection for emotional control, as Jerome Barkow boldly proposed in 1980. Among some groups, individuals who excel in the ability to manipulate their emotional expressiveness might acquire extra social and economic benefits. Some research suggests that dominant or influential people are particularly adept at portraying the kinds of expressive behaviors that make for convincing appearances—whether conveying the truth or disguising it (Keating & Heltman, in press). What features of the human/environment interaction would likely favor such emotional control over spontaneity? Would predictions be the same for all emotions? For women and men, boys and girls?

Answers to these and other questions about the nature of nonverbal communication offers an intriguing future for cross-cultural researchers with a penchant for puzzles.

REFERENCES

Darwin, C. E. (1872; 1965) *The expression of emotions in man and animals.* Chicago: University of Chicago Press.

Ekman, P. (1972) Universals and cultural differences in facial expression of emotion. In J. Cole (Ed.) *Nebraska Symposium on Motivation* (vol. 19). Lincoln: University of Nebraska Press.

Kanaya, Y., Nakamura, C. and Miyake, K. (1989) Cross-cultural study of expressive behavior of mothers in response to their five-month-old infants' different emotion expression. *Research and Clinical Center for Child Development,* Annual Rrt 11, 25–31.

Keating, C. F. (1985) Human dominance gestures: The primate in us. In S. L. Ellyson and J. F. Dovidio (Eds.) *Power, dominance, and nonverbal behavior.* New York: Springer-Verlag.

Keating, C. F. and Heltman, K. (in press). Dominance and deception in children and adults: Are leaders the best misleaders? *Personality and Social Psychology Bulletin.*

Keller, H., Schlomerich, A. and Eibl-Eibesfeldt, I. (1988) Communication patterns in adult-infant interactions in western and non-western cultures. *Journal of Cross-Cultural Psychology, 19,* 427–445.

Krauss, R. M., Curran, N. M. and Ferleger, N. (1983) Expressive conventions and the cross-cultural perception of emotion. *Basic and Applied Social Psychology, 4,* 295–305.

Termine, N. T. and Izard, C. E. (1988) Infants' responses to their mother's expressions of joy and sadness. *Developmental Psychology, 24,* 223–229.

Wierzbicka, A. (1986) Human emotions: Universal or culture-specific? *American Anthropologist, 88,* 584–594.

26
Values and Culture

NORMAN T. FEATHER

There is a Japanese proverb that the nail that sticks up gets pounded down. This proverb expresses the belief that a person should not stand too far above the group to which he or she belongs, but should submerge individual ambition and self-interest, and act in ways that promote the interests of the collectivity. This does not mean that Japanese workers do not value achievement. They do, but the achievement refers more to the success of the group or organization than to the success of individual members. Achievement in Japan is embedded in a set of concerns that relate to maintaining group harmony, loyalty to the firm or family, humility, and other behaviors and values that express interdependence with others rather than an independent pursuit of one's own goals.

There are proverbs or statements in other countries that are similar to the Japanese one. For example, Australians value achievement at the individual level but they are also accused of wanting to cut down "tall poppies" (or those who have been conspicuously successful). In their case, however, cutting down tall poppies probably represents a reaction against authority and rank and a belief that success should not lead to inequalities and large differences in status. This kind of belief is probably not so evident in the United States where there is a lot of emphasis on individual achievement and the virtues of hard-won success and perhaps less emphasis on reducing inequalities.

These examples illustrate the different sorts of values that exist at the cultural level. One of the central topics in cross-cultural psychology concerns the analysis and description of cultural similarities and differences in basic values. The topic is a complex and difficult one. Values are abstract concepts that pose special problems as far as their definition and measurement are concerned. We may find it relatively easy to investigate similarities and differences across cultures in simple overt behaviors such as gestures and facial expressions but how do we compare cultures in regard to the value they place on equality, freedom, honesty, achievement, loyalty, or on other values that are assumed to be basic and to have some universal status? How do we define these values and how can we measure their importance across cultures in ways that satisfy the usual test requirements of reliability and validity? The task may seem to be impossible given the subjective nature of values. However, a lot of attention has been paid to these questions over the years. This chapter will provide an overview of some of the ways in which values have been investigated by researchers who have considered culture's influence on values.

Norman T. Feather, an Australian psychologist, graduated with a Ph.D. from the University of Michigan in 1960 and is the Foundation Professor of Psychology at the Flinders University of South Australia. He has written extensively on achievement motivation, expectancy-value theory, attribution theory, cross-cultural psychology, gender roles, the psychological impact of unemployment, and the psychology of attitudes and values. He has authored or edited five books, including *Expectations and Actions: Expectancy-Value Models in Psychology* (Erlbaum, 1982) and *Values in Education and Society* (Free Press, 1975).

THE DEFINITION OF VALUE

The concept of value has been discussed and studied by many social scientists, including philosophers, anthropologists, and psychologists. The attention paid to the concept across many disciplines attests to the fact that in the normal course of their lives people are constantly involved in the process of evaluation—judging what actions or outcomes are good or bad, or what is desirable or undesirable in relation to more general beliefs and standards. Thus, valuing is part of the human condition.

Our values influence many aspects of our lives, affecting both the way we construe and evaluate situations and the actions that we take in pursuit of important goals. In this regard it is important to distinguish between the values that people hold and the values they place on objects and events within their immediate environment. For example, the person for whom pleasure and a comfortable life are important values construes the world differently from the person who assigns less importance to these values. These kinds of differences in personally held values are important influences on an individual's beliefs and attitudes and on how the individual behaves in specific situations (Feather, 1992).

Values involve general beliefs about desirable or undesirable ways of behaving and about desirable or undesirable goals or end-states. They differ from wants and needs in that they involve reference to a dimension of *goodness* and *badness*. Moreover,

Values involve general beliefs about desirable or undesirable ways of behaving and about desirable or undesirable goals or end-states.

they are assumed to have an "oughtness" quality about them. If one believes in honesty rather than dishonesty, then one "ought" to act honestly and one should try to promote honesty in other people. In that sense values are prescriptive or proscriptive and they involve a clear preference between a specific mode of behavior (e.g., being honest) and its

opposite (e.g., being dishonest) or between a general goal (e.g., equality) and its opposite (e.g., inequality).

Values are assumed to transcend more specific attitudes toward objects and situations but they influence the form those attitudes take. Our attitudes toward a political leader, for example, may be influenced by how much we value freedom and equality and honest ways of behaving. Values provide standards or criteria that can be used to evaluate actions and outcomes, to justify opinions and conduct, to plan and guide behavior, to decide between alternatives, to compare self with others, to engage in social influence, and to present self to others. They are also assumed to be core aspects of the self-concept and to be closely linked to our basic emotions. We usually see our central values to be important for the way we define ourselves and we feel happy when these values are fulfilled and sad or angry when they are not.

Rokeach (1973) presented a seminal discussion of these defining aspects of the value concept. He defined a value as "... an enduring belief that a specific mode of conduct or end-state of existence is personally or socially preferable to an opposite or converse mode of conduct or end-state of existence" (p. 5). Thus, values can refer either to modes of conduct like being helpful (instrumental values) or to general goals or end-states of existence like a sense of accomplishment (terminal values). Rokeach assumed that the set of values that people hold is considerably less than their total number of attitudes and specific beliefs and that the instrumental and terminal values become separately organized into relatively enduring value systems along a scale of importance. Some values are highly important to a person while others are relegated to positions that are lower down in the hierarchy. Moreover, the value systems are modified over the course of the life span as people take on new roles and responsibilities (e.g., getting a job and raising a family). Value systems also vary across groups and different segments of a culture (e.g., across gender and social class). The antecedents or determinants of values and value systems are complex and involve culture, society and its institutions, and the individual's personality.

Other more recent discussions of the value concept have been presented by Feather (1975, 1992) and by Schwartz and Bilsky (1987). These conceptual analyses were influenced by Rokeach's (1973) position but they also involve unique features of their own. For example, Feather (1975, 1980, 1992)

conceives of values as abstract structures involving associative networks that are linked to positive and negative affect or feelings, and that function as motives. Schwartz and Bilsky (1987) developed a theory concerned with the universal content and structure of human values and with conflicts and compatibilities between different value types.

THE MEASUREMENT OF VALUES

Braithwaite and Scott (1991) describe various procedures that have been developed to measure the importance of values (see also Feather, 1980). Value measures vary considerably in the assessment procedures that they use and in the number and kinds of values that they assess.

In this section I will focus mainly on the Value Survey (Rokeach, 1973) and on related developments. This is because a lot of recent cross-cultural research has involved the use of this instrument or similar approaches. In the Value Survey respondents are asked first to rank a set of 18 *terminal* values (end-states of existence) and then a set of 18 *instrumental* values (modes of conduct) in terms of their importance for self, as guiding principles in their lives. The terminal values comprise values such as a comfortable life, a sense of accomplishment, equality, family security, pleasure, salvation, self-respect, true friendship, and wisdom. The instrumental values comprise values such as being broadminded, capable, clean, forgiving, honest, intellectual, loving, responsible, and self-controlled. Each value is accompanied by a short descriptive phrase and the values in each set are presented in alphabetical order. The procedure therefore provides two sets of rankings from each respondent, one that defines the person's terminal value system and one that defines the instrumental value system. Rokeach (1973) attempted to cover a wide range of values in the two lists that he assembled. They were values that he assumed were universal.

The Value Survey has advantages and disadvantages. It is easy to translate and administer, and respondents generally find it interesting. It has been used to investigate a wide range of questions (Feather, 1975, 1980, 1992; Rokeach, 1973). With it, one can examine similarities and differences in values and value systems across groups and cultures. Moreover, the structure of value systems can be investigated. The value systems that respondents report can be related to the value systems that they

perceive are promoted by other individuals, groups, or organizations. The fit between a person's *own* value priorities and *perceived* value priorities can be assessed and related to other variables such as a person's adjustment and psychological well-being. Changes in value priorities and value systems can be investigated across the lifespan as individuals become older. Value priorities can be related to attitude measures and to specific behaviors. The Value Survey can also be used to investigate how migrants assimilate to a new culture (Feather, 1975).

The Value Survey has been criticized because the ranking procedure only provides information about the relative importance of different values and not about their absolute importance. Furthermore, each value is presented as a single item to be ranked along with other values. It would be preferable to measure the importance of a value by using multiple items. The use of multiple items to measure the importance of honesty for a person, for example, would enable one to assess the structure and internal reliability of the scale and would provide a clearer definition of the construct being measured than would occur if a single item measure of being honest was used.

Another recently developed measure is the Schwartz Value Survey (Schwartz, 1992). It uses a rating procedure and was influenced in its style by Rokeach's (1973) measure in that it separates terminal from instrumental values and presents each value as a single item. The Schwartz Value Survey consists of 56 values. It was developed on the basis of a theory of the universal content and structure of human values (Schwartz & Bilsky, 1987). In this theory values are assumed to represent three universal requirements of human existence to which all individuals and societies must be responsive, namely (1) to satisfy biological needs, (2) to achieve coordinated social interaction, and (3) to meet social institutional demands for group welfare and survival.

The values in the Schwartz Value Survey are classified into a number of motivational domains or value types which, in the latest statement of the theory (Schwartz, 1992), comprise the following classes: self-direction, stimulation, hedonism, achievement, power, security, conformity, tradition, spirituality, benevolence, and universalism. For example, the achievement domain includes successful, capable, ambitious, and influential as values; the conformity domain includes obedient, honoring of parents and elders, politeness, and self-disci-

pline; the benevolence domain includes helpful, honest, forgiving, loyal, and responsible. The value types are arranged around a circle or "circumplex" in the order in which I have listed them. Thus, some value types (e.g., achievement and power) are adjacent to each other in the circle while others (e.g., self-direction and conformity) are opposite to each other. The different value types or domains were arrived at by analyzing the intercorrelations between the importance ratings for the total set of 56 values, using the appropriate statistics.

Adjacent value types are assumed to be compatible—opposite value types to be in conflict. For example, power and achievement are held to be compatible because they both emphasize similar goals that relate to superiority and esteem; self-direction and stimulation are held to be in conflict with conformity, tradition, and security because the goals emphasized by the former value types (independent thought and action, favoring change) are incompatible with the goals emphasized by the latter value types (submissive self-restriction, preservation of traditional practices, maintaining stability).

The value types in the Schwartz Value Survey can also be compared in regard to the interests they serve. Some value types are assumed to serve *individualistic* interests (power, achievement, hedonism, stimulation, self-direction), other value types serve *collectivist* interests (benevolence, tradition, conformity), and others serve mixed interests (universalism, security).

Individualism and collectivism have received a great deal of attention in cross-cultural research. Whereas in the case of individualism, the focus is on self-interest, self-realization, and personal autonomy, the collectivism variable involves a greater emphasis on the in-group rather than oneself, an emphasis that is manifested in attention to the in-group's shared beliefs, needs, social norms, and in a readiness to cooperate with in-group members in pursuit of common goals.

STUDYING VALUES CROSS-CULTURALLY

So far we have considered how values are defined and how they might be measured. The focus has been on approaches that provide a standard set of items to which individuals respond. The aggregated responses are then assumed to inform us about similarities or differences between groups,

organizations, or cultures. This approach is called the *nomothetic* approach and it is in contrast to *ideographic* procedures where the focus is on the *individual* and the way he or she constructs social reality in personally unique ways. Our bias is toward the nomothetic position, consistent with Braithwaite and Scott's (1991) assumption that ". . . the more researchers refine, consolidate, and bridge available nomothetic measures, the sooner we will have a strong empirical base for understanding human values" (p. 670).

Using nomothetic measures of values in cross-cultural research involves administering value scales to representative samples from each culture or to samples selected from a defined segment of each culture (e.g., students, teachers) and then aggregating the individual responses for comparison. There are other procedures that could be used that do not rely on the responses of individuals to specially designed scales. For example, one might study a culture's values by analyzing the content of the mass media (e.g., newspapers, radio, TV), by investigating distinctive features of the culture's laws and enactments, by observing the norms and rules that are followed in the culture, by examining how organizations and social groups function in their particular cultural context, by a detailed study of language forms and practices, and by analysis of the literature and myths that are specific to the culture. The cross-cultural psychologist might also employ laboratory studies, field observations, or other special procedures that relate to conceptual frameworks and hypotheses. These different approaches represent important alternatives to the use of paper-and-pencil questionnaires and scales but discussion of them is beyond the scope of this chapter. It is important to use a variety of procedures when investigating values cross-culturally. Information about values that comes from different reliable sources enables us to build up a more accurate picture of a culture's values than information that comes from only one source.

How can we be sure that the values that we measure are appropriate for the culture that is being studied? Cross-cultural psychologists have attempted to answer this question by using lists of values that are assumed to be universally appropriate in that they are consistent with basic aspects of human nature and the requirements of human existence (e.g., Rokeach, 1973; Schwartz, 1992; Schwartz & Bilsky, 1987). In the case of the Schwartz Value Survey (Schwartz, 1992), respondents in each culture are permitted to add values to

the list that are relevant to their own country ("emic" values) and to reject values on the list that are inappropriate (pseudo-"etic" values). The aim is to end up with a set of values that are universal, appropriate, and comprehensive, and to develop a classification of values in terms of value types that are linked to different motivational goals (e.g., achievement, power, self-direction, security). The researcher can then compare different cultures in regard to these value types and also investigate the conflicts and compatibilities that underlie relations between them.

But even if we have been successful in developing lists of values that have universal significance, how can we be confident that values with the same verbal label have the same meaning in different cultures? For example, equality probably has a different meaning in the United States than in Australia (Feather, 1975, pp. 201–222). In the United States equality is tied to *equality of opportunity* and coexists with values relating to achievement and individualistic enterprise. There is the belief that individuals should not be handicapped because of their age, gender, religion, ethnic background, or some other factor, but should start with the same opportunities and be free to move ahead. In Australia, equality of opportunity is also valued but there is also an emphasis on *equality of condition*, a belief that every Australian citizen should enjoy a fair and reasonable standard of living. The value coexists with an ambivalence about special excellence, with a dislike of authority and status seekers, and with a degree of anti-intellectualism. The Horatio Alger myth that preaches the virtues of a spectacular career from humble beginnings is not an Australian product but an American one.

The meaning of a value is bound up with the pattern of associations that surround the value. For example, it may be clear from semantic analysis, from observations of individual behavior, and from other sources of evidence (e.g., the mass media, government enactments concerning social welfare and taxation), that a particular culture defines equality as primarily meaning a situation where inequalities in condition or state are reduced. This value may have a somewhat different meaning in other cultures, although it may share a common core of meaning across cultures that makes the concept communicable and intuitively understandable.

In general, we try to obtain evidence that values are equivalent in meaning by observing whether or not there are regular patterns of relations involving the value with other variables or criteria within each culture, patterns of relations that are similar or the same across different cultures. Such evidence demonstrates functional equivalence because it indicates that the values appear to function in equivalent ways across cultures.

THE ACTIVATION OF VALUES

Cross-cultural studies of values should be concerned not only with comparing cultures in regard to the nature and structure of their values but also with determining the conditions under which values are activated in different cultures and how they are expressed in action. The ease with which a value is activated in different cultures will vary depending on the importance of the value within a culture and the particular situational context. Values are more readily activated in a situation if they are strongly held values and if there are cues in the situation that trigger them off. For example, when equality is a very important value within a person's value system, it may be activated with relative ease, and the person may become sensitive to many forms of equalities and inequalities within situations. As a further example, freedom as a value will be more readily elicited in situations when freedom is under threat than when such threats do not exist. In this case the situational cues are an important basis for the activation of the value and the value may be elicited even though there may be other more important values that remain latent. These linkages between situational cues and values may vary across cultures. We need research that examines these differences. For example, the cues that activate the value placed on pleasure may vary from culture to culture, or there may be cross-cultural differences in the cues that activate the value placed on being self-controlled. This kind of research will inform us about the specific contexts that engage values in different cultures.

Values may also be expressed in different ways depending on culture. Let me return to the examples I gave at the beginning of this chapter. We have found that Japanese students are more likely than Australian students to approve of the fall of high achievers or "tall poppies" who have been conspicuously successful (Feather & McKee, 1993). However, the findings also showed that both groups were equally in favor of rewarding high achievers. These results are consistent with the view that achievement is valued in both cultures. However, as I indicated previously, in Japan, the

expression of achievement values is linked to inter-dependence and group harmony. Success that takes a person too far above the person's group meets with disapproval because it conflicts with an inter-dependent view of self that is an important aspect of Japanese culture (Markus & Kitayama, 1991). In Australia, wanting to bring down tall poppies seems to be related to a conflict or tension between values concerned with achievement, authority, and equality.

THE EXPRESSION OF VALUES

The question of how values are expressed in behavior can be approached in terms of motivational theory if values are considered to be general motives that influence the way situations are construed (Feather, 1992). I have argued that a person's general values can function like needs to induce subjective values on specific objects and events. I use the term *valence* to refer to these subjective values. Valences are defined in terms of the degree to which objects and events are seen to be attractive or aversive in the psychological environment and they are related not only to the nature of the situation itself but also to a person's needs and values. When a need like hunger is activated, objects and events like food and eating become attractive or positively valent. Similarly, when a value is activated, some actions or outcomes become attractive or aversive while others remain neutral. For example, when equality as a value is activated in a particular context, social arrangements that are designed to reduce inequalities are seen as attractive (or positively valent). Or, when being logical as a value is activated, ways of behaving that involve divergent rather than convergent thinking may be seen as undesirable (or negatively valent) and to be avoided.

In each of these examples, the value influences the way a situation is construed both cognitively and in terms of how we feel toward it. But people do not act only on the basis of what they perceive to be attractive or aversive. They also consider the likelihood that positive or negative outcomes will occur given their own behavior and they have expectations about whether or not the outcomes will lead to other consequences. Their wishes are moderated by the constraints of reality and the *expectations* that they hold about their own self-efficacy and the likely consequences of their actions. Thus, in accordance with a motivational approach that is called expectancy-value theory, valences in combination with expectations are assumed to influence the course of action that a person decides to take (Feather, 1992).

At the cross-cultural level this motivational approach suggests a need to determine the precise linkages between the values that individuals hold within a culture and the valences that they assign to actions and their possible outcomes, once particular values have been activated at any one time. It is likely that these value-valence linkages vary across cultures. For example, actions that are construed as helpful in one culture may be seen as less helpful in others in relation to the general value (being helpful) that is activated. Or, as another example, outcomes that can be interpreted in relation to the general value placed on achievement may vary in their attractiveness or aversiveness across cultures depending on the nature of the achievement and how it occurred.

It should be clear that I have drawn on theoretical ideas from motivation and cognition in an attempt to deal with questions concerning the activation of values and the way they are expressed in behavior. This kind of dialogue is important for the development of cross-cultural psychology. The results from cross-cultural research can usefully inform traditional areas of psychology such as motivation and cognition about the impact of cultural variables. In a reciprocal way, new ideas from these traditional areas can lead to new perspectives in cross-cultural psychology.

FINAL COMMENTS

In this brief discussion of values and culture I have necessarily had to be selective about what to include. The focus has been on studying personal values and value types, how they are defined, how they are organized or structured, how they are activated in specific contexts, and how they are expressed in behavior. There are other theoretical frameworks that deal with social life at a more general level. I have already referred to the interest in individualism and collectivism and discussions of the degree to which people construe self as independent or interdependent (Markus & Kitayama, 1991). In addition, Fiske (1991) has recently described four elementary models "... that people use (unselfconsciously) to construct, understand, respond to, evaluate, and coordinate social relationships" (p. 1). He calls these models communal shar-

ing, authority ranking, equality matching and market pricing, and provides a detailed analysis of the features of these models and how they are implemented in social life. I would expect these four models to be associated with different patterns of values or value types. Also, the work-related values of individualism, power distance, uncertainty avoidance, and masculinity-femininity that Hofstede (1980) and others have used with considerable influence in many cultures should be considered another rich source for understanding variations in values.

I have also excluded discussion of the antecedents of values and what determines similarities and differences in value priorities across cultures. These are complex questions and their answer will depend not only on inputs from psychology but from other disciplines as well.

It should be clear, however, that the study of values is a central topic in cross-cultural psychology and one that touches us all because valuing is a basic aspect of everyday life.

REFERENCES

Braithwaite, V. A., & Scott, W. A. (1991). Values. In J. P. Robinson, P. R. Shaver, & L. S. Wrightsman (Eds.), *Measures of personality and social psychological attitudes* (Vol. 1, pp. 661–753). New York: Academic Press.

Feather, N. T. (1975). *Values in education and society.* New York: Free Press.

Feather, N. T. (1980). Values in adolescence. In J. Adelson (Ed.), *Handbook of adolescent psychology* (pp. 247–294). New York: Wiley.

Feather, N. T. (1992). Values, valences, expectations, and actions. *Journal of Social Issues, 48*(2), 109–124.

Feather, N. T., & McKee, I. R. (1993). Global self-esteem and attitudes toward the high achiever for Australian and Japanese students. *Social Psychology Quarterly,* forthcoming.

Fiske, A. P. (1991). *Structures of social life: The four elementary forms of human relations.* New York: Free Press.

Hofstede, G. (1980). *Culture's consequences: International differences in work-related values.* Newbury Park, CA: Sage Publications.

Markus, H. R., & Kitayama, S. (1991). Culture and the self: Implications for cognition, emotion, and motivation. *Psychological Review, 98,* 221–253.

Rokeach, M. (1973). *The nature of human values.* New York: Free Press.

Schwartz, S. H. (1992). Universals in the content and structure of values: Theoretical advances and empirical tests in 20 countries. In M. Zanna (Ed.), *Advances in experimental social psychology.* New York: Academic Press.

Schwartz, S. H., & Bilsky, W. (1987). Toward a psychological structure of human values. *Journal of Personality and Social Psychology, 53,* 550–562.

27
Cross-Cultural Views of Women and Men

JOHN E. WILLIAMS & DEBORAH L. BEST

Imagine that you are on an extended trip around the world and you have visited a number of different countries on every continent. On your final airplane ride home, you decide to thumb back through the diary you have kept while on your trip—to reminisce a bit before you have to face the many tasks that will require your attention when you get home. While looking back through your diary you note that during your stay in Pakistan, you observed that men were highly visible in day-to-day activities and seemed to be "in charge" in most situations. Women were rarely seen in public places and, when they were, they appeared to be on specific errands and were often dressed in a manner that made it difficult to tell much about them. You rarely saw young men and women walking together as couples, enjoying what would be called a date in the United States. Moving a few pages ahead in your diary you see an entry that indicated that during your stay in Finland, you noticed that men and women seemed to participate equally in many daily activities. Heterosexual couples were everywhere and many young women and men were dressed in a similar unisex style.

Reflecting on the various experiences you had in Pakistan, Finland, and the other countries you visited, you conclude that there are important differences in the way that men and women behave in different countries. It is obvious that the customs governing appropriate relations between men and women differ from country to country, but you wonder if there are differences in the way that people of the same gender in different countries view themselves. Are the self-concepts of men different in Pakistan and Finland? Do women in Pakistan view themselves as more feminine than women in Finland? Are the self-perceptions of men and women more similar in Finland than in Pakistan? What are the cultural perceptions and accepted behaviors of men and women in Pakistan and Finland?

John E. Williams is Wake Forest Professor and Chair in the Department of Psychology at Wake Forest University, Winston-Salem, NC, U.S.A. A personality-social psychologist, his research work has primarily been concerned with racial attitudes, gender stereotypes, and self concepts, all of which have been approached from a cross-cultural viewpoint. One of the two longest serving graduate department chairs of psychology in the United States, he currently serves as editor of the *Journal of Cross-Cultural Psychology*.

Deborah L. Best is Professor of Psychology at Wake Forest University, Winston-Salem, NC, U.S.A. As a developmental psychologist, her research has concentrated upon the development of gender stereotypes, beliefs about aging, racial attitudes, and memory development in both children and older adults. She has conducted cross-cultural projects in the first three of her research areas. She is a consulting editor for the *Journal of Cross-Cultural Psychology* and the *Psychology of Women Quarterly*. She also is Treasurer of the International Association for Cross-Cultural Psychology.

These questions address the three distinct but related aspects of the way that women and men are viewed in different cultures, and these are the focus of this chapter. The first aspect concerns *gender stereotypes* which are the popular views of how men and women differ in their psychological makeup. For example, men are often said to be more aggressive than women while women are said to be more emotional than men. The second aspect addresses the manner in which women and men view themselves, that is, the degree to which the gender stereotypes are incorporated into the *self-perceptions* of the two gender groups. To what degree do men have more "masculine" self-descriptions and do women have more "feminine" self-descriptions? The third aspect to be discussed is *sex-role ideology* which pertains to beliefs about the proper role relationships between men and women in different cultures. For example, is it appropriate for men to be dominant over women or should the two gender groups relate to one another in a more equal manner? We will consider some cross-cultural research findings bearing upon each of these three matters, in turn.

Cross-cultural research can be valuable when looking at gender differences because it provides a greater range of beliefs and roles than do single-culture studies. With greater variation comes the opportunity to look for possible causes of gender differences.

GENDER STEREOTYPES

We will begin our discussion with gender stereotypes because they serve as the foundation for gender differences in self perceptions and roles. First, let's look at how gender stereotypes are related to gender roles. In all societies, men and women generally carry out different occupational, homemaking, and leisure roles. For example, in the United States more men than women are construction workers and more women than men care for young children. These role assignments are supported by assumptions that men are stronger, more robust, and more rational than women, and are therefore more suited to be construction workers. Women, on the other hand, are gentle, kind, patient, and understanding, and as a consequence working with children is more suited to what women are like. Cultural assumptions or stereotypes about what men and women are like may also be reflected in

self perceptions and influence the way that men and women interact with one another.

> **Cultural assumptions or stereotypes about what men and women are like may also be reflected in self perceptions and influence the way that men and women interact with one another.**

Over the past 15 years, we have conducted gender stereotype studies in more than 30 countries around the world. In each country, university students were asked to consider a list of 300 adjectives (e.g., aggressive, emotional) and to indicate whether, in their culture, each adjective is more frequently associated with men, with women, or equally associated with both genders. The responses of the individual subjects in each country were then tallied to determine, for each adjective, the frequency with which it was associated with men and with women. In this manner, we identified the characteristics that are most highly associated with each gender group in each country.

When these data were analyzed, we found a high degree of pancultural agreement across all the countries studied in the characteristics differentially associated with women and men. This agreement is evident in Table 1 which shows the psychological characteristics that were generally associated with men and women across the 30 countries.

Looking at the table, it is clear that very different qualities are associated with men and with women, but with so many items, it is difficult to summarize what the major differences are. To solve this problem, we scored the male- and female-associated adjectives in each country in terms of affective meaning, the *favorability, strength,* and *activity* of the adjectives. Other researchers have shown that affective meanings are important in understanding more than just the dictionary definition of words. Our analysis produced an interesting pattern. In all countries, without exception, the characteristics associated with men were *stronger* and *more active*

TABLE 1 **The 100 items of the pancultural adjective checklist**

Male-Associated		Female-Associated	
Active	Loud	Affected	Modest
Adventurous	Obnoxious	Affectionate	Nervous
Aggressive	Opinionated	Appreciative	Patient
Arrogant	Opportunistic	Cautious	Pleasant
Autocratic	Pleasure-seeking	Changeable	Prudish
Bossy	Precise	Charming	Self-pitying
Capable	Progressive	Complaining	Sensitive
Coarse	Quick	Complicated	Sentimental
Conceited	Rational	Confused	Sexy
Confident	Realistic	Curious	Shy
Courageous	Reckless	Dependent	Softhearted
Cruel	Resourceful	Dreamy	Sophisticated
Cynical	Rigid	Emotional	Submissive
Determined	Robust	Excitable	Suggestible
Disorderly	Serious	Fault-finding	Talkative
Enterprising	Sharp-witted	Fearful	Timid
Greedy	Show-off	Fickle	Touchy
Hardheaded	Steady	Foolish	Unambitious
Humorous	Stern	Forgiving	Unintelligent
Indifferent	Stingy	Frivolous	Unstable
Individualistic	Stolid	Fussy	Warm
Initiative	Tough	Gentle	Weak
Interests wide	Unfriendly	Imaginative	Worrying
Inventive	Unscrupulous	Kind	Understanding
Lazy	Witty	Mild	Superstitious

than those associated with women, but there was no general pancultural pattern for the favorability scores. Taken as a group, the male stereotype characteristics were more favorable than the female characteristics in certain countries (Japan, South Africa, and Nigeria) and the female stereotype characteristics were more favorable in other countries (Italy, Peru, Australia). Across cultures, the stereotypes of women and men are equally favorable, but stereotypes of men are generally stronger and more active than those of women.

Despite the high degree of similarity in the gender stereotypes across the various cultural groups studied, there was also some evidence of systematic cultural variation. For example, male and female gender stereotypes were more differentiated in Protestant countries than in Catholic countries. Perhaps these differences reflect the varying place of women in both the theology and religious practices of these two religious groups.

Having found that adults hold stereotypic beliefs about characteristics associated with men and women, we naturally wondered how early in life young children begin to associate different characteristics with the two gender groups. We explored this question in a study of five-year-old and eight-year-old middle-class children in 25 countries. In this study, children were shown silhouettes of a man and a woman and were asked to select between the ones described in a brief story. The stories were written to reflect the more important features of the adult sex stereotype characteristics. For example, in one story the child would be asked to select "the person who gets into fights" (aggressive) or in another story "the person who cries a lot" (emotional).

The results indicated that the five-year-old children in all countries showed at least a beginning knowledge of the adult stereotypes. The stories most frequently associated with the male figures were those involving the characteristics strong, aggressive, and cruel while those most frequently associated with the female figures were emotional, soft-hearted, and weak. There were also some interesting variations among the five-year-olds from different countries in their knowledge of the adult stereotypes. For example, Pakistani children showed the greatest knowledge of gender stereotypes while Brazilian children showed relatively little knowledge.

In all countries, there was an increase in sex stereotype knowledge from age five to age eight

and, based on the few countries where children were studied, it appears that stereotype knowledge increases regularly through the teenage years and into young adulthood. In comparing the performance of the children across countries, it is interesting to note that the stereotype knowledge of the eight-year-olds was more similar than that of the five-year-olds. In other words, three additional years of exposure to their individual cultures did not lead to increased diversity but to increased similarity. Presumably, this similarity is another reflection of the generality of the adult gender stereotype model which is learned by children in all cultures studied.

The children in the study just described were all from the middle classes in their respective countries, so we could not tell whether sex stereotype knowledge differs as a function of social class. In a later study, however, this question was addressed in a few countries. Children from the higher social classes learned gender stereotypes earlier than children from the lower classes, perhaps due to differences in exposure to stereotypic presentations of women and men in children's stories, in the mass media, etc. Moreover, it may be a reflection of the fact that children from higher class groups tend to be somewhat brighter than children from lower class groups and, as a result, they may learn many things more rapidly, including sex stereotypes.

SELF CONCEPTS OF WOMEN AND MEN

We have seen that there is a widespread belief that men and women differ significantly in their psychological makeup and that children begin to learn these beliefs at an early age. In view of these findings, a related question concerns whether these stereotypic characteristics are reflected in the self concepts of men and women.

We addressed this question in a 14-country study in which university students were asked to consider each of the 300 adjectives that we had used in the earlier gender stereotype studies and to indicate those adjectives that were descriptive of self or ideal self. These self and ideal self descriptions were then scored in two different ways. First each description was scored in terms of "masculinity/femininity" by examining the adjectives that were male-associated and female-associated in the earlier sex stereotype study in their country. For example, the self descriptions of subjects in India were examined for the items that had been identified by the earlier group of Indian students to be male-associated and female-associated. Because we used these culture-specific sex stereotype data in scoring, we were able to obtain a culture-specific definition of masculinity/femininity. Hence, a subject's self and ideal self descriptions were considered to be relatively masculine or relatively feminine depending upon how many culture-specific male-associated or female-associated adjectives the subject used in the descriptions.

Looking at masculinity/femininity, there were some interesting pancultural findings. In all countries, as expected, both the self and ideal self concepts of men were more masculine than women's while those of the women were more feminine than men's. Comparisons of the self and ideal self concepts are more informative. One might have expected that in moving from self to ideal self, men would like to be more masculine and women would like to be more feminine. However, in all countries both genders described the person they wanted to be, the ideal self as more masculine than their actual self. What might this mean? Think about the earlier finding that, in all countries, the male stereotype is stronger and more active than the female stereotype. Perhaps in saying that they wanted to be "more masculine" subjects were, in effect, saying that they wanted to be stronger and more active than they saw themselves to be.

When the masculinity/femininity data were examined for cross-cultural differences, some variations were observed but these variations were not systematically related to cultural differences. So, the intriguing idea that there are important cultural differences in masculinity/femininity was not supported in this study.

A different picture emerged when the self and ideal self concepts were scored in terms of favorability, strength, and activity. First, there was a modest tendency in most countries for the men's and women's self descriptions to parallel the strength and activity of the sex stereotypes—the self concepts of men were somewhat stronger and more active than those of women. More interesting findings were obtained when the differences between men's and women's self concepts in each country were compared using a combination of all three affective meaning scores. In some countries the men's and women's self descriptions were more similar and in other countries more differentiated.

The degree of *differentiation* of the men's and women's self concepts was related to a large number of cultural variables. Men's and women's self concepts were more differentiated in countries that were low in socioeconomic development, low in the percentage of women employed outside the home and attending the university, low in the percentage of the population identified as Christian, and relatively rural. In contrast, the countries where the self concepts of men and women were more similar tended to be more developed and more highly Christian, with higher percentages of women employed outside the home and in the university population, and relatively more urban in population distribution. One of the more intriguing relationships found was the tendency for the self concepts of men and women to become more similar as one moves north from the equator into the higher latitudes. What might account for this finding?

In summary, our cross-cultural study of self concepts of men and women suggests that there may be some interesting but relatively minor differences related to cultural factors. On the other hand, the results suggest that looking at these differences in terms of "masculinity/femininity" is not a very profitable approach.

SEX ROLE IDEOLOGY

We turn now to sex role ideology, beliefs concerning the proper role relationships between women and men. The same university students from 14 countries who participated in the self concept study completed a questionnaire expressing agreement or disagreement with statements concerning relationships between women and men. For example: "The husband should be regarded as the legal representative of the family group in all matters of law."; "A woman should have exactly the same freedom of action as a man." The questionnaires were scored so that high scores indicated a relatively egalitarian or "modern" ideology while low scores indicated a male dominant or "traditional" ideology. In each country, the ideology scores were examined separately for the men and women subjects and the results are shown in Figure 1. Here it can be seen that the most modern or egalitarian sex role ideologies were found in the Netherlands, Germany, and Finland while the most male dominant or traditional ideologies were found in Nigeria, Pakistan, and India. The United States fell toward the middle of the distribution of countries.

Perhaps not surprisingly, in the great majority of countries the women subjects tended to have

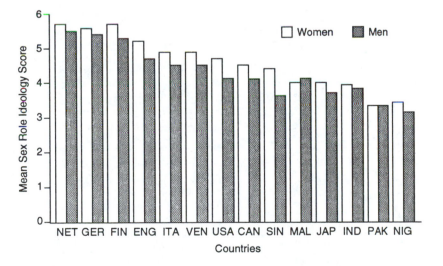

FIGURE 1 Mean sex role ideology scores for female (F) and male (M) subjects in 14 countries

Note: Countries are:

Netherlands	Italy	Singapore	Pakistan
Germany	Venezuela	Malaysia	Nigeria
Finland	United States	Japan	
England	Canada	India	

more modern views than did the men, but the differences were relatively small. Indeed, culture seems to contribute more to variations in sex role ideology than does gender, with more agreement between men and women in the same cultural group than among women or among men from different cultural groups.

The sex role ideology differences among the countries seen in the figure were related to a large number of cultural comparison variables. Sex role ideology tended to be more modern or egalitarian in countries that were more developed, more highly Christian, more urban, and, once again, from the higher northern latitudes. Stated the other way, sex role ideology tended to be more traditional and male dominant in countries that were lower in socioeconomic development, lower in the percent of Christians, more rural, and closer to the equator. These findings suggest substantial cross-cultural variations in beliefs about the proper role relationships between men and women.

SUMMARY

Across countries as different as Finland, Pakistan, New Zealand, Nigeria, Canada, and Venezuela, there appears to be widespread cross-cultural agreement in the psychological characteristics believed to differentiate women and men. In each of the countries studied, children's learning of gender stereotypes generally begins before age five and continues through childhood and adolescence. Despite the powerful model provided by the general gender stereotypes, the self concepts of young men and women reveal only a slight echo of these stereotype characteristics. Moreover, there is substantial cross-cultural variation in beliefs concerning proper role relationships between men and women, and in most countries women have somewhat more modern or egalitarian views than do men.

SUGGESTED READINGS:

Williams, J. E. & Best, D. L. (1990). *Measuring sex stereotypes: A multi-nation study.* Newbury Park, CA: Sage Publications.

Williams, J. E. & Best, D. L. (1990). *Sex and psyche: Gender and self viewed cross-culturally.* Newbury Park, CA: Sage Publications.

Richmond-Abbott, M. (1992). *Masculine & feminine: Gender roles over the life cycle.* New York: McGraw-Hill.

28
Mate Preferences in 37 Cultures

DAVID M. BUSS

Every person is alive because of a successful mating. People in the past who failed to mate are not our ancestors. But how do we choose our mates? What characteristics do we seek? And why?

Social scientists have long assumed that our mate preferences are highly culture-bound—that people in North America, for example, desire different characteristics than people in Asia or Africa. Even Charles Darwin, a pioneering scientist on the topic of mating, believed that mate preferences were largely arbitrary. But little scientific knowledge has been gathered about what we want in a mate. Until recently.

A startling new study shows that traditional scientific assumptions have been radically wrong. With 50 other scientists residing in 37 cultures around the world, I set out to discover what people want in a mate.

These findings, involving more than 10,000 people in 37 cultures on six continents and five islands, were extraordinarily difficult to obtain. In South Africa, the data collection was described as "a rather frightening experience" due to political turmoil and violence in shanty-towns. Government committees hindered data collection in some countries, and banned the study entirely in others. Revolutions and mail strikes prevented some collected data to be sent. It took us more than five years to gather all the information, and two years to perform the needed statistical analyses. But it was worth the wait.

We did find some striking differences across cultures, as scientists and common lore had long suspected. But we found apparently universal preferences as well—things that people worldwide expressed a desire for. And we found a few key differences between men and women in all cultures—universal differences that appear to be deeply rooted in the evolutionary history of our species. This chapter summarizes a few of the most important findings.

UNIVERSAL MATE PREFERENCES SHARED BY MEN AND WOMEN

We asked people to tell us how desirable 32 characteristics were in a potential marriage partner. We used two instruments. The first was a rating instrument, where subjects indicated how important each of 18 characteristics was on a scale ranging from "0" (irrelevant or unimportant) to "3" (indispensable). The second instrument requested subjects to rank each of 13 characteristics from "1" (most desirable) to "13" (least desirable).

When we analyzed the data for each of the 37 cultures, we found that people in nearly every culture agreed about which were the top few most

David M. Buss is Professor of Psychology at the University of Michigan. In 1981, he earned his Ph.D. from the University of California, Berkeley, and took an Assistant Professorship at Harvard University. Buss is the winner of the American Psychological Association Award for Early Career Contribution to Psychology (1988), the G. Stanley Hall Award (1990), and author of *Human Mating Strategies* (Basic Books, in press). Buss is Director of the International Consortium of Personality and Social Psychologists, which conducts collaborative research in 33 countries.

desirable characteristics. Not only was there agreement across cultures on the top few, men and women were statistically identical in nearly all of the 37 cultures on these most valued attributes. Everywhere, both men and women wanted a mate who was kind and understanding, intelligent, and was healthy (ranking instrument). Universally, as shown by the rating instrument, both men and women wanted a mate who possessed emotional stability and maturity, dependability, a pleasing disposition, and good health (see Table 1).

What about love? Many scientists believe that love is a Western notion, invented just a few hundred years ago. Our findings show those scientists to be wrong. People the world over value mutual

> ## What about love? Many scientists believe that love is a Western notion, invented just a few hundred years ago.

attraction and love. Love is not merely something seen in Western Europe or even the Western world. Love is just as highly prized by the Chinese, Indonesians, Zambians, Nigerians, Iranians, and Palestinians. At least with respect to these characteristics, people everywhere have roughly the same desires. Our scientific theories need revision. At least some mate preferences are not as culture-bound as we had thought.

TABLE 1 Universally desired mate characteristics

Universally Preferred Characteristics— Ranking Instrument

1. Kind and Understanding
2. Intelligent
3. Exciting Personality
4. Healthy

Universally Preferred Characteristics— Rating Instrument

1. Mutual Attraction—Love
2. Emotionally Stable and Mature
3. Dependable Character
4. Good Health
5. Pleasing Disposition

CULTURALLY VARIABLE MATE PREFERENCES

But it's not that simple. Not all characteristics showed uniformity across cultures. Indeed, for a few characteristics, what people desired in potential mates varied tremendously across cultures. Chastity—the lack of previous sexual intercourse— proved to be the characteristic most variable across culture (see Figure 1). This surprised our research team.

We expected that men worldwide would value chastity, and would value it more than women. This is because of the differences between men and women in the certainty of their parenthood. Women are 100 percent certain that they are the mothers of their children. But men can never be entirely sure that they are the fathers. Over thousands of generations of human evolutionary history, this sex-linked adaptive problem should have imposed selection pressure on men to prefer mates for whom their paternity probability would be increased. Valuing chastity might have been one way that men could be more "confident" that they were the fathers. We found that not all men feel that way.

We were surprised that men and women from the Netherlands, for example, don't care about chastity at all. Neither is virginity valued much in the Scandinavian countries such as Sweden and Norway. Indeed, some people even wrote on the questionnaires that chastity was "undesirable" or "bad" in a prospective mate. In China, however, virginity is indispensable in a mate—marrying a non-virgin is virtually out of the question. People from India, Taiwan, and Iran also placed tremendous value on chastity. In between the Western European countries and the Asian countries were Nigeria, South Africa, Zambia, Japan, Estonia, Poland, and Columbia—they all saw chastity as only moderately desirable in a mate.

Cultures, however, do not seem to be infinitely variable in this regard. We could find no cultures where women valued virginity more than men. In fact, in two thirds of all of our cultures—an overwhelming majority—men desired chastity in marriage partners more than women. Culture does have a large effect on how much chastity is valued. In the majority of cultures, though, so does whether one is a man or a woman.

Although the value men and women place on chastity in potential mates overwhelmingly showed the greatest cross-cultural variability, several other factors also showed large cultural differ-

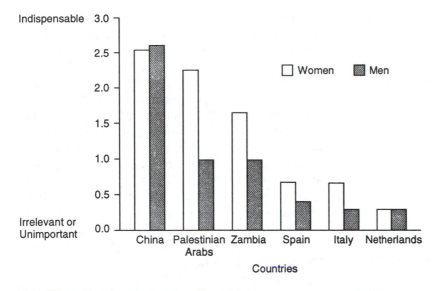

FIGURE 1 Chastity: No Previous Sexual Intercourse

ences. Examples include: *good housekeeper* (highly valued in Estonia and China, little valued in Western Europe and North America); *refinement/neatness* (highly valued in Nigeria and Iran, less valued in Great Britain, Ireland, and Australia); and *religious* (highly valued in Iran, moderately valued in India, little valued in Western Europe and North America). These large cultural differences, important as they undoubtedly are, probably mask a great deal of variability across individuals within cultures.

WHAT DO WOMEN WANT?

From Aristotle to Freud to contemporary society, scholars have puzzled over the question: What do women want? Trivers's (1972, 1985) seminal theory of parental investment and sexual selection provided a powerful evolutionary basis for predicting some female preferences. Trivers argued that the sex that invested more in offspring should be selected to be relatively more choosy or discriminating than the sex that invested less. Poor mating decisions are more costly to the heavily investing sex. A woman who chooses poorly, for example, might end up abused or find herself raising her children alone—events that would have been reproductively damaging in ancestral (and likely modern) times. Because humans are like other mammals in that fertilization, gestation, and placentation are costs incurred by females rather than by males, it is clear that the *minimum* investment

needed to produce a child is much greater in women than in men. But in other species, such as the Mormon cricket, the pipefish seahorse, and the poison arrow frog, males invest more heavily in offspring and in these species, males are more choosy than females about who they mate with. This highlights the fact that relative parental investment, not biological sex *per se*, is the driving force behind relative choosiness.

But in species where the less investing sex can accrue and defend resources, where they vary a lot in how many resources they have to contribute, and where some show a willingness to devote resources, the more heavily investing sex is predicted to prefer mates who show an ability and willingness to invest resources. Folk wisdom has it that the concern with material resources is prevalent only in cultures with capitalist systems. Our international study of 37 cultures shows otherwise. In a striking confirmation of Trivers's theory, women value "good financial prospects" and "good earning capacity" more than men. From the Zulu tribe in South Africa to coastal dwelling Australians to city-dwelling Brazilians, women place a premium on good earning capacity, financial prospects, ambition, industriousness, and social status more than men—characteristics that all provide resources.

We were surprised to find these results even in socialist countries and communist countries where there is less income inequality. Women seem to value resources in mates more than men regardless of the political system. Women throughout human

evolutionary history have needed material resources that can help their children survive and thrive.

Are women more choosy than men? Across nearly all cultures, women indeed were more discriminating and choosy than men. Women express more stringent standards across an array of characteristics—they want more of nearly everything. These findings support another key prediction from Trivers's evolutionary theory.

WHAT DO MEN WANT IN A MATE?

Men expressed more stringent standards than women on only two characteristics. The first is *youth*. Men worldwide prefer wives who are younger than they are (see Figure 2). But how much younger depends on the nature of the mating system. In cultures that permit men to acquire multiple wives, such as Zambia and Nigeria, men prefer brides who are much younger than they are—by as many as 7 or 8 years. In cultures that restrict men to one wife such as Spain, France, and Germany, men prefer brides who are only a few years younger. Interestingly, women in all cultures preferred husbands who were older—because men mature somewhat later than women and because older men often have access to more resources than younger men.

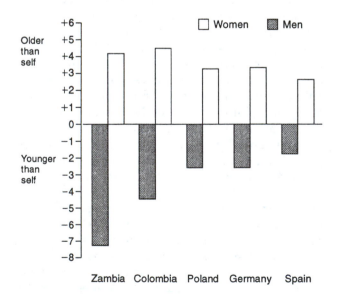

FIGURE 2 Age difference preferred between self and spouse

But youth is not the only thing that men want. Men across the globe also value "physical attractiveness" in marriage partners more than women.

Traditional social science theories have assumed that what people find beautiful is culture-bound—that beauty is merely "in the eyes of the beholder" and that standards of beauty are rather arbitrary. We now know that these theories are partially wrong. The available evidence shows that people across cultures see clear and supple skin, absence of wrinkles, lustrous hair, full lips, clear eyes, good health, regular features, and other signs of youth and health as attractive. Although there are cultural preferences for slightly more plump or thin mates, men worldwide regard the same women as beautiful.

The importance men place on good looks is not limited to Western Europe or North America; nor is it limited to cultures saturated with visual media such as television, movies, and videos; nor is it limited to particular racial, ethnic, religious, or political groups. In *all* known cultures worldwide, from the inner-continental tribal societies of Africa and South America to the big cities of Madrid, London, and Paris, men place a premium on the physical appearance of a potential mate. And they do so for a very good reason.

According to a new scientific theory, these qualities provide the best signals to a man that the woman is fertile and has good reproductive capacity. This is not necessarily done at a conscious level. We like sweet foods without knowing the nutritional logic of caloric intake. Men prize physical appearance and youth without knowing that these qualities signal a woman's fertility and reproductive capacity.

MATE PREFERENCES AND ACTUAL MARRIAGE DECISIONS

People act on their preferences. Worldwide, men do marry women younger than they are, on average. And interestingly, men who possess a lot of resources can obtain younger and more physically attractive mates. Women who are physically attractive can obtain men with more resources and social status. In societies where men purchase their wives, young women command a higher "brideprice" than older women. Finally, among the most prevalent causes of marital dissolution worldwide are infertility, infidelity, and a man's failure to provide

economically (Betzig, 1989). Mate preferences, in other words, are reflected in the actual mating decisions that people make.

CONCLUSIONS

Where does all this leave us? First, it is important to recognize that each person is at least somewhat unique, showing individual patterns of mate preferences. Second, culture clearly matters a lot. The tremendous cross-cultural variability on preferences for "chastity" demonstrate that even characteristics that are close to reproduction are not immutable, unchangeable, or intractable. Third, it is now apparent that men and women worldwide do differ consistently on a few key mate preferences—those where the sexes have faced different adaptive problems over human evolutionary history. Fourth, there are many preferences that men and women

share the world over, with both sexes valuing them highly in a mate. In an important sense, as variable as we are across culture and across gender, we are all one species when it comes to mating.

REFERENCES

Betzig, L. (1989). Causes of conjugal dissolution. *Current Anthropology, 30,* 654–676.

Buss, D. M. (1989). Sex differences in human mate preferences: Evolutionary hypotheses tested in 37 cultures. *Behavioral and Brain Sciences, 12,* 1–49.

Buss, D. M. (in press). *Sexual strategies: The evolution of human mating.* New York: Basic Books.

Trivers, R. (1972). Parental investment and sexual selection. In B. Campbell (Ed.). *Sexual selection and the descent of man: 1871–1971.* Chicago: Aldine.

Trivers, R. (1985). *Social evolution.* Menlo Park, California: The Benjamin/Cummings Publishing Company.

29
Prejudice and Guilt: The Internal Struggle to Overcome Prejudice

PATRICIA G. DEVINE & JULIA R. ZUWERINK

What is prejudice? What causes it? How can it be cured? These and other questions about intergroup hostilities have puzzled and intrigued social scientists for decades. Undoubtedly, the answers are multifaceted. Indeed, there are so many pieces to the puzzle of intergroup prejudice that it becomes a problem too big for any single discipline to explain. Therefore, a complete understanding must rely on insights from history, anthropology, economics, sociology, and psychology. Gordon Allport's (1954) classic volume *The Nature of Prejudice* is the best general introduction to the study of prejudice at all these levels of analysis. We highly recommend it to interested readers.

But we are social psychologists. As such, it is our preference to study prejudice at the individual level. To illustrate the kinds of issues that have piqued our interest, we would like to tell you the story of John. John is real. And his struggles are real.

John grew up in a white Anglo-Saxon protestant family. His parents were good people living in a decent community. But they were prejudiced. John didn't have much contact with Blacks as a child (their neighborhood, in the mid-50s, wasn't integrated). But he knew Blacks weren't like Whites; they were lazy, dirty, untrustworthy. . . . he'd learned that at home, at school, around the neighborhood. When he graduated from high school in 1964, John was prejudiced just like his parents. But in college he soon found himself confronted with the Civil Rights Movement and liberal politics. This new egalitarian way of viewing the world and the people in it seemed right to him. So despite his family and community socialization, he embraced the egalitarian tenets of the Civil Rights Movement and abandoned his prejudiced beliefs. He quickly learned, however, that shedding the influence of a lifetime of prejudicial socialization is not an all-or-none event. Like being influenced by an old habit that's hard to break, John found himself still having prejudiced reactions based on the stereotypes he had learned. The conflict between those unwanted stereotyped-based reactions and his own personal, non-prejudiced beliefs often left him feeling very guilty and self-critical. It still does.

Patricia G. Devine is an Associate Professor of Psychology at the University of Wisconsin-Madison. Devine earned her Ph.D. in 1986 from the Ohio State University, after which she joined the Department of Psychology at the University of Wisconsin. Devine is committed to working with her students to explore the psychological processes involved in prejudice and intergroup tension.

Julia R. Zuwerink received her undergraduate degree at Hope College in Holland, Michigan and is currently a doctoral student in social psychology at the University of Wisconsin-Madison. Zuwerink's research on prejudice is a specific example of her more general research interests in the psychology of attitudes.

But despite his own internal struggle, John has decided to raise his family in an integrated neighborhood. He is still vulnerable to an initial, automatic reaction of suspicion or fear when a new Black family moves into the neighborhood. And he feels guilty about it. But at least his children are growing up without those same suspicions and stereotypes—as far as he can help it.

Is John prejudiced? Some would say yes, because he sometimes has negative reactions toward African Americans. Others would say no, because he has rejected prejudice and adopted a new set of nonprejudiced beliefs and values. In trying to decide for yourself if John is prejudiced, what evidence would you focus on? How would you make sense of the disparity between what John *says* about his beliefs and his actual *reactions*, which sometime seem prejudiced? If you find this question a difficult one to answer, you are not alone.

Indeed, John's personal experiences map onto an important debate in the psychological literature concerning what should be taken as evidence for the manifestation of prejudice. This debate grew out of a set of paradoxical findings: Survey research has shown that over the last 40 years, white U.S. self-reported attitudes toward African Americans and other minorities have become substantially less prejudiced. Hooray! Racism in America is declining! *But*, other research, which does not rely on what people say about their attitudes, suggests that prejudice is still a prevalent problem among U.S. whites (see Crosby, Bromley, & Saxe, 1980, for a review). In such studies, researchers use things like amount of eye contact and interpersonal distance as measures of prejudice. These kinds of nonverbal measures are thought to be good indicators of prejudice because they usually do not involve a great deal of thought or planning, and people cannot control them in the same way that they can control their verbally reported attitudes.

What should we conclude from these conflicting findings? Some reject the optimistic conclusion suggested by survey research and argue that prejudice in America is *not* declining, it is only changing its form—becoming more subtle and disguised. By this argument, most (if not all) white Americans are assumed to be racists, with only the *type* of racism differing between people (see Dovidio & Gaertner, 1986). Such conclusions are based on the belief that *any* response that results in differential treatment between groups should be taken as prejudice. How-

ever, this definition fails to consider *intent* or motive. Further, it implies that real change only exists when all behaviors and responses are consistent with nonprejudiced standards. From this perspective, the fact that John still sometimes has a nega-

By this argument, most (if not all) white Americans are assumed to be racists, with only the *type* of racism differing between people.

tive reaction when African Americans move in next door is taken to be evidence that he is still a racist— never mind that he says he opposes prejudice in himself and others. This assumption obviously implies that what people say they believe and think cannot be trusted.

Such arguments are based on the assumption that nonthoughtful (e.g., nonverbal) responses are, by definition, more trustworthy than deliberate and thoughtful responses. But we believe that there are unfortunate negative consequences associated with this assumption that lead us to overlook or deny real change when it is present. Rather than dismiss one or the other response as necessarily untrustworthy, we want to understand the origin of both thoughtful and nonthoughtful responses. In John's case, for example, we seek to understand and explain why negative responses persist despite the fact that he has renounced prejudice and adopted nonprejudiced values.

In our work (e.g., Devine, 1989; Devine, Monteith, Zuwerink, & Elliot, 1991), we argue that to understand why low-prejudiced people sometimes respond in prejudice-like ways, one has to understand an important distinction between what cognitive psychologists call *automatic* and *controlled* cognitive processes. Automatic processes are ones that occur unintentionally, spontaneously, and unconsciously. We have evidence that both low- and high-prejudiced people are vulnerable to the *automatic* activation of the cultural stereotype of African Americans (Devine, 1989). Once the stereotype is well-learned (and therefore part of our cognitive system), its influence is hard to avoid because the stereotype so easily comes to mind. John's first thoughts about his new African-American neigh-

bors were ones of suspicion and fear. Why? Because the stereotype of African Americans as lazy and violent came to mind automatically—without his consent or bidding. Such automatic activation, one might even say a Pavlovian response, is the legacy of his socialization experiences.

Controlled processes, in contrast, are intentional and under the control of the individual. An important aspect of such processes is that their initiation and use requires time and sufficient cognitive *capacity*. If John is to respond consistently with his new personal beliefs and nonprejudiced values, he has to have the time and cognitive energy to *inhibit* the spontaneously activated stereotype, to replace those thoughts with his own personal beliefs, and then to respond on the basis of those beliefs. Without sufficient time or capacity, John's response may well be stereotype-based and therefore appear prejudiced. The important implication of the automatic/controlled process distinction is that if one looks *only* at nonthoughtful, automatic responses, one may well conclude that all white Americans are prejudiced. Yet, our research suggests that this is not a valid conclusion.

We have found important differences between low- and high-prejudiced people based on the personal *beliefs* they each hold. This is true despite similar knowledge of and vulnerability to the activation of cultural stereotypes. For example, low-prejudiced persons reject the stereotype and believe it is an inappropriate basis for responding to stereotyped group members. Further, they have established nonprejudiced personal standards, and these standards are important to them. When given sufficient time, low-prejudiced people censor responses based on the stereotype and instead respond on the basis of their nonprejudiced beliefs. High-prejudiced people, on the other hand, do not reject the stereotype and are not personally motivated to try to overcome its effect on their behavior (although they may decide to respond in nonprejudiced ways to avoid social ridicule or sanction).

The distinctions between automatic and controlled processes and between knowledge of and endorsement of cultural stereotypes also provides a theoretical framework for understanding why those who have renounced prejudice may continue to experience prejudiced thoughts and feelings. Even if beliefs change, stereotype-based responses continue to be automatically activated in the presence of members of the stereotyped group. However, a key issue in the debate is whether the reported change in beliefs reflects real change or

superficial changes designed to present a socially desirable image. The automatic/controlled and knowledge/endorsement distinctions don't help us out here. How can we tell if people's verbal reports of nonprejudiced attitudes are trustworthy? What type of evidence would convince you? Keeping in mind that many social scientists do not trust verbal reports, we thought that it was important to provide evidence that verbally reported nonprejudiced attitudes are trustworthy. We believe we have such evidence.

In recent work, we have shown that people high and low in prejudice (as assessed by a self-report technique) have qualitatively different affective reactions to the conflict between their verbal reports concerning how they *should* respond in situations involving contact with members of stereotyped groups and how they say they actually *would* respond. It is the distinct nature of these affective reactions that provides at least initial evidence for the trustworthiness of low-prejudiced individuals' claims of being—and desire to be—nonprejudiced.

In our work, we collect a number of different measures from both low- and high-prejudiced people. First, we have them report their own personal standards for how they *should* respond to members of a stereotyped group. (For example, we now have data on how people believe they should respond to groups such as African Americans, male homosexuals, and women.) Low-prejudiced people, for example, believe that they should not feel uncomfortable about sitting next to an African American on a bus. High-prejudiced people disagree, indicating that it's fairly acceptable to feel uncomfortable in this situation. We also ask subjects to tell us the extent to which their personal standards are important and self-defining, and whether they are committed to responding consistently with those standards. In other words, we get a measure of the extent to which subjects' personal standards are *internalized*. Finally, we get a measure of subjects' emotional reactions to violating their standards. For example, if we asked John to think about how he actually *would* respond to sitting next to an African American on a bus, he would probably admit that he would actually feel somewhat uncomfortable. This response represents a violation of his standard, because he believes he *should not* feel uncomfortable. Given this kind of situation, we ask subjects to tell us how they feel about violating their personal standards.

Think about it. What would you expect if low-prejudiced individuals' self-reported standards

were trustworthy and represented personally important, self-defining standards? Our expectation was that violating such well-internalized standards would threaten low-prejudiced individuals' nonprejudiced self-concepts. We further expected that they would hold themselves personally accountable for the transgression and, as a result, would feel guilty and self-critical for violating those standards. In contrast, what would you expect if low-prejudiced peoples' self-reported standards were not trustworthy, if they were lying or just trying to make a good impression on the experimenter? Would you expect them to feel badly about themselves for violating a standard that was not internalized? We didn't. We expected that if they were simply lying about their standards, a violation of the standard would neither threaten their self-concepts nor lead to feelings of guilt.

Our research supported the idea that low-prejudiced people's personal standards are trustworthy. We found that although low-prejudiced people have internalized their nonprejudiced standards, they reported that their actual responses sometimes fall short of those standards. Moreover, they felt guilty and self-critical for not living up to those standards. Such findings represent strong evidence that low-prejudiced people like John are honestly trying to overcome their prejudiced tendencies. On the other hand, high-prejudiced subjects in our research did not feel guilty or self-critical when they didn't respond in ways they said they should. These subjects told us that the standards they reported were not an important part of their self-concepts. Therefore, a violation of the standards did not have negative consequences for how they felt about themselves.

In sum, we find that low-prejudiced people hold themselves personally accountable and feel guilty when they fail to live up to their standards. An important question at this point, however, is whether the guilt that low-prejudiced people experience when they violate their personal standards actually helps them to overcome prejudice. Or are they destined to fail and feel guilty about their failures? Is there any hope that people like John, who renounce prejudice but continue to experience prejudice-like responses, can actually overcome prejudice?

Recent work by Monteith (1992) provides reason for optimism concerning these questions. Monteith's research suggests that failures to live up to internalized nonprejudiced standards, along with the guilt such failures engender, can actually *help*

people learn to more effectively live up to their nonprejudiced standards in the future. That is, Monteith argued that the guilt associated with failures to live up to one's standards serves as a psychological signal that something has gone wrong and needs attention. More specifically, following a failure/guilt experience, low-prejudiced people should slow down their responses, attempt to understand why the failure occurred, and try to figure out how to avoid failures in the future (and thus avoid future guilt feelings). Monteith suggested that these reactions to a failure experience would help low-prejudiced people to use controlled processes to inhibit the unacceptable (prejudiced) responses and to replace them with responses that were based on their nonprejudiced beliefs.

Monteith's research provided strong evidence in support of these ideas. Low-prejudiced subjects who had recently experienced a failure (and therefore felt guilty) were more effective at avoiding failure experiences in the future than were low-prejudiced subjects who had not recently experienced a failure (and therefore did not feel guilty). Moreover, when failure experiences involved standards that were not well-internalized, as was the case for high-prejudiced subjects, Monteith found no evidence of guilt or efforts to avoid failure experiences in the future. Thus, it would appear that not only do low-prejudiced subjects feel guilty about violating their nonprejudiced personal standards, but also this guilt facilitates their prejudice reduction efforts (i.e., learning to avoid failure experiences).

Based on this program of research, we have come to see the importance of characterizing prejudice reduction as a *process* rather than as an all-or-none event. It's like breaking a habit. The process begins with the renunciation of prejudice and stereotype-based responses. That is, people must decide for themselves that prejudice is an inappropriate way of relating to the people around them. Secondly, they must *internalize* their new nonprejudiced beliefs. These beliefs must be an important part of their self-concepts so that they will be motivated to continue efforts at change. Finally, people must learn to inhibit automatic, prejudice-like responses and, using controlled processes, replace them with belief-based (nonprejudiced) responses.

We are sanguine about the efforts of people like John who are sincerely committed to overcoming prejudice. We believe that prejudice is a habit that *can* be broken. It is very important to recognize, however, that we are not claiming that the preju-

dice-reduction process is going to be easy—as in breaking any habit it will require a lot of hard work, practice, and time. We understand that people will slip up sometimes and "fall into old habits." But our research suggests that people can learn from such mistakes. Just as it took time and learning to acquire stereotypes and prejudices, it takes time to unlearn prejudiced responses and to learn a new set of responses. Being realistic about the difficulties associated with reducing prejudice may lend people the resolve to continue their efforts and persevere even though they may often fail.

We believe that our analysis of the process of prejudice reduction affords a number of advantages over previous perspectives, which have claimed that change is more apparent than real (cf Crosby et al., 1980). First, we can make sense of why persons who *say* they are low in prejudice sometimes respond in "prejudice-like" ways. Second, we can provide both theoretical and empirical evidence for why the verbal reports of low-prejudiced people can be trusted. Third, our analysis gives us a way of understanding the prejudice-reduction *process* as experienced by low-prejudiced people like John. Finally, it allows us to be at least cautiously optimistic about the potential for real prejudice reduction in the lives of real people.

However, we are neither claiming to have solved the problem of intergroup prejudice nor suggesting that prejudice has disappeared. Quite clearly it has not! Indeed, recently there has been a disturbing increase in hate crimes directed toward various minority groups and an increase in the activity of groups such as the Ku Klux Klan. Nevertheless, we hope that by developing an understanding of low-prejudiced people, we may gain insight into the reasons why they have established and internalized nonprejudiced standards and taken on the challenges associated with breaking the prejudice habit. Armed with this knowledge we may be able to determine ways to encourage high-prejudiced people to renounce prejudice and take on the challenge of breaking the prejudice habit.

Finally, our analysis to date has focused exclusively on the internal, individual struggle associated with learning to control prejudice. Although we believe that this intrapersonal analysis is informative, it is important to recognize that prejudice and prejudice reduction are not simply intrapersonal phenomena. Indeed, prejudice is inherently an intergroup and interpersonal phenomenon. To understand the dynamics associated with the expression of prejudice and efforts to control it, we must expand our analysis to consider how these issues are played out in interpersonal settings. We are confident, however, that understanding prejudice and its effects at the individual level of analysis can help us to understand it and know how to think about it at broader levels of analysis. The insights gleaned from the individual level of analysis will, we believe, provide useful pieces to the puzzle of intergroup prejudice.

REFERENCES

Allport, G. W. (1954). *The nature of prejudice.* Reading, MA: Addison-Wesley.

Crosby, F., Bromley, S., & Saxe, L. (1980). Recent unobtrusive studies of black and white discrimination and prejudice: A literature review. *Psychological Bulletin, 87,* 546–563.

Devine, P. G. (1989). Stereotypes and prejudice: Their automatic and controlled components. *Journal of Personality and Social Psychology, 56,* 5–18.

Devine, P. G., Monteith, M. J., Zuwerink, J. R., & Elliot, A. J. (1991). Prejudice with and without compunction. *Journal of Personality and Social Psychology, 60,* 817–830.

Dovidio, J. F., & Gaertner, S. L. (1986). *Prejudice, discrimination, and racism.* New York: Academic Press.

Monteith, M. J. (1992). *Self-regulation of prejudiced responses: Implications for progress in prejudice reduction efforts.* Manuscript submitted for publication.

Section VI

The Stresses, Strains, and Challenges Facing Humans in Transition

Torture is a particularly terrible human activity. The aim of torture is normally not to kill people, but to break down or destroy their personality. Survivors of torture are then sent back to their surroundings. There they serve as "negative models" or as a warning for what might happen to others in the survivor's society if they got involved in activities that the torturer was trying to prevent—for example, certain political activities, social reforms, or writing that might be considered subversive. The survivor of torture is often tired, in poor health, confused, depressed, anxious, irritable, and has strained family and interpersonal relationships in the wake of the severe stress he or she has endured. Other members of the survivor's society who observe this behavior of course want to avoid similar consequences. This is why it is said that torture is the most effective weapon of those who want repression and dictatorship, and who do not want democratic conditions.

There is an important organization that is totally devoted to the study of torture and its victims. Based in Copenhagen, Denmark, the International Rehabilitation Council for Torture Victims (IRCT) consists of a network of psychologists, psychiatrists, political scientists, and peace activists of all kinds. Because torture is so widespread, affiliates of IRCT are kept very busy in their work. One of their main concerns is how people cope with the incredible stresses and strains of being subjected to extremely brutal treatment, both physical and psychological, at the hands of other human beings who may not care for their ideas, political preferences, religion, ethnic origin, or skin color. IRCT has its own scholarly publication, the *Quarterly Journal on Rehabilitation of Torture Victims and Prevention of Torture.*

Even in the face of horrendous torture and brutality, many victims survive. They survive by developing different coping mechanisms. For instance, one researcher interviewed about 2,000 survivors of Nazi concentration camps in an effort to determine how they coped when hundreds of thousands gave up and succumbed. He found several strategies that were used by those who made it through the ordeal. One strategy is called *identification with the aggressor.* Here the prisoner became a "superprisoner" and took on jobs somewhat like a trustee in a normal prison. Although this coping mechanism is "negative" and distasteful to both themselves and their fellow prisoners, it did allow some to survive the death camps. The most common coping mechanism was called *stable pairing.* This involved developing a sharing and helping relationship with another person; the pair was their basic unit of survival. Probably what pulled them through was the knowledge that someone was there to help, no matter how rough the going got.

Another type of coping mechanism was made possible by some prisoners being placed in situations where they could *retain their personal values and norms* by working in pre-incarceration capacities that helped others. Many doctors and nurses, for instance, were assigned to work in the camp "hospitals," and this allowed them to be somewhat insulated from the more devastating influences of the camp, at the same time doing useful things in line with their training. Yet another strategy involved taking on an attitude of being a *detached observer.* Prisoners who used this coping strategy convinced themselves that life in the camps was "actually" no concern of theirs. They were not the ones who were ill treated. As one researcher put it, "They were just spectators of a terrible drama in

which their own bodies 'by chance' were also the actors." They used an interesting cognitive strategy by telling themselves that the torture was happening to their bodies but not to them. A coping mechanism related to being a detached observer was *denial:* some simply refused to admit that things were as horrible as they were. Denying realities such as daily vermin control could be life-saving if it helped the prisoners behave as though the most dangerous situations did not exist. Still others survived because they retained a sense of humor and found, even under incredibly trying times, some reason to live, a strategy poignantly and unforgettably described in Viktor Frankl's *Man's Search for Meaning.*

We mention torture in the introduction to this section because it ranks among the most extreme forms of stress that a human can endure *and,* unfortunately, it is universal. However, one does not have to go very far in *everyday* life to see examples of stresses and strains and the challenges faced by humans in transition or in circumstances that are more or less in the "normal" range of human activity. The seven chapters in this section are related because in some way they concern transition and threat to the status quo. Chapter 30 by John Berry appropriately leads off the section because it discusses "acculturative stress"—the stress that most immigrants, refugees, and others feel to some extent when subjected to culture change.

Most people take risks, with risk referring to taking some action in potentially damaging or threatening circumstances where the outcome is unknown. In Chapter 31, George Cvetkovich and Timothy Earle summarize a growing body of international research concerning how culture affects risk-taking behavior, thereby potentially affecting how much stress one might experience as a result. In Chapter 32, Douglas and Susan Davis report on their lengthy stay in a Moroccan town when they witnessed the impending breakdown of traditional values, and the ensuing stress that individuals experienced. A major source of stress and conflict is when individuals from different ethnic groups or cultures anticipate contact with each other. Many years ago the Israeli psychologist Yehuda Amir made a significant contribution to the potential resolution of intergroup hostility when he advanced his "contact hypothesis." This hypothesis looks into the possible *decrease* rather than *increase* of tension and hostility as a result of people being required to live side by side. Amir gives an update of this hypothesis in Chapter 33.

The last three chapters in this section form a distinct unit. It is common for individuals to move to other countries, usually for employment reasons. Such moves can be very stressful. In Chapter 34 Richard Brislin summarizes various ways that social psychologists and others who are involved with "culture training" help individuals prepare for encounters with other cultures. In a large number of other-culture encounters, even *with* preparation and training, the crunching phenomenon of "culture shock" can be daunting and quite stressful. Bochner has written extensively on culture shock, and in Chapter 35, he gives an overview of the various ways that it can be experienced and dealt with. The final reading in this section, Chapter 36, was written by Joyce Hickson, and it addresses an intriguing problem. After people have been away from their home culture for a significant period of time, they often report how difficult it is to return home (one only has to consider how difficult it is for many students returning home for the summer after the freshman year to recognize this important source of stress). This has been called *reverse culture shock* or *re-entry shock,* among other terms. Regardless of what it is called, the question remains the same: Can you go "home" again without feeling at least some stress?

30
Acculturative Stress

JOHN W. BERRY

One of the central lessons to be learned from the study of cross-cultural psychology is that there are close links between the cultural context in which individuals grow up and the psychological characteristics that they develop. The question naturally arises: what happens to individuals when they come into contact with another culture, either by moving to another one (for example, by becoming immigrants or refugees), or by becoming colonized by a dominant culture (for example, by being an indigenous person in North America)? The answer is that people change, both culturally and psychologically, in numerous and various ways. To help describe these changes, anthropologists and psychologists have coined the term *acculturation,* literally meaning "to move toward a culture." One of the more common features of acculturation is the experience of being stressed by such changes; and for this, cross-cultural psychologists have coined the term *acculturative stress.* In this chapter, we begin with an outline of what is known about acculturation itself; we then use this background as a basis for a discussion of acculturative stress.

John W. Berry is a Professor of Psychology at Queen's University in Canada. He received his Ph.D. from the University of Edinburgh in 1966. He has been a lecturer at the University of Sydney, a Fellow of Netherlands Institute for Advanced Study, a visiting Professor at the Universite de Nice and the Universite de Geneve, and is a past president of the International Association for Cross-Cultural Psychology. He is the author or editor of twenty books in the areas of cross-cultural, social, and cognitive psychology.

ACCULTURATION

Acculturation was first identified as a cultural level phenomenon by anthropologists (e.g., Redfield et al., 1936) who defined it as culture change resulting from contact between two autonomous and independent cultural groups. In principle, change occurs in both groups. In practice, however, more change occurs in the nondominant than in the dominant group. For example, nondominant groups often accept (or may be forced to accept) the language, laws, religion, and educational institutions of the dominant group. However, dominant groups are often influenced in return, for example, in adopting modes of dress and eating habits. These cultural changes are highly variable from one contact situation to another, and the actual outcomes are not very easy to predict.

Acculturation is also an individual-level phenomenon, requiring individual members of both the larger society and the various acculturating groups to engage in new behaviors, and to work out new forms of relationships in their daily lives. This idea was introduced by Graves (1967), who proposed the notion of "psychological acculturation" to refer to these new behaviours and strategies. One of the findings of subsequent research in this area is that there are vast individual differences in how people attempt to deal with acculturative change. These strategies (termed *acculturation strategies*) have three aspects: their preferences ("acculturation attitudes"; see Berry et al., 1989); how much change they actually undergo ("behavioral shifts"; see Berry, 1980); and how much of a problem these changes are for them (the phenomenon of "acculturative stress"; see Berry et al., 1987).

Perhaps the most useful way to identify the various orientations individuals may have toward acculturation is to note that two issues predominate in the daily life of most acculturating individuals. One pertains to the maintenance and development of one's ethnic distinctiveness in society, deciding whether or not one's own cultural identity and customs are of value and to be retained. The other issue involves the desirability of inter-ethnic contact, deciding whether relations with other groups in the larger society are of value and are to be sought. These two issues are essentially questions of *values*, and may be responded to on a continuous scale, from positive to negative. For conceptual purposes, however, they can be treated as dichotomous ("yes" and "no") preferences, thus generating a fourfold model (see Figure 1). Each cell in this fourfold classification is considered to be an acculturation strategy or option available to individuals and to groups living together in a society; these are *assimilation, integration, separation,* and *marginalization*.

When the first question is answered "no," and the second is answered "yes" the *assimilation* option is defined, namely, relinquishing one's cultural identity and moving into the larger society. This can take place by way of absorption of a nondominant group into an established dominant group; or it can be by way of the merging of many groups to form a new society, as in the "melting pot." In either case, sooner or later a single relatively uniform culture evolves.

The *integration* option (two "yes" answers) implies the maintenance of the cultural integrity of the group, as well as the movement by the group to become an integral part of a larger societal framework. In this case there are a large number of distinguishable ethnic groups, all cooperating within a larger social system, resulting in the "mosaic" that

is frequently promoted as an alternative to the "melting pot." In this case, there is a plural society in which there are some core values and institutions, but also many cultural variations that are accepted and valued characteristics of the society.

When there are no relations with the larger society, and this is accompanied by maintenance of a distinct ethnic identity and traditions, another option is defined. Depending upon which group (the dominant or nondominant) controls the situation,

> **The maintenance of a traditional way of life outside full participation in the larger society may derive from people's desire to lead an independent existence, as in the case of separatist movements.**

this option may take the form either of *segregation* or *separation*. When the pattern is imposed by the dominant group, classic segregation to keep people in "their place" appears. On the other hand, the maintenance of a traditional way of life outside full participation in the larger society may derive from people's desire to lead an independent existence, as in the case of separatist movements. In these terms, segregation and separation differ primarily with respect to which group or groups have the power to determine the outcome.

Finally, there is an option that is difficult to define precisely, possibly because it is accompanied by a good deal of collective and individual confusion and anxiety. It is characterized by striking out against the larger society and by feelings of alienation, and loss of identity. This option is *marginalization*, in which individuals lose cultural and psychological contact with both their traditional culture and the larger society.

It is possible to use this framework to examine acculturation orientations in a number of ways (see Figure 2). If we distinguish between dominant and nondominant groups, and between group and individual orientations, we observe four distinct ways in which to employ this framework in under-

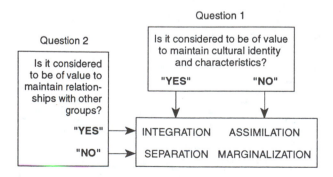

FIGURE 1 Four modes of acculturation as a function of two issues

	Group	**Individual**
Dominant Group	National Policies	Acculturation Ideologies
Acculturating Groups	Group Goals	Acculturation Attitudes

FIGURE 2 Domains of use of acculturation modes

standing acculturation phenomena. At the group level, we can examine national policies and the stated goals of particular acculturating groups within the plural society. At the individual level, we can measure the general ideology in the dominant population or the attitudes that acculturating individuals hold toward these four modes of acculturation (Berry et al., 1989).

With the use of this framework, comparisons can be made between individuals and their groups (and also between generations within families), and between acculturating peoples and the larger society to which they are acculturating.

Inconsistencies and conflicts between these various acculturation strategies are one of many sources of difficulty for acculturating individuals. Generally, when acculturation experiences cause problems for acculturating individuals, we observe the phenomenon of *acculturative stress*.

ACCULTURATIVE STRESS

In a recent overview of this area of research (Berry et al., 1987), it was argued that stress may arise, but it is not inevitable during acculturation.

A framework for understanding acculturative stress is presented in Figure 3. On the left of the figure, *acculturation* occurs in a particular situation (e.g., migrant community or native settlement), and individuals participate in and experience these changes to varying degrees; thus, individual acculturation experience may vary from a great deal to rather little. In the middle, *stressors* may result from this varying experience of acculturation. For some people, acculturative changes may all be in the form of stressors, while for others, they may be benign or even seen as opportunities. On the right, varying levels of *acculturative stress* may become manifest as a result of acculturation experience and stressors.

The first point to note is that relationships among these three concepts (indicated by the solid horizontal arrows) all depend upon a number of moderating factors (indicated in the lower box), including the nature of the larger society, the type of acculturating group, the mode of acculturation being experienced, and a number of demographic, social, and psychological characteristics of the group and individual members. That is, each of these factors can influence the degree and direction of the relationships between the three phenomena at the top of Figure 3. This influence is indicated by the broken vertical arrows drawn between this set of "moderating" factors and the horizontal arrows. These moderating factors may be viewed as sources of variation at both group and individual levels. Each case will have to be considered independently.

Results of studies of acculturative stress have varied widely in the level of difficulties found in acculturating groups. Early views were that culture

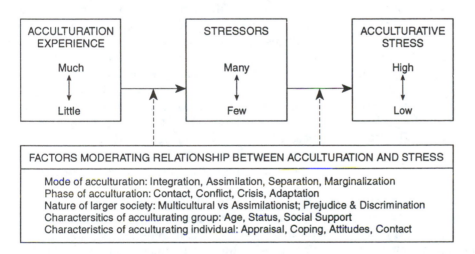

FIGURE 3 Factors affecting acculturative stress

contact and change inevitably led to stress; however, current views (as depicted in Figure 3) are that stress is linked to acculturation in a probabilistic way, and the level of stress experienced will depend on a number of factors.

The first factor on which acculturative stress depends is one's acculturation strategy: those who feel marginalized tend to be highly stressed, and those who maintain a separation goal are often almost as stressed; in contrast, those who pursue integration are minimally stressed, with assimilation leading to intermediate levels. The phase of acculturation is also important: those in first contact, and those who have achieved some long-term adaptation tend to be less stressed than those caught in a conflict or crisis phase, especially, as we have noted, if they also feel marginalized.

Another moderating factor is the way in which the dominant society exerts its acculturative influences. One important distinction is the degree of pluralism present in a society (Murphy, 1965). Culturally plural societies, in contrast to culturally monistic ones, are likely to be characterized by two important factors: one is the availability of a network of social and cultural groups which may provide support for those entering into the experience of acculturation; and the other is a greater tolerance for, or acceptance of, cultural diversity. One might reasonably expect the stress of persons experiencing acculturation in plural societies to be lower than those in monistic societies that pursue assimilation.

In assimilationist societies, there are a number of factors operating that will plausibly lead to greater acculturative stress than in pluralistic societies. If a person regularly receives the message that one's culture, language, and identity are unacceptable, the impact on one's sense of security and self-esteem will clearly be negative. If one is told that the price of admission to full participation in the larger society is to no longer be what one has grown up to be, the psychological conflict is surely heightened. And if, collectively, one's group is offered admission only on terms specified by the dominant society, then the potential for social conflict is also increased. Thus, assimilationist policies and actions on the part of the larger society can be plausibly linked to greater acculturative stress when compared to integrationist policies.

A related factor, paradoxically, is the existence of policies designed to *exclude* acculturating groups from full participation in the larger society through acts of discrimination. To the extent that acculturating people wish to participate in the desirable features of the larger society (such as adequate housing, medical care, political rights), the denial of these may be cause for increased levels of acculturative stress.

A final set of social variables refers to the acceptance or prestige of one's group in the acculturation setting. In most societies, some groups are more acceptable on grounds of ethnicity, race, or religion than others. Those less acceptable run into barriers (prejudices, discrimination, exclusion) which may lead to marginalization of the group and which are likely to induce greater stress.

Beyond these social factors, numerous psychological variables may play a role in the mental health status of persons experiencing acculturation. Here again a distinction is useful between those characteristics which were present prior to contact, and those which developed during the process of acculturation. Certain experiences may predispose one to function more effectively under acculturative pressures. These are: prior knowledge of the new language and culture, prior intercultural encounters of any kind, motives for the contact (voluntary versus involuntary contact), and attitudes toward contact (that can range from positive to negative).

Contact experiences may also account for variations in acculturative stress. Whether they are pleasant (or unpleasant), whether they meet the current needs of the individual (or not), and in particular whether the first encounters are viewed positively (or not) may set the stage for all subsequent ones, and affect a person's mental health.

Among factors that appear during acculturation are the various acculturation strategies: as noted previously, individuals within a group do vary in their preference for assimilating, integrating, or separating. These variations, along with experiences of marginalization, are known to affect one's mental health (Berry et al., 1987).

The personal and societal outcomes of acculturative stress have been known for decades. At the personal level, reduced health (physical, social, and psychological), lowered levels of motivation, a sense of alienation, and increased social deviance have been documented. At the societal level, there are direct counterparts in increased health costs, lower educational and work attainment (with related higher welfare costs), increased social conflict (intrafamilial and intergroup), substance abuse, criminal activity, and a general societal malaise. Clearly, with these outcomes likely, policies that seek to avoid, or at least control high levels of accul-

turative stress are to be preferred over those that may increase it.

CONCLUSION

It should be clear that a desire to participate in the larger society, or a desire for cultural maintenance, if thwarted, can lead to a serious decline in the mental health status of acculturating individuals. Policies or attitudes in the larger society that are discriminatory (not permitting participation, and leading to marginalization or segregation) or assimilationist (leading to enforced cultural loss) are all predictors of psychological problems. Acculturative stress is always a possible consequence of acculturation, but its probability of occurrence can be much reduced if both participation in the larger society and maintenance of one's heritage culture are welcomed by policy and practice of the larger society.

REFERENCES

Berry, J. W. (1980). Social and cultural change. In H. C. Triandis and R. Brislin (Eds). *Handbook of cross-cultural psychology, (Volume 5, Social psychology)*. Boston: Allyn & Bacon.

Berry, J. W., Kim, U., Minde, T., & Mok, D. (1987). Comparative studies of acculturative stress. *International Migration Review, 21*, 491–511.

Berry, J. W., Kim, U., Power, S., & Bujaki, M. (1989). Acculturation attitudes in plural societies. *Applied Psychology, 38*, 185–206.

Graves, T. (1967). Psychological acculturation in a tri-ethnic community, *Southwestern Journal of Anthropology, 23*, 337–350.

Murphy, H.B.M. (1965). Migration and the major mental disorders. In M. B. Kantor (Ed.). *Migration and mental health*. Springfield: Thomas.

Redfield, R., Linton, R., Herskovits, M. J. (1936). Memorandum on the study of acculturation. *American Anthropologist, 38*, 149–152.

31
Risk and Culture

GEORGE T. CVETKOVICH & TIMOTHY C. EARLE

WHAT'S RISK?

Some Risky Choices

Do you smoke cigarettes? Would you have unprotected sexual intercourse with a stranger? Do you ever speed in a car? Do you eat a balanced diet? Do you wear a seat belt when riding in a car? Do you ever bet on the outcome of sporting events? Do you participate in an activity such as rock climbing or hang gliding? Do you invest in the stock market? Are you concerned that the "greenhouse" effect will greatly increase the temperature of the earth's atmosphere? Do you think that we should develop nuclear energy? Are you worried about the effects of the destruction of the world's tropical rain forests? These and many more of the choices that we think about and make everyday involve risk. Risk is commonly defined as the chance of injury, damage, or loss. Risk is what makes something—an activity, an industry, a health condition, an environmental characteristic—hazardous. In this chapter, we explore the possibility that differences

in conclusions about risks can be attributed to cultural differences in beliefs and values. We begin by elaborating the definition of "risk" and examining how people reach decisions about what is risky.

Determination of Risk

The physical properties of a thing contribute to making it risky. But risk is not directly determined by physical properties. The determination of risk involves human judgment about physical properties. In this way risk is very much like other concepts used to describe human reactions to environmental conditions, for example noise and crowding. We hear a sound because the little hairs in our inner ears are vibrated as a result of air movements. The waves have physical properties such as amplitude and frequency that affect the hairs, and hence the sound, in different ways. The characteristics of the waves make the sound appear loud or soft, high pitched or low and so forth. Calling a sound noise—undesired, noxious sound—is a judgment partly influenced by the physical charac-

George T. Cvetkovich, a social and environmental psychologist, is Professor of Psychology, Director of the Western Institute for Social and Organizational Research, and an Associate of the Center for Cross-Cultural Research at Western Washington University. He has conducted a number of studies on reactions to natural and technological hazards including earthquakes, water contamination, toxic waste facilities, hazardous industrial plants, and nuclear power. He is currently studying how cultural values affect social trust and the management of environmental risks.

Timothy C. Earle is a Research Associate at Huxley College of Environmental Studies and Western Institute for Social and Organizational Research, both at Western Washington University. He received his Ph.D. in Social Psychology from the University of Oregon in 1972. His research activities, pursued in both private research institutes and public university settings, have focused on the understanding of risk judgments and risk communication. In collaboration with George Cvetkovich, he currently is developing a new social trust theory of risk communication.

teristics of that sound. But it is also influenced by psychosocial factors. You might conclude that a sound is noise if it is very loud (it has the physical property of high amplitude) or high-pitched (it has the physical property of high frequency) or because it is unexpected, interferes with something you are trying to do, or you are unfamiliar with it. Crowding is the uncomfortable feeling that there are too many people in a situation. This feeling is only partly related to density which is the number of people physically present. If you want to be completely alone, one other person in the room might make you feel crowded. At other times, say at a sporting event or a rock concert, thousands of other people might not make you feel crowded. Likewise, a conclusion about risk reflects a judgment about physical properties of a hazard influenced by psychological and social factors, all of which can vary tremendously across individuals and as we will see across cultures. (If you are interested in individual differences in risk-taking you might see Bromiley & Curley, 1991).

RISK PERCEPTION

The activity of making judgments and arriving at conclusions about hazards such as their likelihood, their possible severity, how concerned we should be about them, what can be done about them and so forth is referred to as risk perception. One direction taken in the study of risk perception has been the psychometric approach. This approach, like psychometric approaches in other areas of psychological research, uses scaling techniques and sophisticated methods of statistical analysis to systematically measure responses to aspects of the environment, in this case hazards. A series of psychometric studies conducted on samples of people in the United States has identified some consistencies in how people in the United States perceive risks (Slovic, 1987). By assessing how people respond to hazards the psychometric approach helps explain why people show extreme aversion to some hazards, but indifference to others. People were asked to make judgments about the riskiness of different hazards (e.g., nuclear power plants, pesticides, commercial aviation, prescription drugs). Judgments were also made about the status of each hazard on different characteristics. Comparison of the sets of judgments shows that hazards that are judged as being both "dreadful" and "unknown" are perceived to be highly risky. Dreadful hazards

are ones that are perceived to be difficult to control, have a high catastrophic potential, involve fatal consequences, and involve an unequal distribution of risks and benefits in society. Unknown hazards are ones having the characteristics of having unobservable effects, are not fully understood, are new, and contain delayed effects.

Using the same or similar sets of hazards as those used in the original research in the United States and the same statistical analysis techniques, studies in other countries (e.g., Germany, Hungary, Japan, Hong Kong, Poland, the Netherlands, and Norway) have also identified hazard perceptions defined by the dimensions of dreadfulness and the unknown. This suggests that on a general level people from different cultures may have similar beliefs about hazards. (The universality of this conclusion has yet to be shown using other analytic approaches and people from non-industrialized countries.) However, conclusions about particular hazards may greatly differ from one culture to another. A comparison of the risk perceptions of United States students and Japanese students are shown in Table 1. Both groups of students agree that "electric fields" (such as those generated by high power transmission lines and electric blankets which have been suggested as causing disruptions in cell behavior resulting in cancer) and "lead paint" are high dread and high unknown hazards. While U.S. students perceive AIDS, pesticides, and nuclear power to also be high dread and high unknown hazards, Japanese students do not. The Japanese, unlike the U.S. students, perceive commercial aviation, dams, fossil fuel generated electricity, and hydro power to have these characteristics. While it seems reasonable, based on psychometric studies, that there are some general, cross-cultural similarities in perceptions of risk, there is also evidence that there are culture-specific differences as well.

It is important to notice that the results of risk perception studies indicate that people are not usually relying solely on information about the probability of negative outcomes or the actual amount of damage done when arriving at their judgments of risk. In many cases, people might not have a very accurate idea of such probabilities or damage. The judgments of hazards that most of us usually make are directed at identifying the "signal value" of a hazardous event or activity. That is, we focus on identifying information (signals) that can be used to avoid undesirable outcomes in the future. We do this by classifying events and activities according to

TABLE 1 **Ratings of the unknown risk and the dread risk of 25 hazards by American and Japanese university students**

UNKNOWN RISK—LOW DREAD RISK—LOW		UNKNOWN RISK—HIGH DREAD RISK—LOW	
Alcohol diseases	—US	Commercial aviation	—US
Bicycles	—US	Dams	—US
Caffeine	—US	Hydro power	—US
Farm machinery	—US		
Surgery	—US		
Smoking tobacco	—Both	Asbestos	—Both
		Skateboards	—Both
Microwave ovens	—Japan	Bicycles	—Japan
Oral contraceptives	—Japan	Caffeine	—Japan
Prescription drugs	—Japan	Farm machinery	—Japan
		Hang gliding	—Japan
		Microwave ovens	—Japan
		Surgery	—Japan
UNKNOWN RISK—LOW DREAD RISK—HIGH		**UNKNOWN RISK—HIGH DREAD RISK—HIGH**	
Hang gliding	—US	AIDS	—US
Microwave ovens	—US	Pesticides	—US
Oral contraceptives	—US	Nuclear power	—US
Prescription drugs	—US		
Food preservatives	—Both	Electric fields	—Both
		Lead paint	—Both
AIDS	—Japan	Commercial aviation	—Japan
Nuclear power	—Japan	Dams	—Japan
Pesticides	—Japan	Fossil fuel electricity	—Japan
		Hydro power	—Japan

Adapted from Kleinhesselink & Rosa, 1991.

their underlying dimensions. Many people were very concerned about the reactor accident that occurred in 1978 at the Three Mile Island, Pennsylvania nuclear power plant even though no one was killed in the accident and experts concluded that the probability of a similar event occurring again was very low. The accident was taken by many to be a signal about future dangers that could happen in an industry that was perceived to be risky. Few people are as concerned about the safety of automobiles even though about 50,000 Americans are killed every year in accidents. Automobile transportation is perceived to be a well-known, old risk (low unknown, low dread) that is not likely to get worse in the future.

Another important point is that we share with others the beliefs about risk that we hold. There are good reasons to conclude that culture, which can be defined as shared ways of interpreting and giving meaning to experiences, has some important effects on shared beliefs about risk. Consider the difficulty you would have if you had to discover by yourself about life's risks. Is this plant poisonous to eat? Should you engage in that activity? What's the best way of protecting yourself from disease? Life is filled with such uncertainties. At least some of the uncertainties are reduced by being a part of a community of people who share a common way of understanding the world and who have the ability both to communicate with each other about their experiences and to retain a collective memory about what is safe and what is not and what to do about each. Culture constructs a reality for us which provides the means for understanding the world and acting as if we know for certain what it is we should be doing. This social construction of reality, which

is reflected in a society's technology, laws, religion, rituals, rules, values, attitudes, and other beliefs,

Consider the difficulty you would have if you had to discover by yourself about life's risks. Is this plant poisonous to eat? Should you engage in that activity?

reduces the uncertainties of life as well as "tuning" people in a culture to be sensitive to particular risk signals.

CULTURAL DIFFERENCES IN RISK PERCEPTION

Examples of Differences

Different cultures have developed different constructions of reality. In this section we examine some examples of how cultural differences in institutions and beliefs affect constructions of risks.

Example 1

Following typhoons on the Pacific island of Yap, villagers would begin to worry about their supplies of food. This occurred even after typhoons that had not seriously affected the island's major food sources such as coconut trees and gardens and had left the villagers' existing stores of food untouched.

Example 2

Compared to the Netherlands or Britain, there is a higher preference in Germany and Austria to have rigorously defined rules and regulations. This is true both for the management of hazards as well as for other aspects of life. For example, in Germany and Austria, there are severe penalties for the failure to carry required citizen identification cards. Somewhat surprisingly, however, Germany and Austria permit higher maximum speeds on highways and in Germany there are no speed limits at all on the Autobahn system (equivalent to the Interstate Highway system in the United States).

Example 3

While the French are similar to Americans in their perception of the risk of nuclear power they have not engaged in as much public protest against it. The result has been that while no new nuclear plants have been built recently in the United States, a majority of the electricity used in France is now nuclear-generated.

How Does Culture Influence Risk Perception?

How can culture account for the differences illustrated in these examples? Two important functions of culture are that it helps us make sense of the world (i.e., it constructs reality) and that it provides the means for coordinating our interactions with other individuals (Fiske, 1991). Both of these functions are illustrated in the three examples given above.

Example 1 illustrates that cultures construct realities by providing deeply held beliefs about how the world works which tune people to be sensitive to particular risk signals. Yap islanders believed that typhoons occurred because the village headman had not taken effective actions to prevent them. Another of the headman's duties was to insure through planning and organization that the village had an adequate supply of food. Because of this belief, typhoons were taken as a signal that the headman had not been performing his duties diligently. An irresponsible headman who would allow a typhoon to occur, the islanders reasoned, probably had not taken care of his other responsibilities.

Anthropologists have long studied what are called "folk understandings" of how society and the natural environment work which lead to conclusions about the causes and possible controls of hazards. There are a growing number of psychological studies that seek to find out about our everyday understandings of how things work, including the risks produced. Some recent studies have examined understandings of the dispersion of radon gas in homes, global climate change, river floods, and how prescription drugs work (e.g., Bostrum, Fischhoff & Morgan, 1992). Discovering how people make inferences about the physical world could have several important uses. It could permit the development of better, more understandable ways of presenting technical information. Presenting information that does not match what a person knows is not likely to be understood. It could be also used to identify when people have beliefs that

lead them to take dangerous actions. Some trained technicians have been found to have beliefs about x-rays that could lead to dangerous on-the-job actions (Keren & Eijkelhof, 1991). It seems important that these be identified and changed.

Example 2 illustrates how *cultural values* affect views about risk. Values are another way in which cultures help construct reality. Values reflect thoughts and feelings about what is important and what is not, about the preference for one state of affairs over another. They operate so that we unselfconsciously are biased to make certain kinds of judgments and decisions. One value identified by Hofstede (1980) as having a direct effect on risk perception is that of *avoiding uncertainty*. All cultures attempt to reduce uncertainty, but this is a much more important value for some than for others. Cultures that place a high value on avoiding uncertainty, such as Germany and Austria in Example 2, are characterized by having rigorously defined rules and regulations and less risk-taking. People in cultures placing a high value on uncertainty avoidance like to have clear requirements and preferences spelled out for them. People who subscribe to this value do not think that company rules should ever be broken, prefer that specialists make society's decisions, are often anxious about the future, and fear failure. Citizens in countries with a high uncertainty avoidance value do not mind strict laws about carrying identity cards because this is a way of avoiding uncertainty about personal identity. Hofstede reports that countries that place a high value on uncertainty avoidance also tend to have higher speed limits on their highways than do countries that value this less. This reflects a desire not to handicap unduly people's efforts to arrive at appointments on time. One price for avoiding the uncertainty of late arrivals seems to be human lives since countries with higher maximum highway speeds also have higher traffic fatality rates. Countries high on uncertainty avoidance also tend to have more accurate public clocks and more punctual public services such as transportation.

Other values besides uncertainty avoidance have been identified as related to risk. Many of these values reflect beliefs about appropriate social interaction. The reason for this connection is that risk decisions, especially those at the society-wide level, represent choices about the treatment of other people. A society's decisions about risk determine how that society faces the future and, to some extent, determine what the future will be. Deciding to eliminate industrial pollution as a major health risk, for example, will have certain effects on citizens. Deciding, instead, that health risks are less important than the economic risks represented by the costs of required pollution controls, will have others. As can be seen, often questions about what's fair? what's just? what's moral? and important questions about how people should be treated underlie questions about risk.

Different cultures prefer to follow different values or apply different values in different domains—that is, they "frame" risk issues in different ways (Vaughan & Seifert, 1992). Three important interaction values are individualism, hierarchism, and egalitarianism. Each of the values has been shown to lead to different perceptions of risk (Dake, 1991).

Individualism places great importance on self expression and self determination. Each person should be free to pursue his or her own interests in self-determined ways. Self regulation is preferred to regulation by others. Individual freedoms should not be limited. People adhering to this value are not much concerned about environmental dangers such as pollution, nuclear energy production, or hazards of technology, believing that government regulations may be a greater hazard to the future of society than the dangers themselves. They also tend to take a "cornucopian" view of the environment. That is, they believe that humans have the right and ability to use the natural environment which is seen as being resilient and infinitely capable of providing for human needs and desires.

Hierarchism sees society in terms of distinctions between people. It values the recognition and respect of these distinctions. People should follow the roles that they hold in society. Like those adhering to individualism, adherents to this value also are not much concerned about environmental dangers. Deviancy, people not following roles and rules, is seen as a major risk. The value of hierarchism does support government intervention, since governments have a legitimate responsibility to deal with risks. Hierarchism is not concerned about technological dangers or depletion of the environment as long as established rules and regulations are being followed.

Egalitarianism values equality among people. Distinctions between people based on things like gender, wealth, race, and roles are not important and should not be used in determining the outcomes of life. People adhering to this value do not like role differences favored by the hierarchism since the differences imply inequality. Egalitarian-

ism leads to a concern about environmental dangers. Nature is perceived to be fragile and overuse by some prevents the equal sharing of earth's finite resources by all.

As can be seen, the values operate both to construct a social reality and to coordinate interactions. It is easy to imagine how difficult it is to resolve conflicts occurring when people's risk perceptions are influenced by different values. This is what happened during the 1992 United Nations Conference on the Environment and Development. The U.S. government's actions were framed by the value of individualism and reflected an extreme reluctance to enter into environmental protection treaties that restricted opportunities to use natural resources. Concern about the effects of these restrictions on the economy were expressed. President Bush, expressing an extremely individualist sentiment, said, "The United States' standard of living is not up for negotiation." Other countries, particularly non-industrial ones, took a more egalitarian viewpoint that held that sacrifices to protect the environment should be shared by all countries equally. If non-industrial countries were being asked to protect the environment by restricting the cutting of their rain forests or changing their course of development, the industrial countries should share the costs. After all, industrialized nations such as the United States produce most of the world's pollution and are the major consumers of the world's raw resources. The divergent views resulting from the different values were not reconciled during the conference. Agreements, described in the words of Maurice Strong, the Secretary-General of the conference, "serving the common interests of the entire human family" were not reached.

In Example 3, the French/U.S. national difference in reactions to nuclear power generation plants is accounted for by differences in trust, which is based on the perception of commonly-held values. French citizens have a greater trust that plant operators, regulators, and other responsible persons will manage the hazardous nuclear technology in an acceptable and safe way (Bastide, Moatti, Pages, & Fragnani, 1989). They have a greater feeling of certainty that the responsible individuals share their values and will do what is expected of them. Trust is a necessary ingredient of the management of hazards in complex modern societies. Trusting others to study, understand, and control these hazards relieves us of the difficulties of doing these things ourself. It allows for the orderly coordination of risk management in society.

But trust also involves a risk. Is the trusted person or organization worthy of the trust? It has been argued that there is now a great amount of distrust of those who should be responsible for hazard management, especially in the United States. The reason for the distrust is partly because people are aware of a number of examples of apparent mismanagement which have caused deaths, injuries, and destruction. Some of the most publicized of these include releases of toxic chemicals in Bhopal, India and Seveso, Italy; toxic substance contamination in Love Canal, New York and Times Beach, Missouri; nuclear power reactor accidents at the Chernobyl reactor near Kiev, Ukraine and a reactor at Three Mile Island, Pennsylvania; and oil tanker spills such as the Exxon Valdez accident in Prince George Sound, Alaska. Widespread distrust, since it prevents coordination of activities, makes the management of hazards difficult or impossible.

PRACTICAL IMPORTANCE OF UNDERSTANDING RISK AND CULTURE

Compared to most other species, humans are physically puny. We are not the fastest runners, nor do we have the strongest muscles or the sharpest claws or fangs. Yet we have (so far) survived and prospered. We have become in some very important ways the strongest species on the planet. The reasons for this are our sociability and our mental capacity. These have allowed us to create powerful understandings of the ways that the world works and to apply these through technology to change our world. We have become so successful, some now argue, that unless we learn to manage ourselves better we are our own biggest threat.

At the heart of most questions about human survival is the way we think about risk. Culture, as we have seen, influences risk perception in a number of ways. These effects, like most of culture's effects, are often tacit, unquestioned, and unselfconscious. We may have reached a point of needing to go beyond culture, examining how it produces its effects. Research on risk and culture gives us insights into why we are doing what we are and opens possibilities for change. It helps us to know what we want and how to work with others in getting it. Answering these questions may be very directly related to the ultimate survival of the human species.

REFERENCES

Bastide, S., Moatti, J., Pages, J. & Fagnani, F. (1989). Risk perception and social acceptability of technologies: The French case. *Risk Analysis, 9,* 215–223.

Bostrum, A., Fischhoff, B. & M. Granger Morgan (1992). Characterizing mental models of hazardous processes: A methodology and an application to radon. *Journal of Social Issues, 48,* 4, 85–99.

Bromiley, P. & Curley, S. P. (1991). Individual differences in risk taking. In J. F. Yates (Ed.) *Risk taking behavior.* New York: John Wiley & Sons.

Dake, K. (1991). Orienting dispositions in the perception of risk: An analysis of contemporary world views. *Journal of Cross-Cultural Psychology, 22,* 1, 61–82.

Fiske, A. P. (1991). *Structures of social life: The four elementary forms of human relations.* New York: The Free Press.

Hofstede, G. (1980). *Culture's consequences: International differences in work-related values.* Beverly Hills, CA.: Sage.

Keren, G. & Eijkelhof, H. (1991). Prior knowledge and risk communication: The case of nuclear radiation and X-rays. In R. E. Kasperson and P. M. Stallen (Eds.) *Communicating risks to the public: International perspectives.* Dordrecht, the Netherlands: Kluwer Academic Press.

Kleinhesselink, R. R. & Rosa, E. A. (1991). Cognitive representation of risk perceptions: A comparison of Japan and the United States. *Journal of Cross-Cultural Psychology, 22,* 11–28.

Slovic, P. (1987). Perception of risk. *Science.* 236, 280–285.

Vaughan, E. & Seifert, M. (1992). Variability in the framing of risk issues. *Journal of Social Issues, 48,* 4, 119–135.

32
Sexual Values in a Moroccan Town

DOUGLAS A. DAVIS & SUSAN SCHAEFER DAVIS

All human societies impose rules on the form and meaning of sexual behavior. As Freud observed a century ago, such rules are partly learned during early childhood, but they are fully expressed only during the years after puberty, when increasing sexual drive and new opportunities for sexual contact lead the individual to confront the restrictions imposed by society. Straight/gay, faithful/unfaithful, sexy/frigid: the words we use to describe the sexual side of ourselves reveal a lot about who we think we are, and who or what we think others are. The study of sexual behavior and values is thus a means of understanding both cultural patterns and the shaping of individual personality.

Sexual attitudes and feelings are usually among the most private aspects of a person's life, and even in the case of the most thoroughly studied individuals it is unlikely for the biographer to have full access to the secrets of the bedroom (or, for that matter, those of the nursery, the kitchen, or the bathroom). The ethnographer or cross-cultural researcher who wishes to understand sexual values starts with the realization that these are shaped by broad social forces such as religion, language, or ethnicity: by family and community or neighborhood-level influences such as gender, birth order, or socioeconomic status; and by such individual factors as identification, anxiety-tolerance, and imagination.

Whatever one thinks about Freud's notion that sexuality is the *central* problem of personality development, any adult who has tried to have a frank conversation with a teenager about who did what, and with what, and to whom, will acknowledge that accurate information about sexual actions is hard to get and that erotic feelings are often mysterious even to the person who has them. As part of our research on adolescence in Morocco (see Davis & Davis, 1989), conducted as part of the *Harvard Adolescence Project* (which sent field teams into seven different cultural settings) in 1982 and following years, we returned to a Moroccan town we have studied since the middle 1960s and attempted to learn in detail about the family relationships, friendships, sources of pleasure and conflict, and marriage and career plans of a group of teenagers.

Douglas A. Davis is Professor of Psychology at Haverford College. He earned his Ph.D. in Psychology in 1974 from the University of Michigan. His primary scholarly interests are personality and culture and psychoanalytic psychology. He has done fieldwork in Morocco and worked for the Peace Corps in Morocco and India. He is co-author, with Susan Schaefer Davis, of *Adolescence in a Moroccan Town: Making Social Sense* (Rutgers Press, 1989).

Susan Schaefer Davis is an independent scholar, and consultant on international development for the World Bank and Peace Corps. Research interests are gender, relationships, and women in development, especially in North Africa. Her Anthropology Ph.D. is from the University of Michigan (1978); she's taught at Haverford and Trenton State Colleges. She has several articles and two books: *Patience and Power: Women's Lives in a Moroccan Village* (Schenkman, 1983), and *Adolescence in a Moroccan Town*, the latter with Douglas Davis.

Sexuality touched each of these topics but, despite the fact that we are well known and trusted in this community and speak Moroccan Arabic fluently, it was hard to get anyone to be completely frank about their own sexual behavior and sometimes impossible to reconcile what we heard from individuals about their own behavior ("Who? Me? Never!") with what the same young people said about their peers ("*Every*body does it."). We are confident about the generalizations we make below because we have lived in this community for years and were able to compare individual's statements with those of their friends and neighbors. But like the rest of the members of the Adolescence Project we came away with a real sense of the complexity of obtaining accurate information about sexuality.

ISLAM AND SEXUALITY

Like other major religions, Islam has lent itself to a variety of interpretations of the role of sexuality (Bouhdiba, 1985). Sexual pleasure is recognized as an essential part of human life, and some Muslim writers have described it as a foretaste of paradise. On the other hand, most Muslims view sex outside of marriage as sinful and dangerous to the social order. Thus Muslim societies have usually placed great emphasis on marriage as an essential part of adult life, and the seclusion of women in many of these societies serves the function of keeping both female and male sexuality under control. The traditional emphasis on female chastity is changing in a town like Zawiya, but gender differences in sexual behavior are much greater than in most European or North American settings, as we will see.

THE SETTING

We describe in this chapter the sexual side of adolescent life in a small town in North Africa, whose Arabic-speaking Muslim young people we have come to know as part of our 25-year interest in their community (Davis, 1983; Davis & Davis, 1989). In the semi-rural town of Zawiya in central Morocco, the changing sexual attitudes and practices of teenagers have been influenced by many of the same factors seen in the United States and Europe: coeducational public schooling, television, popular music, and travel to large cities. On the other hand, Moroccan society is strongly shaped by the values of Islam and by traditional Arab views concerning

honor, modesty, and gender. The picture we give here is of one relatively traditional town in a country with remarkable diversity. While we believe many of these observations about sexuality could be made of other small towns in Morocco and the Middle East, Zawiya is quite different from both the truly remote villages of the Atlas Mountains or the Saharan fringes and the cosmopolitan centers of Casablanca or Tangier.

Zawiya in 1982 was a town of roughly 12,000 located in a fertile agricultural area in north central Morocco. While Zawiya has the look of an impoverished country town, with few paved streets and no restaurants, modern stores, or movie theaters, a provincial city of 50,000, 2 kilometers away provides all these amenities. Train and bus connections make it possible for Zawiya residents to visit major Moroccan cities within a few hours. The young people we studied in the early 1980s were therefore still in close touch with the traditional family and religious values of their parents, most of them uneducated country people, but they had knowledge of a world of other possibilities from their experiences in school, their travels to visit relatives in large cities, and their daily exposure to TV and radio.

The youth of Zawiya today are coming of age at a time when social roles and institutions are undergoing significant and rapid change. Morocco was controlled by France from 1912 to 1956, and the current generation of Moroccan youth are being formed in part by the tension between traditional religious values and modern political and economic ones. Parent-child relationships are interesting in such a community, as illiterate parents try to help prepare their children for a world far beyond their own experience. Young children of both sexes are affectionately and indulgently cared for by their mothers. Although both boys and girls now typically attend at least elementary school, girls remain under closer maternal influence during the elementary school years as they help with a variety of child-care and housekeeping tasks. Since Zawiya houses have not had running water until the past few years, girls often spent hours a day getting water from one of seven public taps. After puberty, girls are still likely to be kept closer to home than boys, even if they continue in school, and they have many more responsibilities in the household. Boys, on the other hand, typically have much less supervision by parents during adolescence, and many of them spend hours hanging out with male friends. In the later teen years, relationships outside the

family are especially important for adolescents in most cultures, and these include friendships between like-sexed age-mates and romances or sexual relationships between males and females. As Zawiya teenagers make the long walk to high school in the nearby larger town, or leave home to take jobs, they have increased opportunity for interaction with the opposite sex—and this has led to conflicts between traditional and modern sexual values.

SEXUAL ATTITUDES, SEXUAL ACTS

Like most predominantly Arab societies and much of circum-Mediterranean culture (including such countries as Greece, Turkey, Lebanon, and Egypt), growing up in Morocco involves learning strongly-differentiated gender roles. Boys and girls have a very different experience in the family as preschoolers; they are subject to different levels of constraint as they reach sexual maturity, and they have different expectations from friendships with the other sex.

The most striking features of adolescent sexuality in Zawiya today center on three factors. First, there is a clear *double standard,* in which males have

> **Finally, courtship, sexual values, and marriage choices are undergoing significant and rapid change as a result of increased access to education and electronic media.**

a good deal of sexual freedom and are assumed to be sexually active, while females are much more restricted in opportunities for sexual activity and are expected to remain virgins until marriage. Second, there is a much greater *range* of sexual practices by males than by females, including homoerotic play and masturbation. Finally, courtship, sexual values, and marriage choices are undergoing significant and rapid *change* as a result of increased access to education and electronic media.

Chastity and the Double Standard

The sexual behavior of males has always been subject to much less restriction than that of females in Morocco, and even in traditional communities men sometimes sought sexual outlets other than their wife. While the extramarital activity of a man could bring scandal on his family, or provoke violence from a cuckolded neighbor, it is understood that males will on occasion consort with prostitutes or attempt to seduce married women and virginal girls. Young men in Zawiya today often attempt to have sexual relationships with young women classmates and friends, while still expecting both to protect the virginity of their own sisters and to marry a virgin themselves. A young man may decide *not* to marry a girl because she has given in to his own sexual advances. The responses from 100 young people ranging in age from 9 to 21 whom we asked about the qualities wanted in a mate emphasized good character and honorable reputation, along with physical attractiveness, as central concerns shared by both sexes (Davis & Davis, 1989, pp. 125–126). The hope is to combine love and mutual respect for a mate of whom family and community will approve, and, among more educated youth, we often heard about intentions to combine career and family and to share two incomes. At the point of actual marriage, however, many young men from backgrounds like Zawiya are drawn to younger and less educated girls, and they expect these brides to defer both to themselves and their families. If they do select someone of similar age and education, she is likely *not* to be a neighborhood girl but someone met at school or on the job in the city.

Even in an age when most U.S. young people are sexually active, brides in the United States usually wear a white dress signifying sexual purity. When a marriage is celebrated in a traditional semi-rural town like Zawiya, the wedding festivities often culminate in the bride's and groom's retreat to a bedroom nearby. After a brief time, a female family member will bring out blood-stained sheets for triumphant display to the crowd, attesting to the bride's virginity and the groom's potency. Since many young couples today have in fact been sexually active before the wedding, however, the display of the sheets can pose a problem. We heard of cases where the bride brought a vial of her own blood into the bedroom, or where the groom cut himself, or where animal blood was used. This custom is changing and has been abandoned in many middle-class urban weddings, and often couples

will begin living together after government civil marriage papers are signed and celebrated with a small family party. This saves the expense of a large wedding; it also means that demonstration of the bride's premarital virtue never becomes an issue.

Girls do fear loss of their virginity, and thus possibly of opportunities to marry, and they are well aware that the risks of sexual intimacy are mostly theirs. Yet, despite strong traditional censure of the unwed mother, premarital pregnancies do occur in this community, and in these cases the Moroccan family is usually pragmatic. We heard several reports of young women who left the community before giving birth, but there have also been recent instances of a young woman's giving birth at home to a child who is then raised by her or her parents. Abortion, which in the past was provided by midwives or knowledgeable older women, has become widely available in recent years through private doctors in nearby towns, and some unmarried young women are reported to have had several abortions. The difference between the traditional emphasis on chastity as a matter of family honor and the actual behavior of young people and their parents in a community like Zawiya should caution the anthropologist not to mistake a statement of the social norm (what is thought to be right or desirable) for a valid generalization about normative (typical) behavior.

The Variety of Sexual Acts

Social scientists now generally recognize that the range of normal sexual behavior includes a variety of feelings and acts, including homoerotic and auto-erotic (masturbatory) experience. In American society, however, despite the general relaxation of sexual prohibitions over the past several decades, and despite widespread recognition that homosexuality is fairly common in most societies, few teenagers admit readily to homoerotic feelings or homosexual acts (Coles & Stokes, 1985). Morocco seems to be distinguished from the United States not so much by a different proportion of people who are homosexual as by a relative absence of the homophobia that makes homosexuality the focus of so much fear, hostility, and anxious humor in America. In Zawiya, various forms of homoerotic play, including nude swimming and group masturbation, were reported as fairly common for boys in the early teen years. Older males sometimes engage in homosexual acts, sometimes including interfemoral

and anal intercourse, but these young people do not think of themselves as homosexuals but rather as going through a phase. Homosexuality in adulthood seems to be rare and is still considered shameful by most Moroccans. Separate terms are used for the partner who plays the active and the passive role in intercourse, and the term for the passive participant (*zamel*) is an insult and a frequently seen graffito on walls near Moroccan schoolyards. In contrast to what we heard from young men, most young women in Zawiya seemed never to have considered the *possibility* of female homosexuality, and both sexes stated that lesbian relationships were very rare.

Another striking difference between the sexes in Zawiya was with reference to masturbation. Kinsey's researchers, surveying Americans in the 1940s, found that most males and a majority of females recalled masturbating in the years following puberty. This topic was very difficult to discuss with young people in Zawiya, however, and we concluded that masturbation is viewed more negatively in this traditional Muslim community than in most American groups. A few boys and young men admitted to masturbating, and estimated that most males did so, but *no* young women either admitted or described female masturbation. Generally, we were struck by the much greater range and frequency of sexual experiences reported by males, although both sexes were fascinated by romantic images.

Inducements to Change

As part of our research in Zawiya, we asked adolescents about their exposure to influences that we suspected might change their ideas of traditional gender roles. These included watching television, listening to radio or cassettes, reading books, attending films, and travel to larger towns. We took detailed educational histories and asked people in and out of school to describe their daily activities, so we could determine the effects of schooling on attitudes and activities. It is easy for those of us growing up in societies where almost everyone has attended public school to overlook the profound effects on a traditional society of suddenly uprooting all young people born in a given year from family and neighborhood and compelling them to spend most of their waking hours together in school. Indeed, the unverified assumption that adolescence is a universal lifestage seems to us to grow

directly from the institution of a lengthy moratorium between childhood and adulthood during which youth are prepared by employees of the state for a life different from that of their parents.

We asked about preferences for Arab or Western programs on radio, television, and cassettes. A wide range of music is available on Moroccan radio stations, including popular Moroccan groups in Arabic and Berber, Middle Eastern romantic ballads, and both French and American rock and country music. On television, Egyptian romances share the airwaves with U.S. evening soaps ("Dallas," "Dynasty"), crime dramas ("Colombo"), and sitcoms ("The Cosby Show").

One apparent effect of TV in Zawiya has been on attitudes toward marriage. Traditional Arab cultures specified a parent-arranged marriage to a patrilateral parallel cousin (father's brother's son or daughter) as the ideal but cousin marriages are now quite uncommon in Zawiya, and most young people expect at least to play a role in selecting a spouse. Today's educated young people have more idea of what they want in a spouse. This inclination is fed by romantic magazines and television programs. A recurrent theme of Egyptian TV dramas, for example, is the love match opposed by parents, who prefer a rich older man for their daughter; the love match usually triumphs. As one young Zawiya woman said, "Girls today learn a lot from films. They learn how to lead their lives. They show the problems of marriage and divorce and everything in those films. TV explains a lot. TV has made girls aware—boys too, but mainly girls." While most of the roughly 100 Zawiya youth we asked "Who should choose the spouse?" answered "the parents" (64% of females and 55% of males), about 25% of each sex wanted to take part in the decision. The number saying they wanted to be involved increased significantly as youth increased in age and in level of education.

The two sexes in Zawiya have a very different exposure to cinema. Of girls, 80 percent had never been to a movie, while 40 percent of boys went occasionally and another 40 percent went weekly or more often. Like television, movies in the nearby city offer exposure to a range of cultures. In addition to Egyptian, French, and U.S. films, Italian westerns, Hindi fantasies, and Oriental karate films are popular. The most important influence on gender relations may be the soft-core European films, portraying sexual behavior that is banned on television. Young men's sexual fantasies, and their expec

tations of girlfriends, seem to be changing as a result of exposure to these imported images. As guides for adult living, the TV, pop music, and movie images available to youth in Zawiya seem to influence fantasies and premarital behavior, but these imported notions are often of little relevance to the actual relationships these young Moroccans are likely to experience with a future spouse.

In terms of media preferences, significantly more girls than boys preferred Arabic entertainment on radio, cassettes, and television. For radio, 83 percent of the girls preferred Arabic programs compared to 35 percent of the boys; for cassettes (mostly music) 85 percent of girls and 56 percent of boys preferred Arabic. On television, 44 percent of girls and 12 percent of boys preferred Arabic programs. While boys on the average were more educated than girls (and thus more comfortable with non-Arabic languages), it appears these differences are due to sex rather than educational level. Young men as a group are more deeply involved with Western media and the assumptions about relationships and sexuality implicit therein. While both Western and modern Middle Eastern media are preoccupied with love and romantic encounters, the former are more sexuality explicit and less compatible with traditional Moroccan and Muslim ideas about marriage.

CONCLUSION

The sexual side of life for these young Moroccans is characterized by rapid change, sharp gender-differentiation, and some contradiction between traditional and modern expectations of a relationship. Sexuality can be problematic in such a community, since sexual activity either involves, for the young man, persons unsuitable for marriage (prostitutes, "dishonored" girls) or, for the young woman, a need to conceal her actions and feign virginity at marriage. Because of the double standard, the sexes approach each other with contradictory motives, and often with distrust, so that maintaining emotional intimacy is difficult. On the whole, however, we have been impressed with the respect these adolescents still show for parental and traditional religious values, even as they prepare for an adulthood very different from what their parents have known. The youth of Zawiya still tend to assume they can have new social roles, and new kinds of relation

ships, without openly challenging family and religious values they share with their parents.

SUGGESTED READINGS

Bouhdiba, A. (1985). *Sexuality in Islam*. Boston: Routledge and Kegan Paul.

Coles, R., & Stokes, G. (1985). *Sex and the American teenager*. New York: Harper & Row.

Davis, Susan S. (1983). *Patience and power: Women's lives in a Moroccan village*. Cambridge, MA.: Schenckman.

Davis, Susan S., & Davis, Douglas A. (1989). *Adolescence in a Moroccan town: Making social sense*. New Brunswick: Rutgers University Press.

Mernissi, F. (1987). *Beyond the veil: Male-female dynamics in modern Muslim society*. Bloomington: Indiana University Press.

33
The Contact Hypothesis in Intergroup Relations

YEHUDA AMIR

Coming from the Middle-East I have many times observed a seemingly paradoxical behavior of people, which seems to be typical of this geographical area as well as elsewhere in the world. On the one hand, individuals are willing to endanger, even sacrifice their lives, such as in military combat or in a disaster situation, to save the life of a friend, neighbor, or even someone from their community they have never met. However, at the same time, they can completely ignore the lives of others (such as an enemy or member of a rival group), walk away from the disaster area, and let them suffer or even die when with a little effort the latter could have been saved.

One suggested remedy for our rejection of outgroups and outgroup members is intergroup contact. This indeed sometimes works, but on other occasions may have quite a negative effect. Thus, for instance, I remember a statement given during one of my studies in the Israel army by a young, upper middle-class soldier regarding his attitude and feelings towards soldiers from a much "lower" socioeconomic background. He responded: "Before I met them in the army I always thought that they are quite ignorant and limited in their interests, and I did not like it; now, after I met them I really know that that's what they really are—and I hate it."

In an opening statement for a special issue of the *Journal of Social Issues* on intergroup contact George Levinger, the editor of that journal, wrote in 1985, generalizing the above examples:

> One admirable characteristic of humans is their loyalty towards members of the ingroup ... Conversely, a deplorable characteristic of humans is their rejection of members of an outgroup ... Much human divisiveness, not to speak of exploitation, war, and even genocide, stems from prejudice against members of outgroups.

And he continues with regard to the contact hypothesis:

> It is sometimes assumed that, if only members of different groups can have "contact" with one another, they will learn to appreciate strangers as worthy individuals ... But there are also many cases in which the principles of "contact-leads-to-appreciation" fails. In some cases, in-

Yehuda Amir is a Professor of Psychology at Bar-Ilan University, Israel. He has served as head of the Department of Psychology and the Israel Army Manpower Research Division. He has published over 100 articles and books, mainly on intergroup conflict and cross-cultural psychology. He heads the Institute for the Advancement of Social Integration in the Schools and the Winston Institute for the Study of Prejudice. He is the incumbent of the Thomas Bradley Chair for Ethnic Integration.

Author's Note

This chapter was written during my sabbatical leave at the Psychological Institute IV, University of Muenster, Germany. I would like to extend my thanks to the Institute and especially to Professor Amelie Mummendey for their assistance and positive atmosphere during my stay in Muenster.

tergroup contact only confirms that "those other people" are "indeed" hostile, incompetent, or untrustworthy.

This general statement already demonstrates the complexity of the topic we shall be dealing with in this chapter, namely: When people from different groups—ethnic, racial, or cultural—meet with each other, what happens? Many aspects or components are involved in such a contact situation that may have a bearing on the outcome. In the following sections we shall try to analyze systematically variables that have already been studied and found to be relevant on this topic, namely: Under what conditions does intergroup contact have an impact, for whom, and regarding what outcomes? The main variables for which there is already some conclusive evidence will be elaborated henceforth under the following headings: intuitive and theoretical assumptions regarding intergroup contact, input and outcome variables, techniques for change, and conclusions.

INTUITIVE (COMMON SENSE) AND THEORETICAL ASSUMPTIONS

A social and perhaps even naively romantic myth accompanies intergroup contact, attributing to it the power to positively change ethnic and racial attitudes and promote better intergroup relations. This belief is based on the assumption that if people only had the chance to meet each other and interact, the invisible walls separating them would crumble, and better understanding would follow. Many international activities such as sport and cultural events, congresses, student and faculty exchanges, and direct talks between rivaling groups or countries are examples of this basic belief in the power of intergroup contact.

There is some basis in favor of this notion, both in psychological theory and research findings. Still, some disappointing results of intergroup contact are also seen. So, the question arises, why do we always return to "contact" as a major remedy when ethnic and racial conflicts arise? At this point I would like to mention two factors which I think contribute to this tendency:

1. Since the middle of this century, especially after WW II, a strong tendency toward intergroup interactions and international intermixing can be observed. Many countries absorbed immigrants from different ethnic and racial origins as well as foreign workers. New countries have been established that are based on a multiplicity of ethnic groups. International visits and tourism are more frequent and available for broader strata of the population, and more commercial and industrial enterprises have become international, requiring exchange of personnel between countries and cultures. Furthermore, this multiethnicity was followed by the realization, and maybe also an ideological belief, that people will *have* to live ethnically together rather than separately. Therefore, the question today is no longer "Should we live apart or together?"; it is rather "How can we live together?" The sooner we are able to provide an optimal answer to this question, the better for all of us.

2. Though "contact" has its limitations, it involves a possibility, even a probability, of success. As yet, society and social science have not provided a better approach or technique to help us overcome or reduce prejudice and discrimination. Thus, contact seems, at least for the present, the best potential remedy that can be offered.

There are a number of theoretical considerations that provide the basis for the assumption that intergroup contact can produce change. Here are a few.

Social psychological research has demonstrated that, in general, *similarities* between people attract them to one another while *differences* keep them apart. Moreover, people tend to like others who resemble them while they dislike and even resist others who are different. When considering groups, especially ethnic and social ones, it has also been found that in many cases individuals lack a basic knowledge or even have misconceptions about the other group. Such misconceptions are in most cases negative. For instance, in my own country, Israel, many of the Jewish mothers will address (and quite loudly) their children when they are very noisy: "Don't shout like the Arabs." However, one has only to visit a few Arab homes to observe how quietly the interactions between children and their parents are conducted. And another example: during the cold war between the United States and the Soviet Union, people in *both* countries attributed the *same* negative personal characteristics as typical of the members of the *other* group. Thus, there is a high probability that members of one group will

wrongly attribute negative characteristics to the other group. The power and damaging effects of stereotyping are important factors in this process.

One prominent social psychologist labeled this phenomenon "assumed dissimilarity of beliefs." In more general terms, outgroup rejection seems to stem from a conceptual distortion among members of one group that members of the other group are much more different from oneself or one's own group than they really are.

When contact occurs, a process of disconfirming initially held stereotypes regarding another group may start, stressing similarities between oneself and the other group, and consequently reducing prejudice, facilitating acceptance, and thus improving intergroup relations.

In recent years additional theoretical considerations have been emphasized, primarily based on principles evolving from cognitive psychology. The notion is that as intergroup contact increases, a number of cognitive processes may follow in the mind of the interacting group member: ingroup favoritism and outgroup rejection will tend to be less pronounced; people will perceive more variation among individuals of their own group and lesser differences between the groups. In other words, following contact I may feel that not all members of my group are nice and good and similar to each other, and not all the "others" are bad.

In addition, group members may start to interact on an interpersonal rather than an intergroup basis. That is, they will observe members of the other group and attribute characteristics to them as individuals rather than as representatives of the other group. They will *equally* attribute positive characteristics to the two (or more) interacting groups. In more concrete terms, the tendency will be to look for positive or negative aspects in other people, regardless of whether he or she comes from one's own group or another, even opposite one. Thus, the initial categorization into "we" and "they" may change, centering on the individual regardless of the group to which he or she belongs. Consequently, this may result in deemphasizing intergroup aspects and reducing stereotyping.

INPUT AND OUTCOME VARIABLES

Outcome Variables

Until recently almost all studies on contact dealt with minority/majority relations in the United States. The emphasis was on the effects of interethnic or racial contact on change in attitudes towards the other group. Most studies have concentrated on the majority (e.g., whites) and its attitudes towards minority (e.g., black) members. Fewer studies investigated attitudes of minority group members towards both the majority group (e.g., whites) and themselves (e.g., self-image, feeling of competence of blacks). In most studies, the emphasis has been on attitudes and feelings towards the other group. Studies on how one behaves in reality towards the group are much rarer. The settings that have been studied are places of work, housing, schools, recreational activities, etc. Thus, a typical study would involve the change of attitudes, perception, or feelings of whites toward blacks following a certain period of racial interactions in a desegregated school, or after working together with blacks in a department store.

Lately, this field of research has broadened: On the one hand, the groups involved in intergroup relations studies became somewhat wider including physically handicapped, slow learners in schools, racial and immigrant groups outside the United States, and so on. An additional development, primarily as a result of Tajfel's (1978) studies and theoretical contributions, is the emphasis on ingroup and outgroup relations in more *general* terms, regardless of whether the groups are based on ethnic/racial differences or minority/majority relations. While theoretical and empirical contributions regarding ethnic and racial relations originate primarily from studies in the United States, the latter (i.e., Tajfel and his followers) stem from European origin.

One additional important aspect concerning outcomes relates to the issue of generalization. Generalization occurs when contact results in changes that are not confined to the contact situation itself, but also spread beyond it. Furthermore, if a generalization occurs, one wants to know if it refers to intergroup settings or groups other than those related to or involved in the contact experience itself. Most empirical findings indicate specific effects, typical of a certain situation or group studied, rather than generalized results. At present, various social psychologists present controversial arguments as to the conditions required for a contact situation to produce generalized changes. However, it is beyond the scope of this chapter to detail these various arguments. At any rate, we will need more research to clarify this scientifically and socially important issue.

Input Variables

Research has shown that variables related to both the individual and the contact situation may have a decisive effect on outcomes. Findings indicate that most of these effects stem from situational (e.g., the general atmosphere in the group regarding intergroup relations, political attitudes related to the other group, the leadership's position on this issue) rather than individual (e.g., personality aspects or background variables of the interacting individual) aspects. However, before discussing these aspects, we should stress a preliminary consideration, namely, that such contact will occur *at all.*

People tend to function in groups that are relatively homogeneous in terms of ethnicity, religion, social class, and related factors. Generally, people will not make an effort to go out of their way to

> **People tend to function in groups that are relatively homogeneous in terms of ethnicity, religion, social class, and related factors. Generally, people will not make an effort to go out of their way to meet and interact with "others."**

meet and interact with "others." So, the first question regarding possible effects of intergroup contact is whether such contact will occur at all in our daily life. As this generally does not occur, special emphasis is put, both in research and in policy decisions, on situations where such intergroup contact is unavoidable (e.g., at work) or occurs as a consequence of a social policy (e.g., interethnic housing projects or school desegregation). In these cases, the effectiveness of intergroup contact is especially important because the *policy itself* is built on the premise (and promise) of producing better intergroup relations.

We turn now to *situational* components. The following seem especially important:

1. *Acquaintance potential,* as termed by Cook (1970), is a general label expressing the opportunity inherent in a contact situation for members of one group to get better acquainted with members of the other group. Social settings

(e.g., work, schools, social or political groups) may have quite different potentials for producing intergroup changes.

2. *Equal status* of the interacting groups. This variable is especially important in majority/minority group relations when the majority has higher status and the minority is of lower status. There is evidence that when the interacting groups are of equal status or have the same power within the contact situation (e.g., come from the same socioeconomic class, have the same occupational rank or position, or have the same educational background), the attitudes of the majority towards the minority will change in a positive direction. If the minority group or its representatives are on a higher level than the majority group and this does not threaten the latter group, the expected positive change may be even more marked. On the other hand, contact by the majority group with lower-status minority members (similar to the example I gave regarding the soldier who met in the army a "real" low-class member from the other group) may reinforce and even "justify" existing stereotypes, thus resulting in a negative change.

The following table illustrates the changes that tend to occur among majority members when they meet with minority groups or members of different status levels.

Type of Minority Group or Members		Direction of Attitude Change
Low status	→	Negative
Equal status	→	Generally positive
High status	→	Very positive

There is still disagreement among social scientists as to what the important components of status are. Are these the *general* status components in society, such as educational and socioeconomic and occupational levels, or are the decisive elements the ones which are relevant in the contact situation *itself* involving specific individuals (e.g., in school—a good or socially accepted student; at work—an efficient worker; in sports—an excellent player; etc.). The latter consideration is being used in many contact intervention programs. This is because it turns out to be easier to manipulate status components of a group or its members *within* the contact situation rather than bringing together groups on an equal-status basis when in reality they are of unequal status. Thus, for instance, in

desegregated schools, the status (e.g., level of achievement, general attractiveness) of the white students is generally regarded as higher than that of minority student groups. There is little that can be done about this. Still, what some of the intervention programs in the schools, especially those related to what is labeled "cooperative teaching" strategies, are trying to do is to assign, in rotation, both minority and majority students to status positions (leadership, resource persons, etc.), thus giving both groups *equal* power and *importance* within the classroom situation.

3. *Cooperation versus competition.* There can be little doubt that cooperation (e.g., interdependency, common goals, etc.) brings people together while competition draws them apart. This is true for individuals as well as for groups. If a group is involved in activities that require intergroup cooperation, mutual acceptance will follow. On the other hand, if competitive elements prevail, relations may even get worse (e.g., in desegregated schools never compose teams of the same ethnic or racial group, and then let them compete with each other; always intermix the rivaling groups racially). Positive research findings are quite conclusive when cooperative elements are successfully introduced into the contact situation (e.g., cooperative learning in schools).

4. *Intimate versus superficial contact.* When intimacy develops between members of different groups within the contact situation, positive intergroup change will result. Positive and ego-involving relations with a member of the other group and the new information thereby provided tend to facilitate changes in a positive direction. However, when the contact is only casual and on a relatively superficial level, intergroup relations do not change; if such a contact is prolonged, it may even reinforce and strengthen existing negative attitudes.

In studies on summer camps and interracial housing projects, intimacy seems to be a major factor in producing positive intergroup change. On the other hand, when the potential for intimate relations is relatively low, such as in work situations, findings are less consistent and at times even negative.

Ethnic and racial contact in the schools is an interesting case concerning this topic. Here research results are quite diverse. Some show positive changes, many do not report significant or psychologically meaningful findings,

while others even indicate a trend in a negative direction. However, when the school desegregation process is accompanied by programs or interventions involving cooperation between the groups, the results are quite impressive in terms of both the development of intimate relations among students of the different groups and the positive change in attitudes and behavior. Though it is not always clear which element produced what outcome (i.e., what did the trick—was it the equal status, the cooperation, the intimacy, or whatever else), the interdependence and interconnections between these components seem to be quite obvious.

5. *Normative support.* The effectiveness of intergroup contact is enhanced when supported by societal norms and consensus. The backing for such intergroup mixing may come from accepted authorities in society such as political, religious, spiritual, or other prestigious public figures, by public institutions such as law-enforcing and other governmental agencies, the constitution of a group or country, and so on. Such support may directly promote social desirability in favor of intergroup contact; indirectly it manifests the social appropriateness of intergroup contact and thereby endorses it.

6. *Need satisfaction.* Hardly any research has *directly* investigated this dimension in order to evaluate whether attitudes and relations of members involved in intergroup contact will positively change if some personal need is satisfied through this experience. Still, many researchers emphasize the positive attributes of "enjoyment" from intergroup contact and the contact situation itself and its influence on change. In some studies, additional needs were studied, such as affiliation or power. It was found that when personal needs were satisfied through the experience of intergroup contact, enjoyment followed and consequently a change towards the other group was found.

It seems therefore advisable that this dimension should be further studied because it could serve as an important tool for improving intergroup relations through contact. After all, it seems much easier to create an enjoyable and satisfying intergroup experience than to change the groups themselves or to create special situations that can meet the specific conditions mentioned above.

Let us now briefly turn to variables related to the *individual*. In this area of study we can find some

seemingly contradictory results. On the one hand, we know that a person's attitude and behavior towards "others" is a basic deep-seated characteristic of one's personality. How a person thinks and feels about "different" people and also acts towards them is learned early in life and frequently reinforced during the socialization process. This attitude is also related to other central traits such as rigidity/flexibility, closeness/openness, tendency for scapegoating, liberalism/conservatism, socioeconomic and educational levels, and so on. Such a personality syndrome does not easily change. If all this is true, what possible effect can intergroup contact have? Still, research indicates that if, as a result of ethnic contact, positive changes do occur, they are *equally* found among different types of personalities, as well as among those who had initially shown negative attitudes towards the other group. Thus, it seems that the attempt to use contact for policy-oriented programs to improve intergroup relations is, in principle, worthwhile because potentially it may produce changes where they are indeed needed the most.

Another question may arise whether contact can be effective when the individual already had previous experience with "others." The effects of contact depend to a large extent on the contact situation itself. Thus, if the additional contact is "more of the same," probably no change will occur. However, if the type of contact is different, change may occur regardless of the subject's previous intergroup contacts.

Summarizing the above points, one may reach one of two contradictory conclusions. On the one hand, it is quite clear that the conditions needed for contact to promote better intergroup relations cannot be easily met and implemented; even if that is achieved, success cannot be promised automatically. On the other hand, when the contact situation was carefully designed and carried out according to the facilitating principles already known, positive changes have been found both in research and in practice. At any rate, other alternatives for producing better intergroup relations are at present not very promising. Thus, in spite of the difficulties involved, if societal changes in this area are desired, intergroup contact still seems to be a promising avenue.

TECHNIQUES FOR CHANGE

An enormous amount of research and information has been accumulated during the last half a century, both on ethnic and racial relations in general and on intergroup contact in particular (Amir, 1969, 1976; Hewstone & Brown, 1986; Miller & Brewer, 1984). It seems, therefore, surprising that so little has been converted into action-oriented programs. Only lately some major shift can be detected whereby attempts are made to convert theories and findings into practical tools. This effort is especially salient in desegregated schools and the many intervention programs produced in this area, but also in other areas such as preparing diplomats to interact positively with the foreign population they are assigned to, improving police and civilian interactions, peace negotiators (including third-party interventions) in different national and international conflict situations and many more areas of intergroup encounters.

Most of these programs are geared toward youth and ethnic integration in the schools. They basically try to create an interactive situation with optimal conditions for producing positive change in intergroup attitudes and relations. These programs utilize the principles mentioned above for promoting such a change. Many of them are accompanied by solid research indicating that changes can indeed be produced through these interventions. Still, more programs are needed to encompass broader strata of the population and we need to accumulate more knowledge as to how to successfully implement them with real life groups and organizations.

CONCLUSIONS

The following points summarize most of the research in this area as well as much of what we hear in the news and observe in everyday behavior:

1. Ethnic conflicts and prejudice are a major basis for hatred, discrimination, and genocide. In an era of mass destruction possibilities, reduction of these phenomena should get the highest priority.
2. If one desires positive change in intergroup relations and prejudice without relying solely on possible economic or major political changes, intergroup contact is still the most promising avenue psychology and social sciences can offer.
3. However, contact leading to a decrease in prejudice and an increase in harmony is only an option or possibility, not a "guaranteed" remedy.

4. Only when we take into consideration essential conditions pertaining to the contact situation, is there a good chance to achieve the desired goals.

5. Many real-life situations do not afford these essential conditions. Therefore, we must create specific circumstances involving special programs, techniques, and interventions to achieve positive changes.

6. It is necessary to define a priori the aims and outcomes of such interventions because different outcomes may require specific and differing inputs.

7. Similarly, as intergroup relations and social settings in different societies probably involve different elements, one should be quite hesitant when making generalizations from one situation or culture to the other.

8. The development of interventions may be difficult, time-consuming, and therefore expensive. It will probably require prolonged training of the intervening agents and meticulous preparation of the target population and its organization.

9. In spite of all the difficulties involved, dealing with these problems effectively will probably prove to be less expensive as well as socially more constructive than dealing with them superficially or ignoring them completely. Thus, priority should be given to an intensive effort and further developments, and the sooner the better.

REFERENCES

Amir, Y. (1969). Contact hypothesis in ethnic relations. *Psychological Bulletin, 71,* 319–342.

Amir, Y. (1976). The role of intergroup contact in change of prejudice and ethnic relations. In P. Katz (Ed.), *Towards the elimination of racism.* New York: Pergamon Press.

Cook, S. W. (1970). Motives in a conceptual analysis in attitude-related behavior. In W. J. Arnold & D. Levine (Eds.), *Nebraska Symposium on Motivation* (Vol. 17). Lincoln: University of Nebraska Press.

Hewstone, M., & Brown, R. (Eds.). (1986). *Contact and conflict in intergroup encounters.* Oxford: Basil Blackwell.

Miller, N., & Brewer, M. B. (Eds.). (1984). *Groups in contact.* Orlando, FL: Academic Press.

Tajfel, H. (1978). Social categorization, social identity, and social comparison. In: H. Tajfel (Ed.) *Differentiation between social groups.* London: Academic Press.

34
Preparing to Live and Work Elsewhere

RICHARD W. BRISLIN

People who live and work for long periods of time in cultures other than their own face a number of issues. At times, before they actually live in another culture, people have the opportunity to participate in a cross-cultural training program. Such programs have the goal of giving people information and introducing them to skills that will allow them to adjust to other cultures, to meet their goals, and to do so with the least amount of stress possible (Bhawuk, 1990). Within a cross-cultural training program, one of the best ways to introduce people to cultural differences is to examine critical incidents, or short stories, that highlight common experiences (the approach taken by Brislin, Cushner, Cherrie, and Yong, 1986). Here is an example that contains several cultural differences faced by international students from Asia working on college degrees in the United States.

Richard W. Brislin is a research associate at the East-West Center in Honolulu, Hawaii. He received his Ph.D. in 1969 from The Pennsylvania State University. He directs yearly programs for professors who want to develop cross-cultural and intercultural coursework; and for community leaders who offer various types of cross-cultural training programs to diverse groups such as business people, social service providers, and health care workers. He is the author or co-author of several books, including *Intercultural Interactions: A Practical Guide* (1986) and *Understanding Culture's Influence on Behavior* (1993).

Yukihiro, from Japan, was working for a master's degree in psychology at a large university in the Northeast United States. About a year into his studies, he examined how he was doing in comparison to the other graduate students who entered graduate school the same time he did. He was happy about some things and unhappy about others. He was getting good grades and was doing well in his written work, but he felt he wasn't called on by professors very frequently. Further, he thought that some of the U.S. students who the professors did call upon did not have responses of the same quality that he *could have* contributed. The other thing that bothered him was that he wasn't invited to very many of the informal social gatherings that the graduate students organized. For example, many of the graduate students met at a nearby tavern at about 5:00 PM on Friday afternoons to chat and to socialize—the typical American "Happy Hour." Yukihiro was invited once early in the academic year, but not since.

Yukihiro had a good relationship with a fellow student, Betty, since they were working on research projects under the guidance of the same professor. As a high-school junior, Betty had spent a year in France living with a family there under the sponsorship of the organization, Youth For Understanding. Yukihiro sensed that Betty might be sensitive to his problems, and he asked her to lunch and talked about them. Betty gave these suggestions:

"It's possible that professors don't call upon you because you never *volunteer* information when they ask general questions that anyone in the seminar might answer. Since you don't give answers in those situations, maybe they feel that you don't *want* to contribute and so don't call on your personally. I was reading some work by Triandis (1990) who wrote about individualists and collectivists. People like me in the United States are often socialized to be individualist. We learn to speak up, to make our individual contributions known, and so forth. We take courses in public speaking where just one person learns to address a whole group. Being from Japan, you might have been socialized to be more collectivist and to work well in a group but not stand out from them. You told me once that you never had a course in public speaking and that few Japanese students do. So you are not as used to volunteering your own opinions and calling attention to yourself as having ideas that might be quite different from someone else in the seminar.

"As for social gatherings, you might have been sending the message that you don't want to come. For some of these gatherings, like the ones on Friday, people just show up! There are no invitations! People come and share their experiences, tell jokes, bitch about the statistics professor, and so on. Sometimes, someone says that he or she will be doing something on Saturday or Sunday and then others say they'd like to come along. So by not being there Friday, you miss out on these other social events on Saturday or Sunday."

All of this made a great deal of sense to Yukihiro and it helped him understand his problems. Since he felt so much better, he wanted to show his appreciation to Betty. So he had his mother send him one of the most recent Japanese hand-held calculators with some features that are rarely found on ones readily available in the United States. He gave it to Betty who exclaimed, "It's great! I just love it! It's very thoughtful of you!" Yukihiro was rather astonished at the excitement that Betty showed and took it as a sign of personal interest. He later asked Betty out for dinner at a nearby French restaurant (dim lighting, expensive menu), but Betty said she did not want to mix her social life with her work life to that extent. Yukihiro took this response badly and grew to be uncomfortable when he had to interact with Betty in the psychology department. Is there anything Yukihiro can be told that might make him feel better?

CULTURE PROVIDES GUIDELINES FOR BEHAVIOR

If Yukihiro had participated in a good cross-cultural training program shortly after arriving in the United States, he would have been exposed to cultural differences between behaviors that are common in Japan compared to the United States. With this knowledge, he might not have had the unpleasant experiences depicted in the incident. Before discussing the exact cultural differences Yukihiro is confronting, a few words about the purpose of training programs is necessary.

The purpose of cross-cultural training programs is to provide people with the information and skills necessary so that they will experience success during their sojourns in other cultures. Such programs benefit greatly from cross-cultural studies in psychology since researchers committed to this area are centrally concerned with culture's influence on behavior. When cultural differences

> The purpose of cross-cultural training programs is to provide people with the information and skills necessary so that they will experience success during their sojourns in other cultures.

are discussed, they refer to visible distinctions in the guidance that a culture gives to behavior. The word "guidance" is carefully chosen. There is a danger in overgeneralizing about culture's effects on behavior. Culture gives *guidance* in appropriate ways of behaving in a society such that people are given opportunities for happiness and are appreciated for being good citizens. This does *not* mean that all people behave according to the guidelines. All cultures place limits on the amount of aggressive behavior considered acceptable, but there are deviants in all cultures who exceed these limits. In the example involving Yukihiro and Betty, culture gives guidance. As Betty points out, many Americans are socialized to speak out and to make their personal opinions known to others. Japanese are

socialized to integrate their opinions with those of a highly valued group (their family, their organization). There is far less guidance given for behaviors that will allow a person to stand out from a group and to call special attention to himself/herself. In fact, the guidance is to not stand out. Virtually all Japanese people know the maxim, learned during their childhood, "The nail that sticks up gets hammered down." Notice that this maxim is quite different from one learned by many Americans: "The squeaky wheel gets the grease."

With this knowledge of cultural differences, people can be prepared for common experiences that they will almost surely encounter in another culture. Yukihiro can be prepared for the fact that he must speak up to be noticed by professors. Interestingly, if Betty went to Japan, she would also be confronted with a cultural difference that involves communicating with others. If she was a member of a seminar in a psychology department in Japan, she might have to be much quieter. She might experience rejection from her Japanese peers if she spoke out too much and did not quietly contribute her ideas to a group product with which all the seminar members could identify. But just as the cultural differences must be discussed, there must also be coverage of exceptions. Remember, culture provides *guidance* and not invariant, iron-clad rules. Not all people accept the guidance. In Japan, some individuals are very fine public speakers who are very skillful in putting their ideas forward. In the United States, there are very shy Americans who rarely speak in a graduate seminar. Neither of these facts interferes with the reasonable generalizations permitting us to say that (1) Americans who speak up in seminars are likely to be noticed by professors, and (2) Japanese who integrate their opinions with others are likely to be appreciated by their peers and by professors. The existence of both cultural guidelines to behavior, and the presence of exceptions to the guidelines, must be recognized.

EXAMPLES OF THE CONTENT OF CROSS-CULTURAL TRAINING PROGRAMS

The coordinators of good training programs, then, can communicate the insights of cross-cultural research and can make these insights applicable to people's personal experiences. For example, there are at least three important cultural differences in the incident involving Yukihiro and Betty.

Individualism and Collectivism

One is the distinction between behaviors that are common among individualists compared to collectivists. As Betty mentioned in her explanation, and as can be studied more fully in the writings of Triandis (1990), individualists are socialized to pursue their own goals. In so doing, they learn a number of skills that allow them, among many other things, to set and work toward their goals: public speaking, calling attention to themselves, and making *their own* personal opinions known to others, and so on. Collectivists, on the other hand, are more likely to be socialized to integrate their goals with the goals of a larger group (e.g., family, organization). They are more likely to learn behaviors that promote harmony with others, that allow them to integrate their views with those of others, and to *not* call attention to themselves.

Ingroups

A second cultural difference is involved in Yukihiro's concern about his lack of invitations to social gatherings. To begin the analysis of cultural differences, we have to start with a cultural universal. People in all cultures become comfortable with and attracted to individuals much like themselves. This is a group of people's "ingroup" (Brislin et al., 1986): a number of people who are similar, who look forward to each other's company, and who communicate easily because they have had so many shared life experiences. When newcomers enter a society, it is hard for them to become members of an ingroup since they are not familiar with the other people and do not have the same shared experiences. So far, the findings about developing an ingroup would apply to Betty studying in Japan just as they apply to Yukihiro studying in the United States. The difference is related to another distinction between individualists and collectivists: Individualists have an easier time joining new groups. This may seem at first glance to be contradictory, but the key is to understand the *strength* of group ties. In individualist countries, people join many groups since it is easy to do so. In addition, there is usually not a strong affinity or allegiance to *any one group*, and so people can spread their time, energy, and loyalty over many. People can join the

bridge club, a new church, the student government organization, among many others. As long as they have the requisite skills and interests, they can join all sorts of groups. They can also switch groups easily. For instance, they can quit the bridge club and join the chess club. U.S. readers might want to think back on their high school careers. Wasn't there a value placed on joining a lot of groups so that there would be many names of student activities under one's picture in the school yearbook? Individualists develop skills related to joining new groups (e.g., meeting people quickly, finding out about where meetings will be, telling group leaders how much they enjoyed the meetings). They then can apply these skills when entering a new community. Betty, for instance, can apply these "group joining" skills when she wants to interact with fellow students in graduate school.

The strength of group ties in collectivist cultures is much higher. People usually have only a few group ties that are very important in their lives: their family, their organization, and their religion. Yukihiro, for example, had the cultural guidance to join and to be loyal *to one club* during his undergraduate college years. It might have been the English club, the drama club, the jazz club, or a sports club. The cultural guidance in Japan is that one should learn about group involvement and group loyalty though spending large amounts of time and energy on one's choice of college club. Spreading oneself over several clubs (which is something individualists studying in Japan might do) is seen as superficial and undesirable. Loyalty to one club has important implications. When they are interviewed for a job, for instance, applicants are often asked about the club to which they belonged. The interviewer judges the answers on the basis of how hard the applicants worked for the club, how they "fit in" to the club, how much loyalty they demonstrated, and the like. The qualities of hard work, loyalty, and ability to fit in are all considered important in hiring decisions. Americans who want to work in Japan need to know about this. They should be prepared to talk about *one* club to which they were loyal and should avoid giving a bad impression by talking about the range of their extracurricular activities. Note that the expectations are different if they are seeking employment in their own country. In the United States, they would be expected to show the range of their skills and interests by talking about the many activities in which they have engaged.

Communication Style

A third difference, perhaps more subtle since people think about it so infrequently, involves the *style* or *manner* in which people communicate (Carbaugh, 1990). Misunderstandings involving communication style are often difficult to analyze since people do not have a set of commonly used terms to talk about it. People *do* have terms to discuss the *content* of people's conversation: what they disagreed about, what unpleasant words were exchanged, how ignorant people were of basic facts, and so forth. There are fewer conveniently available terms to discuss the style in which people communicated, especially when one style is quite appropriate in one culture but unfamiliar and puzzling in another. In the incident under discussion here, Yukihiro is unfamiliar with Betty's expressive style (Brislin, 1992) when she accepts his gift with an enthusiastic, "I just love it!"

One of the cross-cultural specialists who has worked with me, D. P. S. Bhawuk, is from Nepal. He has prepared an overview of cross-cultural training programs that has already been cited (Bhawuk, 1990). Moving from Nepal and living in the United States for two years, he had to become accustomed to this expressive style. His insight is that people from collectivist cultures (e.g., Japan and Nepal) take enthusiastic responses as signs of *personal* interest. Such enthusiasm is not common in people's communications with each other in their own countries, and it takes on special significance when it is encountered. This type of enthusiasm is very common in the speech of U.S. individualists, however, and it has no special meaning beyond "I am being polite." If we asked Betty to discuss her enthusiastic response, she would say, "That's the way I always react when receiving gifts." Bhawuk argues, on the other hand, that collectivists are likely to say, "She says she loves the gift; I gave her the gift; . . . she loves me!" Where does this expressive style come from? One possibility is that people from individualist cultures learn to use it as they meet new people and develop new group ties, as discussed above. This expressive style makes them memorable, makes them interesting to be with, and encourages others to conclude that they really want group membership. Collectivists, who have fewer but much stronger group ties, do not need to develop this expressive style so that they can meet and interact with others easily. They already have people with whom to interact, members of their collective. Since they are well-known to others in

their collective, and since the others already know that group membership is valued, there is no need to frequently show a great deal of enthusiasm.

VARIOUS APPROACHES TO DEVELOPING CROSS-CULTURAL TRAINING PROGRAMS

In planning a program to communicate the insights of cross-cultural research to those that can benefit from it, various guidelines are available (Brislin et al., 1986; Bhawuk, 1990). Specialists in cross-cultural training programs recommend that people's cognition, attitudes and emotions, and actual behaviors be addressed in training. Although each of these three aspects of cross-cultural training will be covered separately, in actuality any one good program gives attention to all three.

Training Aimed at Cognition

When attending to cognitive aspects of people's cross-cultural experiences, trainers attend to the information that people will find useful in making their adjustment. Take the example of preparing people who are taking their entire families to live in another country. Information on schooling for children, housing, transportation, climate (to help decisions concerning clothes to buy or bring), and the availability of familiar foods will all be useful. In addition to information that addresses people's immediate needs, information can be presented that can help in long-term adjustment. People might be asked to list their hobbies, their approaches to reducing stress that they use in their own country (e.g. , exercise, socializing with friends), and the job skills that they enjoy using in the workplace (e.g., troubleshooting, helping others with computer problems). Then, with the help of the trainer, they can explore how they can pursue their hobbies, stress-reducing activities, and desire to use certain job skills in the host country. Are people interested in U.S. bluegrass music? If they live in Japan, they will be able to find host nationals who play this music well. Do they enjoy jogging to both obtain exercise and to reduce stress? Given the air pollution in some urban centers in certain countries, this can be unwise. People would be encouraged to substitute another vigorous activity, such as swimming in an indoor pool.

Training Aimed at Attitudes

The goal of training that deals with people's attitudes and emotions is to prepare them for the fact that living in another culture is stressful, anxiety producing, and sometimes downright irritating. Good training can introduce people to the types of emotional experiences that they will surely encounter. A good method is to ask people to role play various intercultural incidents and to then discuss their feelings about their experiences. The exact roles to be played will be determined by program goals. If the goal is to help international students make steady progress toward their degrees, aspects of the incident that introduced this chapter could be used. One student could play Yukihiro, another could play Betty, a third could play a person who has had extensive experience living in other cultures (sometimes called a "cultural informant"), and a fourth person could play the professor. The international student playing Yukihiro, for example, would ask the cultural informant for advice. Upon hearing the advice that professors expect graduate students to volunteer their comments during seminars, the trainer would then ask the program participants to act out typical graduate-student professor interactions. After they role-play, program participants are asked to share their feelings. Were they uncomfortable? How much more practice will they need before they will be able to speak up as frequently as U.S. students? How much does it bother them, once they share their opinions in seminars, to hear from others who disagree?

The goal of attitudinal training, then, is to prepare people for the challenges to their emotions and feelings that result from extensive intercultural interactions. If trainers decide to try role-playing various critical incidents that people frequently encounter as part of their intercultural experiences, the one-hundred incidents collected by Brislin et al. (1986) may prove helpful. The sorts of emotional experiences covered include such varied activities as developing friendships, reacting to miscommunications during which one has been misunderstood, facing difficulties achieving one's goals, and assisting members of one's family during *their* adjustment.

Training Aimed at Behaviors

People often have to modify familiar behaviors to be successful in pursuing their goals in other cultures. In programs that are admittedly intense,

trainees can be put into social settings that present them with problems that must be solved. These problems should be very similar to those that they will face in the actual intercultural experiences subsequent to training. The difference between this approach (sometimes called "simulated cultures") and role playing involves the extent and number of new behaviors that trainees are called upon to perform. In one of the most intense programs that has been documented (Trifonovitch, 1977), participants about to live on remote Pacific Islands lived in a simulated village that had been set up in Hawaii. There, they learned to behave in ways that would contribute to adjustment and to job effectiveness. They learned to gather their own food since there would be few or no grocery stores. They learned to entertain themselves since there would be no televisions or movie houses. They learned to perform their jobs in the absence of technological aids to which they had become accustomed. They learned to deal with a lack of privacy, since many of the islands are simply too small for people to engage in behaviors of which others are unaware.

Returning to the example of Yukiro and his graduate studies in the United States, many U.S. colleges and universities offer cross-cultural orientation programs prior to the start of classes. If they choose this active approach to training aimed at behaviors, program administrators create social settings that demand that participants behave in appropriate ways to achieve their goals. Participants can engage in extensive exercises where they have to discover what courses are offered; how to register; how to drop and add courses; how to identify helpful fellow students who can answer questions; how to make appointments with professors; how to meet people with similar interests; how to find the types of food that they prefer; how to deal with landlords, and other everyday problems facing college students in the United States. These tasks, of course, are those faced to varying degrees by students everywhere, but a special training program is helpful since there are differences in the best ways to accomplish the tasks in any one country.

A PREDICTION FOR THE FUTURE

There are many reasons to support the prediction that the future will bring more intercultural contact. These reasons include the increasing number of students who take advantage of educational opportunities in countries other than their own; increases in the availability of jet travel; the continuing development of a global marketplace; the demands of people from various ethnic groups to be heard in the political arena; and increases in the number of independent countries (e.g. , in what we once called the U.S.S.R), necessitating greater amounts of diplomatic contact. Given that people often enter into these intercultural contacts with inadequate preparation, psychologists can provide major assistance by continuing to make contributions to the development of cross-cultural training programs.

REFERENCES

Bhawuk, D. P. S. (1990). Cross-cultural orientation programs. In R. Brislin (Ed.), *Applied cross-cultural psychology* (pp. 325–346). Newbury Park, CA: Sage.

Brislin, R. (1992). *Understanding culture's influence on behavior.* Fort Worth, TX: Harcourt Brace Jovanovich.

Brislin, R., Cushner, K., Cherrie C., & Yong, M. (1986). *Intercultural interactions: A practical guide.* Newbury Park, CA: Sage.

Carbaugh, D. (Ed.). (1990) *Cultural communication and intercultural contact.* Hillsdale, NJ: Lawrence Erlbaum.

Triandis, H. (1990). Theoretical concepts that are applicable to the analysis of ethnocentrism. In R. Brislin (Ed.), *Applied cross-cultural psychology* (pp. 34–55). Newbury Park, CA: Sage.

Trifonovitch, G. (1977). On cross-cultural orientation techniques. In R. Brislin (Ed.), *Culture learning: Concepts, applications and research.* Honolulu: University Press of Hawaii.

35
Culture Shock

STEPHEN BOCHNER

INTRODUCTION

The anthropologist Kalervo Oberg is thought to have coined the familiar phrase "culture shock," in a 1960 article in which he described how people react when they find themselves in new, strange, or unfamiliar places. There is no doubt that a sudden descent into the unknown can be an uncomfortable and at times terrifying experience, whether we are talking about a young American student's first trip abroad to Southeast Asia, a farmer from the U.S. Midwest visiting New York, a New Yorker hiking in the Rocky Mountains, or an Australian visiting Tokyo for the first time. Note that only the first and last of these examples refer to a genuinely cross-cultural "shock," a point we will come back to later.

Since its introduction over thirty years ago, "culture shock" has become one of the most widely used and misused terms in cross-cultural psychology. The snappiness of the images it evokes is its main attraction, but also its main weakness. Its strength lies in the way it captures some of the

feelings and experiences of culture travelers. On the debit side, the "shock" half of the phrase tilts the picture too much towards the negative aspects of culture contact, drawing attention away from the many very real *benefits* that can be derived from second-culture contact. The "culture" half of the phrase obscures that what we are really talking about is the response to the unfamiliar, to "unfamiliar shock," differences in cultural background being only one such instance, albeit a prominent one.

Finally, the term is basically descriptive. What is wrong with that, you may say? Well, the problem with descriptive labels is that once people have stuck it on a process, they think that is the end of the matter, needing no further analysis. Not so. Calling an experience "culture shock" does not tell us why people in contact with an exotic culture respond the way they do. It does not shed light on why some people suffer extreme shock, others mild shock, while still others thrive on the unfamiliar. It also does not say anything about how culture shock might be prevented, or dealt with once it occurs. *Naming* phenomena should *not* be confused with explaining them. Unfortunately, the snappier the label, the greater the tendency to fall into this pseudo-scientific trap. I am sure that you can think of several other examples, but my favorites are "jet lag" and "nervous breakdown" (as in "tell me, precisely, which nerves are broken").

In this chapter we will go beyond the phrase to the underlying process and restrict the discussion to *culture contact* while acknowledging that we are dealing with a more general phenomenon—the shock of the new. Although referring primarily to the negative outcomes of culture contact, we will show that these are not inevitable, and that culture

Stephen Bochner is an Associate Professor of Psychology and the Director of the Applied Psychology Programme at the University of New South Wales in Sydney, Australia. Among his books are *The Mediating Person* (Schenkman, 1981), *Cultures in Contact* (Pergamon, 1982), and *Culture Shock* (Methuen, 1986), co-authored with Adrian Furnham. His research interests include culture learning, the psychological implications of culturally diverse work places, culture and the definition of the self, and health education in multi-cultural societies. On most weekends he can be found sailing his 33 foot yacht on Sydney Harbour.

contact potentially can have many positive consequences. Finally, we will go into the how and why of the matter, that is, explain what determines both the positive and negative reactions to unfamiliar cultures. And we will put all this into a general theoretical framework that is emotively neutral and that can be used to design preventive and interventive programs.

CULTURE CONTACT AND CULTURE SHOCK: WHO "GETS" IT

Let me break my own rule and start off with another snappy label. We are constantly being reminded that the world is shrinking. Is this the same as my socks becoming three sizes smaller after they have been left in the dryer for too long, also a very common occurrence for me? Well, not exactly. Among its several meanings, the image of a shrinking world refers to the huge and rapid increase in culture contact. Elsewhere (see the references at the end of this chapter) I have drawn the distinction between two types of culture contact: those that take place *within* particular societies; and those that occur *between* societies. Let me stress that I am talking about actual individuals meeting other individual persons, not some abstraction like a nation or an institution, but *you* meeting Person X in Place Y.

Within-society cross-cultural contact is a characteristic of multicultural countries. Such societies contain diverse groups of people each with their own ethnic identity, yet unified by some sense of national purpose, and by nationwide structures such as the educational, legal, commercial, and political systems that are the glue holding it all together. The United States from its earliest days has been such a country. More recently, previously relatively homogeneous nations such as Great Britain, Australia, and Canada, through their immigration programs, have become culturally more diverse. Worldwide, because of political, social, and economic upheaval, many countries have become the recipients of large numbers of immigrants, refugees, and other permanent settlers, and these societies are in the process of changing from having been monocultural to becoming heterocultural societies.

Between-society cross-cultural contacts occur when members of one nation go abroad to another as visitors. The term *sojourner* captures the essence of this process. Various categories of sojourners have been identified and studied, including tourists, overseas students, Fulbright professors, inter-

national business persons, missionaries, diplomats, Peace Corps volunteers, army personnel, spies, employees of international agencies such as the United Nations, and persons working for the various charitable and aid agencies that distribute food and medicine to the world's needy.

When it comes to culture shock, the distinction between settlers and sojourners is relevant because their respective contact experiences, and hence their reactions, differ. For instance, the two groups have different time frames. *Settlers* are in the process of making a permanent commitment to their new society, whereas *sojourners* are there on a temporary basis, although this may vary from a few days with tourists to several years in the case of foreign students. There is, therefore, less incentive for sojourners to *engage* with their new society, because their psychological anchor remains their country of origin to which they intend to return ultimately. The immigrant or refugee settler does not usually have this perspective or choice.

Another major difference relates to the psychological territory on which the contact occurs. In sporting events, it is well known that the home team has an advantage, simply by virtue of playing on its own familiar field in front of spectators, most of whom are its own fans. And so it is with culture contact. It is true that very recently arrived settlers are sometimes regarded as intruding on territory that "belongs" to the more established inhabitants of a country. Nevertheless, settlers interact with members of their new society on territory which is psychologically joint or at least neutral, in the sense that settlers are seen and see themselves as ultimately joining their new country as full members, and hence achieving psychological ownership of its facilities. In contrast, sojourners interact with the locals on territory that clearly belongs to their hosts. The host-visitor distinction which contrasts sojourners from their hosts captures this process, and the treatment of individual sojourners depends on how their hosts categorize them. For instance, in many parts of the world, and particularly in the South Pacific, the traveler who was once regarded as an honored guest is now seen as an intruder and treated accordingly.

The more general distinction is between being a participant versus being an observer. Settlers tend to be or are in the process of becoming *participants* in their new society. Sojourners, on the other hand, tend to be *observers*. As such, they are less involved with local issues and concerns, and they often live in physically separate residential enclaves. Both groups are prone to culture shock, but the actual

experience may be quite different for these two groups.

THE SHOCK OF THE DISSIMILAR

The Similarity-Attraction Hypothesis

Several thousand experiments, and most of the major theories in social psychology, confirm that people prefer the company of others who are similar rather than different. Similarity itself is a complex idea, as people can be similar in a variety of ways. However, almost all of the conceivable areas in which people can be alike have supported the hypothesis, including similarities in beliefs, religion, gender, race, social class, nationality, political opinion; and more subtly, in inferring similarity in beliefs and values from nonverbal signals such as how a person dresses, the car they drive, or their occupation.

The resulting degree of attraction has also been studied in all sorts of ways. In addition to asking people how much they like or dislike particular target persons, attraction has been gauged indirectly, by measuring behaviors and intentions that imply positive discrimination. Examples include asking subjects to choose preferred coworkers from alternatives who are either similar or dissimilar to themselves (e.g. Would you rather work with a white or a black colleague?). Other studies have asked subjects to indicate who they would prefer as a companion in leisure activities. The ratings of the personality attributes of selected target persons, such as their perceived trustworthiness, or credibility, provide another indirect measure of affiliation, as does voting behavior. Another strategy has been to look at the willingness of subjects to come to the assistance of another person needing help, who is either similar or dissimilar to the "good Samaritan."

Various psychological theories have been invoked to account for the powerful effect of real or perceived similarity, a topic we cannot go into detail here as it would need a whole chapter of its own. In essence, however, these theories say that the similarity of another person is reinforcing, reassuring, and safe. Values by their very nature often tend be unclear, ambiguous, and open to debate. "Am I doing the right, respectable, correct, cool thing?" is a question everybody, young or old, rich or poor, has asked themselves since time immemorial. What is the answer, how can we tell? One way is to look at how other people have solved this problem, the technical term for this process being *consensual validation*. A person who holds similar views or performs similar acts to our own provides such support for our opinions, behaviors, and decisions, makes us feel safe, virtuous, and that we belong; and is unlikely to threaten or challenge us. In short, familiarity is comforting, while unfamiliarity is disturbing.

The Culture-Difference Hypothesis

Culture is an organizing principle for values. Membership in a cultural category is based on shared developmental experiences, sanctions, values, and social structures. The technical term for this process is *primary socialization*. We learn, or more correctly overlearn, from an early age that certain behaviors

> **By its very nature, contact between culturally diverse people is a meeting that occurs between individuals who are dissimilar, and moreover, often with respect to important, deeply felt issues.**

and attitudes are approved, correct, good, valued; and others frowned on, sinful, bad. But, despite the claims of some theological doctrines, empirically there is no universal code of ethics. Different cultures have evolved unique philosophical systems about the meaning of life and how it should be conducted. In many instances the differences are large and diametrically opposed, so that what is a virtue in one society may be offensive in another. Therefore, by its very nature, contact between culturally diverse people is a meeting that occurs between individuals who are dissimilar, and moreover, often with respect to important, deeply felt issues.

To take this one step further, cultures can be thought of as located on a near-far continuum. For instance, Australia and New Zealand are much closer to each other culturally than Australia and Japan. Consequently, other things being equal, an Australian individual will have more in common

with a New Zealander than a Japanese. I say "other things being equal" because it is not quite that straightforward, since subcultural similarities also come into play. For instance, an Australian surgeon may have more in common with a Japanese doctor than with a New Zealand sheep farmer or a member of New Zealand's Maori, that country's indigenous people. Nevertheless, as a broad generalization it can be said that intercultural contact tends to occur between *dissimilar* individuals; that contact between dissimilar individuals is *stressful*; and that the greater the dissimilarity the greater the stress experienced.

One final complication must be noted, namely the extent to which the people in contact are in an *interdependent* relationship. In many cases it is possible to agree to differ, even when the opinions are strongly held and mutually incompatible. For instance, many Westerners regard the tendency of the Japanese to seek group consensus and their deference to authority as a sign of personal weakness. By the same token, some Japanese respond to American aggressive individualism with distaste, perceiving it as disrespectful, selfish, and uncivilized. Still, this does not prevent representatives of the two countries from trading and dealing with one another, as they are united by the superordinate goal of mutual financial advantage. However, in a marriage between a liberated, western woman and a traditional Islamic fundamentalist man, it is unlikely that the participants would be able to agree to disagree about their respective roles.

THE OUTCOME OF DISSIMILAR CONTACT

Most of the studies of culture shock have been done on sojourners rather than settlers, because sojourners usually have institutional affiliations, either at the sending or receiving end, or both. Sojourners go to another country for a purpose, to achieve a particular defined goal, whether it be to gain a university qualification, build a sanitation treatment plant, run the local branch of a multinational conglomerate, convert the heathen, or administer humanitarian aid. It costs serious money to select, train, and ship people and their goods and chattels out into the field. If after a couple of months into a five-year assignment, the sojourner ceases to cope, makes a mess of the job, becomes depressed or anxious, breaks the law, abuses alcohol and then takes the first available plane home to mother (all exam-

ples from actual case studies), this hardly escapes notice. This is particularly so when the people who make an awful hash of things abroad are the same individuals who at home were resourceful, competent, stable, and with a bright future ahead of them, the very qualities that got them the posting or scholarship in the first place. Company bottom lines are affected, questions get asked in Parliament, and both the sending and receiving institutions engage in much soul searching, and perhaps a little research. Over the years, much of the work on culture shock was spurred by the need to find solutions to the practical problems facing various categories of sojourners. Settlers also have to contend with these problems, but the literature there is not quite as focused on the individual, being more concerned with social trends such as the incidence of mental illness or crime in designated immigrant groups.

Let us now return to Oberg, whose very considerable contribution was to describe graphically what may take place in the minds of persons suddenly exposed to strange surroundings. The items in the original list were grouped under several headings, which I will now summarize, not necessarily in the language or within the conceptual framework used by Oberg. The first four themes deal with stressful aspects of the new environment, which I am calling "push" factors. The rest can be thought of as "pull" factors, associated with what the sojourner left behind back home.

The Four Push Factors of Culture Shock

1. Going from the general to the specific, operating in an unfamiliar physical and social environment is hard work. You have to watch your step much of the time, try to work out what it all means, worry about being offensive, ripped off, or humiliated. And because you have trouble in interpreting the feedback you are getting, you are uncertain about whether you are doing the right thing.
2. All this leads to feelings of helplessness, and self doubt as to whether you will be able to cope.
3. More specifically, you may be confused about your role, about what you can expect others to do to and for you and you to them, both in your professional and social life.
4. As you learn more about the other culture, the differences between your values, practices, and

beliefs and theirs come into sharper relief. You may discover that it is the locals' custom to spit into their handkerchiefs, beat their dogs, circumcise their young girls, and eat the eyes of sheep, all practices that you regard as disgusting. This in turn may make you simultaneously indignant and guilty, because back home in the pre-departure seminar they told you all about how values are culturally specific, and that you should therefore respect local customs, something that you have abysmally failed to believe and achieve.

The Two Pull Factors of Culture Shock

1. In some but not all cases, you may suffer a loss of status. Back home you might have been a big fish in a small pond, but now you are a minnow in a vast ocean. When I was a student I had a close friend who was the son of a Fijian chief, which in that society signifies a very high social status. On the campus of the Western university where he and I were students, to the locals he was just another dark-skinned scholarship holder from a third-world country. Rightly or wrongly, such people may feel that the locals do not respect, like, or accept them as much as is their due, and in turn are ashamed to find themselves disliking and rejecting the locals they meet.

2. You miss your friends, your family, your cat, and the gang you go out with on Saturday nights. In plain English, you become homesick. You worry that while you are away, someone will get your job, your friends will forget you, they will elect your life-long rival to be the Commodore of your Yacht Club, or that your mother will throw out your stamp collection in the next spring cleaning.

Other writers have come up with variations on these themes, but there is general agreement that the core characteristics of culture shock are confusion, uncertainty, depression, anxiety, and interpersonal awkwardness. However, there have been significant differences among commentators in how to interpret these reactions, what they mean in a more fundamental, theoretical sense, and what if anything can be done about reducing the negative impact of culture contact. The final section of this chapter deals with these last two issues.

CULTURE SHOCK: PERSONALITY OR SOCIAL SKILLS DEFICIT?

Much of the pioneering work in this area was done by researchers whose background was in clinical, personality, or abnormal psychology. They thought of culture shock (the response) as a manifestation of a weakened, disturbed, or overtaxed personality. Their prescription for cure was to improve selection, that is to choose people for overseas service who had tougher, more resilient and stable personalities, and to treat those that did break down with the traditional methods of psychotherapy. This meant helping sojourners to achieve greater insight into their personalities, to become more tolerant of ambiguity, more flexible cognitively, and more self-confident. The technical term for such an approach is *intra-psychic*, because it locates both the cause and the solution of the problem inside the person's psychological space.

There are two problems with a clinically oriented, intra-psychic approach to culture shock as a response. The first is empirical. One of the largest sojourner programs in recent history was the Peace Corps, set up during the sixties by the U.S. government. Twenty years of systematic, well-designed, well-conducted, and adequately funded research was unable to discover selection methods that would significantly improve the survival rate of volunteers in the field. Moreover, volunteers who performed impeccably at home failed miserably abroad; and borderline candidates at home shone brilliantly in the villages of Southeast Asia, Africa, and Central America. George Guthrie, one of the leaders in this research program, concluded that the crucial ingredient was not so much what people brought with them but what happened to them after they arrived in the field. Particularly important were the social support and training the volunteers received during their assignment.

The second problem with an intra-psychic, clinical approach to culture shock is that it is cumbersome, time-consuming, and an invasion of privacy, is largely irrelevant, and distracts from the real issues. What sojourners need is not a greater insight into their personalities, but specific skills to deal with specific problems. The alternative is a social skills-based model of culture shock and how to prevent and treat it, the approach with which I have been associated. From this perspective, the feelings and responses that have been labelled as culture shock are due to the person lacking the nec-

essary culturally specific social skills. This formulation locates culture shock in the sojourner's social psychology, in their interpersonal engagements rather than their internal functioning. True, these social dealings may result in feelings of panic, worthlessness, and depression, but they originate in the inability to cope with and master quite specific interpersonal, work and non-work related situations. For instance, as research has shown, they include: giving an order to a subordinate; bargaining with a supplier; making a complaint; ordering a meal in a restaurant; being a guest; asking for a date; making a speech in public; touching or not touching another person (as in shaking hands or kissing cheeks); the correct physical distance during conversation with a colleague; and all the other incidents that make up the daily fabric of social life.

The remedy implied in this version of culture shock is to devise individually tailored training programs to impart those social skills that sojourners actually lack and need in order to cope, both in their general transactions with local people, as well as in their particular work or role-related contacts. This latter stipulation explicitly recognizes that, for instance, the interpersonal problems that students face may be different from those of businesspeople or hydroelectric construction workers.

To illustrate, the Japanese are indeed relatively inscrutable to Western observers, because the Japanese rules for the displaying of emotion facially are rather muted compared to those in the West, and also differ in substance. This makes it difficult for a Westerner to "read" a Japanese counterpart, leading to all sorts of problems in communication. Westerners doing business in Japan might benefit from learning how to interpret Japanese display styles. Another example: Some Eastern cultures are very indirect in the way in which they decline, i.e. say "no," or more precisely, do not use "no" when they refuse, because that would be rude. People from direct cultures where language is used more literally and "yes" means "yes" and "no" means "no" have a dreadful time in less literal cultures, both when they emit and when they receive refusals.

SOCIAL SKILLS-BASED TRAINING PROGRAMS

The social skills model of culture shock emphasizes culture-specific learning (or its absence) as both the cause and the cure of culture shock. This formulation leads to training interventions of a particular kind. Although there are orientation programs whose aim is to prepare sojourners for life abroad, many of these exercises suffer from the following deficits: (a) they are too general, in the sense of preparing people for life in a non-specific unfamiliar setting, rather than for work in a particular country (e.g. Japan) in a particular occupation (e.g. teaching English as a second language); (b) they tend to emphasize the exotic (e.g. how to deal with snake charmers) rather than the mundane (how to order a meal in a restaurant) even though the sojourner may only meet a snake charmer once in a blue moon, but have daily unsatisfactory encounters with waiters; and (c) many of the programs rely heavily on the cognitive transfer of information, such as providing a history of the host country and its culture, which is certainly useful, but often does not translate into coping with the day-to-day problems that sojourners encounter as they go about their business. Individually targeted training programs with a behavioral focus avoid all of these shortcomings.

SUMMARY AND CONCLUSION

The social skills model provides distinct guidelines for intervention. Furthermore, it also provides clear ways of evaluating the effectiveness of the programs, because it is possible to compare before and after levels of competence in the targeted behaviors, or compare treated with untreated groups of comparable sojourners. It deemphasizes selection and places importance on training, and on providing social and technical support in the field on a continuing basis. Finally, the conventional view of culture shock casts the blame for poor intercultural performance on the sojourner, which adds insult to injury. The social skills model, on the other hand, clearly states that culture shock is not the result of some personality defect, but is due to the skills a person does not possess, a lack for which the sojourner can hardly be blamed (although the sojourner's institution can be criticised if it has failed to provide the requisite training and support). The model also implies that culture shock is not inevitable, and that properly prepared cultural travelers can greatly benefit from their exposure to new experiences, which have the potential of expanding the mind and providing an exciting global, non-parochial perspective on life.

To end on a practical note, culturally relevant social skills can be acquired with much greater ease than a new personality, even if that were desirable. And such skills are now a highly marketable commodity. In today's shrinking world, what I have called "mediating persons"—individuals who can act as bridges between different cultural systems—are in great demand in commerce, industry, and public service, but in very short supply. The bicultural, bilingual, and culture shockproof individual has it made.

BIBLIOGRAPHY

Adler, N. J. (1986). *International dimensions of organizational behavior.* Belmont, Calif.: Wadsworth.

A general reference on cross-cultural aspects of work-related behavior.

Asante, M. K., & Gudykunst, W. B. (Eds.), (1989). *Handbook of international and intercultural communication.* London: Sage.

A general reference on the psychology of cross-cultural communication.

Bochner, S. (1986). Training inter-cultural skills. In C. R. Hollin & P. Trower (Eds.), *Handbook of social skills training, Volume 1. Applications across the life span.* Oxford: Pergamon.

A reference on the social skills approach to culture learning.

Furnham, A., & Bochner, S. (1986). *Culture shock: Psychological reactions to unfamiliar environments.* London: Methuen.

A general introduction to the area.

Kim, Y. Y., & Gudykunst, W. B. (Eds.), (1988). *Cross-cultural adaptation: Current approaches.* London: Sage.

A general reference on adapting to new cultures, culture contact, and the stranger/host distinction.

Turner, J. C., Hogg, M. A., Oakes, P. J., Reicher, S. D., & Wetherell, M. S. (1987). *Rediscovering the social group: A self-categorization theory.* Oxford: Blackwell.

A general reference on the in-group out-group distinction.

36

Re-entry Shock: Coming "Home" Again

JOYCE HICKSON

I recently completed a six year appointment as an academic in South Africa. In retrospect this experience proved to be richly rewarding. Having dared to get my feet wet in a new stream, I profited greatly by my experience. I learned a great deal about other peoples and different cultures. Most of all, I learned about myself.

A great deal has been written about the stresses, strains, and displacement of relocating to a new community. Even if the move has the comfort of being within the same geographical area or state, or even if it is just down the block, such a change is still jolting. The shock can be that much greater when the move involves thousands of miles, a different country, and even a different hemisphere. Most individuals prefer to cling to what is familiar, predictable, and comfortable.

The trauma of moving to a foreign country is thought to impact even more severely on the sojourner. Various models of the stages each individual presumably experiences in the adjustment process have been given. In one model, stage one is the *contact* or *honeymoon* stage in which differences

are intriguing and perceptions are biased toward the positive direction. Stage two is *disintegration*, where differences have a great impact. Stage three is *reintegration*, where the unique and new ways of doing things in the host culture are rejected as less desirable than the more familiar ways of one's home culture. Stage four is *autonomy* where differences and similarities are both identified and accepted as legitimate and accurate perspectives. Finally, stage five, *independence*, is when differences and similarities are valued as significant and are perceived independently in a new set of familiar values (Adler, 1975).

It is important to recognize that culture shock does not necessarily progress neatly and in orderly fashion from one stage to the next. The entire process may be delayed or may be compressed. Adjustment models do have value in psychologically preparing the individual who is making a major relocation move, yet exactly how any individual will actually react is probably more the result of a complex set of variables. These may include prior life experiences, the individual personality characteristics of the sojourner, preparation for the journey, "goodness of fit" with the new location, and so on.

In my own case, although I grew up in Birmingham, Alabama and was the product of a Southern culture, I somehow managed to escape total cultural encapsulation in a number of ways. Wrenn (1985) described the culturally encapsulated individual as one who evades reality through ethnocentrism ("mine is best") and who becomes insensitive to cultural variations among individuals. Reality is

Joyce Hickson, Ph.D., is Chair, Department of Counseling and Clinical Programs, at Columbus College in Georgia. She spent six years in Southern Africa and served as an adviser to the World Health Organization. She has published 35 journal articles and is the author of a forthcoming book, *Multicultural Counseling in a Divided and Traumatized Society* (Greenwood Publishing Group, 1993). She is a member of the World Future Society and is interested in parapsychology.

defined according to one set of cultural assumptions and stereotypes that become more important than the real world outside.

Despite growing up in a cultural context that was considered a closed system by many, I was fortunate enough to have parents who celebrated diversity and found differences intriguing. Every summer there were cross-country automobile trips throughout the United States. We often stopped at native-American sites, Amish locales, and the like. My travel experiences were similar to the popular Charles Kuralt "On the Road" television vignettes.

I can also remember being encouraged to have pen pals who lived in Germany and corresponding with someone who was located in the Phillipines. The latter was always a guest in our home when she returned to the United States on visits. Books of all kinds were abundant, and reading about foreign lands was one of my great pleasures. Africa particularly fascinated me.

While growing up I had the experience of changing homes and living in three different neighborhoods. As a young adult I had the "going off to college" experience and graduate school represented yet another move. While married there were four more moves. Although these relocations were limited to cities in the Midwest and Southeast, I suppose they served as a valuable preparatory training ground. Yet I still had never lived or traveled abroad prior to my overseas appointment.

Innumerable books have recommended techniques designed to facilitate individual adaptation to "culture shock" when moving to a foreign country. The early pioneering efforts of the Peace Corps have been particularly helpful in this regard (Weeks, Pedersen, and Brislin, 1977). In virtually all the models that address the "culture shock" experience of living abroad, the major theme is that such relocation represents a major life stressor. That much planning and prior preparation is needed in order to facilitate a less harrowing transitional experience is a foregone conclusion. Accordingly, such travelers are advised to read relevant literature, see pertinent films, talk to people who have lived in the host culture, and even adopt pen pals within the designated culture who can answer personal inquiries and give general counsel (Pedersen, 1988).

Prior to assuming a teaching post at the University of the Witwatersrand in Johannesburg, in 1985, I took all of this advice very seriously. I was one busy American preparing for my new experience. Six months prior to my South African departure date an intensive study plan was devised. Going back to 1975, every issue of *South African Digest*, a news periodical, was read, as well as assorted news periodicals about the southern Africa region. Johannesburg newspapers were subscribed to as well. People in the university community where the author was presently teaching, Mississippi State University at Starkville, who had either lived in the region or had visited it, were contacted. Friendships with international university students from the targeted area were also initiated and innumerable rap sessions conducted. Daily "to do" lists designed to ensure greater knowledge and insight about South Africa were dutifully completed. All natural tendencies toward perfection were marshalled toward the one goal of "getting it right." In short, I "absorbed" the host culture prior to the actual event much like a highly motivated mother or father might have prepared for a long-awaited family vacation.

In July of 1985 I departed for Johannesburg via South African Airways. Fortified with the fact that I had done my homework, I was "prepared." Like a prize fighter, I had "trained." On foreign shores for the first time, I didn't feel cautious, but I did feel curious. Let the show begin.

Indeed, the advance preparation aided me tremendously. Like an actor I knew my script well. The first six months were filled with the predictable crises of not only coming to a new country, but beginning a new job as well. A further challenge was that I had come on my own, knew no one, and did not have a ready made support group. I had purposely chosen to take the risk of growth. Such experiences can be exhilarating and can be sources of real personal growth.

Reflecting on the experience of living in a foreign culture six years down the road, I now know that it has been one of those "mountaintop" experiences. It was a significant "marking" in my life, and catalyzed a personal change which can only be described as "creative dislocation." I had conquered *uncertainty*—or so I thought.

CAN YOU GO HOME AGAIN?

After feeling the great exhilaration at the airport of returning permanently to U.S. soil, I was caught totally off-guard and totally unaware that I would have yet another hurdle to face: my return to my own country. In my own case my return home actually caused more upheaval than the demands of the

initial cross-cultural adjustment. The major reason for this, I believe, is that problems in adjustment were totally unforeseen. I did not envision any possibility that I would have difficulties in the culture I already knew so well. I did not know that sometimes I would feel uncomfortable and lost in conversations, that encounters would be somehow awkward and stilted, that many exchanges would have the effect of instantly revealing the lack of common points of reference. I did not realize that hardly anyone would pay much attention to the fact of my sojourn and experiences abroad. I did not realize that I would feel like a stranger in a strange land and like an outsider.

It never occurred to me that my expectations concerning my return home would not be met. I am now slowly beginning to realize that whenever there is *change,* adjustment is needed. There have been and will continue to be difficulties readjusting to my original society. I now realize that the adjustments I had to make in order to live in South Africa have left me a *changed* person. Now certain other adjustments have to be made in order to function in my original society. In a very real sense my return home has the "feel" of a cross-cultural situation itself.

One of the most difficult feelings I've had to deal with is that of ambiguity or lack of reference. No guidelines seem to be available for "re-entry

I knew what to look for in the great trek to a foreign culture. But where is the instruction kit for returning to the endless landscapes that were previously known, and yet now have a strange and unfamiliar topography?

shock" and how to adapt to it. It is very strange indeed that the things that should seem so familiar and comforting actually make me uncomfortable.

In navigating re-entry into one's country of origin, a special compass is needed. I knew what to look for in the great trek to a foreign culture. But

where is the instruction kit for returning to the endless landscapes that were previously known, and yet now have a strange and unfamiliar topography? What I feel I can't quite describe, but there are feelings of alienation and estrangement, as if I don't quite belong here.

How do you explain to your countrymen that you have experienced the reality of a "deep culture vision," a transformation, if you will, brought about by what anthropologists call "deep cultural immersion?" The turnabout in your consciousness is that you no longer perceive yourself as a "Southerner" or as an "American." You now realize that you are part of the family of man. Your concerns have become global and you realize that what violates one person in a distant land now violates a part of you. Seen with new eyes you are now aware of the interdependence with the rest of human society. The world really is a global village.

You realize, however, that you are still faced with a good deal of uncertainty. How can you "connect" with those in your land of birth who, when learning of your move to a foreign country, can only think to say, "What did you do *that* for?" How can you explain that "that" was not *destructive* but *instructive*?

A large part of re-entry shock and coming home is a realization that many, if not most Americans, uncomprehendingly feel that there is no rational reason for experiencing a foreign culture. Trying to communicate your vision means to experience communication apprehension:

I think to myself, That's the problem all right, where to start. To reach him you had to back up and back up. And the further back you go, the further back you see you have to go, until what looked like a small problem of communication turns into a major philosophical inquiry (Pirsig, 1982, p. 64).

Having returned to America I wondered if other peoples in distant lands also saw no need to experience other cultures. A part of me asked, "Is this just *America?*"

Paradoxically, one of the real values of directly experiencing a foreign culture is that it may trigger a critical shift in thinking which may itself prove problematic. The experience, for you, may be likened to an entry point, which becomes a turning point, which becomes a point of no return. You may feel like Dorothy, who, in the *Wizard of Oz* said, "Toto, I've a feeling we're not in Kansas anymore."

Perhaps the experience cannot be properly communicated except to fellow sojourners:

You might describe purple to someone who knows red and blue, but you cannot describe red to someone who has never seen it (Ferguson, 1982, p. 69).

In returning to the home culture, in "coming home" again, my re-entry has left me feeling like a voyager who has just hatched out of the space capsule and into the water after an interesting voyage. I'm having to learn how to swim in a strange and yet familiar ocean without benefit of a gyroscope or mission control. I'm not sure where the traps, caves, quicksand, and dangerous crossings are.

On reflection, it would seem that the returnee can either adopt a passive acceptance with a futile world view or accept that although uncertainty can be very uncomfortable, at the same time, it can be a life enhancing and enriching experience. Kelly (1955) developed a theory of personality that placed primary emphasis on each person's active, cognitive construction of his or her world. He posited that all events are open to alternative interpretations and that people can always define their present difficulties in different ways. In Kelly's view each person has a unique set of personal constructs and a belief system which determine the way he or she will think, feel, act, and define new situations. I hope I can be guided by the belief that every problem is really a gift and that I can come to appreciate ambiguity and the lesson it has to teach me.

WHAT IS "HOME"?

C. Gilbert Wrenn (1985) in a personal reflection wrote the following:

Once, as a young man, I "revisited" my childhood. I returned to the village where I had spent the first few years of my life and was sorely disillusioned. The houses and yards were all smaller—and dingier—than I remembered them to be, the streets were narrower, my "swimming hole" was a puddle—and only ten years had elapsed. I regretted the return (p. 233).

What "home" means to an individual varies with age and maturation. Yet an individual of any age needs stability in living patterns and relationships with significant people. A universal need is to feel grounded and to have a place to which one can go in joy as well as in sorrow and defeat. Without this anchor most people feel insecure and adrift. If indeed, however, life is best understood as a journey that begins at the moment of conception and continues through an individual's lifespan, throughout the journey a variety of transitions must occur. A transition itself may be defined as a passage or movement in life from one stage to another. An environmental transition, particularly when adjusting to a foreign culture, can serve to facilitate important behavioral transitions, such as skillful mastery related to operating in one's surroundings. Being transported to a different cultural setting can result in psychological transitions as well, such as changes in an individual's internal ways of perceiving and processing perceptions. All transitions involve change and a movement toward something new and different for the developing individual. Experiencing a foreign culture can serve as an important learning experience in preparation for future journeys. Moreover, the process of being open to a foreign culture and strange and unfamiliar ideas can be an integral part of one's personal odyssey and voyage of discovery.

In coming home again to my country of birth, I realize, as Aldous Huxley noted in the *Doors of Perception,* that the person who comes back through the "Door in the Wall" will never be quite the same as the one who went out. Prior to my relocation experience I was like a little chick encapsulated in its egg. All it knows is what it is experiencing while locked up in its shell, yet it does not even *know* that it is locked inside the shell.

In pecking through the shell I have been able to hatch out of my embeddedness. I now have begun to catch a ray of light from outside and to realize that there is something out there that has not been seen, something I have not felt, some place I have not been. Outside the shell I have found more new and interesting things than would a child at the foot of a Christmas tree on Christmas day. I have experienced the realization that I am no longer restricted and bound from being able to see, hear, feel, and experience countless things in a great new world. Breaking through the limitations of a mind that tried to tell me that there were only the people and the territory around me, I have discovered lands and countries and people of all nations. But I had to go beyond all that I knew or thought I knew and I had to travel beyond my small community. Indeed,

I had to break out of the shell of my own narrow experience.

It is with a touch of sadness, however, that upon returning to the United States I realized that the old familiar landmarks didn't look as familiar as they once did. I realized again, however, that the richness of the growth experience of living in a foreign land will forever be part of my consciousness. I discovered in strange and unfamiliar foreign places personal experiences that opened the way to a dimension of wisdom that was new. I also discovered the truth behind Henry David Thoreau's wisdom: "You never gain something but that you lose something." You can't come home again.

REFERENCES

Adler, P. (1975). The translational experience: An alternative view of culture shock. *Journal of Humanistic Psychology, 15,* 13–23.

Ferguson, M. (1982). *The aquarian conspiracy.* London: Granada Publishers.

Huxley, A. (1955). *The doors of perception.* New York: McGraw-Hill.

Kelly, G. A. (1955). *A theory of personality: The psychology of personal constructs* (2 vols). New York: Norton.

Pedersen, P. (1988). *A handbook for developing multicultural awareness.* Alexandria, Va: American Association for Counseling and Development.

Pirsig, R. (1982). *Zen and the art of motorcycle maintenance.* London: Corgi Books.

Sue, Derald Wing and David (1990). *Counseling the culturally different.* New York: John Wiley & Sons.

Weeks, W., Pedersen, P. & Brislin, R. (1977). *A manual of structural experience for cross-cultural training.* Yarmouth, ME: Intercultural Press.

Wrenn, C. G. (1985). Afterword: The culturally encapsulated counselor revisited. In P. B. Pedersen (Ed.), *Handbook of cross-cultural counseling and therapy.* Westport, CT: Greenwood Press.

Section VII

Health Psychology as Mediated by Cultural Factors

There is a mental condition, known as *Pibloktoq*, that seems to occur only among certain Eskimo groups. The condition is also known as "arctic hysteria," and according to relatively few outsiders who have seen people afflicted with this disorder, the behaviors associated with it are colorful and unusual, to say the least. Read how symptoms were summarized some years ago by a cultural anthropologist:

> *Suddenly, with little or no warning, the victim becomes wildly excited. He may tear off his clothing, break furniture, shout obscenely, throw objects, eat feces, or perform other irrational acts. Usually he finally leaves shelter and runs frantically onto tundra or ice pack, plunges into snow drifts, climbs onto icebergs, and may actually place himself in considerable danger, from which pursuing persons usually rescue him, however. Excitement may persist for a few minutes up to about an hour (Wallace, 1961).*

This description is taken from a detailed chapter in a book on psychological anthropology. In the chapter, Anthony Wallace gives various interpretations of this syndrome, including one that is based on orthodox (that is, *strict*) Freudian psychoanalysis. In finally explaining *Pibloqtok*, Wallace focuses on complex interrelationships between culture, geography (latitude, which affects sun angle, which in turn affects the synthesis of certain vitamins), seasonal dietary conditions, and biological factors.

Pibloqtok is one of a large number of conditions known to clinical psychologists or ethnopsychiatrists (that is, psychiatrists who combine their medical specialty with the fields of ethnography and anthropology) as "culture-bound" syndromes. Others have intriguing names such as *Amok*, *Latah*, *Koro*, and *Windigo*, the latter involving homicidal behavior combined with cannibalism and associated mainly with the Ojibway and Cree Indians of Canada.

Interesting as it is to read about these specific and "exotic" conditions, we want to point out several things. First, these departures from the norm may *sound* strange to all but those who live in the culture in which the illness is manifested. Our second point is that it is *likely* that all cultures have syndromes that are either specific to themselves or that *universal* syndromes or illnesses are colored by complex circumstances. The fact that there are so many names for mental illnesses or "deviations" from the norm suggests strongly that no culture is free from states of mind that are described by members of that culture as "deviant," "crazy," or "undesirable." Third, the establishment of causal connections between culture and abnormal behavior will more than likely pay dividends in terms of treating such conditions as humanely as possible and helping to prevent or restrict their future occurrence.

The seven chapters in this section constitute a sample of orientations in the area of health psychology, giving the reader an introduction to a very diverse field that uses the talents of anthropologists, psychiatrists, cross-cultural psychologists, demographers, and others. The chapters do *not* focus on aberrant behavior. Rather, as a small sample of the many chapters that *could* have been included, they do what the rest of the chapters in this book have done for other facets of human behavior—give the reader a small taste of how various dimensions of health psychology are influenced by cultural factors. That's a major concern of the World Health Organization, with which Chapter 37 by Norman Sartorius is concerned. It is important to study epidemiological factors in the incidence and spread of conditions that contribute to the ill-health of a group or culture, and perhaps ultimately to the

world. Similarly, scientists who study world population and human demographics make great contributions to the field of health psychology. In Chapter 38, Andrew Davidson, a psychologist who has done research for over 20 years on human population and its real and potential problems, gives a sampling of the kinds of research he and his colleagues do. Population experts who take a worldwide view make substantial contributions to the understanding of complex interrelationships between states of good health and, on the other hand, conditions that create ill health and reduce the quality of life. In chapter 39, Frances Aboud, a Canadian psychologist, writes about community health in Ethiopia. Because of the topic and the country, it's a natural chapter to follow the first two in this section. Aboud gives a very personal account of her experiences in that country in northern Africa, which borders on Somalia—a country much in the news in 1993.

A person who is displaying certain symptoms that seem to indicate "mental illness" is far more likely to be diagnosed as schizophrenic in the United States than in England. This might seem strange, given the similarities between the countries, both culturally and linguistically. Cultural differences in medical diagnosis, followed by appropriate treatment, is the focus of Chapter 40 by Lisa M. Beardsley, a psychologist who works in a large medical school. The theme of how culture influences diagnosis is continued by Spero Manson, who also works in a medical and psychiatric setting, and who specializes in Native American health problems and delivery services. In Chapter 41 Manson specifically discusses depression, often called the "common cold" of mental conditions because of its high rate of occurrence around the world. It appears that, while depression may well be universal, culture or ethnicity gives it local "color" or uniqueness. The last two chapters in this section deal with the delivery of mental health services to those in need of professional help. Strong evidence accumulated over the years shows that all cultures or ethnic groups have what might be placed under the generic title of "native healers"—people in particular societies who have been chosen or trained to work with the mentally ill, the disillusioned, or the confused. In Chapter 42, Paul Pedersen, a leader in cross-cultural counseling, discusses counseling from a cultural base. Similarly, in Chapter 43, Snowden and Hines discuss the various problems that stand in the way of delivering mental health services to special populations who have traditionally been underserved because of their age, where they live, and the extent of their financial resources.

Taken together, these seven chapters provide an excellent sampling of different approaches that are involved in a very large and exciting field—a field that draws on the talents and resources of anthropologists, psychologists, sociologists, many kinds of medical personnel, and population experts, to name just a few. As the world grows larger and becomes even more diverse, the broad area of health psychology will grow in importance. This field is clearly one of the most exciting and challenging for future generations. The field offers a nice blend of theory and application, which is a main reason why mental health workers (counseling, clinical, and community psychologists, psychiatrists, and others) are so numerous and in such demand.

REFERENCE

Wallace, A. F. C. (1961) Mental illness, biology, and culture. In F. Hsu (Ed.) *Psychological anthropology.* Cambridge, MA: Schenkman.

37

Description of WHO's Mental Health Programme

NORMAN R. SARTORIUS

The World Health Organization is a specialized agency of the United Nations. Its work is funded by fixed contributions of its 170 member states. In addition, it is receiving voluntary contributions for specific projects (for example for work on the control of tropical diseases). The Organization performs its function in collaboration with governments. The governing bodies of the WHO are the World Health Assembly, the Executive Board, and the Regional Committees. The Assembly meets once a year and brings together top health administrators; it could be likened to the Parliament of the Organization since it decides on policies and overall directions of work of the Organization. The Executive Board is composed of 33 individuals: these are selected by member states and their function is to review the Organization's work and give specific guidance to the Director General.

Norman R. Sartorius obtained his M.D. in Zagreb (Croatia). He specialized in neurology and psychiatry and later obtained a Masters Degree and Ph.D. in psychology. Dr. Sartorius joined the World Health Organization in 1967, where he has been principal investigator of several major international studies. In 1977 he was appointed Director of the Division of Mental Health of WHO, a position which he holds today. He has published widely and prolifically, and is affiliated with universities in Zagreb, Geneva, London, China, and the United States. In addition, he holds several honorary degrees and positions in various countries and is on the editorial and advisory boards of many scientific journals.

The Director-General of WHO has a staff of some 1500 professional officers and a similar number of supporting staff. About one-third of these are located at its headquarters in Geneva, Switzerland. It has Regional Offices in Copenhagen (for Europe), Washington (for the Americas), Brazzaville (for Africa), New Delhi (for Southeast Asia), Manila (for the Western Pacific), and Alexandria (for the Eastern Mediterranean). Each office covers a group of countries sharing similar problems and located in geographical proximity. Each of the regional offices has a Regional Director, elected by the Regional Committee performing a function similar to that of the Assembly but at the regional level.

The Constitution of the World Health Organization defined health as a state of complete physical, mental, and social well-being and listed the promotion of mental health and of the harmony of human relations among the functions of the Organization. Several other constitutional functions of the Organization also involve action in the field of mental health, for example, those requiring the Organization to carry out activities leading to the prevention of illnesses of public health importance and to produce international standards and guidelines governing the provision of health care.

The Organization has to carry out duties in accordance with its Constitution and along the lines defined in its General Programmes of Work which cover periods of six years. The Organization has a number of *major programmes*, each containing a number of *programmes*. The Protection and Promotion of Mental Health is a major programme of the Organization with four programmes composing it:

1. Mental Health programme formulation and evaluation
2. Psychosocial and behavioural factors affecting health and development
3. Organization of services for the prevention and treatment of mental and neurological illness
4. Biomedical research on mental functioning in health and disease

MENTAL HEALTH PROGRAMME FORMULATION AND EVALUATION

A national mental health programme is an organized aggregate of activities directed towards the attainment of specified objectives and targets. It documents agreements reached among all concerned (e.g., different ministries, syndicates, professional organizations) about the order and timing of activities. It is congruent with the overall health and development policies and plans. It should contain explicit descriptions of activities which are its content, an account of infrastructure which will be involved in its implementation, and an outline of arrangements which will ensure that all those concerned can participate in planning, carrying out activities, and evaluating success. It should have specified indicators of progress and a clear indication of budgetary provisions.

A national mental health programme should contain specific information on activities that will be undertaken to deal with:

1. Promotion of mental health
2. Prevention of mental, neurological, and psychosocial disorders including those related to alcohol and drug abuse
3. Management of those disorders when they occur
4. Development of psychosocial skills and knowledge which can facilitate and improve the functioning of the general health care system and help to prevent untoward consequences of socioeconomic development and change (World Health Organization, 1992)

The promotion of mental health is a fundamental part of the programme. It means raising the value attached to mental life and mental health in individuals, communities, and societies. If the value attached to mental health is high, the motivation to undertake measures to prevent or treat mental illness is high; community participation in such programmes can be expected; and societal support for appropriate programmes will be forthcoming (Sartorius and Henderson, 1992).

Prevention of a significant proportion of mental, neurological, and psychosocial problems is now possible. It has been estimated that as much as one-half of all such disorders in developing countries could be prevented. Much preventive work will have to be done by general health services and through the intervention of other social sectors. Provision of iodized salt to expectant mothers in areas of iodine deficiency prevents cretinism in children. Early (and appropriate) stimulation of the child and the discovery and correction of sensory deficit (e.g., poor sight, hearing) can significantly decrease the numbers of children labelled as mentally retarded. Crisis intervention (e.g., support to the recently bereaved) brings significant health benefits. Hypertension leading to cerebrovascular disorder can be prevented or controlled. Many types of epilepsy (e.g., those due to brain infestation by parasites) can be prevented by reducing the illnesses in the course of which they appear. Psychoses such as schizophrenia and most of the neurotic illnesses cannot yet be prevented; but this should no more affect countries' determination to carry out preventive programmes concerning other mental illness than the non-availability of malaria vaccines stops the immunization against diphtheria.

Sufficient evidence has been obtained about the possibility of providing appropriate *management* for a number of mental, neurological, and psychosocial disorders in the framework of primary care. The technology which can be used to prevent the occurrence of disability and minimize the impairment which may occur in the course of mental and neurological disorders, drug and alcohol dependence, and psychosocial problems has also been developed. In many situations, treatment of these disorders and the prevention of disability that may result from them will be the central point for a national mental health programme. By no means, however, should such a programme restrict itself to these two tasks only (World Health Organization, 1990).

The current practice of medicine in many countries is overreliant on technology. The use of psychosocial skills which could render the health care worker more efficient and more satisfied with his work is insufficient in most countries. The popula-

tion's satisfaction with health care is decreasing in spite of increased expenditure for health services. Health disciplines contain knowledge and skills necessary to overcome these problems: it is the task of mental health programmes to provide them. In addition, mental health programmes can and should make a variety of specific contributions to programmes aimed at dealing with somatic diseases ranging from cardiovascular diseases to sexually transmitted diseases, whose origin and course are significantly influenced by psychosocial factors (Dasen, Berry, and Sartorius, 1988).

Similarly, but on a different plane, socioeconomic development often leads to situations of major psychosocial impact. Untoward consequences of developmental projects can often be avoided and comprehensive mental health programmes should contain the capacity to collaborate with those responsible for planning and economic development and provide knowledge that may render social change and development more harmonious with the expectations and psychological needs of people. The particular situations in which an input of mental health skills and knowledge would be beneficial vary from country to country. They may include management of psychosocial problems in refugees in resettlement programmes, coping with rapid urban growth, and many other situations.

By the mid 1990s more than 60 countries have formulated national mental health programmes with WHO's help. Sometimes this consisted of visits of consultants to the country, sometimes of training activities for key administrators involved in the drafting of plans (World Health Organization, 1992). WHO is often invited to assist in the evaluation of the progress of national programmes and requested to provide technical guidelines and other materials—e.g., training manuals. An extensive fellowship programme is also managed by the Organization which has, over the years, trained some 80,000 professionals, mostly from developing countries.

PSYCHOSOCIAL AND BEHAVIORAL FACTORS AFFECTING HEALTH AND DEVELOPMENT

The importance of psychosocial and behavioral factors for health and health care has only recently been recognized in the relatively few countries in which this opinion now prevails. In part the difficulty of raising the awareness of politicians and health administrators about these factors results from the often vague and complex presentations made about these factors and about the interventions needed to harness them in the service of health improvement. In part, the resistance to tackling psychosocial factors stems from the necessity to seek help and collaboration of sectors other than health in almost all interventions which aim to deal with them. To change lifestyles of individuals, for example, it is necessary to involve the educational system and the social services, to change legislation, to secure support of the professional and scientific community, and to seek areas of agreement with those who are interested in maintaining the lifestyles of the community unchanged for a variety of reasons (including, for example, financial gain).

In its work on psychosocial factors and health, the Organization has concentrated its efforts on the achievement of three targets. First, the Organization tries to raise awareness of politicians and all others concerned about the importance of these factors for health. Second, it develops instruments and techniques that can be used by researchers and public health personnel in their work. Third, it promotes a wide application of methods that have been found useful in well-documented investigations.

Whenever possible, these three targets have been pursued in the same project. In recent years WHO has, for example, worked on the development of an internationally and cross-culturally applicable method for the assessment of health-related quality of life (Sartorius, 1993). This method, abbreviated WHOQOL, serves to record the functional status and performance in social roles as well as the individuals's perceptions of their status, their performance, and their position in life in the framework of the culture in which the assessment has been made. Once fully tested the instrument will be promoted in the hope that its wide application will lead to an improvement of quality of care, a greater awareness of doctors and others involved in health care about the psychological needs of their patients, and a better understanding of diseases and effects of treatment.

Other activities will use the same strategy of producing a technique and use the process of doing so to advocate the use of the method and to raise awareness of the importance of this work. In 1992–93 these activities included the promotion of psychosocial development of children and adolescents,

the production of specific modules for teaching of behavioral science in schools of medicine (a module, for example, would deal with breaking bad news to a patient), and the development of patient-centered health interventions developed on the basis of research in health beliefs in different cultures.

ORGANIZATION OF MENTAL HEALTH SERVICES

Estimates of the frequency and severity of mental and neurological diseases are staggering. At least 400 million people in the world suffer from such disorders. About one-third of all cases of long-term disability are due to mental or neurological illness such as schizophrenia, or to brain damage from different causes. With increasing life expectancy, the prevalence of the dementias is growing. There are also reports that depressive and stress-related illnesses are on the rise. In developing countries, the rates of chronic mental and social impairment are similar to those found in developed countries, but there is also an excess of psychological reactions

Estimates of the frequency and severity of mental and neurological diseases are staggering. At least 400 million people in the world suffer from such disorders.

associated with severe environmental stress, and of organic brain syndromes due to a variety of causes, including exposure to toxic substances, trauma, and parasitic and other diseases. Nearly a quarter of all contacts with health care services in developed and developing countries are prompted by psychological problems. The epidemic of HIV infection and AIDS, often associated with mental and neurological disorders, presents an enormous new challenge to health programmes (World Health Organization, 1991).

The rate of increase of mental and neurological problems in developing countries, coupled with the trends towards population increase in several regions of the world, far exceeds the capacity of national health systems to deal with these problems. WHO has therefore collaborated in the development and promotion of strategies facilitating the inclusion of mental health activities into general and particularly primary health care (World Health Organization, 1990). This included the development of training materials, reviews of knowledge, e.g., on treatment evaluation, guidelines for large-scale prevention, treatment and rehabilitation programmes, support to national workshops, and several studies. WHO studies have produced the scientific basis for the recommendation that mental health care must be provided at all levels of service delivery, including in particular primary health care. The studies continue. The largest of these has recently begun; it deals with the frequency and type of mental disorders in general health care in 14 countries. More than 25,000 patients contacting general health services have been examined in this study (Sartorius and Üstün, in press).

Improvements of information systems about mental illness and about the way it is managed in different countries have been slow in coming. WHO has supported country efforts in this respect and produced sets of definitions of mental disorders and related issues for clinicians, researchers, and primary care workers. These definitions and the classification of mental disorders are among the components of a "common language" in mental health. Others, whose development has also been supported by WHO, include instruments for a standardized assessment of mental disorders now available in some 20 languages, guidelines for developing information systems for services for the mentally ill, and standard instructions for quality assurance in mental health care (Sartorius, 1991).

The interest of groups of countries in dealing with a particular mental illness has been harnessed in several WHO initiatives (to help the chronically mentally ill; to improve treatment of epilepsy) each leading to the concerted efforts of sizable groups of countries.

Guidelines for improving mental health and mental health care through statutory and regulatory legislation are an important tool for the organization of mental health services at the country and local level as well. In order to produce and update such guidelines, WHO carries out occasional sur-

veys of mental health legislation. Most recently it has started a comparative review and analysis of legislation concerning mental health (e.g., of Mental Health Acts) and social support provisions (e.g., concerning housing and education) in 45 countries. The review will cover prevention and treatment of mental illness and the rehabilitation of those disabled by such disorders.

There are good indications that a significant proportion of mental disorders could be prevented using simple and affordable methods. Guidelines for the primary prevention of certain mental and neurological disorders (e.g. mental retardation, psychoses, epilepsy, etc.) based on the most recent scientific evidence were published in 1992. These guidelines include a description of specific activities which should be performed, indicating the levels of care and the health workers who are to be engaged. These guidelines are now widely disseminated.

In the area of treatment of mental disorders the greatest need is the development of clear indications of how to take the greatest advantage of proven treatment methods. To this end, a series of activities leading to the development of instruments, standards, and guidelines for quality assurance in mental health is underway. This work covers both the areas of treatment of the mentally ill and the rehabilitation of persons disabled by mental illness. Outputs expected include:

1. A set of instruments for the assessment of a range of facilities in the mental health care system
2. Production of staffing standards for mental health care facilities
3. Publications on essential drugs in psychiatry
4. Production of guidelines for the treatment of specific mental and neurological disorders (e.g., schizophrenia and epilepsy)
5. Publications on the contribution of different professional roles to mental health

Training represents a key issue for the development and improvement of mental health services. In this respect three priority areas are identified and activities will be directed at them:

1. Development of learning materials and training packages for the inclusion of mental health into primary health care
2. Development of guidelines and curricula for the training of mental health professionals

3. Management of fellowships in psychiatry and in neurosciences

BIOMEDICAL RESEARCH ON MENTAL FUNCTIONING IN HEALTH AND DISEASE

The enormous scientific progress made over the past few decades made it possible to grasp the huge promise and the magnitude of gaps in our knowledge about the functioning of the human brain in health and disease. These gaps could be overcome faster if there were more communication about work in progress, more willingness to share new information, and more similarity in the methods used in data collection.

The mental health programme of WHO has been engaged in the initiation and coordination of research on public health aspects of mental illness, its prevention, and treatment for the past three decades. It has carried out numerous studies on specific mental disorders (e.g., schizophrenia) on the operation of mental health services, and biological parameters of mental illness (Sartorius, 1989).

With respect to schizophrenia, WHO has, for example, carried out four major transcultural studies involving centres in some 20 countries. In all, some 3000 patients have been included in these studies which have demonstrated the feasibility of cross-cultural research on mental disorders, produced sets of instruments for their assessment in different countries, and developed important new knowledge. Among the main findings of these studies were that schizophrenia can be found in all the very different cultures in which the studies were done, that the outcome of the disease is better in the developing world, and that no single determining factor can explain all differences in the form, course, and outcome of the disease (Jablensky, et al., 1992). Other studies dealt with dementia and depression, with treatment effects in different populations, the functioning of health services, and other topics.

In its promotion of biological research on mental disorders, WHO has also carried out several studies and maintained a network of centres engaged in collaborative research. The current areas of concentration in biological research are the following:

1. Molecular genetics, with particular emphasis on the accumulation of genetically informative families in different cultural settings
2. Biological properties of receptors of particular relevance for mental functioning
3. Evaluation of the impact of environmental factors on brain functioning and development
4. Development of new treatment methods

STRUCTURES OF PROGRAMME IMPLEMENTATION

WHO implements its programmes in collaboration with government authorities, academic and other institutions, nongovernmental organizations (e.g., professional associations), and individual experts. It also collaborates with other international agencies such as the United Nations and its specialized agencies (e.g., the International Labour Organization). The Organization also tries to actively involve social sectors other than health, for example, the sectors of education or social welfare in its projects and activities (World Health Organization, 1991; Sartorius, 1988).

REFERENCES

Dasen P. R., Berry, J. W. & Sartorius, N. (Eds). (1988). *Health and cross-cultural psychology: Toward applications.* Newbury Park, CA: Sage Publications.

Jablensky, A., Sartorius, N., Ernberg, G., Anker, M., Korten, A., Cooper, J. E., Day, R. & Bertelsen, A. (1992). Schizophrenia: manifestations, incidence and course in different cultures: A World Health Organization ten-country study. *Psychological Medicine, Monograph Supplement, 20.*

Sartorius, N. (1988). The mental health programme of the World Health Organization. *Asia-Pacific Journal of Public Health,* 2(1): 48–58.

Sartorius, N. (1989). Recent research activities in WHO's mental health programme. *Psychological Medicine, 19:* 233–234.

Sartorius, N. (1991). The classification of mental disorders in the tenth revision of the *International Classification of Diseases. European Psychiatry,* 6:315–322.

Sartorius, N. (1993). A WHO method for the assessment of health-related quality of life (WHOQOL). In: S. R. Walker and R. M. Rosser, Eds. *Quality of life assessment: Key issues in the 1990s,* pp. 201–207. Dordrecht/Boston/London: Kluwer Academic Publishers.

Sartorius, N. & Henderson, A. S. (1992). The neglect of prevention in psychiatry. *Australian and New Zealand Journal of Psychiatry,* 26(4):550–553.

Sartorius, N. & Üstün, T. B. (in press). An international study of psychological disorders in 14 countries; Standardized assessment of ill-defined problems in primary care: The background and rationale of the WHO Collaborative Project on 'Psychological Problems in General Health Care.' In: *Mental Disorders in Primary Health Care.* J. Miranda, (Ed.).

World Health Organization (1990). *The introduction of a mental health component into primary health care.* Geneva: WHO.

World Health Organization (1991). Protection and promotion of mental health. In: *The Work of WHO,* 1990–1991, pp 65–69. Geneva: WHO.

World Health Organization (1992). Mental health programmes: concepts and principles. (document WHO/MNH/92.11). Geneva: WHO.

38
Problems of Rapid Population Growth

ANDREW R. DAVIDSON

During the next four decades, we will witness the greatest increase in human numbers in all history. According to the latest United Nations estimates, the world population will nearly double from 5.5 billion today to 10 billion in 2050, before leveling off at 11.6 billion after 2150. For the remainder of this century, the world will add 97 million new people every year.

Practically all of this increase will occur in countries that have the fewest resources to deal with rapid population growth. Ninety-seven percent of the increase is expected to occur in the developing countries of Asia, Africa, and Latin America. Africa alone is expected to account for one-third of the rise.

This unprecedented growth in human numbers will have profound political, economic, health, and ecological effects. In much of the developing world, population growth rates will outpace national economic growth, leaving greater numbers of people living in absolute poverty. Moreover, rapid population growth will overwhelm the very health and

Andrew R. Davidson is an Associate Professor and the Dean of Academic Affairs at Columbia University's School of Public Health. He holds a Ph.D. in Psychology from the University of Illinois and an M.B.A. from Harvard University. His research has focused on the fertility decision making of low-income couples in the United States and in a number of developing countries. Currently he is investigating the acceptability of two newly available methods of contraception, Norplant and Depo-Provera.

educational services that offer the promise of raising the standard of living of the poor. Many developing countries have already experienced cutbacks in primary health care systems, with a lessening of immunization rates and with fewer per capita resources for control of such widespread health problems as malaria, tuberculosis, and parasitic diseases.

A critical concern is whether the earth can provide adequate food for 10 billion people. In recent years, substantial increases in agricultural productivity have matched population growth. Between 1950 and 1990, the world's population increased from about 2.5 to 5 billion, but the "green revolution" in agriculture prevented famine on a massive scale. The development of new high-yielding varieties of seeds, combined with increased irrigation, fertilizer use, and the amount of land under cultivation produced significant yield increases.

Now, however, there is widespread agreement among agricultural experts that engineering a second green revolution to outpace the next doubling of the world's population will be much more difficult if possible at all. Most of the world's arable land is already in use. In addition, crop yields are rising more slowly and, in some parts of the developing world, are declining. Finally, irrigation, once viewed as a solution, has become a major problem. Irrigation accounts for most of the freshwater used each day, contributing to serious water depletion in much of the world. Moreover, it is now estimated that half of the total irrigated cropland may be in danger from deteriorating soil, primarily salinization (United Nations Population Fund, 1991).

The earth appears to be approaching its maximum agricultural capacity, with its depleted soil and water resources unable to support another 5 billion people.

The effects of rapid population growth are not limited to economic and land resources at the national level. There is growing recognition of the significant negative impact of population growth and consumption activities on global climatic changes. Of greatest concern is the progressive accumulation of greenhouse gases in the atmosphere (principally carbon dioxide) that are thought to increase global temperatures. Warming, in turn, will lead to worldwide changes in weather conditions and to a rise in the sea level, the ecological consequences of which remain unclear.

Human activities such as the burning of fossil fuels, deforestation, rice cultivation, use of fertilizers in agriculture, and production of chlorofluorocarbons lead to the emission of a number of greenhouse gases. Developed countries currently account for the majority of greenhouse gases, due to their heavy use of fossil fuels. In the developing world, however, rapid rates of population growth and economic development are expected to raise its emissions above those of the developed world for most of the next century (Bongaarts, 1992). Reversal of the greenhouse effect would entail increasing the tree cover of the globe and reducing the combustion of fossil fuels. These outcomes would be difficult to attain with a stable population and appear to be impossible in the coming decades of unparalleled population growth. If current predictions of population growth prove accurate and patterns of human activity of the planet remain unchanged, science and technology may not be able to prevent irreversible degradation of the environment or continued poverty, sickness, and starvation for much of the world.

These projections are frightening because of their massive global scale. However, it is important that the scope of the problems does not divert us from realizing that concealed behind these trends is the reproductive behaviors of individual families. If we double the world's population it will be one birth at a time. Conversely, efforts to slow the rate of growth must in some way influence the reproductive behaviors of individual couples. But how can couples be influenced to have fewer children?

This question has fascinated a growing number of psychologists, sociologists, anthropologists, and economists. Rather than attack the change question directly, their efforts have focused on understanding the central issue of why people want children. By analyzing the motivational underpinnings of high fertility, they hope to identify humanistic means by which the socially desirable end of reduced fertility can be obtained. In the paragraphs that follow, I will briefly review some of the major findings concerning the motivation for children. I will then discuss research on fertility regulation decisions. In both of these sections, I will focus on findings from developing countries.

In most of the developing world, couples living in traditional agrarian societies have large families. The explanations for this high fertility can be found in the positive advantages, at the familial level, of having many children. John Caldwell (1983) presents one of the best summaries of the direct economic costs and benefits of children. Foremost

For most of the world's population, the only satisfactory source of protection and support in old age is surviving children.

among these benefits, children represent an investment for the future. For most of the world's population, the only satisfactory source of protection and support in old age is surviving children. Even where money or land is available as another investment source for old age, these alternatives are realistically distrusted because of fears about the effects of political change or inflation. Moreover, land and money cannot be fully protected without relying on physically capable offspring.

It is only surviving children that can provide insurance against destitution. As a result, the very high rates of infant mortality in the rural areas of most developing countries provide an additional upward pressure on fertility rates. For example, a couple must be sure that one or two sons will survive to provide care in old age. If child mortality is high this means having three sons, and at least six children. The average fertility for traditional societies, approximately seven children per family, appears to be the result of a careful strategy.

The second major benefit of children in traditional agrarian societies is that they are an important source of relatively inexpensive labor. Most children in these societies work from a very young age, often starting when they are less than 10 years old. As adolescents, they are expected to be almost as productive as adults. The children live very modestly and do not have first claim on food or other work profits. Caldwell argues that in traditional societies, before the onset of a fertility decline, net intergenerational wealth flows in an "upward" direction, from children to parents.

To take his analysis one step further, when net intergenerational wealth (including labor and services, goods and money, and old age support) flows in a "downward" direction, from parents to children, lower fertility should result. Factors that increase the cost of children and the downward flow of wealth include urbanization; compulsory primary and early secondary school attendance; nonfamilial employment structures; women having access to income earning opportunities, including jobs not easily compatible with childbearing and childrearing; and the development of private and public insurance and pension schemes. Consistent with Caldwell's theory, when at least some of these conditions are met, the demand for large families decreases.

The discussion up to this point, focusing only on the economic costs and benefits of children, must seem like a "cold" view of parents' fertility motives. Clearly the benefits of children are not limited to the economic. A number of psychosocial values influence couples' motivation for children: the desire for companionship, the need to love and be loved by children; the play, fun, and distraction that children provide; the desire to continue the family name; the search for a sense of achievement from having children; the idea that children provide fulfillment, improve character, and allow one to attain goals vicariously; and the desire to fulfill religious or social obligations or to attain adult status through having children. These values have the potential to vary in importance across cultures and social classes, and could, in many settings, be more prominent than economic factors.

Comparative research by James Fawcett (1983) and his colleagues provides the most comprehensive information on the relative importance of the psychosocial and economic values of children. Their studies focus predominantly on a selection of East and Southeast Asian nations. And, unlike many other fertility studies, in which motives are inferred from behavior, these researchers asked the couples themselves to identify and rate the significance of various costs and benefits of children. In a number of important ways, their findings are consistent with the findings cited above on the economic determinants of fertility.

In each of the high fertility developing countries that they have studied, many couples view instrumental contributions as a main reason for having children. General financial and practical assistance from children, along with expected help in old age, are among the most frequently cited advantages of children. By contrast, very few respondents in more developed countries cite any economic advantages to children. Instead they focus on the companionship children provide, their role in personal development, and their strengthening of the marital bond. These differences among countries are repeated when rural and urban groups are contrasted within each of the Asian countries. Rural parents emphasize the economic and practical benefits to be derived from children. Urban parents emphasize the psychological and emotional benefits that result from interacting with children and guiding their growth and development. On the negative side, urban parents are concerned about opportunity costs and restrictions on freedom, along with economic costs, while rural parents tend to give greatest weight to economic factors and the physical burden of children.

Fawcett (1983) has summarized these findings by noting that "where children have economic or practical value in the household, these benefits dominate the way parents perceive the satisfactions of children. Only when the instrumental value of children is absent or of lesser consequence are children valued primarily for the emotional rewards they provide to parents" (pp.433–434). He goes on to point out that the pattern of costs attributable to children seems to reflect conditions external to the household, such as the availability of alternative sources of gratification in urban areas and in societies at higher levels of development, as well as differences in preferences and income at the household level.

The discussion up to this point is certainly consistent with the idea that "economic development is an excellent contraceptive." Rural and traditional settings, in which the net benefits of children are the greatest, and the odds of children surviving to adulthood are the lowest, are associated with

higher levels of fertility. With modernization and urbanization, the net costs of children increase, resulting in lower levels of fertility. However, while development might serve as an effective contraceptive, it tends not to be a fast-acting method. Human fertility behavior often adjusts slowly to economic change, and economic development is only at a nascent stage in much of sub-Saharan Africa and south Asia—regions with some of the fastest population growth. As a result, population researchers have continued to search for alternative ways to reduce population growth.

Recent changes in some developing countries indicate that rising incomes and urban life are not necessary preconditions for reducing the size of families. The evidence from countries like Thailand, Sri Lanka, and Indonesia shows that fertility rates can drop sharply in poor countries if governments adopt the right policies. For example, in 1965, the average Thai woman had 6.3 children but by 1987 this figure had fallen to 2.2. Yet as late as 1989 Thailand was only 22 percent urbanized and two-thirds of the population worked in agriculture.

What distinguishes many of the developing countries that have had the greatest success in slowing population growth is the attention to the human aspects of development. Key factors are better education and health care for women, including the provision of acceptable and accessible methods of family planning. Not surprisingly, women who have easier access to modern contraceptives tend to use them more, and those who do use them have fewer and healthier babies.

The mere presence of family planning programs has an impact for two reasons. First, there are large numbers of women who want no more children but lack access to contraceptives. Surveys carried out in developing countries in the late 1980s revealed an unmet need for contraception, ranging from a high of 24 percent in sub-Saharan Africa to a low of 13 percent in Asia (World Health Organization, 1992). Simply making services available to these women would have a measurable impact on birth rates. Second, quality family planning services create the demand for more family planning. As Harrison (1992) has described, contraceptive technology, with the education and discussion that accompany it, make more women aware that they can space their births or limit their family size—at the same time as providing easier ways of doing so.

Great strides have been made over the past 20 years in improving the accessibility of family planning services. The World Health Organization (1992) estimates that 60 percent of the people in developing countries have access to at least one safe and effective method of contraception. There are, however, wide differences among regions in the availability of family planning. Couples in East Asia have almost universal access to contraceptives. In Southeast Asia and Latin America, roughly half the population has access. But in the Near East and North Africa, the proportion falls to 13–25 percent. In sub-Saharan Africa the situation is dire with fewer than 10 percent of the couples having access. In sum, 300 million couples who do not want any more children have no access to safe and reliable forms of contraception.

A sustained and concerted program is needed to curb the expansion of the world's population. This action is necessary to reduce poverty and hunger and to protect the earth's natural resources. There is clearly an important role for social scientists in these efforts. More needs to be understood of the social, economic, and motivational determinants of the demand for large families and of the manner in which these demands respond to structural changes. More information also is needed about the conditions under which the supply of family planning services contributes to reductions in fertility. Social scientists have an important role to play in the design of culturally acceptable family planning services, and in the creation of appropriate information, education, and communication programs (Davidson, 1989). There is much wisdom that is available to build upon. However, the challenges to be faced are daunting and complex and we have only a limited amount of time to deal with them.

REFERENCES

Bongaarts, J. (1992). Population growth and global warming. *Population and Development Review, 18*, 299–319.

Caldwell, J. C. (1983). Direct economic costs and benefits of children. In R. A. Bulatao, R. D. Lee (Eds.), *Determinants of fertility in developing countries* (pp. 458–493). New York: Academic Press.

Davidson, A. R. (1989). Psychosocial aspects of contraceptive method choice. In R. A. Bulatao, J. A. Palmore, & S. E. Ward (Eds.), *Choosing a contraceptive:*

Method choice in Asia and the United States (pp. 27–39). San Francisco: Westview Press.

Fawcett, J. T. (1983). Perceptions of the value of children: Satisfactions and costs. In R. A. Bulatao, R. D. Lee (Eds.), *Determinants of fertility in developing countries* (pp. 429–458). New York: Academic Press.

Harrison, P. (1992). *The third revolution: Environment, population and a sustainable world.* London: I. B. Taurus/Penguin Books.

United Nations Population Fund. (1991). *Population, resources and the environment: The critical challenges.* New York: United Nations Population Fund Office of Publications.

World Health Organization, Special Programme of Research, Development and Research Training in Human Reproduction. (1992). *Reproductive health: A key to a brighter future: Biennial report, 1990–1991.* Geneva, Switzerland: World Health Organization Office of Publications.

39
Community Health in Ethiopia

FRANCES E. ABOUD

The urge to travel abroad strikes many people sometime during their adult lives. Working with people in another country satisfies this desire in a deep and lasting way. Satisfaction comes not only from helping people by passing on to them the skills you have, but also from learning their ways of coping with a difficult life situation. Your skill and hard work will be particularly appreciated if it is combined with an openness to see that helping is a partnership between the helper and the recipient. In addition to service, most aid agencies identify their main objective as helping to make people self-reliant by training local people to identify their needs and resources, and by giving them the skills to develop themselves and their country.

For several years I worked as a psychologist with a team of university professionals to improve the health of Ethiopians in rural communities. In the mid-1980s, the health statistics for Ethiopia, as for many developing countries, were grim. The life expectancy was 47 years; out of 1000 children born, 15 died in their first year and one in four never reached its fifth birthday. Only 15 percent of children were immunized against the six major child-

Frances E. Aboud is a Professor of Psychology at McGill University in Montreal, Canada. She earned a Ph.D. from McGill University in 1973, and went on to teach at the Center for Cross-Cultural Research at Western Washington University before returning to McGill. Her research on racial prejudice is described in her book, *Children and Prejudice,* published in 1988 by Basil Blackwell. More recently, she lived and worked in Ethiopia, teaching and researching behavioral aspects of community health.

hood diseases, and less than half were enrolled in primary school. Part of the problem was the lack of health facilities: only 20 percent had the use of clean, safe water, and 46 percent were within 10 km (6 miles) of a health clinic. In comparison, the life expectancy in North America is 77; only 8 per 1000 newborns die in their first year; more than 85 percent of children are immunized; and virtually all children are enrolled in school. This comparison highlights the fact that children in Ethiopia do not have the same opportunity to lead a healthy, productive life as children in North America.

Most members of the team were familiar with television images of drought, famine, and war in Ethiopia. However, much of the country is not in a state of devastation. Farmers simply cannot produce enough for their needs using traditional farming techniques, and the distribution system is poor; coffee and cotton do not bring in the hard currency they once did. The health and education systems are stretched to accommodate the needs of 50 million people. The goal of our project was to work with health professionals in Ethiopia to train people in the field of community health so that they could more efficiently use their meager resources to tackle priority health problems. This entailed training in the use of surveys to identify the needs of rural people, and designing programs that would reach previously inaccessible people.

As a psychologist, I realized that the emphasis should be placed as much on health behaviors as on delivering the services. Health education was needed to help people understand why immunization would allow their babies to be healthier, why clean water would reduce diarrhea, why birth spacing was necessary for a mother's health, and why

young children need five small meals a day even when they are sick. Mothers are in charge of the family's health, and because one cannot simply phone the doctor for emergency advice, they need to know a lot about prevention and care. Rather than waiting for sick people to arrive at the clinic, health professionals had to encourage prevention of illness and promotion of health at the family and community level. Family planning, immunization, and building safe water wells were some of their prevention strategies. This is what community-based health rather than hospital-based care was all about. This is what aid agencies call *development* as opposed to *relief*. Development agents seek to work with communities to build the infrastructure necessary for growth, so that people can rely on their own resources and skills long after the agents have left.

COMMUNITY PARTICIPATION

One important focus of development is the training and support of community health workers. These are people who have completed high school and are selected by their communities for further short-term training in health matters. When they return to their village, they are expected to encourage healthful behaviors among the people, deliver babies, treat minor ailments, and refer more serious problems to the nearest clinic. This scheme has been put into practice in many developing countries as a way of spreading health services to otherwise inaccessible areas. Unfortunately, the scheme has failed in many places because the lone worker in an isolated community lacks support from professionals in the clinic, lacks supplies and drugs, and loses the credibility and respect of his or her clients. As many as 50 percent of them drop out.

A program was developed by one of our physician trainees to encourage community support on the one hand, and clinic support on the other. Each month, the community health workers were visited and supervised by a professional from the nearest clinic, maybe 20 km away. The supervisor provided on-the-spot training and problem solving. This simple procedure provided a much-needed boost to the workers' morale and as a side effect increased their credibility in the community—if they were worthy enough to be visited by a professional, then they were worthy enough to be sought for advice and help by those in need. The result was that the community health worker stayed on the job and in-creased dramatically his/her activities in the community—visiting sick children, checking pregnant women, teaching about nutrition and sanitation, and giving first aid. This is one example of how providing a service does not always work unless the social and psychological needs of the worker and the community are considered. The worker's self-respect and the community's respect for the worker must be developed along with skills and resources.

Helping to develop community participation is difficult in a place where people have not previously been asked for their opinions. However, in most developing countries there already exists a strong tradition of social support. Lacking professional agencies to provide help, people have learned to rely on the family and community for material and moral support in difficult times. These social connections are not only strong, but they are hierarchical in the sense that they are dominated by fathers in the family and elders in the community. Foreigners or even educated locals bringing in new ideas and services are outsiders to this network. Their contribution to the community will only be accepted to the extent that they include local men and women in their decisions and in their efforts.

Involving the community in development efforts is a long, slow process, with many frustrations along the way. The local people may not initially see the need to send their children to school or to dig garbage pits or latrines. One community we visited managed to convince us that garbage pits were not a priority—as a result of their poverty, they actually had little that could be called waste. The need for latrines may have to be concretely demonstrated by showing that diarrhea in children is less frequent in homes where a latrine is used. Similarly the need for a source of clean water can be demonstrated in relation to the prevalence of diarrhea.

A safe water project is a good one upon which to develop community participation, which may then be maintained in order to initiate other projects such as immunization. Water is used daily by everyone in the community; it therefore has a high profile. When agencies such as CARE and USAID plan to build a safe water well, they meet with village leaders and other interested people. A village committee is set up to decide how many wells are needed and where they should be located. They also decide how each family will contribute, such as transporting rocks to the site and paying money for its maintenance. They found that as the project pro-

gressed, the input of the community increased and the input of the agents could decrease. The participation structures that were created were subsequently useful in promoting other schemes because the organization existed, leadership and communication skills had been developed, and community members saw that a cooperative effort brought positive results. Although these participation structures probably already existed in the communities, they may never have been used to initiate something new.

MALNUTRITION

One very prevalent problem in developing countries is malnutrition. Men, women, and children all engage in a full day's work, planting and harvesting crops, tending livestock, collecting water and firewood, preparing meals, and minding young children. Moderately active men and women need on average 3000 and 2200 kcal, respectively, of energy per day; for children the required food intake depends on their age. Many people in developing countries do not eat enough to support their activities. Children in particular receive less than required, and as a result their height and weight are less than expected. The prevalence of malnutrition in an area is often determined by noting how many children weigh less than 80 percent of what they should at their age (an international standard is used). An estimated 40 percent of children in developing countries are malnourished according to this criterion. In most cases, it is because they simply do not receive enough protein and energy foods, or because they lose weight from being often sick with diarrhea or fever.

Malnutrition has many unfortunate side effects. One is to make the child vulnerable to infection. Another is to slow their mental development. When malnutrition is present before birth, the result is a low birthweight child (less than 2500 gm) whose nervous system may not be fully developed. When malnutrition occurs later, the child's low energy level may result in less exploration of the environment and consequently less verbal and visual development. It also results in the child being more irritable and less able to cope with novelty and stress. In Ethiopia, we found that low birthweight children were at risk for later problems, but so were normal birthweight children who during their first 18 months lost their advantage and became as underweight as the low birthweights. Consequently,

all children were at risk for mental and physical health problems.

A large part of the problem is the lack of available food, particularly in the season before the harvest. Another part of the problem is the way mothers feed their children. Although Ethiopian mothers breastfeed their children for several years, they often do not start feeding solid foods when the child reaches 6 months. Consequently, children under 6 months are well fed, but after 6 months they begin to fall behind. Furthermore, they are not in the habit of eating fruits and vegetables, and may believe these to be difficult foods for a child to digest. When the child gets sick with diarrhea, as they do on average 5 times a year, mothers believe that restricting food and fluid is the best way to stop the diarrhea. This restriction does stop the symptoms, but it also leads to dehydration and death in 5 million children a year around the world. For these and other reasons, children become stunted (short for age) and wasted (underweight). In addition, the lack of vitamin A has led to prevalent night-blindness, the lack of iron to anemia, and the lack of iodine which we have in our salt to goiter.

Identifying these problems has resulted in a number of programs aimed at providing food aid in the form of vitamin, iron, or formula supplements to children. However, food supplements by themselves do not help people become self-reliant. Nutrition education is needed to teach mothers how often, how much, and specifically what foods are required by children. Growth charts have been simplified so that mothers can see when their child has fallen below the desired weight and height. And more recently, psychologists have been involved in teaching mothers how to stimulate their children with toys and speech to promote full mental and physical development.

TRADITIONAL HEALTH BELIEFS

Every culture has a way of understanding health and illness. These beliefs are created because people have a need to understand what happens to their body, particularly when it changes or does not function normally. Because most people do not have access to scientific information, their beliefs are based on a conceptual model that has been passed down through many generations. In many respects, these explanations diverge from biomedical expla-

nations which are based on scientific, empirically tested hypotheses about cause and effect. The clash between traditional and modern medical beliefs is most apparent when identifying the cause of the problem and specifying a treatment. The traditional system in Ethiopia as in many developing countries seeks to explain illness in terms of causes outside of

The clash between traditional and modern medical beliefs is most apparent when identifying the cause of the problem and specifying a treatment.

the body, such as the sun, the moon, and social conflict. If you did not know about the germ theory of transmission, you would probably look for events that happened close to the illness in time or space and identify those as the likely causes. This sometimes results in a fairly close estimate of the cause, and sometimes in a farfetched estimate of the cause.

There are many interesting examples of both to consider. One traditional belief is that morning mists cause malaria. This is close in that malarial mosquitos are found in wet places where there are often morning mists. Another belief is that fruits are bad for children because they lead to diarrhea. In fact, fruits often produce the same symptoms as diarrhea but only for a short time. Similarly, mothers believe that the emergence of milk teeth or an accidental fall causes diarrhea in children. This belief develops because children tend to get diarrhea when they put contaminated objects in their mouth; this happens to coincide with the emergence of their first teeth and with increased mobility, though the latter is clearly not the cause. When mothers think that the emerging teeth have caused the diarrhea, they ask the traditional healer to pull out the teeth, but of course this does not help. We found that children who visited a traditional healer were more likely to die of diarrhea than those who did not.

Traditional beliefs about the causes of health and illness are also connected to the importance placed on spiritual and social forces. Religious peo-

ple place great importance on the powers of local spirits, some of whom are mischievous and some protective. The mischievous ones bring illness to careless people who wander out at night; for example, venereal disease comes from urinating while facing the moon. Protective spirits are thought to help if the newborn is kept indoors for the months before christening or if an amulet is worn around the neck. The evil eye is recognized almost universally as a bad spirit, though its characteristics are somewhat different in different traditional cultures. In Ethiopia, it is often the eye of a jealous person, who may unconsciously throw a malicious and harmful look your way. They may be jealous of your attractive looks, your plump baby, or your happy marriage. Similarly, the evil eye may be cast because of neighborly disagreements. This points out how important it is to maintain social harmony and avoid conflicts with others in traditional societies.

Religious leaders and traditional healers are considered to be particularly powerful in dispelling bad spirits and invoking the help of good spirits. With the help of holy water, amulets, and special herbs, they dispel harmful forces. Often, these traditional practices are harmful in that they provide a false sense of security while the sick person neglects to obtain more useful medication or advice until it is too late. On occasion, the healer makes an incision that leads to bleeding, infection, and death. However, in one sphere of illness, traditional healers have a well-earned reputation, namely when the patient has a mental health problem such as anxiety, depression, or psychosis. Their emphasis on the spiritual and social life of the patient appears to be particularly effective in dealing with these problems.

Traditional healers continue to thrive in Ethiopia and elsewhere for a number of reasons. It is often quicker and less costly to go to the community healer than to travel long distances to the nearest clinic. However, even when the health service was close and free, we found that Ethiopian mothers often preferred traditional healers. Healers have been around for a long time and their success rate has been passed down through generations; their failure rate is conveniently forgotten or attributed to harmful spirits. They hold the same beliefs as their patients; consequently they use treatments that are familiar to the ill person and his or her family. This reduces the anxiety and stress that accompanies illness and makes the whole family feel better. Moreover, they may be successful at treating

certain kinds of illness because they deal with the social and psychological aspects of the illness—a principle now universally recognized.

These are important considerations when developing any service; the needs of the whole person and not just their bodily functions must be attended to. I am not suggesting that candy-coated placebo pills be given to anyone who demands a quick cure for their problems, but that beliefs and needs be discussed as part of the treatment. This was the lesson I learned quickly while working in Ethiopia. The principles of behavioral science were usefully applied only when recast into the traditions and social relationships that already existed in that culture.

SUPPLEMENTAL READINGS

Kloos, H. & Zein Ahmed Zein (Eds.) *The ecology of health and disease in Ethiopia.* Boulder: Westview Press, 1992.

Lambo, T. A. & Day, S. B. (Eds.) *Issues in contemporary international health.* NY: Plenum, 1990.

UNICEF, *The state of the world's children.* Geneva, published each year.

40
Medical Diagnosis and Treatment across Cultures

LISA MARIE BEARDSLEY

INTRODUCTION

In this chapter you will "peer through the keyhole" of the doctor's office door to see how physicians make diagnoses and what happens when misdiagnoses occur. You will become familiar with criteria used to make a medical diagnosis. Reasons for more variation in diagnosis in the area of psychopathology compared to biopathology are discussed. Examples and causes of misdiagnoses in cross-cultural settings are also described.

As a result of having this insider's perspective through reading this chapter, you can have more control over your own health care when you visit your physician or are in the hospital receiving treatment. If you are a health care professional, your own diagnoses will be more accurate because of your awareness of some of the diagnostic pitfalls that are influenced by cultural differences. As a result, you will be better able to give or receive health care.

Lisa Marie Beardsley is Assistant Dean at the University of Illinois College of Medicine at Peoria. She is also on the faculty in the Department of Psychiatry and Behavioral Medicine. Her interest in cross-cultural psychology started early—she was born in England to a Japanese-American clinical psychologist and a Finnish national. She has lived throughout the United States, in England, Finland, Sweden, and the Philippines. She earned a Masters in Public Health from Loma Linda University and a Ph.D. from the University of Hawaii.

TOOLS AND RULES FOR OBSERVATION AND DATA GATHERING

Every profession uses its own special tools and materials. Farmers drive tractors and harvesting combines, teachers instruct with books and blackboards, and dentists use drills and amalgam, gold, or composite to fill the holes they drill.

Some methods that different professionals use to get the information they need to do their work properly are unique to their field. Limnologists collect water, algae, and seaweed samples from rivers and lakes. Lawyers study legal records and court cases. Sociologists conduct and analyze surveys and observational studies of human behavior.

All of these different approaches have something in common. They are all ways to make observations and gather information. Sophisticated instruments such as electron microscopes, laser-disk data bases, or laboratory tests are designed to further increase our ability to make observations and collect information.

GATHERING DATA FOR DIAGNOSIS AND TREATMENT IN THE HEALTH PROFESSIONS

In the medical profession, the most fundamental method of getting the information needed for a

medical diagnosis is to interview and examine the patient. Physicians and other health professionals will then use specialized tools and tests to allow them to obtain information beyond what can be obtained by talking with and performing a physical exam of the patient.

Making a diagnosis about the nature of a person's illness depends on a physician's ability to gather sufficient information. This allows the physician to rule out competing explanations of an illness and zero in on the most likely one.

A diagnosis does two basic things. It classifies a particular instance of illness into a category which in turn, informs both physician and patient about the prognosis—the natural course of the condition and the likely outcome of alternative methods of treatment. The most important aspect of making a diagnosis, at least to the patient, is so that he or she may receive relief and appropriate treatment for the problem. The better the physician, nurse practitioner, or other health professional is at gathering information, the greater the likelihood that the patient will receive appropriate and timely care.

There are many manuals available to physicians that describe signs, symptoms, and other criteria used to classify diseases. The mission of the World Health Organization is to promote health on a global scale, and it has been instrumental in the development of manuals that are designed to increase consistency in the collection, coding, monitoring, and reporting of diseases in different countries. Some of these manuals include The *International Classification of Disease* (Ninth revised edition, 1977) and the *International Nomenclature of Diseases: Infectious Diseases* (Volume 2, 1985).

In the area of psychopathology, the American Psychiatric Association's *Diagnostic and Statistical Manual of Mental Disorders* (DSM-III-R) is the standard reference for psychiatric conditions, and it has been translated into Danish, Dutch, Finnish, Japanese, Spanish, and other languages. However, even though classification manuals such as the DSM-III-R describe criteria for diagnoses, physicians from different cultures are more likely to agree on the diagnosis of biopathological conditions such as malaria or coronary heart disease than with psychopathological conditions like major depression or antisocial personality disorder.

Causes of cultural variation in disease and reasons for medical misdiagnoses are discussed in the next two sections.

CAUSES OF CULTURAL VARIATION IN PATTERNS OF DISEASE

Many variations in disease and health cross-culturally are due to biological, economic, and social rather than psychological factors. The majority of longitudinal studies, such as the two large-scale multicentered studies sponsored by the World Health Organization, have found significantly better outcomes of schizophrenia in non-Western countries compared to Europe or North America (Lin & Kleinman, 1988). One reason for this are mediating factors such as more work opportunities, greater tolerance of, and more social support for, mentally ill patients by family members and the community in non-Western cultures.

The effects of diet and other lifestyle factors are seen in the health status of an ethnic group or entire nation. Because this chapter looks at the psychological aspects of misdiagnoses cross-culturally and because there is more agreement about biological and environmental factors that affect health, these latter factors will not be discussed further here. Some of the most significant culturally-rooted lifestyle factors that affect disease patterns are discussed elsewhere (see Ilola, 1990).

What is the relationship between the perception and the expression of physical pain or symptoms? Are psychosomatic symptoms such as upset stomach or insomnia real or imagined? A study of depressed patients of Western and Asian origin who immigrated to Israel showed that culture did not affect the patients' subjective experience of physical distress. All depressed patients had more physical complaints than did controls. This lead to the conclusion that in addition to experiencing *feelings* of depression, depressed people actually do have more *physical complaints* than do people who aren't depressed. Culture affected the voicing of complaints, the weight attached to them, and the significance the examining physicians attached to them, but not the prevalence of complaints (Silver, 1987).

REASONS FOR MISDIAGNOSES IN PSYCHOPATHOLOGY

There are a number of things that contribute to the problem of disagreement among clinicians about

cross-cultural diagnosis in psychopathology. First, the manuals used to classify diseases differ somewhat in various cultures. For example, even though the *Chinese Classification of Mental Disorders* is based on the DSM-III-R, one study found only 75 percent agreement when Chinese and U.S. psychiatrists evaluated the same Chinese patients. The diagnoses of schizophrenia were identical but the U.S. psychiatrist was more likely to recognize major depression whereas the Chinese psychiatrist diagnosed those patients with anxiety disorder or neurasthenia, a type of neurosis (Altshuler, et al., 1988).

Differences in diagnosis are accompanied by differences in treatment. In the example cited above, the Chinese psychiatrists were more likely to hospitalize manic patients but not depressed patients, probably because a nonsuicidal, withdrawn person is well-tolerated by the family and society in Chinese culture.

A second reason for misdiagnosis is that psychopathological conditions have a degree of plasticity. There is a difference between disease (biological process) and illness behavior (the psychological experience and social expression of disease). Cultural variables interact with biological processes and as a result, there is overlap in the culture-specific (emic) and culture-general (etic) features of a disease. There are also differences in the way sick people report symptoms and express signs of illness. For example, Hispanics and Asians are more likely than Caucasians to express their illness as physical illness, something called the somatization trait.

To make diagnostic matters more complex, some culture-bound syndromes have been docu-mented. Even though underlying symptoms may be universal (insomnia, upset stomach, anxiety), a condition may be expressed in a culturally-stereo-typed manner. Some examples are the eating disorder of *bulimia* in North American Euroamericans (mostly females); *susto* in Latin America, characterized by severe anxiety, restlessness, fear of black magic and of the evil eye; and *taijin-kyofusho* (anthropophobia) in Japan. This latter syndrome affects mostly males and is a type of social phobia characterized by the etic components of anxiety and fear of rejection and the emic components of fear of eye contact, concern about body odor, and easy blushing. Figure 1 shows how the emic components of a culture-bound syndrome relate to the etic aspects of the more general condition, in this case social phobias. The percentages are approximations only for the sake of illustration of the relationships among emic and etic components of a condition.

A final pitfall in diagnostic accuracy arises from the use of culturally-biased tests (intelligence tests, questionnaires, etc.). The purpose of back-translation procedures is to minimize testing error and maximize the cross-cultural equivalencies of terms and concepts in diagnostic and screening tests.

What is of particular interest to cross-cultural psychologists is how the diagnoses a clinician makes are affected by internal psychological factors that are the product of socialization within another culture. These culturally-influenced psychological factors affect perceptions and the attributions used to explain observations. These factors include culturally defined expectations and roles that the as-

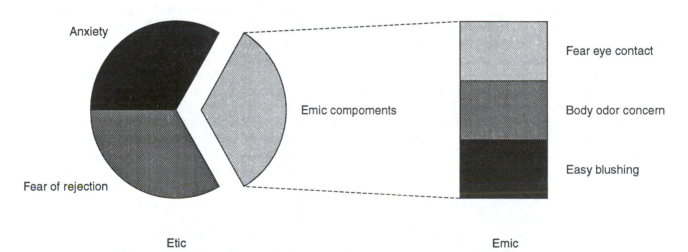

FIGURE 1 Etic and emic aspects of social phobias as illustrated by taijin-kyofusho

tute health professional can use for the benefit of the patient's health.

One dimension along which cultures differ is the psychological distance among those who have power and those who don't. In Japan there is high

What is of particular interest to cross-cultural psychologists is how the diagnoses a clinician makes are affected by internal psychological factors that are the product of socialization within another culture.

power distance and those who are lower in social standing (e.g., students, employees) show respect for superiors (e.g., teachers, supervisors). Patients are also more compliant with physician directions in a culture with high power distance. Health professionals from an individualistic culture may feel uncomfortable with this non-egalitarian hierarchy, but in order to be a more effective therapist they should assume the culturally-ascribed role. Draguns (1990) describes other specific techniques for the therapist who must cross cultures in psychotherapy.

There are other culture-general phenomena such as role expectations and social hierarchies that transcend many cultures. What some of these are and how they affect day-to-day interactions are discussed in more detail in Brislin, et. al. (1986).

Even though clinicians from different cultures may agree about a diagnosis, the diagnosis can still be wrong. The diagnosis must really be what it is judged to be (construct validity). This can only be determined by observing the course of the condition and the effects of treatment over time. For example, it has been argued that episodic heavy alcohol consumption by American Indians does not constitute alcoholism. A 10-year follow-up study of 45 American Indians, however, showed higher mortality from alcohol-related causes and deteriorated health and social status in those who continued to drink heavily. Those who had been abstinent for from 3 to 10 years improved in health and/or social status. This pattern is the same for alcoholics in the

general population and therefore demonstrates the cross-cultural validity of the initial diagnosis of alcoholism in this sample of American Indians (Westermeyer & Peake, 1983).

In summary, both reliability and validity are needed for an accurate cross-cultural diagnosis. The first is demonstrated by agreement among clinicians about the diagnosis (interrater reliability). The second is verification that the disease really is what it is thought to be (construct validity). The natural course of the disease or the results of treatment are the final judge in the latter case.

CONSEQUENCES OF MISDIAGNOSIS

The consequences of a misdiagnosis of illness can be serious and costly. The patient may receive painful, useless, and expensive tests and treatments without any relief from what is really causing the illness. A youngster may be placed in a special-education class for mild to borderline mentally retarded children—as has happened to some Native Americans tested with standard intelligence tests. Or, the person may be subject to social controls such as psychiatric institutionalization because it is decided that the person is a danger to others and himself.

For example, in one study of the reliability of diagnoses, 109 refugees to the United States appealed the psychiatric diagnoses that led to them being institutionalized or incarcerated before they were to be sent back to Cuba (Boxer & Garvey, 1985). The second medical board that reviewed the cases overturned 43 percent of the exclusionary or "Class A" certifications. The most common diagnosis that was overturned was that of antisocial personality disorder. They upheld the majority (72 percent) of the 54 diagnoses of schizophrenic disorders, organic mental disorders, mental retardation, and psychoses.

Other studies have also found similar patterns of consistency in diagnoses, with the highest interrater reliability for organic syndromes (e.g., senile dementia), intermediate levels of agreement for schizophrenia, and the lowest agreement for depression and affective disorders.

Why were the diagnoses of antisocial personality disorder overturned so frequently? One reason is because the diagnosis was made on what the person chose to tell the physician about his past behavior, without any confirming evidence from

medical or prison records, family members, friends, or employers still In Cuba. Because the physicians knew the initial diagnosis and its consequences (expulsion), there may have been some rater bias toward greater leniency. Also, there are two types of antisocial behavior. A technicality in the immigration law allows someone with *adult* antisocial behavior to immigrate but excludes someone when there is evidence of antisocial behavior before the age of 15. Such evidence is difficult to obtain when the person is a refugee.

Even though "antisocial behavior" is detailed in the DSM-III-R, it is also in part culturally defined and environmentally determined. Such behavior may be necessary for survival for someone growing up in a rough and deprived environment. An extreme example is the riots and destruction in Los Angeles after a jury verdict failed to convict police of brutality in the beating of a black man, Rodney King. The verdict surprised millions of people internationally who had seen the beating on television. Even more unexpected was the destruction that followed—innocent victims were attacked, shops were looted, and millions of dollars were lost as homes and buildings burned to the ground. This reaction was antisocial by any definition. But these behaviors were also the combined product of interracial hostility and resentment and frustration because of a lack of economic and social opportunities available to inner-city minority groups in particular.

Racial differences have contributed to the volatility of judicial decisions as in the example above. They have also been found to affect the diagnosis and choice of treatment of psychiatric patients. When compared to indigenous psychiatric patients in one study, the behavior of Asian patients was interpreted as more bizarre and as a result more members of that group were diagnosed as schizophrenic. Treatment also differed according to diagnostic labels. Because more Asian patients in this sample were diagnosed as schizophrenic, they were also more likely to receive electro-convulsive ("shock") therapy than were the non-Asian controls (Saikh, 1985).

Being a member of the majority group does not prevent one from becoming a victim of misdiagnoses. The table may be turned when the physician is culturally different and a foreign medical graduate from the Philippines, Mexico, India, or some other country. This is not to suggest that they are less competent as physicians. However, even though they may have completed medical resi-

dency training in the United States, England, or Canada, they still bring with them some of their own cultural assumptions. Language difficulties increase the potential for misunderstanding and a feeling by the patient that the physician is too different to be trusted. This can have negative effects on patient compliance and satisfaction with the care provided by the physician.

Perceptions aside, there are two sides to the coin. There are also benefits to having physicians and psychiatrists from developing countries, particularly if the patient comes from a developing country too. Because of their training in both developing and industrialized cultures, these psychiatrists are more accurate in diagnosing patients from both developing and industrialized countries. Although their accuracy is good with patients from industrialized countries, psychiatrists from industrialized countries are less reliable when diagnosing patients from a developing country.

SUMMARY

In this chapter it was shown that the first step in making a medical diagnosis is to gather information. It is obtained by interviewing and performing a physical examination of the patient. Laboratory tests and medical reference manuals are also used to identify distinguishing characteristics of a disease. The making of a diagnosis is to classify a particular instance of illness into a category. This is done to determine its prognosis and to select the most appropriate treatment for the problem.

A number of factors contribute to misdiagnoses when the clinician works in a multicultural context. These factors include differing systems of classifying and screening diseases; confounding effects of emic and etic manifestations of illnesses; the existence of culture-specific syndromes; and cross-cultural differences in the perception, attribution, and expression of signs and symptoms of diseases.

The better the physician, nurse practitioner, or other health professional is at gathering information, the greater the likelihood that the patient will receive medically sound, culturally appropriate, and timely care.

REFERENCES

Altshuler, L. L., Xida, W., Haiqing, Q., Hiqng, H., Weiqi, W., & Meilan, X. (1988). Who seeks mental health

care in China? Diagnoses of Chinese outpatients according to DSM-III-R criteria and the Chinese Classification System. *American Journal of Psychiatry, 145*(7), 872–875.

Boxer, P. A. & Garvey, J. T. (1985). Psychiatric diagnoses of Cuban refugees in the United States: Findings of medical review boards. *American Journal of Psychiatry,* Jan.; 1421: 86–9.

Brislin, R., Cushner, K., Cherrie, C., & Yong, M. (1986). *Intercultural interactions: A practical guide.* Beverly Hills, CA: Sage.

Draguns, J. (1990). Applications of cross-cultural psychology in the field of mental health. In Brislin, R. W. (Ed.), *Applied cross-cultural psychology.* Newbury Park: Sage, 302–324.

Ilola, L. M. (1990). Culture and health. In Brislin, R. W. (Ed.), *Applied cross-cultural psychology.* Newbury Park: Sage, 278–301.

Lin, K. M. & Kleinman, A. M. (1988). Psychopathology and clinical course of schizophrenia: A cross-cultural perspective. *Schizophrenia Bulletin. 144*: 555–567.

Saikh, A. (1985). Cross-cultural comparison: psychiatric admission of Asian and indigenous patients in Leicestershire. *International Journal of Social Psychiatry.* Spring; 31(1): 3–11.

Silver, H. (1987). Physical complaints are part of the core depressive syndrome: evidence from a cross-cultural study in Israel. *Journal of Clinical Psychiatry, 48*(4), 140–142.

Westermeyer, J. & Peake, E. (1983). A ten-year follow up of alcoholic Native Americans in Minnesota. *American Journal of Psychiatry, 140,* 189–194.

41

Culture and Depression: Discovering Variations in the Experience of Illness

SPERO M. MANSON

As a medical anthropologist who works at the interface of culture and mental health, I am keenly interested in the ways in which people talk about the nature of their distress and illness. These forms of discourse, for me, serve as a means of entry into the models that they employ to make sense of emotional and psychological problems. Over the years, my interests have encompassed a number of disorders, from alcohol abuse and dependence through post-traumatic stress disorder. However, depression was the first to capture my attention and remains among the most intriguing illnesses to understand in terms of its phenomenology, manifestation, as well as treatment across different cultures (Kinzie, Manson, Do, Nguyen, Bui, & Than, 1982; Manson, Shore, & Bloom, 1985). In this chapter, I hope to convey how the struggle to understand the content, form, and meaning of depression among the people with whom I work leads us to

reconsider many of the basic assumptions that we may have about the world around us and our way of viewing it.

In 1978, having just completed my doctoral work, I joined the faculty in the Department of Psychiatry at the Oregon Health Sciences University. During the first few months of that appointment, it became clear to me that if I wished to pursue a career investigating the relationship between culture and mental health, I needed to properly equip myself for this endeavor. Consequently, as an anthropologist, a logical first step was to focus on the practices of the colleagues around me. Thus, I undertook a clinical fellowship that spanned two years, and took me into the local psychiatric emergency room every week. There I observed, and later employed, structured diagnostic techniques. This experience gave me a firm grounding in the nosology that guides modern-day psychiatry. Sitting with psychiatric residents in training and intermittently supervised by my colleagues, I gradually learned the logic and language by which they brought coherence to the illnesses presented by their patients.

This logic is codified as the American Psychiatric Association's *Diagnostic and Statistical Manual*, commonly referred to as the *DSM*. There have been, to date, three major editions of the *DSM*; presently the field operates in terms of the third version, which was revised in the mid-1980's. Work is underway on a fourth edition, which will appear in

Spero M. Manson (Pembina Chippewa) is Professor, Department of Psychiatry, and Director, National Center for American Indian and Alaska Native Mental Health Research, at the University of Colorado Health Sciences Center. He also co-directs the Robert Wood Johnson Foundation's Healthy Nations Initiative, a $13.5 million effort to assist Indian and Native communities in their struggle to reduce substance abuse. Manson received his doctorate in medical anthropology from the University of Minnesota in 1978.

1993. I return to this development at the close of the chapter, indicating how some of the lessons that I and others have learned over the years are informing the latest revision of this taxonomic system.

During the early phase of my clinical fellowship, I was amazed at the extent to which fellow trainees and supervising clinicians gleaned similar insight from the stories that they elicited from their patients: the words that they found important, the themes that they attempted to articulate, and the consistencies or inconsistencies that they found therein. Over time, I acquired a similar ability to identify elements of patients' discourses that my peers and teachers considered important. However, I also spent a great deal of time in the reception area, observing patients and their family members upon entry to the emergency service. Visiting with them there, I noticed that they tended to speak differently about their problems, using not only other words and phrases, but emphasizing different aspects of their experiences than did my colleagues. I decided to study this matter more systematically.

I began by searching many sources for words and phrases that may be used to describe depression and anxiety, the most common complaints voiced in this clinical setting. I scoured textbooks, journal articles, even biographical accounts of the mentally ill. Eventually, I accumulated 100 words or phrases frequently associated with depression and anxiety. Each word or phrase was carefully reproduced on a 3" × 5" note card. I began interviewing individuals using these words or phrases as stimuli.

The groups of interest to me included white middle class U.S. patients attending an adult outpatient clinic at the university where I worked; American Indian patients seen in an adult outpatient clinic at a service unit on a Northwest reservation; and psychiatric residents in training (virtually all of whom were from white, middle or upper class backgrounds). Over a five-year period I interviewed nearly 150 individuals in each of the patient groups and approximately 75 psychiatric residents.

The interview revolved around a fairly simple task, called a Q-sort procedure. Specifically, I presented each individual with the same stack of 100 3" × 5" cards and asked him or her to flip through it one-by-one, placing each card in a pile that represented words or phrases that she or he believed "belonged together." There was no limit to the number of piles that a person might construct or to the number of cards that could be placed in any given pile. Individuals were permitted to change their minds (and often did) about which cards they

wished to assign to certain piles; they even lumped and split piles as the process unfolded. The only constraint was a 10-minute time limit that I imposed on this task: many people became so engrossed in sorting the cards that they lost all track of time! Having finished, I questioned each individual about how she or he approached the task: "Why did you group these cards together in this (each) pile?" "What is the common feature(s) among them?" "What distinguishes one pile from another?" "Are certain piles more or less like some than others?"

This procedure provides a quick means of eliciting the cognitive maps by which people order phenomena in their everyday world. Anthropologists, linguists, and cross-cultural psychologists, for a long time, have used such techniques to describe how people organize colors, flora, kinship relationships, even life on skid row (see Spradley, 1972). Though there are limits to such methods, the investigator nevertheless acquires some insight into other constructions of reality.

I proceeded to analyze the data, employing sophisticated multivariate statistical procedures that enable one to determine patterns otherwise not observed easily. The results revealed a remarkable degree of consistency among individuals from the same group and significant variation across white, middle class patients, Native American patients, and psychiatric residents. Figures 1, 2, and 3 depict the cognitive maps that emerged.

Each box signifies a "pile"—cluster, grouping, or category—that was common to the individuals from a given setting who completed the task described above. The lines between the boxes similarly indicate relationships reported to exist between "piles."

Before continuing, take out a piece of paper, write the numbers 1, 2, and 3, and indicate the group of individuals to which you believe each figure corresponds: white, middle class patients, American Indian patients, or psychiatric residents. Done?

Figure 1 represents the organizational schema that characterizes the responses by psychiatric residents; Figure 2 that of the American Indian patients; Figure 3 that of the white, middle-class patients. Surprised? Most people are.

Actually, many mental health professionals are able to guess correctly that Figure 1 recapitulates the psychiatric perspective. These five clusters or groupings mirror central themes of the *DSM*—referred to as diagnostic criteria—in regard to the

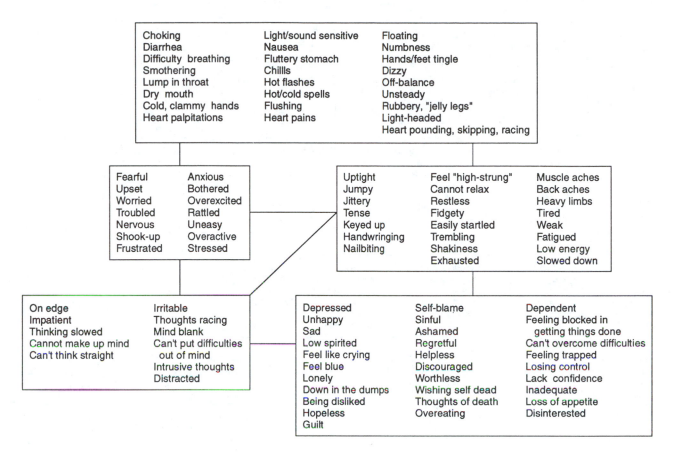

FIGURE 1

nature of mood and anxiety disorders. These included dysphoria or depressed affect, hyperarousal, self-focused attention (increased sensitivity to physiological cues), and cognitive distortion, especially heightened perceptions of threat. When questioned, the psychiatric residents unhesitantly referred to the *DSM* as the basis for their decisions about how they categorized the cards.

The American Indian patients (Figure 2) sorted the same words and/or phrases into eight quite different categories. There are some similarities to the young psychiatrists-in-training, notably with respect to feelings of sadness and despair. However, close inspection reveals that many signs and symptoms have been realigned with others in unanticipated ways. Moreover, one cluster (the one not connected to any of the other clusters) is seen as totally unrelated to *any* of the other clusters: a perspective without parallel among either the residents or white patients. One reason for such differences is the lack of similar emphasis in distinguishing between psyche and soma, which reflects

a long Western intellectual history of mind-body dualism.

Perhaps the most counterintuitive results are those from the white, middle class patients (Figure 3). They perceived 15 separate groupings or clusters among the 100 cards. Clearly, these individuals more finely discriminated certain kinds of experiences, especially somatic or bodily sensations, from others.

You might have expected the cognitive map of American Indians to differ from their white, middle class counterparts and from psychiatrists. However, few of us probably would predict the divergence between the latter two, especially since they seem to share so much in terms of their respective cultural backgrounds. Yet, this is a very powerful example of how culture shapes the organization of the key signs and symptoms of an illness experience, in this case, depression and anxiety, which often are assumed to be universal in nature.

Here, there are three cultures at work: those specific to the families and communities of white

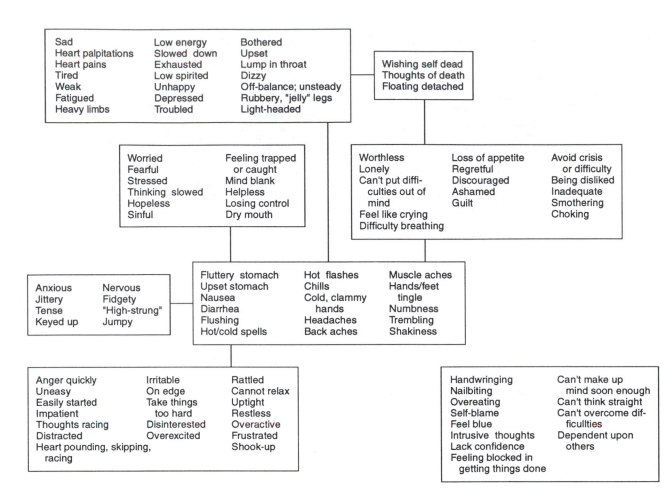

Sad	Low energy	Bothered
Heart palpitations	Slowed down	Upset
Heart pains	Exhausted	Lump in throat
Tired	Low spirited	Dizzy
Weak	Unhappy	Off-balance; unsteady
Fatigued	Depressed	Rubbery, "jelly" legs
Heavy limbs	Troubled	Light-headed

Wishing self dead
Thoughts of death
Floating detached

Worried	Feeling trapped
Fearful	or caught
Stressed	Mind blank
Thinking slowed	Helpless
Hopeless	Losing control
Sinful	Dry mouth

Worthless	Loss of appetite	Avoid crisis
Lonely	Regretful	or difficulty
Can't put diffi-	Discouraged	Being disliked
culties out of	Ashamed	Inadequate
mind	Guilt	Smothering
Feel like crying		Choking
Difficulty breathing		

Anxious	Nervous
Jittery	Fidgety
Tense	"High-strung"
Keyed up	Jumpy

Fluttery stomach	Hot flashes	Muscle aches
Upset stomach	Chills	Hands/feet
Nausea	Cold, clammy	tingle
Diarrhea	hands	Numbness
Flushing	Headaches	Trembling
Hot/cold spells	Back aches	Shakiness

Anger quickly	Irritable	Rattled
Uneasy	On edge	Cannot relax
Easily started	Take things	Uptight
Impatient	too hard	Restless
Thoughts racing	Disinterested	Overactive
Distracted	Overexcited	Frustrated
Heart pounding, skipping,		Shook-up
racing		

Handwringing	Can't make up
Nailbiting	mind soon enough
Overeating	Can't think straight
Self-blame	Can't overcome dif-
Feel blue	ficullties
Intrusive thoughts	Dependent upon
Lack confidence	others
Feeling blocked in	
getting things done	

FIGURE 2

and American Indian patients and that of the biomedical tradition, in which the psychiatric residents, like children in the others, are acquiring a basic set of values, beliefs, logic, and language. Let me illustrate.

As all of us have, while growing up, I sometimes feigned being too sick to do a chore, go to school, or comply with some other expectation of me. I vividly remember times when my mother responded: "Well, you certainly don't look sick," and forced me to follow through with the obligation at hand.

This simple example suggests that we are subject to subtle, but profound socialization processes that deeply affect our perceptions, behavior, and attributions of meaning. Families, friends, and coworkers are the primary groups of socialization in most of our lives, and at different points in our lives. Hence, the psychiatric residents that I interviewed were applying lessons learned from their "families" (fellow trainees and supervising clinicians) to make sense of the many words and phrases presented to them by their patients. These

Everyone possesses models for explaining illness and distress. These models are not necessarily the same from one group to another.

particular lessons are intended to communicate the basic elements of the cognitive map characteristic of psychiatry, as embodied in the *DSM-III-R*. Medical

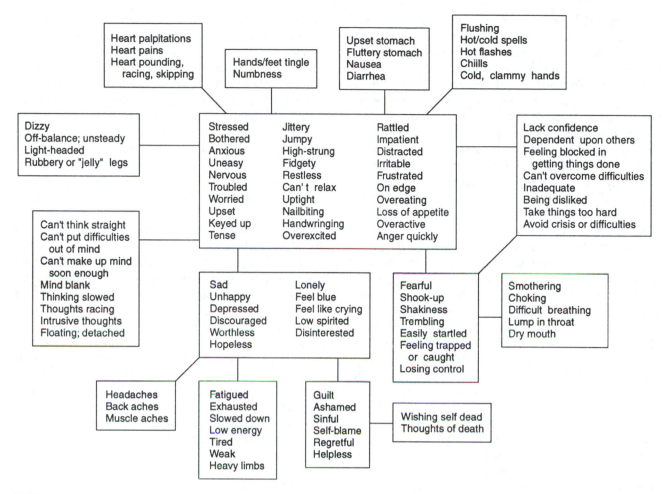

FIGURE 3

anthropologists refer to such cognitive maps as "explanatory models" (Kleinman, 1988). Everyone possesses models for explaining illness and distress. As the responses to the sorting task described above suggest, these models are not necessarily the same from one group to another.

Explanatory models of illness not only organize the signs, symptoms, labels, or idioms that people employ to talk about matters like depression and anxiety, but also their beliefs about causation, associated psychological processes, precipitating situations, and treatment alternatives (Kleinman & Good, 1985). For example, from the biomedical perspective, disease is presumed to be a consequence of some maladaptation, maladjustment, or malfunction of human biology. Thus, psychiatrists speak of major depressive disorder as a biochemical imbalance, resulting from the interaction of psychic trauma and physiological mechanisms. However, among Catholic Pentecostalists, depression may be seen as God's retribution for moral transgression; for Haitian Blacks, it may follow from supernatural intervention.

Meaningful distinctions among the concepts of depression as a transient, everyday mood, as a symptom ("I feel depressed"), and as a disorder (major depressive episode) also are embodied in a culture's explanatory models. The *DSM* assumes that such experiences are unidimensional, linear, and additive in nature, not unlike a ruler. A combination of depressed affect (feeling sad, blue, or downhearted), cognitive impairment (inability to concentrate), physiological disturbance (trouble sleeping, fatigue, psychomotor agitation), and behavioral change (rapid weight gain or loss) lasting two weeks or longer defines major depression. However, the "markers" on a ruler may vary from one group to another akin to the difference between metric and non-metric systems of measurement. Not only may the scale of measurement differ in

terms of minimal unit(s), e.g., millimeter versus 1/32th of an inch, but the significant categories of aggregation may not correspond as well, e.g., centimeter and meter versus inch, foot, and yard. Thus, backaches, exhaustion, and persistent distress may not be perceived as abnormal by a single, impoverished African-American mother for whom such ailments are a part of her day-to-day life. Likewise, a period of prolonged grief and mourning, lasting up to one year, in regard to the recent death of a loved one may be acceptable, indeed expected among older Hmong, with behavioral and dietary proscriptions as well as anniversary celebrations to commemorate the deceased.

Explanatory models also posit that certain situations expose an individual to pathogens or agents of illness. The *DSM* lists job loss, divorce, family conflict, and chronic illness as situations of vulnerability that contribute to risk of major depression. Among American Indians, ignoring important social obligations or failing to observe religious dictums may leave one open to potential harm. Among Punjabi Muslims, violating dietary restrictions or trespassing on sacred places invites divine interdiction.

Lastly, explanatory models typically encompass assumptions about available, relevant, and desirable methods for treating an illness. A psychiatrist often recommends antidepressants and cognitive-behavioral therapy to control the psychophysiologic symptoms of depression and to resolve emotional distress. White, middle-class Americans may try homeopathic as well as naturopathic medicines. Asian Americans typically view acupuncture and herbal treatments as appropriate; Christian fundamentalists may seek faith healing alternatives. Key people in these cultures serve as gatekeepers, validating symptom expression and directing the individual toward potential treatment resources. Different kinds of help-seeking behavior may be encouraged in terms of simultaneous or successive hierarchies of resort (e.g., seeking help from more than one source at the same time or from multiple sources one after the other).

This growing body of evidence in regard to cross-cultural variation in the content, form, and meaning of illnesses like major depression poses a significant challenge for present-day psychiatry. Maser, Kaelber, and Weise (1991) recently surveyed 146 mental health professionals, primarily psychiatrists and psychologists, from 42 countries as to international uses of and attitudes toward the *DSM-III-R*. Nearly a quarter of the respondents reported that the mood disorders are problematic and need revision. Maser et al. concluded by emphasizing the cross-cultural deficiencies of the *DSM*, and the need to address this broader range of experience in the nosology and diagnostic formulation.

There are no easy means available by which to accomplish this goal. Much more is required than tinkering with the kind, number, clustering, or duration of symptoms. The focus needs to be on the process of inquiry, the way in which a clinician elicits the respondent's story of his or her illness (Kleinman, 1988). This process should continue to emphasize the careful clinical description that led to the development of the *DSM-III*; however, in this case, that tradition now needs to be extended beyond the middle and upper classes of U.S. and European society to the remaining, non-Western world that constitutes the vast majority of humankind. A better understanding of the phenomenology of mood disorders across these settings will have to encompass much more than simply the symptoms expressed by a patient. It must take into account the social contexts and cultural forces that shape one's everyday world and that give meaning to interpersonal relationships and life events.

REFERENCES

Kinzie, J. D., Manson, S. M., Do, T. V., Nguyen, T. T., Bui, A., & Than, N. P. (1982). Development and validation of a Vietnamese-language depression rating scale. *American Journal of Psychiatry, 139*(10), 1276–1281.

Kleinman, A. (1988). *Illness narratives.* New York, NY: Academic Press.

Kleinman, A., & Good, B. (1985). *Culture and depression.* Berkeley, CA: University of California Press.

Manson, S. M., Shore, J. H., & Bloom, J. D. (1985). The depressive experience in American Indian communities: A challenge for psychiatric theory and diagnosis. In A. Kleinman & B. Good (Eds.), *Culture and depression.* Berkeley, CA: University of California Press.

Maser, J. D., Kaelber, C., & Weise, R. E. (1991). International use and attitudes toward DSM-III (-III-R): Growing consensus in psychiatric classification. *Journal of Abnormal Psychology.*

Spradley, J. (1972). *You owe yourself a drunk.* Seattle, WA: University of Washington Press.

42
A Culture-Centered Approach to Counseling

PAUL PEDERSEN

Counseling is a broadly defined aspect of communication focused on giving help toward the solving or management of personal problems by skilled providers. This help-giving may range from the formal methods and setting of scheduled office interview to a less formal setting in more spontaneous surroundings. Counseling as psychotherapy has emphasized the medical model of treating persons who are ill, while counseling as education has emphasized the psychoeducational model of teaching or training persons toward greater competence. Counseling as guidance is a 20th Century phenomenon growing out of humanitarian reform movements and the need to identify skilled work force or vocational guidance. This emphasis was replaced during the 1940s with an emphasis on counseling as psychotherapy. More recently the emphasis seems to be returning to psychoeducational goals for counseling. Throughout these changes counseling has always emphasized values based in

Paul Pedersen is a Professor in Counseling Education at Syracuse University. In 1968 he earned his Ph.D. from Claremont Graduate School in Asian Studies emphasizing Asian psychology. He has an M.A. in American Studies and an M.S. in Educational Psychology from the University of Minnesota. He taught in Indonesia, Taiwan, and Malaysia for six years and was Director of NIMH cross-cultural counseling program at the University of Hawaii for four years. Among his several books is *Counseling across Cultures* (University of Hawaii Press) of which he is the senior of four co-editors. He is a Fellow in Divisions 9, 17, and 45 of the American Psychological Association.

a Euro-American, dominant culture perspective. There has been considerable controversy about the extent to which counseling has supported the status quo and protected the interests of a majority culture without regard to the interests of minorities. In its pervasive emphasis on "the person," counseling as a field has frequently disregarded the cultural context in which that person lives.

A culture-centered approach to counseling is focused on *both* the person *and* the cultural context in which that person lives. If "person-centered" counseling is focused on the individual then "culture-centered" counseling focuses on the culturally-defined factors that shape that person's identity. If individual differences are what you were born with, then cultural differences include everything that has happened to you since that time in socialization and enculturation processes that vary from group to group. Your skin color, for example, might be an individual difference you were born with but *what* that skin color has come to mean is very much part of your cultural identity.

Many approaches to counseling emphasize the importance of culture. Cross-cultural counseling emphasizes the methods of interacting with persons from different cultures, usually defined as nationalities or ethnicities. Intercultural counseling likewise emphasizes methods of working with culturally different persons. Both of these approaches tend to compare cultures. This frequently results in one culture being valued higher than the other. Both approaches also tend to define culture narrowly according to ethnicity and nationality exclusively. Multicultural counseling emphasizes the

multiplicity of cultures to which we each belong—defining culture broadly rather than narrowly—and is focused on the complex and dynamic *salience* of each culture in turn according to the situation. The culture-centered approach favors a multicultural rather than a cross-cultural or an intercultural perspective.

Culture embraces many factors that can have an impact on the counseling process. They include demographic variables such as age, gender, place of residence; status variables such as social, economic, and educational; and formal or informal affiliations to your family, your career, or to the ideas you share with others as well as ethnographic variables such as nationality and ethnicity. Any one of these many different identities you have might be the most important part of your life as you move from place to place and time to time. For example, you might live in a wheelchair but that doesn't mean that age, gender, ethnicity, nationality, or socioeconomic status are not important parts of who you are. Culture is therefore defined not as an exotic, abstract, or detached phenomenon but a learned perspective inside each person central to that person's identity.

Your *identity*—who you are—changes as you talk to different people, move from one place to another, and as you grow older. That cultural identity is a combination of how you are *similar* to the people around you as well as how you are *different* and unique. If your cultural identity overemphasizes similarities then you will lose your identity in a "melting pot" of the stronger or dominant cultures. If your cultural identity overemphasizes differences then you will be stereotyped or isolated from other groups or individuals around you. Within-group differences are at least as important as between-group differences. To see culture clearly you need to become "cross-eyed," with one eye looking at similarities and the other eye focused on differences at the same time (Pedersen, 1991). Within-group differences are at least as important as between-group differences, a fact that researchers on stereotypes emphasize.

Think of your culture as your "teachers" who have taught you when and how to do what you do. Each person has many cultures just as each student has had many teachers in school. Before you were born, cultural patterns of thought and action were already prepared to guide your thinking, shape your decisions, and help you take control of your life. Culture is inside you in the memories of what your thousand or so "culture-teachers" taught you to say and do or not to say and not to do. Culture is

important because it "teaches" you what to do or say. It teaches you the "rules of the game." What you *do* and the *meaning* behind what you do comes from your culture teachers. For example, two persons come toward you and both of them are smiling—same behavior—but only one of them wants to be your friend—different expectation. The culture inside you is important because it controls your behavior and your interpretation of other people's behavior. It is only when you understand the culturally learned expectations and values of somebody else from their cultural viewpoint that you can hope to understand their behavior. Even when people act differently from you they might share the same expectations or values. If you focus on the "strange" way people from different cultures behave you will never understand that they may want, expect, and value the same things that you do. These similar expectations and values become the "common ground" for mediating multicultural conflict (Pedersen, 1988).

A "culture-centered" approach to counseling is not distracted by the strange ways that people from different cultures behave. Rather, it is focused directly on the culturally-learned expectations and values behind those behaviors. If you can find the common ground of shared expectations and values, then you will be much more tolerant and accepting of behaviors that seem strange to you. For example, think of your best friend and ask yourself whether or not that person always behaves exactly as you do. You will probably be more accepting, tolerant, and even understanding of your best friend's strange behavior *because* you share the common ground expectation of friendship. If a stranger said or did those things to you it would have a very different reaction. The "culture-centered" approach to counseling is based on the search for common ground across cultures. If you understand the culturally-learned expectations and values of other people, you will be better able to help them understand or interpret the different behaviors.

Other approaches to counseling have emphasized the "unconscious" (psychodynamic) forces which control a person's life; or the "response" (behavioral) to stimulating and attractive rewards which guide our behaviors; or the positive meaning of "self" (humanism) which describes our search for self fulfillment. This culture-centered approach is a fourth way of explaining behavior in the complex and dynamic but not chaotic ways in which we have responded to our many different culture teachers. We have "learned" our culture and part of

that learning is almost certainly "unconscious," and "rewarding." To achieve self fulfillment, it is essential to develop or fulfill a cultural identity of who you are in relation to your culture teachers.

COUNSELING AS THE UNDERSTANDING OF "CULTURAL DIALOGUES"

The culture-centered approach to counseling is a conversation not just with the individual client or counselee but with the many different culture teachers who have taught the individual the values and expectations which shape that person's behavior. The individual person becomes like a "committee" of these culture teachers discussing together the problems or decisions that confront the individual. To understand and help that person, the counselor or helper needs to hear the "internal dialogue" among those culture teachers that is taking place inside the individual.

One approach to training counselors for work in multicultural settings helps train counselors to understand the "internal dialogues" of culturally different clients (Lefley and Pedersen, 1986). When a counselor works with a client, there are three conversations going on at the same time. One conversation is the counselor talking with the client ("How are things going today?"). A second conversation is the internal dialogue inside the counselor's head ("I wonder if I said the right thing"). A third conversation is the internal dialogue inside the client's head ("What should I say in response to that polite question?").

To do a good job of counseling the counselor needs to know what the client's "culture teachers" are saying inside the client's head reminding that

To do a good job of counseling the counselor needs to know what the client's "culture teachers" are saying inside the client's head reminding that person of culturally learned values and expectations.

person of culturally learned values and expectations. You have to know what he or she is thinking but not saying before you can accurately interpret what that person means. You may not know what someone from another culture is thinking but you *do* know two things about their thinking. You know that part of their thinking is positive—about good things that are happening—and part of their thinking is negative—about bad things that are happening. These are the culture teachers guiding the client by reminding that client about what to expect and value. For example, right now as you read this chapter part of your own internal dialogue is probably looking at the way these ideas fit with your own and part of that dialogue is probably looking at the way these ideas do not fit. That internal dialogue is a discussion between your different "culture teachers" while you make up your mind what you think.

TRAINING IN MULTICULTURAL COUNSELING

One way that multicultural counselors are trained is by matching a coached client with two other culturally similar persons—one as a *procounselor* emphasizing the positive and one as an *anticounselor* emphasizing the negative side of what the client is thinking but not saying in a role-played interview. The culturally different counselor can now hear both the positive and the negative side of the client's internal dialogue and learn more about what that person's culture teachers are saying. This has been called *triad* or *triadic* counseling (Pedersen, 1988).

The different theories or skills a counselor uses are judged by the client's culture teachers as friendly or unfriendly, helpful or hurtful, useful or useless depending on whether that counselor can find common ground with the client. Being helpful to others depends on being able to hear the internal dialogue of culturally different clients—to hear the things that others are thinking but not saying. Listening to the client's culture teachers will help counselors understand and translate the values and expectations behind behaviors to find the common ground.

The definition of culture-centered counseling involves awareness of culturally-learned assumptions, knowledge of culturally relevant facts, and skill for culturally appropriate action (Sue, Bernier,

Durran, Feinberg, Pedersen, Smith, and Vasquez-Nuttall, 1982). An awareness of culturally-learned assumptions is the first stage and foundation for culture-centered counseling. However, if the counselors don't go beyond awareness, they will lack the knowledge and the skill to make a difference (Pedersen, 1988).

A knowledge of culturally relevant facts about different cultures based on accurate assumptions is the second stage of culture-centered counseling (Pedersen, Fukuyama, and Heath, 1989). Some approaches to counseling across cultures emphasize the importance of facts and information by themselves but without culturally accurate awareness or culturally appropriate skill. Just *knowing* about other cultures is insufficient.

Translating counseling skills appropriately to culturally different settings is the third and most developed stage of culture-centered counseling. The temptation is to disregard the importance of accurate awareness and relevant knowledge while jumping directly to skilled action. Without awareness and knowledge, the counselors will never know whether they are making things better or worse for culturally different clients, no matter how skilled the counselor is. This "multicultural three-step" from awareness to knowledge to skill describes the development of a culture-centered approach to counseling.

The arguments for culture-centered counseling have traditionally been based on the ethical importance of recognizing the other person's viewpoints. The ethical imperative to "do good" is a strong and persuasive argument, but professional counseling associations have not yet dealt with their own "cultural encapsulation" through the implicit culturally learned assumptions of a dominant culture in the ethical guidelines they present (Pedersen, 1988). A still stronger argument for culture-centered counseling can be based on the importance of *accuracy*. If you criticize someone because their behavior is unethical, they may very well dismiss your criticism by saying you have your way and they have theirs. If, however, you criticize someone because they are inaccurate or factually wrong they are much more likely to pay attention.

Culture-centered counseling is primarily an attempt to increase a counselor's accuracy in helping other persons. Without accurate assumptions and relevant knowledge about other cultures, coupled with appropriate skills, the counselor will be unable to match what others are doing to the values and expectations that shape those behaviors. The same

behavior most often does not have the same meaning across cultures. The same behavior will be exactly right according to some cultures' times and places but exactly wrong according to others. For example, a familiar western fable about the grasshopper and the ant celebrates the ant's individualistic diligence and hard-working nerseverance by gathering food while in other non-Western cultures, the same fable judges the ant's behavior as selfish and uncaring for the welfare of others. If you don't know the rules, you can play the game but you probably will not succeed. A culture-centered approach to counseling means attending to the different rules that each of us has learned from our culture teachers about what to do and when and how to do it.

There are several advantages of the culture-centered approach to counseling. First, emphasizing culture will help counselors be more accurate in matching a person's culturally-learned expectations and values with that person's behavior. Second, being culture-centered will help counselors become more aware of how their own culturally-learned expectations and values shape their own behaviors. Third, a broad definition of culture allows the culture-centered counselor to discover common ground with culturally different people and their strange behaviors. Fourth, staying centered on the individual's culture will help counselors track and follow individuals being pulled this way and that way by their culture teachers as those individuals develop and apply their own cultural identity. All of this can only lead to more accurate diagnoses and consequently more accurate treatment.

The culture-centered approach to counseling allows people to be different from one another without blame because no matter how different people are from one another, there will always be some area of common ground where they share the same culture teachers. The culture-centered approach is based on finding that common ground and building on that area of shared culture as a platform where people from different cultures can find a place to stand. The culture-centered approach goes beyond what people do to the culturally learned reasons for doing it.

We are moving toward a future which is so different from life as we know it that it is literally beyond our wildest imagination. Many of us will not be able to survive in this future culture because we will not be prepared for that radical a change. How will we learn to survive in a vastly different future culture? We will learn by deliberately put-

ting ourselves in contact with those who are culturally different from ourselves instead of isolating ourselves among people who are culturally similar. A counselor who isolates himself or herself from the multiplicity of cultures cannot be totally effective. By learning to work with people who are different from ourselves, we will develop the facility for being culture-centered and that facility will prepare us for the future.

REFERENCES

Lefley, H. P., & Pedersen, P. B. (1986). *Cross-cultural training for mental health professionals.* Springfield, IL: Charles C. Thomas.

Pedersen, P. (1988). *A handbook for developing multicultural awareness.* Alexandria VA: American Association for Counseling and Development.

Pedersen, P. (1991). Multiculturalism as a generic approach to counseling. *Journal of Counseling and Development, 70*(1), 6–12.

Pedersen, P., Fukuyama, M., & Heath, A. (1989). Client, counselor and contextual variables in multicultural counseling. In P. Pedersen, J. Draguns, W. Lonner and J. Trimble, (Eds.), *Counseling across cultures: Third edition.* Honolulu: University of Hawaii Press.

Sue, D. W., Bernier, J. E., Durran, A., Feinberg, L., Pedersen, P. B., Smith, E. J., & Vasquez-Nuttall, E. (1982). Position paper: Cross-cultural counseling competencies. *Counseling Psychologist, 10*(2), 45–52.

43

Reaching the Underserved: Mental Health Service Systems and Special Populations

LONNIE R. SNOWDEN & ALICE M. HINES

In seeking to help people in need, most governments around the world often create social programs. These government-sponsored efforts complement ongoing activities by individuals and organizations seeking to meet similar needs but financed by private fees or an exchange of services. Frequently, government involvement comes about because the system of private arrangements leaves some people in need without access to help, either because they are poor and cannot afford help or because they are different from most people and need special assistance, or both.

One area in which the U.S. government, for example, has begun to take responsibility is for problems in mental health, particularly for persons with special needs. The Community Mental Health Center Act of 1963 authorized the creation of a national network of community-based mental health centers. The Child and Adolescent Service System Program (CASSP) was created to address the needs of children and adolescents with mental health problems by promoting greater coordination of effort among agencies providing care. Governmental advisory bodies such as The President's Commission on Mental Health which issued a 1978 report have helped to inspire and monitor such initiatives. The National Institute of Mental Health (NIMH) responded by assigning a high priority to meeting the mental health needs of various special populations including the elderly, children, and adolescents, residents of rural areas, and members of cultural and ethnic minority groups.

There are several reasons for thinking of the elderly as a group with special mental health needs. In an industrialized society like the United States, biological and social factors operating in later life place the elderly at a high level of risk for problems in mental health. The attempt to respond to these

Lonnie R. Snowden is a Professor in the School of Social Welfare at the University of California at Berkeley. He also serves as Acting Director of the Institute for Mental Health Services Research and as a Co-Investigator at the Center for Self-Help Research. He has spent 15 years doing research on race, culture, and ethnicity and mental health programs and treatments.

Alice M. Hines received her Ph.D. from the School of Social Welfare at the University of California at Berkely. She is currently a research associate at the Alcohol Research Group, Institute of Epidemiology and Behavioral Medicine, Medical Research Institute of San Francisco. Her research interests include cross-cultural and cross-ethnic issues related to families and adolescents. She is a co-author with Jewelle T. Gibbs of "Negotiating Ethnic Identity: Issues for Black-White Adolescents," in M.P.P. Root (Ed.), *Racially Mixed People in America* (Sage Publications).

problems effectively with social and psychological services is made difficult by several factors operating in the lives of elderly people. Chief among them are a lack of understanding of the biological and psychological processes that cause people to suffer from problems, and a stereotyped belief held by many people in society that the elderly are inflexible and incapable of being helped. In societies where older people are held in greater esteem than in the United States, such problems may be less common.

Children and youth also require a special effort to understand the problems they may experience in mental health. They need psychological and physical nurturance to ensure healthy development; but they cannot provide for their needs by themselves. The family is generally regarded as having the primary responsibility for nurturing its children and youth. In many societies, the extended family, clan, and community at large are available to support parental child rearing and to take the place of the parents if the need for such assistance should arise. In other societies, like the United States, there is often a reluctance to take steps that might be seen as interfering with the parenting practices of the nuclear family.

This reluctance by wider U.S. society to take responsibility for children and youth has left many needs unmet. A governmental body convened to assess problems in the society in psychological well-being, the President's Commission on Mental Health, reached the following conclusions: "As the commission traveled through America, we saw and heard about too many children and adolescents who suffered from neglect, indifference, and abuse, and for whom appropriate mental health care was inadequate or nonexistent" (President's Commission on Mental Health, 1978, p. 6).

Residents of rural areas also face obstacles not faced by their urban counterparts in finding help for mental health problems. Rural life is often lived within close-knit networks of relationships emphasizing loyalty, respect for authority, and a sense of family and personal responsibility. People with mental health problems may be stigmatized by the community. Professionally-trained people needed to provide services often are reluctant to settle in rural areas, preferring instead the amenities of urban life.

Ethnicity and culture also are important considerations in designing mental health services. The manner in which mental illness is defined as well as preferences for forms of intervention express cultural beliefs. Indeed, the very idea of calling certain problems "schizophrenia" or "depression" and interventions "psychotherapy" or "medication" is one that is culturally conferred. The truth of this realization was brought home to the present authors through a research study in which they were involved. Information was gathered from more than 50 percent of Buddhist ministers serving Japanese-American ministries and belonging to a statewide professional organization in California. The ministers were asked about mental health-related problems of church members and how they tried to help in response. The ministers were divided in their answers. Those who had been trained in the United States and spoke English were more likely than others to use mental health counseling and to make referrals. Ministers who had been trained in Japan and spoke Japanese, on the other hand, felt we had asked the wrong questions. They viewed the problems we described as indicating that the church member had suffered a crisis in religious faith. The idea that such problems indicated difficulties in mental health was not a part of their thinking.

Scholars seeking to understand the needs of special populations and to understand how to respond appropriately with services address the problem at several levels of understanding. One level focuses on the epidemiology of mental health problems, on help-seeking and the use of mental health and other services, as well as on the use of cultural and community-based forms of help as alternatives to formal mental health treatment.

Epidemiology is concerned with understanding the distribution of mental health problems. Which groups are most troubled by which problems? How can we best understand group related differences in levels of suffering? Epidemiological information is useful both to analyze the nature of special needs and to establish priorities for addressing problems that are most pressing.

As part of the largest study of mental health epidemiology ever conducted, the Epidemiologic Catchment Area (ECA) Study (Robins and Regier, 1992) researchers studied Americans of Hispanic and Black African descent. They found surprisingly few differences between these populations and whites in the rates of mental health problems. Other investigators have found differences between African and Hispanic Americans and whites, but they have largely disappeared after differences in income, education, and other indicators of socioeconomic standing have been considered. Thus, if Blacks and Hispanics have more problems than whites, then this difference is reduced and usually

eliminated if the comparison involves people who are different in ethnicity but similar in socioeconomic standing.

On the other hand, epidemiologists have found reliable differences between groups from Native American and Alaska native backgrounds and whites as well as for certain groups of immigrants and refugees. One study conducted in Northern California (Meinhardt & Vega, 1987) found in particular that Cambodians and other people from Southeast Asia suffered from high levels of psychological distress. Many of these people suffered terribly as a result of the war in Southeast Asia and government-sponsored political terror. These traumas were compounded by suffering in refugee camps and made the already stressful process of adjusting to the United States especially painful.

People in need must initially explain to themselves why they are feeling badly; often they will then take action on their own in an attempt to solve problems themselves. Their cultural background influences the way in which they perceive, describe, and explain the problems they are having. They may decide that they are in spiritual crisis and visit a religious figure, that they are possessed by supernatural forces, or that they are suffering from a problem in mental health. Thus, only after deciding that their problem involves mental health would they seek psychological treatment or other mental health care. For example, suppose a person feels dull, lacks his/her usual level of energy, becomes disinterested in work, recreation, and family, and is generally unhappy. In the United States, it has become accepted in some places for people with these complaints to label themselves ill and to use the psychiatric term "depression." To alleviate these symptoms of depression, such a person might seek counseling or other forms of psychiatric or psychological treatment. In some non-Western cultures, a person with these same symptoms might think of him or herself as having a medical problem and seek the services of medical personnel.

It has been learned that most people in the United States suffering from problems that we would label as problems in mental health believe themselves physically ill and visit a physician. Physicians and nurses often lack proper training and can easily misunderstand the problems they are seeing. Several projects are underway to help medical personnel recognize mental health problems and to treat them properly or to refer mentally disturbed patients to trained mental health caregivers.

Relatively few people from minority communities suffering from mental health problems visit psychiatrists, psychologists, social workers, or mental health programs. A larger number of whites visit these caregivers, although even among whites, far more do not visit them than do.

Studies have shown that in a number of ethnic minority populations, there is an especially pronounced tendency to discuss problems first with members of their families and, if possible, to keep problems within the family. If their problems continue, some minority people visit healers in their communities. These helpers use rituals, herbs, prayer, and other techniques that are not a part of the program of care found in mental health clinics. Practices such as these are similar in certain respects to other practices that have been accepted in the larger society, including acupuncture and health foods.

A well known critic of western psychiatry who is himself a psychiatrist, E. Fuller Torrey, has written a book on the similarities between the western practice of psychological counseling and therapy and the work of folk and native healers in non-Western cultures (Torrey, 1986). In Puerto Rico and among some persons of Puerto Rican heritage, for example, there is a tradition of consulting healers practicing in the community called *espiritismo*. According to Torrey, *espiritismo* believe in a system in which "many problems in life are caused by *causas*, wandering spirits of deceased persons, which may cause pain, disease, unhappiness, anxiety, and interpersonal problems. All of us have *faculdades*, the ability to communicate with these spirits, but in only a few persons does this ability become developed so the person becomes an *espiritista* (also called a medium). People who are troubled by *causas* consult *espiritistas* either privately (a *consulta*) or in a group meeting (a *reuniones*), usually held on a regularly scheduled basis in storefronts called *centros*. The therapy consists of the *espiritistas* attempting to educate and influence the wayward *causa* so that it will no longer cause problems and the person will be well" (p. 155).

To encourage minority people to use mental health programs, it is important to understand how to design programs and how to pay for them in ways that increase access. What types of programs are most likely to provide for the unique needs of ethnic minority populations? How should we finance the services that are provided within such programs?

Several characteristics of programs that help minority people to use them have been discussed extensively. These include involvement of leaders from ethnic minority communities in running the

program, consultation with folk and native healers, and observance of cultural traditions and practices.

Perhaps greatest attention has been given to the proposed use of counselors and therapists who speak the same language as minority clients and are of the same ethnicity. Indeed, the presence of such

To encourage minority people to use mental health programs, it is important to understand how to design programs and how to pay for them in ways that increase access.

staff has been viewed by some critics as the essential ingredient of programs that successfully meet the special needs of ethnic minority people.

On the other hand, there is growing recognition that the true state of affairs is complex and does not lend itself to simple solutions. The fact that a mental health therapist is African American or Chinese American, for example, does not guarantee that he or she and the client are similar enough in background and beliefs to ensure that they can work together effectively. Other factors are sometimes more important: How long have they been in the United States? What is the sum total of their life experiences? Do they like and trust each other? A helping relationship between people from the same ethnic background is more likely to have these elements, but a relationship between people from different backgrounds also may have the same elements. This problem is, of course, not limited to the United States. Almost any country will present somewhat similar patterns.

In order to gain access to counseling and psychotherapy, people from ethnic minority backgrounds must feel that programs in which the services are offered are convenient and welcoming. Factors that promote the easy use of these services include location in minority communities and offering of services according to a flexible schedule.

Certain programs that have these features have come to specialize in serving a minority clientele. These programs are somewhat controversial. They result in the separation of societal groups on the basis of race, ethnicity, and culture. This practice runs counter to an ideal of the past 30 years promoted in social policies, in education, housing, and elsewhere: to encourage the integration of people of differing races and ethnic backgrounds and common participation in communities and programs. Nevertheless, separate programs for mental health treatment appear to be successful in keeping minority clients in outpatient programs and out of mental hospitals.

Along with the design of programs, the manner in which services are paid for affects access and use by ethnic minority people. It has been claimed sometimes that problems of access by people from ethnic minority populations are no more than problems in financing. Many minority group members are poor and are much less able to pay for services than are whites; if everyone had equal incomes or were provided with insurance, according to this argument, failure to use needed services by ethnic minority people would disappear as a problem. There has been little research on this issue but it points consistently away from this conclusion. It is true that when the government has paid for mental health care or has provided such care free of charge, then more mental health services were used by minority people than when they had to pay. Use of mental health care increased for everyone, whether white or minority, but a gap remained between use by ethnic minority people and by whites. Other factors—community and cultural beliefs and characteristics of programs—appear also to be important.

Finally, there are questions to be considered in bringing services to ethnic minority populations focusing on the effectiveness of treatment and quality of care. People come to mental health programs because they wish to be helped with their problems. Like teaching, health care, and other areas in which people need to learn or be helped, certain of the things done to make improvements in mental health are successful in achieving their objective, whereas other things are not. Counselors and psychotherapists attempt to distinguish between those things that are effective in helping people and those that are not; they seek to use the former in working with clients and to avoid the latter.

Typically, this kind of thinking has not taken into account the possibility that therapies that are effective may not be effective with everyone. Thus, some therapies may work with some groups of people but not with others. Among groups for whom there are no benefits, alternative forms of assistance

must be sought. Often these alternatives will involve an understanding of cultural knowledge and practices that make the kind of help being offered more acceptable to people from racial and cultural minority groups, or that are better in line with their outlook on life and beliefs about personal problems.

At the same time, there is a danger in seeking to change therapies that have been shown to work in an attempt to meet special culturally-based needs. Not everything must be changed, nor are all changes necessarily helpful. The challenge is to know when it is most helpful to adapt a counseling procedure or therapy to address cultural differences and when counseling and therapy are already effective and can be performed as is.

The existence of ethnic minority and other special populations challenges us to think carefully about the problems in living that we call mental health problems; about who can use counseling and psychotherapy and in what kind of programs; and about the fact that people go to many different places to solve their personal problems. To help such people, we must recognize and respond to their understanding of their problems and to their preferences, as well as to special psychological and financial needs. We must ensure that they have available to them appropriate forms of care that are effective and delivered by concerned personnel striving to meet the highest standards of practice.

REFERENCES

Meinhardt, K., & Vega, W. (1987). A method for estimating the levels of underutilization of mental health by Mexican Americans and other minority groups. *Hospital and Community Psychiatry, 38,* 1186–1190.

President's Commission on Mental Health. (1978) *Volume 2: The Nature and Scope of the Problem.* Washington, DC: U.S. Government Printing Office.

Robins, L. N. & Regier, D. (1992). *Psychiatric disorders in America.* New York: The Free Press.

Torrey, E. F. (1986). *Witchdoctors and psychiatrists: The common roots of psychotherapy and its future.* New York: Perennial Library.

Psychology and Culture: What Lies Ahead

WALTER J. LONNER & ROY S. MALPASS

If you have read even 75 percent of this book, you have read a lot about culture and behavior. You have been exposed to a wide range of information—some of it more or less obviously interrelated, some of it not so. Your guides in this venture have been accomplished researchers who share our interests in expanding psychology's vistas. We will take some space here to comment on where you have been, on what the issues were—and are—and on what are the implications of having somewhat expanded your comprehension of the world. Some issues are simply those the various chapters are obviously about. Others cut through the individual chapters. We'll try to elaborate on some of these, as well as to emphasize some themes we think are particularly in need of repeating. First, we comment on the concrete aspects of confronting another culture as a traveler, and on some aspects of the value of a broadened understanding of human thought and behavior. Then we will examine some ideas about where this field of scholarship is headed, and close with an invitation to join us.

EVERYTHING'S DIFFERENT; EVERYTHING'S THE SAME

Adult men and women everywhere are mostly unself-conscious examples of their culture. They embody cultural differences. Children, however, seem to have a universal quality that in many ways makes them appear very similar across cultures, at least superficially. They have the same kind of look about them—large heads, big eyes. They're cute. But very early they become children of their own culture, and therefore very early they become dif-

ferent. Children are born to couples who are generally recognized as belonging to a more or less stable relationship, and as having responsibility—in some sense of that term—for their children. But the ways in which children relate to their biological parents, and the social roles the parents and the families they came from relate to their children are remarkably variable around the world. The economics of marriage also differ widely. In some places, such as India, the pressures for new wives to bring wealth into the husband's family (dowry) are so great that wives who fail to respond to the demands of the husband's family are often killed. Now that sounds very strange to a North American mind. Yet spouses are killed in North America daily, some in arguments about family issues, and family economics, or as a result of alcoholism—a condition that is nearly unknown in India. We might reasonably ask, what's the difference? No difference? Totally different? It reminds us of the story, from a few years ago now, of the two economists, one American, one Polish, comparing the economic systems of their two nations. The Polish economist claimed there was no difference between the two economies. The American objected, saying there was a vast difference. The Pole responded with an example:

Pole: "OK, look at the marketplace. In the United States, You can buy anything you want with dollars, and nothing with Zloty's (the Polish currency). Right?"

American: "Right."

Pole: "Right! Same in Poland!"

To a great degree, the extent of differences among cultures will depend on the level of abstrac-

tion at which you approach them. A visitor from North America to a new and different land deals first with lots of concrete and specific differences, at a very low level of abstraction. The people look different. Their clothes look different. Their language is different. The taxicab may be a motorscooter with an enclosed bench on the back, or it may be open, and pedalled rather than motor driven. Outside the airport your bags may be grabbed so fast you can't respond and taken to your cab by boys (hardly ever girls) who then surround you wanting to be paid. You are outside the airport for 20 seconds and already you are hit with culture shock.

You go to a restaurant, find an empty table that has room for four, and sit down. You are soon joined by a group of three who fill up the table, talk with each other, and pay no attention to you apart from an initial smile and a nod. This makes you only slightly uncomfortable. You may find that in public toilets the facility is not a toilet with a seat, but rather a porcelain aperture in the floor with raised places on which to put your feet. After a moment it occurs to you that you are supposed to squat. At least there is no question of how clean is the seat! By this time, you may feel not very much at home, and may wish you were. But in the face of these differences in customs—in how things are done—we should not lose sight of the fact that the things that are done are familiar, at a higher level of abstraction.

There was a "cab" at the airport.

There were "porters" there to help you with your bags.

The porters wanted to be tipped.

There are public restaurants, where people gather to sit and talk.

There are public toilets.

Being joined at the table is a really simple difference in custom. But it comes as a surprise the first time it happens, when you're from North America where a single person generally is left to occupy a table for four alone. You can accept this difference easily. It is a pretty concrete event, and it may not have any more general implication about social behavior and culture. After all, North Americans sit elbow to elbow with complete strangers in theaters, church, and school. Why not in restaurants?

Some differences are less easy to accept at first, but are also understood with a little thought. In some places, cows roam the streets, are not owned by people or families, and are not eaten. In other places, dogs are kept by villagers, and are eaten. These differences may signal differences that persist at higher levels of abstraction.

Let's try to draw a thumbnail sketch of what happens when you face concrete cultural differences as simple as those noted above. We'll attempt a brief cognitive analysis of cross-cultural experience. The meaning of all objects and events is defined by the automatic associations that are triggered when we perceive the object or its symbolic form (e.g., a word that names it). For many objects and events, these associations appear also to contain the anticipation of a series of events (sometimes called scripts) in which we act in certain ways, others in the environment respond in anticipated ways, and the whole set of events goes as expected. To a large degree, this is what it means to be a competent actor in some culture—to have your expectations about what will happen and how to act in most situations fit with the actual unfolding of the events. The very fact that these are automatic processes, requiring little conscious awareness and calculation, allows us to navigate most of our interactions effortlessly. Life is different, however, when we cannot rely on the automatic responses we know so well, and have to consider our options, for both interpretation and action and for their appropriateness.

So when one's expectations are not confirmed, and when the things that actually happen signal that bad things may result, it is understandable that one might respond with a certain amount of apprehension. To make it worse, when you get off the airplane after 20+ hours of travel, you are already in a vulnerable condition. So when you get to your destination, and the young men grab for your luggage, you can be forgiven for thinking what you might reasonably think in other places (back home?) that you are about to lose some of your belongings. Then they want to be tipped. That's no big thing. It is easy to understand tipping in that context. But then you are confronted with trying to figure out how *much* to tip, in a currency which you do not understand, and where you do not know what is enough, and what is too much. There are lots of situations like this. A major characteristic of them is that your own cultural scripts don't work very well, and sometimes they shout danger when it doesn't exist. It doesn't take much intelligence to figure things out, but often the time demands don't help. It would be easy to figure out how much to tip the guys who helped with your baggage. You might

think of calculating the exchange rate based on an appropriate tip in New York, and give that. But it might be too much. After all, you don't want to be a "patsy." You could ask the cab driver. But the point is that any of these things will take seconds to do—seconds in which you imagine that the world has stopped to look at you while you figure things out. It would be nice if you could have a nap before you decide. It takes a while to figure out that one of the highest purposes of tourists is to leave money behind for the benefit of the people who made the travel memorable.

But wait a minute. Is this the kind of cultural knowledge that this book is about? Well, yes, and no. This kind of cultural knowledge may not seem to go very deep, but it is just the kind of confrontation with another culture that puts people off. Ready understanding of simple events and differences is really useful, and allows one to move further. You may recall from the introductory chapter that this is what happened to LeAnn during her second trip to France. People interpret each other's behavior all the time. We go through life giving and interpreting one-item tests. We see someone fail to act in a quick and clever way, and diagnose "stupidity." We hear someone say something inept, and diagnose "insensitivity." Who knows what our accuracy rates are for our cultural peers, but it's likely to be less when there is a discrepancy in cultural experience. Being from North America, we'd rather not have our appreciation for subtlety of color and design judged against an Indian standard, or our ability at language to be judged against a European standard.

BROADER PERSPECTIVES

Some people are able to encompass the rules of more than one culture. These are very interesting people. For emphasis and clarity, permit one of us (RSM) to report one of his experiences in first person singular.

Of the people I have met, over the course of 30 years of involvement in cross-cultural research, there are some whose understanding of the world I would like to have or to emulate. While I have been fortunate to meet people from many places around the world, few are fundamentally different from people I know at home in the depth or breadth of their understanding. There are many whose life experiences are rich and who have seen and lived through things that I have not. But then they have

not lived through what I have lived through. They are as limited as I am. It's just that their limitations are restricted to different things.

People who are really interesting are those whose understanding extends into more than one life—more than one world. I remember, for example, the most important lecture I ever had about cross-cultural research methods. It was delivered by the Chief of a band of MicMac Indians in Nova Scotia, Canada. The story is worth telling because it shows a depth and sensitivity of experience in this man whose education was cultural, but not based in school.

I was setting out to measure the values of the members of the 40 or so households in this group. My colleagues and I had lived with these people for a couple of months, and had very consciously managed our contacts with them so that no household would see us very much more or less than any other. We had spent a lot of time in their homes—the best and the worst—had eaten at nearly every table, and as a fundamental part of our research, we had been very interested in their views on all sorts of issues relating to their community, their history, their relations with other communities, and many other things. I grew to like and respect these people, even though I was still somewhat nervous about being a 25-year-old novice researcher in a community of people who must have seen me as a strange event in their lives.

The people knew that we would write reports of our experience with them—we had told them that much about our purposes. When we conversed with them informally it seemed to us that there was little attempt to conceal their views and feelings. They seemed very open, friendly, and expressive. Obviously, we were strangers, and would not get the same kinds of candor people would share within their family and community, but within those limits, our interactions felt genuine. But we wanted to do more than talk informally. We wanted DATA—data that come in "objective" forms, on questionnaires, and that are amenable to statistical analysis. So we went to the band Chief to get permission to administer questionnaires throughout the community: questionnaires about cultural values.

He could not allow it. He explained the difference between the informal conversations we had been having with his people and the formal interaction of a questionnaire. He reminded us that the people would know that what they would say on the questionnaire would find its way into print, and that they would say nothing to cast themselves and

their community in a bad light. His view was that they also would do nothing to jeopardize the respect they felt we had for them. Rather, they would tell us what they wanted us and the world to think of them. That would not be an accurate reflection of their community, he said, and so he could not allow it. He suggested we just keep talking with the people if we wanted to understand.

Privately, I was embarrassed. I knew well all the arguments he gave us, and had the feeling that I had just had a finger wagged at me by an experienced researcher—or maybe I was getting a pat on the head. He was right, of course, and I have carried that lesson with me ever since. But the point of the story is that this man lived in a world of more than one culture and understood much of the rules, processes, and preferences of both. What's more, he was reflective and articulate about the differences and their implications. I felt that his knowledge of the world was superior to mine because it could encompass more ways to look at things.

There is something interesting about this way of looking at knowledge. If there is no single and simple answer to the more interesting questions in this world, then being knowledgeable may well involve knowing a lot of possible answers and having ways to choose among them. If that's so, it is a good argument for knowing about "culture."

CULTURAL KNOWLEDGE

There really are two contexts in which to consider much of our knowledge of behavior and its cultural surroundings. The first is the formal knowledge that comes from empirical studies, theoretical analyses, and the systematic examination of firsthand observations. This is the sort of knowledge found in the published research literature in cross-cultural psychology. And it results in the kind of knowledge that is the substance of much of this book. But there is another kind of knowledge that is at least as interesting, at least as important, but not as well studied. It is the kind of cultural experience and comprehension that allows one to understand another culture "deeply" and to act appropriately. It is the kind of knowledge we wrote about briefly earlier.

It seems clear that these two kinds of knowledge may not be very highly correlated. Plenty of people who are consummate "natives" in various Western or other societies would be hard pressed

indeed to say anything very intelligent about culture and behavior from a scientific or formal point of view. Certainly one could find people with a very sharp formal understanding of culture who are not outstanding as practitioners of even their own (first) culture.

An interesting question concerns whether there is some point in life beyond which one cannot learn to be a "native" actor in a second (or third) culture. Is there a point beyond which we are forever destined to be "an upstate New Yorker," or a "man from Montana" (assuming these to be subvariants of U.S. culture)? What kinds of learning experiences lead us to be acceptable and appropriate actors in new lands? We hesitate to propose that there is a critical period for acquisition of cultural knowledge, but perhaps it is only early in life that we can acquire "unaccented behavior" just as we acquire unaccented speech.

Of course it is not an all or nothing matter. Some cultural learning, some progress towards becoming a native actor, can be very helpful in interpreting events in a new cultural context. Knowledge of culture in the second sense (implicit understanding) may be important in acquiring cultural knowledge of the first sense (formal knowledge), because observations need interpretation before they can be fed into the formal grinder of science.

The interplay of formal and informal knowledge doesn't stop here. We think most scientists would agree that the origin of good ideas in science is something of a mystery. It seems clear that they are closely related to "the times" (*Zeitgeist*, or spirit of the times), but some people have a knack of generating ideas that will turn out to be worthwhile. Yet we know of no one in the world of universities who has ever told of a course offered for graduate students on "how to have a good idea in (whatever field)." While that's what everybody is quite obviously working towards, they aren't explicitly taught how to do it (just as they most often are not explicitly taught how to teach!).

Most researchers who have thought much about it would probably also agree that the main business of science as a rational process has to do with evaluating and choosing among competing explanations for observations, or "phenomena." Science and its great repertoire of methods and methodologies is powerful as a choice strategy, but it has almost nothing to say about where to get the alternatives to be chosen among in the first place.

There's a story (we've forgotten the source) of a young magician who went out to buy a magic card trick at the store. He thought he was going to buy knowledge about the "magic" of the trick. When he got the package home, the instructions said: "bring the target card to the top of the deck by your favorite technique." He thought that *was* the magic, and having bought the trick he was still as much in the dark as before. Having good, and maybe new, ideas is part of the magic of science. Where do good ideas come from? How can we have more of them?

These questions lead to some intriguing implications, and it may be worthwhile to sketch where they might lead. Where do we get the knowledge that we use to understand new or puzzling events? Unless you want to admit the possibility of some kind of primal or genetic memory, it has to come through our life experience. If you accept the idea that both formal knowledge-developing processes (e.g., science) and informal or personal knowledge depend first on generating alternative possible "truths," then the person who can generate more possibilities, from a greater diversity of perspectives, will more likely end up with useful knowledge. So it is quite possible that the person who has had the more diverse experience—in both the sense of personal experience and formal experience—will generate more alternatives. How do we come to understand more? By being able to generate more alternative understandings, upon which the formal analytical thought processes can operate. Through reading, thinking, meeting new people, experiencing new places, and playing around with ideas, we become able to generate more contexts, more different points of view from which to generate alternative knowledges. One way to move in this direction is to learn about a diversity of cultures and the ways in which they shape thought and behavior. Many people through years of exposure to both formal and informal knowledge about cultures eventually become sophisticated and sensitive in their understanding of the world. We hope this book assists you in that direction.

Perhaps we should apologize for having complicated your life. From now on, when you encounter a specific difference between how it is done where you're from and how it is done among the people you will meet, you not only have to decide whether it is a fundamental or arbitrary difference (like what side of the road cars are driven on), but also from what perspective it ought to be viewed—relativist, universalist, or absolutist (see Adamopoulos & Lonner, Chapter 18).

THE ONGOING EVOLUTION OF CROSS-CULTURAL PSYCHOLOGY

The authors of the chapters in this book have already voluntarily, and gladly, complicated *their* lives by sharing a strong interest in studying the complex interrelationships between psychology and culture. Topical coverage in this volume has been as broad and representative of the field of psychology as we could make it, given the space limitations that any book imposes. Most contributors to this book, including ourselves, are "hard-core" cross-cultural psychologists. This means that we scarcely *ever* think of *any* topic or concept in psychology without considering its implications in a broader international context. Despite our strong identification with this particular way of looking at the world, we are not (yet, at least) so totally blinded by this perspective that we have lost the ability to ask questions about what we do and why we do it. A scientist who doesn't ask questions about what he or she does has lost something very important—the ability to wonder and to search for the often elusive truth. Thus, we frequently turn the binoculars around and look at ourselves with our own eyes, penetratingly and critically. We try to answer questions such as "What does all this mean?" "What do we *really* know about interrelationships between psychology and culture?" "What is the future of cross-cultural psychology?" "Maybe *we're* interested in these topics, but does the rest of the world care?"

To develop some context for this exercise in self-examination, we will present an analogy. In doing so, we will provide some information about a debate that has interested many who study relationships between language, thought, and reality. The last four words of the last sentence were the title of an influential book written nearly forty years ago by Benjamin Lee Whorf (1956). Whorf was an insurance adjuster who was fascinated with human languages, so much so that he became a very well known amateur anthropologist who attracted sizeable following of scholars. Whorf's basic idea—which has variously been called the Whorfian hypothesis, the Sapir-Whorf, or the Whorf-Sapir hypothesis (Edward Sapir was a famous anthropologist who worked closely with Whorf for number of years), contained two interrelated hypotheses about language. The first was that all languages are *relative* to one time and place, and hence are not entirely intelligible to speakers of any other

language. The second hypothesis posited that language, any language, is singularly important in shaping how a person sees and thinks about the world. Thus, language *determines* what we think, what we see, and how our "reality" is constructed. Some even argue that a culture can *never* be known by an outsider unless and until its language has been mastered.

Claims by devoted "Whorfians" over the years have been interesting and stimulating, and they have sometimes bordered on the preposterous. For example, Whorfians have argued that if a group of people have many opportunities to develop different words for snow or sand (Eskimos and desert dwellers, for instance), and others have not, their vocabulary will be such that they can actually *see* things others cannot see. Such claims have little basis in fact, as explained in a recent book, *The Great Eskimo Vocabulary Hoax* (Pullum, 1991). Nevertheless, words and concepts do in fact contribute to how humans think about the world. For instance, the rabid fan who would rather watch football (U.S. variety) on television than eat, or the highly experienced football coach, will "see" things on the football field, and develop words for what he sees, at a far greater and more sophisticated level than those who know hardly anything about the game. A football play called "wideout right, veer centerpost X, double D route" might be exceptionally clear to a coach, but would likely be total nonsense to anyone with little interest in sports. Similarly, the clinical psychologist who says that her patient "has a residue of latent hostility brought about by repressed, secondary libidinal processes that were arrested in pre-puberty rituals within the family" might be "seeing" things, on the basis of a highly specified language, that others cannot. Maybe what language does is to provide a road map to help like-minded people negotiate very complicated terrain. Maybe it's true that language and culture are one and the same.

In a book that is also concerned with interrelationships between language and culture, Berlin and Kay (1969) showed that the number of terms that humans use to describe colors can be understood in "evolutionary" ways. The essential idea here is that (1) all cultures naturally use terms to describe colors, and (2) the number of color terms that a culture has is largely a function of how "advanced" the culture is. Putting it in less pejorative terms (because in this context evolution is *not* associated with Darwinian theory), it appears that a culture will develop words for colors to the extent it *needs*

those terms to survive. Berlin and Kay showed that "focal" colors (essentially the terms used to denote the basic colors found in the visible electromagnetic spectrum) have emerged among cultures in a definite, developmental sequence. Thus, if a culture has only two words for focal colors, they will be black and white. If a third term exists it will predictably be red, followed by green and/or yellow, then blue, then brown, and next purple, pink, orange, and grey. Only in highly sophisticated and technologically advanced cultures will one find words such as mauve, burgundy, ecru, and chartreuse. It's not that less "advanced" peoples cannot actually *see* colors that have been described by such specialized terms; they simply don't *need* such a refined and variegated vocabulary to describe the enormous range of hues (stimuli) that the electromagnetic spectrum provides for anyone to see. Nature is an equal opportunity employer; cultures and their variable demands are more selective in determining what is important to know.

Back to analogy, now that some context has been given. How likely is it, do you suppose, that all the peoples of the world look at phenomena in the same way psychologists or anthropologists do? If you agree with us, you'll assert that it's not very likely. You might even express some relief that they don't! We pointed out in the introductory chapter that the word "culture" is not a God-given term. Rather, it was created by scholars and others to serve as a convenient guide, or marker, to help explain variations in the behavior of people in different parts of the world. Thus, consistent with Whorf's ideas about language, thought, and reality, a cross-cultural psychologist may be able to see a pattern of culture-mediated behavior—perhaps giving it a term like "collectivism," "clinical depression," or "stereotyping"—and make a big deal out of it, while most people would rather go fishing.

The analogy extends to Berlin and Kay's research on the evolution of basic color terms. Suppose that people in a "primitive" culture had only one word that they used to describe a particular position or function in their culture that a person from a highly advanced culture would call "scientific." What function would that word describe? We suggest that it might relate to numbers or arithmetic in some way; after all, counting things seems to be of paramount importance to any group regardless of its level of sophistication. What if the culture had a second term to describe the activities it does within its borders? We suspect that this second word would describe something similar to what

physicists do—that is, to try and understand how the world works. A third word might describe the work of people who try to save lives, people who are called physicians in the industrialized world. Of course, these words would likely not translate directly into mathematician, physicist, or physician—but they would be functionally equivalent.

Maybe you've seen what we're driving at: the number and sophistication of words that a culture has developed that are used to describe those people who do "scientific" things is *very directly* related to how technologically advanced a society is. Modern psychology, important as we think it is, is only about 115 years old. In the grand sweep of things, the importance of psychology may be miniscule compared to the importance of the more "basic" disciplines of math, physics, chemistry, and the like, all of which can be traced to the ancient Greeks and even much earlier. We suspect that the earliest people who roamed the planet were much more interested in how to move boulders with levers so they could plant more crops, and what to do about illnesses that wiped out whole tribes, than they were about the nature of a neighboring tribe's value structure or philosophy. Putting it bluntly, psychology as it is understood and practiced in the West is definitely *not* a universal discipline. We think that it *should* be, and we have a hunch that it eventually will be, but currently it isn't. To a very large extent psychology, as we know it and as it has been portrayed in this book, is strongly associated with the highly Westernized, highly "psychologized," and relatively affluent world. Ever since the barbarism of the Nazi regime resulted in a great "brain drain" from Germany in the 1930's, the United States has had the largest number of psychologists—well over 100,000 today—which *probably* leads the world in the *proportion* of psychologists per million inhabitants. However, with differing societal definitions of who or what a psychologist is, we can't be sure of such figures. Not far behind the United States in psychologists per capita are a number of Western countries, including Australia, Canada, New Zealand, Spain, Sweden, Finland, the Netherlands, Germany, and Israel. Several countries with large populations, such as Russia and China, have relatively few psychologists. Moreover, the qualifications to become a psychologist vary considerably around the world. So do the functions that psychologists serve. Argentina, for instance, has a large number of active, energetic, and resourceful psychologists, but a very high percentage of them practice a type of psychology that is hardly even known

in the Northern hemisphere. However, Argentine psychologists are well aware of cross-cultural psychology, and see it as very important as they continue to develop psychology within their country. Two highly related books give interesting accounts of how psychology is defined and practiced throughout the world (Russell, 1984; Sexton and Misiak, 1984). A helpful overview of "Psychology in a World Context" can be found in McConnell and Philipchalk (1992).

Related to this pattern of national and regional differences in the nature of psychology around the world is a growing movement called the "indigenization of psychology." When something is indigenous it is "locally grown" and "locally valid." Thus, many people believe that psychologists should not be as concerned about developing universal laws as they should be about developing a psychology that is valid *for* a particular society because it has been developed *in* that society by psychologists who have always lived and worked there (see Kim and Berry, 1993).

We have noted throughout this book that a growing number of psychologists in many countries are focusing on culture and ethnicity as major influences on human behavior. These psychologists might call themselves cross-cultural psychologists, cultural psychologists, ethnic psychologists, or indigenous psychologists. Regardless of which description they prefer, they share a common belief: In an increasingly complex world, psychology's traditionally narrow perspectives must take into account cultural, ethnic, and ecological realities. As cultures evolve, so must psychology, and as psychology evolves, so must it involve culture. One particular researcher, perhaps from Switzerland, may wish to help establish universal principles of behavior by comparing many cultures on some common dimension. Another, from Kenya, may derive primary satisfaction from understanding behavior only in the culture he or she calls home. A third, from the United States, might wish to understand the various ways in which Native Americans or African Americans define, diagnose, and help prevent psychopathology. Psychologists who are interested in studying how culture influences behavior form an interesting mosaic in terms of methodological priorities and how problems are defined and studied with different methodologies. As the interrelationships between psychology and culture continue to evolve, so too will the ways to conceptualize and study these interrelationships. Cultures and ethnic groups are living and changing phenomena; psy-

chology must continue to be prepared to meet the challenges of studying how such groups affect the thought and behavior of individuals.

AN INVITATION TO "JOIN THE PARTY"

Cross-cultural psychology, which we and most of the contributors to this volume represent, has been an identifiable method in psychology for many years. However, as mentioned in the introduction, it gained "formal" status as a field by itself only about 25 or 30 years ago. It has its own organization called the International Association for Cross-Cultural Psychology, its own publications, including the *Journal of Cross-Cultural Psychology* and the *Cross-Cultural Psychology Bulletin*. It enjoys cordial and scholarly relationships with other associations such as the Society for Cross-Cultural Research and a French-language organization called the Association pour la Reserche Interculturelle. Approximately 700 people in over 70 countries identify themselves as cross-cultural psychologists—but they all are *first* psychologists in some other aspect of more traditional psychology.

We hope that this book has stimulated your interest in this growing, and we think critically im-

portant, domain of psychology. We can provide you with details about the various organizations and publications. In the preface we listed the different ways you can contact either of us—by regular mail, telephone, facsimile (fax), or E-mail. We encourage you to join us in looking at human behavior from this broadened and broadening perspective.

REFERENCES

Berlin, B. and Kay, P. (1969). *Basic color terms*. Berkeley: University of California Press.

Kim, U. and Berry, J. W. (Eds.) (1993) *Indigenous psychologies*. Newbury Park, Ca.: Sage Publications.

McConnell, J. V. and Philipchalk, R. P. (1992) *Understanding human behavior* (Seventh edition). Fort Worth, TX: Harcourt Brace Jovanovich.

Pullum, G. K. (1991) *The great Eskimo vocabulary hoax, and other irreverent essays on the study of language*. Chicago: University of Chicago Press.

Russell, R. W. (1984) Psychology in its world context. *American Psychologist, 39*(9), 1017—1025.

Sexton, V. S. and Misiak, H. (1984). American psychologists and psychology abroad. *American Psychologist, 39*(9), 1026—1031.

Whorf, B. L. (1956) *Language, thought, and reality*. Boston: M.I.T. Press; New York: John Wiley.

Index

Abacus, 143
Ablutions, 68
Absolutism, 9, 129, 130, 133
Acculturation, 25, 37, 211
Achievement in Australia, 183
Achievement in Japan, 183
Acquaintance, and interpersonal distance, 180
Addiction, 82
Affect, and prejudice, 205
Affection, 113
Affluence, and individualism, 170
African Americans, 13, 17
Aggression, as universal, 132
Aggression, sex differences in, 108
Agriculturalists, 110
Alcohol, 80
Alcohol, American Indians and, 82
Allah, 66
Allocentrism, 24
Altered state of consciousness, 60
American Dilemma (Dubois), 18
American Indians, 35 ff
Antisocial personality disorder, 282
Approval, 113
Arctic hysteria (Pibloktok), 259
Aristotle (politics), 56
Arranged marriages, 123
Asian Americans, 13, 29
Assimilation, 37
Assimilation, cultural, 212
Association pour l'Reserches Interculturelle (ARIC), 310
Attitudes, and cross-cultural training, 243
Attributions, 43
Australian Aborigines, 146
Authority ranking, 170
Autonomy stage, in cultural adjustment, 253
Aziz, Tariq, 169

Back-translation, 281
Baker, James, 169
Baths, public, 67
Bathtub, 65
Behavioral approaches, 292

Behavioral observation, 110
Behaviors, and cross-cultural training, 243
Belief systems, parental, 98
Beliefs, and cross-cultural training, 243
Beliefs, nonprejudiced, 206
Beliefs, prejudiced, 206
Beliefs, stereotyped, 53
Belonging, support for, 103
Bender-Gestalt test, 159
Biculturalism, 26
Bigots, 85
Binge drinking, 83
Biomedical research, mental functioning and, 265, 266
Block Design test, 159
Brunswik, E., 136
Buddhistic orientation, 165
Butte, Montana, 8

Caffeine, 80
Caretaking, sex differences in, 108
Carpentered world hypothesis, 136
Causas, 299
Central processor model (in cognition), 140
Chastity, 198, 227
Chernobyl, 222
Chewa, 161
Child and Adolescent Service System Program, 297
Childhood rejection, 116
Children, as caregivers, 105
Children, economic values of, 269
Chin, Vincent, 30
Chinese aggression, 44
Chinese Classification of Mental Disorders, 281
Chinese Culture Connection, 166
Chinese Exclusion Act (U.S.), 31, 32
Chinese Immigration Act (Canada), 31
Cleanliness, 65, 66
Cleanliness, and age, 68
Cleanliness, and social status, 68
Clinical method in Piagetian psychology, 145
Coca, 80
Cognitive process, automatic, 204